ENDLESS HIGHWAY

D0931809

David Carradine

ÆE

JOURNEY EDITIONS

Boston ⇐ *Tokyo*

First published in 1995 by
JOURNEY EDITIONS
an imprint of Charles E. Tuttle Co., Inc.
153 Milk Street Fifth Floor
Boston, Massachusetts 02109

LIBRARY OF CONGRESS CATALOGING-IN-PUBLICATION DATA
Carradine, David.
 Endless highway / David Carradine.
 p. cm.
 ISBN 1-885203-20-9
 1. Carradine, David. 2. Actors--United States--
 Biography.
 I. Title.
 PN2287.C275A3 1995
 791.45'028'092--dc20
 [B] 95-24783
 CIP

First edition
1 3 5 7 9 10 8 6 4 2
05 04 03 02 01 00 99 98 97 96 95

Printed in the United States of America

CONTENTS

PART TWO
WHAT'S HAPPENIN' MAN?

PART THREE
CHILDHOOD'S END

➛

This book is dedicated to the god, Apollo

*I'd like to thank Hunter Thompson, who showed me
how to write about what I am.*

*Special thanks to my heroes:
Adam, Hercules, Praxiteles, Plato,
Shakespeare, Thomas Jefferson, Thomas Edison,
Auguste Rodin, James Dean, John Lennon,
and Dad.*

Part One

MADE IN AMERICA

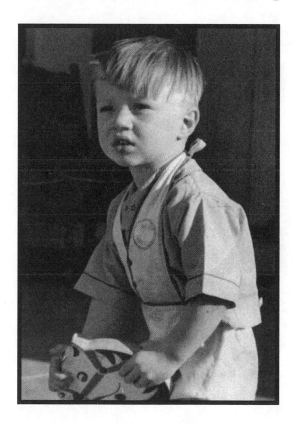

1936-1955

CHAPTER ONE

DAD

When I was a little kid, I had a problem with God. I didn't know if God was good or bad, or if maybe there were more than one of him. There was some possibility that he didn't like me; I wasn't sure. It was important, for instance, to keep secret what I really wanted; otherwise, God might go out of his way to fuck it up. I didn't really have it together to ask him to help me out. I'm not even sure that ever occurred to me.

My God was an angry God. You didn't ask for his help; you just tried to stay out of his way.

You could say things weren't going all that well. When I was five, I tried to hang myself in the garage by jumping off the bumper of the Duesenberg. My father saved me, and then confiscated my comic book collection and burned it—which was scarcely the point.

The comic book collection today would be worth as much as the Duesenberg. The family doesn't have either of them. If we did, we wouldn't have to work. That's the way it is with actors, real actors. We're not big savers.

John Carradine, born Richmond Reed Carradine, on February 5, 1906, in New York City, came out to California in 1927. He was just twenty-one years old. He had more or less run away from home when he was fourteen. His father, William Isaac Shelby Duff Green

Reed Carradine, a correspondent for the *New York Herald* and a part-time graphic artist, died from tuberculosis when little Richmond was two.

The first Carradines came to this continent in 1623. They were Irish mercenaries in the British Army. The original Irish Carradine is supposed to have been a Spaniard who swam ashore after the wreck of the famous Armada. This refugee was himself an Italian mercenary in the Spanish Army. His Iberian name was Caradegna. The patron saint of Barcelona is San Pedro Caradegna: St. Peter Carradine. The Italian name was Corodini. They came from Bologna: the Baloney Carradines. But that was a very long time ago.

According to the story, one of the children of that Caradegna who swam ashore to Galloway Bay (lucky him) became the indentured playmate of an Irish lord's little boy, like the nigger friend of the Southern plantation owner's son. In Gaelic, his name sounded like "Carra deen," or "Little (or dear) friend." So the name became an Irish name. There is a branch of the family in Galloway and a branch in Cork.

There were two Carradines, brothers, who came to America: David and Parker. When the American Revolution came around, the Carradines sided with the rebels, and afterward one brother went to Canada and fought Indians. He founded the Caradines (pronounced "Karadyne"). The other brother went to Tennessee and fought Indians. That branch became the Carradines (pronounced "Kerradeen.") Nobody knows anymore which brother went which way. We are the southern Carradines.

There is, to this day, the remnant of a plantation outside of Natchez, Mississippi, that is still known as "The Carradine Place." In Arizona, perched on the Great Divide, on the old Route 66, is Caradine's Drug Store. In San Antonio, there is a bronze statue of a pregnant woman holding an American flag, underneath which is the legend: ANN CARRADINE—MOTHER OF TEXAS. That one is a long story which we might get to later on.

My dad's mother, Genevieve Richmond Carradine, a very strong-willed lady, was the daughter of an innkeeper, but glorified the story that her family went back to James Madison and George Washington.

In the mix-up, Genevieve and husband William together are supposed to be able to claim as relatives Chief Justice John Marshall and political assassin Aaron Burr as well. Richard III is rumored to be in there somewhere.

William's father (my father's grandfather, and my great-grandfather) was the Reverend Beverly Carradine, a Methodist minister who wrote several books and was credited with starting the "Holy Rollers" movement, or the "Howling Methodists," as they are sometimes called, though Beverly himself denounced the movement, saying, "That's not what I mean, damn it!"

After William's death, Genevieve went back to school and managed to become a surgeon, a very unusual accomplishment for a woman of that time. She later married a Philadelphia paper manufacturer named Peck, who thought the way to bring up someone else's boy was to beat him every day just on general principle.

Genevieve and Mr. Peck had two more children: Leonard and Mary. Uncle Leonard went on to become a professor of History at Harvard and the coach of the Yale Cup sailing team. Aunt Mary successfully committed suicide some years ago.

My dad told me that he saw a production of Shakespeare's *The Merchant of Venice* when he was eleven years old and decided right then what he wanted to do with his life.

He developed his famous diction while studying at The Episcopal Academy in Swarthmore, Pennsylvania. This is also where he developed his remarkable memory. It seems that when one did something wrong at that school, the punishment consisted of memorizing portions of the *Episcopal Book of Common Prayer*. Dad was a very bad boy, so by the time he left he had memorized almost the entire book.

It's not totally clear to me exactly how things really went during this period of Dad's life. I have only his stories to rely on, some of which are at least superficially contradictory.

Although I know he ran away at fourteen, I also know that he had a bet with his stepfather that he would not smoke until he was twenty-one; the stakes were a hundred dollars. On Dad's twenty-first birthday, Mr. Peck walked into the room to find him in bed smoking a big cigar. Peck reneged on the bet.

I can only assume that Dad ran away from home and then ran

back. He never graduated from high school; however, he was an omnivorous reader and became an authority on everything. He held honorary degrees from several universities.

There was an uncle who lived in New York City who took care of him during the runaway phase. His name was Peter. Dad worked as a bank runner in New York, and for a while he worked for the Public Library cataloguing the theatrical archives—clippings and so on, incidentally absorbing, with his remarkable memory, his enormous and ultimately legendary knowledge on the subject.

I once met a retired stuntman (he lived across from me in Laurel Canyon in the late sixties) who had known my dad during this period. This stuntman, who at that time was more or less a bum, used to lounge around on the steps of the New York Public Library, on or about the huge stone lions, smoking grass. We're talking about 1922 here, you understand. When my dad would take a break from his cataloguing, he would stand out there and fraternize with this weirdo.

I get this picture of Dad hanging out with this prehistoric pothead, getting himself a contact high without knowing it, and then going back into the dusty archives and grooving on the Drews, the Booths, the Barrymores, etc., never realizing that he was trippin' on Mary Jane. This accidental potheadedness may have been the most influential aspect of his whole education, though he is turning over in his grave right now to hear this.

Most of the stories Dad told me about his early life were laid on me at two or three in the morning, after the bars had closed. He'd climb the stairs and come into my room to check on his firstborn. I was usually awake (forbidden, but I'm as much of a night owl as he was). I'd be under the covers with a flashlight reading comic books, or playing with myself. When he bent over to kiss me good night, I'd pretend to wake up and would then engage him in conversation. He'd sit on the edge of my bed and talk to me for hours on every subject imaginable: Greek architecture, music, philosophy, history, Shakespeare, of course, and other literature, poetry, art—you name it—plus the stories. There were hundreds of them, maybe thousands. I usually fell asleep in the middle of all of them but, fortunately, there were lots of repetitions.

While still in his teens Dad went to Richmond, Virginia, to visit

the great sculptor Samuel Chester French, the artist who fashioned the Lincoln Memorial. He asked French to take him on as an apprentice. French replied that he really didn't have enough work at the moment to warrant an apprentice; however, he let him sleep in a corner and sweep up, keep the clay wet and the tools clean, and work on his own things, which French would critique (a perfect description of an apprentice). At one point French did let Dad work on the edges of some of his sculptures, much as St. Gaudens had let the young Rodin work on the hands and feet of his monuments, but the acting bug and wanderlust finally carried young Richmond away.

At the beginning of his travels, Dad went from town to town painting portraits. He would walk into an office and offer to make a sketch. He told them, "You don't need to pose; just go on with your work. I'll be finished in ten minutes. If you don't like the picture, you don't have to pay for it." If they liked it a lot, he'd talk them into an oil painting, which would entail a fee, a lot of sittings, and a certain number of dinner invitations, during which, aside from eating his fill, he might grab up another commission and maybe even a young lady for a night or two.

One time in Tennessee the system failed. He was arrested for vagrancy and was on his way to a chain gang. What saved him was a beating he received in jail.

The judge took one look at him, all bleeding and broken, and said, "This man has been punished enough. Let him go!" He was released and told to get out of town. Dad was happy to comply.

That night in jail, his nose had been smashed. The way it healed without medical aid was what eventually determined the look that would become world famous. Funny how things work.

For a poor wanderer there is safety in numbers. Dad joined up with a traveling tent repertory theatre, as a caricaturist and portrait painter. One night the actor who was playing the villain was too sick or drunk or something to go on. Well, Dad knew all the lines by heart, so he got his big chance that night. He stayed on to play lots of parts in everything from musicals, comedies, and melodramas to Euripides and Shakespeare. The star and manager of the outfit was an old classical actor named R.D. MacClean. He became Dad's mentor and his only real teacher.

It was old R.D. who told Dad that in order to play the great roles he had to "darken" his voice and taught him the exercise to accomplish that.

At some point Dad decided to try his luck in Hollywood and started working his way west. He got a job as a banana messenger, which consists of riding on a freight train along with a load of bananas and carrying the bills of lading to the destination. At one point during the trip his hat flew off and he pulled the cord to stop the train so he could run back to fetch it. It was an expensive hat, a homburg I think, and he didn't want to lose it. The conductor explained to him patiently how much it cost the company to make an emergency stop with sixty cars and two locomotives, not to mention the havoc it created in the caboose, and kicked him off the train, leaving him stranded in the middle of Kansas. He hitchhiked the rest of the way.

OLD HOLLYWOOD

R ichmond Reed Carradine arrived in Los Angeles at an exciting moment. Movies had just gone to sound, and what was needed were actors who could talk. My father certainly qualified in that respect; still, breaking in is a bitch, and he was friendless, broke, and completely unconnected.

Dad told me once (or maybe a dozen times) that in those days he slept in parked cars. He'd walk along, say, Hollywood Boulevard, trying doors until he found an unlocked car, slip into the backseat, and go to sleep. One morning he woke up being driven down the street. He sat up in a panic and the owner, spying him in the rearview mirror, almost wrecked the car. Dad jumped out and ran. From that point on, he favored sleeping in the bushes.

There's a story that's been going around for years that, at this time, Dad made a habit of walking down Sunset Boulevard, wearing a cape and reciting Shakespeare. Well, of course he recited Shakespeare as he walked along; why not? However, the "cape" was an overcoat someone gave him that was too small. Los Angeles is plenty cold in the winter, especially for an itinerant actor who has no place to live. He couldn't get his arms into the sleeves, so he wore it over his shoulders; hence, the "cape."

He managed to get himself invited to cocktail parties and ladies' teas on the strength of his ability to recite. He told me that the cakes

and cookies at these functions were, for a time, his sole source of nutrition. Every other night or so, after the bars closed and the parties wrapped, he would go to the Hollywood Bowl to practice R.D. MacClean's method of voice improvement, which consisted of shouting Shakespeare at the empty seats until he was hoarse. Then he'd go away, heal up, and do it again. He would position a friend in the back seats, usually Art Yoeman or Morton Lowrey, who would shout at him, "Louder! I can't hear you!"

This practice came to an end when someone who lived up the hill from the Bowl called the cops on him. My father told this story to John Ford years later, and Ford said, "That was me who called the cops. You were driving me crazy." I've always wondered if it really was Ford or if he just said that. Ford was quite capable of creating that legend on the spot, just as a gag.

Dad started to make ends meet with his drawing and painting; designing restaurants and stage sets, doing portraits, murals, Christmas window dressings. I did a lot of this stuff myself during my early lean years. You go around with a portfolio and try to talk a merchant into buying your work, and they say, "No thanks." Every once in a while, you score.

One of Dad's accomplishments during this period was writing and illustrating eight little booklets on makeup techniques for Max Factor. These booklets are now out of print and collectors' items, but you will find them in most makeup artists' kits to this day. Dad knew more about makeup techniques than most of the big studio departments. He taught me most of his secrets and formulas. To this day, in some respects, the industry still hasn't caught up with him.

When Dad showed up in California, there was an enormous amount of theatre in L.A. The inroads of movies and television had yet to take their scythe-like toll on live drama. Dad, after a while, picked up a lot of work in L.A. theatre. He told me that his first appearance in L.A. was singing at the Million Dollar Theatre, as accompaniment to a young dancer named Agnes de Mille. Later he landed the part of Romeo in Shakespeare's play, with Agnes as Juliet, at the Ebel Theatre in Hollywood. The director of the piece, who was at the same time the actor who was to play Mercutio, was an elderly matinee idol (in his seventies).

Dad, who had by now changed his name to Peter Richmond in homage to his kindly uncle Peter, was uncomfortable in the role of the romantic lead, and the director-Mercutio was too old to cut the mustard, so he talked the producer into firing the old man. Dad took over Mercutio and the directing, and he cast a young stud who was Agnes's friend to play Romeo. All went well except, I guess, for the poor old matinee idol; but that's showbiz.

Around this time, Dad engineered his way into directing and acting in a series of Shakespeare's historical plays at the Pasadena Playhouse. The heavy role he had to assay was Richard III. He decided to go talk to John Barrymore, who had played the part on Broadway with great success and still remained arguably the foremost Shakespearean actor in Hollywood, if not in the country and in the world.

Dad found out where the great man lived and went to see him unannounced, wearing his best clothes, which included striped pants, spats, his beloved homburg, dove-gray gloves, and a malacca cane. My father affected this kind of dress, with variations, all his life. The cane was strictly for style back then. It seemed to me he always wished he were older than he was.

He walked down the sidewalk and up the steps to the front door, very elegant and stylish, if old-fashioned, though threadbare and painfully skinny. He rang the doorbell with his cane and stood back to wait, striking a jaunty pose. Getting no response, he went through the process again with the same flair. Still getting no answer, he, with a flourish, rapped on the door with the stick. He was about to try for the fourth time when he noticed something out of the corner of his eye.

He turned to look and there was Barrymore himself, in a robe and slippers, standing on the lawn watching him, his hands in his pockets and a cigarette dangling from his lips.

Barrymore said later of this meeting, "He looked like something that had been dead for twenty years and then [pause, snort] dug up again!"

"Peter Richmond," my father said, and extended his hand. Barrymore just stared at him. Undaunted, Dad launched into his explanation of why he was there: his ambitious plans for the

Shakespeare cycle, and how he'd like to get some pointers from the Master.

Barrymore took the cigarette out of his mouth and said, "You are intending to direct yourself?"

Dad said, "I am."

Barrymore looked at Dad: 125 pounds, threadbare finery, twenty-six years old, broken nose and all. He turned away. "Follow me." They walked around the house to the back and Barrymore sat down on a tree stump in the middle of the yard. He yelled, "Nieche!" A Filipino houseboy appeared. "Drinks!" The houseboy disappeared. Barrymore turned back. "Show me your walk," he said.

Dad immediately launched into a long dissertation on Richard III's character, how he was a nobleman and attractive to women and a strong swordsman and all in spite of his deformities. He then limped around Barrymore on the stump, exhibiting his "withered" arm. During this, Nieche reappeared with glasses of gin and California orange juice. Barrymore took a swallow of his drink, stood up, and said simply, "I walk like Lionel." He then demonstrated, doing a perfect imitation of his brother.

They spent the rest of the afternoon, and most of the next ten or fifteen years, drinking and talking.

I think it must have been around this time that Dad changed his name to John Peter Richmond.

Dad now had a studio that he was renting from another starving artist, and he was producing an immense amount of work there. Dad was working on a twelve times life-size bust of John Barrymore, some large figures, and some other works: drawings, paintings, miniatures, and so on.

Through Agnes de Mille, Dad met her uncle, Cecil B. DeMille, the great director of biblical epics who was to be responsible for his start in pictures. C.B. hired Dad as a scenic designer on *King of Kings*. DeMille didn't like his designs and fired him. The story is that Dad didn't put enough pillars in them to suit C.B.

Dad had a story about DeMille. DeMille and his crew were all walking down the beach and C.B., who was dressed in biblical robes, was pointing at the cliffs and saying, "Build me a city here!" and gesturing toward the sea and saying, "Give me a mighty harbor!" Two

bums were lying in the sand. One of them said, "Let's get out of here. This guy is crazy!" "No! Wait!" said the other bum. "I wanna see him walk on the water!"

Dad obtained a commission from DeMille to do a heroic-size bust of him, in the style of a Roman senator. Since DeMille would not pose, Dad needed to make sketches of him on the set of his present production, which was *The Sign of the Cross*. DeMille put Dad in wardrobe and paid him as an extra.

During a noisy crowd scene, DeMille heard a huge bass voice that overpowered the hundred or so yelling extras. He looked around for where the voice had come from and was amazed to see it emanating from the cadaverous form of Dad. He subsequently hired the young sculptor to do voice-overs on the picture. Notably, he had him recite the Sermon on the Mount, which was dropped into the mouth of another actor who appeared to recite it while walking among the Christians about to be fed to the lions in the Coliseum.

Dad's face never appears in the picture but his voice is all over it. Dad eventually became a member of DeMille's stock company. By the end of it all, they had done eight pictures together.

One night Dad came home and discovered that his landlord, an unsuccessful sculptor who had been trying for years to get the commission to do DeMille, had, in a drunken fit of jealousy, let himself into the studio and destroyed everything. The plaster of DeMille— which was to go to the bronzers the next day—had been smashed with a hammer, the huge bust of Barrymore was torn apart and stuffed back into the clay bin. Everything else in the place was wrecked.

Dad's career as an artist never recovered from this setback. After he sobered up and calmed down, he began concentrating on his acting career in earnest.

The records show that Dad's first film role was as a half-wit in a picture called *Tol'able David*, but Dad told me that he did over seventy pictures before he got billing. Most of them were one-scene bits. According to him, the first was a bit in which he stands inside a store window while a black car drives by and sprays the window with machine-gun fire. This was in the infancy of such effects, and the way to create the illusion was to really do it. They sprayed the window with live machine-gun fire.

Just before the shot Dad was told, "Make sure you get way down."

Dad was faced with an awful dilemma: duck down too early and he wouldn't get any camera time; too late and he'd take a burst of machine-gun fire in the chest. To the grateful relief of all the subsequent Carradines, he did it just right.

For a long time Dad didn't have an agent. He would respond to calls from Central Casting or he would get his jobs through the stage manager, a designation that is no longer used in films. Dad would show up on the set and the stage manager would say to the director, "See that guy over there? He'd be great for the drunk in the café scene."

One notable Central Casting call was for him to appear at the Universal makeup department. They sat him down in a chair and proceeded to make a plaster cast of his face. Dad said, "Wait a minute. What kind of a part is this, anyway?"

"It's a monster."

"Does it have any dialogue?"

"No, it just grunts."

"I don't play parts like that." And he got up and walked out. The next person in line was Bela Lugosi. He expressed the same sentiment. Boris Karloff was next and he accepted the part; Frankenstein, of course.

Somewhere along the way things started working well enough for Dad that he was able to get an agent. He began to be offered better roles. He took just about every offer that came his way, notwithstanding Frankenstein.

He knew a plastic surgeon who offered to fix his broken nose for free. When he came out of the anesthesia his nose was straight, but it was a different nose, the surgeon having waxed creative while John was unconscious. Since he was stuck with a new nose, he gave himself a new name: John Carradine.

He fell in love with a girl named Mary, who went back East to think it over and died there, of pneumonia, I think. After a period of inconsolable grief and extreme drunkenness, he settled back into his old unforgettable-character, revolving-party mode.

According to Dad, it was his seventy-fifth picture that broke

him through and gave him his first featured billing as John Carradine: *Prisoner of Shark Island*, directed by John Ford and starring Warner Baxter. Dad, as the mean warden who tortures Baxter and then repents at the end, stole the picture. Twentieth-Century Fox offered him a seven-year contract.

Dad said to his agent, "Wait till the picture comes out. I'll be able to write my own ticket." The agent said, "You're getting the big head, John." Dad caved in; he signed the contract, starting at $250 per week. Not great pay, even for the time, and they made him work for it. Sometimes he acted in three pictures in one day; two was common. He'd speed from set to set by bicycle, playing little one-scene bits. Along the way there were juicy roles for him in a dozen of the best pictures ever made.

Even though he was underpaid, the weekly checks were a bonanza to him. The high life began to scare him. He started looking to settle down. He was sitting in an easy chair at a Christmas party when a beautifully dressed girl walked in who was an absolute dead ringer for dead Mary. She sat down on the floor at his feet.

According to her, the conversation went like this:

"Are you married?"

"No."

"Can you cook?"

"I'm a great cook."

"Can you sew?"

"I make all my own clothes."

"Do you like children?"

"I have a two-year-old boy of my own."

(pause)

"Madam, you and I are going to be married."

"You're stark raving mad!!"

"That's what all my friends say, but nevertheless, you and I are going to be married."

They did the deed two weeks later, on New Year's Eve.

CHAPTER THREE

MOTHER

rdanelle Abigail McCool was born on a cattle ranch in the mountains near Golden, Colorado. Her father, Ambrose Rucker McCool, had come over in a covered wagon as an infant. He and his large family carved out the territory, as they say: built towns, fought Indians, hunted bears, all the usual stuff.

The Colorado pioneers broke the ground with a shovel in one hand and a rifle in the other. When he was twelve, Ambrose participated in a cattle drive. During the night, Indians wiped out two of the three wranglers' camps. If the braves hadn't miraculously missed the outfit Grandpa was in, I wouldn't be here to tell about it.

When Ambrose was about fifty, a cattle drive took him north to the Platte River in Nebraska where there was a railroad. There he sold his cattle and, with a big wad of money in his fist, went looking for a wife. Sort of like John Wayne in *Red River*. His friends called him "Brose."

Brose found Edith Foster, a lovely seventeen-year-old with three strapping brothers. Impressed with McCool's strong manner and his obvious solvency, the Fosters arranged the wedding and Edith headed off to what she thought would be a magnificent ranch house.

When she arrived, what she found was a log cabin with outside facilities. The trip south had toughened her up and prepared her

somewhat and the marriage had been consummated on the road, so she gritted her teeth, stayed, and bore Ambrose a son and a daughter: John and Ardanelle Abigail McCool—Nellie.

Edith also talked Ambrose into moving the family into a proper house near a church. Later, when the population began to grow, she taught school. Grandpa himself would have told you he had bitten off a little more than he could chew.

The three strapping brothers—Will, Clay, and Albert—later on spread out all over the country. One of them, my mother's uncle Will, spent a brief time driving an ambulance in World War I (they let him go back home after he wrecked a couple too many of them), then went to New York and became a highly paid illustrator for the *Saturday Evening Post*.

One day Uncle Will came home and found his young wife in bed with a stranger. He mounted his motorcycle and rode it to California, leaving everything behind: money, property, wife, daughter. He became a carefree struggling artist and an art teacher. He stayed just that way for the rest of his life. He was an enormous inspiration to me later on; I grew up surrounded by his leftover unfinished paintings; and I mean surrounded. There were literally hundreds of them.

Uncle Will died at the age of seventy of heart failure, as the result of a debauch that included a gallon of spaghetti, a gallon of red wine, and a "daisy chain" of the best of his models. (Actually, my mother was his favorite model; easily a third of the paintings that I grew up with were nude or half-nude studies of my mother, from the age of twenty-five to fifty-five; however, she would never let him "enrich" the relationship the way he would have liked to.)

Uncle Clay was an ambulance driver too, but he hung on to the job and later worked for the Board of Health tracking down fugitive tuberculars. He settled down on his pensions to two acres in Camarillo: avocados, grapefruits, ducks, chickens, and rabbits.

Every month he'd cash in his pension checks for cases of gin and cartons of Raleigh cigarettes. (They were the cheapest cigarettes you could buy, and they had coupons you could get stuff with.) He'd sell his avocados and grapefruits for the rest of his needs, and when company showed up he'd kill a chicken, a rabbit, or a duck. He had

to get very drunk to do this; he loved his livestock. More than once I saw an imperfectly axed fowl flopping around the yard, spraying blood all over the place, and Uncle Clay pursuing it with an ax, staggering and weeping as he lurched after it in a combination of put-it-out-of-its-misery mercy and "you–God–Damn–Motherfucker!" drunken madness.

The name of his ranch was "The Hide Out." There was a sign out front that proclaimed that fact (which, it seemed to me, defeated the purpose), and everybody had a hand in building the place at some point. It was part of anybody's visit there. You had to work on the place: painting, or sanding, or nailing, or digging. It was worth it. There was always a lot of loving, laughing, and music. My mother's brother Johnny once shot a hole through pretty much the whole house (two floors and three walls worth) with a theoretically unloaded .357. It was always exciting at The Hide Out.

Uncle Albert married a battle-ax woman that no one in the family liked (even, maybe, including Albert), and he became an avocado farmer somewhere in the San Bernardino Valley. He was the only one of the brothers who was ever sober, though he would have had it some other way if he could have got it past his ever-vigilant wife.

Grandma McCool—Edith—was a very sober person. She was a devoted religionist, reading her lessons every day and going to church twice a week. She was, however, an easy person and no kind of Bible snob. My mother inherited her saintly nature, though for some years Mother cut quite a swath and she was capable of great rages every once in a long while. She could also carry a grudge, but not forever.

By the time little Nellie followed her wayward uncles to the warm California sun, she had married a photographer named Frank Cosner, had a son, Bruce, got divorced, and then met John Carradine. Nellie had changed her name to Abigail, Gail for short.

John moved her and little Bruce into a house on Canyon Drive in the Hollywood Hills and proceeded to strive to produce an heir.

CHAPTER FOUR

POOKY

On December 8, 1936, at precisely twelve noon, Abigail dropped her foal on the ground. I know the exact time because the doctor had a bet with the interns (a case of beer) that the baby would be born before noon. My mother was lucid enough to be able to deliberately push extra hard to help the doctor win. She liked him. He had to pay anyway, because he had said *before* noon. Mother told me I wasn't a difficult birth at all; she said it was just like taking an enormous shit. I'm sorry, but that's what she said.

My earliest memory is of sitting in the bathtub with my mother. I don't know how old I was, but I'll never forget those thighs and those enormous tits.

Much later (the sixties, of course), under the influence of a massive dose of LSD, I re-experienced the birth canal and other early moments—having my bottom powdered, enormous people making faces at me, that sort of thing. I went on, in that acid trip, to relive my whole life up to the wretched moment when, in my single room at the Montecito Hotel, unable to go on with life as it was, I dropped the pills. Then I went out into the world and started over again—but we'll get back to that later on.

The moment I think of as pretty much the beginning of every-

thing was what I guess you could call my first encounter with the concept of Art.

The family had moved out of the house on Canyon Drive to a place in the San Fernando Valley, in a little hamlet called "Valley Village." One day my mother left Dad alone with me while I was taking my nap. He used the time to work on one of his sculptures. As will happen, I woke up and started yelling. I don't know how old I was but I was still in my crib. He came into my room to find me standing up shaking the bars and screaming. He scraped some of the clay off his hands, rolled it up into a ball, and handed it to me. I was delighted and sat down quietly, absorbed in this miracle. He went back to work, leaving me happily gurgling.

Inevitably, I squashed the ball and started yelling again. He came back and I held out the ruined thing to him. He took it, restored it, and gave it back to me. I looked at it, squashed it, and handed it to him again. He showed me the magic once more.

Now you've got to understand that balls are a special item to little boys. They're the essence of Fun, and you don't make them, you buy them. This miracle meant more to me than any of my father's nude women or clever portraits. I sat down and started to try. A sculptor was born.

Before long I was sitting on the floor beside my dad in the studio, making little things. I remember particularly three little men in a boat; I can still see them very clearly when I think about it. Chances are, it was "Rub a Dub Dub, Three Men in a Tub." The greatest sculptures are all based on myths.

Later on Dad took me to see Walt Disney's *Fantasia*. Next morning there was a line-up on the windowsill of all the dinosaurs, arranged in order of height, meticulously reproduced in plasticine from the illustrations in the souvenir program. From that moment on, I was "the Artist." My development in that direction was encouraged whether I liked it or not. That's also the moment when my older brother Bruce started beating me up.

Dad's contract had been picked up more than a couple of times by Fox, and he was now making a big $400 a week. In those days, a fortune. He'd also put a few great pictures under his belt: *A Message to Garcia, Mary of Scotland, White Fang, Captains Courageous*

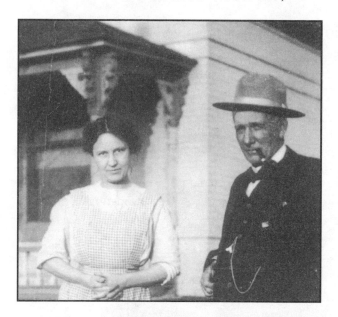

Above: Mother's roots: Grandma Edith McCool and Grandpa Ambrose McCool, Colorado, 1916.

Right: Ardanelle Abigail McCool and brother Johnny, Colorado, 1916.

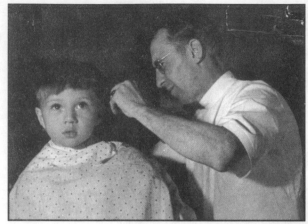

My first haircut.

*Right: I **hated** carrots!*

Below: First piano lesson, with brother Bruce.

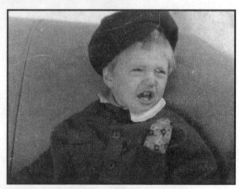

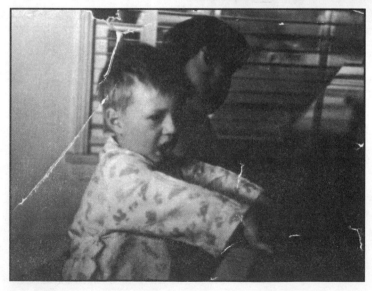

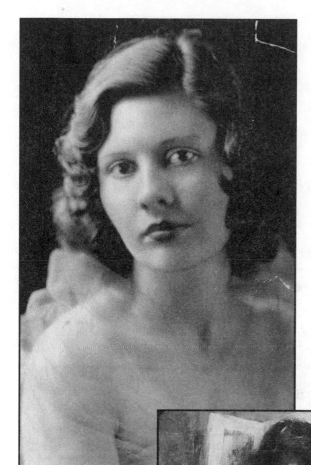

*Mother. Photo by
Frank Cosner.*

*Mother as painted by
Uncle Will.*

Me at age 3, practicing "the look."

(his personal favorite), and *Of Human Hearts,* in which he played Abraham Lincoln.

Right after *Captains Courageous,* the call of the sea hit him and he bought himself a sixty-four-foot schooner, the "Bali," which he skippered himself.

The Bali was built by a famous boat designer named Hand. He had never designed a pleasure yacht before, so he took plans for a Gloucester schooner, the ship that had originally won the Americas Cup, and scaled the design down from 110 feet to 64. The Bali had been owned by a stockbroker. During the crash of '29, this good Samaritan had juggled his books to make it easier on those clients who could not afford the loss. The authorities caught up with his Robin Hood act. He knew they were going to move in on him. The stockbroker secretly loaded the Bali with provisions and stole away in the night, sailing the boat alone. This would have been impossible except that he had put in a system of blocks (pulleys) so that he could handle the sheets (ropes) from the helm (wheel).

He sailed south, around the Horn and up to the Caribbean. After a couple of years, thinking that the heat was off, he sailed back. Going around the Horn from east to west and up the coast of South America is a different matter. It's all uphill—against the wind. By the time he reached Baja California, he was sailing on bare poles. His sails had been ripped to nothing by the hurricane-force winds. He lashed the helm over so the boat would drift in circles and he swam ashore. The feds were waiting for him on the beach.

Some ne'er-do-well fishermen rowed out to the boat to claim it for salvage. To make better their claim, they poured gasoline into the engine room and set it on fire. The damn boat wouldn't burn. It was teak. Teak won't burn easily. When the gasoline ran out, so did the fire. The bank ended up with the Bali.

Dad bought it for a song. In the captain's cabin was a map table. When you lifted the top, there was a hatch that led to the engine room. Under the top there was a quarter inch of char.

After a lot of work, there was no more beautiful boat in San Diego harbor. Dad was king of the yacht crowd. He hired a pro to teach him how to skipper the beast. After a couple of days, the bloke

told him he couldn't teach him any more. Dad was a great sailor but a lousy navigator. We got lost a lot.

It took three or four people to sail her, so rather than hire on a crew he would invite some people to go out with him, set one sail to get out of the harbor, and when he had them trapped out on the ship he'd invoke the "Law of the Sea" and force them all into service. He drilled them in their duties, and when they'd got it right he took them for the sail of their lives, though they had to put up with him acting like Captain Ahab. He brooked no mutiny, though I don't think he ever keel-hauled anybody.

Dad also invested in a used Duesenberg Roadster. Gary Cooper had an identical Duesy and they used to race each other across the valley. After nearly buying it a couple of times, they made an agreement to keep the cars in second gear for their races, which held them down to about 80 mph.

There was only one garage in L.A. that had tools for the Duesenberg. Both Dad and Coop would rent the tools from the guy who owned the place and work on their cars themselves. They would lie in the oil under their Duesenbergs and pass wrenches back and forth. Dad told me that Coop's idea of a relationship was absolute silence. He didn't like to talk. According to my dad, he just liked to sit and whittle. If you tried to engage him in conversation, Coop would clam up and just keep whittling or fold up his jackknife and go away; but if you could sit next to him for an hour or so and not say anything, he'd start to like you.

The house we lived in on Ben Avenue in Valley Village cost Dad $4,500, and right away he remodeled it to include, among other things, a formal library, a sculptor's studio, and a darkroom.

My father's success allowed my mother to take her father, Ambrose, out of the rest home and bring him to live with us. He was eighty-six years old and he didn't really know what the hell was going on. He used to stand on the front porch and piss on the lawn, with the cars going by and people walking their dogs. He had no idea where he was. He'd spent all his life in the mountains of Colorado and a suburb of Los Angeles was outer space to him.

He used to say, "By God and by damn, kid, this is the damnedest

thing I've ever seen." Grampa always preceded everything he said with "By God and by damn."

Ambrose didn't last long in the valley. He said to my mother, "By God and by damn, Nellie, I'm headin' for the last round-up. Now, by God and by damn, don't you get all trussed up in black lace and come to my funeral with a whole bunch of flowers. Wear a spring dress and a picture hat and dance and laugh for me. Take that flower money and buy yourself a good steak."

He went out quietly, shortly after that. Mother followed his instructions to the letter, much to the outrage of most of the rest of the family. When they castigated her, Mother just said, "Oh, you make me tired." Her love for the old man was hers and hers alone. I was not invited to the funeral.

I think when Grandpa "went away" was when I started wandering. Not very far at first—next door, say, or across the street. Gradually I became one of those dogs that just can't be kept in the yard. I would take my little red wagon, load it up with some good stuff—my teddy bear, my blanket, something to eat—and set off. Sometimes I'd bring things home, like a bunch of rocks, or a harvest from one of the nearby orchards.

One time I brought a duck home. I sneaked it past the grown-ups and stashed it in my closet, which had just been painted. At bedtime, when my dad came to tuck me in, I said, "Don't look in the closet." He did, of course, and there, of course, besides the duck, were a lot of duck paint-prints. He asked me how the duck got there. I told him I didn't know anything about that duck.

As part of my wanderlust story, I should mention the times that I climbed out the window when I was supposed to be taking a nap.

Eventually Dad caught me at it. He said, " All right. If you want to climb out windows, then that's what we'll do." He made me climb in and out the window until I got sick of it; or so he thought. I climbed in and out the window willingly and happily, until he finally went and got himself a chair. He sat in that chair and watched me; eventually I started singing: "In and out the window, in and out the window." I wore out a pair of socks. This incident didn't even approach making me tired of climbing out of windows—or, much

later, climbing in windows, for that matter. That's another story, which we'll get to.

When things weren't going right for me, I would take my wagon and run away from home, usually to the next block to the Boders' house. They were a large family with kids all ages, and lots of cookies and things. I would announce on arrival that I was going to live with them now. They'd call my mother and then keep me there until I wanted to go home; usually a few hours, though sometimes overnight.

Once in a while, though, I traveled farther. Many times my parents had what we then called the "radio" police looking for me, though they rarely found me before I made it back on my own. There are some policemen in greater Los Angeles, who by now are captains or commissioners, who, as rookies, were forced to beat the bushes for Pooky Carradine. I have to watch myself in this town. I have a long record.

With Grandpa gone, Grandma McCool came to live with us. Grandpa had left her a sizable legacy, which she gave over to the accountants to administer for her. Though she had been a teacher of arithmetic in Colorado, she seemed to have no head for business, and though she was financially independent, she preferred to live in the maid's quarters behind the kitchen.

It was Grandma who gave me my nickname "Pooky," which is German for "Little Fart."

She read me the comics (I would correct her on her characterizations), and she sewed and made cakes and cookies, just like Grandma is supposed to. Once she made me a Lone Ranger outfit. I argued with her about the design of the shirt. For Halloween, she collaborated with my mother on a pirate costume. She made me a Superman outfit, with which I had no argument. I took it up to the roof and tried to fly. It didn't work, but I didn't hurt myself either.

I would have flying dreams pretty regularly. I flew all over southern California. In my dreams, I had a hard time with the "regular" earthbound people. They used to chase me as I desperately tried to gain enough altitude to be out of their reach. If they caught me, they'd definitely do something weird to me. I had to stay out of their clutches. It seems to me I always did, though there were some close calls.

One particular flying dream I remember vividly. I had flown a great distance. I was hovering at about 5,000 feet or so, a great height for a five-year-old flying without mechanical assistance; around me were many other fliers. Far below us was an island, with a harbor and ships. The older fliers cautioned us not to get any closer. We were all waiting for something that we expected to happen. Nothing ever did happen before I woke up. We just waited and talked a little. I know the exact date of this dream because it was the night before my fifth birthday: December 7, 1941.

I'll never forget that birthday party. One of my guests stole my party favor. I hit him and got sent to my room. I cried myself to sleep, while the adults whispered offstage about the Japs.

CHAPTER FIVE

JACK

The San Fernando Valley is a really hot, dry place in the summer. I spent most of my time in swimming trunks, sitting in the upper branches of a giant apricot tree that grew at the corner of the farm, eating apricots and stuffing my trunks full of them to take home.

In 1939, when we moved there, Valley Village was an isolated two-block town in the middle of miles and miles of orange and walnut groves, peach orchards, and cornfields. It was situated at what you might call the end of Los Angeles: the city, the county, and the idea. Across the street from the house was a dirt farm, usually in corn: acres and acres of it. After that, there were no more streets. The edge of the city.

In the other direction from the house was an empty lot; well, that's what we called it. It was actually a peach orchard.

That empty lot peach orchard was where I had my first erotic encounters. There were two little girls, one a cheerful blonde and the other a smoky brunette. I know this characterization sounds like a cliché, but I was seeing it that way even at that young age. And my best buddy Michael was in on it too. He lived in the house behind us. He was the scion of the Westmore family: the makeup artists who had created Frankenstein and the Wolf Man. We'd climb the fence between our houses to get together. We were all about five years old.

To us the peach orchard was an untracked wilderness. We took off most of our clothes and mostly just ran around. It was the sweetest thing; wide open, innocent, and sexy as hell. Full of promises of things we knew nothing about. I remember the smell more than anything. It was like horses. Horses and ripening peaches. I'll never forget that aroma. To this day a peach orchard gets me horny, not just for blondes and brunettes, but for the future, the stars.

But I especially remember the hair. Girls and their hair. My God! I have to admit it was the brunette I favored. Not that it mattered at the time, except for my destiny; they both had their mothers to go home to.

We used to play cowboys and Indians. I was the Indian. I'd run and jump through the trees in my loincloth, or breechclout I guess it was. Such freedom; such joy.

One beautiful day, deep in the woods of the empty lot next door, the grandmas caught us at it. Things were never ever quite the same again after that.

I'm not really sure—it was a long time ago—but I think I probably never saw those girls again; or, at least, I never played with them in the empty lot again.

Really it was Grandma McCool's fault—she started up my libido in the first place. Every Saturday we would take the trolley into town and she would drop me off at the Hitching Post Movie Theatre on Hollywood Boulevard. For a quarter I would see two westerns, four cartoons, and a serial. She'd go shopping at the Broadway and pick me up after the show. We'd have lunch at the Tick-Tock Tea Room, and then come back on the Red Car again.

In the peach orchard, my buddy Michael and I would act out these movies.

Of the western stars, my favorites were Bob Steele and Tim Holt; Steele because he was a little guy who was tougher than anybody. I related to that; I was a little guy. All five-year-olds are. Tim Holt I loved because of his smile: one of the most beautiful smiles in the history of showbiz.

I didn't learn to appreciate Roy Rogers until much later. I had to discover music first. Roy defined cowboy music for the world; and he could actually, for real, play the guitar, sing, and ride Trigger at a

full gallop at the same time. (Someone once said to Gene Autry, "I don't understand your success. You're fat, bald, you can't sing, and you can't play the guitar." Gene replied, "I don't have to be able to do those things. I'm Gene Autry.")

Anyway, the thing at the Hitching Post that had the biggest effect on me was the serial, a fifteen-minute episode ending in a "cliff-hanger." My favorite serial was called *The Black Whip*. Sort of a female Zorro. This prim, proper cowgirl would sneak out to a cave in the desert where she'd dress up in black leather and mask, climb on a black stallion, and go out and horse-whip the bad guys. She was the "Black Whip." There was a lot of tying up and death threats involved too, of course.

The Black Whip had a boyfriend who was sort of a wimp. He was supposed to be soft on the cowgirl, but he was crazy about the avenging angel in black leather. She was always saving him, sometimes from a fate worse than death.

It was a bizarre choice for what to show to five-year-olds at a Saturday matinee; but I'm grateful.

⇒ ⇐

WITH HIS BIG family now, Dad traded in his two-seater Duesenburg on a Duesenberg Phaeton, which had a backseat. For his escape vehicle, he bought himself an Ariel Square-4 motorcycle, which was sort of a rocket ship. He was having a good time. Every Sunday morning we'd drive the Duesenberg down Laurel Canyon and over the mountain to St. Thomas Episcopal Church. Dad was one of the founders of the church and the lay reader, which meant he would dress up in sort of priest's robes and read passages from the Bible during the service. He would always place Bruce and me in the front row so he could keep an eye on us. He would usually forget to give us the quarter for the collection, so we would signal to him in panic and God's minion would step forward, pull up his robe, dig into his pants pocket, and reach down to us with the money.

Mother would always sit in the back, but the truth was, she would sneak down the street to attend her own service at the First Church of Christ, Scientist. She'd be back before the end and nobody the wiser. Dad finally caught her at this. One day he mentioned how

great the soloist had been. Mother said, "Yes. Wasn't she wonderful?" He said, "She?" Mother talked her way out of it. She had a trick of convincing people that she was sort of dyslexic.

After church, we'd drive down Sunset to the Players' Restaurant, where all the actors hung out, and we'd have brunch while Dad would greet all his friends. In those days actors were a different breed. Mostly they were English, or at least talked as though they were. They wore blazers and ascots, and went to concerts, read books. Nowadays actors wear leather jackets and snort cocaine and don't open doors for ladies. Classical music is out of the question. Nobody reads anymore, except for actor's autobiographies. Silver-toned eloquence is out; for the most part, actors mumble, or just grunt. Dad would hate it; did, in fact.

Due to Dad's growing fame, his mother Genevieve, who hadn't seen or heard from him since he left home, showed up on the scene to claim her grandchild.

She and Grandma McCool squared off in a full-contact battle for supremacy in the "Grandma" field.

She instructed us to call her "Granny Peck" for the sake of clarity, and proceeded to straighten out our pagan California ideas about how little boys should act, injecting us with her Pennsylvania Puritan ethic. She was more than a match for Grandma McCool's pioneer spirit, and Grandma moved out. She bought herself a tiny shingle house in Glendale on an acre of ground and continued the battle from a safe distance.

Right after Granny Peck showed up, she decreed that I would no longer be called "Pooky." It was not fitting for a descendant of James Madison and John Marshall and James Monroe. My real name was John, but that was too confusing with my dad being called John by everybody now; so it was decided I would be "Jack."

I cried bitterly. "I'm not Jack!" I bawled. "I'm Pooky!" To no avail. I was Jack. Thank God they didn't start calling me "Junior." I couldn't have handled that. That, however, was never really a strong probability. Since my father's name was actually Richmond, I wasn't really a junior at all. I was John Arthur Carradine. My father hadn't named me after himself; he'd named me after his dream. Nevertheless, when my mother yelled, "John Arthur Carradine!" I jumped.

At some point, the two grandmas split up the kids between themselves. Bruce, after all, wasn't Granny Peck's family at all, though Bruce and I didn't know that. Dad had adopted Bruce when he married Ardanelle, and it had never been mentioned that Bruce was somebody else's firstborn son. We kids didn't understand what was going on at all.

There was also the fact that Frank Cosner, Bruce's father, was one-quarter Cherokee Indian, making Bruce one-eighth Cherokee, or so Granny Peck, with her Waspish perspicacity, thought she had figured out.

Bruce got the sweet grandmother, and I got the battle-ax disciplinarian. Grandma McCool, being a Christian Scientist, believed everything was bound to turn out all right, while Granny Peck was more into the Original Sin concept and believed that the devil had to be forcibly extricated from us.

I don't really mean to cast Granny Peck as the heavy here, or anywhere else. She was all right. She was as tough and as lovable and as proper as a well-polished old army boot. She had her sweet side and made great blueberry muffins and cherry pies. One summer Bruce and I spent our vacation at her house in Pennsylvania, and it was a beautiful time. We climbed trees, got bitten by whole colonies of mosquitoes, and went blueberry picking. It seemed to me that Granny Peck must have known every berry patch in Pennsylvania. She was also a great gardener. Hers was the first compost heap I ever saw. She could make anything grow, no matter how dead it looked when she got hold of it.

Granny Peck was just a little stuffy. She always had a Negro maid, for instance, who would formally serve dinner with crystal and silver and special forks and lids on the dishes and all that. I remember once her maid quit on her. Granny asked her why and the maid tossed her head and said, "Too much fixin' of the dishes for the fitness of the vittles." Hear, hear!

After dinner, the whole family would gather around to listen to the radio. My favorite was Edgar Bergen and Charlie McCarthy. It took a long time for me to get it straight that Charlie wasn't the general in charge of the Pacific campaign.

My mother was powerless as well in the face of Granny Peck's

resolves. When I would chance to mention out loud some idea that mother had laid on me, Granny Peck would snort and scoff, "Oh, that's a 'Nellie.' Don't pay any attention to that." It was many years before I finally figured out for myself how valuable my mother's ideas were.

I remember this one time at dinner when I wouldn't eat my carrots. They locked me into the high chair, which I had long outgrown, and tried to force feed me. I just screamed and spit out the carrots. It was getting kind of messy, so Granny Peck took me into the bathroom and put me in the tub. She kept trying to force the carrots down me, and when I spit them out, she threw cold water at me. I just screamed. I never did eat the carrots. As a matter of fact, I don't think anyone could get me to eat a carrot for eight or ten years after that. This incident also instilled in me an innate defiance of all authority from that time forth.

WHITE BOY

The summer of '41 was a busy season for the Carradines. Granny Peck had never been out to the Wild West before, so we decided to show it to her. We all piled into the Duesenberg and set out for the Grand Canyon. Grandma McCool, Granny Peck, Bruce, me, Dad, and Mother. The battle of the grandmas continued as we rode.

One of the stops was the obligatory Indian reservation: a Navajo village adjacent to the Four Corners, an area where Utah, Colorado, Arizona, and New Mexico all come together at one point. Granny archly mentioned that we'd better keep a close watch on Bruce or, with his coloring, the Indians would be likely to mistake him for one of their own and keep him. Bruce was terrified and started screaming. I felt really left out. I thought it would be great to be left with the Indians; but I was just too darn white.

Dad had a routine that was guaranteed to stop any child from crying: he would bounce the kid on his knee and sing "Shortenin' Bread." This was the only time I ever saw the routine fail. Bruce just kept on yelling. Undaunted, Dad switched to a more adult song, a folk thing from Pennsylvania. It centered around "My Son Joshuay," who went to "Philadelphiyay." It had many verses, always ending with the chorus:

Well, I'll be blowed! The hay ain't mowed.

Get up, Napoleon, it looks like rain.
Well, I'll be durned, the butter ain't churned.
Come in when you're over at the farm again.

One of my big regrets in life is that I let the old man die before I had committed the whole song to memory. If anyone who reads this knows it, please get in touch with me. I want to pass it on to my grandchildren.

By the time we got back from our adventure, I knew something was wrong. I didn't know exactly what it was, but through deduction and eavesdropping I figured out that it had something to do with Bruce and me not really being brothers somehow. This realization was world-shattering for me; utterly unacceptable, though inescapable. You see, Bruce was the strongest boy I knew, and a great athlete. There was something very special about him, and he was mine, so there was something special about me too. I walked in his reflected glory. The fact that he beat me up all the time was a side issue.

Now, suddenly, I lost all that. The image I had always had of myself—I didn't know why—was of a young brave, leaping and dancing through the woods, with a magnificent Thunderbird superimposed across my back. The image vanished. I was a skinny little white kid, five years old, in starched pants and a tie, sitting with my knees together drinking tea with the old ladies or something. I felt awful.

Granny Peck, having shattered our world, went primly and contentedly home to Swarthmore, Pennsylvania.

I decided to commit suicide. That's what people did when they felt that bad. I went out to the garage and rigged up the rope and jumped off the front bumper of the Duesenberg. Surprisingly, it hurt, and not only that, once hanging, I couldn't seem to get back on the Duesenberg again. It was beginning to look like an irreversible act when suddenly Dad came tearing through the back door of the garage and grabbed me up. His face was completely white. I don't know where Bruce was all this time; not hanging himself, that's for sure.

That little glitch in my childhood faded away quickly, and nobody ever knew what it was all about, not even me, really, and I eventually developed my own glory to walk in.

I forgot the whole incident for years until it came back to me during that acid trip at the Montecito Hotel, along with the birth

canal and my mother's tits. I guess everything is always in there some-
where, permanently stored in the mainframe. You just have to know
how to access it.

➡ ⬅

BACK HOME IN Valley Village, the long autumn days were an invitation
to trouble. Anything to break the monotony. My friend Michael and I
decided to try shoplifting. We'd walk into the dimestore and put things
in our pockets. Outside, we'd compare our hauls to see who'd copped
the best stuff. It wasn't a question of personal gain. Strictly excitement.

We got into pea-shooters, for which you need peas. Beans, actu-
ally. I decided to steal a bag of beans from the supermarket. I was
caught. What ensued was a terrifying, exhilarating chase. I finally
escaped by running between the legs of my potential captors. When
I hit the safety of the alley, the rush I felt was so exciting it made me
a confirmed thief for years.

It came time for me to start school. Kindergarten was interest-
ing. There were games, and hints of new knowledge, and there were
a lot of girls.

A major glitch showed up in my life when we discovered I was
color-blind. You couldn't pass into the first grade until you learned the
colors. They were beginning to think I was dumber than I looked
when they finally figured it out. Bruce was titanically amused. He
kept pointing at bushes and flowers and sweaters and saying, "What
color is that?" then exploding in laughter.

People think color-blindness is all gray. Not correct. We are
men, not dogs. The truth is, with most cases of male color-blindness
everything is especially colorful. You just can't name colors right. It all
looks sort of psychedelic; though, of course, I wouldn't know that for
two decades or so. I finally figured out that it's green when it looks
like it's on fire.

Anyway, I was eventually passed on to the real thing: first grade.
My parents set me up in Carpenter Avenue School, a high-grade
operation in the Hollywood foothills just down the street from
Republic Studios. I had great trepidation but it turned out to be more
heaven than hell. Learning how to read was as much fun as anything
I'd ever done; and I discovered I was one of the smart ones, which was
certainly a cool thing to find out.

I managed to make a deal with my parents that I could ride my bike to school; the only requirement was that I had to come straight home afterward. When my parents laid down a rule, it was law. One day I walked my bike down Valley Spring Lane with Joanie Scott. Joanie was a little older than I. She was tall for her age. She had lots of long dark hair and remarkable eyes. She knew something I didn't know. Her parents were friends of the family; her father, Benton Scott, was a painter and a student of Uncle Will's. Benton made his living by operating a cleaning route. We were on it.

That day at school I had suddenly realized that Joanie was the sexiest girl I had ever met. We walked and talked and dallied along the way. In those days the walk down Valley Spring Lane past Valley Heart Drive to Joanie's house included such special niceties as a river, complete with willow trees. We talked and walked, and delayed the parting as long as possible.

When I got home, I was in a lot of trouble for not coming straight back from school. Women! They always spell trouble. Dad was a harsh disciplinarian and never made empty threats. I lost my privileges and had to stop going to Carpenter Avenue. Instead, I was sent to North Hollywood Grammar School. Compared to the private school, they were so far behind scholastically that they literally put me to sleep. I never really got my interest in school fully back again.

I never got to follow up my discovery of Joanie either. Much later on, I saw her again, after she had grown up, run off to get married, left her husband, and come home again with her baby. She had grown up fulfilling every aspect of the potential I'd seen in her at six. She was an absolute knockout. She was still tall for her age, and it was clear she still knew something I didn't know.

⇒ ⇐

L.A. IS FULL OF "RIVERS." They only flow when there is rain, but there they are: carved into the sand all over the county. In those days they freely wandered through the valleys, overflowing into floods at certain times of the year. Now they have all been turned into concrete channels, with cyclone fences surrounding them. But back then we went down to the river to collect sand for the sandbox.

One day when the water was up, we kids decided to go for a swim. I was swept away by the current. It took me two bridges to get

out. I grabbed hold of an overhanging branch and pulled myself out, just like in the movies. I walked back upstream but there was nobody there, so I went home.

I walked into the house just in time to hear the tail end of my friends telling my mother that I was dead. From that time on, Grandma would sew my shirt together at the top so that I couldn't go swimming without getting caught; however, just about that time, I read *Tom Sawyer* and I kept a sewing kit with me. All this was totally unnecessary; it would be a year before there was another flood in L.A. and, by then, I would be a totally different person, which I actually was already.

Right around this time Dad insisted I take piano lessons. He had purchased a concert grand Bechstein on which he could play exactly one easy piece: a Rachmaninoff Prelude; great for a party trick, but he had nothing to follow it. I was designated as the purpose for the Bechstein. At first I took the lessons at home on that beauty. I learned "Papa Haydn's dead and gone, but his memory lingers on" and other goodies. My absolute favorite was something called "From a Wigwam." I still had this Indian thing. The problem was the piano lessons invariably coincided, or conflicted with, the neighborhood baseball games. I grew up with a precious musical heritage that I wouldn't trade for anything, but I lost baseball.

When I began to founder over this issue, I was sent to study with a real master: a little old man who lived right next door to Uncle Will the painter. I fell in love with Uncle Will, who had a life in art, spent mainly painting beautiful women who posed live. The smell of turpentine turns me on to this day. The other thing was, Will liked me. He and the old master played duets together. Will was a cellist. He had a habit of putting his cello into his paintings, in the hands of his naked women. He told me once that there wasn't much difference between women and cellos, except that cellos are more reliable. This idyllic sojourn into music and art was very short: less than a year probably. Things were about to change radically, not just for me—for everybody on the planet.

CHAPTER SEVEN

THE WAR

A t the same time that all this was happening, we were getting into a war with Germany and Japan. We started to have blackouts every night—I remember Dad painting all the window panes green—and every night he'd walk the perimeter to make sure there was no light leakage. Rationing had started and things were in short supply. Dad went down to sign up with the Navy. They turned him down because of his teeth. He asked them, "What do you expect me to do? Bite the Japs to death?" But they were adamant.

Right after Pearl Harbor, the military came around and commandeered the Bali to use to watch for the Japanese fleet, which was expected imminently. Dad said they could have the boat but he had to go with it as the skipper. They wanted to put a three-inch deck gun on the bow, but Dad convinced them not to, with the reasoning that the first time it fired it would rip itself out of the fabulous teak deck and fall overboard.

Darryl Zanuck at Twentieth-Century Fox was enraged at the risk his workhorse was taking, but public sentiment being what it was, he couldn't very well complain out loud.

The Bali, and hundreds of other small boats, sat out there at eight miles, with their binoculars and their two-way radios, for six weeks, expecting at any moment to be torpedoed. As we all know,

the Japanese didn't know how badly they'd hurt us and the invasion fleet never showed up. In the meantime, people were selling beach property in Malibu for the price of train fare to Kansas.

I definitely remember a big hole in the ground next to the gas station on Laurel Canyon Boulevard just south of Chandler, which everybody knew had been caused by a Japanese bomb (the first time I saw it was the morning after, and it was sort of smoking; I thought it was incredibly cool). I've never been able to get any government agency to admit that such a bomb ever existed.

As his war effort, Bruce meticulously fashioned an international squadron of fighter planes out of balsa wood, complete in every detail, with all the proper decals and weaponry. He spent countless hours on this fleet. Bruce had a toy chest in his room, with a padlock to which only he had the key, where he kept all of his (what were to me) incredibly adult treasures.

I eventually discovered where he kept the key and when he was gone would feast my eyes on these wonders. One day I took some of the planes and flew them off the garage roof. They were strictly for show, it turned out. They didn't fly any better than the Superman costume had. They went straight down; perfect crash landings.

In terror, I returned the planes, broken and bleeding, to the toy chest. When Bruce found them, he confronted me in the library. In a towering rage, he yelled, "You little prick!" and threw the sacred keys at me. God guided his hand. From a distance of at least fourteen feet, they struck me right in the teeth, chipping one of my bicuspids, thereby beginning my long and intimate association with the dental profession. I happened to have a small ice pick in my hand and I threw that, striking him with equally divine accuracy. The ice pick stuck in his forehead, erasing any chance I might have had for sympathy regarding my chipped tooth.

The rule is, if someone strikes you, you're the good guy unless you strike back. Then you're dead meat, particularly if your strike is in the area of excessive use of force. I was definitely dead meat, and I wasn't allowed around sharp things for a while. My sibling rivalry with Bruce reached truly vicious proportions after that incident.

With the war on, we couldn't really take advantage of the open-seaworthiness of the Bali. We were confined to sailing up and

down the coast, and trips to Catalina Island (fourteen miles) and back. Dad had one great trick. He'd taught his crew to pull down the sails (there were a lot of them) in less than a minute. He'd sail into the isthmus at Catalina under full canvas, drop the sails at precisely the right moment, and drift up to his mooring. All the other boats would pull down the sails outside the reef and motor in. The way Dad did it was quite a sight to see. A crowd of people would always gather on the shore and in front of the Yacht Club to watch the Bali come in.

The Bali was so big and seaworthy, it wasn't that much fun to take her out, at least for Dad, unless the weather was rough. He'd wait until the small-craft warnings were up to go out in her. As he'd pass the Coast Guard where they were turning boats back, they'd just wave at him and say, "Have a nice sail, John!"

Once we were caught in a bad squall (actually a mini-hurricane) and Dad relived *Captains Courageous* for real. The wind ripped the sails off the masts and he ran before the storm on bare poles with seas as high as the masts. We all almost bought it. My strongest image of that incident was when the storm first hit us broadside. The ship keeled over to starboard to the point where the gunwales were in the water. I was on the other side of the deck with Bruce and Mother, clinging to the sheets while the waves hit us broadside, almost drowning us each time. I was absolutely terrified and utterly thrilled. Dad was at the helm, windblown, pipe in his teeth, watching the swell for his next move, yelling orders to his crew. It was actually better than *Captains Courageous*.

Dad watched the jib rip off into the wind. It went up over the forward mast and, in seconds, was ripped to shreds by the wind. We tried to start the motor, which was a no-go. The Bali had a semi-diesel engine, which meant it had a small gasoline engine as a starter-motor. His strongest crew member, who was built like a water buffalo, could not turn it over.

We later discovered why that was. The Bali did not have a one-way valve in its exhaust system. Instead, it had a six-foot gooseneck. Normally, that would suffice, but on this occasion, the following sea had forced a wave up the gooseneck into the cylinders. The engine was full of water.

After we'd ridden out the storm, a seaplane showed up from Twentieth Century-Fox. (Dad was late for work.) He put us on it.

After that, a couple of blokes came out in a motorboat and towed the Bali in for repairs. Dad ended up in a court battle with them. They contended that they had claim to the boat as salvage. Dad had prudently left Skippy, the ship's dog, on the boat, which is technically not abandoning ship. It also turned out that there was no record from the weather people of the storm; it had been so local. When the judge broke the court for lunch, he said, "No fortunes will change hands today."

Dad decided to get rid of the Duesenberg and buy himself a brand-new Cadillac Town Car with a window in between, jump seats, and the whole shebang. It would be the first new car he'd ever had, and it would be his last chance at such a thing for the duration, if not for eternity. Since there was a war on, he figured he'd never get delivery unless he picked it up himself, so he took the train to Flint, Michigan. At the factory they were all gaga over him, and took him to watch it come off the assembly line. It was the last Cadillac made until after the war, and one of the very few '42's made at all. Dad told me that right behind it on the line was a Sherman Tank.

We had some good times in the Caddy, but it was nothing like the Duesenbergs for pure fun and excitement. The Duesenbergs, particularly the roadster, were a rock-hard ride on a prancing horse; a board attached to wheels and an engine. Utterly lacking in comfort, totally classy, totally ridiculous, and more or less orgasmic. But this was a new era; what it held for us, we didn't know. I think Dad had the idea that if he couldn't be a naval officer, the only way he could save face was to become a gentleman.

Since they wouldn't let him fight, Dad started doing appearances for the War Effort: Victory Bond drives mostly. These were largely radio shows, where his fabulous vocal chords could have their greatest effect.

Meanwhile, at the movie theatres we now saw newsreels showing our heroic warriors blowing the shit out of the Huns, and later the Japs. I remember one particular piece of footage that today seems incredible: a bunch of Marines with flamethrowers blasting away at a cave; after a while, out come several screaming, writhing figures,

engulfed in flames, turning into black cinders before our eyes, unrecognizable as Japs or anything else. All this while triumphant, almost gay music plays and a strong, manly voice applauds the great strides we are taking.

The audience cheered. We all swallowed it whole at the time; maybe rightly so: God on our side, keeping the world safe for democracy. After all, that was the good war. It's definitely true Hitler was not a nice guy.

However, there is that thing about us dropping The Big One. But Truman asked MacArthur how many lives it would take to end the war. Mac said one million Americans, a whole lot more Japanese, plus an indeterminate number of European allies, all of whom had been reaped once already. And then there was the incredible expense of it all: ships and planes, bullets, bombs, rubber, steel, rope, morphine, plasma, artificial legs, cities, works of art. Our wives and daughters wearing pants and steel-toed boots, slaving away in munitions factories. Women in hard hats! That alone changed our standards and our rules forever.

What about the concentration camps? What about the lack of roast beef, for that matter? Maybe it had to be done. It sure seemed like SOMEthing had to be done. I'd hate to have to bear Harry's burden of responsibility; but so did he.

Anyway, it ended. I really didn't know it had ever started. For me, the beginnings were lost in antiquity. Actually, I thought War I and War II had sort of run together, with no space in between at all. Well, what the hell; as we said, it ended. Everybody came home.

Everyone who was old enough at the time to remember anything remembers what they were doing when the war in Europe ended.

I was in a school bus, coming home from Golden Arrow Summer Camp. The news spread and we kids were stuck in an intersection for three or four hours. Traffic was stopped for miles. The bus driver was afraid to open the doors. A crowd of happy people were jumping, dancing, crying, making love in the street all around us. That sounds like poetry, I know, but I personally saw a sailor fucking a beautiful young girl in a flowered print dress on the hood of a Plymouth four-door sedan; blue, I think it was.

CHAPTER EIGHT

SONIA

Many wise sages and Hollywood gossip columnists would say that John Carradine, being a fickle man, blown up with his own success, head turned by the glitter, fell overboard for a pretty blonde and abandoned his loving wife and family for a more glamorous existence. There is certainly some truth in this description; however, this is how I have pieced together the true scenario.

Abigail found herself married to a rising character actor who was becoming the number-one feature player in town. He consistently received first feature billing right after the stars, which was as high as you could go as a character man in the old studio system.

Dad found himself married to a sweet, domestic woman who gave him a good household and a decent life and all the good home cooking he could eat. She did not share his love of classical music, literature, or Scotch whiskey.

Dad continued to spend a lot of his time out on the town with the wild crowd of merry men he had become a part of. This group's chief jokers were John Barrymore, now very old, very drunk, and more or less senile, but still a wild card; Art Yoeman, Dad's closest friend and my godfather (my mother couldn't stand him); Paul Carady, a concert pianist and composer; Sandro Gilio, an operatic baritone; John Decker, the painter and caricaturist; Sadakichi

Hartmann, the crazy half-German, half-Japanese poet (if he weren't so crazy, he would have been locked up in a "detention" camp for the duration of World War II, just because of his lineage). Sometime players included Errol Flynn, W. C. Fields, Basil Rathbone, Cedric Hardwicke, and Gene Fowler, who wrote some wonderful books about this wild bunch. I was too young to be in on any of their wild rides anyway, so it would have to be all hearsay from me.

I do remember Barrymore sleeping it off on our couch a few times. Mother would hide the booze, but he was a genius at finding it. His memory was so bad by then that he usually didn't know where he was, or whom he was talking to. He still, however, retained some of the fire. I remember hearing a home recording Dad made of him reciting the "To be or not to be" soliloquy from *Hamlet*, which impressed me so much, even at that age, with its naturalness, power, and gravity that it actually became a defining force in my own acting style.

There is one incredible story about Barrymore at this time. The studio had signed him to do a picture. To sober him up, they sent him out to a ranch, which was far out on a dirt road in the Malibu mountains. With him, they sent a young woman as his keeper who was instructed to acquiesce to his whims. Barrymore convinced her that he was into bondage. She allowed him to tie her up, whereupon he took the car and went into town, leaving her in that state. After a couple of days, the studio heard he'd been seen in bars around town. They sent somebody out to the cabin to check it out and found the girl, still tied up.

Abigail didn't want to be tied up in a cabin in Malibu and left for dead; but she did want to be a part of the glitter of Hollywood. John wanted to get her pregnant again. Another baby was not part of her immediate plans. She had a secret abortion.

By about 1942 or so, John's contract had been dropped by Fox. Darryl Zanuck decided he wasn't worth the next year's fifty-dollar-a-week raise; odd, since Fox was lending him out to other studios at great profit. John was delighted. He was now free to make his own way and to try to realize his dreams. Foremost among these dreams was the formation of his own Shakespearean repertory company.

Mother had another secret abortion. Dad found out about it. He

was furious. She was killing his babies. When Dad got angry about something, there was no question of resisting him. After a lot of yelling and a lot of tears, it was agreed they would start another child forthwith, one he could keep, no buts about it. They got right down to the task that very night.

Now that they had that question straight between them, Dad got down to putting his Shakespeare company together. He decided to do *The Merchant of Venice*, the play that had inspired him when he was eleven years old, and *Othello*, a part that a white man would have a hard time getting away with today. More or less at the last minute, he decided to throw in *Hamlet* as well.

To finance the venture, he put the Bali up for sale. I think he may have sold the Cadillac too. I'm not sure.

One of the major catalysts pushing Dad to get on with the task of attempting to establish himself as the foremost Shakespearean actor of his time (that's how he thought of it) was probably the death of his friend and mentor, John Barrymore.

Barrymore was doing a radio show when he collapsed. He was taken by mistake to Dad's dressing room. Dad walked in and found his buddy, his idol, collapsed and unconscious on the couch. The old man died shortly afterward.

Later on, when Gene Fowler was writing about this, John Decker said to him, "Do you have to say it was John Carradine's dressing room? He's just a kid, for Christ's sake; a beginner. He's not even in Barrymore's league. Couldn't you just say, 'in the dressing room of a fellow actor'?"

Gene said, "My job is not to decide who is an actor and who is not an actor. My job is to write down the facts as they are."

The story about Dad and the boys taking Barrymore's body and sitting it in a chair in the bedroom of Flynn, Fields, or whoever it was, is true.

Dad got drunk and cried, very much in public, for a couple of months, until someone told him he was making a fool of himself; then he sobered up and went back to work.

He went to the auction of Barrymore's estate and bought the sets, costumes, and props from Barrymore's production of *Hamlet* done in New York in 1923. Dad paid $300 for the whole production.

The stuff was still in pretty good shape, considering. It would cost three hundred thousand to recreate today. It was built by a legendary Broadway designer and, having been created for a play about an eleventh-century Danish prince, couldn't very well get out of date.

Dad altered it to work as a unit set for the three plays and added some niceties of his own. That production remained in his possession and ready to go to work right up to a few years before his death, when he lost it for non-payment of a storage fee.

I remember an elaborate, working model he made of the set, with little figures and lights, which eventually became a toy of mine. Of course, it was destroyed very quickly under my care.

Dad started holding auditions. What he needed was a whole troupe of excellent classical actors with a great deal of stamina, who could be capable of handling different roles in all three plays. In repertory, you alternate the plays: a different show every night. It takes a lot out of the actors. His biggest problem was to find an actress who could play Ophelia in *Hamlet,* Portia in *The Merchant of Venice*, and Desdemona in *Othello;* three of the juiciest and most demanding roles ever written for a woman.

What walked in the door was Sonia Sorel.

She was young, she was beautiful, and she could ACT. You couldn't trust her any farther than you could throw her, but she had a smile like an angel. She was Dad's kind of woman.

To make it tough on her for her audition, Dad had her read the Queen in *Hamlet;* a difficult role for a young girl. Well, she made him cry, and that was probably IT right there; though for the moment, Dad kept his pants on. He hired her, and went home to Mother and the kids.

In the middle of rehearsals, Mother had a miscarriage. She almost died. Art Yoeman gave her a blood transfusion, and that almost killed her; they never did get along. It had been a boy. The doctor said that the two illegal kitchen-table, more-or-less wire-hanger abortions had damaged her so badly that she probably couldn't ever have another baby, shouldn't even try. He said it would probably kill her.

This was shattering news for Dad. That word "never" was a killer; he had been planning on a baseball team. He went unsteadily back to rehearsals, his world in shambles; and there was Sonia to

stroke and comfort him. He must have seen more than the glimmer-
ings of the way out right then. (Resist how thou wilt, Brave Knight,
thy soul is mine!)

Meanwhile, my mother started sleep-walking. She would wan-
der around in her nightgown, looking in corners, intoning, "Where
are my babies?" She had an idea that they were all in a basket behind
a door or something.

After a tryout at the Pasadena Playhouse, the repertory opened
at the Biltmore Theatre in Hollywood to great reviews and full hous-
es. One night after *The Merchant of Venice*, D. W. Griffith came back-
stage and the old man told Dad it was the best job of directing he had
ever seen. Dad considered that praise from Caesar.

Before his death, Barrymore had gone to see a rehearsal of the
show and, during a rare moment of lucidity, had said, "You lean,
cadaverous son of a bitch! You can play anything!"

The shows went on a brief tour, ending in San Francisco. Dad
was in his element and at his best. He and this goddess of an actress
were together every night on stage, wowing the public, and the
excitement between them was at a fever pitch. The inevitable hap-
pened; had already happened. They succumbed, of course. How could
he help it? How could she?

An offer came from the Shuberts to tour. The stage manager
took the phone call. He wanted to go home for Christmas, so he took
it upon himself to turn down the offer without telling Dad. The
Shuberts just figured John was nuts and couldn't be dealt with; they
told everybody else that. The word was out! That's Dad's story. The
show closed in San Francisco and Dad lost half his shirt.

By the time Dad and Sonia arrived back in L.A., the divorce was
pretty damned inevitable. Sonia, though, took a strange, noble turn.
She told him to go back to his wife and kids and, for good measure,
ran away where he couldn't find her. He did, though. She was work-
ing in a bomb factory, hard hat and all.

Dad brought her back to town and set up housekeeping at The
Garden of Allah, a fabulous pile of cottages, with a swimming pool
and all the perks, set at the corner of Laurel Canyon and Sunset. I vis-
ited them there and Sonia and I fell in love. Like father, like son.

Dad and Sonia were a gay, happy couple at that time. They were

great to be around: energetic, funny, and full of love and music. They had a tiny Crosley hot-shot convertible, which looked exactly like the cartoon car in *Who Framed Roger Rabbit*; I remember breezing through Hollywood with them, laughing all the way.

You didn't just get a divorce in those days; you had to have cause. It was Mother who had the cause, and it was she who sued for divorce. She went for the throat.

Dad had one momentary change of heart, typical of prospective bridegrooms or divorcees. He tried to commit suicide by chugalugging two quarts of Scotch whiskey, Ballantine's, I think it was. He got riotously drunk, but survived. He went back to the task at hand with new resolve.

The Garden of Allah was getting to be too small for their act; so John and Sonia moved into a rented California-, Spanish-Mediterranean mansion on North King's Road in Hollywood, right up the hill from Sunset Boulevard. Mother more or less moved into her lawyer's office.

The terms of the divorce were tough, but there's nothing special about that. Ask Johnny Carson. She got custody; he got visitation. She got lots of money and the house and a liberal alimony agreement; he got Sonia, and Sonia got Dad. It was all they really wanted. American jurisprudence in action.

Around that time, I went down the street with Dad and held a garden hose while he set fire to a mountain of film; it was a lot of fun for me. I didn't realize until years later that what we were burning were all the home movies and photos of my childhood. My mother meanwhile was cutting in half all the photographs of Dad and me together, to remove him from them. I wish they could just have traded pictures, or put them all in a time capsule.

When Dad and Sonia married. I was the ring bearer at the wedding. I don't remember the ceremony very well. I do remember the reception at their Den of Iniquity on King's Road. They cut the cake with his Hamlet sword, the one Hamlet holds up when he says, "Swear! Swear by my sword!"

The flower girl was a dark-haired beauty the same age as myself (six), named Arrianne Ulmer, the daughter of Edgar Ulmer, who had produced a few films with Dad. Arrianne and I sort of had it figured

that it was our wedding too. After the ceremony, we spent a delicious afternoon together on a hill behind her house, feeling delicious. We promised each other to follow it up. I thought of her as my girlfriend for some time, throughout my coming troubles and loneliness; like a soldier gone to war. I've never forgotten her.

With Dad gone, things weren't, of course, the same. But you know, I never had really seen that much of him lately, anyway. The fun times were isolated, separate happenings, like visits to Grandma's house. That was always the way between us right up to the day he died. I remember one baseball game, and one football game, one fishing trip; many sails.

Now I had weekend visitations. Absolutely lovely outings with the carefree, charismatic new Carradine couple.

I really didn't know what Dad did for a living until around the time of the divorce. He never brought me to the studio. I actually thought he was a sea captain. He was always dressed like a seaman, double-breasted dark blue blazer, yachting cap, insignias and all; and sailing was all he ever talked about.

When I was about five, I went, with Mother, to a performance of an operetta, *The Vagabond King*, in which Dad was playing the heavy. When he made his first entrance, I stood up on the seat and yelled, "That's my dad!" I guess that's when I first started to figure it out.

In terms of Pooky being affected by his daddy's line of work; I remember a recurrent dream that scared the hell out of me: my daddy, dressed up in a Dracula cape and a black hat, coming at me on a red tricycle with wings.

When he was home, it was usually, "Don't bother him, he's in his workshop," or his darkroom; or "Don't bother him, he's in his studio, working on his sculpture"; or "Don't wake him up; he was out late last night." The only time I could really depend on having a real talk with him was when I needed discipline. It was almost worth a whipping just to get his attention.

On the subject of discipline, Dad did it with a razor strop. Mother did it with a hairbrush. With Dad, justice was sudden and swift, and totally without anger; he would beat the hell out of me

totally dispassionately; strictly as a duty. My mother would never even think about beating me unless she was in an absolute rage.

If I confessed, things would go a lot easier for me. The worst punishments were for lying. If I admitted my guilt, I might even get out clean. The George Washington cherry tree story was very big in our house. One time I actually chopped down a tree in the front yard. The system did not work; I said, "I cannot tell a lie. I cut down the tree." And he beat the hell out of me.

There was the incident of the scissors that disappeared. My mother accused me, and I denied responsibility. She attacked me with the hairbrush for lying. I protested my innocence throughout the torture. Twelve years later, she had the love seat recovered and she found the scissors in the bowels of it when they ripped out the old upholstery. Mother, in tears, begged my forgiveness. I didn't even remember the incident until she brought it up, but I reveled in the moment anyway.

One of the advantages about the separation was that we now had legal access to Dad's workshop. This treasure cave was located in a loft over the new front door. It was accessible via a retractable stair. Unauthorized entry into this inner sanctum while Dad was around was guaranteed to result in severe trouble. Now we could raid it with impunity. Another advantage was that I could collect comics again. There was one issue of *Supersnipe* that had a perpetual motion machine in it. I could imagine creating such a thing in Dad's workshop.

Grandma McCool came back to stay with her abandoned daughter, and Bruce and I started attending Christian Science Sunday School. I liked that. Bruce liked it a lot more. He took the whole thing very seriously; but he was older. I thought of it as sort of like "The Force," or magic. I couldn't wait to get back and find out some more about this "God" stuff.

Mother hired a carpenter, sort of, Tom Scott, a brother of a friend of the family, Benton Scott, the father of the famous Joanie. Tom built a partition between the library and the new wing, turned the darkroom into a dark kitchen, and Mother rented it out. Tommy gave her a beautiful antique wall clock and then proposed to her. She turned him down and he took the clock back.

Things went downhill quickly. Bruce and I had some terrible fights—actually tried to kill each other. I started wandering the streets. I got hit by a truck. Mother and Grandma prayed over me. Doctors weren't allowed anymore on Ben Avenue. The faith healers had taken over. That leg hurt me for years.

My mother had an answer for the people who judged Christian Science harshly in the name of those who died from medical deprivation. It was, "How many people die in hospitals?" Answer: "Millions." She thought if they were going to prosecute parents whose children died from not going to doctors, then they should prosecute those whose kids died from going to doctors. It makes as much sense as anything else.

Dad was having a hard time coming up with the alimony checks. He and Mother were in court a lot. She had him arrested for non-payment. I remember the front-page picture in the paper of him looking out through the bars. While he was in, he shared his cell with a famous murderer whom he said was a brilliant conversationalist and an excellent chess player.

To pay the alimony and get rid of some of the debts he'd piled up with the Shakespeare Repertory, he signed a contract with Monogram to do ten (count 'em, ten) cheap horror movies: one a week. That batch of horror piled up to alter his career drastically.

One time I came home from school and Mother was fixing up the house to sell it. There was a little guy with red hair helping her. She told me this was "Sam." He was all spattered over with white paint. He grinned a salesman's grin at me. I sensed something was up.

Mother took a job working in a pottery factory. She was doing okay; not exactly a gay divorcee, but okay. She never really got over Dad. According to her, she carried a torch for him for twenty-four years. According to him, he continued to hate her for at least as long, maybe right to the end.

The total collapse of my happy childhood, such as it was, came when Mother sold the house and moved out. My mother was relocating up north to San Francisco; something to do with "Sam." Grandma McCool moved back to Colorado to stay with her son, Uncle Johnny. Mother packed up us kids and shipped us away to The Busy Bee Home, a twenty-four-hour care center run by Church

Ladies. They watched us and fed us and bedded us, and we all went to a public school, which was next door.

Along with the care came a lot of church dogma, which wasn't fun like the stuff at Sunday School had been. I remember you were supposed to sleep on your back with your arms up beside your head; supposed to be healthy. No pillows either; same reason. Bruce ran away after about three days. He showed up at Mother's place and she brought him back. He ran away again; and this time he went to Dad and Sonia. That got Mother's attention. She sent him to live with Grandma and Uncle Johnny on their ranch in Colorado. At eight years old I was all alone. Even Bruce had deserted me.

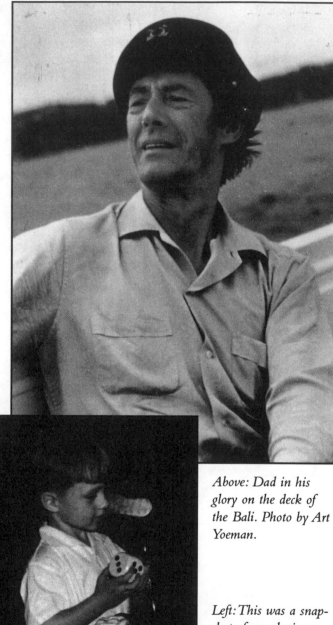

*Above: Dad in his
glory on the deck of
the Bali. Photo by Art
Yoeman.*

*Left: This was a snap-
shot of me playing
with my dad. After the
divorce, Mother cut
him out of the picture.*

Carried Away by Love

The divorce that didn't work out. During their trial, Dad and Sonia changed their minds about the divorce and Sonia scooped him up and carried him out of the courtroom.

Dad and Sonia on "that" day.

Sonia and me in the bloom of our first love. Garden of Allah, 1944.

BAD BOY

This is where the *Oliver Twist* part of the story starts. Dormitory life was a pretty dismal affair, at least for me. They took good care of us—fed us well and all but it was a long way from a happy family. There were, however, certain similarities: carrots, for one thing. Inevitably, these appeared at the table and it was strictly, "Eat what's put before you" in this place. I got out of it by pretending to throw up; one of my first truly great performances.

The public school was too easy, to the point of being terminally boring. I ceased to be interested in sports, or reading, or dinner, or the company of my peers. I became a somnambulant loner. I remember once I squatted all day in the dirt lot behind the place and watched a war between the red ants and the black ants.

My friends were music and sleep. I started having a dream. Not a recurring dream: a continuing one, like *The Black Whip*; every night a new episode. I walked around all day in a kind of daze, remembering the dream. I couldn't wait to get back to sleep and dream some more of the story.

The music was from a radio one of the house mothers had. The two tunes I remember were "Mairsy Doats" and "Oh, What a Beautiful Morning." And there were singing classes held outside in

the yard every morning. My favorite was "La Cucaracha." On visits to my mother and her girlfriends, I remember liking western music; not Country-Western, not Country, but western. I already had a nodding acquaintance with The Sons of the Pioneers from the Roy Rogers movies, but now I also came to know Tex Ritter, Hank Williams, and some girls whose names I can't remember. The tunes were "Navajo Trail," "Empty Saddles in the Old Corral," "Blood on the Saddle," "Ragtime Cowboy Joe," "I'm an Old Cowhand (from the Rio Grande)," and, of course, "Cool Water."

My father came to visit once; he hung around with me and impressed the other kids. We had a high-jumping thing going. He showed us how to do the "Western Roll," state of the art high-jumping at the time. It was the last time I saw him for a couple of years.

Mother had him arrested again. He was just unable to come up with those big alimony payments as a freelance actor.

The judge had laid a hard trip on him: pay or else. So when he got out, he jumped bail. He hailed a cab right in front of the courthouse and told the driver to take him to Denver. Sonia met him there with all their movable effects packed into their 1941 Cadillac convertible, and they drove to New York City.

Now I was really alone.

I started getting in trouble, little things, but it was always a hassle in this place.

Punishment was usually no dinner, which was great. The cook would make up this "bread and milk" that was delicious. Vanilla, cinnamon, sugar, nutmeg. She couldn't stand to see a child deprived of food.

One valuable aspect of my sojourn at the Busy Bee Home was finding out that fucking made babies. I knew about fucking, and I knew about babies, of course, but I didn't know they were related. It was a revelation. This discovery may have had something to do with what would be my final solution to the Busy Bee Home situation (not to mention with most of the pleasures and tragedies of the rest of my life).

I made a little sculpture with the clay I always carried with me. The subject, I suppose, represented my newfound carnal knowledge. It was a man and a woman embracing. Naked, of course. By and large,

one does not put clothing on a sculpture. The reaction at the Busy Bee Home was extreme. I was called into the Head Battle-Ax's office and chewed out. Then she crushed the sculpture into a blob.

This was something I had to think about. One thing you do NOT do is destroy an artist's work. I searched myself and decided that, for certain, I had done no wrong. I could not make the same judgment about the Head Battle-Ax, or the Busy Bee Home in general. There wasn't anyone else to refer to, so I got really bad. I have no memory of just what "really bad" was; but it's probably true that you would have to consider the source of the judgment.

About this time, Bruce showed up at the school. He was about twelve years old. He'd been sent down from Colorado to talk to me. He was large and strong, and very serious. It was like Superman had walked in. My hero had come to see me in my dungeon. He told me I was a bad boy and to straighten up; and then he went away.

I devised a plan. I ran away. I left during dinner, when I was being punished. I climbed onto the roof and dropped down and slipped out the back, Jack, and took a walk. I was out all night and all the next day. I had marvelous adventures, not far off from something out of *Alice in Wonderland*; and then I went back. There was an incredible uproar and I was expelled and sent to my mother.

CHAPTER TEN

THE GRAIL

M y mother had spent a brief time in San Francisco as a housekeeper until she discovered her employer's intentions for her were more than employerly and perhaps a little less than matrimonial. She now was working for the Pacific Gas and Electric Company and relying ever more on "Sam." I had a short visit and was off to Montezuma Mountain School for Boys in the Los Gatos Mountains.

Surprise, surprise; Bruce was already ensconced there. He was not that happy about his gnarly little brother showing up to crimp his big-man-on-campus style; as it turned out, we had very little to do with each other at Montezuma: upperclassman, lowerclassman, and all that.

Montezuma turned out to be a dream situation, though it's true there was an upperclassman named Funch who regularly beat me up. I doubt if he'd want to try that now. Funch grew up to be a very rich man. He inherited his family's fig empire, sold a lot of it off, and built a fig theme park. There was a housemother, named, believe it or not, Miss Brooks, who used to chase me through the beautiful Pueblo architecture of the place, beating me on the back with her high-heeled shoe; nevertheless, it was a happy time.

The best part of the place was the horses. The school operated

a remuda of about two hundred. The kings of this action were the Barn Boys. For seven dollars per week, you got your own horse, which you would cut out of the herd and train yourself. You also were privileged to care for the horse, and no one else could ride it but you. Mother couldn't come up with the seven dollars so that was out for me, but I managed to accomplish pretty much the whole thing anyway. You see, if you were willing to WORK for it down at the stables, you could get it all.

In between the school and the horses was another barn, which was full of hay bales and apples. Delicious apples were another sideline of Montezuma. I spent many hours eating cold storage Delicious apples and making hideouts among the hay bales. One of my jobs was sorting through the apples in the barrels for the rotten ones. I did a lot of eating-my-fill.

At the other end of the place was the woods. This was serious forest. Mountain lions and bears. We built a treehouse using four trees that stood in a square. We put it fifteen feet above the ground to keep it away from the bears. You got up to it by a rope ladder. It had two stories. We used to camp out in it and watch the mountain lion and her cubs go by below. One day we came back and the bear had climbed one of the trees and taken the whole thing apart.

We found bear claw marks on one of the trees. We tried to think of a way to keep the bear out of the treehouse but never really came up with anything. We thought of burying big spikes in the trees, but we figured that would just piss him off. We just put it back together and went on having fun. At least the nocturnal mountain lion wasn't climbing up on us.

One great thing about Montezuma was the K.O.S.S., the Knights of the Silver Shield. There was this old guy, who used to be headmaster; he had his own house, down the hill. One of the assignments was a session with this sage once a week.

He showed us swords and a silver shield and told us what we were really there for: to do valiant deeds and to follow the Grail. That's what all the learning was about. We all knew he was senile. We also knew he was the only one who knew what was really going on.

This idea of life as a holy Arthurian mission stuck in me pretty deep. I have since read everything there is on the subject (there's a lot

of it, going all the way back to contemporary accounts from the first millennium), and seen all the movies. I played King Arthur once in an opera house in Texas.

On my birthday and at Christmas, I always got a telegram from Dad with a money order. Birthdays were five dollars; Christmas was ten. I'd spend it on ice cream and caps for my cap pistol.

There was a tiny lake or large pond, full always of mud hens, ducks, and Canadian geese. We would camp out on the lake and cook pancakes over a campfire. The woods-craft I learned there on that pond has sustained me as an expert-master till today. Anyone would think I was a Boy Scout, which I never was.

My greatest accomplishment at Montezuma, which totally eclipsed my considerable prowess in the spelling bees, was the pancake eating contest. I consumed, at one sitting, twenty-two plate-sized flapjacks, establishing a new record.

At a campfire meeting, I gave my first public performance, spurred on by the impression left on me by a visit from Red River Dave (if you don't know who that is there's no point in my telling you). I sang "Red River Valley" and recited "Casey at the Bat." As far as I know, I was a smash hit.

We went for a camping trip in Big Bear State Park, over the hill. During the evening, after dinner, we had a Snipe Hunt. The way a Snipe Hunt works, the underclassmen wait in the woods, holding snipe sacks and flashlights, while the upperclassmen beat the bushes and drive the snipes toward them. The snipes are drawn by the flashlights and jump into the bags.

I was an underclassman but I'd been through this shit before. There is no such thing as a snipe. The upperclassmen make noises to scare you for a while and, when they get tired of it, they either come up and scare you good, then take you home laughing; or they go home without you.

I got the attention of all the snipe-catchers and said, "Listen. We've got to talk."

We folded up and stole away back to camp. We sat around the campfire for a while, drinking hot chocolate, and then snuggled into our sleeping bags. The upperclassmen spent half the night trying to find us while we were snoring sweetly.

At dawn, when I woke up, we were surrounded by forest animals, just like in *Bambi:* deer, squirrels, rabbits, fox, even a skunk; all kinds of birds. The bear and the lion were mercifully absent.

There was no sign of a snipe. The reason I was awake for the Dawn Show was because the Lost Boys had come in just before. They had just dozed off when the natives started showing up.

The second year of Montezuma, the sixth grade for me, I played the only full season of football I ever had a chance to do. As skinny as I was, I wasn't exactly tailor-made for the sport.

My position was left end. In those days we didn't have offensive and defensive teams; certainly not in the sixth grade. So I had to double as irresistible force and immovable object. I mainly excelled as a wide receiver. Because of my speed, I didn't have to deal very much with the fact that I weighed twenty pounds less than anyone else. To my greater glory, I took a lateral pass eighty yards for a touchdown on the last game before Christmas break. I was really looking forward to a glorious career on the team when I got back after New Year's, but it never happened. My mother arranged for me to visit Dad in New York for Christmas. Just before she put me on the plane, she asked me if I really wanted to go. I said, yes, I really wanted to. She said, "Well, that's a good thing because you're going to be there for a long time."

It was five years. She figured that since Dad wouldn't pay for my upkeep, she would send me to him and he couldn't very well avoid supporting me.

Everybody thought Dad and Sonia were living high. In a way they were; but New York wasn't really working out for them. They were basically subsisting on unemployment insurance ($21 a week), with an occasional radio show at scale.

Dad had thought Broadway would snap him up hungrily, but New York is a tough town.

CHAPTER ELEVEN

MANHATTAN

It was snowing when I hit New York. The plane was held up for over an hour before it could land. Dad and Sonia picked me up in their '41 Caddy convertible, which was looking pretty ragged. New York is as rough on cars as it is on actors. Dad asked me, "Are you here for good?"

I said, "Yes."

Sonia said, "I thought so."

Then there were a lot of hugs. It looked like this was going to be okay. After a few weeks, I asked Sonia if it was okay if I called her "Mother."

She cried and said, "Yes."

I was eleven years old.

Dad and Sonia had a kid now, Christopher, a few months old, and a dog named Tucket, a little thing that was oh-so-cute and also insanely jealous of the baby. One of its favorite forms of protest was to wait till it was diaper-changing time and then drop a load right in the middle of the diaper freshly laid out on the daybed. The daybed was also where I slept.

Sonia had done some remarkable drawings of Christopher from day one, day two, etc. She really was a fine artist. I had to get into these; they were the Carradine version of baby pictures.

Dad and Sonia were living on MacDougal Alley. No. 7. Upstairs.

For $110 a month, they got three rooms, a skylight, a tree in front of the place (rare in NYC), and lots of friendly cockroaches.

Later on this would become some of the most expensive and desirable real estate on the planet, but for now it was the inexpensive secret of the Bohemian actor-artist crowd.

Right after I arrived, New York had a blizzard: twenty-eight inches of snow. For a California boy it couldn't have been better. The whole city was stopped dead. What did I know? It was great.

⇒ ⇐

I WAS SETTLED INTO P.S. 41 to finish out the sixth grade. I started out right away on my wandering. I walked or took the bus or subway all over New York. I'd go all the way past Coney Island to Far Rockaway, or uptown to 243rd Street—these were the last stops. One great trip was to go to the Battery. For another nickel, I could take the Staten Island Ferry across the bay, sliding right past the Statue of Liberty. New York was a nice, peaceful place then; or maybe I just didn't notice.

To make money, I would shine my dad's shoes. It was either that or steal the change out of his pockets, which I did as well, actually. I couldn't believe how many shoes my dad had. They were lined up the full length of the long closet. There must have been twenty of them; all kinds of different old-fashioned traditional styles. I, personally, these days lean toward cowboy boots, but I found out how that plethora of footwear happened to him. It's not a foot fetish, as one might think. You take them home with you from parts you play, and they kind of build up on you.

I got ten cents a pair for shining them; the price of a comic book. It was important that I perform this task as a front for my stealing. When he discovered a stack of comic books, he said, "How did you get these?"

I said, "I traded for them."

He said, "Now, son. The dates on them are all this month's."

I said, "They always put them out in advance."

True enough, but a narrow escape, nevertheless. Beatings with the razor strop were still always an imminent possibility.

MacDougal Alley was an artists' colony and Dad took advantage

of that, working all the time on some sculpture or another. I worked right beside him. I did one really fine bas-relief of a horse's head, always pretty much my favorite subject. Messing around with his hunting knife, I cut off the end of my finger. Dad's extremely ahead-of-his-time doctor friend fastened it back on, and it stuck.

The '41 Caddy was buried under the snow all winter and when spring revealed it, the car was pretty much gone. The canvas top looked like Spanish lace. The car still ran, though; and the whole family jumped in and we did the Summer Stock circuit; Dad and Sonia as a team, doing *20th Century* and *Bill of Divorcement*, and me as the baby sitter for Christopher. This was absolutely the best time ever for that particular little family. We were like an itinerant circus act. We were special; all over the eastern seaboard, in all the most fun resort towns.

In Reading, Pennsylvania, in a converted barn called The Hayloft Theatre, the director was always picking on one particular very green young actor. Dad pulled the kid aside and told him not to worry about it because he definitely had it; he was going to be a big star. The kid responded beautifully to Dad's encouragement, ignoring the director's insults and getting his laughs. Sonia remarked how sweet of Dad it was to do that. Dad replied that he had meant every word of it. The kid's name was Jack Lemmon.

There was one particular place that Chris will never forget. The company put us in an old Victorian hotel where the fire escape was a spiral slide, built inside a metal tower. I went down it again and again. It was like a ride in an amusement park. More than a few times, I held the one-year-old Christopher in my lap and we went down together. Chris would scream with delight. Eventually, we were caught at it and they made us stop. Now Chris designs the rides at Disney World.

By the time I reached the seventh grade, Dad's fortunes had improved somewhat. I was farmed out again, to Riverdale Country School for Boys, a more-or-less Ivy League prep school famous for the fact that JFK went there. There I buddied with Eddie Foy III, who was sort of the group bully, and Walter Winchell, Jr. We had a lot of fights and got into plenty of trouble. Finally, I got kicked out and Dad brought me back to the hearth.

We moved to Gramercy Park, across from The Players Club. The view from the bedroom of Edwin Booth's statue in the park was a big selling point. I was installed in Grace Church School, just down the street, the New York equivalent of The Episcopal Academy, I guess: theology dished out with the algebra. There was some talk of making me an altar boy, but all that studying and the inevitable priestly fondlings were not to my taste.

I started going to a lot of movies. Of course, I had to go see Laurence Olivier's *Hamlet*; the ghost gave me nightmares. I had to sleep with my door open for a while. Orson Welles became one of my favorites. I walked down to 14th Street and plunked down my dollar to see *Black Magic*, wherein he played Cagliostro, the hypnotist who started the French Revolution.

The other thing that was really getting to me was musical comedy, particularly the dancers: Judy Garland, Fred Astaire, Gene Kelly, Ray Bolger, Dan Dailey—all of them, but particularly Fred and Gene. Fred was the ultimate stylist and dressed like a prince; his taps were the best in the business. Gene's acrobatics and his "regular guy" image (he danced in loafers and a sport jacket, eschewing the Astaire-style top-hat stuff) brought it all home to me.

I taught myself how to tap dance on the sidewalks of New York. I'd go see a movie and perform all the way home in the dark streets and through Central Park. I never once had to deal with muggers.

I had this habit of tap dancing whenever I was nervous, which was a lot. It drove my dad crazy. He'd introduce me to someone and I'd slip into a time-step. I asked if I could take tap lessons but Dad said, "No! No son of mine is going to make his living with his feet!" Years later I became famous for kicking people. Destiny prevails.

Dad decided suddenly to be close with me; so he arranged on my birthday to take me and my best friend to lunch on the town and a matinee of *Guys and Dolls*. We couldn't get tickets and we ended up at *As the Girls Go*, starring Bobby Clark. The show was definitely X-rated. My best friend and I loved it. In the middle of the second act, Bobbie worked Dad's name into a skit. After the show, we got to meet the lunatic comic himself. I figured my dad knew everybody.

There was one truly wonderful Christmas at Gramercy Park. All dazzle and lights, presents galore. Christopher got a rocking horse

made out of pinto calfskin, with a "real" mane and tail. Chris was ter-
rified of it and screamed every time we tried to put him on it.

We finally gave it away to someone else's less fortunate and
braver child. Dad was paying for that Christmas for years. It was all
done on credit.

My main job during this period was taking care of
Christopher. He was just about two years old and the principal thing,
aside from pure custody, was toilet training. I accomplished this by, at
regular times, putting him on the john and not letting him off until
he did number two. He would scream and squirm, so I got out his
little alphabet book to entertain him. In the end, I taught him how
to read and toilet-trained him at the same time. Chris definitely has
the most developed brain in the whole family. His memory is virtu-
ally photographic. I'm sure I had something to do with that. I have
it on good authority that he takes his laptop computer with him to
the john.

Our apartment house had an old-fashioned open freight eleva-
tor that ran on a cable you operated yourself. I discovered you could
get on top of it and ride up and down, and even operate the cable
from there. I wrangled Chris up there a few times. He loved it; so
much so that he would scream with glee. These screams brought a
quick end to the game. I was not allowed to do this anymore. Number
one: not with Chris, with which I complied. I had to; he'd blow our
cover. Number two: not at all. Yeah, sure.

Every day I would take Chris to the park and watch him play
for an hour or so. The park was private. The residents of Gramercy
Park had a key. There was also a guard. I'd sit there with the nannies,
on a bench next to Booth's statue, and watch Chris on his scooter or
digging holes, break up the occasional fight, and cuddle him when he
fell down.

One day I decided to sneak out on an errand. I wanted to go to
the Magic Store. I'd developed quite a passion for parlor illusions; and
Chris had a real passion for watching them. Part of my power over
him came from the fact that he thought I was a Wizard. It took me
longer than I expected, and when I got back, he was gone. In a panic
I went to our building, and was informed that he had looked for me
and started screaming. The guard had brought him out and someone

had called Dad or Sonia and got him home. I knew I was about to face some tough music. I was right. My credibility had been seriously strained.

I still haven't lived down that incident. Chris, to this day, does not trust my word on the subject—thereby relieving me of a terrible responsibility—and Sonia mentions the incident every time I see her. Give me a break! I was twelve years old and it was over forty years ago. Why is it that when people get a little senile it's always the bum trips they repeat themselves about?

The taste of money had become sweet to me, so I obtained an after-school job as a tailor's apprentice. Two dollars an hour. My job consisted mainly of deliveries. Sometimes I got tips. I also had to sweep up, of course. After only a couple of months, I got fired. I did not have the call.

Dad really needed to get back into movies again. He'd had a few offers, but they all shot in Hollywood and he'd be thrown in jail for nonpayment of alimony if he went back. He really wanted my mother to get married so the meter would stop. Sonia was sure she was staying single out of spite.

Dad found a new career reciting Shakespeare and poetry in gin mills. That's what he called it. Actually the "gin mills" were the most famous jazz spots in New York, Chicago, and Boston. He was really accomplishing something by headlining in these places. He had no patience for jazz himself, but I loved the stuff.

At one of these gigs—it was the Village Vanguard—his opening act was a newcomer named Eartha Kitt. I made stupid jokes about her all through her act. I was a real snot-nosed kid sometimes. If my dad had been there, instead of backstage, I wouldn't have dared to do that. He would have turned me over his knee right there in front of everyone.

A year later, I saw her starring on Broadway in *New Faces of 1952* and loved her. I guess the rudeness of a stuck-up twelve-year-old didn't mean that much to her in the long run; still, I've always wished I'd had the opportunity to beg Miss Kitt's forgiveness.

I continued to write to Walter Winchell, Jr., who had been kicked out of Riverdale too and was living on a ranch somewhere. Sonia opened one of my letters to him and deemed it obscene (which

I'm sure it was, but I didn't think that was any of her business). I went on the carpet and the letter was never sent.

I lost track of Walter. Later on, he committed suicide with his father's gun. I've always thought that obscene letter might have made the difference, if it had been sent. Both of us were antisocial broken-home misfits who had only each other to talk to; the difference was that MY father wouldn't have a gun in the house. Lucky me.

Dad was finally starting to land some Broadway parts. *The Cup of Trembling*, with Ruth Gordon, *The Duchess of Malfi*, with Elisabeth Bergner, both turkeys; *Volpone*, with José Ferrer, at the City Center—also a flop—but Dad took all the reviews, totally mystifying and enraging José and his friends. Years later the two of them met on the street. José stared at Dad and then said, "Well, John, you knew what you were doing and we didn't."

Television appeared on the scene and Dad became one of the monarchs of the medium. A transmitter and a soundstage resided on top of Wannamaker's Department Store. They broadcast something like eight hours a week, variety shows and dramas. Dad was king of the drama department.

One Christmas he played Scrooge. I got the part of "Young Scrooge," the kid the ghost of Christmas past shows him. I had three lines. I guess you could call this my TV debut. They paid me twenty-five dollars for it. My dad bought me a suit with the money. The suit cost fifty dollars, so I actually went into debt on that job. It's been working pretty much like that ever since.

In the meantime, Sonia had understudied Uta Hagen in *A Streetcar Named Desire* and starred in a flop of her own. I guess I saw *Streetcar*, with Uta and Anthony Quinn, about thirty times. I saw it once with Brando and Jessica Tandy. I personally liked Quinn's version of Stanley better; he was as rough and real as hell, not at all stylized, and so damn funny at the same time.

That summer I got my first full-time job: menial slave at a restaurant on Fire Island, twelve dollars a week and room and board. I hung out with the kids on the island and discovered I was a comedian. I also discovered that girls like guys who can make them laugh. I fell in love with a girl named Ann who lived in White Plains. She was absolutely stunning when she laughed.

In the fall Dad finally landed a hit Broadway show, *The Madwoman of Chaillot* (his caricature drawn by Hirschfeld in the *Times*), and could now hold up his head at Sardi's. He also was able to get Sonia a small part in the show. She was pregnant again and they kept enlarging the costume. When she was eight months gone, she suddenly ran home to Mother; never a good sign. She took Christopher with her.

I started calling Ann up on the phone in White Plains. We eventually arranged to meet for an evening in the city. I picked her up at Grand Central Station and took her to the opera: *Rigoletto*. We were bored stiff, so during intermission we jumped ship and went to a movie, *April in Paris*, with Ray Bolger and Doris Day. We necked in the back row of the balcony. Ann got her purse stolen. She took the last train back to White Plains. I guess you could call that my first date. I was supposed to go visit her family, but things changed.

Dad traded in the dead '41 Caddy for a really cherry '48, and we went off to stock, just the two of us. This was the absolute best: Pooky and big John off on their own together. One outrageous thing about those trips was a game I invented. I would tie a rope to the back of the front seat and, hanging on tight, climb out the back of the convertible and play chariot driver. Eventually, I would get all the way down to standing on the back bumper (at seventy miles per hour). Dad was busy singing opera. He never even knew it was happening. I know it's hard to believe, but he was never the kind of guy who looked in his rearview mirror a lot.

One of the best things about Summer Stock was the great resort towns we played. At Cape May, New Jersey, I was smitten by the boardwalk; particularly the arcades. These, however, required coins. One day, while counting my meager funds, I dropped a quarter. It went between the boards and fell to the sand below. I noticed during rehearsals the next day that the floor of the audience was made just like the boardwalk. People were always fishing for change at intermission to buy those stupid orange drinks. There was about a foot of clearance underneath. I crawled under and I was rich! My dad saw my wild spending and accused me of stealing money. I had to go under to prove my innocence. I came up with $2.40 in about six minutes.

I spent part of that summer at Uncle Leonard's place in Cotuit, on Nantucket Sound. Leonard was a Yale professor by winter and a teacher of sailing by summer. The time that wasn't spent learning to sail was spent in or under the water. At the end of the summer I had a deep tan down to my shoulder blades, and the rest of me was white.

I had a couple of adventures during which I almost lost it. One was a solo trip in a canoe during a mini-hurricane. I decided to paddle out of the harbor; when I passed the point, the wind hit me, and I was swept away into the turbulent vastness of Nantucket Sound. It was a tiny repeat of the storm on the Bali.

The other was the time I capsized Leonard's skiff in a race trying to jibe to get a tack ahead, and ended up in a gooseneck (if you know what all that means; if you don't, forget it). I lost the centerboard. I spent the afternoon getting the boat right side up again. When I told Leonard, he told me sternly to go back and find it: an impossible task. He made me dive for it for three days. I got it back.

The only really bad incident in Cotuit was the time they left me to babysit their kid, and I took the opportunity to teach myself how to operate the blow torch and came close to incinerating Leonard's firstborn, myself, and the house in Cotuit. Leonard was pretty pissed.

I was sent off to join Dad in Kennebunkport, Maine. That was utterly heavenly. Wind, water, and sand, and live lobsters broiled on the beach. Dad had to get back to New York right away to do the TV show "Suspense."

Before he left, we rented a small sailboat, and while he sailed I fed him his lines. It was a half-hour show and he was the only character in it. All he did was talk to his cat. By the time we made it back to shore, he had his part down pat.

Inevitably, summer came to an end and something had to be done with me. Sonia was back, with Christopher and the new one, Keith, and she just couldn't handle it. There were a lot of loud fights. Dad was going on the road, so something had to be done with me. I ended up going to live on a dairy farm in Vermont, more or less as an indentured slave.

Years later—actually, at my father's funeral—I found out that Uncle Leonard had offered to take me in. According to Leonard, Sonia turned him down because it would have made her look bad. So

instead of studying sailing, literature, and history, I spent the winter shoveling shit and getting beat up by a Yankee farmer. I'm not complaining; the farm was a great and unique experience.

Hell, I never knew Leonard even liked me until my father's funeral. I always figured trying to burn his kid alive had ruined our relationship for all time.

CHAPTER TWELVE

THE FARM

The Bullards' farm was situated up the river from Brattleboro, a mile away from the town of Townsend, population 400. It was three miles around the mountain when the snow was deep and the short road was impassable.

Mr. Bullard had made a fortune manufacturing zippers. He had sold out his holdings and risked the whole thing on making it as a dairy farmer. He was about to lose it all. The farm consisted of a quarter section (640 acres) of the Green Mountains; 140 acres of it was what we called "tillable," meaning you could get a plow through it. A little bit more, 80 acres or so, was usable as pasture but too rocky to plow and plant. The rest was forest and mountain.

When my dad dropped me off, he remarked on the beautiful view. Mrs. Bullard replied, "You can't eat the view."

Mr. Bullard's problem was a matter of violating the basic economic rules of dairy farming. To whit: you can't break even with less than forty milkers and you cannot buy feed. The cows must be fed completely off the land. We had forty milkers, but we had to buy some of our hay. This works when everything goes well, but the system collapses when something goes wrong: if milk prices drop; if there is widespread infection among the herd, making the milk unsalable; if there is a poor crop one year; if you are snowed in for too long

while you are unable to get the milk to market. All of this happened to Mr. Bullard that winter.

There's a saying in the Vermont dairy country: "We grow more corn, to feed more cows, to make more money, to buy more land, to grow more corn." This area is also probably the place where the saying "You can't get there from here" originated. Directions from a Vermont farmer were a study in obtuseness. If one of them said, "You can't miss it," you were in a lot of trouble. Distances were reckoned by "looks." The guy would say, "You go about four looks down the road." That meant you fixed your eye on the farthest point you could see on the winding road; go to there and look again. Then he'd probably say something like, "You'll see a big tree, with a road next to it. Don't turn there."

Mr. Bullard's herd was a mixed bag of Jerseys (which give the richest milk, but not much of it), a few Guernseys (medium richness and medium quantity), and one Holstein (which gave thirty thin quarts at a milking). Mr. Bullard had a bull, bred from his best Jersey cow and sperm from an expensive and famous bull. This creature threatened all of our lives daily.

To get around the place, we had a World War II personnel carrier. It could go where a modern RV wouldn't dare. During the warm months, the big job was clearing land. This was a race against time and Mr. Bullard's dwindling backup resources of zipper money.

He would sell the logging rights of, say, forty acres to a lumber company. They would come in and cut the trees down. Then we'd go in with the tractor and pick and shovel and pull the stumps. Then we'd start pulling out the rocks. There were thousands of these in every field. We'd throw the rocks onto a "boat" and then drag the boat over to the wall we were building. These low walls were all over the place. There was no mortar involved, just piled rocks. They served to contain the cows, which were not very athletic. They also were a place to put the rocks.

When the field was clear enough to take a plow, we'd plant alfalfa. We would also plant a cover crop of clover, which would come up right out of the melting snow and protect the young alfalfa, which was delicate until the roots took hold.

Every morning at dawn we would go out to the barn and feed

the cows and calves. Then we would do the morning milking. This was accomplished with machines, though the cows then had to be stripped by hand. All this was done to pop music radio, which was said to calm the cows and sweeten the milk. The main record I remember, for no known reason, was Bing Crosby's "Red Sails in the Sunset."

Each cow had to be tested for possible infection before the milk was combined. If there was any anomaly, it would be treated locally with a syringe up the teat, and that milk would be fed to the cats. There were usually a dozen or so of these cats; the population went up and down. The cats were never vaccinated, so every once in a while a whole bunch of them would be wiped out by distemper or something. They were fed only milk. The cats were not pets. They were there to get the inevitable rats. They were completely wild. You couldn't get near them.

When you were doing the hand "stripping" for the milking, you had to lean your shoulder against the cow's hip. If she tried to kick you—which they were all very likely to do—she'd fall off balance from your leaning on her and have to put her foot back down. There was one Jersey named Bess, my favorite, who would reach around and grab my hat with her teeth. When I reached for it, she'd kick me. It was best to let her have the hat. She'd drop it in her feed trough and I'd pick it up later. Bess was kind of an old maid. She was almost dry and she wouldn't take the bull. When Mr. Bullard bought her, she hadn't been milked for several days and she seemed to be a good milker. In Vermont it's definitely "Let the buyer beware," especially if you're a retired zipper manufacturer who doesn't know the tricks. Bess pretty much symbolized the incipient failure of the farm.

One time I was working on the electric fence, wearing rubber boots, and Bess walked up and licked me. A cow's lick is shocking enough—it's like sandpaper—but this was really something. She grounded us both out. We both jumped a foot. It took me awhile to get her confidence again. I think she thought I was some kind of electric Guru after that.

After milking, the cows would be let out to pasture and the shit shoveling would begin. The shit would be put into a manure spreader. When there was a lot of it, which was often, it would be spread

around the place from the tractor. The half-track would go down the short road with the milk. It would be picked up then from its platform beside the main road and taken to the dairy.

After the morning chores came breakfast. Many eggs, toast, pancakes, and, perhaps, venison steaks; lots of milk, of course. There were many mouths to feed: Mr. and Mrs., the two boys, Phil and Ron, myself, and the housekeeper, an eighteen-year-old named Mary who was an indentured slave like myself.

Five acres of the place were devoted to a truck farm, where the Bullards grew all their vegetables, most of which were frozen and put away for the winter. There were two bull calves on the place, who eventually were taken down to a slaughterhouse and came back as veal. Bread, sugar, salt, and such big-city necessities as mayonnaise, catsup, Jell-O, Kool-Aid, we bought. These luxuries, as well as electricity, fuel—particularly heating oil—and the thousands of pounds of grain needed for the livestock were what made the farm not self-supporting.

At this time I went on the only hunting trip I've ever been on. We (me, Phil, and some other kid) took .22s and went out after hedgehogs. We never saw any but we blew hell out of a lot of trees and rocks.

When school started a little old lady picked us up after breakfast in a Model A and took us down the short road (unless the snow was too bad, in which case the long road).

School was a one-room affair, containing the seventh and eighth grades. Phil was in the seventh, I was in the eighth. Ron was in the ninth, which was in the high school: one room across the street. This school was so far behind where I was at the time that they considered promoting me to ninth grade. It was decided, however, that the ninth graders, particularly Ron, would resent that, so I spent the winter studying things I had already learned. I amused myself, as I always had, by drawing a lot of pictures.

Very quickly Phil and I developed a quasi-sibling rivalry, which eventually developed into full-blown hatred. One of the ways Phil expressed this was by tattling on me. As a result, I was almost always in some kind of trouble. Some of these tales were apocryphal, but as a newcomer from New York, of all places, I was not in any position

to refute them. Actually, I still thought of myself as a Californian (still do), but that would probably have gotten me even less of the time of day in Townsend, Vermont.

Things got really out of hand when Phil reported that I and two other kids had been smoking behind the swings during recess. The swings were the best part of school in Townsend. That's where the girls hung out. Many lovely moments were spent hanging around the girls who hung out there. Naturally, this near-erotic contact led to experimentation with harder stuff. We didn't inhale (the cigarettes, not the girls—we inhaled THEM deeply). It was just the forbidden fruit idea.

We were all three taken into the gym (a half-basketball court) one by one and spanked with a Ping Pong paddle. When it was my turn, I wouldn't cry. The teacher broke the paddle on me, and still I didn't cry. I wasn't being brave—just defiant—and, anyway, it didn't hurt that much compared to Dad's razor strop.

When we got back to the farm, Phil told the story. Mr. Bullard confronted me with it. He took me out to the front of the house and told me to drop my pants, bend over, and grab hold of the sapling that was growing there. He took off his belt, saying, "You think you're brave, do you? Well, by God, I'll make you cry if it scars you for life." He hit me with the belt and right away I started screaming bloody murder. There didn't seem to be much to be gained by holding out; he was likely to beat me to death. He gave up in disgust very quickly, calling me a coward. I figured that was better than a cripple.

When the first real snow hit the Green Mountains, we all went over the hill where there was a ski-lift. The Bullards rummaged around and found some old equipment that would do for me. They ran me through the beginner's slope, then the intermediate slope. I did so well that they sent me down the expert slope, and I promptly flipped and flew. We didn't have breakaways and all in those days. I sprained my ankle and was out for the season. Every Sunday we'd go there, and I'd have to hang around freezing while everybody else frolicked on the slopes. I never did ski again. That was over forty years ago.

Christmas was pretty at the farm but it was a relatively dismal

affair for me. Just after the first of the year there was a major blizzard. The snow drifted so high on the windward side of the barn that it looked like a big hill. You couldn't see the barn at all. The electricity failed and we went to the generator: a Ford truck chassis in the garage, complete with radiator and dashboard. The temperature went to 20-below. Inside the barn was warm as toast. The forty-odd cows generated a lot of heat.

Amazingly enough, we were not snowed in. The half-track made it down the short way to the main road, and the little old lady showed up in her Model A to take us to school the long way.

The second blizzard snowed us in. Nothing got in or out. We were completely self-sufficient, as long as we didn't run out of fuel, but we couldn't get the milk to market. We separated out the cream, fed the skim milk to the calves and chickens, the dog, and, of course, the cats, and made ice cream out of the cream, which we would sell in town as soon as we could get it there.

The best thing, or so it seemed, was the fact that the little old lady couldn't get up the hill to take us to school. This turned out to be a mixed blessing. The alternative was nothing but work. With the cows trapped inside, the shit really piled up. We had to shovel it up and haul it out constantly. We spread it out over the snow; knowing in the spring it would sink right in.

At the end of February there was a partial thaw, then a freeze, and then we were really trapped in. The whole place was solid ice. To get up the slight incline from the house to the barn, Ron went up with spiked boots and skipoles carrying a line. He attached it to the barn and the rest of us hand-over-handed ourselves up.

Toward the end of winter Mr. Bullard's unpreparedness became evident. We ran out of hay and had to buy a barn full of store-bought stuff. The silo was down to the bottom as well. During this period there was more money going out than the milk was bringing in.

Sunday dinner, which happened at midday, was the best meal of the week. Sometimes we had chicken. Once I asked for more. I was told, as though I were a stupid, bad child, that I could not have seconds on chicken, only on potatoes and vegetables. Oliver Twist was alive and well in Townsend, Vermont. I might add that Ron and Phil could have seconds on chicken if they wanted, and they did.

Sunday night supper was popcorn. Tons of it. And milk, of course. Always lots of milk.

Every Saturday night we sat around the radio and listened to The Hit Parade. I learned all the tunes as recreated by Dorothy Collins, Snooky Lansing, and Russell Arms. I particularly remember "Mule Train," which was number one for an incredible nineteen weeks. It was amazing to hear how many different ways there were to perform "Mule Train."

Spring came late; the first hint was when the sap started to flow, which brought us to the sugaring season. Vermont was full of maple trees then. They're all dying now—from the acid rain, they say.

When the sugar is in and all boiled down there's a big celebration with mountain music, dancing, snow cones made out of, right, snow, and maple syrup, maple popcorn balls, and some harder stuff for the grown-ups.

The day the snow melted, Mr. Bullard came charging in just before breakfast in a towering rage. He went straight for the rifle he kept in the breezeway, grabbed up some hollow-point shells, and headed out. We all followed. What was going on was that the starving deer had come down into (believe it or not) the south forty and were eating the clover, which had, sure enough, appeared the instant the snow melted. The problem was that, the ground being so soft, with every bite the deer pulled the clover out by the roots; and their feet did damage to the underlying alfalfa crop as well.

Mr. Bullard laid his 30.06 along the side of a big tree to steady it and took aim through the telescopic sight; took up the slack, let out his breath, held it, and squeezed. He may have been a zipper manufacturer who didn't know how to make a go of dairy farming, but he knew his 30.06s.

The eight or ten deer that formed the herd bolted. After about twenty yards of flight, one fell. The rest jumped the wall and disappeared. Mr. Bullard motioned for us to stay still, and waited. After a few moments, one deer (the mate) reappeared at the wall. "Come on, come on," the farmer whispered. He didn't have a clear shot. Like any good killer, he would not shoot to wound, mainly because he didn't want to have to chase down a wounded deer in the slush. The deer hesitated, took in the hopeless situation, and fled. Mr. Bullard lowered

his weapon, ejected the unfired shell, and put it on safety. That moment is ingrained in my mind, like all the rest of the moments of this happening. These memories formed the core of my deportment around guns.

We all started forward. "Careful," he said. "Don't go near it. It might still be alive. It could do you a lot of harm."

No chance of that. The bullet had gone cleanly through the beast just behind the left shoulder. There was a small hole there. The deer had run those twenty yards on sheer spirit. On the right flank, there was a much bigger hole. Spewed out of that hole for twelve feet or so were the viscera. The victim had been a doe. At the end of the trail of guts was a uterus with a fawn in it.

Mr. Bullard almost lost it when he saw that. It was the only time I ever saw him go soft. He sent us to get shovels. He was very definite about all of us going. When we came back, he had himself in hand again. Phil asked him why we didn't eat the doe, and Ron asked, "Shouldn't we report it?"

"No," said Mr. Bullard, the deer slayer. "It'd just mean mountains of forms to fill out if we told the game warden about it." (Farmers were allowed to shoot deer out of season if they were destroying the crops, but the paperwork was enormous.) "And," he added, "she wouldn't be any good to eat. She's been feeding on hemlock all winter. The meat would be bitter as hell. Best just bury her and forget it."

We dragged her into the hole we'd dug. I got the job of scooping up the guts with a shovel. We buried her with her fawn. I almost thought for a minute we were going to say words over her, but we didn't. I never hunted again. Couldn't. Still can't.

With spring came romance, and baseball. Every young person in Townsend jumped with joy at the sense of freedom that came with the melting snow. There was a school picnic with contests and races. Sack races, three-legged races, wheelbarrow races. Phil was the acknowledged junior champion of the foot race. I was harboring the secret of being the fastest boy alive.

When the "city kid" toed up next to him, Phil and all the local boys laughed. I won it hands down. The prize was a bottle of pop. I shared it with a girl named Lorraine. Phil could never get over that defeat. He and his friends tried to convince themselves it had been a

fluke. I didn't really care. I had won. I didn't have to prove anything more. Days later, I played one of the six games of baseball that I have played in my whole life. As always, I got a hit.

I was told that Lorraine was not a good girl. Her family was poor and they didn't go to church. I said, well, neither did we. Yes, I was told, but they don't even go on Easter. This stigma didn't seem important. Actually it made sense: we were both outcasts.

Lorraine was pretty, and sweet to me; more important, she let me touch her breasts. This was a first for me. However, she wouldn't let me kiss her on the lips; she was saving that. She had to draw the line somewhere.

⇒ ⇐

WHEN SUMMER CAME I gave up the dairy business and went to work on a hay farm. That was a lot of hard work but I was really there as a companion for the farmer's daughter, who had had polio and was more or less shut in. One of my chores was taking care of the piglet, who became my good friend. He grew into a full-sized hog before the summer was out; and then he was sent away and came back as bacon and ham. I couldn't seem to hang on to a friend.

At the beginning of the next school year, I somehow ended up living with a small family in Greenfield, Massachusetts—a couple with a baby, and a Dalmatian that drank beer. A foster home, I guess you'd call it.

I heard through the grapevine that the Bullards had lost the farm. On the way to Massachusetts, I actually saw Bess standing next to a fence in a pasture. I made them stop and let me talk to her. It was Bess for sure. We were still in love. I wondered if her new owner had been fooled the same way by Mr. Bullard.

At school in Greenfield (we're talking about HIGH school now) I went out for football. There was a minimum weight rule for the freshman team: 125 pounds. I tipped the scales at 104. They refused to give me any equipment; so I went out and scrimmaged in my tee shirt. I outran everybody but no one threw the ball to me. I made one spectacular flying tackle on a big, fully suited candidate. He just kept on running. After a few yards I began bouncing down his torso, still

hanging on. I bounced on down to his feet. He just stepped out of my grip of steel and went on.

I joined the drama club. I was elected president. This knocked me for a loop. It was important that I look good, as all the best-looking girls were in the club; however, because of my terminal shyness, I was almost incompetent as president.

Somebody in the neighborhood poisoned the Dalmatian. We kids knew who had done it, or who would do it. We snuck up behind their house and shot an arrow through their picture window. There was a note tied to it which said, "We don't like people who poison dogs." They moved away.

Behind our house was a wooded area where I played alone for hours every chance I got.

I would take off all my clothes in the woods and run and climb naked. It was a delicious feeling of freedom. Eventually this exhibitionism did me in. I indulged my Indian fantasies by painting myself with mahogany wood stain and was running around the woods naked with my bow and arrow when the foster father caught me at it. The big issue seemed to be that I had painted ALL of me mahogany. This thoroughness was shocking to the family. It seemed perfectly reasonable to me. Anyway, I was sent back to my father in New York—as incorrigible. Going home! What joy! Or so I thought.

STREET SMARTS

Back in the Big Apple, things were proceeding apace. We had moved into a brownstone house on West 12th Street. That had to mean Dad was making some good money.

I started high school as a late-comer, at Straubenmuller Textile High (P. S. 3), a trade school, on the lower West Side of Manhattan. This was not a good period for me. There were kid gangs with knives and zip guns, and I was completely without protection or friends. I had to battle with a gang every day after school.

Between classes, I would be jumped in the halls and beaten. It had something to do with my dad being famous; specifically, with the fact that he had shot Jesse James. My assurances that my dad really was a hero who had never killed ANYone fell on deaf ears. These kids couldn't make that distinction; didn't want to, anyway.

There was one potentially glorious moment when they followed me home and my dad came out and chased them off; now, maybe, he would understand what I was going through. Dad, though, was a really old-fashioned guy. He figured the pierced ears and long hair, tight pants, and jewelry signified that they were all a bunch of faggots. He told me the next time one of them came after me to hit him in the stomach. I did, and that REALLY made him mad.

Once, for a brief moment, I had a champion. I was on my way

to a movie at the Greenwich RKO Theatre, which was on our turf. A couple of large tormentors stepped in front of me and asked me where I was going. I told them, meekly, to the movies. The head large tormentor allowed as how they'd like to go too, but they didn't have the cash. Why didn't I give them some? I said I only had enough for me. "Large" laughed. He said I'd better give him what I had.

Things looked bad, when, out of a dark storefront, a voice said, "Are these guys bothering you?" It was Mark, the president of the drama club, and some of his fellow actors. Mark was pretty large himself, and he was holding a two-by-four with a bunch of ten-penny nails driven through the end of it. "Large" and his buddies moved out. I chatted with Mark for a few moments, and then he wished me well and sent me on. I missed the beginning of the movie, but it was well worth it.

Mark's interest in me was the same as the others': my famous father. He was my protector for a few weeks, but he lost interest in me when he realized I couldn't get him into showbiz, and things drifted back to normal.

I started cutting classes; using my lunch money to go to movies. For 55 cents, before 1:00 P.M., you could go to the Rialto, the Rivoli, the Paramount, or any of the first-run movie houses on Broadway and see a movie and a stage show, with a full orchestra, a chorus line, acrobats, magicians, dog acts, and real stars as headliners: I saw Abbott and Costello, Martin and Lewis, Frank Sinatra. It was easy to forget my troubles in the dark on "The Street of Dreams."

The other thing I discovered was cigarettes. There was a reason for that. I thought that if I started smoking, I wouldn't get beat up as much. I determinedly taught myself how to do it with the help of a hedonistic baby sitter. It worked pretty good. When I'd see my enemies down the street, I'd pull out the pack and light up in true tough Humphrey Bogart style, and walk right past. Generally, nobody wants to fuck with a thirteen-year-old kid smoking a Camel. And if that failed, I always had my running prowess to get me out.

One time I was walking with a friend down Greenwich Avenue, one of the hot spots, when up ahead we saw four tough-looking guys we didn't know sitting on a low wall at a construction site. As we came up to them, one particularly vile-looking dude stepped down

from the wall and said, "Gimme a cigarette." If I were alone I might have run, but you do strange things to impress a buddy. I took the Camel out of my mouth, blew smoke in the fiend's face, said, "Sorry, I don't smoke," and kept on walking. I expected to be jumped from behind any second, but nothing happened.

More and more, I was fighting back and holding my own. New York was toughening me up, for sure.

Every day after school there would be a bunch of guys waiting for me around the corner. I was really scared of these confrontations. These guys would beat the shit out of me every time. One day I walked around the corner and swung at the first guy I saw. There ensued a major rumble at the end of which I stumbled home, having lost my books, suffering from a suckerpunch-induced stomachache. Some kid followed me home and gave me my books back.

The next day, as I rounded the corner, some kid stepped in front of me and told me I had put his brother in the hospital. I couldn't believe it! Me? I asked him if he wanted to join his brother. Things were getting better; not a lot better, but better.

⇒ ⇐

THE BROWNSTONE HAD four stories. My room was at the top. There was a trapdoor to the roof and I took advantage of that escape route often, jumping from rooftop to rooftop until I found a way to the street. I also spent a lot of time beating my meat.

My dad sat me down one day and told me that changes were about to happen to me. It was called puberty. He said that I would do all kinds of things for no real reason; that parents never understood this period in their children's lives, but that HE would understand because, unlike other parents, he remembered what it was like for him. He was right about the puberty thing, though a little late, but he was full of it about the understanding part. He forgot just like the rest of them.

The house was always full of people. It had twelve rooms and someone was always staying over, sometimes for months. There were parties and famous people. Tennessee Williams was even there once in his heyday. All he did was sit and talk with the crowd of people he

brought with him. Andrés Segovia was there that night and played for us. Tennessee talked all the way through the recital. Segovia broke a nail trying to drown him out.

Dad bought a square grand piano that he spent a fortune restoring and which never did sound very good. So he got another Bechstein, which he spent another fortune restoring, and the square grand became furniture. I spent a lot of time with the piano restorer and pretty much learned how to do it myself. Sonia was the musician; and sometimes someone would play while my dad sang: opera, mostly, though he did a mean version of "September Song."

My taste in music was going a completely different way, influenced by Sonia's record collection. I went crazy for Tennessee Ernie's "Sixteen Tons," Phil Harris's "Loaded Pistols" and "Loaded Dice," and Jimmy Durante's "Inka Dinka Do." Then there was Benny Goodman's Carnegie Hall concert, a landmark. I soaked up Burl Ives, Josh White, Harry Belafonte, and Eartha Kitt; and I discovered the blues on a Billie Holiday album. My dad thought this stuff was all crap, but Sonia, and I, with the wisdom of youth, knew better.

Around this time I found out where Sonia was really coming from. I had just had a little talk with her, which had ended with a big, affectionate hug and kisses. I was coming down the stairs afterward and heard voices in the kitchen. It was about me so, naturally, I eavesdropped. I heard the big-hunk aspiring actor who was staying over say, "I think it's great the way you are with the kid."

Sonia replied, "Oh, you mean that loving stepmother act?"

I heard nothing else. I reeled up to my room in lovelorn panic.

The fourth floor was a fascinating place. All kinds of stuff was stored there, like the Stetson Dad had worn in *Stagecoach*, preserved in perfect shape. I could almost wear it; Dad had a small head: 6 7/8.

For a while, Dad rented out the spare room next to mine to an old friend of his who was down on his luck: Jim Moran, the notorious publicist who had sold a refrigerator to an Eskimo, and who personally sat on and hatched an ostrich egg while dressed up as an ostrich (so the bird wouldn't be startled when it first saw its "mother"). That stunt was for a movie called *The Egg and I*.

The stunt that got him in trouble was for Sugar Crisp, the first sugar-coated breakfast cereal. He sent up huge kites in Central Park

with midgets attached to them wearing teddy bear costumes, carrying signs that said, "I'm handy, I'm dandy, I'm candy." The police shut him down. He made the papers, which was the whole point. When they asked him, "What if they crashed?" he replied, "They're insured."

His room was full of strange odors, erotic African sculptures, and drawings and paintings by Jim himself of naked women, very well done, and very graphic. I studied this artwork closely. Thirteen-year-olds didn't get much chance to see that sort of thing in 1950.

Eventually, the class-cutting did me in. The truant officer reared his ugly head. For a couple of months I was assigned a "Big Brother," a sad little fellow who was just simply not equal to my huge criminal intellect. I landed in reform school.

STIR

Children's Village was the place you were sent to if you had a kindly judge. Built on a beautiful campus outside of Dobbs Ferry, New York, it was the juvenile version of a prison farm. It wasn't really so bad. We lived in "cottages" of about thirty-five boys, each ruled over by a married couple. The wife dispensed cookies and cakes, and the husband dispensed discipline, swift and sure, mostly with a bat.

I received a prison haircut and a suit, for which I was in debt $25. The suit was for Sunday. It was a double-breasted affair that made me look like George Raft.

In the morning, after chores, we went to "school"; a joke. In the afternoon we worked at learning a trade. You could pretty much pick your job. I picked farming. We grew tomatoes; starting them in a greenhouse, then thinning them and transferring them to a cold flat. We'd keep them in the cold flat until they were stunted and strong, like Bonsai trees. Then we'd put them in the ground when the weather permitted. They would shoot up. We had ripe tomatoes in six weeks.

We got "paid" for our work; 25 cents an hour I think it was. This "money" would go to our "necessities." If we wanted extras—cigarettes, ice cream—we could earn that money by doing volunteer jobs.

You were allowed eight cigarettes a day: two after breakfast, two after lunch, one at the mid-afternoon break, and three before dinner, which had to last until bedtime. Cigarettes, of course, were a big trading item, so even the non-smokers worked to get their cigarettes. The three basic trade goods were cigarettes, desserts, and chores. I would always take someone's chores for the extra desserts.

Seeing that I was a willing slave, the establishment gave me a cushy volunteer job. I became the houseboy for the assistant warden. I'd sweep and clip and rake his yard, and vacuum his carpets, and his wife would come up with sandwiches and cold drinks and an occasional piece of cake.

There was one pervert-inmate who taught me how to box; mainly his teachings consisted of beating me up, but I learned.

If any of the kids had a beef with another, they'd go down in the basement and slug it out with fifteen-ounce gloves in front of everybody. We had two-minute rounds, and the fight went on until one of us gave up. The housefather was the referee, of course. I saw several big bullies brought down in that cellar, to the enthusiastic cheers of the inmates. One thing became clear to me in these matches: it was not as important if you could dish it out as if you could take it. It was obviously also important to control your anger. Wild rages begat bops on noses.

We were affiliated with a soccer league. The same one I'd played in at Riverdale. When the Riverdale team had had to play Children's Village, we were always terrified. We figured those hard-case juvenile delinquents would tear us apart. Now that I was on the other side, I found out that we criminals were terrified of the "good" kids. Burdened with guilt and shame as we were, we could not face these upstanding young boys. The day we played Riverdale, I called in sick.

There was a really cool guy named Charlie that everybody looked up to. He really didn't belong there any more than I did. He was a cartoonist, and we all had a lot of fun hanging around Charlie and his drawings. About twenty-five years later, I ran into Charlie while I was doing a picture about railroads. He was a hobo. Still funny, still an artist, and he still didn't really belong where he was.

There were movies every Thursday night. This was a time when most of the campers were thrown together. It was sometimes bedlam;

fights would break out. The atmosphere was a lot like the chain-gang audience in *Sullivan's Travels*.

There was a little one-room building they called The Band House, but there was no band. There were no musicians, no instruments, and no band leader; we did have sing-alongs, but not in the bandhouse. It was used for storage.

We had TV, and a bunch of us watched "Crusader Rabbit" every afternoon before dinner. There were also the Wednesday night fights, and once they let me stay up late to watch one of my dad's old movies. It made me miss the hell out of him.

One day I'd had enough. Wretchedness, loneliness, boredom, and (the main thing) homesickness got me. I broke into the Boss's room and helped myself to my cigarettes and my money, and went over the fence. I made it into Dobbs Ferry and found the railroad station. My plan was to wait until dark and then stow away on the train to New York. I wasn't really running away; I was going home. The cops picked me up and brought me back. I was put on probation and lost all my privileges for a while.

Dad and Sonia came to visit. Sonia was very loving and motherly, but I was on to her now. We were developing a new relationship. We'd joke a lot and kind of dance around each other.

I didn't talk to Dad much; he was closeted with the Bosses, but before he left he had extracted a promise from them to let me go for two weeks in the summer. From that time on, all I did was wait for that day. I don't know how long it was I waited. It could have been weeks; it could have been months.

Finally it came. I was put on a train by myself and sent to some little town in New Hampshire. I don't remember the name of the town, but it was somewhere on Lake Winnipesaukee. Sonia wasn't there. She'd gone home to Mother again. It was just him and me.

Dad had been offered a Broadway play called *The Silver Whistle*. Sonia read it and told him he would hate it. It had opened with Clifton Webb and become a big hit. Clifton got to do the movie version. Now Dad was doing it in Stock; plus an occasional *Hamlet* or *Julius Caesar*. Cassius was one of his favorite roles. Dad was also starting to take over the direction on these deals.

The reunion on Lake Winnipesaukee was delicious. We went on

the only fishing trip we ever had together. Dad taught me how to cast for bass. We practiced by casting into a Borsalino hat. When the visit came near the end, I pleaded with him not to send me back. I cried, I promised anything.

He went for it. He actually had no choice in the matter as far as New York State was concerned; he just didn't send me back. Later on, when he had to, he dealt with the legalities of it. I knew all the time he could do anything. We spent the summer together, laughing and crying. He had his own problems. Sonia and he were breaking up, though none of us knew that yet.

CHAPTER FIFTEEN

VERONICA

I would have given anything to have had a real family, but the way it worked out, I was basically brought up by strangers and boarding school teachers. I actually have no idea what real family life is like.

Dad was going back on the road again, and he rented the house out to Veronica Lake. She offered to take me in; and Dad, unusually, asked me what I thought about it. I thought it was a great idea. Veronica was a very famous movie star/sex kitten, the idol of every young woman and most men. She was the second most beautiful woman I had ever met in the flesh, and I fell hopelessly in love with her instantly.

The first most beautiful was my dad's best friend's wife, Hyla Jones. We used to have dinner at the Joneses' house once a week or so. They had two children: Ellen and Sheldon. They lived in a basement apartment that had as its backyard a beautiful, expansive garden that belonged to a church. We attended Shelly's baptism there; Dad and Sonia were the godparents.

Paul Jones was an executive at Actor's Equity, the stage actors' union. Hyla had given up a singing career to have his babies. We knew the Joneses long enough so that I watched both the kids learn how to walk and talk and start to grow up. Ellen was in love with me. I promised to marry her when she grew up. Hyla used to sing to the

kids when she put them to bed, before they said their prayers. She had a beautiful voice.

Once I walked into the bedroom and caught Hyla naked. She covered up immediately and I backed out just as quickly, but the image of her perfect, creamy body and her soft flowing hair was burned into my soul. I judged all art by comparison with this fleeting vision of Hyla from that time forth.

Veronica Lake was preparing to go on the road in the touring company of *Peter Pan*, the (on Broadway) Jean Arthur/Boris Karloff version, with Boris playing the evil Captain Hook, music by Leonard Bernstein, and book and lyrics taken from the original James Barry play. As far as I'm concerned, it was vastly superior to either the Disney or the Mary Martin rip-offs. Veronica's co-star was the opera singer, Lawrence Tibbett. This was to be Ronnie's comeback. I watched her get her hair cut. She chopped off her famous over-one-eye blondness into a pixie cut. She looked even sexier.

Veronica had been through a bad divorce with Andre De Toth, after which he had taken custody of the kids. She needed somebody to mother. That was okay with me, although the hugs and kisses we indulged in were something more for me than they were for her.

She arranged for me to audition for one of the "Lost Boys." I was deemed too tall, but they called me an understudy and I traveled with the company. I never did play the part.

Veronica toured in style. She carried fourteen pieces of luggage, including two steamer trunks, a phonograph, and a large record collection.

The show opened in Baltimore, and went on to Charleston, Birmingham, and Atlanta. As we swept through the deep South, I had my first real confrontations with real, above-board segregation; several of our members were black. Veronica gave a birthday party for me in the hotel in Memphis. The only way we could get the black member of the "Lost Boys" into the hotel was to dress him up in a miniature chef's uniform and tell them he was a servant.

The tour continued, describing an arc through Texas, Oklahoma, Kansas, and Missouri. Ronnie was wonderful in the part and everyone loved her—especially the gays, who all cried when Tinkerbell was dying—but Lawrence Tibbett was drunk just about

every night. Several times the stage manager had to go on for him. The show fell apart and so did the tour. We folded in Chicago. Veronica's comeback folded too.

When we settled back into the brownstone in New York, we had a new addition to the family. Veronica had converted one of the dancers temporarily to heterosexuality. (Such was her power.) They spent a great deal of time in bed, dashing some of my own hopes concerning Veronica, but not anything like all of them.

Instead of sending me to school, always a risky business with me, Veronica arranged for me to be tutored. She sent me to the teacher who had traveled with *Peter Pan*, tutoring the "Lost Boys" as well as playing an Indian, a pirate, and Nana, the dog. Frank was his name. He was a fine painter as well, and a musician. He was also black. I would walk across town to his apartment on the East Side and spend the afternoons with him, soaking up culture.

Around this time, I discovered science fiction and became addicted to it for years. The thing that got me started was a story in *Astounding* about a mutant boy who was telepathic. He couldn't stand to be around people because their minds were always shouting at him. He had to keep his talent a secret from everyone. If they found out he was a mutant, they would do unspeakable things to him. At the end, he contacted the mind of a girl who was like him. I really related to this kid's problem, and quickly went out to find more of this literature.

I got sweet on a girl I picked up on a bus. She had red hair. We took to riding all over town together. Life was going pretty good. It had to end, though. Veronica drifted away to Florida to become a cocktail hostess. Her dancer-lover reconverted and drifted his own way. Frank, my tutor, frustrated with my lack of application to my studies, gave up on me, telling me I had no respect for him because of his color.

That, actually, was far from the case; I had the utmost respect for Frank. The real problem was I was in a sort of dream state most of the time, my head full of science fiction and sexual fantasies.

During one of my prowls, I was picked on by three tough guys. I was bouncing the leader around when one of the girls with them said, "Leave him alone, you bully." Me? I couldn't have that. I would have to become a hero.

STABLE BOY

I had to go back to school. My dad came up with his best move yet. He managed to enroll me as a latecomer in Stockbridge Academy in Massachusetts. This place was fabulous. It was run by UNESCO and had students from important families all over the world. The student body was limited to known geniuses who were going through difficult childhoods. It seemed I qualified. The school dummy was a sad little kid who only had a 130 I.Q., the lowest in the school.

There were only seventy-two students at Stockbridge. There were nine teachers. The campus was a big chunk of country out in the Berkshires, with a beautiful huge old mansion, and the largest barn in New England. In this barn were most of the classrooms, the gym, and the boys' rooms. There were three of us to a room, and the roommates were carefully chosen for compatibility. The food was good, the atmosphere extremely convivial, the curriculum was stimulating; and, best of all, the place was coed. Across the soccer field, in the big house, were GIRLS. Lots of them; pretty ones; and all geniuses.

The cadre that ran this place were a bunch of visionary maniacs; just what I needed. Alex (everyone at Stockbridge was on a first-name basis) who tutored English history, Latin, French, and German, was in British Intelligence during WWII. He spoke five languages with native fluency and was totally capable of second-guessing the

rebellious geniuses in his care (which he would have plenty of reason to have to do). Harry tutored music, American history, math, and semantics, and also drove the jeep. He was a holy terror.

Phil taught English and physical education, mainly soccer, at which he made us absolute killers. He was the least flamboyant of the guys; he was also our housefather, and he was great at that. Richard was the dour Swede who was the shop teacher and also the foreman of the construction, repair, and maintenance crew. That was us: the shop class. Julie was the art teacher, and a dish. Alex had a thing going with her, but Phil was always trying.

There were two standard middle-aged biddies who were in charge of most of the girl stuff, but I don't remember their names. Harold was the assistant headmaster, and picked up the pieces, and was also in charge of business affairs. Hans was the headmaster. He had spent some time in a Nazi concentration camp and had a tendency to take things very seriously. His word was Law. Nobody wanted to be on his carpet.

We all had chores we had to do. We were supposed to be assigned to one job for a month at a time. One of the chores was taking care of the horses. Nobody liked that job. I said, "Are you kidding! Take care of the horses? I'll take the job; in perpetuity." Actually, I don't think I knew how to say "perpetuity," but, anyway, I got the job: permanent horse-boy. I was not allowed to ride the horses unsupervised, but I was supposed to exercise them. I rode them. Day and night.

There were three of them: a Thoroughbred gelding who thought he was a stallion (you couldn't relax on him for a second, unless you wanted to be on the ground); a quarter-horse gelding (who was absolutely the best ride, well gaited and well mannered). These two horses belonged to girl students who never rode them. Then there was the old, white Percheron, who was an absolute pussycat. He belonged to the school.

One night I had quite an adventure with the quarter horse. I took him out into the rolling fields, dotted with cathedrals of evergreens, by moonlight. It turned out I had not tightened up the saddle enough. It slipped around to his belly, throwing me off; and then he was terrified by the saddle hanging under him and wouldn't let me

near him. He kicked and bucked and tried to run for an hour. I got hold of him once, and he slipped out of the bridle. I had this vision of going back to school and admitting I'd lost or crippled him. Or maybe I'd get killed.

Finally, he wore himself out and stood there trembling, letting me get near enough to undo the cinch. By this time, I didn't have the nerve, or the strength, to get back on him. I carried the saddle and led him home, with the reins around his neck; about three miles. The next day, we were really buddies. We were also both really worn out.

There were also two gelded bull-calves, which the school was raising for veal. I used to ride them too. That was a lot of fun. They were a wild ride, but small enough so that I could keep my feet on the ground if I needed to. I think I broke their backs down sitting on them, but I reasoned it didn't make much difference; they were dead meat, anyway.

If I was late in feeding the stock, the Thoroughbred would kick the barn apart and I'd have to rebuild it. That happened more than once. I've never been the picture of punctuality; particularly in the morning; comes from having a Broadway actor for a father.

As I settled into the studies, I began to figure out that the real purpose of this school was to train revolutionaries. The first hint came in Harry's American history class. After reading the first chapter of Muzzey's *American History,* I remarked that the text had contradicted itself three times. Harry said, "Very interesting. Give me a paper on that next week."

Every Tuesday we went down to Lenox on the truck to buy toothbrushes and junk food and go to the library. This was a very complete library; particularly on the subject of American history. I found a book called *The Secret History of the American Revolution*, by Mark or Carl Van Doren, I don't remember which, that had some real eye-openers in it; like the fact that when John Hancock signed his name so big for Independence, he was wanted for embezzlement back in England; then there was a facsimile of King George's diary, which contained the entry that George, on the day that he received the Declaration of Independence, was having an attack of indigestion. Naturally, he said, "Nuke the Bums!"

I came back to class with the news that the books were lying to

us. Harry said, "Ain't it the truth?" Then he proceeded to show us how they were doing it. That's where the semantics came in. Hayakawa's book on the subject had just been written, but Harry was up on it.

I was taking art at first but for some reason, I don't know why, maybe because art was too easy, I decided to switch to music; even though I had to leave the company of sexy Julia. Actually, I know why I switched: it was a heroic life decision; I wanted to learn.

Harry put me through a trial by fire, and for the first time I really started to get it. Music, you know, isn't just some tunes that people have made up; it's a demonstration of the Laws of Harmonics, some of the most basic stuff in the universe. Harry was the first person who tried to get that idea into my head. I'm eternally grateful to him for that, though he was very impatient with me. He put me up as an example of how stupid most people are about music, but I stuck with it.

I joined the choir as a bass, a very manly thing to do.

I fell in with "The Bad Boys." There were about five of us who made up The Group. Howard, one of my roommates; Bill Chamberlain, my closest friend, who lived next door with the two other guys who were the comedians in the group; Bob and Ray, so to speak. Not a real member, but sort of a mascot was the dummy, Charles. We had to let him in to keep his mouth shut; he was my other roommate. There was one other kid across the hall in the tower room (Benson was his name), who was sort of an honorary member, but he was crazy as a loon and hard to get along with except for us.

The big sport at Stockbridge was soccer. We had a team which was dedicated to victory at all costs. I was a halfback, and I was great. Howard was our secret weapon. He got a pair of boots that were two sizes too big for him; and, in the tips, he stuffed some ball-bearings, with rubber behind them to protect his toes. When we were in trouble, Howard would wade in and cripple the enemy. Fair play was not one of our strong points.

On the subject of the girls, there was constant contact with them, carefully chaperoned, of course, but at every turn there was a beautiful woman. Meals were the best of the regular get-togethers. Everybody was there and circulating around. You had to go to the

kitchen to get served your entrée. Then one of the revolving chores was helping out with the serving, setting the table, and helping with the dishes. Everybody, eventually, got close to everybody. At breakfast, lunch, and dinner we all laughed and talked and played practical jokes, and had emotional breakdowns. It was a real family.

When the first big snow came, it coincided with the Princeton ice-sculpture issue of *Life* magazine. We decided we should make an ice sculpture of our own.

When the dawn rose on the soccer field, there was a seven-foot-tall representation of an erect cock and balls standing on the fifty-yard line, between the boys' dorm and the girls' dorm. We had a great laugh at breakfast. Harry tried to knock it down with the jeep, with the snowplow attached, but it wouldn't budge. We'd watered the thing down before we finally snuck back to bed, and, during the night, it had turned into a glacier. Hell, after all, it was supposed to be an ICE sculpture. Later in the morning, Alex, Harry, and Phil rounded us up and said, "Get shovels and picks. You're going to break it down." We said, "Why us?" They said, "Come on, guys. Don't be silly."

Now and then we had dances. We put on records and drank pop and got goony over the girls of our choice. My favorite was the school princess, the favorite of everybody else as well. Joan was her name; Ebenstein. She was very beautiful, and very aware of her power. She was from a rich New York family, and she got to see all the Broadway musicals, while I only listened to the albums. I could sing the songs better than she, but she could describe the scenes; an untoppable ability. Bill Chamberlain told me Joan was just a prickteaser, but I was smitten.

Getting in the truck to go to Lenox was another great opportunity to mingle with the girls. With luck, you could even get wedged in between a couple of them.

The other outing was the trip to Pittsfield, which, as I remember, happened every Saturday. Pittsfield was a relatively large town and we could be fairly anonymous. We had shoplifting contests. Because of our fascination with music, I concentrated on stealing LP records. I would go into the music store and play records in the booth, stick a bunch of them inside my overcoat, and walk out the door with them. I fashioned a thief's kit consisting of a towel, sewed in half, attached

to my belt as a pouch. One day I walked away with seven twelve-inchers and four ten-inchers. I thought I was doing pretty good until Howard told me that I was endangering the whole game by over-fishing.

Howard was the genius who built the hi-fi set we played the records on. He built a system so powerful that when we pointed the speakers out the window, cows would turn around a half-mile away. We listened to everything, but we leaned toward the classical composers. When we discovered Hindemith and Bartok, they became our favorites for a while because they sounded like a horror movie. We would impersonate The Wolf Man, Dracula, Frankenstein, and Igor, while the music played.

Another big favorite was jazz, particularly Stan Kenton, who was new to us and weird, the main requirements. We were very impressed with Maynard Ferguson's high notes.

One day one of us, I think it was Howard, decided to play the piano and learned a piece: the *Wanderer Fantasie*, by Schubert. All the rest of us had to learn it and the point was, how fast could you play it? Bill Chamberlain was the Master.

Harry taught the music students a Christmas chorale; everything from jingles to a small requiem. We performed on local radio. The Monster 5 sat up for many nights and composed gory parodies on them. Just before Christmas break, we congregated in front of the various teachers' windows and performed these horrors, like the carolers of old, all in perfect four-part harmony: "God Damn Ye Merry Gentlemen," "The First Oh Hell," "Hark the Herald Angels Scream," "Gory Night. I've forgotten all the Latin quotations of Julius Caesar, and the Shakespeare soliloquies, but I still remember those parodies.

When I went home for Christmas there was a special surprise. My mother came to visit. I met her and Sam (they were now married) at their hotel on the East River, right next to the U.N. We stood on the balcony of the Penthouse Bar, looking across the river at Queens, and tried to get to know each other again. The point of it was she missed me and wanted me back. I really didn't know what to think about it. There was still a court order demanding Dad's arrest if he showed up in California; so going back with her would mean I couldn't see him. Mother said maybe she would do something about

that. I was actually negotiating my dad's return to Hollywood. But, on the other hand, what about Joan Ebenstein, the Monster 5, and the horses for that matter?

Mother's Christmas present to me was a ring with a small diamond. It was ridiculously inappropriate, but I cherished it anyway.

Stockbridge had a lake, and when it froze over the Monster 5, along with the rest of the school, got seriously into ice skating. We had all the usual thin-ice near-catastrophes, but no one went through the ice that year. The other thing we got into was ice-boats: a latine-rig sail on blades: definitely too much fun.

Once in a while we had dances in the clubhouse, a little shack off at the edge of things. These were more or less spontaneous, put together by the girls themselves and poorly chaperoned. We had a 45 RPM changer, and we'd put on a stack of singles and get dreamy. I wasn't any kind of a dancer, but I loved the contact with the girls: bittersweet and dismal, potential joy and heartache; it's the greatest.

I developed a bantering flirtation with Joan Ebenstein. We decided we were going to get "married." I said, "When?" After some hilarious discussion, we decided on September.

As an indication of my success at Stockbridge, I grabbed off the lead in the school play: *Doctor Faustus*, by Christopher Marlowe, with Bill Chamberlain playing Mephistopheles. I wanted desperately for my dad to see me do it, but he arrived after it was over. I think he was drunk. He told me why a year or two later. His best friend had played Faustus to Dad's Mephistopheles just recently, and the little devil had made it with Sonia.

The school year ended and everyone went home; everyone, that is, except me. Dad told me I had to stay for six weeks more. I was furious. He said, "I thought you liked it here." I said, "I do. But now I want to go home." No chance. I stayed. I had no conception of the pain he was going through, and he had no conception of mine.

Once I got over my Mad, Stockbridge in the summer was just fine. The frozen lake became the swimming pool; and there were still the horses. They were now out to pasture and there was very little work involved with them, just fun. The best of the fun was watching the Thoroughbred unseat various macho males who thought they could handle him.

A secret dividend that Dad had arranged as part of my education was to apprentice me to Richard, the carpenter. He had the job, that summer, of making extra rooms out of the attic of the barn, and I was his helper. We would frame in the room, cut out the roof, construct a dormer with a window, install the electricals, put in the insulation and the wallboard, and paint it all. By the time we did five or six of these, I knew how to build a house.

At one point we took off to build a new gate for the horses. Just outside the pasture was a crabapple tree. The horses coveted those apples. One day the Percheron got down and put his head under the gate. He lifted up and pulled the whole thing right out of the ground. After it crashed, he stood up and walked over it, going straight for the crabapples. The other horses followed. No one but me could catch the horses up. I was very proud, but the reason I could do it was not because I was expert; it was just because the horses and I were friends.

One of the big things that happened to me that summer was getting my Life Guard Certificate. To do this, I had to learn how to swim. Well, I knew how to swim, but not formally. To pass the test, I had to illustrate the various strokes. I didn't know how to do any of them; or so I thought. Actually, I just didn't know the names.

What it finally came down to was: Phil, "Do a trudgeon." Me, "A what?" Phil, "Throw your arms over like a crawl, but don't put your head in. With your feet, do a butterfly and then a flutter." Me, "Oh! You mean like Johnny Weissmuller." And I'd do it.

Finally, after many happy days at Stockbridge Summer Camp, my purgatory ended and my dad came and got me. He swept me away with him, and it was like old times. Summer Stock!

The play he was doing was *Tobacco Road*. The part of Jeeter Lester was going to become his greatest role. He ended up doing it for the rest of his life: anywhere, anytime.

On one of the gigs, it could have been Cape Cod, there was a problem about payment. Dad was supposed to be paid on Friday night after the performance, Saturday night being the last performance. It didn't happen. He was told he would be paid Saturday. During the Saturday matinee, he found out that everyone BUT him had been paid.

That night, the house was packed. He went on and played the

first act. At the end of the intermission, the stage manager came by his dressing room to give him his call and found Dad in his dressing gown, out of costume, with his wig off. Dad, of course, said he was not going on until he was paid. Their choice was pay him or refund the tickets for the best house they'd had all week. They held the curtain for twenty minutes while they scraped up the money. Then Dad went out and gave Jeeter hell.

The money Dad got for these shows was incredible to me. All in cash. The first time I ever saw a hundred-dollar bill was on Dad's dresser on a Saturday morning. There was a whole stack of them; and right beside it, a stack of fifties.

Dad developed a *Tobacco Road* stock company that traveled with him. He had the wig (his Shylock wig) and the costume. Georgia Simmons played his wife, Ada, until she died. Dad would direct.

The first thing he'd do when he got to town was take a truckful out to the country and buy an old barn. He'd tear it apart, bring it back to the theatre, and build the set out of it. He'd also collect a truck full of dirt and spread that all over the stage. He had a thing about it being red Georgia dirt. If it was the wrong color, he'd paint it. Over the years, everything Dad touched tended to turn gradually and inexorably to a Georgia-dirt red.

I was always supposed to grow up and play Dude, Jeeter's son, but I never did. (Never did grow up, and never did play Dude.) Keith, however, years later played the part with Dad once; and understudying Keith in the role was brother Bobby's first job in the business.

SEX OFFENDER

I went happily back to Stock-bridge, and there was Joan Ebenstein. I remembered our deal. September only had a couple of weeks to run. I got right down to the business of reminding her and thereby getting on with the "marriage." Neither of us had defined to each other just what was the meaning of our metaphor. I, for one, was eager to test the water.

On the last day of September, I decided I had to do something about it now or never. After lights out, I threw the fire-rope out the window and climbed down. I made it over to the Big House and infiltrated.

Joan had her own little room. I don't know if that was because she was so special, or because the other girls didn't like her. I slipped in and woke her up. Well, Bill was right about her. She was completely unfriendly, scared actually, and told me to get out. I was very confused, but I left.

On the way out, I stopped in on some other girls. There was a lovely little black girl who, if I had any sense, I would have realized was the one I really liked. I spent an hour whispering with her and her roommates. We had a lot of laughs.

I left by the drainpipe, the traditional method. The little black girl and I shared a long kiss at the window before I went over the side.

The whole adventure had been pretty great. On the way across the soccer field, I ran into Phil. He too was coming back from the Big House. We walked along together. He was very cool about it all, but the next day the shit hit the fan.

Joan Ebenstein had blown the whistle. I had to go on Hans's carpet. He was very grim. He explained to me that if one of his girls got pregnant, they'd have to close the school. He asked me if my penis was hard. I said, "When?" Hans said, "A hard penis has no conscience!"

In my search for depravity, I discovered drugs for the first time: in the form of cigarettes and aspirins. I'd heard about this, and decided to try it. You take the last half-inch out of a cigarette and replace it with crushed-up aspirin. It produces quite a rush. I also took apart a Benzedrine inhaler and chewed the contents. That was okay. I ate a whole box of nutmeg, but that was a bum trip. I got sick as hell.

With my new carpenter expertise, and my intimate knowledge of the bowels of the barn where we lived, we constructed a secret clubhouse behind the walls, under the eaves. We started by kicking the back of the closet out and then asking Richard for tools and materials to repair our broken closet. Richard was impressed by our industriousness and our public spirit.

What we built was a secret door. Howard contributed an electrical early warning system that would shut down the lights and the hi-fi when the outer door was opened. We had a coffeepot, and we were able to get a wino in Lenox to buy gallon jugs of muscatel for us. We needed food, so I took a suitcase across the field, picked my way into the kitchen with a coat hanger, and helped myself to some goodies.

We had a great time with this secret sanctum, but, of course, they eventually caught us at it. I let myself into the kitchen one night and found Alex having hot chocolate with the art teacher. The suitcase and the coat hanger were a dead give-away.

There had been reports of missing food. Alex, being the ex-British Intelligence Agent that he was, figured the whole thing out. Assembly took place in the Big House every Thursday evening, just before dinner. One night Alex and Harry were missing. We noticed through the windows that, across the soccer field, lights were turning on in our rooms.

After assembly, we came back to find the entire system boarded up and all our improvements removed. Alex's and Harry's senses of humor extended to spreading dust and nails and such around, so that it looked as though the hideout had never been there.

I went on the carpet again. Hans had had me on some kind of probation ever since the drainpipe incident. He frowned a lot and sent me home to my father.

The whole thing had kind of collapsed anyway. The five monsters had caused so much trouble that they had decided to split us up. Howard overdosed on chloral hydrate and pure grain alcohol that he had distilled himself. He was crying and saying "I blew it!" like Richard Pryor. Harry and Alex pulled him out, but after that he seemed to have lost his nerve.

Benson committed suicide.

Ron, who was the tough guy at the school, got the daughter of the farmer next door pregnant and ended up in jail. Anyone could have predicted all of this would happen, but nobody did.

When I showed up in New York, unannounced, Dad was living in a room at the Wyndham Hotel. Sonia was back with her mother again, with the kids. There was a very beautiful lady there with Dad named, believe it or not, Maria Magdellena. Dad stared at me and said, "What are you doing here?" I said, "I've been kicked out." He said, "Me too!" and burst into tears. Things did not look good.

We spent the next few months hanging out together in bars and at Maria's apartment. The routine would go like this: I slept on the couch in his incredibly messy room at the Wyndham. About noon, or later, we'd go out to lunch. Dad would have a few drinks and then we'd spend the afternoon "making contacts." When the time was right we'd go to Cheerio's, a restaurant-bar run by Vincent Sardi's son. Dad would have several drinks at the bar, collecting friends along the way. Then he'd ask for a table for us and the "friends." By the time we got to the food, I was starving absolutely to death. I think Dad pretty much always picked up the check.

After dinner we would go "pub-crawling." We'd hit all his favorite bars; he'd sing and tell stories. After the bars closed (which in New York is 4:00 A.M., except on Saturday, when it's 3:00, to give the Catholics time to sober up for Mass), we'd go to a bottle club. There

would be more stories and songs, and more drinks. I even got a few myself. The girls would sneak them to me. We'd pour out of the bottle club about 8:00 A.M. and go to breakfast; then back to the Wyndham; though if Dad still had the energy for it, he'd go home with Maria and I'd go back to the room alone.

I had some interesting sessions alone in the room at the Wyndham, having Scotch-induced out-of-body experiences. I made a lot of little sculptures that reached right out to the edges of the Cosmos, or down to the depths of my black teenage soul.

We spent Christmas at Maria's place. She was a great gal, full of love and sexy as hell. So sexy, as a matter of fact, that my dad confided in me that she was likely to kill him. Some possibility of that. She was twenty-five years younger than he, fully as tall, and outweighed him by twenty pounds. A very healthy organism capable of great endurance, she could have stripped his gears in the course of any one night.

She used to sing to him in the bars: pop songs in Swedish. On one occasion, there was someone else around who understood Swedish. We found out that Maria wasn't singing the lyrics at all. She was just saying "meat and potatoes, I gotta go to the bathroom" and, every once in a while, "I love you." Never mind; she was Dad's salvation during that period.

There was a revival of *The Madwoman of Chaillot* at the City Center. At that time, Dad was taking liquid Phenobarbital. At least once, I think he tried to kill himself with that stuff. We pulled him out of it with amphetamines and coffee, and threw him on stage.

Dad realized this wasn't the right life for a fourteen-year-old, so he sent me to live with a salesman in Nyack, as though THAT were the right life for a fourteen-year-old. I started piano lessons again with an old lady. She taught me half of a duet. *Death and the Maiden,* it was called, by Schumann, I think; or maybe Schubert. We'd play it together.

I showed the salesman's little boy my peepee, and they called my father to take me away. Well, the kid asked to see it.

A FRESH START

D ad came out to Nyack. He took me back to New York in a rented car. On the way, he told me that there was nothing wrong with me. "All boys go through a stage like this," he said. I was just doing it a little late.

"Great!" I thought. "I'm retarded."

He asked me what I thought about going to live with my mother. I said, "But I wouldn't get to see you." He said, "Nope. I'm on my way out there myself."

Dad had made a deal with my mother and the judge, using me as bait, whereby he would be allowed back in California. He would have to be arrested, as a formality, for jumping bail and get his hand slapped; and that was all. The years of unpaid alimony had been reduced to $25,000, to be eked out in reasonable monthly payments. He could work in Hollywood again! He even had a picture already: *Casanova's Big Night* with Bob Hope, at Paramount.

Dad put me on a Continental flight to San Francisco. He gave me a big hug and six dollars, and told me he'd see me soon.

Continental was then what was called an "Unscheduled Airline." That meant that they didn't have to keep a schedule with their flights. They could take off whenever they had a plane and enough passengers. They could hold the flight as long as they needed

to fill the plane, and they could pretty much land wherever they wanted to pick up more. The point was, it was cheap.

The flight was full of marines on their way to Fort Pendleton. I got along really well with them. We were provided with a box lunch.

The DC-7 made unscheduled stops in Chicago, Salt Lake City, and then Phoenix. Phoenix was not for passengers. There was something wrong with one of the left engines. We stayed there quite some time while the ground crew tried to fix it. We still had received nothing to eat but the one box lunch.

The facilities in Phoenix were very light. There was a candy machine; and there was a Coke machine. We'd been on the road by that time for over thirty hours. Everybody on the plane had re-opened their box lunches and eaten all the leftover crumbs. I used the last of my six dollars in the candy machine. We were all starting to look pretty ragged and hungry.

Finally we took off, after about three hours. Halfway down the runway, the faulty engine cut out again. The plane just circled around and tried another run at it. This time we made it up.

On this leg of the flight my kleptomaniacal tendencies surfaced again, as I stole the insignia off the hat of one of my marine buddies while he slept. I wanted it a lot.

We limped into Burbank. They tore down the engine there, telling us there was no estimate as to when we would get back in the air. I called my mother, and she called Benton Scott, you remember, the famous Joanie's father? He came and got me. He took me home with him and put me in a real bed. In the morning, while his wife, Edith, bustled around talking a blue streak, Benton cooked me up some corned beef hash and poached eggs. Joanie passed through, looking like a wet dream; and then Benton took me to visit Uncle Will.

Will was just like I'd always remembered him. There was a huge semi-draped nude on the easel wearing a picture hat, with a bunch of grapes in her hand. He sat me down and asked me what I was going to do. I told him I was going to be a sculptor. He said that was a fine idea, but what was I going to do right now. I said, "Oh. I'm going to live with my mother." He allowed as how that was nice too, and we promised to keep in touch. I never saw him again.

⇒ ⇒

BENTON TOOK ME BACK to the airport, where the plane was still being worked on. He gave Continental holy hell. He was wonderful; just boiling over with righteous anger about this poor little kid on his way home to his mother. Continental caved in under the assault and gave me a free ride on a United flight to San Francisco. The difference between United and Continental was night and day. The stewardesses treated me like a little prince. I feel sorry, though, for all the marines who were listed as AWOL.

Mother and Sam picked me up at San Francisco Airport and took me across the Oakland Bay Bridge, pointing out all the sights. I was sure, after my sojourn in Children's Village, that one thing I wanted definitely to concentrate on was staying out of Alcatraz. My new home was a rented California-Mediterranean little thing up in the Oakland hills. As soon as I got there, Mother immediately began to try to feed me to death.

To her, I was the same eleven-year-old she had sent to New York four years ago. It took her quite a while to adapt. Her perception of things is typified by a remark she made at our first dinner together. She told me I couldn't have a cigarette until I finished my vegetables.

Bruce was out of high school and on the verge of college. He lived in a room in the basement with its own entrance and had his own key. He had become a champion runner and something of a ladies' man. He was a sort of hot-rod, sharpie-tough guy and intensely religious at the same time, going to the Church of Christ Scientist twice a week, and spending some time every day on Bible lessons. Like some kind of WASP pachuco.

The old relationship of mortal combat that Bruce and I had always had was reinstated very quickly. The way it happened was, I was telling stories about New York when I inadvertently referred to Sonia as "Mother." Mother burst into tears, Sam gave me the cold shoulder, and Bruce beat me up. I took it all fairly philosophically. It was a hell of a lot better than Children's Village.

I was given the little den at the top, with a daybed, an antique desk, and a piano in it. It wasn't much of a piano but it was enough of one to fire my soul. Outside my door was a little patio; and just

beyond that, an apricot tree! Everything I needed. It also had a TV set. I would pick myself a whole bucket of apricots and lie on the daybed, smoking cigarettes, gorging myself, and watching "Laurel and Hardy" and the weather. There was this incredibly sexy woman who did the weather.

Mother had a job as a telephone operator at Pacific Gas & Electric. When she originally applied for the job, she lied about her age by four years. The result was that she could expect to work years longer before mandatory retirement. It also meant that she was forced to do so if she wanted her pension.

At one point, she almost switched over to a secretarial job; much more interesting, and there were windows. Mother had a welded elbow joint, left over from a broken arm which had never been set. Dancing with her was an interesting experience. Since she couldn't dip her elbow, she dipped her whole body. It gave her a cute, lilting gait.

Even with the elbow, she could type eighty words per minute. She decided against the secretarial job, though, because she would have to start at the bottom and take a pay cut.

I entered Oakland High School as a mid-season replacement. I found out later that this was supposed to be a tough school; I never really noticed it at the time. After reform school and Lower West Side Manhattan, not to mention the farm, Oakland was a pushover.

The first time I tried to use the boys' room, there was a large black kid standing inside the door who demanded a nickel toll from me. I said what for? He said, "Whatd'ya mean, what for? Whatd'ya think? Gimme it." I refused, strictly out of ignorance, not courage. Finally the brute, out of exasperation, just let me go in. After that, he decided he liked me; he used to shake his head and grin at me every time he saw me in the hall. My nodding acquaintance with this bully gave me a certain protection.

Of course I didn't have any friends; I wandered from class to class without talking to much of anybody.

In French class, I sat behind a very pretty girl who always had her homework. Her name was Donna. I had the idea of looking over her shoulder, but she made a habit of wearing strapless gowns to school, and when I looked over her shoulder I got completely distracted.

French class was fairly recreational. The teacher was a very pretty spinsterish woman who looked as though she should be drinking champagne in a sidewalk restaurant in Montmartre. We read French poets and novelists in their original language; a great privilege. She was always showing us a big map of Paris and telling us the best places to go. This information became very useful to me years later, as did my schoolboy French.

Lunchtime in the cafeteria was no fun for me for the first few months, being without friends; so I skipped it. Instead, I brought a brown bag, slipped into the assembly hall, and played the grand piano at the back of the stage. I did this in the dark. If I turned on the lights, someone would investigate and kick me out.

I "wrote" a concerto and some short pieces, mostly on the black keys; they were easier to find in the dark. One day I was surprised to find Donna standing behind me, digging my music.

Donna didn't live very far from me; just down the hill. I spent a lot of time at her house. There was a way to get back and forth really quickly, if you didn't mind the brambles, which I didn't. Disappointingly, despite her strapless school attire, Donna was a determined virgin. We'd sit on her mother's couch and fool around for hours; I never failed to have a huge hard-on by the time I left her house.

I was standing outside the doors of the assembly hall one evening, waiting for a show to start, when two men dressed in overcoats and black hats started a scuffle. One of them pulled a gun, yelled, "Your name is pricked!" and fired. The other man fell dead. After a few shocked moments, they both laughed and walked into the show. That was my first introduction to Peter Renz and Jim Parrish.

By the end of the semester, I had found myself a new Monster 5; together, we were some of the smartest and most socially inept kids in the school and, therefore, some of the weirdest as well.

Aside from myself, there was Peter, who went on to become a Rhodes scholar; Jim, who made the Dean's List at the University of California at Berkeley; Merrill Malkerson, who was expected to be the superstar actor of the bunch (he had a James Dean complex; he also had a car—a very valuable item); and Terry Zimmerman, who eventually emigrated to Israel to fight in the Palestine wars.

With all these new friends, I started liking to eat in the cafeteria and began neglecting my blind piano practices, but not my greatest fan, Donna.

Mother and Sam decided I needed to go to Sunday school; so Bruce would take me down there in his cherry-black '41 Ford business coupe, with the '48 Mercury engine. He was over twenty-one, so he went to church. In Christian Science you don't go to church until you're twenty-one.

Mother and Sam didn't go to church at all at that time. As a matter of fact, they got drunk every night and passed out. Sam was a salesman, and true to type. Mother, I guess, just went along. I would have to carry Mother up to bed, no easy feat; she was a big girl. Sometimes I carried Sam up too, though usually he could make it on his own feet, with a little guidance. I'd force two aspirins and a glass of milk down Sam, his personal hangover cure. Mother would just take the milk; she didn't believe in aspirins. I had never had experience with drunks like this before. Dad was always drinking but he was always his own keeper. Bruce just stayed away from the whole thing.

Bruce was pissed off that he had to go an hour early to drop me off at Sunday school, but then I had to wait an hour for him to get out of church and after that I had to cruise around with him and wait in the car while he visited with his church friends. Sundays were definitely boring and irritating since I wasn't allowed to smoke in his car.

I started to spice up my Sundays by asking "Doubting Thomas" questions of the Sunday school teachers, which resulted eventually in getting me ejected as a bad influence on the other acolytes. I was of the opinion that, if they were serious about this Christian thing, I apparently needed it more than anyone. After all, Jesus didn't kick Thomas out; and, anyway, I was talking perfectly good theological debate. I had been to parochial schools where they actually had a subject with full credit called Theology 1A and 1B. What the hell!

Bruce was mortified by this expulsion of his Heathen brother. We argued all the time about my "lifestyle" and about "The Teachings." We still do.

For a time I went to the regular church services, but after a

while they decided that I shouldn't be allowed to do that since I was not twenty-one. So I was temporarily relieved of the necessity of salvation and left to the devil. Perfect timing, as it turned out.

At Golden Arrow Camp, Huntington, California, 1939

At Golden Arrow Camp. I'm third from the left in the first row.

First time on stage, Lowell, Massachusetts, 1950.

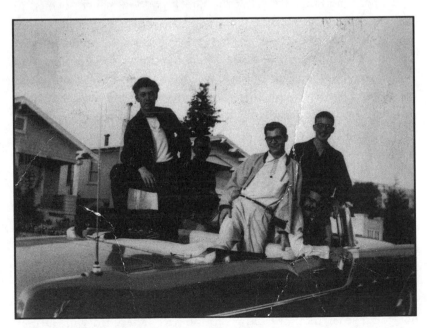

The "Monster 5": me (foot on hood), Jim Parrish, Terry Zimmerman, Peter Renz.

CHAPTER NINETEEN

LOVER BOY

In English class, I started talking to a girl who had long beautiful red hair. Her name was Diane. I called her "the Huntress," after the Greek goddess, which seemed to please her. She was a senior, and more developed than Donna, who was a lowly junior like me. The nature of high school demanded that the only chance we got to talk was one minute at the beginning and one other at the ending of class. We managed to kindle interest in each other in spite of this. The subject, at the moment, was Shakespeare, and I was a whiz at that, which made me a "Big Man" in the class or at least as far as she was concerned. It was my interest in Diane that managed to pull me away from the Monster Five table from time to time.

I was almost Diane's date at her senior prom, which would have been a big coup for a junior and a minor disgrace for her; but what would she have cared? She was never going to see these people again. Anyway, it didn't happen. She was not about to go with me to my junior prom either. That would have carried an even greater stigma. I figured I should go with Donna; however, she turned me down and went with somebody named Bob Kuen. He was a senior. I ended up not going at all, though I did go to the party afterward with Diane; and we danced up a storm.

Things got really sticky once when I was caught shoplifting at

a big drugstore. They took me up to the store detective's office and gave me a really hard time, threatening to take me down. Fortunately, what I had stolen were school supplies, making me look like a poor, industrious little school boy. I pulled some large tears out. They decided to turn me over to my parents. I got a big lecture from Sam and a lot of tears from my mother, and it blew over. After that, when I shoplifted, I looked out for the TV cameras and store detective towers.

Just before the end of the year, it was discovered by the gym teacher that I was cutting P.E. class every day. I started this very early on. When you don't know anybody, and have no friends, contact sports are not much fun.

I would sit still for roll call, and then, in the ensuing scramble, flip over the back of the bleachers and go across the street to the soda fountain, where I would drink a chocolate Coke and listen to the jukebox along with the other truants and tough guys. The tunes I remember were "Ragg Mopp" and "The Hucklebuck." These aboriginal revels convinced me that something radical was definitely happening to pop music.

Eventually, it was noticed that team 4 was always one short. "Why is this?" asked the coach. "Because Carradine always cuts out right after roll call," replied some sniveling fink.

The jig was up. When my report card came, I had an "F" in P.E., an almost impossible feat. I also had a "D" in social studies, my least favorite subject. I had to go to summer school to make up the grades.

As soon as school was out, I went down to Hollywood to visit Dad, who was now straight with the state of California and in the midst of *Casanova's Big Night*. This was my first time on a movie set with him. It was nothing like the times we'd spent in Summer Stock, or on Broadway. Here he was not a Star and was excessively deferential to the other actors, and almost subservient to the powers that were. This was a real eye-opener for me. I'd never seen him like this. I also noticed that, behind his back, his fellow actors were making fun of him. Anybody who tells you that actors are good friends is completely full of it; they're about as constant and as kind as the people in a lifeboat. Cross-sections of self-centeredness; as cruel as eight-year-olds, and as kind as coyotes.

He introduced me to Bob Hope. Bob was in a red paisley dressing gown. He looked huge and incredibly Technicolor. I was used to seeing him on my little black-and-white TV. He also looked totally ridiculous. I vowed I would never, ever appear in public in a red paisley dressing gown. I also vowed I would somehow make them all pay for the humbling they put my father through. I'm still working on that. On the other hand, most of them are dead.

Dad was a gentleman about it all and managed to get in some of his own. Walter Brennan showed up in the commissary, all blown up with the part he was playing. It was the first show in a long time that he had worked with his teeth in. He told everybody he thought he would get a nomination for it. Dad said, "Well, Walter, it's the first time in years you've had a part you could sink your teeth into." Walter was so pissed off he left the commissary. I think he actually got not only the nomination for the role, but the award.

This wasn't the first time Dad had used his acid wit to terminate a friendship. He had once said to Katharine Hepburn, "Why don't you take your Connecticut Station Wagon accent and go home." She did, causing John Ford a day's lost shooting, plus a long session of cajoling to get her back to work. She wouldn't talk to Dad for twenty years after that. Then one day they met accidentally somewhere and she acted as though it had never happened. Either she finally got over her grudge, or mellowed, or just forgot about it.

Dad and Sonia were back together with the kids: Chris and Keith. They were living in Laurel Canyon, and Dad was driving an MG, which I considered very hip. He also had one of his usual late-model Cadillac convertibles. Sonia, though, was pretty much out to lunch. She would sleep till noon, with two kids to take care of; three, if you counted me. Chris would wake up and dress Keith; then we would go over to a neighbor's house for breakfast. They all put themselves to bed. I guess it was good training for them, but it seemed to me like things were not completely all right.

Many of my cherished belongings, as well as many of my dad's, had been seized by the Wyndham Hotel for non-payment of rent. My mother took this opportunity to take me to New York to retrieve some of this stuff, some of which was important to her too. She managed to browbeat the management into letting her remove a bunch

of stuff on the basis that it was not my dad's but hers or mine, and on the basis of the fact that her woman's guile was totally irresistible. One of the items was a little volume of *King Lear,* which Dad had picked up at the Barrymore funeral auction. It had drawings by Barrymore and notations for his proposed production of the play. It was, for sure, a sacred relic.

Summer school took place at Oakland Tech, a posh school on the other side of town. I spent one hour each day getting up on names of presidents and fully comprehending the Electoral College and other oddities; and one hour playing tennis. I was still managing to avoid contact sports.

I was really crazy for a girl there who reminded me a lot of Joan Ebenstein; she was studying to be an opera singer, which might have had something to do with why she hadn't paid much attention to social studies. I tried to impress her with my meager knowledge of opera, gleaned from my father.

My efforts wouldn't have had much effect on her except for the fact that I could sing arias from *Rigoletto, Pagliacci,* and *The Marriage of Figaro,* which I had learned from records and from listening to my dad. "La Donna É Mobile" I learned from Caruso, "Ridi Pagliaccio" from Jussi Björling, and "Il Lacerato Spirito" from my dad. That one I didn't know from beginning to end, but would break off in the middle, pretending to lose interest because of some other pressing conversational turn.

I was just getting to first base when, standing on the bus with her one afternoon on the way home, conversing brilliantly, I experienced a lurching stop that threw me all the way to the back of the bus, knocking her and several other passengers over and landing me on my Prat. She was sort of chilly after that. Thrown out at first.

I, of course, continued to carry on with Donna. We'd go places together and play tennis, at which I was getting pretty good. I needed something else, though, so I made a date to go to a movie with Diane.

I had to meet her parents before they'd let me take her out. Her father showed me his paintings. I was astounded! He owned several Rembrandts and a couple of lovely Renaissance paintings, including a da Vinci and a phony Raphael, which had been painted over an

older painting that was actually a valuable masterpiece itself. There was some talk of getting down to the Original, but he was loath to destroy the phony Raphael. He made himself content by looking at the x-rays a lot. He told me I had to have Diane home before midnight, and off we went.

Since I didn't have a car, I came on the bus and took her to the theatre in a cab. I have no idea what movie we saw. I may not have had any idea then, I was so smitten with her.

Back in front of her house, having sent the cab away, I kissed her good night and, just in case, tried to put my hand on her breast. Miraculously she let me. Within minutes, I found myself creeping hand in hand with her into the garage. I busted my cherry that night, right there in the backseat of her father's Oldsmobile.

Hitchhiking home (the buses were gone for the night) was a positively ecstatic experience. I'd gone over the big hump. I was a non-virgin. I made a note that I must remind myself to score some rubbers.

The summer passed idyllically and erotically. Once in a while Diane's parents would be gone and we could make love in a bed. That was sheer paradise. In between, Donna and I would play tennis together, play piano together, and play with each other together. There was a lot less pressure on our relationship, now that I had another outlet. I, of course, didn't discuss Diane with her, but I think she sort of knew about her. My guess is Donna was actually glad about it. She knew why I was seeing Diane and she took it as a kind of twisted compliment that I still spent time with her when Diane was putting out while she wasn't.

Donna also took my duplicity as a cue for her to see other people herself. She went out at one time or another with all of the Monster Five. Strangely enough, none of us were jealous of each other. Donna was OUR girl. We were, however, very combative about any outsider who moved on her. One such was this Richard Kuen character. We all loathed him. He had wealthy parents and could take her places on a regular basis that we could only handle once a year, if that. He also had a fancy car.

All this notwithstanding, Donna and I had a very privileged communication. I would late-date her; which is to say, she would

come home from a date with Kuen or Peter, say, quickly kiss them off, and then I would show up and stay till the wee small hours. Many of these trysts were late-dates for me too, having spent an evening in ecstasy with Diane.

Diane had a grandmother who had an apartment in town. Whenever Grandma left town, she would leave the key under the mat. We would go down there, with a bag or two of groceries, and move in for the weekend; voraciously shacking up and keeping house. These weekends were Eden itself, and we did our best to eat all the apples we could—not to mention messing around with that serpent.

My mother, out of nowhere, suddenly decided to rebel against my wild ways and told me I had to be home by 2:00 A.M. from now on. I took this opportunity to introduce her to Diane, for breakfast, at six in the morning. Mother never mentioned a curfew again after that.

Shortly after this, my mother switched to the graveyard shift at the P.G.& E. This meant she wasn't around to see what time I came home anyway. Somehow, she was still there at all the important times. I'm not sure when she slept. She continued on that shift until she retired at sixty-nine. She always said she liked it better. There was less to do and she could read and take naps. Still, it must have been lonely.

Once I managed somehow to take a girl named Jackie on a date. Jackie was a serious candidate for Prom Queen. I brought her by the house (at a reasonable hour) and my mother loved her. She told me that Jackie was the best thing I had going. I said, "Yeah, sure, Mother, but she's not my girl."

My fascination with Donna was just as obsessive as the one I had for Diane, and certainly deeper, though not always smooth. Donna could get very feisty; sometimes she would slap me so hard my ears would ring and my brain would rattle. I could always cool her off or shut her up by forcing a long kiss on her.

One weekend a friend of Donna's invited us to go up to her parents' cabin for the weekend, unchaperoned. We went. There were three couples, and when bedtime came we all shacked up.

Donna came down the stairs to me wearing an almost transparent white nightie, the shape of her thighs and pelvis outlined in the backlight. She never took it off all night. We hugged and kissed and

made out and talked and fell asleep in each other's arms. She was still a determined virgin.

What I had here was a classic situation: a "good" girl who I loved and revered, and a "bad" girl with whom I released my animal passions. The Captain's Paradise.

CHAPTER TWENTY

SENIOR PRANKS

Back to school. We were all seniors now and I had the added panache of a graduated girl-friend. Diane had taken a job at Kresse's five-and-dime. Donna joined the Baha'i, a religious club, and went to work for the school paper. Her father, who was a used car salesman, had given her a car—a '48 De Soto business coupe. We had a lot of fun in that car, though Donna was a hilariously bad driver.

Bruce was going to college in San Jose and coming home on the weekends. So I didn't have to put up with his shit for a while. Grandma was giving him fifty dollars a week to help him out. She and he had become an almost unnatural pair. They wrote letters to each other at least once a week, full of Christian Science dogma. I never did figure out just how much of Bruce's devotion to her had to do with the fifty dollars.

The new Monster 5 started an organization called "The Hashim Ben Eeb Society." Hashim was characterized as "The Only True Prophet of Allah," and "Defender of The Faith." We issued proclamations and made speeches in the cafeteria and on the asphalt. We would also distribute circulars; we had access to a mimeograph machine. As an example, just before Thanksgiving break Hashim proclaimed that the school would be closed from Wednesday afternoon until the following Monday to give thanks to Allah. Of course these proclama-

tions always came true because they had already been proclaimed by the School Authorities.

One day there was a bomb scare, and when we were all herded outside Peter Renz and Jim Parrish made a tandem speech claiming credit, adding that this was what the accursed infidels could all expect if they did not embrace the teachings of Hashim Ben Eeb, the only true Prophet of Allah.

This game started to backfire when we began to be suspected of the cherry bombs in the toilets.

We played some other games too: we cut out the coupons from girlie magazines and sent in for anything that was free, to be sent to Paul Pinkney, our principal, at the address of the school. Of course these were all opened by his biddies in the front office, causing Mr. Pinkney some embarrassment.

We also culled some marijuana seeds from commercial birdseed (they used to put it in to make the canaries sing more sweetly) and planted them under his office window, circumstantially implying that Paul was cleaning his grass on the windowsill.

We had a grandiose plan to fill up his office with Jell-O, but we never pulled that off. We did, however, fill up his desk drawers with it. We got a big chuckle out of imagining him opening his drawers on Monday morning to find it full of Jell-O, with his pencils, paper clips, and erasers suspended in the mess like fruit garnish.

Peter managed to obtain the list of locker numbers and we changed the locks of all the lockers on one floor, causing havoc, as everybody tried again and again to work the locks, ending up kicking the lockers and cursing. It was glorious. Everyone was late to class, and it took them several days to sort the thing out. This incident necessitated another proclamation from The Only True Prophet of Allah, which we issued by tapping into the P.A. system. We followed our speech with a recording of Borodin's *Polovtsian Dances*; inappropriate, but what the hell!

Our main source of inspiration for these pranks was our knowledge of the college career of Doodles Weaver, later Spike Jones's lead "vocalist." While at Stanford he had coached a cow up to the third floor of the men's dorm and then shot it. They had to cut it apart to

get it out of there. He had also threatened a history professor that he would kill himself if he did not get a passing grade.

The good doctor ignored him, and Doodles threw a dummy off the Campanile, which was immediately whisked away by white-coated attendants into an ambulance, all hired by Doodles. Doodles then disappeared for a couple of weeks, sending anonymous flowers and hate notes to the class; just as the teacher was about to crumble with guilt, Doodles reappeared with three prostitutes on his arms, laughing and innocently asking what everybody was so glum about.

I signed up for drama class. This was the beginning of my plan to get back at Hollywood for Dad. I figured if they wouldn't let him make it, I'd do it for him. After all, it should be easy; I'd be standing on his shoulders. That would make me at least ten feet tall. We'd have the last laugh.

I started performing in the assemblies and various fiascoes, singing, dancing, and doing skits. Donna was always in these and we usually had a number together. I also ended up in the school play, something called *Pink Magic*. I played a crazy art teacher with a little beard and a French accent.

When it came to the class yearbook, instead of having my picture with the caption "most likely to not register to vote" or whatever, there was an empty space with the notation "camera shy." I hadn't shown up for the photo session. I shared that special distinction with one Theodore Todoroff, a budding concert pianist, who really WAS camera shy.

At least I managed to graduate on schedule, never a certainty.

I took Donna to the senior prom. Then we went to the party together, which was held at a restaurant on a lake somewhere. My tuxedo didn't fit. I was still a terminally thin person. I used safety pins to hold everything on. I don't think anyone noticed.

CHAPTER TWENTY-ONE

WHAT NOW?

It was time to get a job. I went down to the State Employment Bureau in Oakland; what they call now "The Bureau of Human Resources." Gladys Johnsie interviewed me and set it up for me to go to work on a welding gang in Salinas, where James Dean grew his beanfield in *East of Eden*. Starting pay was $2.73 per hour.

My employer was the Southern Pacific Railroad. We all went down there on a train. They had set up the operation in a yard right next to the tracks. Our job was to turn thirty-foot rails into sixty-foot rails by welding them together. There were about twenty of us. We lived in boxcars on a siding. Each car had two rooms, a bathroom with a shower, and a kitchen with a coal stove in the middle.

I shared a room with one of the new guys. The other side was occupied by a seasoned worker, senior enough to have his own room. He broke us in.

The first night on the siding, I woke up with a start as a ninety-car freight train went by at 60 mph or so, three feet away from my head. This happened at least twice every night. The work was incredibly hot and dirty. After the first two days, I was so tired I slept right through the trains.

We would walk to the end of the line of boxcars to scoop up a

scuttle of coal; crank up the stove to cook our dinners, which we chipped in for, and bought at the market; mostly potatoes, pan-fried in Crisco, hamburger, and eggs. The stove also heated up the shower, for which we had to fill up the tank ourselves. After dinner, we went across the road to town.

We'd drink beer and play rotation pool, and then fall in. Ron Purdy was my roommate and my teacher: billiards and knife fighting. Booze and Broads. He looked a lot like Elvis. The other guys called him "Purty."

I did this for exactly a month, and then my step-grandfather Henry Henius (Sonia's father) came through with a job at Lucky Lager Brewery, where he was the brewmaster. This job paid $4.80 an hour and instead of being hot, it was freezing cold. I went to work as a "Tank-Hog," cleaning fermentation vats. I walked down the hill around 4:00 A.M. and caught the bus, usually after a pancake breakfast at the blue-collar joint on the corner. A couple of transfers would take me across the bridge to the city and down the peninsula to the brewery. At 7:30, I punched in.

What the job consisted of was, after the brew had been drained out, we'd open a little hatch on the side, reach in with a long hook, and pull out the yeast trap. Then the yeast would be drained out and sent through the pipes to the yeast room. There were about six inches or so of this stuff.

When the yeast was gone, we'd put a rubber-coated sprinkler in the tank to dissipate the CO_2, which could knock you unconscious or, at the least, give you a real headache. Then you'd go in, with a rubber bucket and your hose, and scrub the tank clean with a long-handled (eight-foot) brush. You did three tanks a day.

At Lucky, we didn't have coffee breaks; we had beer breaks. We didn't drink bottled beer, we always had a keg on tap. Sometimes we'd tap a pitcher out of a storage tank. This would be so cold, we'd have to run hot water over the pitcher to warm it up.

In the summer the brewery operated twenty-four hours a day, seven days a week. Time-and-a-half for Saturday, and double-time for Sunday; double-time-and-a-half for holidays. There were no days off except for illness. Take-home pay came to $137.67 a week.

Sunday was a general clean-up day. No beer was brewed, and no

tanks were cleaned. No bottles bottled, no kegs filled. We'd stand around and push a broom in the corners behind the tanks. Cleanliness is super-important in a brewery. On Sundays, anyone who had been hired during the week, had a wedding, a baby, or a birthday was required to bring a bottle. This would be passed around in the locker room. Jim Beam or Old Crow were preferred, though Old Grandad was perfectly acceptable. Everybody got pretty fried.

One really great thing about working at Lucky was the hours. You got off at 3:30. The whole afternoon was ahead of you.

I started to use my money to improve my life. I collected books and records, bought snazzy clothes. My mother was charging me fifteen dollars a week for room and board. I found a place that sold rare books and started collecting first editions. At the record store I began to compile what was to become the most complete collection of musical comedies I have ever seen.

I decided to take singing and dancing lessons. I found a teacher named Judy Davis, who had trained June Christy and the Kingston Trio. She also coached Barbra Streisand and Frank Sinatra. Judy taught me piano as well, so I could accompany myself. This was the most intensive period of musical training I ever had. Judy taught me theory and dexterity, how to read and write my own stuff.

The tap dancing classes were almost a mistake. I very nearly lost my natural ability. After all, the great dancers I idolized hadn't gone to Judy Davis, or anyone else. They made it up. The teachers just teach standard riffs, which are more limiting than instructive to a natural dancer. The way I escaped being ruined was by not practicing.

One night I came home from the lessons and a late-night session with Donna. I was fixing something to eat in the kitchen when Bruce came up and told me to go eat someplace else; I was keeping him awake. I told him to go to hell, and he leaned over the table and hit me in the jaw with a right cross. I put down my fork and went for him. We fought in the kitchen for about an hour. I tried my best, but Bruce was just too strong for me. I don't think I landed one effective punch. We did, however, move the stove about a foot and a half bouncing each other off of it. Mother and Sam huddled upstairs in their bed in terror, while the Titans battled below. This fight pretty much ended Bruce and me as a brother act for a few years.

About this time, I had my first run-in with a cop. Donna and I were finishing up one of our late-night tennis sessions in the park by her house, when a young cop came out of the darkness and demanded identification from us. Well, we didn't have any; we were in our tennis outfits. He accused us of being under eighteen and out after curfew. We told him we were eighteen. We told him our i.d.'s were right up the street. He said he didn't have to let us get them; he could just run us in. I was getting pissed off now; I said what the hell for? He said for curfew violation. I said I'd sue him for false arrest if he did.

Well, the way it ended, I actually browbeat this rookie into backing down and going back to his squad car with his tail between his legs. This little victory made me cocky enough so that the next confrontation I had with a cop was going to go very badly.

As the summer came to an end, the job at Lucky did too; I was laid off, along with the other summer boys. I decided to go down to L.A. and see Dad.

Dad had moved Sonia and the kids out to a ranch in Calabasas, which is the last authentic western town to be found in the Los Angeles area. The place was called "Calabasas Ranch," which made Dad superficially the Lord of the town. He liked that. I went down with my Monster 5 buddy, Merrill, in his Pontiac to visit the great man and see the new baby, Robert. I also planned to return to him the copy of *King Lear*.

You couldn't miss the place. Coming out on Ventura Boulevard, you'd see a pair of saloon doors about thirty feet high. Above them was a sign that said "Calabasas." That was the ranch. There was a vast automobile junkyard right behind the sign, not a place to buy old parts, just a real junkyard full of nothing but real junk that had been just dumped there. There wasn't one usable part in the whole acre. If you went in that way, you had to thread your way through Studebakers and Nash Ambassadors and risk a flat tire. If you went around the side, there was a long, pretty driveway lined with trees.

The house was a big white thing that dated back to the eighteenth century. It looked like the ranch house in *Giant*.

The barn sat at the back of the compound, down a path with a rail fence, which separated out the junkyard. There was a half-acre

paddock, a two-acre corral, and the rest was in pasture. The barn had four stalls, a tack room, a workshop, a hideaway office-bedroom. A toilet-and-sink bathroom, a hayloft, and enough space left in the center to stash a fire truck.

Outside the barn was the largest prickly pear cactus in Southern California. A whole ecosystem of creatures, from microscopic to the size of large house cats, lived in there. Snake, lizard, rabbit, mouse, rat, all kinds of birds. June bugs, hornets, weasels, and coyotes passed through. Spiders, of course.

We found Dad in the garden, in a sweater and a Borsalino hat, working with a hoe.

Merrill was completely over-awed. Dad paid no attention to him whatsoever. Dad was planting a vegetable garden. He just put us to work. One night I looked out the front window, down on Dad breaking up the ground right in front of the porch. I went down and pitched in. Afterward, we played a game of chess and I went back to bed.

When I woke up in the morning, there were full-grown tomato plants there. That's the way Dad did things.

Bobby crawled through or over the railing of the upstairs porch, fell on his head in the freshly spaded dirt, and crawled away undamaged, though loudly.

So we rebuilt the porch.

Dad had three horses, one for Sonia named Snowy, a white proud-cut Morab. A Morab is half-Morgan, half-Arabian, and proud-cut means he's castrated, but they left a few cords in so he'd still strut around. The result on Snowy was a horse who was always horny.

One time when Sonia came down to the barn during her period, Snowy kicked his way out of his stall and chased Sonia into the house. Then he beat on the door with his hooves and began prancing around the house, snorting and whinnying. Sonia hid in the upstairs bathroom until Dad could get Snowy back in the barn.

Merrill and I rode the other two horses, an old Polo pony and a western Nag, around the spread. There were fourteen acres then, with a lot of empty land around it; destined to be freeways and housing developments, malls, whole communities. Later on we watched all this happen.

For now, we could ride it freely. I saddled up the Polo pony for Merrill, and rode the big gelding myself, with a circingle, a cinch with stirrups attached. We raced around a little bit and I showed Merrill the trick I'd learned to make a horse rear up. This was fun! How long had it been? I offered to teach Merrill how to do the trick but he declined.

Dad never did buy the place. He made vast improvements at his own expense. While he was living there, we watched the acreage shrink. At the end the back twelve acres had been sold off, which left a two-acre chunk, adequate, though sad.

Dad had hung on to the Bechstein concert grand, and I treated him to some of my newfound virtuosity. He was impressed.

I gave him the *King Lear*. He was extremely touched; however, he was pissed off that my mother had meddled in his affairs. Once you bed down with a woman, it's a bitch to get her out of your life.

To be near me, Diane started taking dance classes at Judy Davis's herself. Our relationship was becoming strained. Her father was beginning to ask me if I was going to make an honest woman of her. One night Diane told me she was pregnant. She had a story that there was a guy who was ready to take her to Alaska if I didn't marry her. I said I thought that would be a good idea.

She showed up for her dance class and told the whole school about the "pregnancy." Judy didn't believe a word of it. She told Diane she would take her to a doctor to make sure everything was all right. Diane was missing for a few days, and when she showed up again, she said she had had a "miscarriage."

I realized how close I'd come to getting caught and resolved not to take another chance with her. We rode home on the bus together, and I said I thought we should call it off. She put her hand on my thigh and whispered to me that her grandmother was out of town. Sexual desire washed all over me, but when my stop came I got off the bus.

Every hormone in me screamed, but the Prophet in me cried out, "Destiny lurks elsewhere!" We waved good-bye.

Somebody said the two things that distinguish Man from the other animals are: the use of cutlery and the ability to control sexual desire. I think it was Dan Aykroyd. I guess I had become a man.

DAVID CARRADINE

Bruce was about to graduate from college now. He had transferred to San Francisco State and I went over there to see him perform in a play. He played an old man in it and he was really good. I thought at the time that he would be very successful as a character actor if he went for it, though he'd have to wait until he was old enough. He never really did go for it.

The threat of the draft was looming large in his life. He joined the Navy to avoid the Army, and was whisked off to a destroyer, the U.S.S. Brinkley Bass. He and the ship spent the next three years off the coast of Korea. Bruce was a yeoman. He spent the war at a typewriter.

With Bruce gone, we didn't need the extra bedroom anymore, so we moved to a smaller house. I had kind of hoped I would get his private suite, but no such luck. The new house was a square, old-fashioned thing. I had a big room upstairs, and there was a little sewing room or something which I used as a sculptor's studio.

About this time Judy Davis threw me out. She made an impassioned speech wherein she stated that she didn't give a damn how talented I was, she was not going to put up with one more cancellation or late-coming. She wished me well, but she was emphatic. My options were dwindling.

Actually, this was fairly good timing. The *Donald O'Connor Show* had just been canceled. Musicals were out. I realized that I might be training myself for a profession that was about to become something on the level of a buggy-whip maker. Judy herself saw that. She suggested that I try acting. I replied, "Acting? What is that? You don't do anything."

I could go for a life of fine art, but that meant I'd spend the rest of my days alone in a room with a cold north light, with a bunch of clay. I decided I'd learn how to write operas. That way I'd be surrounded with sopranos and dancers.

Suddenly I was spending a lot of time alone. I got into the habit of climbing out the window into the big tree in the front yard and hanging out there stark naked. A tendency toward exhibitionism is a great quality for someone who is going to grow up to be an actor.

It turned out that the deal Dad had made about the alimony required that I sign the checks. The whole twenty-five grand was sup-

posed to be spent on me. It was all in a special account, earmarked for my college education or some such.

I found this out one night while Mother was dead drunk. We were lying in her big bed, talking about things (Sam was off at a sales convention), and she tried to seduce me. She kept calling me John. She thought I was my father. After all these years, she was still carrying a torch. I managed to escape from this evening without doing Oedipus.

After she sobered up, I talked Mother into plunking down a big $110 for a formidable piano for me: a Kurtzmann upright grand. It was the loudest piano I had ever played, except for the Baldwin concert grand in the assembly hall at Oakland High. It needed a lot of work; I did it all myself. We put it in the dining room and I played it all day whenever I could. I practiced finger exercises and learned Beethoven sonatas and Rimsky-Korsakov rhapsodies. I also continued to make up pieces of my own. Mother took to closing the doors on me when I played. She didn't really love music, she just loved me.

CHAPTER TWENTY-TWO

COLLEGE MAN

I didn't have the grades to get into any college. I went to Oakland Junior College and took the College Board Exam. It was a snap. I was in. I signed up as a music major, with my minor in drama. I took a full load of classes. English literature, creative writing, music theory, music history, psychology, biology, political science. I didn't go out for the team.

I started out there with high hopes, striving to learn all this stuff. My best teacher was Richard S. Vietti, English lit. and creative writing. I was really lucky to have him for two subjects. He was revered by all his students. At lunch, a bunch of us would sit with him on the grass, in front of the library, while he ate his brown-bag lunch and talked about Blake and Byron.

The music theory class was where I put my most serious concentration. This was my "math" class. I spent many hours in the practice rooms with the other guys, freaking out on the pianos with Beethoven and Brahms.

I got really friendly with a blind musician. He lived in a furnished room across the street, next to the soda fountain. He walked without a cane. He had taps on his shoes. He was using sonar to guide himself; he could perceive objects in his way by the echo of his taps; he'd pause and whistle a bit, and walk around. He always ate at the soda fountain. There was a whole little crowd of misfits who hung out

at that soda fountain. It was like a club. I guess you could call it the new, *new* Monster 5.

There was a guy named Corbis who told me how to get laid. He said you take the girl out and treat her like a princess. Then when you take her home, you make as if to kiss her good night. Before she has a chance to turn you down, you change your mind. You say that you have too much respect for her to take advantage of her that way; you need to get to know each other better. Then on the next date, you nail her.

Corbis was building a steam car, based on a Hudson, because it had enough room in the trunk for the boiler. Corbis also always had something for sale. Once he showed up with a huge cardboard box full of condoms, for sale at a bargain rate. Another time it was car batteries, about a hundred of them. I have no idea how he got this stuff.

Ray Crossland was a drama major. He was a little guy, with a long, thin, ravaged face. He looked like he had done a lot of drugs. I found out finally that he was thirty-five years old. That explained the drug-ravaged, college-student look. We did a lot of time together going over Shakespeare and playing mind games.

There was a pinball machine at the soda fountain. I blew my lunch money on it most of the time. One day I had eleven games on it and it was time for me to go to biology. I cut the class and played off the games. You can see what my priorities were.

By the end of the year I was just squeaking by in school, but I had that pinball machine down.

At the close of the term, Grandma came to stay with us again and I went back to work at Lucky Lager. I lost my sculptor's studio to her, but she gave me a recipe for super-hard plaster, so it was an even trade.

I used the formula to fashion some little sculptures that I tried to market. One of them was a muscular fellow set up to hold a candle in his arms as though it were a heavy weight. It never occurred to me until years later that when you put the candle in, it looked like he was holding his enormous cock. I never sold any.

Donna had a new car now, which her car dealer-father had given her—an Oldsmobile '58. This was actually the exact model in

which I had divested myself of my virginity in Mr. Meiers's garage. I was not to repeat the performance; Donna was still determined.

Grandma decided to give my mother enough money, out of her inheritance, to buy a house. We moved out of the little square thing into a beautiful place in Piedmont Pines, a posh district on the border between Oakland and Berkeley. Grandma moved in with us.

I got a room in the basement, just like Bruce's, with my own entrance and my own bathroom. Every morning Grandma would come down the stairs with breakfast and wake me up for work. She would put the tray on my lap. I would have to sit up to prove I was really awake. Usually I would push the tray aside, curl myself around it, and go back to sleep. If you were late for work at Lucky, you would be able to find a time card someone else had punched for you. The brewery took care of its own.

I inherited Bruce's car, not the Ford hot rod, that was long gone, but a '48 Plymouth sedan. This was my first car and it took me about a month to run it into the ground. Traversing the eight miles across the Oakland Bay Bridge as fast as I could go, twice a day, took its toll. The valves were hopelessly burned. We junked it out.

About this time, Dad called me and said he needed my help. I made my way down to Calabasas. He was all alone there. He told me that Sonia had been having an affair. She had started shacking up with a young artist named Michael Bowen. She had taken the kids and Snowy and moved in with her lover on a ranch in Topanga Canyon. Dad had gone in with the sheriff and a photographer. His plan had backfired and the kids were now in Juvenile Hall. Sonia and Mike were charged with contributing to the delinquency of minor children and Dad, as a solitary drunk, was deemed unfit to gain custody of the kids. He had a court hearing coming up and he needed me to stand by him to make him look good. The divorce was pending.

I went to the hearing with him. Hank Henius and his wife, Lil, Sonia's parents, were there. The bailiffs brought out the kids. They looked pitiful. Sonia and Mike were not invited. The judge was very stern. The only way Dad could get his heirs out of jail was to agree to their living with the grandparents.

After the hearing, I stayed with Dad for a few days. The big house seemed incredibly empty. Dad went out drinking with me and,

back at the place, talked for hours. I fell asleep on the floor. He had a call to do a day on a movie at six in the morning. I got him up. He was having a terrible attack of arthritis and could hardly walk. I got him to the gig and he performed as usual. Afterward, fully recovered, he drove out to Topanga. There was a forest fire in progress and he wanted to check on Snowy. We couldn't get past the firemen but we found a high hill where we could see the place. There was Snowy, safe and sound, switching his tail.

I left Dad to his misery and went back up north.

My friends and I were all addicted to the new magazine, *Road and Track*. Sports cars were IT. Terry Zimmerman had purchased an MG. Looking around for something for myself, I tried one of those, but it was too silly and too under-powered. I couldn't afford the Corvette. Corbis had a T Bird and he told me it was not a sports car, it was a small car. A Jag was out of the question. I didn't know what to do until I saw the Jowett Jupiter. A little-known English sports car, in English racing green, with $62^{1}/2$ horsepower of water-cooled aluminum flat-four. I picked it up with my last $750.

The guys at the brewery thought it was pretty strange, but I loved it. A month later, I dropped the transmission during a drag race. I found out then why it had been so cheap: the company had gone out of business; there were no parts. So far I was having great luck with cars.

I put the Jowett in the garage, took it apart, and put it back together several times. Eventually, I sold it to another Jowett fan as a parts car.

Donna was attending San Francisco State College as a drama major. She convinced me I should use my junior college credits to get in there. I tried it out. S.F. State was not very impressed with my record, but they agreed to let me in as a limited student, on probation.

CHAPTER TWENTY-THREE

THE ACTOR IS BORN

S an Francisco State College had just moved to a new location. It had been transformed from a dingy, small pile of concrete in the inner city to a spacious campus in the suburbs, with acres of grass and trees and brand new world-class Architectural Statements for the buildings.

It was a long ride from Piedmont Pines, but it was worth it. You took a bus to the trolley, which took you across the bridge. Then you caught an electric bus to the college. It was well over an hour to get there. If I had a car it would have been a lot shorter, but I didn't.

The music department and the drama department were in the same building. This was really convenient for me, since these were my two major subjects. It also proved to be the downfall of my musical ambitions.

I was permitted to take two classes only during my probationary period. I ended up with theatre history and Shakespeare 1B. I was allowed to skip Shakespeare 1A, ordinarily a prerequisite, after an oral examination on the subject. To keep music alive in me, I audited Dave Brubeck's piano seminars.

Once I discovered the irresponsible joys of auditing (no homework, no tests, no attendance necessary, no credit given, pure love of knowledge) I started going to Semantics, taught by Professor Hayakawa himself, and a humanities class. Greek philosophy, I had

found, was as interesting as Greek mythology, if not more so, which, for me, is saying a lot.

The social life was actually the main part of the educational process. That's where we participated in all our debates. In the cafeteria there were separate tables at which the various majors gathered. I quickly found myself drawn more to the Drama table than to the Music table. The actors were easier to talk to and easier to listen to.

I took to walking down the hall and looking in on the student productions in rehearsal; one-act plays, etc. One day one of the guys I was always talking to in the cafeteria, a fellow named Fred Hoffman, asked me if I wanted to be in a one-act he was preparing.

I said, "I don't know. What would I have to do?"

From there, I was plunged into play-acting. I almost forgot about music entirely; though not quite. I sang in the chorus in a school musical, *On the Town*, and wrote some music for a number in the big variety show. One of the performers in that show was Johnny Mathis. We all made fun of his high voice. Before the year was out he was a recording star.

Always, in these efforts, Fred Hoffman was close at hand. Together, we auditioned, failed, triumphed, discovered Elvis Presley. Fred was the strongest man I had ever met. He had an act that he did where he would lie suspended, with his feet on a chair and his head on another one, with nothing supporting the rest of him. The other thing he would do was to lie on the floor and let a girl jump, from six feet up, onto his stomach.

There was a core of social lions in the drama department. These guys were their own masters. Fred and I were not really part of this scene, but we were candidates.

I had just been asked to play one of the conspirators in *Julius Caesar*, when Fred took me along with him to The Golden Hind Playbox in Berkeley to audition for a role in a Little Theatre production of *Romeo and Juliet*. Fred was hoping to get Mercutio. I was just along for the ride.

We went over the bay in Fred's Mercury Montclair convertible. On the way, we tried out our Shakespeare on each other. That car was destined to hear a lot of Shakespeare from Fred and me before it was all over.

Suddenly the car started acting very strange: sliding sideways, out of control, the rear end coming around. Fred handled the situation coolly. When we had come to a stop, we got out and looked. The left rear tire was flat as a pancake.

"Do we have a spare?" I asked.

"Yes, we do," Fred replied. "But no jack."

I looked around. We could not have picked a more deserted spot for this incident.

What I'm going to tell you now is hard to believe, but I saw it. We got out the spare and removed the lug nuts from the flat. Then Fred put his back to the fender, grabbed hold of the wheel well, and lifted the two-ton Mercury. I slipped off the flat and slipped on the spare. Fred kept yelling, "Hurry up!"

Fred lowered the car and I replaced the lug nuts. There was a big dent in the fender where Fred's ass had been, and his hands were lacerated; but we were on the road again.

There was no chance of Fred's getting Mercutio. It's the plum part in the play. An amateur theatre company doesn't do *Romeo and Juliet* without knowing in advance who among them is going to play Romeo, Juliet, and Mercutio. That's the whole point of doing the play in the first place.

We both got hired, though. I as Tybalt, a juicy heavy, and Fred as Paris, a thankless role. I regretfully turned down the bit part in *Julius Caesar.*

I had now developed some seniority at the brewery and they hired me on for the winter on the graveyard shift. Now that I was a working actor, I was spending days at college, evenings rehearsing, and nights cleaning tanks. There was actually no time left for sleeping. The best place to do this turned out to be the theatre history class.

Things at S.F. State were enlivened by the fact that Donna was there. I could be lounging in a hallway with Fred or somebody and I would hear the clicking of her heels, around the corner. I knew instantly it was her. We had definitely developed ourselves into a classic example of old-fashioned childhood sweethearts.

The way it worked at The Golden Hind Playbox, you rehearsed for eight weeks in the evenings, Sunday through Wednesday, while another play performed Thursday through Saturday. Then you

opened, replacing the former production, and a new one went into rehearsal. There was no pay involved. The price of admission just barely kept the place open. Everybody had a daytime job, except me of course. I had a nighttime job.

One aspect of playing Tybalt was sword fighting. To get us all in shape for that, they brought in a fencing master who had done a lot of movie work. He took to me right away, as I did to him. He told me I was "almost a natural," whatever that is. During the rehearsals, Mercutio came within a half-inch of putting out one of my eyes. I kept him at a distance after that. When he got too close, I poked him in the stomach.

Opening night, when I made my first entrance, I couldn't stop my knees from shaking. I hoped no one noticed, though there was little chance of that. It was a VERY small theatre and I was wearing tights. As soon as I finished my first speech, the shaking stopped and I started to have fun.

Mercutio forgot his sword-fighting routine and I danced around him, saving the day, and my eyes. Every minute I was on stage, I became more confident and more masterful. This was obviously something for which I had a natural aptitude.

At the end of the show I discovered my dad was in the audience. Mother had tipped him off and he had come all the way up from L.A. to see my debut. His presence had been kept a secret because they all thought it might throw me if I knew he was there. They were probably right. He told me I had great promise (apparently, he hadn't noticed my shaking knees), and added that I should come down to the ranch and get some pointers.

He gave me one serious pointer right then and there. He told me that an actor should learn virtually everything he might be required to do in any role he might play. He said that included all of what he called "the gentlemanly pursuits": art, music, literature, foreign languages, and The Manly Arts: shooting, self-defense, fencing, horsemanship. He didn't mention tap dancing.

He also informed me that Sonia and Michael Bowen were expecting a child and going to be married. It was easy to see how he felt about that. Then he told me he had to catch a plane and was gone.

I went out to meet Donna in her car. As I climbed in, she immediately embraced me passionately. I told her to stay away, as my face was covered with the oil I had used to take off the grease paint. She said, "I love it! I love it!" and kissed and kissed me all over my greasy face. I decided right then that I wanted to be an actor. I have since discovered that almost everybody who has become an actor or a musician took it up originally as a way to get girls.

At S.F. State, when I would go into the practice rooms to play the pianos, there was a girl who sometimes found me. I don't think she was a student; just a girl who liked to hang around musicians, sort of a college groupie. She was very pretty in a crude sort of way, her appeal in no way diminished by the fact that she was missing one of her front teeth. She talked like a gun moll in a gangster movie. She would lean against the piano with her chin on her hands and gaze at me in rapturous admiration.

She would say, "Johnny" (she's the only person who ever called me Johnny; it would thrill me when she did it) "Johnny," she would say "play that song again. You know the one I mean." The song was "Unchained Melody." I was faking the chords, but that didn't make any difference to her.

Around this time, we started hearing about this thing called the House Un-American Activities Committee. Over in Berkeley, they were subpoenaing students and accusing the senior class president of Communist conspiracy. There were riots. At S.F. State, we were a much more sedate crowd. I think we just weren't as smart. You had to have super-high grades to get into U.C. Berkeley.

The only big protest thing I remember at State was when they were going to tear down the Palace of Fine Arts, a marvel of architecture which had been built for the World's Fair of something like 1917. It was so beautiful that no one could bear to tear it down. The centerpiece of it was a huge (ninety feet tall) rotunda, covered with sculptures. It looked like stone, but it was all made of wood, plaster, and chicken wire, held together with steel cables with turnbuckles. I know this because I used to jump the fence and climb all over it. It was overgrown with ivy and flowers, crumbling majestically, like a real Greek ruin, and was one of the most memorable sights in San Francisco; but it was a safety hazard, or so they said.

The plan was to put up a high-rise apartment complex. There was pressure to halt its destruction, but they were going ahead, anyway. A bunch of students sat in the swan pond, which was to become a parking lot, and refused to move so that they couldn't blast. The police carted them away and a bunch more took their places. With the news coverage, the whole city rose up in the Palace's defense and the authorities capitulated. Eventually, money was raised to rebuild the old girl in permanent materials as an art gallery but, of course, it was never quite the same, though from a distance you can't tell the difference, except that it's not crumbling now. I did not join in the protest, but I felt like a part of it.

Things weren't going that well for me at S.F. State. My theatre history teacher, Professor Jules Irving, the head of the drama department and later to be the artistic director of Lincoln Center in New York, did not think I should be concentrating on outside theatre work. Well, hell, they hadn't offered me any good parts at school. Prof. Irving, however, had also become aware of my sleeping in his class. I was keeping up well, anyway, but he was watching me closely. Because of my famous father, everything I did was always watched closely. I started drawing in his class to keep myself awake. As always, this ploy worked, convincing him that I was taking notes.

I had a term paper due. I chose the subject of *Hamlet*. I knocked out about 25,000 words. For good measure, I bought a roll of shelf paper and threaded it into the typewriter, producing the Thesis on an eighteen-foot scroll. I attached this to a roller with drawer knobs on the ends and tied a gold ribbon around it. There was another smaller scroll which contained the notes. I got it to school on the last day allowed.

Before the class, I showed it off to the guys. Everybody was impressed and the word spread. By class time, it was already famous; however, before I could turn it in, I broke one of the knobs. Rather than submit an imperfect masterpiece, I took it home, fixed it, and turned it in the next day. Professor Irving announced that there would be no more papers accepted unless they were on scrolls.

When I got the paper back, it said "[A] - Late - [B]," with the notation, "It's a pity it's late, because otherwise it's a perfect paper." I was knocked flat. I needed the grade points to get off probation. I

confronted him in the hall. "If it's a perfect paper, how can you knock it down to a B?" I pleaded. "How about an A minus?"

He whipped out his pen and added a plus to the B. I stared at it. This did me no good whatsoever. The same grade point: 2, not 3. I handed the scrolls back to him and walked out of college, more or less forever.

Today, when people ask me why I dropped out of college, I tell them I had to find some time to sleep and college was the one thing I could do without; but the real truth is as above.

DROP OUT

ith my college education in the wastebasket, I was basing my whole future on my Little Theatre career; unless you wanted to count my job at Lucky Lager as a possibility, which immediately dissolved, anyway. I was laid off at Lucky, with little chance of being re-hired. Those stodgy Germans didn't take kindly to my theatrical airs.

The theatrical airs were working pretty well. I got two more parts at the Golden Hind; the first, kind of a bit, and the second, a really good part in a Sean O'Casey play. I polished up an Irish brogue for the role, which has sustained me many times since.

Now that I was out of the college scene, Mother and Sam wanted me out of the house. Actually not my mother, just Sam, but Mother was powerless to resist.

Uncle Will had died and named my mother as the executor of his estate. His daughter, Donna Trent, suddenly showed up, sniffing around for some of the stuff. She and Will had not spoken two civil words to each other in their whole lives. She had been married to a vice-president of a Hawaii-based sugar company until he committed suicide. She moved into the house with us. After a short amount of time, she had taken over Sam and Mother body and soul. She had them redecorating the house, and changing their diets, and even their

drinking habits. She walked around in a muu muu all the time. I was a definite glitch in her system. She started on me but I didn't respond, so she proceeded to undermine me.

I told my mother that she ought to think twice about putting her life in the hands of a woman who might have driven her husband to suicide (according to the details of the story, it seemed very likely she had done just that), but my mother didn't appreciate the observation; she was already too far gone.

One day I was fixing something on the stove when Sam walked up behind me and hit me over the head with a dining room chair. It shattered across my back. I turned around and looked at him. I think I said, "Aw, hell! Now I'll have to fix that." He yelled something at me and split to the back of the house at a dead run.

I took the cue and found myself a place to stay in Berkeley; in the basement of a guy I'd met somewhere, who was at that time running for mayor of Berkeley on the Socialist ticket. He almost won. You have to remember, this was right in the middle of the free speech riots. He had a beautiful wife. I developed a serious crush on her.

When I came back to the house to pick up some of my stuff, Will's daughter had Mother and Sam totally bamboozled. They acted like Moonies, wearing muu muus, drinking things with pieces of fruit and little umbrellas in them, and eating raw fish. Grandma was simply hiding in her room. They were about to have dinner. I didn't feel too welcome. I went down to my basement to gather up my stuff. While I was down there my mother came down the stairs with a tray of food. Not wishing to cause a scene (HA!), I told her I wasn't really hungry. Nothing could have been further from the truth.

Mother went upstairs, threw the tray to the floor in front of Donna Trent, reached out, grasping Donna's muu muu by the cleavage, and ripped it off her; accompanying the action with appropriate epithets.

I was down in the garage, pulling things out of boxes, when Sam came hurtling through the door and threw a punch at my head. I caught his arm and held it. He stared at me for a moment, then backed off, blustering "I want you out of here."

I said, "I'm on my way."

Donna Trent was gone in a week.

I was collecting unemployment insurance and the basement was rent-free. I found myself a part-time job racking up balls in a combination Broiled Hamburger Joint and College Pool Hall. The pay was twenty dollars a week and all the hamburgers I could eat.

I spent every cent of the unemployment on art supplies bought in the shops surrounding the university, along with books on every subject, College Outline series and instruction books. Everything else, food, walking, around money, came from my salary and occasional tips.

I would put in my time at the pool hall, incidentally playing a lot of solitary pool when things weren't busy, and eating a lot of hamburgers (they were GREAT hamburgers) and would then walk around Berkeley a bit, go home to my cellar, and teach myself how to paint.

Looking for the best art stores, I wandered up to the north side of the U.C. campus. I found what we called an art Movie House, showing old movies and foreign pictures. The place had two theatres in the one place. I saw as many of these pictures as I could.

I drifted easily into the campus crowd. There was a pizza place in the courtyard, next to the art Movie House. It was easy to join a bunch of people, as long as you could pay for your own pizza.

I needed a car, so I looked at the ads and found a 1941 Buick Roadmaster for twenty-five dollars. Donna was going to school in San Jose. Every weekend she would catch a ride up to be with me and I would drive her back late Sunday night. I really blasted on those trips. The Buick had compound carbs and would go a good ninety-five.

On one of these trips, we stopped for a little hanky-panky. I was just getting up to speed again, my head in the clouds, when we came to a little town. A car pulled out from the left and turned into the road, at twenty-five, taking both lanes. I stood on the brakes (never the best feature of the Buick, they grabbed to the right, and we sideswiped two parked cars: a brand new Buick and a brand new Oldsmobile, and plowed into a third: a brand new Lincoln. The cars were parked in front of a Methodist ministers' convention. The owners rushed out wringing their hands.

Fortunately, a cop had seen the whole thing and he cited the

driver who had pulled out. Sometimes the magic works. The reverends were true to the cloth and very understanding, but the Buick was totaled. Chalk up another. I don't remember how I got Donna back to school, but I did.

Somehow, I reconnected with my old buddy from Oakland Junior College, Ray Crossland. We went up to Santa Rosa together to try out for a production of *Teahouse of the August Moon*. I got the part of Captain Fisby, the lead, and Ray grabbed off Sakini, the Okinawan houseboy. Santa Rosa Community Theatre is WAY off-Broadway, but this was my first leading role, ever. It gave me a lot of confidence.

I had heard about a little Little Theatre in Berkeley that had what was supposed to be a great director, so I went down there to see. Robert Ross WAS good, and he was a born teacher. I stuck with him and learned what I could, which was a lot; more than I wanted to know, as a matter of fact.

Donna took me to dinner at her father's house. He had remarried, to a prim little woman. He was an interesting guy for a used-car salesman. As an avocation, he had a band that played high schools, weddings, and stuff like that. He was the drummer but he played every instrument in the orchestra at least adequately. He gave me a pair of sticks and a practice pad, and I sat around for many hours, practicing the exercises he showed me. I took the sticks with me wherever I went and tapped on everything.

He also gave me a tin practice clarinet. I found out Bob Ross was a clarinet player and a drummer. This guy was full of surprises. It turned out he had been a jazz singer and, later, the drummer in Jimmy Giuffre's band. He could do a perfect imitation of Giuffre's breathy clarinet style.

He told me about why he gave up singing. He went to see a young singer who was appearing with Tommy Dorsey's band at a place in New Jersey called The Roadhouse. The singer looked almost exactly like Bob, sang the same songs, and he was great. Bob was nineteen; the kid was eighteen. Bob had to admit that the kid was a lot better than he was; so he became a drummer, scared off by a teenage crooner named Frank Sinatra.

Fred Hoffman showed up in my life again with the idea of doing a production of *Othello*, with himself as Othello and me as Iago.

ENDLESS HIGHWAY

We would produce it together. It took us about six months to pull this off, stealing and scamming and doing everything ourselves.

I widened my larcenous habits to include burglary. We needed a tape recorder for the music cues, so I second-storied my way into The Golden Hind and walked off with theirs. I got all the swords from a fencing academy. To insure us against detection, I used the Tijuana car thief method: taking everything apart and repainting them. The swords looked better in metallic gold, anyway.

Merrill was going to play Cassio, but he dropped out after about three months. He was jealous of my friendship with Fred, as well as being tired of rehearsing with no opening date or even a theatre in sight. Donna played Emelia. We found a beautiful girl named Karen, with tawny gold hair and eyes the same color, to play Desdemona. Actually, I think she probably dyed her hair to match her eyes.

Fred "hired" an assistant named Margarita. She was fourteen years old, beautiful, and crazy about me. There was plenty of precedent around San Francisco for bedding down fourteen-year-olds but I never picked up on her.

Fred and I went to a hamburger stand after rehearsal one night, in our beards. We ran into a street gang. There were twelve of them, I think, and during the confrontation four more showed up. They really wanted to beat us weirdoes up, but Fred defused them. He told the guy who was doing the talking he'd give him first swing with a hammer. Fred was a really big guy and he'd been an M.P. in the Marine reserves. The guy, the leader, I guess, didn't know quite how to deal with that, so he started in on me. "How about you?" he said. "Do you wanna mix?" He seemed incredibly stoned. Fred told him to take a punch at me. I was appalled. Fred continued: "If you want my buddy to fight you, hit him! Then you'll have your fight. He's not going to just stand there!"

This ploy confused the bozo so much that we were able to make it to the car. We burned rubber. We barely got out of there, but we got out. The next morning in the *Chronicle* there was a front-page story about a guy who had been attacked by sixteen gang members in Golden Gate Park, just three blocks away from the hamburger stand. They had inflicted fifty-two knife wounds on the poor fellow, poured gasoline on him, and were about to light him up when a car came by

and scared them away. Those guys must have been so frustrated by their confrontation with us that they just had to waste somebody. The guy lived.

While we were working on *Othello*, I spent a lot of time at Fred's house in the Sunset district of San Francisco. This was a long line of streets, arranged in alphabetical order: A to Z, with each of the houses almost identical to all the others.

Fred had a Saint Bernard dog named Droopy, who spent most of his time lying around, largely in the empty fireplace. He liked the cool stones. We'd take Droopy outside for his constitutional, and then he'd really perk up. Fred would let him off the leash, and we'd watch him terrorize the other neighborhood dogs. There was one particular vicious Chow behind a four-foot fence that he'd drive absolutely nuts. Droop would stand up against the fence and put his nose over the top, and bark at him. The Chow would leap up and snap at him, just missing Droopy's jowls. Droop would bark at the Chow until he was completely crazed, leaping and snapping, and throwing himself against the locked gate; then Droopy would walk on, happily. Once, when the Chow hit the gate, it came open. The Chow came hurtling out, turned around, and ran back as fast as he could, yelping.

Fred had taught Droopy to growl on cue. When he saw what looked like trouble, Fred would take him by the collar and mutter, "Growl, Droop." Droop would snarl and Fred would pull on the collar, making it seem that the dog was straining at the leash. Then Fred would say, "Down, Monstro." Trouble always flew.

We'd brainstorm for days, making our own costumes, designing the sets, scoring the music on the stolen tape recorder, editing the play.

Fred's family had no phone, so when my mother wanted to check on my whereabouts, she'd send the cops after a "missing" child. They'd drop by to check on me, and then call her to tell her I was fine.

One time, the duty fell to a rookie. He had it in his head as a kidnapping and tried to force his way in. Between Fred's mother and Droopy, he almost bought it.

The show finally opened in a converted church. Opening night, the curtain was delayed by an hour. Halfway through the first act, Fred

told me we were going to have to cut some stuff. We went on stage and invisibly and smoothly left out a good half hour of the play. No one caught us at it; not even the other actors. When it was just the two of us, it was easy. When I was working with another actor, I'd just skip over a couple of speeches and throw him his later cue. He would automatically spit out the next line, without even thinking. To smooth over certain transitions, Fred and I would ad-lib in blank verse. This is no easy trick, but we were hot.

We had a cast party at someone's house, and during it we discovered our Brabantio, a funky character named George Moffat III, trying to talk our Desdemona into smoking a joint. Jeff and I bounced George III off a wall a few times and told him if we ever caught him trying anything like that again, we'd break every bone in his body. Really funny, considering what was to come for me.

Fred and I ended up losing our shirts or, actually, our mother's shirts. All the stuff I had stolen for the production became the property of our creditors, the people who owned the converted church. The show was actually pretty good; as good, certainly, as you could expect from a couple of twenty-year-olds playing two of the most difficult roles in dramatic literature, but businessmen we were definitely not, even for twenty-year-olds.

After the play closed, I went down and visited Dad. We fenced and played chess and recited scenes from *Othello*. He hated all my line readings, and he beat me at fencing and chess. Dad wasn't really a great chess player or a great fencer; however, he was telepathic (I proved this, beyond the shadow of a doubt) so, consequently, you could never catch him off guard. He was living now with a tall, striking blond woman named Doris, and it looked serious.

On the way back home, I dropped in at the Heniuses, Sonia's parents, and got a look at Chris, Keith, and Bobby. My mother had asked me to. She had, remarkably, developed a close relationship with the Heniuses, and with the kids as well. She was always able to do this sort of thing very easily. Till the day she died, she treated the other kids as if they were her own. She just couldn't carry a grudge for very long.

Chris had never forgiven me for leaving him in Gramercy Park that day; still hasn't, actually. Keith was excited to see me, and showed

me how fast he could run. Bobby told me, "You're a bad boy, aren't you." They were doing pretty great, except that Bobby had a lisp that Grandma and Grandpa thought was cute. I suggested it was probably a result of falling off the porch and landing on his head. They were scandalized. I figured, if they can't take a joke, fuck 'em; so I split.

Donna came to me with a proposal from her ballet teacher, a wonderful old queen named Raoul Pause (with an accent over the "E"). He wanted to put on plays at his studio. He wanted Fred and me to set it up. We came up with an evening of two one-acts. *Salome* by Oscar Wilde and *A Phoenix Too Frequent* by Christopher Fry. I played John the Baptist in *Salome*. Fred directed and played Herod.

After this, I started dabbling a little in ballet classes with Raoul. He was really supportive, and inspirational. He tried to get me to write the music for a ballet. I gave it a try, but it was a little beyond me. I was crazy for Raoul's number one student, Geraldine, but I was promised to Donna and never did anything about it.

Raoul came up to me one day and offered me a job. At his school in Fremont, his tap teacher had got sick or died or something. He wanted me to take over the class. He knew I'd studied tap. I was not sure I could do it, but he convinced me. He stayed after classes at night and gave me private coaching in ballet tap. These were wonderful soaring moments. He taught me things I didn't know the human body could do. I went out to Fremont filled with confidence. It was a lot like the time I was elected president of the drama club. I was totally inept as a teacher, and all the mothers were there to watch me blow it. After two classes, half of them took their kids out and Raoul had to let me go.

Coffeehouses had become a big thing. There was a big place in Berkeley where everybody went to get their cappuccino. I can't remember the name of it. This place was full of interesting conversations and unusual haircuts and clothing. I spent a lot of time there. One day I was standing on the sidewalk in front of the place, and someone called out my name. I turned around and there was Sonia.

CHAPTER TWENTY-FIVE

FORGIVE AND FORGET

I was dumbfounded. Before I could think how to respond, Sonia had me smothered in hugs and kisses. Standing beside her was a good-looking kid about my age, with a big split between his two front teeth and a devilish little peach-fuzz beard, grinning at me. I was actually standing face to face with the son-of-a-bitch who wrecked my dad's family, and he was smiling at me. I should be doing something; punching him out or spitting in his face. The truth was, he proved to be so charming that I couldn't help but like him. I could see how he'd grabbed off Sonia.

There, beside them, in a stroller, was the main legitimizing factor in their relationship, in the form of a year-old blond baby boy named Michael Jr.

After the amenities were over, they insisted I come home with them. This seemed bizarre, but I had nothing better to do. They lived just down the street, on the second floor of a ratty old duplex. On the stairway I began to be introduced to Michael's art, splashed all over the walls and doors with big broad strokes; most of it at least a little obscene. At the top of the stairs, there was a lever which, when you pulled it, rang the doorbell. Michael had painted a nude figure around it, so that the lever became a phallus.

Once the opening festivities were over, we got down to the old "What are you doing with yourself?" routine. We all know what I was

157

doing. Sonia was rehearsing for a Little Theatre production of *Come Back Little Sheba*. Michael was trying to sell his paintings, and working as a salesman. Little Michael was shitting and pissing. Big Mike asked me if I wanted a job. I wasn't sure. He told me that his partner, Stan, was going to show up any minute and that he, Michael, could get me in with him—possibly making a lot of money, which would not interfere with my unemployment insurance. I asked Michael if this was anything illegal. He said, "No way." "You'll like Stan," he added. This proved to be an understatement.

I looked at some of Michael's work, including the one he was doing at the moment; a painting of a girl's face on some kind of rough paper, done in white oil paint, mixed with some brown printer's ink he happened to have around. Sonia's work was evident too. Apparently, Mike had had his effect on her; gone were her carefully executed, heartbreakingly evocative portraits. In their place were primitive, almost infantile explosions of color, with real flowers lacquered into them, and wild squiggles surrounding everything. It was not a very lasting form of art; if you hung around long enough, which I eventually did, you could watch the flowers shrivel and fade.

Sonia was deep into *Come Back Little Sheba*. She, as she always had, was taking the character very much to heart. It wasn't easy to be around her. Mike could hardly stand the process. As a matter of fact, he eventually made her drop out before the opening. I think that's what really pushed Sonia over the edge to real functional lunacy. She was unable to act out the character of Lulu and get rid of her. She remained stuck in the part of an unhappy, crazy, and desperate middle-aged woman until she was too old to play the part; then she became an unhappy, crazy, and desperate OLD woman. She was still sexy and charming most of the time, but when Lulu took over, everything changed.

Right now, though, Mike and Sonia were at their best. We drank some herb tea and then the phallus-cum-doorbell rang. "That's Stan," Mike said. And it was. Stan proved to be a terminally thin Jewish fellow, with a wonderful cynical sense of humor and a superb education. He was full of schemes and theories, and he was a great salesman. He sold *me*. We hit it off pretty well right away; and, sure enough, he hired me on. I was to go out with Michael and learn the ropes.

The next day, I met Mike and we piled into his Austin A-40 and went across the bridge to San Francisco. The name of the job was "Proof-passer." What we were doing was selling baby pictures.

Phil, the canvasser, would go door to door, selling a coupon for $2.98, which entitled the sucker to one free 8x10 color print. Phil collected a dollar in advance, which constituted his salary. You had to be thick-skinned to do this. Phil was. He could rake in fifty dollars in a day, when he wanted to; which was about two days a week. That was all he needed.

Stan would take the pictures, collecting another $1.98. I know that doesn't sound like much, but Stan could do three sessions an hour, making him more highly paid than a tank-hog at Lucky Lager Brewery; and, besides, Stan increased his take by passing some of the proofs himself.

The film would be sent to the home office in Philadelphia to be processed, and six weeks later we'd take the proofs around and talk the parents into buying a bunch of extra pictures. The company paid for the film and the processing, and the free 8x10. We got 20 percent of what we sold. Usually, we'd take a 20 percent deposit and walk away with our commission right then and there.

As we cruised along, Mike opened the envelopes and eye-balled the transparencies while trying to steer at the same time, making me nervous about traffic. The ones he didn't like, he'd toss out the window. I was shocked. Mike told me that if the customers saw bad pictures, it hurt the sale.

Mike's pitch was spectacular. He walked in, with his beard and sandals and a turtleneck sweater, looking nothing like a salesman, which was the whole point. His story was that we were opening a photo studio in the area and this offer was a promotional stunt to get us known. He himself, he would say, didn't know anything about selling. He was just a photographer. We'd set up a slide projector and beam the baby's picture at a piece of white paper, which used an opened magazine as a prop-up. The magazine, coincidentally, had a baby on the cover. The mothers would see their baby looking just like a magazine cover and melt.

We had a price list that had two sides to it; one side had even numbers, and one odd. If the customer wanted three copies, we'd

show the even side and say, you're better off price-wise getting four. If they wanted four, we'd show them the five-for side. If they said, "these transparencies are dirty," Mike would tell them that we clean them radiologically with a cyclotron. Later on in my proof-passing career, I had that backfire once when it turned out the lady's husband worked at the Berkeley Cyclotron.

On the way back after our short day's work, Mike asked me if I'd ever been to North Beach. I said, "Sure," thinking he meant the ocean. He drove me into San Francisco to Grant Street, one block away from Chinatown, across Columbus, in the Italian section, and we walked into a place called the Co-Existence Bagel Shop. The place was packed with guys in turtleneck sweaters, sandals, and beards, and some very racy-looking women, all drinking coffee by the gallon and talk-talk-talking. I had stumbled upon the Beat Scene. My life would never be the same again, which made sense. After all, who needed the life I had?

I made a lot of money, by my then standards, passing proofs. The great thing about it was you could keep your own hours. When you needed some money, you went to work. The other great thing about working with Stan was it was all cash. I kept right on with my unemployment insurance, just like Mike had promised.

There was a saying in the company we worked for that everybody's sales record eventually averaged out to $10 per sale. I was an anomaly. I consistently averaged $15 to $20. The sages said, "You'll see. You'll hit a slump when you won't see a dime for a while." It never seemed to happen to me.

Back in my basement, things sort of fell apart. The FBI showed up to ask a lot of questions about my landlord. This made me nervous, it being the McCarthy era. Also, I had made a feeble pass at the landlord's wife. Things were a little strained after that.

I found an apartment in Berkeley, on Milvia Street, the top floor of a duplex, for fifty-five dollars a month. I put down the first and last, moved my paintings and equipment in, and set up housekeeping.

This apartment thing had one tremendous advantage. I had a place to take Donna; not only that, there was a bed. In that duplex, with the help of an overnight stay and a bottle of May wine, we finally made love.

Again, I was living three lives: a day job, art, and theatre. I continued painting. Now I had windows! I could actually see what I was doing. I passed proofs with Stan and Michael, and I hung out with the beatniks. I took to carrying a little handmade notebook of art paper with me wherever I went. I would draw what I saw, and write: poems, stories, etc. As I wandered around North Beach, I became aware of the whole historical significance of the scene. The rebellion from the appliance society, the poets and authors, artists and musicians. I read Jack Kerouac's books, *On the Road* first, and then *The Dharma Bums*, and then *The Subterraneans*. In these books, I could recognize people and places I knew in San Francisco.

While reading *The Dharma Bums*, I looked out my back window, and suddenly realized that I was staring straight at the bungalow that Kerouac and Neal Cassady had lived in. In my mind there was no doubt about it.

Part Two

WHAT'S HAPPENIN' MAN?

1955-1960

CHAPTER TWENTY-SIX

BEATNIK

My mother started showing up at the apartment, leaving care packages on the doorstep: food and soap, toilet paper. She started letting herself in to pick my dirty clothes up off the floor, take them down to the river, and beat them against the rocks. She'd bring the stuff back all folded and neat. I rarely saw her, but she was still seriously mothering me.

Sonia and Michael moved to San Francisco. They found an apartment near Russian Hill, which was populated mainly by outcast mixed ethnic couples; mostly black and Chinese. Mike was trying really hard to get ahead as an artist. I went around with him a couple of times to art galleries and watched him get turned down. It was really demeaning. They'd essentially tell him to go home and practice. Mike eventually proved they didn't know what they were talking about. Today, I swear, Mike paints exactly the way he did then, and his works pull in thousands of dollars at a crack. Some of the same galleries that used to turn him down now hold one-man shows for him.

Stan was turning out to be a fascinating guy. He was a faithful friend, and something of a philosopher. He had gone to college for seven years without getting a degree. He was a couple of credits away from a bachelor's in any of several subjects: sociology, psychology, humanities. He had some weird ideas, some of which were very

sound and some of which were completely arbitrary. His I.Q. was 152, but he said that test was meaningless in the real world. He thought that I.Q. tests should concentrate on real effectiveness; that most of the "high I.Q." guys couldn't cross the street, or figure out why their car won't start, or talk to a girl. Stan always had at least one good-looking woman around.

Stan had theatrical pretensions of his own. He got the part of Archie in *Archie and Mehidabel* in a little theatre production. He kidded that he was type-cast as a cockroach. In spite of his talent and his keen intelligence and his success with women, Stan had a low opinion of himself. Actually, he was great in the part.

Stan came up with a brilliant idea for our baby picture racket. Since our canvasser was unreliable, we never had enough pictures to take, or proofs to pass. Stan figured a way to eliminate the canvasser completely. Actually, Raoul Pausé germinated the idea by asking us to photograph his students. We would go to a ballet school and convince the teacher that we were a new business in town and to get ourselves known, we would take pictures of all her students and provide one free picture for every student, which she would hang in her studio. Of course, the parents could buy pictures too if they wanted. The teacher would think we were for sure going to lose our shirts. She had no way of knowing that the film and processing were paid for by the outfit in Philadelphia.

She would alert the parents, and they would spend a couple of weeks getting excited and fixing up costumes. A date would be set and Stan would set up his lights and a blue background and knock off thirty or so sittings, or posings, a day. Then we would use the studio as an office, calling up the mothers on the dance-teacher's phone, making appointments for them to look at the pictures there at the studio. We overbooked so that the mothers could sit and wait together, talking each other up. We cleaned up. The home office was so impressed that they brought Stan to Philadelphia where he spent a month teaching the technique. The program was a failure, though. The system just didn't work for anyone but us. You had to be crazy.

We hit every dancing school in the Bay area; from San Mateo to Petaluma and beyond. Eventually, though, we had used up all the dance schools and pickings got lean again.

Mike dropped out of the team somewhere during this. He moved to a little house in Mill Valley, which was, and is, a sort of Bohemian colony. He got a job at the Co-Existence Bagel Shop as a waiter. Mike liked to play around, and having his wife and kid way out there made it a lot easier. He tried to keep Sonia more or less barefoot in the woods with the baby, but she was getting some action on the side herself.

Mike and I were born on the same day, a year apart. It made us sort of kindred; also, he was almost my stepfather. It was weird having an almost stepfather who was a year younger than myself, but the really weird thing was that Mike actually felt paternal toward me. When I'd show up at The Bagel Shop without funds, he'd say "Are you getting enough to eat, Jack?" Then he'd sneak food to me. He couldn't get me entrees, those had to go through the cash register; but he could get me all the side dishes I could handle. The choices weren't enormous but they filled the hole. My favorite, which isn't saying much, was macaroni salad. I started calling Mike "Pop." "Hi, Pop!" I'd say. I always loved to joke with Mike, just to see that split-toothed grin poking out from under his mustache.

Phil was very inconsistent in the hours he put in, and getting more so. He wasn't really completely sane. He lived in a huge apartment house in Chinatown, which was a sort of Chinese YMCA. He was practically the only Caucasian in the place. His room was about 12 x 12 and had no windows. It was in the center of the building. He said that was better for security, though the halls of that place were scarier than the street by far.

He had minimal cooking facilities, and the bathroom was in the dreaded hall. He had a fifty-pound bag of rice and equally huge amounts of other non-perishable and cheap foodstuffs. These were his emergency stores, in case things got bad. (How bad could they get?) This was really alien thinking for guys like Stan and me, who never, for one second, worried about the future.

Stan and I had a lot of techniques for getting by when Phil was laying back, or sick, which he was a lot. We'd go into the box of "pick-ups": pictures for people we'd never been able to contact. We'd target an area where several of these people lived near each other.

We'd get in Stan's '48 Oldsmobile convertible, rolling all the

windows up to improve the aerodynamics; Stan would take off his right shoe, so as to feel the gas pedal better, and we'd drive ever so easily to the location, getting incredible gas mileage; coasting down every hill in neutral, or with the engine off. They didn't have locking steering wheels on '48 Oldsmobiles. We had, usually, only three readings on the gas gauge that related to us: high E, middle E, and low E.

When we got near the location, we'd stop at a pay phone. Stan had a way of making phone calls for free. He needed a dime, but he got it back. He'd make the calls, set up some appointments; then we'd put the dime into a candy machine. That was breakfast. After a couple of sales, we'd put some gas in the Olds and have lunch at a hamburger stand.

If, at any time, we were really pressed for gas, we'd drive into some gas station and order the guy to fill it up with regular. Then we'd start an argument about who was going to pay; it would quickly turn out that neither of us had any cash. Stan would yell at him to stop the pump. It was important to get to this point quickly. The pump had to stop at about a buck and a half at the most, or the scam wouldn't work. Then we'd argue some more. I played the bad guy in these dramatizations. The attendant would usually say "Oh, the hell with it. Get out of here." If he didn't, Stan (the nice guy) would swear he'd come back and, if that failed, offer to leave his license as security.

One late Saturday night we tried this, and the guy reached in, took the keys out of the car, and locked himself in the building. We pleaded with him but to no avail. He said, "When you clowns find some money, your car will be here. Meanwhile, storage is two dollars a day." Stan told me I had overacted. We found a drunken sailor on the street corner and offered to drive him to the base if he would buy us some gas. He gave us five dollars, and we were on the road again.

The cheapest way to eat in a restaurant in San Francisco is go to Chinatown. Stan's favorite place was Jackson Chow Mein on Jackson Street. It had a counter. For 45 cents, you could get a huge bowl of Egg Flower soup, with two eggs in it. A bowl of rice was 10 cents. If you sat at the counter, ate with chopsticks, and they got to know you, they would drop little extras—desserts and such—in front of you, no charge.

Once I brought Donna there, and they gave me a table with a tablecloth, real cloth napkins, fancy chopsticks, and real porcelain spoons instead of the usual plastic ones. They treated Donna like a princess. She was very impressed.

I really needed my own car for the job. Stan told me the way to buy a car was to pay so little for it that if it stopped running, you could walk away from it without losing any money particularly. I went out and found a '51 Nash Ambassador for fifty dollars. It turned into a bed, so I could sleep in it; and I did, a lot. It had an overdrive, so it was good on gas mileage, and if I had enough room I could get it up to an indicated 90 mph. Stopping it was a different matter. I had a few extremely close calls in that car.

I never got around to paying any rent on the duplex on Milvia Street, just the first and last. Miraculously, I wasn't evicted. I kept promising. One day I came home and there were Robert Ross, his wife, and his baby, with all their stuff. They'd taken over the front bedroom. I said, "What's going on?" Bob said they were moving in with me. I couldn't seem to stop them. I thought they should pay half the rent, but Bob thought since I wasn't paying any rent, they should get to share in the free ride. I hated the new arrangement, but I put up with it for a while.

I continued shopping for provisions the way I always had: shoplifting; only now, I was stealing for four. The presence of Bob and his little family actually helped. The baby in the shopping cart made us look innocent. Even so, you couldn't just walk out of a supermarket with full pockets. You had to buy something to avert suspicion. We would purchase, with our meager funds, all the large stuff, milk, eggs, vegetables, breakfast cereal, detergent and such, all cheap stuff; and I would fill my pockets with the small items: steaks, chops, meat patties, cheese, frozen orange juice, razor blades, canned tuna; anything that would fit. He told me my technique was bad; I took too many chances. At the checkout counter, we got nothing but loving sympathy for our poor, valiant, little family.

I started spending less and less time at home, which meant more and more with Stan and Michael and in North Beach with the beard-and-sandal crowd.

It also meant spending more and more nights sleeping in the

Nash. Finally, it broke down. I managed to nurse it to a parking space right near Donna's house, where it died. At this point, I had to admit, it was not a vehicle, it was an apartment. Eventually, it was towed away.

I should probably introduce some of the "beatniks." There's all this talk, to this very day, about the "Beat Generation." I never could figure out whether it meant "beat," as in "beaten," or if it had something to do with drums, plenty of which were around—bongos and congas.

In any case, the "generation" consisted of, as far as I could tell, about fifty people, mostly male—the scene was a little rough for girls, although there were a few notable exceptions. Linda Lovely (sigh), for one. There were some others who hung around for the fringe benefits: parties, music, black guys looking for white chicks, crazies no one else would associate with, curiosity-seeking college students. Then there was me, I didn't fit any of the categories. I couldn't be a beatnik since I had a job, and one of the definitions was "I won't work."

There was Herman, who had "blessed blessed oblivion" tattooed on his shoulder. Patrick (Paddy) O'Sullivan walked around in knee-high boots, a cavalier hat, and a cape. He had a little book of poetry he'd had printed privately by the City Lights Press, the company owned by Lawrence Ferlinghetti. Paddy would walk around reciting; getting tourists (there were a lot of them) to buy him drinks, and maybe sell them a book. Price, $1. Paddy had a hard time getting chicks, because of the egg fu yung that was usually in his beard.

Monty Pike was a playwright. He wrote things about the scene that read like Tennessee Williams of San Francisco. There was Alex the talker; he always sat at the same table in The Bagel Shop and dished out philosophy, a sort of black Socrates. The joke was, somebody was likely to slip him some hemlock.

Actually, this wasn't far off. The police regarded the scene as a problem. There was a constant program of harassment.

Anyone with a beard found out on the street in the neighborhood was likely to get taken down. There were a few incidents of cops beating up guys we knew. Really sad; they were all such gentle people.

The term "beatnik" was coined by Herb Caen, a columnist in the *San Francisco Chronicle*. This was right around the time of the Russian satellite "Sputnik," and for a while, Herb called everything a "Nik." "Beatnik" stuck and spread all over the country.

Bob Ross took me to a nightclub called The Hungry I, to see a new comic he knew about. He said this guy was the most talented comedian ever, but he would never be famous because he was too far out. It turned out to be Lenny Bruce. We got in free because Bob knew the owner. We had to go in the afternoon to butter him up, and then hang around until he asked us if we wanted to see the show.

Lenny was the opening act for Jonathan Winters. We saw Jonathan in the lobby. He was grabbing the little potted evergreens and saying, "Come on out, Tarzan. I know you're in there!" We thought it was pretty funny, but actually he was flipping out.

That night, after Lenny warmed up the audience, Jonathan was announced. "The Hungry I proudly presents—" etc. Jonathan came on stage with a pronounced limp. He really was nursing an injury; but who knew that? Naturally, everybody automatically laughed. When he got to the mike, he said, "That's right. Laugh at a cripple." Of course, they laughed even harder. He did half of a very disjointed act, and then ran off the stage and disappeared. They looked all over for him but he was gone.

Later on that night the police found him in the crow's-nest of the Balclutha, a square-rig schooner that was a popular tourist attraction down by Fisherman's Wharf. They told him to come down, and he replied, "I can't. I'm the Man in the Moon!" They finally got him down and took him away to the loony bin. He was in for many moons; even underwent shock treatment.

Lenny Bruce filled in for him at the "I," playing out the rest of the week as the headliner. A star was born.

The Hungry I had started out in another spot as The Purple Onion, essentially a jazz club. There were three partners: Enrico Banducci, Eric Nord, and someone else whose name I can't remember. The story was that the someone else had ripped off Eric and Enrico. Enrico went on to open a couple of other places, El Cid and Enrico's. Eric was the building contractor, so he built these places.

I got a job carrying bags of cement for the construction of

Enrico's and got friendly with Eric Nord. Eric knew the pattern of The Hungry I. It had started as a tiny little unofficial operation in somebody's house; not even a business. Eric figured he could do it again.

He rented a warehouse, moved in, and had parties there on Friday and Saturday nights. Donation at the door, 50 cents; bring your own wine. People with instruments admitted free. The place, called Eric's Pad, was a huge success. It had four stories, and every one of them, including the roof, was packed with people who came there just to open and close their pores, and mix.

The police took a dim view of the action and began arresting people for being drunk as they came out in order to get enough on the place to close it down. There was a certain amount of marijuana smoked inside, a serious crime in those days; so, to keep the police out, Eric hired a rent-a-cop.

I was sleeping largely on people's couches and floors right about then, so when Eric offered me a bed on the third floor, I jumped at it. Life at Eric's Pad was pretty strange. Eric was a really huge fat man. He was a part-time painter, a very bad one. The place was hung all over with his massive orange nudes.

I remember one day I was sitting in an easy chair on the main floor and out of the gloom of what I suppose was the bedroom a very attractive nude woman walked toward me. She came right up to me, put a cigarette in her mouth, and said in a husky voice, "You got a light?" I fumbled in my pockets and came up with a match. She leaned over, dangling her large tits almost in my lap, and lit up. "Thanks," she said, turned, and disappeared back into the gloom.

One Sunday morning I woke up with a huge wine headache, and all around my cot was a sea of broken bottles. Apparently I had slept right through some kind of riot. I took my blanket and cleared a path to my shoes, put them on, and moved out. Back to people's couches and floors.

There was a system for sleeping at people's houses while you were at a party. Stan taught it to me. You had to stretch out with your head on the arm of the couch and both feet on the floor. You made believe you were falling asleep by accident. People would think you

were cute, particularly if you were entertaining before you fell asleep, and said something witty when you woke up. You couldn't just curl up and go to sleep, or you were a deadbeat.

You could go into the bathroom and use a razor, wash up, even shampoo your hair but, of course, you couldn't take a shower.

There was a set of rules for freeloading that Stan compiled. If someone lets you crash at his pad:

Never take the last one of anything in the fridge. When the guy comes home from work and goes straight for a beer, you'll lose some of your popularity. Once in a while, buy something. Milk is good. It's big, so he'll notice it, and it's cheap.

Never make long-distance phone calls. It's tempting, but it will always catch up with you.

Never sleep in his bed. It's a violation of his sovereignty.

Never be in bed when he goes to work. He's working his ass off to pay the rent. If he sees you sleeping in, it will depress him. Get up early and leave the pad. Come back when he's gone. Then you can crash all day, but don't be in bed when he comes home. Be gone. People will ask him, "How's Jack working out?" And he'll say, "Fine. I hardly ever see the guy."

When you're visiting someone, don't sit on the couch. Sit on the arm. That way you won't take up anybody's space and you look like you're not going to stay long.

A little housekeeping will extend your welcome. Don't let him see you doing it. It will make him nervous. Empty ashtrays, wash the dishes. Take out the trash. Make your bed.

Flush the toilet.

One of the constant problems of being dead broke was getting cigarettes. When I got crazy for one and there was no one around to bum from, I'd go out in the street and check the gutter near a bus stop. People were always lighting up at bus stops, and then throwing them away after only a couple of puffs when the bus came. When I couldn't find any good long ones, I'd collect the short ones and crumble the tobacco into a pipe.

I started going across town to a section called the Fillmore district. This was a largely black area. I would go into the jazz clubs and

listen away the nights to wailing saxophones, drinking Cokes and beat-
ing in time on the table. I got sort of friendly with some of the locals.
I was usually the only white person in the place. They couldn't figure
out what I was doing there. Neither could I.

CHAPTER TWENTY-SEVEN

THE PARTY'S OVER

E ric's Pad came to an end one night when a drunk fell off the roof to his death. The rent-a-cop had seen him sitting on the edge and came over to tell him to get away from there. The drunk looked up, saw a cop, and it startled him so much that he fell over backwards. The moment he hit the street, his friends were rifling his body. Somebody got his keys and cleaned his meager belongings out of his pad before he was cold. The spirit died. In a small way it was the Altamont of the beatniks. The party was over.

The cops started to really crack down. The tourist trade in North Beach had become a big thing, so they started a program of busting well-dressed tourists as well as all the beards they could find. Posh couples, military, college crowd. The authorities would rough up these gentle people, subjecting them to fingerprints and drunk tanks. The theory was to discourage the tourist trade and put the places out of business.

They had plenty of support from the neighborhood. The Italians who had been living there forever didn't like the scene very much either. The hope was to get rid of the scruffy bunch who customarily slept on the sidewalk in front of the Church of St. Francis of Assisi.

A sign appeared in the window of The Bagel Shop. It was actually more of a proclamation. It derided what was going on, and

washed the management's hands of the New Deal. At the end it read, "This is a tourist trap. Beer: $3."

What eventually happened as a result of the crackdown was that the real people moved to the Portrero district and eventually from there to Haight-Ashbury. We all know what that led to.

The last time I visited the old turf, about a year ago, the Italians had it back. There were still bums sleeping in front of the church.

My mother and Sam broke up. Mother moved to San Francisco. She told me the way she had convinced Sam to leave her. She feigned insanity, copying her routines from various old movies. It took awhile, but finally he slipped out the back and went to live with his mother.

Bruce got a job teaching English and speech in a high school. He had a real aptitude for it. He'd wear hats and jump on tables and play boogie woogie piano. The students loved him. He should have stuck with teaching, it was a real calling, but there was no money in it. He became a business machine salesman. He never made any real money at that either, and never was really happy, though he cut a wide swath with the local ladies.

He also started running marathons. He ran all the time. It was hard to have a conversation with him; he was always in a hurry.

Bob Ross took his family and moved to New York to try to break into the theatre there. I had my place back, but only for a short while; my landlord finally kicked me out. My mother got worried about my belongings and paid the rent (four months) so she could recover my stuff. She stored my paintings in Donna's father's garage. I never saw them again. Fifty-two of them, as I remember. Some of them were pretty good.

I moved into a hotel around the corner from The Bagel Shop: The Swiss American. Seven dollars a week. Bath in the hall, sink in the room. I hung around North Beach more than ever.

The scene here had become pretty lively. Things had really opened up. There were more people, and more places to go and things to do. Just down the street from The Bagel Shop, a place named Cassandra's (after Agamemnon's crazy foreteller of Doom) had opened up. It was a coffeehouse with extras. They had live music pretty regularly, mostly drums, and Monty Pike had a play produced there called *The Potato Eaters*, about North Beach. Sometimes there would

be a jam session. Everybody would bring a drum. These things would grow until there were maybe twenty drummers or more.

In the middle of one of these, one of the paying guests had a fit. He was on the floor, jerking around. I thought it might be epilepsy. I knew you were supposed to put a spoon in his mouth so that he wouldn't bite his tongue off. We could only find a fork, and we cut him up a little trying to jam it into his mouth.

I liked hanging out there because when the place was busy it was easy to grab a pastry without paying for it.

One late night Stan and I were in The Bagel Shop and there was a drunk asleep at one of the tables. If you did that, the cops would bust you, so the other customers took up a collection to get the dude a hotel room. Since Stan was the only one who had a car, we were elected to take the drunk to the hotel. Some other guy, with a beard, went along to help out. Stan didn't have his Olds anymore; he had a cherry '40 Studebaker four-door. We went from hotel to hotel. No one would take the guy; he was too drunk. After one try we were standing in the street trying to get him back in the car, when an unmarked police car drove up. Two huge Irishmen got out and proceeded to give us a hard time. We tried to explain, but when we mentioned The Bagel Shop things suddenly escalated. They searched the car and our persons and talked mean.

I started to get pissed off; after all, we were just trying to be good Samaritans. I snidely remarked, "Somehow, I feel my constitutional rights are being violated."

This enflamed the bigger of the two Irishmen. He said, "Get in the car!" (meaning the cop car).

I said, "Is this an arrest?"

He said, "Just get in the car!"

I repeated, more emphatically, "Is this an arrest?"

He was becoming absolutely apoplectic. He spit out, "Yeah. It's an arrest!"

I was enjoying myself, falsely secure in my naive righteousness. "What's the charge?" I asked with silky tones.

He hit me over the head with his flashlight.

They took me to the hospital, then to jail, where I was booked for resisting arrest and disturbing the peace. Stan had played it very

cool, so he was let go at the site. When they were finished booking me, some guy was there waiting for me. I said, "Are you an attorney?"

He said, "Don't talk here."

I looked around at all the police in a paranoid fashion and followed him out the door. When we were outside, he offered me his hand and said a name, adding "Bail Bondsman." And then, there was Stan.

The next day, a screaming front-page story:

CARRADINE BOPS COP!

The other San Francisco rag blared:

ACTOR'S SON BAD ACTOR

I would have made the banner headline, but Arthur Godfrey had an operation and beat me out. Still, front page with a picture taken by Stan, and nothing good to say about me. Stan called up the papers and told them they got the story backwards, but they didn't care. What really rankled Stan was that they hadn't given him credit for the photo.

CHAPTER TWENTY-EIGHT

OUT OF THE FRYING PAN

ll other considerations of my life now became secondary in the face of my trouble with the law. Right away, some of the well-connected beatniks (believe it or not, there were such people) introduced me to a rich lawyers' firm that would take my case as a cause célèbre. The junior partner they handed me said, "We're gonna get those sons of bitches. We can't let them get away with this stuff."

It was important to the "cause célèbre" theme that I be squeaky clean, so they asked me all kinds of questions: had I ever been arrested before; had I ever smoked marijuana, etc. I could truthfully answer with a blanket negative. The reform school was a closely guarded secret; on my record, it appeared as "Woodland Academy" or some such alias. I didn't volunteer any information about my shoplifting and burglary careers. They told me they'd get me out of this thing for sure and not to worry.

We all knew what was going on. Having beaten me over the head, the cop HAD to get me convicted of something in order to save his own skin. There was, in everybody's head, the strong possibility of a false arrest/police brutality situation. My attorney demanded the damaged flashlight as Exhibit A.

My dad came up to San Francisco to lend a hand. I was charmed by his concern at first, but it turned out he'd only come

up to scold me and put a lid on me. He told me that the publicity wasn't doing him any good. I said I didn't think it was doing me too much good either, but that I was going to beat the rap. He fervently advised me to cop a plea; otherwise I'd have nothing but trouble. I'd never be able to walk the streets of San Francisco again. My sense of youthful, righteous indignation prevailed. No way was I going to plead guilty to something I didn't do. Hell, let's face it, there was no way I would plead guilty to something I DID do. Dad went off shaking his head, and I went off shaking mine; a definite generation gap there.

About this time, something really good happened. A Shakespearean repertory was coming to San Francisco and they were casting some of the small parts here in town. I went to the audition with Fred as usual. Wonder of wonders, they had lost their juvenile lead to a better job; and I got it; my wildest dream. Pay: $100 a week.

They wanted a pro but it was easy, with my father's name, to convince them that that was me. Fred lost out, which filled him with jealousy. They said he was "stiff," which I suppose he was. Fred was never a good auditioner. He always seemed to think the process was beneath him.

Things were looking really good for a moment, and then another ax fell: my attorney called me and told me I had to go down to the station with him to answer charges on a bounced check. Apparently, a storekeeper had seen the headlines and had come forth with an old check on an account that was now closed. The cops were calling it a "fictitious" account to make it a more serious charge.

My junior attorney took me to the station and there were the same two Irishmen. We waltzed in, I sweated bullets, and then we waltzed out. The Irishman who had bopped me with the flashlight said, "That address on your driver's license, the one in Berkeley; you don't really live there, do you? That's just a mailing address." I kept mum, as the attorney had told me to do while I was in there. Naive though I was, it was clear to me that I didn't want this cop coming around, with his flashlight, to my little room at The Swiss American Hotel.

When we got outside, the attorney told me that those guys didn't have anything to do with this and shouldn't be there. They

were scared, he said, now that they'd discovered I wasn't a nameless beatnik-ne'er-do-well (little did they know that, nameless or not, I WAS pretty much a beatnik-ne'er-do-well), and they were trying to put the pressure on me. Then he said, "We have to talk."

Back at the office, he said, "I thought you told me you had nothing in your past; and now here is this thing."

I said, "Well, I didn't know about it."

He asked me if there were any other bad checks floating around.

I said "No," hoping to hell that was true. Then he asked me the checkered-past questions all over again.

Thinking I had to give him something, when he came around to the marijuana question I told him, totally untruthfully, that I had had a puff off a joint once in school in New York City.

Bad move. The rich law firm allowed as how they no longer wanted to represent me, since I had not been straight with them at the beginning, not realizing that it was NOW that I wasn't being straight with them. Obviously, it was too late to change my story yet again; so, I was, yet again, looking for representation.

I called up Donna, and she told me her father had forbidden her to see me. She had told him, "But, Daddy, you're all wrong; he's happening. He's got a job acting." He said, "Too late. He'll never amount to anything. He's a paper hanger." I felt Donna should have told her father to piss off. This lack of loyalty pretty much ash-canned our romance; I turned my back and went on. Stan loved the story. He kept saying, in a New York accent (or Chicago, I don't know which), "De kid's a papah hangah."

A new lawyer appeared on the scene quickly (I was a hot property), a young guy who would take the case for its publicity value. He wasn't rich and his motives weren't as noble, but he was hungry and tough—street-wise, you might say—and he needed to win.

One day I borrowed Stan's Studebaker. It ran pretty good, but it wouldn't start. You had to always park it on a hill. I met Stan later, and told him I had inadvertently parked it on the flat and couldn't get it going. He said, "Well, that's okay, Jack. We'll get it straight." I said, "Well, that's not all of it. They towed it away." This was a big problem, since Stan didn't have registration for it.

We had to get a new car, which was just as well, since the

Irishmen knew what his Studebaker looked like and it was a definite standout.

There was a guy on the scene named Bill Dick who owned a '50 Ford convertible, with a flat-head V8. He had been a gun-runner and had fled to Florida to escape federal prosecution. He'd left the keys to his car. Stan reasoned that since the cops knew him to be driving a pre-war, white, Studebaker sedan, a post-war, black, Ford convertible would be the last thing they'd look for. He bought the keys for fifty dollars. The car remained in Bill Dick's name. Stan drove it around, parking it wherever he felt like, and collecting tickets, which he threw away.

One day I was coming out of a bar in North Beach called "The Place" with Stan and a couple of other people, when I saw the Irishmen walking straight toward me, checking out every place as they went along. I KNEW they were looking for ME.

I jumped back inside "The Place" in a panic. I went up to the bar and signaled the bartender.

"Is there a back door to this place?" I asked.

He gazed at me, not entirely unsympathetically. "Nope."

I looked around desperately and headed for the john. Inside there, I checked out my alternatives. There was a tiny, up-high window. I forced it open and squeezed out. It didn't go anywhere, but off to the side was a fire escape. I made a perilous traverse along the wall and went up the fire escape to the roof. From there, I hopped from roof to roof until I came to the end of the block. There, I made it down another fire escape onto a side street, and walked to the car, coming up right behind my friends.

Later, when Stan and I compared notes, we surmised that, since the cops had walked right by him without a second glance, they probably didn't know what Stan looked liked, having only seen him in the dark at the scene of the "crime."

His diabolical mind working overtime, Stan started parking down the street from the police station and following the Irishmen as they set out on their day's work. He reasoned correctly that cops don't expect to be tailed. He found out that they began their day by cruising all over the places where I was known to hang out, before going on to their appointed rounds. I checked with my lawyer and learned

that what they were hoping was to grab me on another trumped-up charge, to give me a history of wrong-doing so that I would look bad in court. Stan and I decided we'd better stay off the street for the duration.

It was a couple of months before the Shakespearean repertory would start, so I still needed to keep selling baby pictures for the moment.

The company in Philadelphia had finally grown tired of our weirdness and inconsistent volume, and cut us loose. We decided to do it on our own. Since we'd sold pictures to every household within ninety miles, we decided to go to Sacramento and break fresh ground; a strategy which would also get us out of sight.

We got in the Ford and went for it. Just short of Sacramento, doing fifty-five, we heard the unmistakable sound of the rods going out. I was driving. I quickly shifted into neutral and coasted down the next off-ramp straight into a wrecking yard. After a long negotiation, the owner agreed to pull the engine and drop in one from another Ford he had there which had been rear-ended. All we needed was $225. We told him we'd be back in a week, and hitched into Sacramento. We knew this would be a snap. Sell a few pictures, and off and running.

Sacramento was a disaster. We might as well have been in the middle of a depression. We kept coming into these dismal, subsistence-level housing developments; no money anywhere; plus, we had to front everything ourselves. All that plus the fact that we were dealing in black and white (how could we afford to process our own color?) added up to Carradine's unique and remarkable $19 average finally bottoming out to zero, zero, zero.

We lived in digs even poorer than The Swiss American and ate potatoes. It took us over a month to save up the $225. We showed up at the wrecking yard, thin as concentration camp refugees, and watched the "new" engine be levered in. We bid farewell to Sacramento with great relief and gunned our "new" engined Ford up onto the freeway, headed south, with me driving again. When we reached fifty-five, we heard the same unmistakable sound of the rods going out.

I shifted into neutral again, coasted down the next off-ramp,

pulled into the first gas station, replaced the engine oil with 50-weight motorcycle oil, and discovered that, as long as we kept the car under forty-five, the rods didn't make any noise. We went on driving it like that, working up to 90-weight transmission fluid in the crankcase.

One night while we were at a party, we heard a huge crash outside. Stan sprinted out with his peculiar gate—head held high and slightly to one side, hands up like a marathon runner—to discover that someone's drunken teenage son had plowed into the rear end, unspringing the thing so that it looked like a stink bug.

Stan got on the phone with the parents and, charitably helping them avoid the insurance companies and the stigma of a drunk-driving charge, settled for $100, cash.

I said, "No, Stan."

He said, "Look. We can't sue him; we don't own the Ford. And, dig it, man, the car still runs!"

We drove it for another six months and then sold it, again without the pink or the registration, with the rear-end still stink-bugged out, for $100. We did, at least, tell the new owner, AFTER we got the money, about the 90-weight oil and the 45 mph speed limit. You have to understand that, on that scene, the fact that the car wasn't registered to oneself was an enormous selling point. All of those guys were deep into the "just walk away, man" syndrome. I would not be at all surprised to hear that the Ford's still running, still unregistered, and still collecting unpaid parking tickets.

Meanwhile, I reported for rehearsals. I had a nervous first day, trying to act as though I knew what I was doing. I learned later that no one was fooled, but no one was worried. The most arresting experience of that first day was meeting, and actually working opposite, Kate Scott. She was the leading lady of the company, and an absolute knockout. I was definitely knocked out.

I had told the company that I was a member of Actors' Equity, the stage union, but had taken a withdrawal card to go to college. At the same time I told Equity that the company had hired me, so I needed to join. Now I needed to get the money to pay the initiation fee, so I told the company that I had neglected to take out the withdrawal card and needed to pay my back dues. The company lent me

the money. Looking back, I think maybe I wasn't actually fooling anyone, but they all went along with my game.

I was making a certain amount of headway with Kate Scott, or at least I thought so. A number of the troupe had taken up residence in a cheap apartment house on the cheap side of Nob Hill. There were four little one-room things on each floor, all sharing bathroom and kitchen; an ideal arrangement for a chummy bunch of actors. I don't remember the details of how I finally got through to Kate, but I did.

I discovered immediately after our first assignation that the director, Rolf Forsberg, was sharing her favors as well. I was madly jealous and found it extremely difficult to look them both in the eye at rehearsals. What was really going on was that I was in deep crush, while Kate had just been having a one-night stand. The energy of youth won out over the experience of maturity (or maybe it was just that Rolf was a married man), and Kate and I became the item. I moved in with her and we burst into flaming romance.

Kate was pure fun, a little moody at times, but that's part of it all. She had worked as a puppeteer for a while and had a lot of funny voices she could do. Our romance was somehow a little scandalous to the company, so we hung out separately. After a couple of weeks everybody else moved out of the cheap apartment building, so we had it all to ourselves.

Someone gave us a sea bass he had caught. Kate baked it in our oven, and we invited the cast to help us eat it. Nobody showed. Screw them. We had each other.

Our "theatre" was a circus tent next to Fisherman's Wharf. We watched the thing go up and did some publicity film for local TV of the event. I, as the best second-story man in the troupe, climbed up the poles and was filmed supposedly working on the riggings.

We opened the first play, which was the one about the Scottish king who has the domineering, murderous wife; the one with the three witches in it and the forest that moves in on the castle.

The reason I'm being so coy about naming this play is because there's a superstition in the theatre that you must never mention that name or quote from the play. My mother told me that I don't have to be superstitious, and I believe her; however, there's a lot of documen-

tation of the good sense of this one. There has supposedly never been a successful production of the play and disaster often dogs an attempt. Such things as actors dying, theatres burning down, chandeliers falling on the audience.

One theory to explain all this is that the witches' speeches contain actual magical incantations and, when the play is performed, you put them to work. Anyway, just for luck, I'm not going to risk the hex right now. This book is entirely too much hard work to take a chance on jinxing it.

All this didn't dissuade Lee Henry from having a go at it. Lee had been in the Compass Theatre in Chicago, which had become The Second City and early on spawned such meteors as Mike Nichols and Elaine May and, later on, "Saturday Night Live." Lee splintered away, not being interested in improv as much as he was in drama. He was the producer of this venture. His wife played the Scottish king's murderous wife. Kate was one of the witches. Her big parts were in the other two plays. She was incredibly cute as the witch.

Lee was great in the play. When I think about it, I can still see and hear him today. If I ever have the nerve to try it myself, I'll certainly draw heavily on Lee's interpretation. This time, however, I was playing Malcolm, a juicy part for a twenty-two-year-old actor, and I was great in it. In between performances I was busy drowning myself in Kate's charms. We went everywhere together, did everything together, and did the old in-and-out as often every day and night as we could get it in and out. Kate was my education in adult sex. She was thirty years old, had been around, and she knew what she wanted. I was a willing pupil, aiming to please.

⇒ ⇐

I STILL HAD THIS trial thing hanging over my head. The D.A. offered me a deal: plead guilty to resisting arrest and they'd drop disturbing the peace. It sounded like a bum arrangement. I held out.

We went to trial by jury. The cops showed up looking like the dangerous animals they were, and my lawyer prodded them into showing their fangs. I was very convincing on the stand. We showed the mashed three-cell flashlight, which was a definite crowd-pleaser. The jury went out, and my attorney and I went to a bar to wait it out.

He was just telling me that if the jury came back in less than an hour, it was almost always a guilty verdict, when the phone rang and we were told the jury was coming back. I looked at the clock: half an hour. I sat down in court, with my heart almost stopped. The jury filed in and said they wanted to see the flashlight again. I caught my breath, and they went out again. We went back to the bar. When the verdict did come in, it was not guilty on both counts.

While we were laughing and dancing, the Irishmen smilingly hit me with a summons, right there outside the courtroom. Parking tickets gone to warrant. Vindictive sons of bitches, these guys. Well, big deal. Right now, it was hard to pierce my balloon. That night I was great on stage; and afterward Kate and I celebrated in our usual way.

We were now deep into rehearsing the second play, which was *The Tempest* (I can say that one out loud). That has become just about my favorite of Shakespeare's plays, but that's partly because I was in love with Kate as Ariel. This was Kate's big moment and she WAS great. I only had a little part in this play, so I could just stand around and watch her smoke.

This interlude in San Francisco was actually the high spot in Kate's acting life; and she was making the most of the moment. As her consort, I was sharing in her glory. I had many a mile to go, but this first lap I would never forget. It molded me. I was learning something new every day: about love, about acting, about showbiz, about life itself.

Kate started telling me who she really was. Her name was Nancy Ringberg; she was not blonde at the roots. She had, just recently, bobbed her nose and changed her name, and this was her first job as her new self. It was also the first time she had played Shakespeare. Before, it had all been one-line bits and puppet shows.

Right about this time I twisted my ankle during a performance and learned about the big Show-Must-Go-On syndrome. I kept on performing, of course. You would have had to chop the foot off to get me to stop. It was funny, me, this young kid, hobbling around like an old man next to an older woman who was jumping and dancing. I almost lost Kate over that. She wasn't sure she wanted to be a nurse-maid just right then; however, love triumphed.

Then, during a rehearsal, I stepped on a nail—same foot, of

course. Now I was really hobbling around. I figured out a method for disguising a limp. You limp with both feet; it comes out even, and you just look like a sailor or something. I've used the technique many times since.

About friendship. Fred Hoffman showed up. We hadn't seen each other for a long time. Things were a little strange for some reason; and then, after a little fumbling around, he said he wanted to talk to me alone. I said, "Kate and I don't have any secrets."

Fred said, "No. This has got to be you and me." I didn't like it, but Kate said go ahead, so we went down to the street. There, leaning against his Mercury, Fred told me that he'd been in touch with an actor who knew Kate in L.A., and he had proof that she was a really shallow, loose chick and a gold-digger and I don't know what else. I looked at Fred sadly. It was easy to see what he was trying to do. Chivalry dictated what I was supposed to do. I had to look away. I said, "Well, thanks for the info, but I already know all that. Like I said, Kate and I don't have any secrets."

He asked me what I was going to do. I said I was going to go back upstairs. He asked if I want to have a drink somewhere. I said no, I didn't think so. We said so long, and I limped away from him. I stood in the doorway and watched my old friend drive off, more or less for the last time, and went back to my shallow, bleached-blond, gold digging, loose, lovable chick.

The third play was *Much Ado About Nothing*. I had a good part in this one, as Claudio, the lovesick youth. Kate was playing Beatrice, the bombshell who dominates the play. *Much Ado* is a zany comedy, full of tricks and turns. It's a lot of fun, and we had plenty of that. My foot healed up, and Kate and I tripped the light fantastic all over town. Stan joined in with us a few times. Unlike Fred, he thought we were a sweet couple.

Our only problem was what I guess you could call "the curse of the Scottish King." The San Francisco Shakespeare Festival was pretty much a flop. Audiences were lean. Well, nobody had told Lee that summer is not the season in San Francisco. June and July are cold months. The tent was never warm enough. The actors were freezing, and so was the audience. We installed heaters, but it was still cold.

Unfortunately, our otherwise good review in the *Chronicle* mentioned that fact.

The night the closing notice was posted, Kate and I missed the last cable car and had to walk home. It was especially cold, with a razor-sharp wind to spice it up. We hugged each other and grimly plodded up the hill. "Hi, diddle-dee-dee! An actor's life for me!" said Kate, in her puppeteer's Pinocchio voice.

Around this time Kate started trying to extricate herself from our Garden of Eden. She said something like "Look kid, you're young. You've got a long way to go. I don't know if I want to go there with you. I've already gone through it all once. I'm not sure I'm up to doing it again."

Though this declamation reeled me, I didn't lose much heart. I knew how I felt, and I knew I could always change her mind just by touching her in the right places.

The show closed and Kate, along with the rest of the company, folded her tent and went back to Hollywood. I stayed on in the apartment. We had vague plans to get together down there, where I would break in to pictures, but the plans stayed very vague. She had an old boyfriend to whom she would have to give the final heave-ho. The whole thing was sort of iffy.

I painted two paintings of her from memory and a couple of photographs, and started a bust in clay.

I conned a car dealer into selling me a '48 Chevy convertible on time, and got a job selling sewing machines door to door. After a month, I blew up the Chevy. I borrowed Donna's car, now a '53 Packard Clipper, and almost sold a machine. Actually, I did sell one but the credit wouldn't clear. I quit the job without ever making a cent.

I joined a team selling the *New World Encyclopedia*. This was a twenty-year-old version of the *Encyclopedia Americana*. I didn't need a car for this job. A crew boss drove us out to a suburb somewhere and dropped each of us off on a corner with our briefcases. He'd cruise by and pick us all up a few hours later. It was heartbreaking work. You caught everybody just before dinnertime. There they were, the happy little families all snug and warm inside their houses. There I was, chilly and miserable, shuffling from door to door. Willy Loman.

I never sold an encyclopedia.

One day my mother asked me to have lunch with her. I showed up at the restaurant of her choice, and we talked about this and that. Then, over dessert and coffee, she told me to get out of town. She said nothing was ever going to happen to me here. What I had to do was go to Hollywood. Maybe get my father to help me. In any case, I had to go. She was very definite about it.

What she was doing was kicking me out of the nest; or throwing me into the fire.

I thought of Kate, which I pretty much did all the time, anyway. Yeah! I went.

> ← →

Well, my dad had a job and a wife and two kids
In the valley, but something was wrong.
He had a three-bedroom house and his name up in lights,
And a yacht that was sixty-feet long.
But he fell overboard for a lady named Sonia,
And blew it all off for a song.

Well, my ma was a girl who made all her own clothes,
And her cooking was the best in town.
She thought she could swing with the high social whirl,
But she ended up riding it down.
She worked out her life in a room with no windows,
Until she was forced to retire.
When I strayed from the path, she said, "See the light, son."
And threw me right into the fire!

And now I'm walkin' down this road on my own,
Though I'm not alone.
Don't give the credit or the blame
To the old salty dog that gave me his name.
I'll take the blame, I'm not ashamed.
Just call me by my right name.

CHAPTER TWENTY-NINE

INTO THE FIRE

I hitchhiked down to L.A. with two suitcases and the unfinished bust of Kate. I made it to the corner of Laurel Canyon and Sunset Boulevard. Pretty much the center of town as far as I knew. Right on the corner there was a Belgian restaurant called "The Villa Frascati." My dad used to hang out there when he lived in the neighborhood. It was sort of his office. People would call him there. He'd come in and buy a drink and they'd give him his messages. Right across the street was the famous Schwabb's Drug Store.

Frascati's was closed, so I stashed my suitcases in a corner of the terrace and crossed the street, carrying Kate's head. Kate lived right behind Schwabb's in an apartment complex called "Laurel Sun Apartments." She had a studio apartment in the back. I couldn't find her right away as she was doing maid service. That was how she paid her rent. Once a week, she changed sheets and vacuumed.

She didn't seem completely overjoyed to see me. I was glad I'd stashed my suitcases. I helped her out with making the beds, and tried to talk. When we got back to her place I showed her the bust and she warmed up considerably. We ended up having a little on her clean sheets.

My mother had arranged for me to stay at Benton Scott's house on Valley Spring Lane until I got my feet under me. I didn't know this until a few years later, but she was paying him for it. Somehow or

other, I made it over the hill to his place. They gave me a little room and were fairly cordial; or, at least, Benton was. His wife, Edo, was her usual bitchy self. Benton had developed a sort of captain's paradise of his own. Every year he went to Paris for a few months. His story was that he could only paint in Paris. This was very important, as painting was now the entire source of income for the Scott family. For Benton, though, it was Escape, obviously with a capital E. I looked at a bunch of his paintings. Mainly, they were indistinct Paris street scenes. They looked as though he had given up on them when his technique gave out; an approach I could certainly understand.

I started trying to get things going in Hollywood—an agent, resumé, pictures. I also kept in close contact with Kate. She gave me a couple of pointers. She was gradually but steadily softening up.

Kate had a job waitressing at Huff's, a counter restaurant on Sunset just a few blocks from her apartment. I would meet her there. She would slip me some of her tip money sometimes, and she was always good for a free meal.

One thing I needed was a job. Kate introduced me to the Tennessee transplant who ran the Shell Station next to Huff's. This redheaded redneck looked at me as though I were some kind of leftover bread, but he gave me a job. Basically, I was supposed to pump gas, but right away, this guy had to put me in my place. He took me around the back to the men's room and told me to clean out the "Pisser" and the "Commode." I didn't point out to him the stylistic anomalies of his nomenclature; I just cleaned out the pisser and the commode. Years later, it occurred to me that the reason he hired me was the same reason he liked me to clean out the pisser and the commode: he was hot for Kate.

It only took a couple of weeks for me to get totally fed up with the Scotts. They were definitely not hip and they didn't like my hours. I would spend half the night with Kate and then, after a long odyssey getting over the hill, sleep half the day. When Kate invited me to move in with her, I was out of there.

Life with Kate in Hollywood was even sexier than life with her on Nob Hill, probably because we had nothing else to do. Every evening, after I had shed my gasoline-soaked khakis and she had taken off her little waitress outfit, we would go to the corner grocery, right

next to Schwabb's, and buy dinner. I would contribute a stolen half-pint of vodka and maybe a tin of caviar.

We would lock ourselves in our little apartment. I'd make the martinis. Then Kate would put everything on the stove and in the oven, while we'd sip, talk, and smooch a little. We'd move the coffee table to the foot of the bed and set the table. Then we'd sit on the edge of the bed and have our second martini. This act would inevitably lead to our sprawling back onto the bed and making love.

We would emerge starving. Kate would turn on the stove and the oven. We would eat the lamb chops, and down the last of the martinis, and then go at it again.

Now that I was making a few bucks, and this being L.A., I wanted a car. I found an ad for a Nash Ambassador in the paper. The price was $35. All I had was $25. The guy let me have the car, but retained the pink slip. I let him keep it. I knew how that worked. I never paid him the other $10 and, of course, never paid a parking ticket either.

Now that I had wheels, I could go out to Callabasas to see Dad. He was still living with the blond lady named Doris, who was taller than he was in her heels and outweighed him by at least ten pounds, which wasn't saying much. She had really taken over. The kitchen had been rebuilt for her; and her two strapping sons, Mike and Dale, were taking up all the spare bedrooms.

Dad took me on a job with him. Some TV western at Universal. I naively thought this contact would result in a job for me. Nothing happened at all. Dad had enough trouble finding HIMSELF work, without trying to push me on people. I didn't realize this at the time; he didn't explain it to me and I wouldn't have believed him if he had. Eventually, I learned it for myself, trying to help brothers Keith and Robert out. No matter what it looks like, we're all self-made men.

I found myself an agent. His name was Mickey something. I was feeling pretty hot but when I read the contract he wanted me to sign, I balked. Mickey said it was just a standard contract, and he was doing me a favor by taking me on at all. I backed out anyway.

I found another agent pretty quickly. He needed pictures. I got some. He told me my stage credits didn't cut much ice in Hollywood, but he'd get something going for me.

The big redneck at the Shell Station got tired of humiliating me and fired me. I cast around a little bit and got a job parking cars.

This job paid $1.25 an hour. The concession we worked for parked cars at all the places on La Cienega's Restaurant Row. We also were entitled to a roast beef dinner at Lawry's House of Prime Rib, our headquarters.

Any tips we received were supposed to be turned in, something that the customers didn't know. I quickly learned that I was supposed to skim, though if I was caught I would be fired. When business was hot, we were supposed to park and return the cars as fast as possible. This rushing around made it easier to pocket the tips. If someone gave you two quarters, you'd pocket one of them. If you got a dollar, you'd switch it with a quarter.

We took incredible chances with these expensive pieces of machinery, hot-rodding them in and out of tight spaces. If you crunched a car, the company would try to slip it by unnoticed. If that didn't work, the company would split the cost of the repairs with the boy who did it. I never actually saw this happen.

Just about everybody working at the car-park was an aspiring actor. One guy I got pretty friendly with. He'd just had his nose fixed, and wore a little piece of adhesive tape. He had many theories about how to get ahead. I adopted some of them and probably slowed myself down considerably as a result.

Kate started to get itchy. She decided we should take a break from each other. I wouldn't have any of that. One day I came home and she was gone; moved out. No forwarding address or phone number. My stuff was in the office. I was devastated. I also had no place to live. Well, the Nash had a bed.

I phoned the company right after finding out that Kate had left me, and told the overseer that I wasn't going to come to work that day. I said I'd had a big emotional trauma, and I wasn't fit to park cars. I'd probably end up crunching one of them. The overseer was completely unsympathetic. He wasn't that big on me, anyway. I'd been overdoing the skimming, and he was getting wise; "suspicious" would be understating it. He said that they were depending on me and I had an obligation. He made it sound like a sacred trust. It was come in or get fired. Fuck it. I quit.

I went in the next day to collect my pay. They had it figured that what with uniform and laundry, I owed them. Fat chance.

I started living in the Nash. At night I would drive to a gas station, change my clothes to a sweat shirt and jeans, fold my slacks and jacket carefully, and use the men's room to wash my dress shirt and shave. The shirt was wash and wear. I would wring it out after washing it, then shake it to get rid of the resulting wrinkles. I'd park in a secluded spot, away from any annoying streetlights or cops, drape the shirt over the steering wheel, put the seats down, and stretch out. In the morning I'd put on the nearly dry shirt, put on my tie and the rest of my finery, and go out looking for Stardom.

I had ways of eating in restaurants for nothing. I'd start out by stealing a magazine or a newspaper. Go into a restaurant. Sit at the back. Order a meal, eat it, while reading. Get friendly with the waitress. Order dessert and more coffee. Go to the men's room, leaving the open magazine, the dessert, and the steaming coffee, perhaps a cigarette burning in the ashtray. Slip out the door. Only once to a restaurant, but there were lots of them. The shave, clean shirt, and tie were essential for this gambit.

Hollywood was not working for me. I had only secured one job: for no money, rehearsing for a play that never got on. My love life was kaput. I was broke. I was really just existing to subsist.

Besides all that, my Nash Ambassador had developed a hole in the radiator. Because I neglected that, it escalated to a blown gasket, and thence to a warped head. When I drove it down the road, it looked like a teakettle. Once a cop stopped me to make sure I wasn't fleeing the scene of an accident.

I had heard somewhere that Eric Nord and some of the folks from San Francisco had moved to Venice Beach, out next to Santa Monica. They were supposed to have set up some kind of an artists' colony at the beach called "The Gas House." I thought maybe I'd nurse my Nash down there and see what was going on. There was nothing happening for me here, so why not? At least for a couple of days. Clutching my bust of Kate and my broken heart, I set off one night, late, in a cloud of steam, heading west down Venice Boulevard; certain that if I stayed on that street, it would eventually take me to someplace better than where I was.

CHAPTER THIRTY

THE HOLY BARBARIANS

The trip to Venice took quite a while. I had to stop about every twenty minutes to minister to the radiator. When I got there, the place was covered in a wet, sticky fog. Most of the buildings looked like Venetian palaces gone to seed, with fancy pillars and arches. I circled around the unfamiliar squares and dead-ends until I found Windward Street.

When I got close enough to the beach to smell the ocean, I could feel the quality of things change dramatically. Venice by the Sea. "Venice West," to differentiate it from that other place; not that there is much real similarity.

Orson Welles shot *Touch of Evil* here, and then there was *Crime and Punishment, USA.* You get the picture.

Someone got this great idea to build a whole little city with canals and bridges, casinos, hotels and saloons, with Venetian architecture, for the rich to play. This was in 1927.

The place had gone bust almost immediately, pulled down by the Great Depression. It's been crumbling away ever since, and the wasted youths of several generations have come here and lived from hand to mouth. The buildings, the residents, and the town itself had become very seedy by the fall of 1959. The lagoon and all but a few of the canals had been filled in, and most of what were left were full

197

of garbage. Even so, the place still managed to have charm, some-how.

I parked the Nash at the corner of Windward Street and Speedway, just before the New City Recreational Center in pink concrete that screws up the beach there. Next to it is this oil pump thing surrounded by pink concrete. When they drilled the well in the fifties, they had the derrick covered with insulation—sound insula-tion, I guess. It was pink too. The recreation center blight was what they bribed the city with to get the oil-derrick blight approved. Two blights make a right.

I turned off the Nash, taking a big chance since I wasn't on a hill, but it was hardly steaming at all.

Lounging up against a fancy Venetian-style pawn shop was a very hip-looking black man. He said to me, "Honey, are you interest-ed in selling that car?"

I got out and locked the door—a funny move, considering the missing trunk lid. "Sure."

"I'll bet!" He said, and laughed, maybe good-humoredly, but more likely just drunk or stoned. Generally, any young person you saw in Venice was either drunk or stoned. No black person with any self-respect would hang around Venice; mostly just alkys and, I guess, junkies.

This particular hip-looking, energetic little black guy said he knew where The Gas House was. It was there all right, though closed up tighter than a drum. Another one of those Venetian structures. My guide wanted to know if I knew anything about the place. He showed me a book. The title was *The Holy Barbarians,* by someone named Lawrence Lipton. The little black guy told me it was about the peo-ple in The Gas House.

He also volunteered the information that he was a burglar. He was very open about revealing this fact to me, having no fear what-soever of his crimes being exposed. He told me that the cops, when they caught him, just took the loot he had and let him go.

Then he went off down the street, talking to himself. I walked down to the ocean and stood next to a palm tree, breathing in the breeze off Hawaii.

I found an open coffee shop on Windward Street and had a

grilled cheese sandwich. There were three people at one table who looked like they might be part of what I was looking for, but I didn't talk to them. At another table were some very tough-looking guys with cut-off Levi jackets, earrings, and boots with chains on them. On the backs of their jackets were identical legends: Satan Slaves M.C. I didn't talk to them either.

With a relatively full stomach, I stepped outside. I gazed briefly at the full-dress Harleys parked in front. While I was standing there, two squad cars hurtled up. Four cops got out and went inside in a hurry. I prudently stepped across the street and watched the action from a darkened Venetian arch. After a bit the Satan's Slaves came out, escorted by Venice's finest, and rode off. The cops went back inside— I suppose for donuts and coffee. I made it back to the Nash and went to sleep. It would all come clear in the morning.

In the light of day, Venice was a happening place. Ocean Front Walk was loaded with people of all varieties. All colors. All ages. All persuasions. I looked into The Gas House. Inside was a huge room with a domed ceiling, desperately needing paint and spackle. There was a balcony running around the entire place. Artwork hung from the balcony and leaned against the walls, most of it pretty awful. In the center of the room was a bird cage on a pedestal. Hanging on it was a sign, reading "Donations." There was about 50 cents in the cage. At the back was a sort of salon area, with well-worn couches and easy chairs. Some of these were occupied by lounging beatnik types. I knew that in my Hollywood-hopeful guise, I didn't look as though I belonged there.

I pretended to be interested in a display consisting of parts of a child's doll and a broken mirror nestled in an old piece of yellow rayon. "That's not for sale," said a voice. I looked toward the voice and saw a short fellow with off-white, kinky hair, fair skin, and pale yellow eyes. "An albino Negro!" I thought. "Now that's unusual."

"Those are," he added, pointing at some small, totally undistinguished, though odious-looking artifacts made out of driftwood and leather.

"I'm not looking to buy anything," I said.

"That's okay," he replied. "You don't have to. This place is free, man."

"Are you the artist?" I asked, stretching the word.

"No way, man," he said; defensively, I thought. "I don't do graphics. I'm a poet, man."

He proceeded to recite in a loud, rather high voice a fervent piece entitled "There's a Shit Fight Going On in the John."

You might ask at this point, why anyone would want to hang around a scene like this; the answer is complex. It begins with hope, nearly unreasonable, that something new can happen. Then, a search. It stands to reason that the searching would be mostly all in the wrong places. After all, what did we know? What had any of us been taught to lead us correctly (if there is any such thing) down the path of peaceful social revolution?

Freedom has a lot to do with it. Breaking away from the idea of a predictable, regimented future. Lost and confused youths, hungry to find a self that is not like every other self, to find, in a thoroughly explored and mapped Universe, a frontier.

I'm sure not everyone had a broken home, alcoholic parents and stepparents, and an upright, acquisitive brother who had an obsession for neatness and order, but that has a lot to do with it too.

We were living in the aftermath of the Great Appliance Boom of 1955. Chrysler was just now phasing out "The Forward Look," with its shark fins on whale bodies.

You've got to understand that we had only, just then, stopped building atomic bomb shelters. In school they had told us, when it comes (not if, when), not to look at the light and to hide under the desk.

Just around the corner in time were the Corvair, the Folk music explosion, JFK, the Beatles, Timothy Leary, and all the rest of it.

Some of us saw it coming. We didn't know what it was, but we knew we wanted it, needed it, couldn't wait for it. Maybe we actually caused it. When I say "we," I'm talking not about the fifty of us in San Francisco or, now, Venice; I'm talking about a whole lot of people: everywhere.

You have to be lost to be found and, anyway, what the hell alternative was there? In our efforts to escape the enormous nothingness, dirt, poverty, indigence, and lawlessness became bearable, acceptable,

desirable, even honorable. We slept on the floor, ate scraps, and generally did not wear underpants.

The strange thing about it all was that this idea of questioning the values of our society, rejecting materialism, defying authority, breaking away, "flaunting it" in general: all this had been carefully drilled into us all by parents and teachers. Thomas Jefferson, Thoreau, Gandhi, Socrates, Christ all told us to set out on this search; and they were all held up to us as models.

This scruffy, lazy, ineffectual, and inept bunch of dropouts were actually engaged in a moral quest.

I asked about Eric Nord, not because I really wanted to see him especially, but because his name was the only calling card I had. Eric wasn't around. He'd already moved on, but I was referred to somebody else who was, apparently, sort of the boss.

Very soon, I found myself in a sort of study, upstairs in the back, talking to a hugely fat man with a beard. He was, it seemed, a legal assistant to a rich, famous, criminal attorney who was charitably financing this undertaking, which was intended as a back-door foundation. An artists' colony. This assistant had been given the job of overseeing its development. The name John Carradine Jr., was something of a convincer, as it had always been. He asked me if I wanted to be in on it. I said I guessed so.

The criminal attorney had bought this building originally to be a gambling casino and was fixing it up with beatnik labor, which is almost a contradiction in terms. The attorney wasn't putting any money into the support of the place, but they, the beatniks, were more or less managing.

They also owned, behind the place, across the parking lot, the Grand Hotel. This was an old four-story flophouse. The bottom floor was devoted to permanent residents: the hot-plate crowd, mostly, though there were a couple of real kitchens wherein I eventually had a couple of real home-cooked meals. The second and third floors were being renovated, by the beatniks, into sparkling-clean replicas of Beatnik Pads, with mattresses on the floor and artwork on the walls. These were to be rented out to tourist-types who wanted to experience a taste of The Scene. The top floor was reserved for the

colonists themselves, who lived there rent free, singly and in pairs and trios.

The paying customers on the bottom two floors were supposed to support the rest of the action. That remained to be seen. At the moment, the hotel was just about breaking even.

To be a part of the project you had to be some kind of artist; actually, you just had to say you were. I was the only actor. This was all supposed to develop into a center for all the arts, with art shows and theatrical presentations, poetry readings and musicales. I was expected to help out with the theatrical part. Actually, none of these grandiose plans were ever to be realized. The whole idea would crumble apart long before that, without getting much further than it had already; but none of us knew that, of course.

I had missed the early days there, when there was no Grand Hotel. People slept in The Gas House itself then, in the cellar. There was a huge basement downstairs, with many partitions and a lot of gas and water pipes everywhere. These pipes were what gave The Gas House its name. At night everybody went down there and partied.

On several occasions, I was told, the police had called to investigate the noise and couldn't find anyone; the place was all dark. A lookout would give the word when the cops showed up, and the noise would abate until they went away. Eventually, though, the cops sneaked around and found the sounds of laughter and bongo drums issuing out of the sewer grates. The city slapped The Gas House with some kind of code violation. Our attorney-benefactor dealt with that easily, but something had to be done; hence, the move to the Grand Hotel.

I was given temporary quarters in a room with a mattress and nothing else, on the unfinished second floor. It wasn't bad. I lay right down and went to sleep. It was awhile since I'd been in a bed.

I was awakened by a knock on the door. I said, "Come in." A man in a gray uniform appeared with a spraying apparatus and, without a word, started spraying the corners of the room.

"Who are you?" I said.

"Exterminator," he said. I considered, and thought that was probably a good idea.

I'd just gotten back to sleep when I heard a voice traversing the hall, loudly calling "Scarf Time!" I opened my door, thinking this might be a fire or some similar emergency. Several destitute-looking young people were milling in the hall and descending the stairs.

I asked what was going on, and someone repeated, "Scarf time."

"What's that?"

"Dinner, man," replied one of the beards.

There were two meals a day, prepared in The Gas House kitchen and served at a big table there. We all took turns at cooking and cleaning.

There was a dope rehabilitation center a couple of miles away in Santa Monica that charitably received day-old milk products from a local dairy, and they shoveled the three-day-old stuff that they couldn't use over to us, so that there was always plenty of sour butter and sour milk and sour cottage cheese. Buttermilk was a big item. The rest of our food came from the bird cage donations. Since these were meager, so was the food; usually potatoes, boiled with the skins on, with a lot of butter; sometimes a vegetable. There was a constant supply of oranges from somewhere. Almost a balanced diet.

Starting with the Albino Black Poet, I quickly found people to talk to. Everyone was very cordial, and very cool.

After dinner I found one of the platoon leaders of this corps— tall, skinny, very long, dirty (literally, I'm sure) blond hair, more or less red beard. Clothes that could be from any period in history. Sandals. He didn't look like Jesus so much, but he could easily have passed for one of the Apostles; his name was Peter. He asked me if I had any money. I said, "Yeah, a little. Why?"

He said, "We could walk down to the Venice West Cafe, and get some coffee."

I said, "Sure."

Ocean Front Walk at sunset. As wide as a two-lane blacktop, the street is restricted to foot traffic and bicycles, except for an occasional cop car. On the landward side, there are rows of little shops, restaurants and bars, some of them with apartments above them. On the west, palm trees, benches and grass, becoming sandy beach. Every couple of hundred yards or so, there is a lifeguard station out there.

Ocean Front Walk is a really diverse and interesting place; retired

Jews from, I don't know, the Midwest; retired gentiles, for sure from the Midwest; retired bohemians, soldiers, bikers, transvestites, lesbians.

Every special interest group has its own place. There's, for instance, the Carousel, a fag discotheque. There's the Westwind, a sad lesbian bar full of soft, boyish, short-haired lady-tigers. The first time I was in there, I thought I'd hit the jackpot. Took me a long time to figure it out. The girls all liked me. They never put out, though.

Then there was the Matchbox: strictly a dyke bar. Crewcuts, leather jackets. Girls weighing a hundred and eighty. Toughest bunch of truck drivers is what they're like. Stay away.

In between are the Hungarian restaurants and New York delicatessens.

If you're going west looking for the frontier, this is the end of the line; next port, Hawaii. People stop here and stay, at least for a while. The only alternatives are to start swimming or turn back. People start over here, or stay to die, or get lost or found.

We strolled down to Brooks Street, past the lovers, drunks, and old people.

The Venice West was a coffeehouse off the main drag and had a more genteel atmosphere to offer the discriminating thrill seeker. Kind of a tide pool for beatnik tadpoles, run by a sweet, strange guy: Pat, the Birdman. We called him that because he bought hundred-pound sacks of bird seed to feed the pigeons and seagulls, which he did every evening. He also let the homeless sleep on his floor once in a while. Refills of coffee were free.

There was usually an informal show where people got up on a table and danced or sang or insulted the audience, all for hope of a coin in the hat.

The walls of the place were covered with writing: not graffiti, exactly. Poems and statements long and short, mysterious, and completely crazy. When the walls got too full, Pat would go around with a big paint brush and a bucket of white paint and edit out his least favorite stuff, clearing the slate for new work. He'd read everything first and save the ones he liked, at least for the moment. For those who wrote on the Venice West wall, it was a great honor to survive one of Pat's purges. There was always room for new talent.

Pat was also a painter. He always had several big canvasses in

progress in his studio in the back. Once in a while, he'd hang one up. Pat didn't exactly clear a profit on the Venice West. He was sort of a remittance man. His family sent him money to keep him away. This was what he wanted to do with it.

A few of The Gas House gang were to be seen in the place when I walked in with Peter, plus a lot of other funky-looking people. We drank coffee and I sat there playing with the candle wax making artistic doodles on my napkin, but deep in conversation with this holy barbarian. A girl caught my eye. I'd seen her at the Grand, but not at dinner. Peter caught me looking. "Don't even think about her," he said.

"Why? Has she got a boyfriend?"

He shook his head. "Nothing like it. Every guy thinks everybody's getting her but him. Personally, I don't think she's putting out to anybody."

"What's her name?"

"Helena."

I forever amaze myself. Here I was suffering from a broken heart and the loss of my sweetheart, Kate, and through my tears, before the ashes were cold, I was getting excited over a strange piece.

Helena, it was eventually revealed, was the goddess in charge of the decorations in the Grand Beatnik Hotel (second floor). She was quite an artist herself and was considered the Queen of The Gas House.

When I came back to my room, there were two sheets folded up on the bed, a blanket, and a towel. Too beat to think about making the bed, I kicked the sheets and towel off onto the floor and curled up under the blanket.

As I drifted off, I heard a lot of passionate screaming down the hall somewhere. I learned later that this would be the other eligible, or at least actual, female on the scene. But she was just about to graduate to the big time. She and her bearded poet-lover had an act. She sang and played the guitar, and he read his original poetry. Right now, he was probably screwing her brains out. Right then, I didn't care if he was eviscerating her.

Helena and I became buddies. It wasn't exactly a sexual thing, though that certainly had something to do with it. We went every-

where together. Part of it had to do with the fact that while Helena was with me, none of the other guys hit on her and I wasn't considered much of a threat. All I talked about was my lost love. The thing I began to realize as I got to know Helena better was that Peter had been very perceptive. Regardless of what anyone thought about her, or what she acted like, Helena was actually a virgin. One of the last of the breed.

It was hard to figure out what Helena was doing there in Venice, or how she had got there. She came from a well-to-do Boston family. She had a very dark complexion that was at least partly earned on the beach. She characterized her ancestral background as Ptolemy. The Ptolemies were the pharaohs of Egypt and were theoretically Greek in origin. In Venice, in 1959, you could get away with stories like that.

Helena took to calling me "Junior," which fit me so well at that time that I really didn't mind, though as it spread around Venice I started, for the first time, to think about changing my name.

CHAPTER THIRTY-ONE

RUN LIKE A DEER

Probably the person who understood the scene on the beach at Venice the most was a huge black guy named Tamboo. No one knew him by any other name. "Tamboo" is Haitian or something for "Drum." Tamboo was six-foot-six and he carried a conga drum with him wherever he went.

I ran into him one day as I was shuffling down the beach. Tamboo was sitting on the back of one of the lifeguard stations playing his drum.

He yelled out, "Hey, my man." I looked up. "Come on over here." I went over to him with some trepidation. "What's happening, man? You look like you been sleeping under a car or something."

I looked down at myself. I definitely was ragged and dirty as hell. "Actually, I've been sleeping IN my car. No bathroom."

Tamboo gestured grandly at the Pacific Ocean. "Nice big bathtub right here. Showers over there by that concrete thing. You don't need to have your own facilities to make it around here, man. You got a cigarette?"

"No."

"You want one?"

"Sure."

"Follow me." Tamboo picked up his drum and started walking

toward Ocean Front Walk. I fell in with him. The first guy he came to, he stopped. "Say, man; have you got a Pall Mall on you?"

The man was nonplussed. Tamboo was VERY tall.

"No. I ah–don't. I have a Viceroy."

"Shit! It's supposed to be a Pall Mall. Well, okay. We'll take it."

The man obediently took out his pack. Tamboo took one. "Thanks, Mister. Mind if I take two? For my bro, here."

"Uh, no. Quite all right."

"Got a light? Thanks. See ya."

Me and Tamboo walked down the street puffing on our Viceroys. "No sweat," Tamboo said. "Life is sweet if you don't need much."

I became Tamboo's regular companion. Tamboo's drum, or Tamboo's "Tamboo," I guess, was a great tool. Attract the tourists; pass the hat.

When there was nothing else happening, Tamboo would go to any amount of trouble to get together the price of a gallon of wine. He'd badger, beg, threaten, and negotiate until it happened, gradually collecting potential drinking buddies during the process. Tamboo loved this cheap chablis. He'd take a gallon of it and add a little can of reconstituted lemon juice to it. It tasted awful to everybody but him. But Tamboo was the boss.

Then we would go out on the beach to one of the lifeguard stations and drink the wine and play the drums. The police would try to clear the beach at night, but in the fog, the officers tended not to wander too far from the pavement.

Tamboo had a small income from the Veteran's Administration. Got his leg shot up in Korea and lost a lot of muscle and tendon. He was listed as having an eighty percent disability, but he could run like a deer.

When he had gone down for his draft physical, they told him he was too tall, but he begged them to let him in and they wrote him down as six-four. He didn't regret it. He saw a lot of special stuff and Uncle Sam was taking care of him.

At night, Tamboo would go to parties. He always seemed to know where they were. His drum was his invitation. He'd play a little, and we'd fill up on canapés or whatever, and the wine.

The idea was, if you could figure out how to stay up all night, then, during the day, you could sleep on the beach in the warm sunlight. When everything else gave out or closed up, we'd hit the coffee shop on Windward if we had any money. Surprisingly, we usually did; or, actually, not so surprisingly. We were all thieves, and parties were easy pickings for small change, especially if there was a swimming pool. People take their clothes off at swimming pools, and unguarded pockets abound.

Tamboo and I got along really well, but I had no illusions. My company was valued largely because of my car. The Nash was in terrible shape mechanically, but it was good for a short haul. Gas was always a problem, but Tamboo was an excellent panhandler.

There were quite a few people in Venice who were there strictly for the tourism aspect. The silliest of these were probably the weekend beatniks. These wild things were businesspeople or attorneys in real life. They would let their beards grow for a few days, put on a turtleneck sweater and sunglasses, and come down to Venice to talk hip and take a chance or two. They had money in their pockets and manicured hands. They were welcome, for their money. In Venice, money meant, say, a dollar.

Eventually, I got around to reading *The Holy Barbarians*. It turned out to be entirely apocryphal. I met the author, Lawrence Lipton. He was a nice, older fellow who lived in a sweet little cottage half a block off the beach with his sweet little wife. He seemed to me to be completely irrelevant to the scene.

THE GREEN PHOENIX

A guy named Jim Murray came to town with a U-Haul truck full of books and a pocket full of cash he'd gotten from selling his identity to a man who was trying to escape from his wife; something to do with alimony. Part of the deal was that Murray would move out of San Francisco; so down the coast route he came to open a book store in Venice, where the final, feeble finger-snaps of the Beat Generation poets and bongo drummers still held sway before the sea.

He moved the books into an empty storefront on Ocean Front Walk and started fixing it up. The store never really opened to the public. Jim got interested in other things, but a sign hung there, made by Helena, which proclaimed "The Green Phoenix Bookshop" in Helena's own "beatnik lettering," for which she had become locally famous. The little goat-like transient that Jim hired to fix the place up lived on a couch in the back, and lots of happenings happened there, including assignations on that couch between the stacks of James Joyce and Henry Miller. If you had nowhere to go late at night, when everything else was closed, there was always The Green Phoenix, if you had a key or knew "The Goat."

The way I met Jim Murray was because he needed a ride to somewhere in Pacific Palisades. He asked me if I'd take him there in the Nash. I said, "Sure. If you'll buy the gas."

He said, "How much?"

I said, "Fifty cents."

We drove into a Chevron station and the attendant ran up. "Fifty cents' worth of regular," I said.

The kid looked at the two of us: me in a swimsuit, and Murray with a beard like Castro, with the army fatigues and the whole bit, looking like a fugitive hitchhiker from Hell. "Yessir!" he replied sarcastically. "Coming right up." He went to the back and performed this piddling task. Then he came back and said, in a radio announcer's voice, "That'll be fifty cents, SIR."

Murray reached across with a dollar bill and said, "Keep the change."

I liked him instantly. We drove off laughing, while the attendant removed his Chevron hat and scratched his scalp in perplexity.

Murray fit right into the Venice scene. When he showed up at The Venice West Coffee House, he quickly established himself as the king chess player, which, at a dollar a game, was a useful skill. Jim would usually spot anyone his queen and a bishop. Once they'd played him a couple of times, no one would risk a dollar any other way. We all knew his game.

The tourists were where he made his money. He could always get them to play, even the ladies. He would seem like such a blowhard, and if no one was hot, he'd play me and barely take me, just to get the interest going. He'd usually just barely beat anyone, but when he got bored he'd walk right through his opponent, then spot them the queen and the bishop and walk right through them again.

The little Satyr who lived in The Green Phoenix became part of the Tamboo crowd. He also tried to interest me in becoming a full-time burglar. I was still making daily calls to my agent in Hollywood, and was not tempted.

Right then, a remarkable thing happened. A truly beautiful little tiny blond creature, in a skin-tight sailor's suit (I think her name was Lisa), wandered into The Venice West. Jim played her a game of chess and took her home to The Green Phoenix. The Satyr and I prowled that night while Venice changed forever.

Down past the Venice West, about a mile, on the edge of Santa Monica, was Pacific Ocean Park. "P.O.P." was a dead amusement park.

All the rides were stilled, the roller coaster falling down, the huge plaster clowns, mermaids, and sea horses peeling and crumbling. The place was built on a huge, rickety pier. It was all locked up now. The only part of the whole complex that still worked was the "International Village" on the mainland in front of it, two blocks of restaurants and souvenir shops that attracted a low-profile kind of tourism. "Let's go to that kooky little restaurant, Honey." You could take the family for a romp on the beach and a quaint Swiss or Scandinavian dinner, and get out for twelve dollars.

It was possible to get onto the pier by going around the ocean side, climbing the pilings, and negotiating the fence. We wandered around in there a few times. Several movies had been made there since it had been closed down. The eeriness of the place lent itself well to horror movies and mysteries.

A little farther along was the Santa Monica Pier. A place that made you feel some old kinds of feelings that are pretty much going out. Just the words "Santa Monica Pier" do it to me. Sounds old. It is; was then. Never a crowd. Never any great-looking chicks on the Santa Monica Pier; old people, fishermen. Weird-looking guys. Some okay-looking ladies in swimsuits down on the beach, maybe. Or riding around on bicycles. All with guys, though. Just to look at.

First thing right off is the big old merry-go-round. Has a big old building built around it, with apartments up in the eaves. I actually used to know someone who lived up there, back when they had real calliope music or whatever it was.

Now the music is strictly in a can; canned calliope. In the sixties, they had tapes of Bob Dylan and Herb Alpert. This place is more or less eternal, like the Acropolis, or the skating rink in Central Park. I once heard of someone, some really famous writer like William Saroyan or William Burroughs, or I don't know, who lived there, way back before my time. (I think it was probably Burroughs.)

But where were all the midgets and fortune-tellers and you know, the action? Eternal, huh? Eternally seedy and eternally half empty. What with live war on television and nude disco dancers and all the rest, people kind of gave up on merry-go-rounds and throw-the-ball. In the meantime, freeways and condominiums grew all around it.

There was this one great beach club—which had probably catered to F. Scott Fitzgerald and Harold Lloyd, and maybe W. C. Fields and one or another of the Barrymores—which was now separated into two pieces. There was a footbridge to connect the club and the beach. Progress had slipped a highway in between.

'ROUND MIDNIGHT

Venice was where I first started to get into drugs. It started with Benzedrine. I got a notification from the draft board. "Greetings." I was supposed to show up for my physical. This required some thought. As an indigent bachelor, I was likely to be at the top of the list. I definitely did not want to go. I dropped 60 grains of Benzedrine, reasoning that I would show up the next day so jangled and out of it that they would turn me down.

In The Venice West that night I got up on the table and recited Shakespeare; some of my inhibitions had obviously disappeared as a result of the Bennies. I passed the hat and collected enough for a bunch of espressos; not really exactly what I needed. When I finally came down, I slept for about eighteen hours, right through the physical. No one could rouse me. When I finally woke up, I asked one of my friends from The Gas House how I'd done in my recital. He said I'd talked extremely fast, but with a great deal of feeling.

I came up with another plan. Peter took me down to the Los Angeles General Hospital and told them I was his roommate and had stopped talking about a week earlier. They put me in the psychiatric observation ward. I gave a perfect imitation of a manic-depressive paranoiac for three days. The idea was to get to a commitment hearing and, at the last minute, say I wanted to go. If you commit yourself, you can uncommit yourself. I'd spend a few weeks at Camarillo

with the dope addict musicians and pitiful wretches and then come out with a psychological history that would keep me out of the Army. Peter visited me once and brought me a carton of Camels. When I came in front of the doctors, I got cold feet and switched off the act. They, of course, sent me home. When I got back to Venice, the guys were pissed off at me for chickening out. Mainly because of having chipped in for the cigarettes that I turned out not to need.

Tamboo had a reputation as a great roller of joints. One day a lady who lived in an apartment overlooking Ocean Front Walk had scored some pot. She had never gotten high before and didn't know how to roll, so she called in Tamboo to do the job in return for getting stoned with her. He took the quartet with him. She didn't object. I think she was relieved not to be spending an afternoon of Reefer Madness all alone with a six-foot-six black man.

This was a little scary to me as I had never smoked it before, but I decided I was determined to try the stuff. We all sat on the floor in the lady's beautiful apartment, while Tamboo cleaned and rolled. He rolled up the whole stash. The lady remarked that she thought there would be more of it. Tamboo explained it was mostly stems and seeds. She was also disappointed in the crudeness of the joints. She said she thought Tamboo's abilities were overrated. Tamboo just shrugged. What she didn't know was that Tamboo was more or less rolling one with each hand and passing half of the joints back to me. I put them into my pocket for later.

She put on a stack of records and we lit up. Everything got very mellow. The album was 'Round Midnight, with Miles Davis and John Coltrane. That music went right into my soul. I could taste it, see it. I lolled in the window and watched the sun set on the Pacific, the music mixing in with the surf and the seagulls. We smoked another joint and giggled a lot. Nina Simone sang "I Love You, Porgy." I decided this stuff was definitely okay.

After this introduction, I smoked pot whenever I could. You could buy a joint on the street for a buck. Benzedrine was 10 cents a grain. There was a little funny guy with a ragged beard who periodically went down into Mexico and brought back hundreds of Bennies. He'd walk back and forth across the border a dozen times a day, until they got tired of searching him; then come across with a plastic bag

full of them in his underpants. The guy looked so greasy, they probably didn't really want to search his undies anyway.

There was this other guy who used to come around every week or so, who would buy souls. I know that sounds weird, but he had a little receipt book and he would give you two dollars cash, which was a significant amount of money in Venice at that time. He would write out your name and annotate "For this sum, I hereby sell my soul." A lot of the people on the scene went for it. I didn't.

Stan Unger said to me, "How can you call yourself an atheist, and turn down that deal when you're dead broke?"

I said, "I'm not an atheist, I'm an agnostic."

He said, "Even so."

I said, "Well, you never know."

There was this one guy, a great painter, who went for it. He was trying to get up enough bread to buy a conga drum. Later, he had second thoughts. He tried to buy back his soul. He offered the devil ten bucks for it, but the devil just laughed.

Jim Murray was another guy who sold his soul off. I met him again a few years later and had a feeling he had definitely lost his soul.

CHAPTER THIRTY-FOUR

MR. AND MRS. MICHELANGELO

Every once in a while, we found ways to make a little money. Someone would come into The Gas House and say he had a truck to unload or something, and he needed so many guys for two dollars an hour. I'd always take it.

One day I showed up in the big room and somebody told me that a couple of people had come in looking for volunteers to take an experimental drug. Same pay: two dollars an hour. It was said that if you were schizophrenic, it would make you straight, and if you were straight, it would make you schizoid. I passed on that one, probably because I wasn't exactly sure which way it would go with me. The experimental drug was called lysergic acid. A couple of the other guys went for it. I never did actually find out what it did to them.

Then a really good one came along. Someone wanted a mural painted in a hotel lobby for a whopping forty dollars. Helena and I took the job.

As we came to the end of the mural, some guy who looked like a cop came up to us and asked if we would be willing to muralize his private club in Malibu Canyon. It turned out he WAS a cop; a retired one. He owned The Carousel and The West Wind, the gay and lesbian bars on Ocean Front Walk. Eventually he told us the story: there had been a fight in one of his bars which had ended with someone's being

217

knifed to death. He closed the places and opened them four days later as gay bars. He never had another knifing. Today I don't think that would be the case, but back then in the Middle Ages, gays were easy to get along with.

We took the mural job and spent about a month living in the club in Malibu Canyon. All day long we worked on the murals, and in the evenings we ate steaks and partied with the deviants.

There were three areas we were muralizing. One was the main room, where the steaks were served and the dancing was done. Then there was a lesbian bar and a homo bar. Helena and I did the main room together, and I did the lesbian bar while she did the homo bar.

Every once in a while, the cops would show up to check out the place. When that happened someone at the front desk would push a button, which would activate a special lighting system. As soon as the lights came on, the boys who were dancing with boys would switch with the girls who were dancing with girls. The place didn't have a liquor license, so the drinks would go under the tables. The cops would come in and look around, sometimes have a steak. When they left, the lights would go back to normal, signifying the all-clear; the drinks would go back on the tables and the deviant festivities would resume.

One day, we saw a bear. Someone was looking across the canyon and saw what looked like a man in a full-length overcoat walking along the mountainside. We found some binoculars and checked it out. It was definitely a large brown bear. I don't think it was a grizzly. That's probably the last time anybody ever saw a bear in the mountains of Los Angeles.

While we were living up there, Helena and I almost made love. Everybody else just assumed that's what we were doing, so, of course, they put us in the same bed. It almost happened. We certainly went all round the perimeter of the thing.

The two hundred dollars we got from the mural was a bonanza for Helena and me. We decided to go up to San Francisco to spend it. We drove the Nash to the Hollywood Greyhound Bus Station (it would never make it to San Francisco). We bought a ticket and got on the bus. That was the last time I ever saw the Nash.

In San Francisco we got in touch with Stan, and he found us a

bedroom in somebody's apartment in the Portrero District, which, you will remember, was where all the beatniks went. By and large, we hung around the house and somehow spent our money without seeing much of the city. We watched a couple of relationships get born and a couple of them break up. I did, however, show Helena as much of the town as I could. I took her up to Coit Tower and walked her down the great aerial stairway. We prowled through Fisherman's Wharf and checked out Chinatown and North Beach. We even got in to Finochio's, the transvestite show, for nothing. Half the guys wanted me and half of them wanted her.

Stan always had his own transportation. He drove us back to Venice; mostly as a way to get rid of us, I think. We arrived back in Venice exactly like we left. The only thing missing was the Nash, but to make up for that, we had Stan.

Helena and I were local celebrities now. We had the pick of the empty walls in town.

Jim had a plan, of course. We could all move into a big house. ("All" meaning Jim, Lisa, me, Helena, and The Goat.) We would give up The Green Phoenix, sell the books, and all do something wonderful in our house. Jim would write, Helena would paint; The Goat would try everything and I would have arguments with Helena. We found a fine old house on Sunset Place, two stories, a big yard, and even bats in the belfry. We made the first and last payments, and lived in it rent free, more or less, until we all left town.

The way that happened was very dramatic.

CHAPTER THIRTY-FIVE

THE ABDUCTION

O ne day we were lounging about in The Venice West, when a sedan stopped in front of the place. Someone in a suit stepped out and got into a confrontation with Lisa. She walked outside with him and then, suddenly, she was grabbed from all sides and thrown into the backseat of the car. I, and another beatnik, tried to intervene heroically to no avail whatsoever. A moment later, in a cloud of dust, they were gone. The whole place was thrown into chaos. We had actually witnessed one of our own taken, against her will, into some kind of shanghai situation. For the very first time, for most of us, we were on the right side of the law. We called the cops. After an interminable amount of time, they arrived and harassed *us*. Was she of age? Etc.

It turned out that the abductor was her husband who was a dentist in New York City. The other guy was a psychiatrist who injected her in the car, and the two took her back to NYC in a state of sedation. The way we found out about all this was she called us from New York. She said, "Help! Come save me!" We rallied. Well, what the hell! It was the most interesting thing that had happened to any of us since we came to Venice.

By the time we got our fuzzy beatnik selves together to make a move, she showed up, having escaped from the ogre and hopped a plane. She was seething mad, but none the worse for wear. We celebrated her return with great joy, and then she hatched this plan to go back to NYC and nail the son of a bitch (the husband) for kidnapping.

This seemed an impossible task for a bunch of penniless beat-niks, but Stan had a solution for us all. He was about to travel across the country by way of a program whereby you would drive some-body else's car. You paid a $100 deposit which was returned at the other end. The car came to you with a full tank of gas. The rest of the gas you provided yourself. The car owner paid a fee to the agency for this doubtful service. Stan offered to take Jim with him, if he would share the gas. He also invited me to come along. I told him I didn't have any money. He said that was all right; he owed me twenty bucks anyway. I suggested that I'd like to take Helena. Stan said No way! We'd just fight and she'd cry all the time. I convinced him we would-n't, and it was agreed I'd make up the difference by shoplifting our food along the way.

Helena cried all the time. Well, I lied.

The car was a 1957 Chevrolet Bel-Air. It had diplomatic plates. It seems it was owned by the Venezuelan consulate.

This fact opened up enormous possibilities for the bunch of con artists that we were.

We decided among us that the preferred route to New York was Route 66, the fact that the road ended in Chicago not withstanding. It was the SONG that convinced us: "Route 66." Get your kicks.

When we started out, Stan made it clear that since he was responsible for the car, no one could drive it but him. Since we were on a mission from God, we had all agreed we should drive straight through, only stopping for gas and to steal food, so this was relatively unrealistic of Stan. But it was his ride.

He dropped some Benzedrine to keep him going. By the time we were halfway across the Mojave Desert, he was completely out of his mind. We took him out of the driver's seat and Jim took over. Stan collapsed into a doped-up, fitful sleep. For a few hours, every time Jim put on the brakes or took a tight turn, Stan would sit up in the back-seat with his eyes as wide as Pinocchio's and say, "What! What's hap-pening?"

By the time we got to the Arizona border, he was more or less back together and more realistic about our immediate futures. It was decided we men would share the driving. Women's Lib wasn't really with us yet then.

At the border was a sort of customs station. California had a thing about checking cars for produce (can't afford to contaminate the garden state with the fruits of lesser places). This began in the thirties, when thousands of immigrants were coming into sunny Cal to escape the dust bowl. Arizona, in retaliation, had set up its own action.

Stan prudently returned to the driver's seat before we got there, he having the papers and all. He kind of surprised us all by going into a perfect Ricardo Montalban accent. The bored official looked into the car cursorily, and then went around the back to open the trunk. In the middle of this task he saw the license plate, which read "CONS CORP," and suddenly slammed the trunk shut. "You don't have to let us inspect you, you know," he said nervously.

"Oh, zat ez all right!" Stan said. "We have nozing to hide" (apparently forgetting the large quantity of speed stashed on him).

Stan explained that he was zee chauffeur, not zee owner. Zee car, he said, was owned by zee Venethuelan consul, and had been entrusted in his care. Zeze other people (weirdos) were guests of zee consulate.

"Zere ees one sing, however. I am not important; I am only zee chauffeur, but zee car must go through. I understand eet ees possible that sometimes a car may be stopped for an infraction of your local traffic laws, and possibly held, so to speak, for ransom. Zees cannot happen."

The Arizona cop scratched his head. "What's he talking about?" his superior asked.

The cop replied, "They want ta know if they can drive acrost the state and break any damn speed laws they wanna."

Stan said, "Zat ees a bad way of pooting eet."

We traveled across Arizona, checking out the Painted Desert and the big meteor crater.

At the crater, we had a little trouble with a sheriff, but nothing serious, incidentally shoplifting our lunch from the adjacent convenience store.

There was a discussion between The Goat and me about who was the best shoplifter. He got twice as much stuff as I did. I pulled out a jar of caviar. My approach was quality. His was quantity. The

issue seemed irreconcilable. Jim added up the prices, and I was the winner, hands down.

On we went, without much incident, until the snowstorm just short of St. Louis. I was driving, and a big truck tried to pass us on a blind turn. In a panic, I drove on to the shoulder, which turned out to be three feet of snow. We found ourselves hopelessly mired in a snowbank about thirty feet off the road. We sat there in the Chevy, gradually freezing to death. We had no idea what to do, but we certainly were not going to leave the car and try to walk across the tundra to nowhere.

After a while, just as our fingers were beginning to get numb, we all cheered when we saw approaching headlights—it was the state police. We still cheered. Stan said, "Okay. Let me do the talking. None of you speak English, got it?

Our elation was short-lived. This big Missourian in a uniform shined his flashlight into the car and said gruffly, "See you got a lot a women in here." Seems "two" is a lot. Jim piped up and blew our ethnic cover before we even had a chance to try it out. Something like, "See here, Officer—"

It worked out okay. They got us towed out and at the police station they all wished us well. Only thing was we owed the tow truck thirty bucks, which we didn't have. Jim offered his tape recorder as security and said we'd be back. The problem now was, we didn't have any gas. We all agreed to give blood to buy gas, but every one of us chickened out. We stopped at a hock shop in St. Louis and Jim pawned his typewriter; a courageous thing for a writer to do, sort of like a musician hocking his trumpet. The Goat offered his "one-hundred-dollar" mandolin. It went for ten bucks.

Anyway, we finally made it to the Big Apple.

Since we had gotten there faster than anyone expected, we decided to keep the Chevy for a few days. It was very luxurious to have our own car in New York City.

Lisa let herself into her dentist husband's apartment. It was like heaven to us beatniks.

It turned out the dentist had checked himself into the psych ward at Gracie Square Hospital to escape prosecution for kidnapping. They examined him and decided he really was crazy, so they would

not let him out. We had the run of the apartment. Only problem was we were broke.

This turned out not to be as big a problem as we thought. The dentist's closets and drawers were full of valuable items: cameras, jewelry, stuff like that. We hocked them and lived off the fat of the land.

After a few days, the hospital released the dentist for a weekend pass. He showed up, of course. We wouldn't let him in, so he climbed up on the roof and tried to come in through the skylight. He probably would have fallen to his death. We called the hospital and had him taken away. They locked him up again.

The dentist had an extensive wardrobe. I dressed myself in a three-piece suit and a herringbone tweed overcoat with raglan sleeves and, armed with my resumé, went out to audition for the Connecticut Shakespeare festival. The clothes were all a little small, but the overcoat made it look okay. I did the audition without taking it off.

They were sort of impressed. They gave me the job of "Advanced Apprentice," which would consist of painting sets, taking classes, and carrying an occasional spear. Pay: forty dollars a week plus room and board. It was a start. I jumped at it.

We all decided to go back home. I had to get together my stuff and move it all to New York. I was hooked. Stan left the gang and went to Florida. We hocked the rest of the dentist's valuables and came up with enough bread to repeat Stan's travel car trick.

I, believe it or not, was the only person with a valid driver's license, so I became the front man for the agency. I found a delivery to Berkeley, which was perfect. I hadn't been home in a long time. The car was a Citroen DS 21; an esoteric and somewhat hilarious vehicle.

We went through the Lincoln Tunnel to New Jersey, me at the wheel, and promptly got lost. We found ourselves driving down a back road through the snow, and came to some kind of loading dock with a lot of truck drivers lounging around in the cold. I rolled down the window and said, "Where's the highway?"

They looked at our funny foreign car and laughed. One of them pointed and said, "There."

I looked and there it was; however, at the top of a steep embankment. The Citroen had a special ability: the suspension was adjustable for height. I raised it up all the way and drove right up over the embankment onto the highway. The truck drivers stared open-mouthed. Even their Mack trucks couldn't do that.

On the Pennsylvania Turnpike, with ice on the road, I slid into a semi that was hogging the road in front of me. The semi had enough clearance so that we slid right under it. If we'd slid farther, it would have been a multiple decapitation; as it was, we just crushed the hood. The car still ran perfectly.

When we got back to Venice, things were about the same; however, it wasn't going to last long. I drove the Citroen up to Berkeley alone. I repeated the routine of keeping it for a few days.

During that period, I had a drag race with a Pontiac and side-swiped a parked Packard Clipper. I just kept going. I lost the drag race.

⇒ ⇐

MY MISSION WAS TO gather together my stuff from Mother; and I thought I'd look up Donna. Maybe the Packard was a sign, but I would have done it anyway.

She came to me in my cheap hotel in San Francisco and balled me. It had been a long time. It was wonderful. We spent the night together.

I took the car to the owner and told him about the accident. He must have been with the CIA. He knew there had been two accidents, and he knew I'd hung on to the car for a few extra days. There was an APB out on me. He had checked out the transfer company and discovered there was no insurance or anything. His own insurance would cover everything. There was a hundred-dollar deductible. He just asked that I pay that. I agreed. Of course, I never did. That still bothers me today, but not much. How would I find him, anyway?

Somehow I made it back to Donna. I was developing a raging toothache. I had a bottle of Courvoisier. I would take a mouthful of it and hold it against the tooth. That would stop it for a while.

Donna and I spent the weekend together, and then she took me

to her dentist. He doused the tooth with oil of cloves—immediate, blessed relief—and then he shot me up with Novocaine and pulled it out. Oh, well. It wasn't the first time.

I more or less proposed to Donna. She said, "Absolutely no!" She wanted a career, and she also said that living with me was like living with an alligator with a toothache. We took our leaves of each other, still in love.

THE BIG APPLE

I took all my stuff, maybe three suitcases, to Railway Express and sent them to the depot in New York. Then, armed with what we used to call an AWOL bag in which I stuffed the dentist's tweed overcoat, a toothbrush, and a razor, I set off hitchhiking to the Big Apple. On the side of the bag, with adhesive tape, I printed NYC. The trick was to put the bag down and stick the thumb out, looking as cold as possible. There was always the tweed as a backup. And I needed to look relatively well dressed. I did the best I could.

I decided to take the northern route, remembering my dad's experience in the South. It was a cold way to go, but a lot better than a chain gang.

I made it into the Rockies and to the outskirts of Denver, with a lot of walking. There's not a lot of traffic on Route 40 in the dead of winter. Outside of Salt Lake City I walked backward for a whole day with my thumb out. Finally, a truck picked me up. He got sleepy and asked me to drive. I almost wrecked his truck. He never knew about it. I woke him up at the fork in the road and went my way.

I went into a truck stop and sat at the counter. Being the con man I was, I made friends with the waitress and told her of my plight. She convinced a truck driver to take me on. The truck, a big automobile semi deadheading its way back to Detroit, had another auto semi

riding piggyback. Hence, two truck drivers. They took me to North Platte, Nebraska. There they shacked up in a cabin for the night with a couple of girls. The cabin, the girls, and a bottle of Jack Daniel's were provided by the truck stop. They were doing a thriving business. I got back on the road. One thing that was really handy: these guys would feed me. I had money in my pocket, but I never let on.

I had made it to some Godforsaken spot when my next ride turned south. He left me standing in the middle of nowhere. I stood there for a long time. Nobody would pick me up. After a few hours, I noticed the same cars and trucks coming back the other way. I trudged over to a truck stop and found there was a bridge out because of a flood. Spring was coming.

I took out a few of my dollars and rented a cabin for the night. No girls, though. In the morning I took a bus south to Des Moines, where there was a working bridge. I learned the trick of hitchhiking with money in your pocket from reading Jack Kerouac's *On the Road*.

In Des Moines, I crossed the bridge and caught a ride in a big Buick that took me all the way to the George Washington Bridge.

➤ ⬅

I HAD A PHONE number for Margarita, the fourteen-year-old who kept notes for us during *Othello*—remember her? She was almost seventeen now, and a highly paid fashion model. I called her up from a phone booth in Harlem and sweet-talked her; she said for me to come on over. I took the subway downtown, and she welcomed me with open arms. She had a little studio apartment; just a bed and some drawers and a kitchen. Bathroom, of course. We sat and talked about old and new times, and then we went to bed.

Next morning, I tried to raid the kitchen. There was nothing in it, except maybe a few slices of bread. Models are always dieting. Margarita was still asleep, so I went down to the corner market to shoplift breakfast. I pocketed a can of frozen orange juice, a jar of instant coffee, and then went to pick up a quart of milk, my usual cover; I would pay for the milk. They were out of milk and cream.

I didn't quite know what to do, so I walked out, saying at the checkout stand, "You don't have any milk?"

The guy said, "Delivery dint come in."

I thought that would cover me, but it probably just called attention to me. Well, in a big old overcoat (remember it had just walked across the continent) no shave, hair standing up like Stan Laurel scared, I must have looked a little suspicious.

Before I could get to the corner, the store owner walked up behind me and reached into my coat pocket and pulled out the orange juice. Just as I was going to start talking fast, as he was pulling out the coffee and the butter, a cop showed up. The owner said, "Now look what you made me do!"

The cop took over. He looked me up and down. "You living around here?"

"Uh, yeah, I'm staying with my sister."

"Where?"

"On—ah—Eleventh street."

"Why'd you steal this stuff?"

"Well, I'm hungry."

"Doesn't your sister feed you?"

"I don't like to ask her for things" (shuffling my feet and looking down).

The cop looked at me thoughtfully. "How old are you?" he said, almost kindly.

I said "Seventeen."

He said, "Go home, and don' let me see you again."

"Yes, sir." I split. So I was without breakfast, but at least I wasn't in jail. I walked up to Eleventh Street and circled around. Margarita was still asleep. I ate a piece of dry bread, and went back to bed. I never told her about the roust.

The next day I picked up my suitcases at Railway Express and took them to Bob Ross's place. I had to drag two of them half a block at a time and then go back for the third one and so on, all the way to the subway. I let myself into Bob's place (I was good at that). There was no one home. I stashed the suitcases behind the couch and slept on the floor. He came home with his wife and kid. The apartment was really small, but it had a bedroom. Bob wasn't too happy about me moving in, but what could he say after having moved in on me in Berkeley? After a bit, it was just like old times.

He told me he was going upstate to do some play or another.

He wanted me to go with him. No pay. I told him I wasn't working for nothing anymore. I was in the Union.

He said to me, "Are you telling me you're only in it for the money?"

I said, "No, Bob, but if I act for nothing, I have to do something else for a living; and I just want to act and nothing else." With relations strained, help arrived in the nick of time. Margarita asked me to move in with her.

I dragged my suitcases down to her place. We ignited each other into a flaming love affair.

While I was staying with Margarita, I looked up a friend, an actor from the San Francisco Repertory, and he took me to see his agent. I told the agent about the job and he said, "Forget it. I'll get you something better." What he came up with was an audition for another Shakespearean repertory, the Great Lakes Festival in Akron, Ohio.

I went down to this little basement apartment in the Village to meet with Edward Payson Call, the director. I asked to go to the john. The bathroom was under siege by a plague of flying waterbugs. Undaunted, I recited the big great speech from *Richard II*, and they cast me as Hotspur, in *Henry IV, Part I* (a really great part) at $150 a week, plus room. No board, but that was okay. I could certainly eat on $150 a week.

My jubilation was supreme.

It was a month or so before the show started. I stayed with Margarita in New York, and we visited with her father a lot. He had a lot of friends, painters, opera singers; and a new wife, who hated them all, probably including Maggie and me. We used to sail down the West Side Highway in his open car (a Singer) singing opera. These people were nothing but fun. However, Maggie and I soon started to fall out.

Maggie's father arranged for an artist friend of his to take me in; he lived in a loft on West 22nd Street.

This guy was incredible; a very large black man, he had a one-man show coming up and turned out an average of two large canvasses a day; all of them really good. I'd never seen anything like it.

One night I came home to the loft and my big black painter was

sitting on a big wooden packing case, which was my bed, with a .22 rifle. He'd been robbed. Lots of his good stuff was missing; so was everything I owned. We were both really pissed off for a while; and then he lifted up the box (must have weighed 200 pounds) and there under it was all my stuff. He had thought maybe I was the thief (a reasonable idea, actually) mainly because they didn't take anything of mine. Well, my stuff wasn't worth anything. We took turns every night for a while with the .22, in case they came back. They never did.

The Ohio Repertory Company came up with an advance. I bought some clothes, a portable phonograph, and a half dozen LPs, mostly classical. Necessities.

CHAPTER THIRTY-SEVEN

A BRIEF GLIMPSE OF
THE GARDEN OF EDEN

Akron, Ohio, was a small town, supported entirely by the Goodrich tire people. There was even a quarter-mile stretch of experimental rubber street, running right through the center of town.

The theatre was a dream. Outdoors, in a huge field, a platform with several risers, light towers, and, behind it all as a backdrop, an honest-to-God medieval castle. We would make entrances through the great arches and huge oak doors.

They put me up in some sponsor's spare bedroom. Sometimes they fed me breakfast. I was a good, neat boarder, though I did steal a pair of cuff links.

The artistic director was one Arthur Lithgow, famous for this kind of venture. He directed one play and Ed Call did all the rest. Ed kept saying that he didn't know anything about directing. He thought he'd just fallen into the job by accident. He was so wrong. Some of the stuff he gave me is still with me. His work was superb.

So was his wife, Rita. Actually, she was spectacular. I fell in love with her from a safe distance and created several large, very evocative pastels of her.

Arthur Lithgow had a ten-year-old boy tagging along with him. His name was John; the eventually-to-be, Academy award–winning John Lithgow. There was a lot of other meat in the company: Larry

Luckinbill, Donald Moffat, more good ones than I can remember. Ed Call went on to head up the Tyrone Guthrie Theatre in Minneapolis and then on to the Globe Theatre in San Diego.

We started out with *Richard II*, in which I had a bit part. Then we got around to *Henry IV, Part I*: Hotspur! In the first reading, I blew everyone away by throwing the script down and striding around the room. You're supposed to just sit at the table. My old director star from San Francisco, Lee Henry, was playing Henry IV. He took up the challenge, striding around, looking at the script when he had to. Everybody else got into it. We were hot. That fire kept on burning right to the end of the run, and then we all took our piece of it away with us.

One sad moment I remember was the time I chickened out. One of my fellow actors and I were downtown getting some ice cream, and outside the store we were confronted by two tough-looking townies. They went after my buddy, a sweet little guy and a great comic. I think it was because he was Jewish. While they were beating him up, they kept their eyes on me. I knew I was supposed to jump in and help my buddy out, but I just couldn't move.

The little guy looked at me with pleading eyes. I put down my milk carton on the hood of the car next to me and almost took a step. One of the guys stopped punching my friend long enough to glare at me. I just couldn't move. The townies went away, and I helped the kid into the car. There was talk in the company of us all going down and taking them apart.

I could see the headlines:

SON OF FAMOUS ACTOR ARRESTED WITH
COMPANY OF VICIOUS
SHAKESPEAREAN ACTORS
AFTER THEY TOOK OVER AKRON BY FORCE.
THE NATIONAL GUARD
FINALLY SUBDUED THE BARBARIANS.

Anyway, nothing came of it, but the memory of that moment of cowardice changed my opinion of myself forever.

We rehearsed on the stage in the blazing sun. We did our matinees that way too. One day I developed a terrible rash. It kept getting

worse. They took me to a doctor and he told me I had poison sumac. He gave me a cortisone salve. I smeared it on and went back to rehearsal. The sun slammed that cortisone right up my pores and burned the sumac right off. I've been immune to sumac, poison oak and ivy ever since.

I was playing several characters in all the plays (except for Hotspur), so I used my dad's makeup lore to give it some variety. In the makeup-wardrobe parade, just before the dress rehearsal, I stepped out with a false nose and my hair colored red. I was supposed to be Welsh. The director looked at me and just stared.

I said, "Is it all right?"

He said, "Who is it?"

⇒ ⇐

WHILE I WAS IN Akron, I called Donna. The moment we spoke, it was as though we touched. A couple more calls, and we were planning to meet in New York. It had to be a secret. She was still living with her parents.

As soon as I got back to the city, flushed with success, I started looking for a place. I found one on West 83rd Street. An old brownstone house converted into furnished rooms. The dining room was available. It had double sliding stained glass doors, its own bathroom, and a sort of a kitchen. It was the most expensive room in the house, but it was pure romance; and, what the hell, I had almost a thousand dollars in my pocket.

Donna arranged to "go on a trip" with a girlfriend. I picked her up at the airport and took her home in a cab. We spent two weeks in an absolute idyll. We made love to Haydn and Frank Sinatra, wandered about the city, and talked and talked. Donna was going for her second acting master's degree. I was going to stick it out in New York—a frightening thought with my money running out and winter coming in.

The idyll ended. Donna went home. The landlord suggested I move to a cheaper room. This sounds kindly, and probably was, but, more important, he didn't want a deadbeat in his best room. I moved. A room, six-by-six feet, by fourteen feet high; an upright coffin. A

cot. A window facing a light well, bathroom next door, $28 a month. I could handle that.

I got back on unemployment and started looking for work. Nothing much happened. There apparently was not a big demand for Shakespearean actors with almost no experience. I remember one director asked me who I had studied with. I said, "Well, nobody, really. I just worked." He looked at me like I was some kind of fish.

My dad told me that acting was something about which there was much to be learned, and absolutely nothing to be taught. New York didn't see it that way. You're supposed to sit at the feet of the famous coaches. The Method was very big.

I painted a really truly fine painting of Donna, standing naked in front of a mirror, in profile, with a towel covering up none of the important parts. To get a long look at it, I had to look in the mirror, hence the one in the painting. It came out sort of backwards but beautiful.

On a lark, I looked up Hyla and Ellen, remember? My father's best friend's wife whose daughter I had promised to marry when she grew up. Paul had died, but I got their number in Chappequa from Equity. I called up and Ellen answered. I told her it was Jack and she almost fainted. So did I. I made a date with Hyla to come up on the train for lunch in a few days.

The next day, I went to Actors' Equity to pick up my mail. The girl said she had a note for me. I was to report to a certain address and speak to a certain FBI agent. The girl told me the agent had said, "It would behoove him to respond." I went. In a city-block-sized room, with a thousand desks, I was told simply that I was about to be prosecuted for draft-dodging. The only way to avoid that was to report for immediate induction.

I said, "What's that?"

Pre-induction physical and, assuming I was fit, induction in about five days. I figured I had enough time to think of something.

I went to the physical bright and early in a three-piece suit. (I had a dinner date with my father and my agent later.) I stepped through the door.

A desk sergeant said, "Name."

"John Arthur Carradine."

He put my file on the desk, looked at it for only a second, and rubber-stamped on each page in letters three-quarters of an inch high:

IMMEDIATE INDUCTION

I said, "What's that mean?"

"Means you're in the Army, Son."

I never heard from Ellen or Hyla again.

Part Three

CHILDHOOD'S END

1961-1981

CHAPTER THIRTY-EIGHT

AT WAR WITH
THE ARMY

I had no desire to be a soldier. I've always liked war stories but, thank you, perhaps not in the first person singular. With my record, I can hardly be characterized as a pacifist. My real objection is not to combat, but to enforced discipline. I don't see how a government has the right to compel its citizens to abandon their lives to take up arms. Wars should be fought by those who want to fight them, who decide for themselves that they want to be controlled and directed by superiors, for booty, or glory, and three squares a day. In 1960, that was not me.

We weren't busy keeping the world safe for democracy at that moment. The Korean conflict was over. Vietnam was a small, distant brushfire. JFK had not yet proclaimed, "Let them wear the green beret. . . ."

And there was my date with Ellen and Hyla, and the lunch with Dad, and I hadn't closed up my furnished room. . . .

I got to a phone and called a lawyer. Then I called the Attorney General of California. No dice. This was one I wasn't going to get out of. Guards stood around with M-1s. I took the oath. The guards marched us to a bus. We burrowed under the Hudson through the Lincoln Tunnel and arose in New Jersey. I watched the towers of Manhattan dwindle in the distance.

We arrived at Fort Dix in various states of individual rebellion and terror. All 200 of us were draft dodgers from all over the Eastern Seaboard, mainly from New York, others from Chicago, a few from the South. We were expected to be hard cases. I went to my bunk with my bedclothes. I looked around and realized this was nothing but a boarding school, a reform school; a piece of cake for me. Nevertheless, I was lonely and scared.

None of us were allowed to make a phone call. Ostensibly the reason was that several hundred soldiers had just returned from Korea and they had priority, but we were not even permitted to stand in line and take our chances. The idea was to keep us incommunicado while we acclimated.

We were given no duties. We spent our time hanging around the compound and getting to know each other. One recruit was a really loud con man. At one point, a black guy worked a scam on him. He bet him that the guy would move before he walked around him three times. He went around the con man twice and then walked away. The con man was stumped. Then he made the same bet with a newcomer, doubling the money. The newcomer fell for it, and our con man walked around him, losing the bet to the black man but turning a profit with the newcomer. This guy was bulletproof. After three days, a bunch of us were shipped down to Fort Benning, Georgia, with what they called a "flying ten": $10 for toothbrushes, razors, cigarettes, etc. We were to do our basic training at Kelly Hill, where they gave advanced training to the 101st Airborne—the idea being that they would whip us into shape.

As we were herded into the barracks, the previous bunch of victims was being herded out. One of them had a cheap, little plastic radio. One of our guys gave him his flying ten for the radio. He plugged it in, and out came Ray Charles singing "Georgia on My Mind." The combination of the song and how lonely we were in Georgia went straight to our hearts. That record changed my life forever.

I wrote Donna, telling her to listen to this wonderful recording. She wrote back asking me if this was some kind of joke. I should have known right then that we were doomed to part someday. But love is a blind man who sees when he dies.

My plan was to do everything wrong, apparently accidentally, and end up being cashiered out of the service. One day they lined us up according to height. One guy had a college degree, so he was made the platoon leader. I was the tallest kid in my squad, so I was the squad leader. Several of my men were totally unfit for military service; they would get into nothing but trouble. The half-breed Cherokee, for instance; or the kid from Arkansas who thought he was supposed to fight anyone who insulted him—which the cadre would do all the time, just on general principles. I had to take care of them. So much for my plan.

I was actually looking forward to basic training; I figured it would toughen me up. The truth was, it was too damn easy.

There was one sergeant, a lean and mean career man, who was supposed to teach us the Articles of War. He told us we were nothing but hired killers. He also told us to forget the Articles. He said (seditiously, I guess) that if we were captured by the enemy (whoever that was), when we tried to escape (which was our solemn obligation according to the famous Articles) as they were torturing us, the officers would be living in the lap of luxury. Look out for yourself, he said. He was also my rifle instructor. I became a crack shot under his care.

He told us something else. He said that any good combat soldier would make a poor peacetime soldier. Killing machines don't make good shoeshine boys. They get in trouble all the time. He also told me I was a natural-born combat soldier.

On one occasion, my authority as a squad leader was challenged. One of the other squad leaders found dirt in one of my men's rifle. He ordered the kid (McCluskey was his name) to give him ten pushups. In my squad we didn't do things that way. I gave an impassioned speech about keeping ourselves from taking on the mystique of our torturers. If we copy those we hate, who can we hate? He didn't buy my appeal, so I went downstairs to the sergeant's room and asked the golden warrior with the Green Beret where I stood. He told me I had total autonomy. Then I ran upstairs and got down in front of the challenger and started doing pushups.

He said, "I was right, huh?" I prostrated myself, gave him twenty pushups, and then told him in a voice trembling with rage (it

helped that I was out of breath), "No, asshole, you aren't right! You want to discipline my men, you have to go through me!"

As I walked back to my bunk, McCluskey whispered, "You tell 'em, Tiger!" I said, "McCluskey, give me ten!" He said, "Ah, man. Let me do it some other time. I just took a shower." I said, "Yeah. Okay." I hate telling people what to do as much as I hate being told what to do.

The big ordeal of basic training is the bivouac. We all marched about twenty miles with full backpacks, combat belts with all the trimmings, and our M1 Garrands (heaviest damn gun imaginable) to the campsite, set up tents, built fires, ate rations, shaved with cold water from our helmets, and generally imitated combat soldiers. An interesting statistic is that it was 12 degrees cooler where we were at that time than it was at the South Pole in summertime. One soldier came down with a burst appendix, one pneumonia, one a broken shoulder, a lot of sniffles.

In the Army, you have to wheel and deal and scam to survive. If something is happening you don't want to be involved in, you report to sick call. If you're broke, you trade a dessert for a pack of cigarettes. If you have bread, you pay someone to clean your rifle or polish your brass. If you fuck up, you feign stupidity.

During the bivouac, we all sat around a fire in an oil drum, toasting our feet and warming the rest of us. I tried to be on the windward side, so as not to eat too much smoke. I toasted my feet so thoroughly one time that when I stood up, I blistered my toes in the near-smoldering combat boots. After a suitable amount of dancing around, I discovered the boots were fried. Shit! Thirty dollars. When I got back to headquarters, I shined them up within an inch of their lives and took them to Supply, complaining that the stitches had given out on these defective boots. They gave me a new pair.

They were always testing us: logic, motor skills, intelligence, problem solving, pattern identification, physical fitness. I scored very high on everything, so they romanced me for OCS (Officer Candidate School; everything in the Army is identified with initials), which is eight weeks' training, then you're an officer and a gentleman. Higher pay, more attractive uniforms, better food, apartment living, no manual labor, free college upon discharge.

And an extra two years in the Army. No thanks. I had other fish to fry.

On Thanksgiving, I sent a telegram to Donna. It said, simply, "Thanks." She responded with a fifty-word night letter.

The time came for the Army to decide what my MOS (Military Occupational Specialty) would be. They asked me what I did. I said I was an actor. They said, "Yeah, but what do you do for a living?" I said, "I'm an actor." They said, "Well, you must have something else you can do." I said, "Okay, I'm a painter." The guy took out a big book (Military Occupational Specialties). He said, "What kind of painter?" I said, "Impressionist-Expressionist." Believe it or not, there was a listing: Painter, Impressionist-Expressionist, with a six-digit number. My future was sealed. I was almost assigned to a reconnaissance corps (life expectancy in battle: twelve minutes), but my talents saved me.

At this point, I wrote a letter to Donna asking her to marry me. She wrote back asking, "What year would you like to marry me?" She did have a great sense of humor.

I spent my twenty-fourth birthday negotiating the infiltration course: crawling through the mud with explosions around me and live machine-gun fire flying over my head. The second lieutenant did the course with us, but he didn't want to get his uniform dirty, so he went through on his feet and hands with his ass up in the air. He looked like a stink bug. If his ass had been a couple of inches higher, it would have been shot off.

One thing about the officers: all the clichés of the ignorance and stupidity of the young lieutenants proved true. Of course, they were always drunk. They'd go to sick call and complain of a cough. The doctor would give them a bottle of terpenhydrate, known as "G.I. Gin." They'd carry it with them and tipple all the time.

At the end of Basic, we were all sent home for Christmas. I went back to Oakland and married Donna in my mother's living room. A Unitarian minister performed the service. Through sheer luck, my father was in San Francisco on tour, and he and his Amazonian wife, Doris, were in attendance. Doris wore a black gown. I don't think you're supposed to do that at a wedding, but Doris was always doing something strange and insulting. Nature of the beast, I guess.

Donna and I had a brief honeymoon; someone lent us a car, a

brand new Corvair, which we loved (I don't care what Ralph Nader said), and we spent a few idyllic days in a cabin in the Sierras.

Donna went back to college and I went back to the Army: this time to Fort Eustis, Virginia. We all called it Fort Useless. In the interim, the airline lost my duffel bag, which had not only all my Army issue but all my drawings and poems as well. I tried to get it back and they just shrugged. I said, "Take me to the lost and found room and I'll find it." They showed me a room about the size of Yankee Stadium, full of duffel bags.

I arrived at Fort Useless (it was said that if you wanted to give the country an enema, Fort Eustis was where you would plug in) with only the clothes on my back, a dress uniform. Not really suitable for the menial tasks they stuck me with at first, and hard to keep clean; an important factor. You could go to jail for having a messy uniform. To get the rest of the stuff, I would have to pay for it myself—difficult to do on $75 a month. Somehow, I finally got the post to issue me the missing items and started to look like a real soldier, sort of.

I never saw the duffel bag again.

My first day at Fort Useless, I found myself in a car with the platoon sergeant, who we came to know as Sergeant Melonhead because he had a completely round head, like Charlie Brown. I had my breast insignias on the wrong sides. He pointed that out. I said, "Well, Sarge, you have to excuse me. I've been alive for twenty-four years. I've only been in the Army for nine weeks." He said, "Carradine, you knowed a hell of a lot mo 'bout the Army befo' you got in than you does now." Untrue, but what are you going to do?

My job (MOS) turned out to be in what they called Training Aids, where I drew pictures. No artist is likely to join the Army, so they have to take what they can get (draftees).

As a test, my boss (a civilian, G11, equivalent in rank to a Warrant Officer) gave me a photograph of a missile taking off, which I was to copy. I asked, "What style?" He told me, "Just like it is." I rendered it in a sort of science fiction style, spending a lot of time on the smoke and flames beneath, very colorful. He looked at it and said, "I think I see what you mean. We can use you." I was in.

Every morning I stood reveille, did what we called the daily

dozen (calisthenics), and now and then I had to fire my weapon and do the obstacle course and, of course, march. In between I drew pictures, maps, and cartoons.

In my spare time (believe it or not, I had some) another private, Bob Baker, and I inaugurated a theatre company. Our first show was *Guys and Dolls*. We built the sets and performed it (three performances) on a tiny stage in a tiny theatre, with only a piano for accompaniment. We got girls from the local community theatre. I played Nathan Detroit. I wanted to be Sky Masterson, who had all the best songs, but we found a handsome soldier with a big voice. His name was Alexander Orfaly; he was really pretty good in a standard sort of way and a true friend.

This was to be the pattern in our little theatre company: I always played the part that no one else could cut. I was the utility player. What the hell! Nathan is a great role. I realized later that this was a way for Bob Baker to tell me that I had a lot of talent, and the experience proved invaluable.

We were so successful with *Guys and Dolls* that General Vissering gave us a big theatre, a full orchestra with a conductor from New York, our own barracks building for offices, and transferred many grunts to help us build sets. The unit was called "Entertainment." Because of my MOS I was never allowed to transfer to the unit, even though I had created it. The Army doesn't even try to be fair. One serves. The next show was *South Pacific*. I had to pass on that one because of my other duties, but I taught the grunts how to stretch and paint the flats for the sets with the expertise I had picked up hanging around my father in Summer Stock. The next one was *Kiss Me Kate*: one of my favorites. I, of course, wanted to play the lead. It seemed a natural. I was a Shakespearean-trained actor, and the show is about a troupe of actors doing a musical version of *The Taming of the Shrew*; but they needed a tap dancer, so I played that part. Orfaly got the lead. We had a problem finding a Kate, but there was a beautiful girl who sang opera in the local community theatre. The Army actually paid her to do it. "Kate" and I got very friendly. I almost violated my marriage vows, but not quite.

Living in a barracks with fifty soldiers was not the greatest; but we were Headquarters Company and, therefore, somewhat elite. I

made friends with some great guys: Eric Thompson, who was a play-wright and a banjo player; Emmet Jarrett, an epic poet and potential Anglican minister; Dave Van Horn, an Expressionist-Impressionist painter (a real one); and a black guy who played trumpet in the Army band, can't remember his name. He ruined my record of Haydn's *Trumpet Concerto,* learning to play it by ear, but it was worth it.

I met another guy at Fort Useless, who turned out to be very important in my life: Corporal Larry Cohen. He was never part of the gang, but we hung out together a lot. He was a screenwriter; he actu-ally sold some scripts while he was in the service. His job in the Army was to write the speeches for General Vissering. In between, he put on comedy shows for the Special Services. They were absolutely hilarious. Larry would go on to become a successful screenwriter, and later a producer and director of, mainly, horror films, but also some significant documentaries, notably *J. Edgar Hoover,* his exposé. Ultimately, we worked on films together with sometimes explosive results.

There wasn't much to do in your spare, spare time. We played pool; I got really good at it. We drank beer and watched television. Our favorite shows were Steve McQueen's "Wanted: Dead or Alive" and anything with John F. Kennedy. We really loved him.

There was a gang of soldiers from another post who had a great racket. They would come into the dayroom wearing overalls with ACME TV REPAIR on the back, and disconnect the TV while the soldiers were watching it and walk out with the set, leaving a sign that read Out For Repairs. They had their own appliance store. Nobody questioned it. That sort of thing happened all the time in the Army. Orders were followed without question. Someone in Supply once slipped some decimals, and as a result instead of five hundred, fifty thousand footlockers were shipped to a port somewhere on the coast of France. They sat on the dock for years. For all I know, they're still there.

⇒ ⇐

DURING HER SUMMER VACATION from college, Donna came out to live with me. We found a little cottage in Buckroe Beach, a resort vil-

lage on Chesapeake Bay, about thirty miles from the fort, and we were very happy. Since I was living off post, I didn't have to stand reveille at dawn, so I was a nine-to-fiver. They gave me extra money because I was married, so we were very comfortable.

On the weekends we'd invite down the gang and have a ball: swimming, dancing, and barbecues. I painted a couple of great paintings. Dave Van Horn gave me some lessons. Donna taught everybody how to folk dance. Our favorite was "Hava Na Gila."

When I wanted a few days off, I'd go to sick call with some phony complaint. I'd paint circles under my eyes with makeup and complain of pains I didn't have. They would confine me to quarters, which was my cabin in Buckroe Beach, and I'd play in the surf for a day or so. I met a doctor who had a little sailboat and we became fast friends, sailing and talking philosophy, art, medicine, and southern prejudice. Donna and I would play in the adjacent amusement park.

This was the life!

COURT MARTIAL
ARTIST

I was in trouble almost all the time I was in the Army. I had it figured that since I didn't believe in the Army, I would not cooperate beyond the point of self-preservation and would not profit from it. I never made rank; I remained a buck private for the whole two years, almost an impossibility.

The Army was split up into two camps, enlistees, the regular Army, whose serial numbers began with "RA," and draftees, known as the "US's." It was a US's duty to avoid the rules and defy the establishment whenever possible. I was dubbed "King of the US's" by my peers.

There was a black recruit who was almost as good as I was. He had an advantage; he could act stupid. The Army had pulled out all his upper teeth for him: gum disease. He looked stupid. We tried to get him to make the Army give him false teeth. He just looked stupid at us and went his way. We all thought he was stupid. When he became a short-timer, and no longer eligible for Overseas Duty, he suddenly showed up with teeth. He looked like a wolf. They won't send you into combat without teeth.

There was always some sergeant who was bringing me up on charges for a uniform infraction, insubordination, something like that. Punishment was usually K.P. They put me on the worst tasks. For a while, it was pots and pans—a hot, dirty job. All day long, I would sing

Judy Garland songs. Usually, "Look for the Silver Lining." They could punish me, but they couldn't stop me from singing.

After a while they put me on garbage detail (supposedly the worst job) so they wouldn't have to listen to me. I would go into the refrigerator, which was about the size of a living room, collect all the rotten food, and take it out to the Dumpster. The Army bought the best food in the world, and then cooked it until it was the worst.

I would take fresh steaks, maybe a ham, quarts of milk, butter, a dozen eggs, bacon, vegetables, fruit, put them in a box, and carefully place them in the Dumpster outside. When my duty was over around dawn, I would transfer the box to my Nash and take it home to Donna, making the best of a bad situation.

There was a legend about a mess sergeant who had a thriving business, a delivery route, stock supplied courtesy of the Army. He'd do his rounds before dawn, and then drive to the post in his empty van and fill it up again.

Donna and I spent a night at some friends' house in their spare bedroom, with candles and pretty sheets and blankets. We waxed romantic. Donna didn't have her diaphragm, but we went for it anyway. You know what this story is leading up to.

We found a seamstress to take in Donna's strapless evening gown, the one she had seduced me with in French class. (Yes, it was still with us.) Since Donna lost her baby fat, it was a little roomy. We went to try it on, and it was too small. We thought the seamstress was an idiot.

On the weekends in Buckroe Beach, we would give little performances for the other guests. I would sing and Donna would dance. This covered part of our rent. One day Donna showed up feeling nauseous, something that never happened to her. The landlady, a lovely old battle-ax, said, "You're pregnant." Donna said, "No way!" She was. This complicated things; on the other hand, the Army would give us more money for that.

We got a new Commanding Officer. A real southern cracker from Arkansas. The first day, he gave a big speech. "The days of long haircuts are over. The days of sloppy uniforms and lateness are over." Stuff like that. He had no idea who he was dealing with. We were Headquarters Company. We ran the Army.

Along with the cracker came a second lieutenant, straight out of
Officer Candidate School. On his first day, he put some of us on
report for not having our hats on as we walked the fifteen feet from
the barracks to the mess hall for lunch.

Like I said, we ran the Army. The first guy he slammed worked
for the paymaster. He threw the lieutenant's paycheck into the
wastebasket. The second guy he slammed worked in finance. He put
the lieutenant's entire pay records in a manila envelope and sent it to
Korea, with a note saying "HOLD TILL OFFICER ARRIVES."
The third guy was in assignments. He put the lieutenant on a levy
to go to Panama for a six-week course in jungle warfare. He came
back, skinny to the bone, uniform ragged, and he still had never been
paid. He never gave us much more trouble, but I don't think he ever
figured out what had happened to him. I don't think he ever got
paid either.

There was a corporal who had made Soldier of the Month
twice in a row. He had a three-day pass. He was dressed up in his pris-
tine uniform and ready to go when Sergeant Melonhead told him he
had to stay for a "G.I. party." That's when you clean the barracks from
top to bottom. It takes all night. One thing the peacetime Army was
good at was cleaning up things. The line was "If you see something,
pick it up, if you can't pick it up, paint it. If it moves, salute it." After
the G.I. party, our Soldier of the Month slid under Sergeant
Melonhead's car and carefully removed all the oil from the crankcase,
without getting a drop on him. Sarge drove away and the engine blew
up. He had to buy another car, not quite as good a one. He never
knew what had happened to him.

I learned from that Soldier of the Month how to make my uni-
form perfect. This was an important factor during inspections and on
guard duty. He had many secrets. He also connected me to an under-
ground that had perfectly prepared equipment for inspections, every-
thing: uniforms, canteens, combat belts, boots, socks, all of it absolute-
ly perfect. We passed this stuff around between us.

There was a special thing about "spin-polished brass." You spread
out a polishing cloth, stuck a tent peg in the center hole of the brass,
and twirled it. The process took hours, but it looked very impressive.

I went down to the woodworking shop and put the brass on a drill press. It took me about a minute, and looked better.

I escaped from many punishments with these uniforms and equipment. I'd be put on report, and show up with newly cut hair and my spectacular uniform, give the snappiest salute imaginable, and say, at the top of my lungs, "Private CarraDINE reporting as ordered, SIR!" The officer would turn to the sergeant and say, "What's this all about? This is a great soldier."

➤ ◄

DONNA HAD TO GO BACK to California to finish her master's degree. I made up a cartoon character: a pregnant cat who tries to dance. I sent maybe twenty drawings to her with funny lines underneath. It was a lot like *Garfield*. Well, I always was before my time. I used the Army facilities to make costume sketches for Donna's master's thesis. I probably spent thousands of government dollars doing that, but they were great. Close to the sexiest costumes ever designed for a master's thesis. They're probably still around somewhere. (I left out the pregnant cat part.)

There was one interesting moment, as close as I ever got to combat. Several hundred of us were sent down to Tampa, Florida, during the Cuban Missile Crisis. Our duty was to sit in a plane, with our backpacks and M1s, in eight-hour shifts. We were on a five-minute alert, waiting for the Third World War to start. The engines were running all the time. I'd usually fall asleep. A sergeant would come by and punch us all awake and we'd file off, not knowing if we were in Tampa or Guantanamo Bay. This went on for a couple of weeks, until Khrushchev backed down. JFK had rattled his saber and risked nuclear war with a madman who used his shoe for punctuation in the U.N. General Assembly; and Khrushchev chickened out, something no one thought he was likely to do. I guess the Russian was playing chess, while the Irishman was playing poker. The blarney won.

I took a trip with one of the guys to historical Williamsburg, Virginia, which had been the shopping center for the big plantations in pre-Revolutionary times. It was two days' ride from the farms to

the port at Yorktown, so everyone would stay in Williamsburg for the night and go to church on Sunday. There was a tavern that was the place where Thomas Jefferson and the rest of the kids drank big mugs of beer and thought up the American Revolution. I was very impressed with this bit of nitty gritty history.

Behind the perfect little village was a shanty town where the black people still lived. They made their living dressing up in livery and pretending to be eighteenth-century slaves. Tom Jefferson tried to put an anti-slavery clause in the Declaration of Independence, but Adams talked him out of it on the basis that the southern states wouldn't sign. Eventually we had to start paying for that one. You have to pick up every stitch.

I guess Jefferson is my number one hero, if you don't count Adam. Jesus was right on, but his trip was too sacrificial for me to want to emulate. Written around Jefferson's monument in letters a foot-and-a-half high is a message that no one ever reads (everybody's over looking at Lincoln). It says, "I have sworn upon the altar of God eternal hostility towards all forms of tyranny over the minds of men." He wrote books, practiced architecture, farmed, and played the violin. He kept slaves, but he educated them, planting the seeds of freedom. He wanted us out of the slave trade. That meant getting out of the rum trade. He planted 200 acres of rye and distilled the first American whiskey. My hero.

I watched the end of a World Series game in the tavern. It was the first year the Giants were in San Francisco. They were playing the Yankees, their traditional enemies. It was the bottom of the ninth, the Giants up. Two outs, bases loaded. The Yankee shortstop made an incredible catch and it was all over.

I went on to Yorktown. There was a place on the hill where you could see six houses over 250 years old. One of them was closer to 400. Looking down you could see sunken ships in the harbor. Several of the brick houses had ancient cannonballs imbedded in the walls from when the Revolutionary Navy had shelled the place, which was then a British stronghold; General Cornwallis's headquarters, in fact.

Around the city, there were trenches, with cannons in them; redoubts, they're called, left over from the Revolution. Washington's Army overran them. They were preserved as an historical monument.

In the Civil War, the rebs used them again and Sherman ran over them in exactly the same manner. Some people never learn.

I decided to try to get out of the Army, so I went to the post psychiatrist. I told him I didn't belong in the service. He said, "You don't belong? What about me? I'm a doctor, for Christ's sake!"

I should tell you about Louis. He had joined the Army and had served four years. Afterward, he fell in love with a girl on the outside. She joined the Army, so Louis rejoined and arranged to be at the same post. She didn't want to have anything to do with him, so now he wanted out. He developed the ability to vomit on cue. He had to eat some bad greasy food first, but there was plenty of that around. He started throwing up on tables and things. They decided to let him out on a medical discharge. That wasn't good enough for Louis. He went to court and pleaded to be allowed to stay. They ended up giving him an honorable discharge.

He and I used to drive up to New York for the weekends (not allowed). We had some hairy rides getting back to the post on time. Louis was a great driver. He taught me a lot.

One time we were barreling back, trying to make it to the base on time through a heavy fog in a VW Beetle. The top speed of the car was just over seventy. There were dips in the road every quarter mile or so. The fog would settle in the dips. If we slowed down, we'd never get it up to speed again, so I'd keep my foot to the floor. Every dip, I'd be completely blind for four or five seconds, maybe more. I never let up. Better to die than to be in the stockade was my thought.

Louis was a man of many talents; he had a huge vocabulary and knowledge in myriad areas. You could never catch him out. To make it worse, if you challenged him he would bet you money. Then he'd make you feel like a worm if you backed down. You always lost. He was unbeatable at chess or pool. It was maddening, because he would tell you how bad you were all the time he was beating you. You prayed fervently to see him beaten, just once. But no chance.

Louis had a plan. As a lithographer, he knew all about those printing processes, including printing money. He wanted me to use the Army equipment to blow up a twenty dollar bill to about three-feet wide, clean up all the edges, and reduce it to a plate. All we

needed then was the right ink and paper. The idea was to run off about a million dollars and pass it off in little towns. Drive up to a convenience store, buy a carton of cigarettes (about $2.00), keep the change and go on to another store, then another town. We had to start Friday afternoon and stop Monday morning, before the banks opened. Then we'd sell the rest to South America at half price. It sounded workable, but I passed on it. So did Louis.

➤ ◀

AFTER AN INTERMINABLE period of loneliness, Donna came back with her master's degree and looking like a pregnant cat. She had the baby at the Fort Monroe hospital, and we were ecstatically happy. We named the child Calista, which is Greek for "Most Beautiful." And she was. Still is, for that matter.

I walked from Buckroe Beach to Fort Monroe every day, picking flowers for Donna beside the road. The prettiest were the dogwood blossoms. The legend is that dogwood was what Christ's cross was made out of. Ever since, dogwood trees have refused to grow large enough to be used for a crucifixion; not that that's very likely to happen these days, but a dogwood tree can't be too careful.

CHAPTER FORTY

BABY MAKES THREE

hen Calista was ten days old, we hitchhiked to Washington, D.C., where my father was opening in *A Funny Thing Happened on the Way to the Forum*. We carried the baby in an apple basket, with fluffy little blue or pink blankets around her. (I can never remember which goes to which; hardly relevant anyway, considering my color blindness.) We introduced Dad to his first grandchild. He loved it all. Doris was extremely jealous and treated Donna very poorly. Donna stood for it like the trooper she was.

About that time, I got in trouble again. Disobeying a direct order. My defense was I didn't know it was a direct order; I thought it was just a suggestion. They didn't buy it. More K.P.

During these punishments, I had to stand reveille. I'd hitchhike to the post. The Nash had died. One day I was running a little late. As I was jogging briskly down the street, I saw a Nash parked on the side. I knew that those Nashes had a special feature that allowed you to pull the key out when it was on and then operate it just by turning the switch. I jumped in. Sure enough. I drove it to the post in a state of total terror and left it in the parking lot of the Greyhound bus depot. I carefully wiped it down for fingerprints and walked on the post. I'm sure everybody thought somebody had left the car and taken a bus somewhere, but I was in a state of paranoia for quite a while.

Then I got into some real trouble. The ultimate climax of my shoplifting career. On payday, I would go to the P.X. They had everything: clothes, appliance—anything you could want—shoes. You had to have the shoes. You were absolutely required to have the shoes, and you had to buy them. They only paid a buck private $75 a month, plus something like $40 for the wife and child. Every payday, the P.X was so loaded with people that you could steal the place blind and they just simply wouldn't notice. I'd find a pair of shoes that fit, take mine off, put them in the box and back on the shelf, then just walk out with the rest of the crowd. I had no moral compunction about this whatsoever.

This one time, they caught me with a whole bunch of stuff. I was feeling really hot with my new baby and all, so I had gone whole hog. I had taken in an AWOL bag and filled it up, taken labels off of things, and worn the clothes as extra layers beneath my own. The woman at the checkout thought the bag looked suspicious. They stopped me. I tried to explain that the stuff was bought someplace else—they didn't buy it.

I went through what they call a Special Courts Martial: one field-grade officer, a lieutenant, and a sergeant. An extremely dangerous situation. I thought, "My God! This could go really wrong!"

They assigned me two attorneys, lieutenants, who didn't want to be in the Army any more than I did. I thought that I had made up a great alibi and the lieutenants told me that it was the first time they'd ever seen a soldier lie, and stick to it, never changing the story. They loved it. Well, I guess I was bad but I wasn't dumb.

As the trial approached, something very dramatic happened to my brain. I thought of my newborn child and I said to myself, "I don't want her to have a thief for a father. She deserves more than that." So I never stole anything again. I became what I always wanted to be, an honest man. But, first, I had to get through the trial.

During the proceedings, Donna sat toward the back of the courtroom, wearing a black cape, dandling Calista on her knee and, when it was called for, feeding her from a bottle. We thought of breast feeding her under the cover of the cape, but decided that would be a little much. After all the testimony, Calista burped, and the major said, "I thought she was getting too much air." The ploy had worked. He

had not paid much attention to my detractors. All he cared about was my Madonna and child.

≫ ≪

AFTER THE COURT MARTIAL, life went back to normal. Our entertainment company went into another show: *Once Upon a Mattress,* a musical about the princess and the pea. There was a part for a tap dancer, which I wanted to play, but they now had another tap dancer and, since Alex Orfaly had moved on, they needed someone to sing the big songs. Larry Cohen played the comic role of the king who can't talk because of a curse. He managed to perfectly replicate Buster Keaton. He was great. Donna danced and, in between scenes, nursed Calista in the dressing room.

I had another company punishment (these guys were really out to get me now). I was confined to quarters. Well, my quarters were a cottage in Buckroe Beach. I would hitchhike to the post and stand reveille at six A.M. After a few weeks, they figured it out. They were furious and put me back in the barracks. A few days later, Eric and Emmet dressed Donna up in military fatigues, put a mustache on her, and snuck her into the barracks. We went out to the car and had a wonderful liaison. I'd never made love to anyone with a mustache before.

We went on the road with *Mattress,* the most memorable performance being at Fort Bragg, North Carolina, the home of the 101st Airborne, Jimi Hendrix's outfit. General Vissering came to the show. He had never seen a play before; too busy jumping out of airplanes, I guess. Halfway through the show, the lights went out. Everybody went to their cars and got flashlights, and we proceeded to do the rest of the show lit by a hundred or so military flashlights. The audience pointed them at the stage and at the orchestra's sheet music. The general sent his staff to fetch a mobile generator. When the lights went on there was a huge cheer, and a lot of dead batteries.

I lost my job at Training Aids, maybe because I used their materials so freely for my own extracurricular projects. I was assigned to Special Services, which was a lot more amusing. I made posters, did sculpture, created jewelry, and hung around with some wonderful artists who were there just for fun.

There was a yearly event called The-All Army Entertainment Contest. I entered it. I wanted to sing but Alexander Orfaly was back, and Bob Baker told me if I did, I'd be beaten out by Alex. He said I should go in as "Individual Specialty." My individual specialty was acting, so I put together a routine where I talked very hip about Shakespeare's play, *Richard II*, and then launched into a full-blown version of my old audition speech: the abdication of Richard. It's a heartbreaker. I won in my category for the post, hands down. The next stage would be the all-Army finals, competing against other posts.

In the interim, I had another court martial; usual bullshit. My punishment was to dig a trench around the barracks every day after work. I got friendly with the sergeant and spent most of the time playing pool with him. The idea was I was supposed to dig the trench and then fill it up again. I did about thirty feet, and then they called me to go to the all-Army finals for the contest. They called it T.D.Y. (Temporary Duty). They fly you to another post and give you extra money. You live like a king. My commanding officer tried to stop it, but the orders were signed by General Vissering. I had a great time. The show was a really big deal—American flags, honor guards, the whole shebang.

The sergeant of the outfit was a huge man, almost four hundred pounds. He had a lot of faith in me. After the dress rehearsal, he said, "Is that it? That's all? I'd expected something really special." I said, "No, that's all there is." He walked away shaking his head. It hurt my feelings but I just figured he didn't understand. I realized I'd have that problem all my life. I lost out to a Hopi hoop dancer. Well, he jumped through fire, I just talked loud.

When I got back, the sergeant and the lieutenant were madder than ever but I was apparently invincible. While I was gone, somebody else had filled up the hole I had dug. Donna had to go home again, with Calista, of course. We gave up the cabin. I got friendly with a local disc jockey. He let me stay at his house. He had a huge record collection and I listened to them all.

I was almost out of the Army by now. Bob Baker gave me a going away present: the lead in *Stalag 17*. It was a perfect role for me: a soldier who is thought of by his peers as a cheat and a reprobate,

but who is actually a patriot and the best of them all. I ate it up. We performed it in a boxing ring, leaving the ropes up and making our entrances through the audience. It was a big hit.

Ten days before I was supposed to get out, they tried the court martial thing on me again. I can't remember what for. The idea was to get me an undesirable discharge. The officer in charge of the trial was a black captain. When my commanding officer testified against me, it was all over. Captain Black was not about to take any shit from this southern, prejudicial little asshole. All that was accomplished was getting my commendation by General Vissering changed from written to oral.

Now they had to get me out in a hurry. They were completely unprepared. They had to rush me through or THEY would be in trouble.

The kid who did the papers said, "You're going to California, right?"

I said, "No, I'm going to New York."

He said, "If you say you're going to California, you get an extra three hundred dollars."

I said, "Okay, I'm going to California."

⇒ ⇐

ONCE OUT OF THE ARMY, I decided to stay in Virginia for a while to get my teeth fixed. I didn't want to show up in New York with missing teeth, and the dental work in Virginia was a lot cheaper. Grandma paid for the work.

In Virginia Beach, I snagged the role of Harold Hill in a community production of *The Music Man*. With my missing teeth, I didn't have a very good salesman's smile, so I went back to the post and used the kiln at Special Services to make a set of porcelain teeth. They worked perfectly for the show but I couldn't eat with them. I felt like George Washington.

I had moved into an attic room: $7 a week. The slope of the ceiling was so steep that there was only about a four-foot-wide strip where I could stand up straight. If I sat up in bed, I would bump my head.

Eating was always a problem; I had absolutely no money.

Somehow, I survived. Mainly, I lived off the kindness of friends; a dinner here, coffee and donuts there. I had one great friend, a female school teacher. We used to talk for hours while I ate her cookies. I don't think she ever realized those cookies might have been the only thing I had to eat that day.

I took to prowling the streets at night, checking out the backs of grocery stores. One night I found a basket of withered snap beans. I boiled them up in my one cooking utensil, an electric frying pan. No salt, no butter. Purely nutrition, no entertainment.

I got three jobs: one as a disc jockey, which didn't last long; one doing a caricature of a used car salesman. (I never did meet him; I did it from photographs. He turned it down. I didn't understand why. Then I found out the photos were from twenty years ago.) Then I did a brief stint as a shoe salesman right after Christmas. Straight commission. Big mistake. Nobody buys anything right after Christmas. They just exchange things. That's why all the regular salesmen were on vacation. I made about four dollars.

Finally, with my new teeth, I struck out for New York.

CHAPTER FORTY-ONE

THE GREAT WHITE CITY OF HOPE

I saw Manhattan as I approached it, spread out and tall, a seductive woman, beckoning to me, arms open wide and ready to crush me if I was weak. I was ready. I looked all over the city for an apartment I could afford. I finally found five rooms in a fourth-floor walk-up, what they called a railroad flat because the rooms were all in a line. Rent was frozen at $29.30 a month. The place was terrible. Nothing worked, but it would do. I went to my old agent, the one I'd had before the "war." He didn't have much happening, so I took a part-time job with a commercial art house as a "decorative illustrator." I would work when something came in, drawing wrought iron furniture and ladies in cloth coats and cotton blouses.

I went to a few auditions. I guess I looked pretty funny with my Army haircut and my P.X. shoes, but the competition looked pretty funny to me. I was one lean and mean killer hoofer. There was something I had going that they didn't even know existed.

I also possessed a determination that bordered on desperation. I was now twenty-six years old. If I was going to make it, I'd better hurry. There were lots of younger actors now who were ahead of me. My friends from the Army and other people I knew all thought I was just pipe-dreaming. But I never had any doubts for a moment.

I sent for Donna. She arrived with Calista, and I met them at La Guardia Airport. There was a rotunda with two levels. I heard, "Jack!" I looked up and there was Donna leaning over the banister, grinning. She lifted up Calista in her two hands and showed her to me. I hadn't seen the kid since she was a little bitty baby. Now she was a year old, a person. I looked at that impish, smiling face and fell in love immediately. For a moment we were all happy just to be together. Then we got "home," and Donna broke down in tears. There was plaster falling off the walls and everything looked like shit. I told her, "Don't worry, I'll fix it up." I did, though it took me a good solid while.

Grandma McCool came up with $50 a month, which helped out. She was hesitant about it, but I convinced her that it was my version of the college aid she had given Bruce. I was eligible for unemployment insurance from the Army—a whopping $28 a week. Donna worked as a Western Girl (temporary office help) and at Bloomingdale's. I took care of Calista. We got by.

Donna taught dance a little and studied with the Joffrey Ballet, a dream for her. She would practice in the apartment every evening, working up a delicious, slippery sweat and looking just out of this world, her thick dark hair clinging to her neck and back, her chest heaving with honest work and artistic zeal. Afterward, I'd stretch her muscles out and usually we'd make love.

I would do most of the cooking; Donna knew almost nothing about that particular art. We shopped frugally, out of necessity, and I waxed creative. I'd start dinner up, and then, after the lovemaking, I'd serve her in bed. Then Donna would take a milk bath. Hot water, bubbles, and a couple of quarts of milk. My father said Donna had a Cleopatra complex.

We paid attention to what we ate and took as many vitamins as we could afford. We worried about the environment and studied mystic disciplines. Most of the rest of the world thought we were just crazy. We were way ahead of our time.

➢ ➣

THE FIRST MOVIE JOB I was offered came about because someone put out a call for a "young John Carradine type." I showed up and a sleazy

little guy explained he wanted me to play a monster and walk with my knuckles dragging the ground. I would have to wear some kind of brace to do it. I told the creep he ought to play it. Neither that kind of part nor that kind of movie was exactly what I had in mind.

Once, while I was talking to some people in a Village bar about playing Norman Mailer in a movie about his life, I met a guy who wanted to promote me as a middleweight boxer. Because of my height, my reach was longer than anyone of my weight division. I went so far as to go into training. I had nothing else to do. I went into the gym and did all the stuff: footwork, sparring, punching the bags, smelling the sweat. I discovered two things. One was that I really liked hitting people. The other was that I really didn't like getting hit. There's no way you can be a professional boxer without getting hit, so I retired before I ever fought a match. The Mailer movie never got made.

The whole gang from the Army came to New York. We got together a lot. They were so impressed with the happiness that Donna and I had that they all got married. I was best man at most of the weddings. None of the vows—including mine—are still in effect today.

Emmet (the epic poet) moved in downstairs with his new wife. We spent a lot of time together, drinking coffee and talking. We were having a continuing, what we thought would be lifelong, conversation on the subject of *Hamlet*. We put together an act, reading poetry on stage, booking ourselves into YWCAs and book shops. We were a big hit. He was "Uncle Emmet" to Calista. On Easter and other holy days, he'd give services, exercising his frustrated seminary consciousness.

His wife had been committed by her parents, against her will, to a psychiatric hospital. She told me that they would treat you like dirt if you were not acting crazy. You had to reveal your insanity, or they'd keep working on you until you were driven insane. They had the idea that they couldn't cure you unless you hit bottom first. They regard as meaningless the idea that you might not belong there in the first place. Lots of parents think their daughters are crazy.

Eric Thompson (the playwright) was in therapy. I told him I didn't see how one could improve one's mental state by taking the advice of a stranger who makes his living looking up people's assholes.

Eric said, "No. I look up his asshole, and then he beats me with a rattan cane."

Across the hall from our apartment was Dikron Kuimjian, an Armenian scholar who was studying for his Ph.D at Columbia University. He taught me a lot.

He showed me a picture of a huge family of Armenians. He said they had all been killed by the Turks except for one little boy. That was his grandfather. He showed me all the clubs in New York that had belly dancers. Dikron was a big music lover. I spent a lot of time in his place, with his great stereo system.

There was always a big problem in New York with burglars. They'd get your telephone number, somehow, and call you up. If there was no answer or answering service, they'd break in and take all your stuff, and maybe write "fascist pig" on your walls. There were answering services that made a point of answering "Hello" to throw them off the scent.

Dikron had some workmen put in a steel door with a police lock. The burglars took the door jamb apart and removed the door from the wall; stole him blind. Right across the hall was my pretty blue door, which was usually left unlocked. Nobody ever robbed us. We had a stereo set too. I think all Dikron's door did was draw attention to the probability that behind it was something of great value.

Every few years I still run into Dikron. The last time was at Charles de Gaulle Airport in Paris. I asked him what he was doing. He said he was a professor at a university there; I asked him, "In what subject?" He said, "In Armenian, of course."

On the floor below us was a madwoman who lived with her father. I went down there with Emmet's wife once. There was a dresser or a big chair or something in front of every window and the back door. Darkness, at noon. The woman never went out except to the hallway. Usually, if someone came by, she would dart inside and lock the door. I'd hear the click—click—click. She would moan and wail for a couple of hours at a time, repeating over and over again, "GETOUTOFHERE! GETOUTOFHERE!" It took us several weeks to figure out that was what she was wailing.

One time a terrible odor, like a dead rat, started up in the building. After a couple of weeks, the Board of Health, assisted by New

York's finest, broke down the door and found the old man dead. His daughter was still trying to feed him. As the cops took the blackening corpse away, she kept saying, "But I care for him."

After that she took a turn for the worse. (Saying that is almost funny.) Emmet's wife, who, because of her time in the bin, had great empathy for the poor lady, befriended her. She talked her into going out for walks with her. Her long, thick hair had not been washed or brushed for, probably, years. It had the consistency of thick cardboard. Emmet's wife (I wish I could remember her name) sat her down and gave her a pixie cut, which effectively disposed of the matted rat's nest. A lot of progress was made but, in the end, she slipped back. After a while, they came and took her away too.

I came up with a job playing Laertes in *Hamlet* in New Jersey. The way this happened was kind of funny. They wanted me to audition for Rosencrantz, which is a thankless part. I had inside information that Larry Luckinbill, who had been cast as Laertes, had dropped out to do something at a repertory in Washington, D.C. I auditioned for Rosencrantz as though I were an actor who should be playing Laertes and was unable to give a good reading for Rosencrantz. They talked for a minute and said, "Would you like to read for Laertes?" Done deal. I gave up my job at the art agency.

The production was presented in a strange venue: we did six matinees and two evening shows. Well, it was a shopping mall. There were always a lot of kids in the audience. Sometimes you had to yell over them. They loved the ghost and the sword play. The house was always packed.

The Hamlet was Ted d'Arms: a six-foot-four, 230-pound actor/still photographer. I asked him why on earth a guy like him was playing Hamlet. He said, "What am I supposed to do? Turn it down? When will I ever get another chance at this part?" Ted talked almost entirely in question marks.

He was marvelous enough in the role to teach me a lot. His broad Shakespearean gestures, he freely admitted, were all taken from sports: tennis strokes, football throws, bat swings, boxing and wrestling moves. For the famous "To be, or not to be" soliloquy, he stood absolutely still, in profile, with his head turned stage front, moving nothing but his mouth.

Well, John Barrymore said the thing he liked about Hamlet was that you could play it absolutely any way you damn pleased. If I were ever to play the role, it would be impossible to get Ted out of my head.

There was an agent in the audience, David Graham, who was with Ashley-Steiner, maybe the best theatrical agency in New York. He said he had a hunch about me, whatever that meant, and signed me up. He didn't say I was great, which I thought I was, he just said, "I have a hunch." He said it a bunch of times.

My dad saw the show too. He hated it. He arranged a production at the Gateway Playhouse on Long Island—him as Hamlet and directing, me as Laertes. (He wanted to show me how it was supposed to be done.) He drove out every day to rehearse us, then took his vacation from *A Funny Thing* for the performances. He was remarkable. He was in his fifties and starting to become crippled by arthritis, but on stage you couldn't tell. He came across as a thirty-three-year-old Leslie Howard.

As far as showing me how it should be done, we never did agree. Our approaches and even our intentions were always miles apart. He believed in masks; I believed into my soul.

His acting lesson was also a bit useless in that I would have learned a lot more if he had let me play Hamlet instead of Laertes: the arrogance of youth! It was years later when I realized the practicality and business sense of the man: he couldn't have sold the theatre on my Hamlet. Fame sells. Ambition strives.

There was a problem: my name. John Carradine, Jr. Everybody seemed to think it was some kind of joke. I was sitting in David Graham's office, hungry for work. He said, "Well, are you going to change your name or not? I don't want to start pushing until you decide."

I said, "Okay. Okay."

He said, "So what's the name?"

"I don't know."

He started tossing names at me. He kept trying them on me, like sports jackets. I got tired of the process. I looked over his shoulder and saw where he was getting the names. It was Ashley-Steiner's client list: Kirk Douglas, Burt Lancaster, James Mason.

I said, "How about David?"

David Graham said, "Great!" and went to work for me.

My dad was devastated that I had changed my name, but it just wasn't working. Anyway, I didn't bear his name; I was named after his Hollywood dream.

OFF AND RUNNING

Right away I got a job. "The Armstrong Circle Theatre." It was the last show—the end of an era. The program had been canceled. All the parts were given to the old regulars. I was lucky to squeak in. I got to know Rodney Tarkington, a very talented, very tough black actor. He didn't take any shit from anybody. They called anyone who had a speaking role in the show a "star." Rodney said, "Star. I'm no 'star.' When I'm a 'star,' you won't have to tell me. I'll know it and you'll have to write it on my contract!"

My part was one fairly long speech, and that was it. No standing around in the background. In and out.

The show was live. They'd run with the cables and push the camera dolly from set to set. It all had to work like clockwork. As they were coming up to my bit, the camera hung up on some cables. I watched in horror as they tried to free it. I could see my spot disappearing. They got it clear just in time—not a second to spare—and I was no longer a virgin. I didn't get much in the way of money. I had to join the union.

Then I got a really good part on "East Side, West Side," a TV series starring George C. Scott. The part was a junk sculptor who lives in a building that's being condemned. The casting director (some squeaky-assed girl) said, "You know, you don't look like a junk sculptor."

I said, "Well, that's really funny! Because I am. Well, not really. In

true junk sculpture, you use things as you find them: pieces of cars and stuff like that. I take the junk and change the face of it, use it as raw material to make shapes that I weld together with a torch."

She stared at me, mesmerized. All this was a complete rap, of course, but it convinced her. She said, "We'll have to use your work in the show."

I gulped. "Great!" Fortunately, the art director had a junk sculptor friend.

After that show, I thought I was off and running. I did fifty-two auditions all over town. Then there was a week or so when nothing was happening. I called up David Graham and said, "How come I'm not doing any auditions?"

He said, "You've auditioned for everyone in town. Nobody wants you."

I had a great audition song that was relatively unknown but really showed off my voice. When I'd do a singing audition, people would come out of the front, the back, from the shadows, to see who was this great singer, but I'd never get the job.

Actually, I had a couple of offers: one for a play called *The Toilet*; I turned it down. It was a dirty, odious piece of work, I thought. Not my kind of thing. The director, Milton Katselas, pleaded with me. I said, "Some other time. Not this play." The other was Marchbanks in *Candida* with Angela Lansbury for public television. At the first rehearsal, I decided Angela was a complete lunatic. I begged to be let out. I was a cocky kid, for sure.

I got an offer from Universal to come to Hollywood and do a screen test. My dad was against it, but I didn't have a lot of choices. Milton Goldman, who was then head of talent at Ashley-Steiner and had been my dad's agent for years, had a meeting with me and Dad as we were walking up the Avenue of the Americas. Dad wasn't sure if I should do this thing. He had languished for so long in slavery under the Fox contract and thought it was a bad idea for me to take the same garden path.

Milton said, "Well, John, the thing is nobody else wants him right now, and these people do want him."

So I finally said, "Well, all right. I'll sign for it." And I set off for Hollywood.

In the East Side Airline Terminal I saw an extremely tall and well-muscled man about my age, with a beautiful head of blond hair, wearing a turtleneck sweater and a sports coat, loading his bags onto the conveyor. I said to myself, "This guy is coming on too strong. He's gonna get in trouble." I got on the bus and the guy sat down behind me.

He said, "David Graham told me to say this. 'Get a haircut.' Okay, I've said it."

This was Jeff Cooper. He was on his way to Universal too.

On the plane, we discovered we had a lot in common. There were five hopefuls on the flight, traveling together. Jeff and I pretty much ignored the other three. We talked about music, art, women, cars, the cosmos. By the end of the ride, we were good friends. We still are. We constantly compare notes on just about everything: acting, music, history, love, morality; anything you can name: food, longevity, how to make your hair grow, what kind of cowboy boots to buy—just everything.

The day of the test, I overslept and almost missed it. I never have been good at getting up on time in the morning. They picked up my contract and Jeff's, and let the others go. A few years later I saw my test. It was awful, just awful. I don't know what Universal saw in it. Lucky me, I guess.

We became the personal wards of Monique James, a bull dyke who ran the contract players. She had a stainless steel yardstick she would slap on her desk for emphasis. She wore a hard hat into staff meetings.

The deal was we would be guaranteed five weeks' work in a year's time, at five hundred a week, and the contract would be non-exclusive; with options, of course. The fact that we were the two that made it cemented our friendship. We came in together; we would go up together. Jeff got himself an apartment. I went back to my family in New York and to my lame attempts to make it on Broadway. I figured if Universal had to pay for my ticket back, they wouldn't bring me out for any dumb parts. Well, it turned out some of the parts were dumb, anyway.

Meanwhile, I became involved with the Helen Hayes Repertory Group. I never figured out what Helen Hayes had to do

with it; it was run by a fellow named Jack Manning. What we did was pick up cancellations at colleges and so forth, playing *Twelfth Night*. If a chamber group, or a folk singer, or lecturer didn't show up, we would come in on a moment's notice and pick up the gig. We'd rehearse a couple of times and jump in the cars and just go do it. I got fifty dollars per performance. It was all cash. I didn't have to report it to the Unemployment Bureau. I could still collect.

Our set consisted of two ladders and a stool. The costumes were unbleached muslin, with colors painted loosely on them. There were lines drawn here and there. They looked exactly like costume drawings. It was a very talented group—in New York, there are always plenty of good actors who are out of work. I started out playing Sebastian, a great comic role, and eventually graduated to Orsino, the lead. One of the actors looked at my hands once and asked me if I was some kind of laborer on the side. I told him I was doing a lot of work on my apartment.

In between my trying to get a part in the Big Apple, there were the Universal idiocies: "Wagon Train," "The Virginian," "Alfred Hitchcock" (actually, the Hitchcock was a pretty good one).

On one of my visits to Hollywood, Jeff introduced me to something close to the most beautiful woman I had ever seen. Her name was Joanie. Joanie was to become the love of Jeff's life. I saw it all happen in the parking lot of Barney's Beanery, a famous hangout for out-of-work actors.

Once I was back again in New York, David Graham invited me one day out to his place for a drink. I thought I must be really making it now. David sat me next to him on the couch and put his hand on my leg. Looking back, it was probably an innocent gesture, but I ran like hell anyway. They switched me over to Jane Oliver, maybe the best agent I ever had. She took me down to an off-Broadway theatre to see a new actor she was interested in. The guy was wonderful. His name was Dustin Hoffman.

Grandma McCool died. She was eighty-six, but it was still a shock. My mother sent me a beautiful paisley scarf that had belonged to her. I kept it for years.

THE DREAM

Around this time, I had what you might call a dream of destiny—like the vision a young Indian brave has that defines his life. It went like this.

I was with my wife, Donna, my infant daughter, Calista, and some of my friends. We were looking at a little house at the foot of a mountain to rent it. As we were checking out the kitchen, we began to hear a sound up on top of the mountain. It was hard to determine what the sound was, but we could tell it was coming down the mountain toward us very fast.

As it came closer, we realized it wasn't really just one sound, it was the sound of many voices, maybe hundreds, thousands even, screaming, shouting. The house began shaking with the vibration. I went out into the hallway and locked the front door.

It was one of those grandmother-house doors that have lots of little panes of glass, a door with more little panes of glass on each side—obviously, no real protection. As I stepped back from locking it, the crowd, or mass, or whatever it was, came sweeping down around the side of the house and slammed into and all over the door and windows.

What I saw were countless faces, all terrible: harpies, ghouls,

demons perhaps, punks, weirdos, cripples, street people, Hell's Angels—you name it—some of them with chains, knives, and clubs, their faces pressed against the glass.

I backed up, scared, and said, "Muriel, call the cops!" Muriel just stood there. Eric and Emmet were frozen in terror. Donna clutched the baby.

I realized I had to do this—whatever it was—alone. Swallowing hard, I faced the door and said, "What do you want?"

The crowd answered as one, in a sort of whispering, wailing roar, "We want you!"

Then I woke up.

I think this dream was my version or vision of what success would be like for me. Once I got over the scare, I decided to go for it anyway.

ON BROADWAY

It was 1963. Things were lean. I auditioned for a good part on a soap called "The Doctors." They were so impressed with me they asked me to become a regular on the show. Ashley-Steiner told me if I did that, they didn't want to represent me anymore. There's a certain prejudice against soap actors.

I was at a pay phone on the street when I got this news. It was just before Christmas, and cold as hell. On the corner was a Christmas tree salesman. I had 50 cents in my pocket. The guy had one tree that was about six feet tall but had almost no branches on it. He gave it to me for my 50 cents. I took it home and cut two feet off it. I drilled holes in the trunk and stuck in the extra branches, making a perfectly respectable four-foot tree. Donna made some snow out of detergent and I made an origami paper bird. That was the totality of the decorations. We put the tree on a table to give it a little height. Actually, that was about the best Christmas I've ever had. Calista loved it. She got detergent all over her and ate the Origami bird.

A really great starring role in a movie was tentatively offered to me. Things were progressing nicely when the director sent a copy of the script to his friend Paul Newman, to see what he thought of it. Paul said he wanted to do it. The director said, "Paul, no way! This is a tiny little movie." Paul said, "Not if I'm in it." So I didn't get to be *Cool Hand Luke*. This sort of thing happened to me several times,

always delaying my breakthrough for a year or so. Sometimes it would make me mad, but I saw *Cool Hand Luke* and I can't figure out how anyone could have played that part better than Paul did; not even me, who actually was Luke.

I kept looking for a break. I auditioned for the role of Orestes in *Electra* for Joseph Papp, who was famous for his Free Shakespeare in Central Park. He was very high-handed, you know. Joe was famous for that. He didn't kow-tow to anybody. They didn't call me and tell me anything. Joe loved to let you sweat. The part didn't pay hardly any money at all, but it was a plum role.

I continued to do other auditions while I waited to hear from Papp. It took them six weeks to get back to me and tell me I had the part. Meanwhile, I won out to take over the lead on Broadway in *The Deputy*. They offered me $500 a week, which was a fortune to me, an absolute fortune. I had the unmitigated joy of saying to Joe "I'm sorry, I'm unavailable." Any small-time actor in New York would have felt the same turning Papp down. He was known to be a cliquish, auto-cratic, spiteful overlord.

To allow me do *The Deputy*, Universal gave me an extension on my contract. Jeremy Kemp had opened in the show, but because of death threats from the Nazi Party had dropped out after six weeks. The play dealt with the Nazi Holocaust and the audience was packed with concentration camp survivors. Every performance was charged with tears and anger. The play was controversial to the point of no return. The Nazis, the Catholic Anti-Defamation League, and B'nai B'rith were picketing the theatre shoulder to shoulder. The Nazis didn't fuck with me. During the run of *The Deputy*, Ron Liebman and I used to bait them, and once we followed one of them up Eighth Avenue, making vague threats to his backside. We had him scared silly. He never showed up in the picket line again.

The Deputy was produced and directed by Herman Schumlin, whose other credits included *Inherit the Wind* and *Watch on the Rhine*. Herman never took off his overcoat and hat, and always carried an umbrella.

He was entitled by the union contract to hold a certain number of brush-up rehearsals. One afternoon he called us in. He wanted all the makeup, costumes, the lights, and the whole set working. He sat

in the tenth row with his hat, his overcoat, and his umbrella. No one else was there. Nobody worked with him. No one advised him. He had no collaborators or associates. He did everything himself.

That afternoon he just sat there in his theatre, dressed for a cold winter day, and watched the whole second act. When it was over, the stage manager said to us, "Would you all please come and sit down on the edge of the stage?"

Herman came up to the front and stood and looked at us all. Then he said, "That was just beautiful. Thank you." And walked out of the theatre. A weird duck he was.

After I'd been in the part for a few weeks, he decided he didn't like me and said he was going to replace me. He just didn't like my performance anymore. He didn't like the way it had grown, or hadn't grown, or whatever. I don't know. He said I wasn't ready and I was ruining his play. We were selling out and people were in tears—you could hear a pin drop while I was performing—but he didn't like it. He just didn't like it.

A lot of people didn't care for the performance. An actor told someone that he'd seen me in my second Broadway lead, *The Royal Hunt of the Sun,* and was told that I'd been in *The Deputy*. He said, "No, it's not the same actor! You're mistaken!" He didn't want to know that's what he had to face: that I could be as horrible as he thought I was in *The Deputy* and still be as great as he thought I was in *The Royal Hunt of the Sun*. He just didn't want that to be true. Herman wanted to fire me without paying me. My contract was for six months. I said, "Well, Herman, you can fire me but you have to pay me."

And he said, "Well, I'm going to pay you and I'm not going to fire you; I can't afford to do that. So you'd better be there every night."

And I was; I stuck with it for a whole six months and then it closed. Herman was very cordial all that time and never gave me any trouble.

Dad came to see the show and was moved to tears. He came backstage during intermission, sniffling, and said he couldn't talk then. After the show, he ran straight into the bathroom and threw up. He came out in tears and had to put down a couple of shots of Scotch

before he could talk to me. I wasn't sure what to think. Then he gave me the highest praise he could have: he told me I was a better actor than he. After he'd had another Scotch or so, he altered his praise to say I was a better actor than he could be in that part.

The play closed, and it was back to Universal's film factory. I had become more doubtful about the contract. They couldn't really afford to activate their option for a long-term contract unless they put me in a series. So I avoided getting into a series and made a few enemies over there. But I was determined that I really didn't want to continue to be a contract player and play the kind of parts they had in mind. I didn't want to just go on and on there; I simply didn't think it was a good idea. Now that I'd had a taste of Broadway, I was certain I was destined for better things.

When my contract came up for renewal, I wanted out. Pretty much all they wanted me to do was play secondary villains in television shows. I asked Jane what to do. She said, "Disappear." I did that. I didn't go to any auditions. When I went in to the inevitable meeting in New York with Eleanor Killgallen to discuss the pickup, I had created the impression that I was dead in the water. They let me go. As soon as I was out the door and on the street, I jumped with glee, dancing and laughing, shouting with joy. Within a couple of months, I was up for three Broadway roles.

One was a musical version of *East of Eden*, for which they were considering me for the James Dean role. One was a musical version of *How Green Was My Valley*, for which I perfected a Welsh accent. The other was *A Lion in Winter*. I went to the callback audition and discovered I had stumbled into the wrong place. It was for a play called *The Royal Hunt of the Sun,* by Peter Shaffer, which I had never heard of. David Shane, the casting director, who knew me from before, told me I would be great as the Inca Emperor. I thought that sounded like a stuffy part but I took the script home with me. When I read it, I flipped. It was clear this role was made for me.

My agents received a firm offer from *A Lion in Winter*. I said, "No way! I'm doing *The Royal Hunt*." I didn't even have the part yet. They said it wasn't ever going to happen. David Susskind had dropped out and they had no financing. I had faith—an important ingredient for success.

It took me thirteen auditions, but they finally gave me the part. They wanted a star, and I was nobody. I memorized the whole play, practicing on the kitchen floor with my legs crossed, the script at my feet. I wrote music for the song and Donna choreographed the dance.

In the end they just couldn't resist me. Donna and I had planned a trip to Fire Island to soak up some sun. I got a call that I had to go down to the theatre right now for what would prove to be my last audition. I sent Donna ahead and did my stuff. At the end of my stint, John Dexter, the director, walked down the aisle positively giggling. He told me I had the part. Peter Shaffer shook my hand on the way out. He was giggling too.

I stopped and bought a bottle of Dom Perignon and a bucket of ice, and took the train to join Donna. When I walked in with the champagne, she knew right away we'd made it.

The only hitch was, John said I had to get muscles. The part was mostly half naked, sometimes almost completely naked. I was just over 160 pounds, which wasn't macho enough for John.

I went to Sigmund Klein, the most famous trainer in New York. (Steve Reeves and Laurence Olivier, among others.) I lifted weights for six months and turned myself into a definite hunk.

The producers came in with an offer of $500 a week. I said, "No way."

Jane Oliver said, "We can't lose this part, David."

I said, "Look, you don't understand. These guys are crazy about me. They're not going to give the part to anyone else." I didn't want to start out like my father, being underpaid for my whole career. Jane brought in a bunch of the big boss agents, who submitted me to a brainwashing. I finally buckled.

Christopher Plummer, who was my costar, got $5,000 a week, a piece of the gate, and a lot of perks, including an unlimited phone in his dressing room on which he talked for hours to his wife, Tammy Grimes, in London. I found out later that he had been offered the Inca. He turned it down and said he wanted to play Pizzaro. Chris was thirty-eight at the time. Pizzaro was supposed to be in his sixties. He pulled it off, though. And he accidentally gave me my big break. I was twenty-seven.

Around that time, Donna and I started to lose it. Things had changed between us to the point that I wasn't willing to stick with it. When I was struggling to get started, and she was the only one who believed in me, she was happy being my support. When it started looking good, and other people were believing in me too, she became insecure. She developed a habit of picking fights with me and keeping me up half the night on the eve of openings and important auditions. I didn't know what the hell to do.

She had this idea we should get a little house outside of town, with a picket fence and blue pots beside the door. She wanted to hobnob with all those nice actors and actresses, go to the parties. I had always thought that to be a specious goal. I didn't want to get sucked into believing that I had arrived someplace. I had no desire to be saddled with a material base. My dream was to keep going on, to keep traveling, to stay on this train till the end of the line. I didn't want to cash my ticket in.

I said, "Donna, you're talking about settling down. I'm not even getting started yet." One day, in the middle of a particularly nasty argument, I told her I was going to leave her in the fall. I don't think she believed me, but I was serious.

While waiting around for *Royal Hunt* to get itself together, I went to Charlotte, North Carolina, to do some Summer Stock: *110 in the Shade.* I played the stalwart sheriff who gets the girl in the end. I continued my workouts. The gay, young juvenile had a crush on me. He started calling me "Hunk."

At the end of the run, during the cast party, I was sitting at the bar with a pretty little girl with big tits named Jenny. We seemed to have a lot to talk about. We stayed until everybody was gone. When the place was closing, Jenny asked me to call her a cab. I looked at her and, suddenly, felt a stirring in my loins, something that more or less hadn't happened to me since I married Donna. I said, "Come home with me." We spent the night together, and the die of the divorce was cast.

Back in New York, I went to work rehearsing *Royal Hunt.* It was heaven. I was acting out my dreams. I mean, starring on Broadway! Unreal. Everything was going my way. My constituents and superiors were constantly surprised by my very eclectic grasp of everything

theatrical. After all, I was a complete unknown. Peter Shaffer was fond of saying I had come out of the woodwork.

The choreographer was working on "The Dance of the Ailu," and not thrilling me. I showed her the dance that Donna had fashioned for the auditions. She threw up her hands. She said, "My God, if I had known you could jump like that. . . ." She changed two moves, just to have her hand in it, and let it go into the show.

There were only two women in the show, representing the favorites of the emperor's one thousand wives. I got very close to one of them. I mentioned to her that, in order to play the King of the Incas, I should experience the psychedelic drugs that the Incas used to take, just to get the feel of it. Peyote, mushrooms, whatever. How does it feel to think you're a god? She said she couldn't help me with that, but she knew a Harvard professor named Timothy Leary and she could get me some LSD. I said, "Okay."

Very little was known about LSD then. I had no idea what the effect would be. I just thought I was supposed to do it. I certainly wasn't afraid of drugs, or much of anything else. To make a commitment to abandon all safeguards and throw my psyche into a sink or swim situation was, I guess, the point. I was told it would expand my consciousness. I not only wanted that, I couldn't go on without it. I took my chances, as always.

I thought it would be a sugar cube, but it was blotter paper.

We took the stuff on the subway and, by the time we got to her apartment, we were ripped. She put on a stack of records: the Beatles, electric Bob Dylan, the Rolling Stones. I'd more or less never heard this stuff before, and certainly not while high on LSD. I was blown away. Halfway through the trip, I called up Donna. I could tell almost immediately that that phase of my life was over. I looked at the costume sketches for the play and said to myself, "No. This stays."

Then my new friend and I made love. She was the best I'd ever had.

I was taking lunch at a kosher restaurant near the rehearsal hall, with some of the cast, the choreographer, when I ran into Jenny. As soon as I saw her, I was helpless. We started up again. She had an apartment right around the corner from where I used to live with Margarita back in 1960. She made her living as a nude model at an

art school. I began spending some of my nights at her place. Jenny was definitely addictive.

She had a cheetah rug. In the dark of night, I was always putting my foot in its mouth. It was as though he were biting me. I guess he didn't approve of me.

A few years later, I told Chris Sergel, a playwright who had been a big game hunter in the forties, about the cheetah. He looked startled. "What was the girl's name?" "Jenny." He blanched. "I shot that cheetah!" He asked me not to mention it to his wife.

Jenny had a little brother named Marty, who was a great pool player. One night I had to take him to the hospital because, while he was hustling up in Harlem, the boys held him down and drove a pool cue through his hand. I suggested he switch to guitar. He took my advice.

⇒ ⇐

WE MOVED THE *Royal Hunt* rehearsals to the theatre and started to get really serious. Peter Shaffer was now actually directing the show. John Dexter was just staging it. John was the meanest director I ever worked with. He was like an effete British prison warden. His method was to create such a corrosive atmosphere that something was bound to happen. Something did. We blew the roof off New York with the show. I suppose he thought the end justified the means, but there are other ways.

Peter Shaffer was a troubled man but very kind, very different from John. He told me once that he had never been able to obtain his father's approval. When his first play, *Five Finger Exercise,* the piece that revolutionized English theatre, opened in London, his father was in the audience. Papa told Peter that the play was a complete piece of crap. I tried to think how I would have responded if my dad had felt that way about my work. I'm not sure I could have handled it.

Chris Plummer was doing a more less humpbacked limp in the show and talking sort of like Anthony Quinn with a little Lee J. Cobb thrown in. One day he was working away with the juvenile, and he said to John Dexter, who was sitting out in the theatre in the dark, "Move him away from me. He's too close."

John said, "No."

Chris said, "Yes."

John said, "No!"

Then Chris dropped his accent and his limp, stood up straight, and said, "I want him moved. I have a good reason for it."

There was a deathly silence. The next thing would be Chris storming off to his dressing room, and everything would stop. Finally, after an interminable pause, John's disembodied voice said, "Martin, move three feet to the right." Chris went back to work, and from that moment he owned the show.

During our first dress rehearsal, John didn't like the way the huge crucifix carried by Ben Hammer was dominating the scene. He said, "Put her over there." There was another one of those dead silences. The crews in New York are all big burly Irish Catholics. Nobody else liked the joke either. None of us had much respect for John after that.

Peter continued to work with me lovingly and patiently. John methodically tortured me, playing every mind game he could think of, and on the eve of the fulfillment of my dreams, when I should be, by rights, filled with delight, he generally kept me miserable and confused.

Just before we opened, I said to Jane Oliver, "I think I'm going to have to break this director's jaw."

Jane said to me, "Don't do it. You'll never work again."

I decided to myself that I would wait until after the opening night show, and then belt him.

Jane said, "You're going to be great in this part."

I said angrily, "Yeah. I know!"

She said, "Now what's wrong?"

I said, "What's wrong is this is probably the best performance I'll ever give, and it's happening right at the beginning of my career. I don't want it now!"

She said, "Well, look at it this way. You'll never have to audition again." That turned out not to be exactly true, but I was definitely over the hump and on my way.

The opening was spectacular. A truly great show to a full house of tuxedos, gowns, and jewels. Al Hirschfeld was sitting in the front row, sketching me for the Sunday *Times*.

Both Donna and Jenny were in the audience. It was tricky keeping them apart. They had never met, and I didn't want them to. Jim Murray showed up to help me out. I could see both of the girls from the stage. They were sitting very close to each other. Well, they were in my house seats. I had bought Donna a silver lamé dress for the occasion. Jenny had made for herself a low-cut, white silk thing that stopped way above her knees—a gardenia in her hair. She loved gardenias. She topped all this off with a snow leopard, three-quarter-length coat she had salvaged from a used fur store. Well, it was three-quarter-length on her. She was under five feet tall. On stage with me was my Emperor's wife. It was a remarkable thing; they were all my girls. It was like being the Inca Emperor. I was sitting in my dressing room getting off my makeup when John opened the door a crack, said, "Lovely, love," and closed the door. I wasn't able to get across the room fast enough to belt him. I never saw him again.

I was about to go to the cast party but my dad said, "No, you have to go to Sardi's first." He hung back at the entrance and I walked in. I received a standing ovation. Traditionally, if Sardi's applauds you, you've got a hit. Then Dad walked in and got an ovation himself. He waited till the applause died down and said, "I accept this as homage to the producer." Donna was there with a couple of other friends. Of course, I had had to ditch Jenny.

We went off to the cast party and hung out with Chris and the rest of them. A little after midnight, the first review came in. It was an unqualified pan. Dad was outraged. The flow of champagne ceased immediately. The party broke up in a funk. Peter said that the critics were just like his father, who had never thought any of his plays were anything but awful.

I took Donna home, and at the blue door told her it was over between us. There were a lot of tears and I went downtown to Jenny's place. On the way, I picked up the *Times*. Another pan. Okay, I figured, that's it. In the morning I went to the theatre expecting to see the closing notice up. There was a line around the block for tickets. The rest of the papers had given the show rave reviews. In the Sunday editions, the other two retracted their pans. I don't think I've ever heard of that happening before.

⇒ ⇐

THE PLAY RAN for six months, 200 performances. Jenny had had a hassle with her landlord, so I had moved her uptown into a huge apartment at a whopping $150 a month. She was nervous about getting in so deep. I was now supporting her and that made her feel insecure. I didn't want to tell her good-bye—I'd just said good-bye to Donna—so I more or less compelled Jenny to stick with me.

I wrote up a little paper outlining how Donna and I should handle the divorce. I specified that I would pay her a minimum amount if I was not working, and more on a sliding scale when I made money, up to a point. I gave her custody of Calista but, remembering my youth, specified that if she ever put Calista in a boarding school, custody would revert to me.

She said, "I have to hire a lawyer."

I said, "Why? It'll just cost us money."

She said, "Well, obviously you hired one."

I said, "No, I didn't." She didn't believe me. Funny. After twelve years, she still didn't know who I was.

Donna called my mother, who told her to take me to the cleaners. I didn't talk to Mother for two years. Donna hired a lawyer, so I had to. The results were essentially the same, except for the attorney fees.

Somewhere in the middle of all that, I had a little reunion with Calista. She was all done up with a pink dress and new shoes. Jenny and I took her to the park. She decided she hated Jenny (who could blame her?) and was an absolute brat.

Peter Shaffer had a talk with me. He told me I was one of the best actors he'd ever seen. He said I would go all the way if I kept my head. He cautioned, "Beware of television. It will beckon, and you'll be tempted, but stick with the great roles."

There were a few offers to play the great roles, but none of them came through.

Chris was really strange to work with. He had a thing about mumbling all the time, right through some of my best speeches. There was a sword fight in the show, and one night he decided to deviate from the routine and just fight me—which was all right except that

he was in armor and I was more or less naked. He wasn't exactly friendly. Beautiful women would come backstage to be introduced and would ask him, "Where's David Carradine? We want to meet him." Chris had great style. He had his dressing room decorated in Spanish colonial and, between matinées and the evening show, he'd have a meal catered in: white tablecloth, wine, and a waiter with a napkin over his arm. He hated me to come into his room because I'd get my bronze makeup all over everything. The makeup was my own invention. I've never told anybody the secret recipe.

Chris developed phlebitis from the falls he took every night (Pizzaro had some kind of falling sickness). He left the show and was replaced by his understudy, Robert Burr, who refused to go on without a contract. He was inadequate in the part, and it was no fun working with him, and he was making four times as much money as I was. I probably would have stayed on in spite of Burr, but the producers of the show were so mean to me. They wouldn't fix the damn water heater. I had to take a cold shower every night to get off the body makeup. They wouldn't give me any concessions at all; so, when my contract came up for renewal, I got out.

I was offered a TV series that was being shot in New York, about an Indian cop. I thought, "My God. Just because I played an Inca—that lacks imagination." They kept romancing me. At the last minute, I turned it down to do the series "Shane" in Hollywood, based on the Alan Ladd movie. I didn't want to play any kind of a cop and, what with my busted marriage, I wanted to get out of town. Also, "Shane" was a guaranteed seventeen segments, not a pilot. I left Donna and Calista with the railroad apartment, packed up all my stuff and Jenny, and off we went. Burt Reynolds got the Indian cop.

Clayton Corbin replaced me in the play. After two weeks he broke his kneecap, trying to do my dance routine, and his understudy took over. The play closed immediately.

HOW THE WEST WAS ALMOST WON

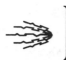Jeff Cooper arrived with Joanie to pick us up at the L.A. airport. A joyous meeting. He avoided the freeway and drove us up La Cienega Boulevard so we could see the sights. He mentioned that the scenery and the women got more boss the closer you got to town. Jenny was frightened of being in "the land of the beautiful people." She was negative and argumentative. Jeff and Joanie wondered what was going on. I figured she'd get over it. We settled ourselves in at the Château Marmont, the traditional hostel for out-of-town actors.

I came down with a recurrence of my old slipped disk and was flat on my back for two days. No doubt mainly psychological—fear of this new leap I was making. At least it gave Jenny something to do besides be afraid herself. She had become very insecure and never really got secure again. Maybe she was just unable to adapt. She always seemed to stay the same, and I kept changing with the wind.

When I was on my feet again, I went in to meet the "Shane" series producer, Dene Peticlerc. He asked me if I had seen any of Kurosawa's pictures. I said, "All of them." He said, "I see Shane as a Samurai." That sounded okay to me. Then he started talking about historical realism. He asked me how my horseback riding was. I said, "I don't know. I haven't ridden for ten years."

Dene sent me to the Silver Spur stables. They had all the flea-bitten gray horses from *Cat Ballou*, which they had taught the various tricks needed for the movie: most memorable being the scene where both Lee Marvin and his horse are drunk and sleeping it off leaning against a wall, the horse with its legs crossed.

My teacher was a crusty old wrangler named Dick Crow. He was a great guy. Dick taught me to ride again and how to handle a buckboard, something I'd never done before.

Dene's instructions were that I should ride like an Argentine gaucho, straight back, reins held high, right hand on my hip. I've ridden like that ever since, except when the horse gets crazy—then I revert to pure self-preservation. Dick also taught me my mount and dismount, and how to make a horse rear up on cue. It's really simple. You pull back on the reins and kick him forward at the same time. It helps if the horse has done it before. Otherwise, it just takes nerve.

They gave me a horse named Candy, a big red gelding. He had carried actors playing Wyatt Earp and Jesse James. He was eighteen years old. He was wonderful. He was such an old hand at acting that he did all the work for me. When he heard the director yell "Action!" he'd go into action. All he needed was one rehearsal. He was very fond of me. He ruined a lot of takes because whenever I was near him, he got a hard-on. Unacceptable on network TV. My costar was Jill Ireland, who had just divorced David McCallum in favor of Charles Bronson. Charles used to come around and growl at me.

I needed to learn how to shoot. The company put me together with Steve Burnette, the nephew of Smiley. Steve was Minnesota State champion in Live Draw Competition. This was done with an electronic timer. The clock started when you touched the gun and stopped when you burst a balloon. Every once in a while, one of these cowboys would disagree with the results. He'd say, "I don't think you're so fast." They'd go behind the barn and draw on each other. People got killed, so they stopped having the competition.

Steve taught me fast draw and a lot of other tricks, some of which I've never seen anyone else do. I'm still arguably the fastest draw in Hollywood. I certainly was then. I got a big kick out of out-drawing the macho villains they would bring into the show. I never

lost the draw—not that it would have made any difference. When the script says I win, I win.

A photographer came in to take pictures of my fast draw. He would say, "Draw!" and press the button at the same time. He was shooting at a thirtieth of a second. I saw the pictures. Half of them were a smoking gun (after the fact), the other half were fire spurting out of the barrel, except for one that was a blur of the gun coming up. A thirtieth of a second is not winning time for competition, it takes about a fiftieth, but the wad from the blank kept hitting him on his forehead, so I was accurate too.

Meanwhile, my lawyer came up with a tactic whereby, due to New York's antique divorce laws, I could get out of paying any alimony or child support if I finalized my divorce right away. I rejected his suggestion—I thought it was dishonest and that it would be really shitting on Donna, which I thought I'd already done enough of, so I waited a couple of years before I got my Mexican divorce.

⇒ ⇐

IN L.A. YOU NEED a car. I found a Lancia Aurelia, something I'd wanted ever since I had seen a new one back in San Francisco. It cost me $1,200. Jeff found me an apartment on the side of a hill with a great view of Hollywood. At the top of the hill was the Yamashiru Skyroom, a Japanese palace that had been imported from Japan in pieces. There was a formal garden that spread all over the hill. At the bottom of the hill was the Magic Castle. I could see the studio from the balcony.

I discovered a complex system of shortcuts, so that I could get to the studio in ten minutes. As my driving skills improved, the time came down.

Later Jeff found me a house in Laurel Canyon, at the top of seventy-nine steps. It was a quaint and beautiful place with four little rooms and lots of space with trees and flowers outside. There was even a certain amount of wildlife: quail, possums, raccoons, even a fox; definitely a far cry from New York City. Jenny called it the "Hobbit house." She had a thing about Hobbits, because of her being so little; actually, she thought she was one. Jenny needed a car, so I found another Lancia, just like mine. I bought a third one, in case I needed parts.

I never got around to buying a bed for our little house. We slept on the floor. After a while, I bought a futon.

The series company was fascinated by Jenny. They made a personalized chair for her that identified her as "Shane's Shady Lady."

Brother Chris showed up one day, looking for lessons, or advice, or something—or maybe he just wanted to get to know me. He must have been about sixteen. Together, we restored one of the Lancias.

➤ ⬅

I REALLY HAD NO IDEA of the obligations and responsibilities I had as the star of a series. I could see there were things wrong—particularly in the scripts. In hindsight, I can see I should have done something about it but I didn't know I was supposed to.

We did a two-parter to end the season. Sam Peckinpah was going to direct it. Then he dropped out. We got David Greene, instead. Our California crew had a hard time understanding a word he was saying; he was English. That, plus the fact that he seemed to me to always be a bit drunk. He'd start out in the morning with red wine in a Styrofoam cup, which looked like black coffee but smelled like red wine in a Styrofoam cup, then he would switch to a highball at tea time. Aside from that, he was a good director.

I was on location, blissfully sitting on Candy, when an extra standing next to me said, "Sorry to hear about the series being canceled." That was the first I knew about it.

I still owed about $2,500 on the Lancias, which was almost exactly what I had in the bank. Chris said, "I guess we cancel the project." I said, "No. We'll see it through."

These larger paychecks had never made much difference to me. At the bottom line, I still lived the way I had when I'd had nothing. No matter how much money I made, I spent it all, and then went back to eking it out until the next bonanza. Money meant very little to me. Still doesn't.

I spent my last dime on the restoration of the car. When it was finished, Oliver, the mechanic, with a big Italian gesture, said, "Now, you are-a-sittinga' in a car!" Chris and I went for a ride together. For an hour or so, it was a great car. Then we were smashed into by a hit-and-run driver. Well, I still had two other Lancias.

Jeff came up to the house and told me I should go to Big Sur or someplace. He said when you flop, you leave town. That was the first moment I realized I had flopped. I didn't take his advice. I stayed in town and played guitar with Marty. Jenny and I were not getting along. I moved into the Montecito Hotel (traditionally where actors stay in Hollywood, when they have no other place to go). One night, in a fit of despair, I took a large dose of LSD. My whole life went by me. In the morning, filled with a brand-new, washed-clean feeling, I drove the Lancia up to the Hobbit house. I told Jenny it was all over between us. I tried to get her to leave the house. She wouldn't go. She cried and kept saying "I can't do it alone! I'm too little."

After a few weeks, she drifted down to Venice by the Sea, where Marty and his twin sister, Muriel, were living. I moved back into the house. I visited the bunch of them in Venice often. Marty didn't seem to be doing much of anything. He told me he was stuck on the guitar and couldn't seem to go any further. I told him to try the blues.

I found out he was shooting up methedrine, big time. Muriel, who would do anything her twin would do, told me she used to sit and stare at Marty while they were both stoned. He would play the guitar as, behind him, she would watch the sun go down, come up, and go down again. Marty would just keep playing until his fingers bled. That was how he learned to play the blues. I told him that shooting speed was stupid and introduced him to LSD. A dubious prescription, but it worked. Got him off the speed and back on the program, more or less. He told me that once, in the interim, he shot up speed and acid together. He said the effect was instantaneous. He lay there for several hours with the needle still sticking out of his arm.

Chris joined the Navy to avoid the Army and Vietnam. He spent his time rebuilding jet engines on an aircraft carrier at a safe distance off the coast of Vietnam. I asked him if he didn't feel strange about that, knowing the plane was going to drop napalm all over the Southeast Asian people. He said, No, that the guys who flew the planes were so handsome and dashing, with their silk scarves and their elite mystique, that all you thought about was keeping them from crashing.

I was assigned a new agent, who turned out to be a good friend.

His name was Saul Krugman and he had been in almost every phase of show business at one time or another. He had also been in steel futures, among other things. He knew more about the business than any man I've ever met. He was a scrupulously honest man and a very snappy dresser. He loved me like a son.

He told me that the thing I had going, aside from being "the best body actor in the business," was the same thing Brando had. I said, "What's that?"

"Menace," he said.

"Menace." I puzzled over that for a long time. It was true that people were afraid of me. I could never figure out why. I wasn't afraid of much of anything, but that wasn't enough. Power. That was it. I didn't know why I projected that either, but I knew I could definitely use it to my advantage.

➤ ⇐

IN 1966 EVERYTHING was happening at once. I suddenly had a series, "Shane," and then it was gone. Jenny was there, and then she was gone. Things fell in and out of my life: my brothers, psychedelics, money, music.

One day Jeff came up to my house and told me I had to go downtown and hear a group called The Electric Flag. He said they had a really good guitar player. I told him I didn't like that kind of music. He said, "Trust me on this one." I went. It was Jimi Hendrix, of course.

On my return, I pulled into my driveway and there was my little brother Keith, probably sixteen years old. I hadn't seen him for years but I recognized him instantly. He was looking to break into the movies. I took him everywhere with me and introduced him to my agents. We played music together. Keith was way ahead of me on the guitar. I introduced him to Marty, and we had sort of a group going.

When Jenny and I finally split up for real, I just stayed up on the mountain with the house to myself. Jeff talked me into going down to the Whisky-A-Go-Go. Iron Butterfly was the opening act. Buffalo Springfield was the headliner. I met the Buffalo's drummer, Dewey Martin. He asked me if I wanted to meet the band. I didn't know who

any of the guys were. Nobody did. Then Dewey asked me if I wanted to meet some girls. I met them all. I danced with them. I went home to bed.

Jeff brought up to the hill two nude models from Santa Monica Boulevard. He took one, I got the other. She was wonderful for a one-night stand. She had beautiful long blond hair. When she took off her wig, she had a crew cut. I can't remember her name. We slept together on my futon and in the morning, as I was sitting on the rug, naked, talking on the phone, she started taking pictures of me with her Instamatic camera. I started to put a stop to it (who knew where those pictures would end up?), when I suddenly thought, "Why not? I don't do anything that needs to be kept a secret. I'm an honest man." That concept was a good one, though it has gotten me into a lot of trouble from time to time.

⇒ ⇐

I WENT DOWN TO De Voss, on Sunset Boulevard, to buy some clothes. This place was the quintessential haberdashery to the "hip." Brioni suits just like the Beatles wore, Indian deerskins, skin-tight bell bottoms, crusader boots. The salesman, Antonio Bandini, the brother of Lorenzo Bandini, the race car driver, introduced me to Osley, the famous maker of LSD. He was the guy who turned on the Grateful Dead, and San Francisco, and the whole world. He asked me if I'd ever taken acid. I told him sure, five or six times. He said I'd probably never really gotten high. I told him he was probably right.

He pulled out of his pocket a small handful of iridescent purple pills, some of his newest batch, and gave them to me. I put them away. He asked me if I wanted to take some now and gave me another one. I swallowed it.

I drove up Sunset Plaza Drive, swimming through a world of swirling, crackling colors. I made it home and found Marty. I gave him a hit and we played guitar until the cops walked in.

You have to understand something about the L.A. police. Sometimes they take stuff personally. I had once been busted by a cop for a busted taillight. When he leaned into my window, he recognized

me as "Shane" and just assumed I was part of the Hollywood elite, that I was in a different class, beyond the reach of a ticket. I'm sure it became his obsession to bring me down, see me fall. He asked to be transferred to my beat, my neighborhood, and began stalking me, looking for any excuse to bust me.

So Marty and I playing music—disturbing the peace—well, that was reason enough for him. The fact that we were tripping was just a bonanza. He busted us for possession of marijuana.

We continued to trip all the way through the arrest process. We were put in a cell with an accused murderer. He started telling us his story over and over. He was very agitated and sort of hypnotized by me, the acid mystic guru. Every time he told the murder story, he brought in a new wrinkle. He kept sounding guiltier. Finally I said, "Hey, man. You're confessing to me. Don't confess to me. You're in jail. Keep your mouth shut." He stared at me for a minute and went over to the bunk and curled up in a fetal position.

Saul Krugman got us out in the morning. I found Julie Shephard, and she took me in. She held me and stroked my head and told me it would be all right. We went up to Santa Barbara to try to get my frightened head back on straight. I was told by the agency's lawyers that if I let them have Marty, I'd get off. I couldn't do that. I hired a lawyer who looked exactly like Perry Mason to represent us both. We won the case, but I lost a career. The tabloids had a field day with it. It was hard enough to be a star of a failed series, but the media circus on top of it all finally sank my blossoming career.

There weren't many options open to me now. I took a part in a little thriller, directed by Fernando Lamas. My costars were Tommy Sands, Aldo Ray, and Melinda Marx, Groucho's daughter. The picture was sort of a fiasco.

I was desperate to get my career going again. The actors didn't seem to be in it for the right reasons; everyone seemed to be involved with booze or drugs. They couldn't work without being under the influence.

I've always thought it dangerous to use drugs for anything but recreation. If you have to depend on a drug to do your work, then it's for sure going to get you. Doing it for kicks or for experimentation

is one thing, but you should get serious when you go back to work. That's where the dependency will hit you. Later on in my life I would have the opportunity to prove this theory.

Tommy decided he was sweet on one of the local girls. The only problem was: so was I. I let him take her. He needed her more than I did. Tommy was writing songs all the time, something like three a day—good songs! The best one was a thing called "Look Out! I'm an Unpaved Road." He was.

Aldo took a liking to me, so I was given the job of keeping him out of trouble. He was enormously strong and, when he was drunk, he was aggressive. I discovered that if you were three feet away from him he was likely to throw a punch at you, but if you got real close to him he'd throw his arm around you and hug you. The hardest part of the job was getting him to his room. He'd stop in the parking lot and pontificate. It could take an hour to get him across that parking lot. Then there would be another hour at his door. I didn't mind. Aldo was a philosopher. Some of his ramblings were definitely worth my while.

The movie consisted mainly of Tommy, Aldo, and me, chained to each other, riding in the back of a truck, with Fernando driving like a madman through the desert.

Fernando Lamas was obsessed. He had complete tunnel vision and was not a good director. He was very arrogant about it, and funny. It was hard to keep a straight face. I fell asleep in the middle of my one close-up, to give you an idea how scintillating the experience was.

A year or so later, I saw the picture, now called *The Violent Ones*, at the St. Mark's Theatre in New York. I thought it was the worst picture ever made.

Jeff married Joanie. I gave him the house and moved into his little place. A one-room cottage in Kent Wakeford's backyard. Kent was a great cinematographer and collector of classic cars. Me and my Lancia fit in just fine. The little guest house was covered with morning glories and surrounded by geraniums. Life was sweet there.

I built a low platform and put a grass tatami mat on it for my new sleeping facilities. I slept on it bare, covered with an Indian blanket. Once a week, I wiped it down with a damp rag to keep it clean.

I went to visit Jeff on a movie set. We were introduced to

Katharine Hepburn. She came up on a skateboard, wearing a cardigan sweater and a wool skirt. The assistant director said, "Miss Hepburn, this is David Carradine, and this is Jeff Cooper." She looked at Jeff and said, "Take chances, young man, take chances" and skateboarded away. Jeff didn't take her advice to speak of. I did.

There was a woman on the set—Diana, an extra, who was about as sexy as things get. I got her phone number and we tried to get something going, with little success. Then, one day, down my path came Diana. I was sitting on the grass playing my Fender Telecaster and she just walked right up and took me. We stayed together for a long time. A year maybe—until I met Barbara.

Brother Chris came back from the front and was stationed at Long Beach. He had served two years of his four-year commitment, but now he wanted out. He engineered a diabolical escape plan, wherein he asked to be let out to care for his aging grandmother. Then he got himself busted for marijuana (something he never partook of) and, after the indictment, allowed evidence to surface that proved the charge erroneous. He then accused the Navy of false prosecution. They let him out early with honors.

Right away, he started to realize his dream of becoming an architect. He didn't want to bother with a degree, so he went to work for a firm as a draftsman. Very quickly, he was designing the stuff, and the guy with the degree was signing the plans. He got married and adopted a suburban, upwardly mobile life-style. After a couple of years, he and his wife divorced.

Jeff and I went to see the Los Angeles production of *Hair*. We were fired up with it. They were casting for replacements, so we got up a rendition of "All You Need Is Love" with Keith playing piano. Jerry Ragny and Jim Rado, the creators of the show, asked Keith to audition. He borrowed a guitar and sang "I'm Easy." He got hired. They sent him to New York to work in the chorus. He stayed with it and worked his way up to the lead.

I didn't have any money. After the rent was paid, I had to make a choice. Either pay for a phone or put gas in my car. I put gas in my car.

Every day I would show up at the agency about six o'clock. I'd help them close up the place and we'd go downstairs for a drink. With the drink always went a mozzarella marinara appetizer. The agents

295

bought. Chances are they had no idea that this was the only food I would have all day.

I was signed to do a western with Peter Fonda. The studio changed hands and the new guys came in and unsigned us. Jim Brown, the football player who became famous for throwing his girlfriend out of a second-story window, replaced me. I don't know who replaced Peter. Larry Cohen was writing it and made the villain into a great part for me, but they were too shy to approach me. They paid me $50,000 not to do the movie. Helpful, but not exactly what I had in mind. I left the business for a while. I followed rock musicians around and photographed them.

Antonio Bandini's brother, Lorenzo, died in a crash during the Formula 1 Grand Prix at Monza. He burned to death because the press helicopter came down and fanned the flames. Antonio tried to commit suicide. He was taken to the hospital to have his stomach pumped. I showed up and took him for a ride to clear his head. I crashed the Lancia into a tree on a horseshoe curve. The tree gave up its life to save ours. We walked to my cottage and picked up another Lancia. No matter what happens, you just have to keep going on.

An agent came up with an okay part. He thought I could do something with it since the character was the most evil villain ever. I was in no position to be choosy. I didn't want to do television segments, so I didn't have a bunch of little jobs to tide me over. The show was a David Susskind Special: a remake of the Jane Wyman movie, *Johnnie Belinda*. My job was to rape Mia Farrow. Frank Sinatra had guards around her all the time, so I didn't get to know her at all. I reasoned that I should avoid the obvious cliché of the snarling, leering villain, so I played him with a charming smile—just your friendly, neighborhood rapist.

During the rehearsals was the Monterey Pop Festival. Not to be completely left out of it, I bought a Mexican 12-string guitar and a Leadbelly book. Whenever I wasn't working, I taught myself how to play. One of the musicians on the show gave me some pointers.

I met a guitar player named Peter who sold me an old Gibson, a much better guitar than the Mexican 12 string. Peter had an extraordinary dog named Hambone that I grew very fond of. No one knew her breeding. He'd picked her up at a swap meet.

⇒ ⇐

I HAD AN INTERVIEW with Marty Baum, one of the most powerful agents in town. I was in my James Dean mode. I wore a cowboy hat over my eyes and put my boots on his desk. He wanted to put me into the movie version of *Paint Your Wagon*. I told him musicals were dead. Clint Eastwood got the part. Marty never invited me to put my boots on his desk again.

One day, while standing in the hall, David Susskind's brother, Murray, asked me what kind of television series I would like to do. I said I wouldn't like to do another series.

He said, "Yeah. But if you would?"

I said I'd like to do a series about Cain, the first murderer, in the Land of Nod. His wanderings. With a mark put on him by God, walking through the old West, to the east of Eden, using his fighting skills to do good in an attempt to atone for killing his brother.

Murray said, "David. I'm talking about a commercial television series."

I said, "So am I, Murray. It would sell. People love mythology."

He walked away, shaking his head.

Later on, I would fall into the opportunity to take that very idea right through the roof. There are no coincidences. Destiny calls. The world turns.

BARBARA

Finally, Saul Krugman came up with a Glenn Ford western called *Heaven with a Gun*. I went to his office and he told me he'd had an offer for $8,000.

I said, "Great!"

He said, "I turned it down."

I said, perhaps hysterically, "Why?"

He said, "Because I'm going to get you ten thousand."

I said, "What? Saul, I need this job. Whatever you do, don't lose it!"

Saul became enraged. He said, "Don't tell me that! Don't ever tell me, 'Whatever you do, don't lose the job!' It ties my hands!" Right then, the phone rang. He picked it up and said, "Yeah?—Okay." He put down the phone and said, "It's done. You've got the ten thousand."

The movie was being shot on location in Arizona. The script was one that Dalton Trumbo had written in Mexico during his exile as a result of the McCarthy purge. Many noble people suffered greatly while that was going on, but Dalton just kept writing. Frank Sinatra attempted to break the blacklist by hiring Dalton, but was talked out of it because he was close to the Kennedy family and could endanger JFK's presidential campaign. Dalton's exile ended when it was revealed that the Academy Award for *Spartacus* was Dalton's, written under another name.

I had a problem with the billing. There was a girl who was being billed ahead of me. Her name was Barbara Hershey. She was almost a nobody as far as I could tell. Saul said her part was bigger and there was nothing we could do about it. I decided to go for it and the deal was made. I went to a reading at Glenn Ford's house. One look at Barbara and I knew she was the one. She knew it too.

Barbara was a Los Angeles girl. Her father was a Russian Jew named Arnold Herzstein; her mother was an Irish girl named Melrose Moore. They had met in Kansas while Arnold was on his way to California. Arnold had been a handicapper for *The Racing Form*, until he got fired for making book. He and Melrose finally settled in Los Angeles and ran a shop that sold baby clothes. He was a great pool player.

Barbara had dropped out of Hollywood High in the eleventh grade to do a TV series, "The Monroes." She changed her name to Hershey because it sounded sweet. Since the series, she had done one movie. She was twenty years old.

I drove the Lancia to Tucson. A little over halfway there, I fell asleep at the wheel and woke up spinning out across the desert. There was a big crunch in the front fender where I had the luck of running into the only tree growing for ten miles. The car still ran, so I kept on going. By the time I got to Tucson I had a ruined pushrod, but I made it.

We went down to Nogales to start the show. I worked all day on horseback. I was thrown off three times. I kept getting back on. The horse wasn't used to gunfire. The third time, as I finished my perfect shoulder roll and landed on my feet, there was Barbara. She said, "You're a great rider." I said, "I just fell off my horse." She said, "Yeah, but you're a great rider." We spent most of the day sitting by a little stream, falling in love.

When the day was over, and we were riding back to town in the station wagon, Dick Carr, the writer who had adapted Dalton Trumbo's screenplay, said, "I'd like to tell you a story." He came out with about five minutes of pure gold about a merry-go-round. Then he said, "Seeing the two of you together makes me think this would be a great movie for you." The die was cast right then, if it hadn't been before.

I arranged a dinner date with Barbara at a place in Nogales. I had a big steak. She had water and a light salad. We talked about everything. She asked me if I believed in flying saucers.

I said, "Well, yeah. I guess so."

She said, "I've heard that out in the desert around here is one of the best places to see them."

We drove out to the desert. We didn't see any saucers, but we saw a lot of stars, mostly in each others' eyes.

I took her home and kissed her good night. (I think it's rude to take advantage of a girl on the first date, just because you're hopelessly in love.)

The next night, we went all the way. She said, "Is forever a good word? Is it okay?" I said, "Yeah. It's okay." She said, "Let's not ever lie to each other." We never did, even once.

Forever is a different story. It takes more than the truth.

Barbara went back to L.A. for a couple of days, ostensibly to break up with her old boyfriend, though, of course, you never know. Another actor and I were running a poker game with some guys from the crew. I got a message during the game. It was shouted up to me on the balcony. "Yes," it said. I looked at the game inside, the darkness and the smoke, and then turned my head to the blazing sun out there, the contented sunbathers down by the pool. I folded my cards. I never played poker again, except in movies. I figured I'd rather gamble on love than money.

When we moved the production to Tucson, Barbara and I took adjoining rooms. We were very much in love. I got the Lancia undinged and repainted and Barbara and I drove all over Tucson together. The best Mexican restaurant in Tucson is The Casa Molina. Try the fresh green corn tamales. Sit on the terrace. Don't neck with your girl in there. You'll get in trouble. We found that out. It's a family restaurant.

There was a scene in the movie where I raped Barbara. We had great fun with that, though I cracked one of her ribs. I was used to a dancer with muscles of steel. It was clear I had to be more careful with Barbara. I always was from then on.

A stuntman broke my nose in a fight rehearsal. I got it sort of

fixed, then I had to do the same fight again with Glenn Ford. It seemed like a dodgy idea, but Glenn kept it clean.

Peter showed up with a bread box full of fresh peyote, at a bargain price. He threw in the bread box for nothing. There was a grip on the show, Billy Record, who won a dirt bike competition in his off time. He taught me how to ride and then sold me the bike.

When the movie finished, I drove the Lancia back home, dreaming of Barbara; Billy followed me in his truck. The funky pushrod went out about halfway home. I just kept going. The Lancia, bless its heart, made it all the way, though that engine never ran again. That was okay with me. All I asked was that it get me home.

The next morning, I had it towed down to Oliver's and we put in the engine from the crashed car.

Barbara came up to my cottage to spend the night. I padded up the tatami mats to make her more comfortable. She said, "No. I want to do it your way." She was very adamant. She kept up with that philosophy the whole time we were together.

Glenn Ford thought we made a beautiful couple and wanted to throw us an engagement party. That wasn't what we had in mind; after all, this was the sixties. There was a blond bombshell in the show named Angelique Pettijohn. She asked me if I wanted to smoke some grass and we disappeared into my trailer. Glenn thought I was cheating on Barbara and decided I was slime. I couldn't very well straighten him out. He probably would still have thought I was slime, anyway.

One weekend, I drove one of the Lancias up the coast to Pebble Beach with Barbara in the navigator's seat for the Concours d'Elegance. We took Route 1, the coast road: a narrow, twisty, cliffside roller coaster. I pushed the car to the limit. Barbara started to get scared. I'd been through this with Jenny, where I had to drive like an old woman to keep her from freaking out. I was not about to do that again. I said, "Don't worry, Barbara. I won't crash." She said, "Oh." And relaxed. What a woman! I really went for it then, passing everything on the road, me and the car a single organism, smoothly outdriving all the other enthusiasts on their way to the Concours. Barbara trusted me. Eventually, I would screw that up too, but for now I was king.

Barbara, Jeff, Joanie, and I ate some of Peter's peyote on the grass

at my little place. This was Barbara's first psychedelic experience. We spent a beautiful night together under the stars, vibing with each other and the cosmos, and then swam in the pool in the morning.

➜ ❦

JEFF AND JOANIE'S CONNUBIAL BLISS lasted one month and then Joanie moved out and they started dating each other. They continued to do this for twenty years or so, through Joanie's second marriage and through thick and through thin. Joanie would call at a specified time once a week and they would see each other on the same basis. They never missed.

Jeff is definitely an unusual man, with unusual ideas and standards. At one point he was living in Rome very happily, going to parties and being gracious and intelligent for a living. Someone asked him what he did. He said, "This." He was informed he was supposed to do something in particular, like work, maybe. He decided to try acting. He made an abortive foray into Hollywood, and then went back to his Canadian birthplace and studied acting. When I first met him in the New York airport he was starting his second try. He was like a wild animal as far as his knowledge of contemporary social practices were concerned. So was I. We compared notes. Some of his ideas and practices were extreme to say the least. Whenever he was contemplating forming a liaison with a woman, he would first take her on the altar of an all-night chapel, demanding that she renounce God and abandon all moral pretensions. He believes that the human race is a blight on the planet, that virually all human actions are antithetical to the design of The Maker, and he denigrates virtually all popular, acceptable pursuits by the species: family life, law, conventional love. The only rare exceptions are music, art, and laughter. He is so critical that he cannot stand to be exposed to almost anything. Media, in particular. He has his heroes, but you've got to be very special to get on his list.

Barbara was living in a suburban house in Studio City. She was buying it. Keith and Marty moved in and I spent most of my time there, getting stoned, making love, and playing music. Chris was a constant visitor, and Peyote Peter came around a lot too with his dog, Hambone. Barbara had a roommate, a beautiful Irish girl with red hair

down to her ass. After a short while, she moved out and left us to our madness. We took a lot of acid and smoked a lot of grass and played a lot of music.

Brother Bobby came up to visit. He was a pretty good guitar player, but he had broken his wrist, and while he had his cast on he was learning to play the bass. He was about twelve years old. He was crazy for cars. He kept asking me, pleading actually, to put my foot on it on dangerous mountain roads. He was hard to resist. We had a couple of close calls.

Barbara auditioned for a movie called *Last Summer*. They offered her the role of the plain girl. I told her to turn it down and play the pretty one. That's what she did. The other girl got an Oscar, but Barbara became a star. I never heard about the other girl again.

CHAPTER FORTY-SEVEN

COWBOYS
AND INDIANS

hile I'd been in Arizona, Saul had picked up two more movies: westerns, both with Robert Mitchum, and both directed by Burt Kennedy.

During the first Mitchum picture, I met Peter Fonda, who had driven up to see someone on the set. Peter told me about this movie he had just finished, which he financed with his Diners' Club Card: *Easy Rider.* I filed his methods in my brain for future reference.

For the second Mitchum/Kennedy movie, I imported to the location Marty and his little gang, which now included Paula, who sang like a bird, and Roger, a very young and excellent flute player. With me on my conga, we were a band. It turned out, however, that we were too far out for Chama, New Mexico. We had to move to another motel.

One day we took a walk in the woods, on acid, of course. It rained and we found shelter under the roof of an abandoned railroad station. The tracks had been taken up. There was an Apache under the roof with us. I asked him, "Why are they tearing down this railroad?" He said, "Because the white men are leaving." In our altered states, that seemed totally reasonable.

My dad was in the movie too, so we had a little fun together— not a whole lot. We had grown so far apart that we didn't have much

to talk about. He was a strict traditionalist and I was an acid freak. There were always his great stories, but Mitchum was a great story-teller too and Dad had to take a backseat to him. Mitchum was an interesting man and was as tough and uncompromising as they come.

The location got snowed in so we had to finish up in Stockton, California. Chama had been full of aspens, so we painted all the trees in Stockton gold. I was always practicing my fast draw. Once I pulled the gun out really fast and a stunt man who was passing said, "Wow!" I said, "Every once in a while."

One of the things I discovered on that location was that Burt Kennedy was almost blind. I thought this was a big problem for a motion picture director. Then I thought about John Ford and Raoul Walsh. I threw in Beethoven just for kicks. I decided I loved this guy.

We finished up the picture on the Warner Bros. back lot. There was one scene where I was supposed to be sort of funny. I didn't bring it off too well. I sat next to Burt Kennedy as they were changing the lights and the camera. I said, "You know, I sure wish I could do that again." Burt jumped up immediately and said, "Flag on the play. We're doing that shot again." The crew reversed itself and put it all back together. I redeemed myself. Burt said, "Print that one. Forget about the others." I felt like a star.

One day, as I was driving to work, I saw the most outrageous car ever with a For Sale sign on it. Huge fenders, great grill, flashy chrome, painted yellow with black flames. It looked like a monarch butterfly. I bought it. I didn't even know what it was.

I put my foot on the gas and almost lost it (understand, I had never been in the car before). I said to myself, "This is going to take a little getting used to."

The old man I'd bought it from yelled, "You'll wreck it! They all do!"

I made it to the set at Warner Bros. without incident. Mitchum was standing outside the soundstage. He yelled across the lot, "Is that a Cad Allard?"

I yelled back, "Yeah."

He just stared with his mouth open.

"Why not?" I yelled, and zoomed away.

After driving it for a day, I could see what the old man meant. The car was a fire-breathing dragon. If you put your foot to the floor at a dead stop, you'd go through a wall before you had a chance to change your mind.

The car would go 150, but it took two or three lanes to do it, it wandered so much. It didn't have much in the way of brakes. When you started it up, a large puff of blue flame exploded out from under the hood. I loved it.

Peyote Peter asked me to consider taking Hambone, saying that he couldn't take care of her anymore. I went to visit him at his little place in Silver Lake. While we were talking, I opened a briefcase on the table and found a kit for shooting heroin, complete with a bag of white powder. Peter said, "Well, now that you know, I might as well shoot up." I said, "No way, I'm not going to watch you do this to yourself." I took Hambone and went.

Hambone and I fell instantly in love. The second day I had her, I drove away, leaving her in the backyard. I looked in my rearview mirror and there she was, running up Laurel Canyon after me. I looked at the speedometer. It read a little over 30 mph. I looked back at Hambone. She was actually gaining on me. I stopped and let her in. After that, I took her everywhere with me. She adored riding in the Allard. She'd lie on the floor with her head on my accelerator foot, which tended to make me drive faster.

My brother Chris showed up and wanted to drive the Allard around the block. I said, "Be careful." When he brought it back an hour later, there wasn't much left of the transmission. Billy Record and I replaced the gearbox in Barbara's garage. It took us days, lying down under the car, covered with grease, struggling with slippery, heavy weights. I never want to do that again.

Barbara and Jeff and I became a constant trio. It was a rare thing, the fun we had together.

Jeff was crazy about the Allard. He took me to an exotic car lot on the Sunset Strip to see another great classic—a 1957 BMW 507, easily one of the prettiest cars ever made. I fell in love with it. (I fell in love a lot in those days—so did everybody else. This was the flower generation.)

I bought the Bimmer and Jeff traded me his Porsche for the

Allard. I probably got the bad end of the deal but we were both very happy. I bought an ecological personalized license that said FOOL.

That BMW inadvertently taught me a little lesson about the movie industry. I drove onto the Universal lot in it, very proudly. A driver captain stepped out and said, "Park it over there, Mr. Carradine."

I said, "No. I'm going to drive onto the back lot." I wanted to show it off.

He said, "No, you're not."

I said, "It's a very valuable car."

He said, "We'll take care of it."

I said, "I've got a guitar inside it."

He said, "We'll take care of it."

I said, "Look, I'm a guest star on this show. Accommodate me. This studio is here for the purpose of making movies, right?"

He said, "No sir. This studio is here for the purpose of providing jobs for teamsters."

I left the car with him.

I convinced Barbara that she should get out of her suburban house and find a place in Laurel Canyon. She did: one of the nicest spots I've ever seen. A little cottage perched on a hill with an enormous fireplace and surrounded by fruit trees. We had some sweet times there.

Somewhere around this time, Jeff found himself an acting teacher. A fellow named Justin Smith. I went down with Jeff one night. I stayed. It occurred to me it wouldn't hurt to find out what all these idiots were talking about. Idiots: Lee Strasberg, Elia Kazan, Jeff Corey, Stella Adler, Herbert Berghoff, Uta Hagen. I bit that bullet for two years. I got Barbara going to the class, and Keith. Keith was amazing. He just couldn't do anything wrong. He would never tell us how he did it. Maybe he didn't know.

There was a young kid, very beautiful and dangerous, with talent locked in where he couldn't get at it. His name was Ron. Ron had been in prison for something to do with assault, possibly manslaughter. He wasn't a tough guy; he was merely lethal. There was a sweetness about him that was a rare thing. If he could have put his real self, with all the contradictions, into his work, he would have

gone far. Someone needed to bring it out, but Justin liked messing with his mind—just for fun, I think. He had Ron twisted up like a pretzel.

Acting lessons can become as psychologically destructive as a therapist/patient relationship gone awry. Many students become guinea pigs for the acting teacher. In this case, Justin was blocking Ron's creativity instead of helping him release it.

Finally, I walked out of the class, forever. I'd learned everything Justin could teach me and I really didn't want to change the way I did things. I went there to learn how to act natural and I had accomplished that. Justin didn't understand my technique and seemed bent on tearing it apart. I remembered my father telling me that acting is something about which there is much to be learned and absolutely nothing to be taught. He also remarked that all acting teachers are failed actors, so how can they help you? There is probably some truth in all of that.

The main duty of an actor is to be convincing. The way I accomplish this is by manufacturing spontaneity: I train the back mind but I don't train the front mind. I let the front mind act for itself. It's really simple. For instance, you need to smile. Basically you smile with the muscles of your mouth. However, if you personally, with your intellect, manipulate those muscles, it won't look like a smile. But if you think of something funny you'll smile in spite of yourself. That's the important thing about acting: you have to be doing it in spite of yourself or it doesn't have a sense of reality.

Anger is something you can push almost a direct button to get to. Happiness and other positive feelings you can't push a button for. People won't believe it. You won't believe it and it won't happen for you. But anger: all you have to do is turn up the volume on anger. You don't have the problem of synthesizing. You have to be circuitous about turning the volume up on tenderness. If you turn it up, it ruins it, sort of plasticizes it—this natural and important thing that people reach out for so much. People will see right through the pretense. Tenderness has to come out tenderly. It can't be pushed out. The corners come off of it. Like the little smile faces you put on your car: it's not a real smile, just a symbol of a smile. We all know that. But anger, even in its symbolic form, is quite believable because

people reject anger rather than going toward it. If I had switches to just turn things off and on, it would be delightful. I just don't have them.

The thing that makes it all work is technique. Pure technique. Every moment is studied, analyzed. Choices are made. The natural reaction, the stumbled line-reading or disarming smile is calculated in advance. The performance may be an "unconscious" process, but it is the result of deliberate decisions.

Looking for these techniques, I studied actors, attempting to reach some understanding of how they felt when they were conceiving and performing their portrayals. I also had to consider how this related to their lifetime images.

I embraced and absorbed icons one at a time. Starting, I guess, with Gary Cooper. He had risen out of my boyhood westerns, head and shoulders above the rest. Humanity was what he had. He didn't go around hitting people; he was slow to draw a gun, shy with women. Funny. Incorruptible (that was a good one). And, boy, could he ride.

Then Judy Garland, Astaire, and Kelly. Laurence Olivier. James Dean, Brando, Newman; then Spencer Tracy, Orson Welles. Bergman, Fellini. Belmondo, McQueen. Peter Sellers was a huge influence. You gotta make 'em laugh. Finally, after long years of holding out, I acknowledged the Duke. Then, in 1965, I threw in Mick Jagger. Since then, I've been making it up on my own.

I rarely really study a character. I just make them up. Try to feel not how they would feel, but how I would feel if I were them. At the same time, as I'm performing, I constantly analyze: my body movements, voice, pauses. Where the camera is. Looking as though you're thinking something is as good as thinking it, and it leaves your mind free to deal with other aspects of the performance. Some actors act while they're reacting. I don't think that works. Why pretend to listen when you could just listen? Making faces is definitely out, unless you're a slapstick comic or supposed to be having an epileptic fit.

It's always seemed to me that what fascinates an audience is the part of the performance that is not understood—ambiguous looks, the mystery. Stillness, quiet strength. The stuff underneath. You can't

decide to be deep now. You have to bring it in with you. Fine actors are deep people.

Supporting it all for me is the built-in aptitude and ability as a second-generation actor. The whole process is second nature to people like us—like the way cats know how to hunt. It's easy to speak French like a native if you're a native Frenchman.

Justin Smith, the acting teacher, had told me I acted off the top of my head. I told him I act with my big toe, which is completely different.

After about a month, I went back to the class. I walked in the door and said, "Ron. Get out of here! This guy's trying to kill you!" Ron walked out with me. A big student who had been a football player tried to block our way, but Ron and I were a little much to take on. He reconsidered. We went up to my place, via Nichols Canyon, the windingest road in town, full of very tight turns. I put my foot to the floor and drove it a lot faster than I dared to. Ron kept right on my tail in his Jag.

We were free!

➤ ◄

SAUL LEFT THE AGENCY he was with and took Barbara, me, Jon Voight, and Tony Zerbe with him.

Barbara starred in something called *The Baby Maker*. We all thought she had a chance at an Oscar nomination for that. Her career was really taking off.

Some people in New York wanted me to do an Off-Broadway play about Gandhi. I spent about a year working toward that. I got the little Hindu down pat. Then they changed their minds and asked me to play the villain. I said it was politically incorrect to use an American hippie as the assassin of Gandhi. They said that was unimportant. José Quintero, the director, called me on the phone and pleaded with me to take the part. I told him that after living with the Gandhi part for a year, I would hate myself and everybody else if I played his assassin.

Instead, I went with a movie Saul had come up with, a real zinger. It was a really great script called *The Last Cowboy*, written by Harold Jacob Smith, another one of the famous "Hollywood 10," those in the industry who had become casualties of the House Un-American

Activities Committee. This was the same guy who wrote *The Defiant Ones*. *The Last Cowboy* was about a black man's troubles after the Civil War. They wanted to call it *Midnight Cowboy*, but that had already been used. The cast included Burl Ives, Jack Palance, Nancy Kwan, R. G. Armstrong (who would become a lifelong friend), Brock Peters as the lead, and my father. Nancy and I were playing Indians. (In those days white and yellow people were allowed to do that.) The picture was shot in Santa Fe, New Mexico.

Pretty much by accident, I had a small affair during the filming. Actually, I was seduced. I almost lost Barbara over that, but we patched it up. At least I didn't lie to her. I kept my promise, but that little liaison plunged me into a period of infidelity. In the seven years I had with Barbara, I was unfaithful to her seven times. The last time broke the back of our eternal love. But that came much later.

Halfway through the picture, we participated in a celebrity softball game: the cast and crew versus an Indian hardball team. Jack Palance played second base. Burl Ives, Brock Peters, and I were designated as pinch hitters, Nancy Kwan was Burl's base runner. When I came up to bat, we had two "men" on, Nancy and Brock. I swung at every pitch. On the third one, I connected. I hit an infield bouncer and turned it into a home run as a result of a couple of Indian errors. I ran so fast that I almost ran over Brock. He had to slide into home plate, or at least he thought he did. I just charged right over him. It was not one of the greatest moments in sports, but at least I hadn't disgraced myself.

There was a moment in the picture which gave it some philosophical grit. The black farmer goes to the Indians for help. He says, "It's my land." The Indian (me) says, "It's not your land. It's Indian land." I cornered the writer and told him, "It's not right." I gave him a line. "It's not your land. It's nobody's land. Nobody owns the land. We say, 'We don't own the land. The land owns us.'" The writer was terrified of the concept. It sounded sort of communist to him. He was gun-shy. He thought if he put it in his movie, they'd blacklist him again. Unlike Dalton Trumbo, he had spent his exile mopping floors. I convinced him.

At the end of the picture, the Indians come to the rescue of the black man, like the cavalry. I got to shoot Jack Palance.

Alf Kjellin, the director, came down with hepatitis and couldn't finish the picture. The producer took over and pretty much bowdlerized the film. The name was changed to *The McMasters*. I don't know why.

I got my first real movie review from that picture. It stated that "David Carradine gives his first decent performance in this picture." Faint praise, I suppose—but any positive comment was welcome.

The picture was bought by Chevron Releasing. They buried it. The kind of idea that a big oil company probably doesn't want floating around is one that denies the concept of property.

Coming home from Santa Fe, I drove the BMW at full bore. I got stopped by a cop in Arizona because I slowed down going through a town. He'd been chasing me for quite a while. I didn't know that because he never caught up with me. He was going to take me to see the judge, but he was so impressed with the car and my honorary deputy sheriff card I'd picked up in Santa Fe that he let me go.

THE TIMES THEY ARE A-CHANGIN'

I showed up in New York on a motorcycle with my pockets full of peyote. I was in town for an Off-Broadway play, a farce about the second coming of Christ. He's discovered walking down the street of a southern town, carrying a plastic cross, with three thousand people following him. He's arrested and put in jail. Eventually, the sheriff shoots him dead.

During the two weeks of previews, we had the audience alternately rolling in the aisles and transfixed with holy terror.

Opening night, we put on a great show but the critics bombed it. We had a champagne party on the stage after the audience cleared out. When the reviews came in we switched to beer. The show closed right then. We got one rave review and six pans. The rave called it "The finest passion play ever: on or off Broadway." The other critics liked it okay, but put it down because it was "largely improvisational." If they had seen it twice, they would have discovered that the apparent improvisations were repeated exactly every time. We had done our work too well. Anyway, the theatre was small enough so that I could see the critics and their faces. I know I had them. They just went home and lied; not unusual for critics. I scared them. What the hell! I scared me too.

Frank Perry was getting ready to do a stage production of *Caligula* with me, but after the reviews, it was dropped.

Marty was living in New York at the moment, so I took him into a studio and we spent a week recording all his songs. Keith was in town playing the lead in *Hair*. He and Marty were collaborating.

On the first day of the session, Keith came in gleefully and said that they had let him off for the matinee. He didn't have to do the show. I said, "Do you really like not doing the show?" He thought for a moment and grinned, "Yeah. Almost as much as I like doing it." Spoken like a true Carradine.

We all took an LSD trip together. Paula never really came down from that one. She's still out there to this day. I'd never seen that happen before, though I'd heard stories.

I was about to go back to California with the tapes and with my tail between my legs when I decided to go to upstate New York to see Donna and Calista. I had two reasons: to get to know my daughter a little and to see if there was anything left between Donna and me before I got in any deeper with Barbara. There was but there wasn't.

No jobs were forthcoming when I got back home. I plunged into my relationship with Barbara full force.

➵ ➴

BARBARA AND I LIVED in our own world. We put ourselves above everything, made our own rules. Shame was not in our vocabulary simply because we could do no wrong. We were a perfect couple.

We were crazy about each other. Every chance we had, we made love. We were not fancy, but we were always there for each other

We were invited to a lot of parties. At every one of them, I would find the door to the back rooms and turn to look at her. She would be talking with someone else and catch my eye. I would turn and go and, instantly, she would follow me. We would find an empty bedroom and ball on the floor. Then we'd rejoin the party.

After a while, Keith came back from New York and I gave him my little cottage; I moved in with Barbara. Keith had to sleep on my ascetic pallet, but he was happy.

To pass the time, I took to repairing guitars. I didn't really know much about it, but I got better. I hate to think how many instruments I must have screwed up while I was learning. Never take your guitar to a tramp repairman.

Hambone got pregnant somehow. She produced a litter of strangely marked hound-like things. Barbara and I decided to keep a pair of them. I named mine Man, and she named hers Flower. Peter showed up and took Hambone back, having kicked his habit for the moment.

Brother Bruce came down to try his luck at acting. He, his girlfriend, Barbara, and I were sitting in a sidewalk restaurant on the Sunset Strip when the famous curfew came down. A twelve-year-old boy ran by us and streaked up the alley, chased by a cop in a hard hat with a 12-gauge pump shotgun. I thought, "What's he going to do? Shoot the kid for being out after ten o'clock?"

Bruce said, "We've got to get out of here! There's something wrong here."

I said, "Hell, no. I'm not leaving."

The streets, those days, were packed with kids, running all over the place, listening to rock and roll, dancing, singing, experimenting, not just with drugs but with life, trying to find a present and a future that were not prescribed. They were looking for a new world that they could call their own, rejecting the scheme their parents and teachers had cooked up for them to keep them in line.

The minions of the law could not allow that. It scared them. These children had to be disciplined, punished, brought in line. So they activated an antique statute that prohibited teenagers from being out after 10:00 P.M. When in doubt, go backwards.

It seemed to me that the curfew itself was a kind of un-American thing on the part of the authorities. It amounted to martial law. This was supposed to be a free country. That night I had the feeling that, if I left my seat in that sidewalk restaurant, the place would become Nazi Germany. You had to be able to just sit. This was America. This was Hollywood. Bruce went. I stayed. Peter Fonda was hassled and almost arrested down the street for taking photos of the event.

The whole incident was a definite sign of the coming times. The city used its zoning laws to tear down Pandora's Box. It was the only way they could get rid of the action there. Shades of The Old Gas House. The authorities are always trying to shut down the radical youth movements. It never works.

In the years afterwards, I made my house a haven for kids like that. The youngsters were a little too young for me to relate to and I would have thought they should go home to their parents, anyway. But the older ones, the nineteen- and twenty-year-olds, casting about and not knowing what to do with themselves—I took care of them. If young people want to bust loose, you have to let them. And you have to be there for them.

A while later, the pot supply dried up because of what the government was calling Operation Abolition, a program to close the borders to Mexico. Everybody started doing cocaine instead. I tried a little and decided it was not for me. I didn't like it. Just lucky, I guess. After a few months, one of my guitar customers offered me some smoke as payment. I was surprised. I asked him where it was grown. He said, "Connecticut." I realized that all Nixon had accomplished was to impel the U.S. to grow its own.

Barbara's dog, Flower, got run over. I buried her up on top of the mountain. A couple of weeks later, one of my neighbors came screaming down the road in his Porsche. I jumped up the hill and threw a peach at his car, yelling "SLOW DOWN!" He stopped and said he wasn't an irresponsible driver. I said something like "Oh, yeah?" Man growled and barked at him.

He said, "What happened to that other little dog, the sweet one?"

I said, with my best Robert Mitchum imitation, "She was run over by a truck."

He said, "Oh" and drove down the hill very sedately.

Things started to pick up a little. A job here and there. Marty and his tribe came back to L.A. By now the bunch of us were really a band of musicians. I decided I needed to find a place for the band to live. I went to a real estate agent and told him I wanted to rent a house in Laurel Canyon. He said there weren't any for rent. There were some for sale. I wanted to know what the difference was. He said, a down payment. I asked him how much. Around $4,500.

So I bought a house. It was four rooms at the top of seventy-nine steps, on an acre and a half. There was a shack next to it, very livable but with no bathroom. I moved the band into the house and I took the shack. Paula's little brother, Warner, and sister Mary joined

us, as did Roger, the flute player. I erected a teepee to accommodate the extra members.

I bought an old milk truck to carry us and the equipment around and we started playing gigs here and there: Marty, Keith, Paula, Roger, and me. I guess you'd have to call me the manager.

Roger turned out to be sort of crazy—well, weren't we all? He lived in the teepee. He developed a huge crush on Mary. Then, when that didn't seem to be working out, he started on Barbara. One day, as he was blindly pursuing his passion, I explained to him that she was off limits to him because we were going to have a child together. Barbara sort of melted into my arms. It was the first she'd heard of it. First I had too.

Around this time, Peter showed up to deliver Hambone for another spell. The dog and I bonded again instantly.

I started growing my own grass. It was a very paranoid activity; I had a rush of dread whenever a helicopter flew over. I also scored some peyote from a "roadman," a member of the Native American Church who was allowed to transport the plant in those days as an expression of religious freedom—although selling it to a white person was strictly a no-no.

Keith got tired of the band. Marty had written some great songs but, as the lead singer, was continually blowing it in performance even though he was always great in the house or on tape. Keith was sick of the whole thing and, anyway, he'd been hired to do a movie, a western with Kirk Douglas and Johnny Cash: *The Gunfighter*. It was only one day's work. He got shot to death by Kirk. It was a start. Marty and everybody else decided to go to their various ancestral homes for Thanksgiving and Christmas. By this time, I too was disillusioned with the group. It seemed to me I was neglecting my own career. Just before Marty left for Michigan, I said to him, "Do me a favor, man—don't come back."

I never saw any of them again. I talked to Marty on the telephone once, after a lot of detective work to find him. He was living in the woods in northern Michigan. I still wanted to try to get his songs out. He told me to go to hell. Keith got a letter from him once, written on a piece of bark.

THE SECRETS OF
THE AGES

That night I moved into the house and started writing my first song. I wrote the lyrics on the dining room wall. In the morning, I called Barbara and asked her to "come live with me and be my love." She moved in right away and gave her little cottage to Keith.

I bought some new tatami mats and made a new platform, and we went back to our pallet-sleeping routine. One interesting thing about this discipline was that you couldn't curl up in a fetal position. You had to sleep on your back. It did wonders for the spine, and when you were sick, or emotionally wrecked, you just had to muscle it through.

Saul Krugman had as a protégé a young agent named Paul Rodriguez. Saul taught him everything, including where to buy his clothes. The agency office was shaped in a circle. One day they made a bet. Saul would go one way and Paul would go the other. They would make out with every secretary on the floor. Whoever made it all the way around first was the winner. Halfway through, Saul had a heart attack.

While he was in the hospital, someone I didn't know introduced himself as my new agent. He told me it was a young man's business, and Saul would never make it all the way back. I told him thanks, but I would stick with Saul. They assigned me a temporary replacement,

Bullets Durgham, an old buddy of Frank Sinatra. He didn't do any-
thing for me but he had a lot of personality.

Around this time, an extraordinary man stumbled into my life:
Nene Montez, a Cuban revolutionary, six-foot-five, strong as a timber
wolf, politically far left, blessed, or cursed, with an uneven genius and
drunk as an Irishman.

He had been brought to Hollywood as the technical director for
the movie, *Che*. He was a former close companion of Che Guevara
and was with him at the time of his death in Bolivia. After two weeks
on the film, Nene walked off the set in disgust. Now he was trying to
make a movie about the way we are all brainwashed by the establish-
ment. Not an easy project to get made in Tinseltown, even in the six-
ties. I allowed him to attach me to his movie. We made it all the way
up to one last meeting with Lou Adler, the music mogul responsible
for The Mamas and the Papas, among others. We stubbornly adhered
to our artistic purity and effectively pulled the rug out from under
ourselves.

Saul came back stronger than ever, though more trepidatious
now of marathon make-out contests. He came up with a job inter-
view at Warner Bros. for a movie titled *Macho Callahan*, starring David
Jansen and Jean Seberg. I went to see the director, Bernard Kowalski.
The part was an elegant, wimpy bridegroom with a missing arm. I
said, "This is a Leslie Howard role, and I can do Leslie Howard with
one arm tied behind my back." I got the part.

The picture shot in Mexico, in an old hacienda that had been a
sugar plantation until Zapata turned it into a ruin; and, then, in a vil-
lage called Tliacapac, where the final scenes of *Butch Cassidy and the
Sundance Kid* had been shot.

A story circulated that Bernie had asked the Mexican govern-
ment if they would allow him to kill a horse in the movie. They said,
"Sin problema." They would just pick one up from the glue factory.
When we arrived on the set, there was a dead horse. Bernie explained
that he wanted to see the horse die on camera. They provided anoth-
er horse.

The scene as it happens on film was remarkable: the horse rear-
ing up with his head to one side, and falling, surrounded by smoke
and fire and frightened soldiers firing off their rifles. It looked like a

painting by Diego Rivera, which was the image that Bernie wanted. I was appalled by the immorality of the thing, regardless of whether or not the story was true. But I was broke and humble in those days.

The flaw in the whole idea is that horses can't act, but the audience doesn't know that. They watch this beast giving its life away with the same interest with which they would watch Ricky yelling at Lucy.

I didn't have much to do; my part was very small. David Jansen shot me to death over a bottle of champagne, and I played dead in the dust of the Tliacapac town square for three days. I got friendly with David Jansen's wife, Rosemary Forsythe, who didn't have anything to do either; we drank a lot of tequila together. I absolutely loved Jean Seberg. She was a great lady. Lee J. Cobb was a lot of fun too.

One day, just before a shot, the wardrobe people were fussing with my clothes interminably. I said, "How do you make them stop?"

Lee said, "You say Basta (enough)!"

Jean said, "No. You say 'No es necessario.'" Sweetness instead of command. Like I said, a real lady. It broke my heart when I heard about her death.

On the set, I fell in with two Mexican actors, Pedro Armendariz Jr., and Hugo Stiglitz, who later became big stars and producers and directors in Mexico. They showed me the ropes.

One day, I was standing around waiting, and a young Mexican said to me, "Senor, do you go to live in the country?"

I said, "What?"

"Do you go to live in the country?"

I said, "I don't understand."

He said, "Okay" and walked away.

I asked Hugo, "What was that all about?" He laughed. "He was asking if you smoke pot. Sort of a code."

Barbara came down to visit for a few days. We ate some peyote and started to see scarabs everywhere. This scarab-sighting thing was something that went on for years. Whenever Barbara and I took a psychedelic together, out they would come. I don't know what it means; something to do with Egyptian deities, I suppose.

On our last day, the village threw us a fair. Everybody bought knick-knacks and ate and drank. I bought a quart of pulque, a drink

made out of cactus juice. I rode back to Mexico City with Hugo. He came up with some grass and by the time we got to El Presidente Hotel, I was snookered. There were a bunch of cameras and they made a big thing about signing the register. I couldn't see to write my name.

I did my little bit of work at Churobusco Studios, saw the pyramids outside the city, and was ready to go home. I had to wait for three days for them to check the film, which was inconvenient since it was just before Christmas. The company was moving up to the high desert for the rest of the shoot, so I decided to take a jaunt and see some Mayan ruins.

I went to the travel agent and asked her if she could get me to Palenque. She said, "How do you know about Palenque? That is an unusual request." For years, in books I had seen pictures of a terracotta head that haunted me like déjà vu or something. (Didn't I just say that?) Under the picture it always said "Palenque," and sometimes, "The Pyramid of the Magicians." She told me I had to take a plane to Villa Hermosa, then rent a taxi and go another two-and-a-half hours. I went for it.

The village of Palenque had one hotel, which was under construction. There were seven rooms finished. They had one left. We all ate at one big table. Seven ruin hounds. The conversation was stimulating. One of the hounds was a building contractor. He had built airstrips in Vietnam, working for a company he said was owned by Lady Bird Johnson. Interesting. He also told me that the main reason for the war was that Vietnam had the richest deposits of titanium on the planet, and as we were defoliating the place we were pulling out the metal. Interesting. What we were doing with the titanium was building jet fighters, quite a few of which were destined to be shot down over Vietnam. Interesting.

The ruins were in the jungle ten miles away. I took a cab. The beauty and mystery of the place were beyond my wildest dreams. My sense of déjà vu grew immensely. There was a guide sitting in a straight-backed chair at the top of the Pyramid of the Magicians. His name, I learned, was Raoul. For a quarter, he took me down to the tomb at the bottom with a flashlight. We stood and played the flashlight beam over the empty sarcophagus. This was where the famous

head had been found. I asked him where the body was. He told me it was in the museum in Mexico City.

The sloping, pyramidal walls of the tomb were covered with sculptures, which were almost obliterated by dripping limestone. The lid of the sarcophagus, which purportedly weighs sixteen tons, was totally intact.

The carving, as fresh as the day it was placed there, depicts a man sitting on a cushion with one hand on a lever and the other on a knob, hoses issuing from his nose and terminating at some bottle-shaped objects. All this is surrounded by an upright, bullet-shaped outline, beneath which flames shoot out. Above it is a bird with wings spread, the symbol of flight. The contemporary tribes there call the man "The King"; others call him the space traveler.

I wandered around the ruins all day, playing my guitar, admiring the wild horses, and swimming in the waterfall. Just as I was leaving, I went in under the trees to relieve myself. Thousands of bugs attacked me and, as I was batting them off, I ran into some members of The Rolling Stones cadre. I said, "Well, I guess it's worth it."

The manager person said, "Worth what?" He stared at my Guild guitar and asked me what kind of strings I was running. I told him just regular Martin Bronze. He said, "Why do they shine like gold?"

I said, "I don't know. Maybe it's the place."

He didn't know what I was talking about. I had expected more from The Rolling Stones.

That night at the dinner table we ruin hounds talked about the "space traveler." My contractor friend explained to me that the tomb itself was at ground level. Three successive pyramids had been constructed on top of it, over a period of centuries. Then, before they disappeared, the Mayans filled in the stairway with rubble and sealed up the entrance at the top. The interesting thing to the contractor was that the construction of the tomb was very advanced while the successive layers were progressively more primitive, implying the degeneration of the society, even during its prime.

For dessert, we had canned peaches. I wanted seconds, so they opened another can for me. I took one bite and it tasted really wrong. I said, "Isn't there something you can get from bad canned peaches?"

"Botulism," said one old man, matter-of-factly.

"But doesn't that kill you instantly?"

"No, on the contrary. It's very slow and painful."

I excused myself and went to my room. I took a long shower, drinking about two quarts of water and forcing myself to throw it up. I repeated the process and ate a few peyote buttons (I almost always carried some with me when I was traveling).

I went over to Raoul's little shack and played music. There was a young man who asked to borrow my guitar. His name was Pepe. He played like an angel. We drank a lot of rum. I asked Raoul why the kid didn't have his own guitar. He said that at a dollar a day, using his machete to keep the jungle from taking over the ruins again, there was no way Pepe could afford a guitar of his own. I determined to rectify that someday.

The next day was Christmas. I went to a service at the tiny Catholic/Mayan church, checked out the band in the pavilion which would be playing around the clock for the whole twelve days of Christmas, and then walked around the outskirts of the village with my young machete friend and two or three others. We drank a lot. We came to a tiny cottage with a Dutch door. A young woman came to the door and her boyfriend talked to her over it, while Pepe played the guitar. I said, "We should leave them alone." My friend said, "No! You do not understand. We cannot do that. They are not married."

I fell asleep on the grass, and when I woke up everyone was gone and so was my guitar. I wandered back to the center of the village, following the music. There was my friend, on stage, playing my Guild.

The next day I wandered into the village square with the Guild. Some very tough-looking guys led by a pushy rock and roll type came up to me. The rock and roller told me he wanted my guitar. I told him he couldn't have it.

He said, "I will buy it from you."

I told him it wasn't for sale.

He said, "I need that guitar."

I said, "So do I."

He said, "What would you sell it for?"

I said, "Okay. A million dollars."

This pissed him off. He and his friends started to get ugly. Then

the other people in the square ganged up and asked him to leave. After the assholes left, my saviors asked me to play for them. I started playing and, after a minute, they all wandered away in disgust.

I stayed in the village until after New Year's and then started the long trek back to civilization. Halfway back to Villahermosa, the driver stopped for gas and I had a cup of coffee in a one room mud hut with a dirt floor. The lady was making salsa. At one point she reached under the counter and pulled out a Waring blender. She plugged it into the dirt somewhere and whipped up the salsa. I walked away with my head spinning. In Mexico City, I went to the museum and found an exact replica of the cherished Mayan head for my mantelpiece.

I checked in with the company. The film was okay. I flew back to my real life in L.A.

⋙ ⋘

HAMBONE WAS PREGNANT again. Actually, to my knowledge she was more or less always pregnant. Out came a bunch of big, beautiful dogs of various colors. I gave them away to everyone I knew. Barbara got Bluebird, Keith got Sun, Bobby got Thumper. I hung on to Man.

I had always, ever since Sunday school, had a Christ fixation. On my thirty-fourth birthday, I was driving through the canyon in my Lancia when I suddenly realized that, since I hadn't been crucified at thirty-three, I obviously was not Jesus Christ. I promptly crashed the car, not an unusual occurrence. But I immediately started to try to figure out what to do next. I decided that, since I was not a divinity, I should try to be a man. My first task as a mere human was to straighten out the car. Later on I would get to the other aspects of this new revelation.

⋙ ⋘

I PLAYED A FEW more villains on television. One day, on "Ironsides," I was acting out a scene wherein, in a drugged frenzy, I was searching frantically for a kitchen knife to chop up a young girl. It suddenly occurred to me that the only contact my daughter had with me was what she saw on television. What must she think of me? I decided I had to stop playing these parts. I told Saul I didn't want to do any more heavies.

He said, "You'll never work again."

I said, "Okay, so I'll never work again."

Things became a little lean. I sat on my mountain and played guitar. Hambone got pregnant again. The father was her own puppy, Man. I was afraid of the incest thing. The vet tried to stop it with an abortion shot. She had two puppies anyway. I assisted her in the birth. She tried to eat them. I had a really hard time stopping her. One was a mauve thing with a dark stripe down her back. I named her Little Smoke. The other, the one she tried hardest to eat, was a wild look-ing thing with a smile painted on one side of his face and tears on the other side, white brown, gray and black, one brown eye and one milky blue-white one. I named him Buffalo. He was definitely the best dog I ever had, which is saying a lot. I've had some zingers. Buffalo was a Shaman's dog. No doubt about it—and he was mine, so what did that make me?

Peyote Peter showed up again to take Hambone. This was get-ting to be a drag. I held on to her until she finished nursing and then let her go to him.

I met a family man named Neal Ames who was a fulcrum for a lot of people. He was a reformed right winger who in another life had voted for Barry Goldwater and who now ministered to artists, bikers, musicians, and Native Americans. I spent a lot of time at his place.

He introduced me to a Shaman of the Sundance cult, Hyemeyohsts Storm—Chuck for short. Chuck was writing a book about tribal legends. He wanted to put it on television. He said these stories had been passed down for a hundred thousand years without ever being written down. I told him, "Don't do it now. Whatever you do, don't put it on TV." He was kind of taken aback by my vehe-mence.

He led us through our first Sundance, using the story of Jumping Mouse and the Sacred Mountains as the catalyst.

At the end of the magic, he passed an eagle's wing with a wide, beaded belt threaded through it around the circle. He explained that the eagle had given it willingly. When it came to me, I was amazed at the life that I felt in it. Everybody had been handling it for the Great Spirit only knows how long, yet it showed no signs of use or wear.

As I was examining it, the belt began to move. It slid faster and

faster through the wing to the floor as I balanced the wing on my hand. Suddenly the belt came to an end and the wing lost its delicate balance and started to fall. Chuck reached out and caught it before it touched the floor. Then he picked up the belt and gave it to me. I was disappointed that he had not given me the wing. I left the belt on the floor when I left.

Eventually, Chuck finished the book: he called it *Seven Arrows*, and it became a best seller. I dutifully read it, but it paled next to my personal experience with him. I don't think it ever got on TV.

At that time, we were all very deep into the idea of re-asserting some power that comes up out of the earth, a power we thought had been lost. This sort of idea was very prevalent in the sixties, partly from the drugs we took, I guess, and partly from the philosophy we were trying to pursue. We were trying to become more natural, to find alternatives to the way civilization was going that seemed to be making life more mechanical and maybe less fun and less heartful.

We were looking for heart and soul. A whole lot of us got very Americanized, so to speak. There was something almost like a lecture circuit of Indian medicine men and chieftains, artists, and militant radicals who came through Los Angeles and who would hold court in people's houses. I had somehow just accidentally accumulated a lot of Indian artifacts: clothing, jewelry, magic potions, amulets of power, along with the radical ideas. I was considered some kind of Shaman in my own right. Well, I'd been into alternative life-styles long before any of the rest of them, what with my beatnik days, and my criminal past gave me a head start at being an outlaw.

Jeff stayed away from this madness for the most part. He had his own madness, and I think he saw our activities as strictly monkey business. He smoked grass and took a certain amount of psychedelics, but mainly in his bedroom with beautiful women. Jeff was just as protestant about society as the rest of us, but he just wasn't part of a group. "Lone Wolf" would be putting it mildly.

⇒ ⇐

THERE WERE STILL PEOPLE out there in Tinseltown who had hopes for me. I kept getting very close to landing some great movies, as I always had, but the brass ring was always just out of reach.

I went to New York to test for a movie called *The Diary of a Mad Housewife*. While I was there, I ate some peyote and saw Keith play the lead in *Hair* from the wings, with Buffalo at my feet. After the show, I visited with Dad at The Players' Club. I told him about a plan I had. I would direct him as King Lear and he would direct me as Hamlet. He asked me, "How do I know you can play Hamlet?" I asked him, "How do I know you can play Lear?" Then we got into a big fight— family stuff.

Dad started yelling. I yelled back that he had to before some-one else did. For emphasis, I threw a cue ball through the glass doors. The doors were carved with comedy and tragedy masks, done by Samuel Chester French. Irreplaceable. For punctuation, Buffalo did number two on the marble floor. Remarkably, I was invited back. I was told it was just like the old days. They needed young hot blood like mine.

Saul sent me to see someone about a movie I was really right for: *Bound for Glory*, the autobiography of Woody Guthrie. I drove up to Harold Hecht's palace in Stone Canyon with my guitar and Buffalo. I spent a couple of hours giving a pretty good impression of Woody. Harold told me that Woody had to be played by a little guy. He was very definite, almost militant about it (Harold was just over five feet tall).

I said, "Well then, just surround me with a lot of big actors."

He said, "No. This picture is going to be done entirely with unknowns."

I stared at him, wondering how someone with no sense of humor could make a picture about Woody Guthrie.

I told Jeff about the incident. He said not to worry about it. When that picture was made, I would play the part. No way around it. He added that there was nothing that said the actor who played the part of a rebellious, anti-establishment, politically radical, itinerant songwriter had to be friendly with the producer.

About this time I talked Jeff into taking up the guitar. I thought it would be good for him. Little did I know that the instrument would eventually consume him. He lives now in Hamilton, Ontario, where he was born, and spends all his hours studying the blues. He doesn't care about anything else.

STRANGE INTERLUDES

Alan Jay Lerner asked me to come to New York to audition for a musical version of *Lolita,* playing the Peter Sellers role. I boarded the plane with Buffalo in a little box, and my Gibson guitar. I looked at this one passenger and said to myself, "That looks just like Elliot Gould with a full beard." Well, it was. First class was empty except for Elliot, me, and Elliot's agent, Freddy Fields, arguably the most powerful man in Hollywood at the time. Freddy sat away from us, and Elliot and I went over the mountain together. Instant rapport. Elliot was gearing up to start a picture that he was starring in and producing called *A Glimpse of Tiger.* It was 1969, and he was very hot right then.

When we got to New York, he invited me to stay at his house with his new flame, Jenny Bogart. Buffalo and I accepted. I did the audition for Lerner and the prognosis was not clear. I was told to come back the next day and give them some more.

I spent the night with Elliot and Jenny Bogart. Elliot had met some hooker (just met her) who told him he should try cocaine, so he had bought a large amount of it from her. Elliot was very naive. He showed me the plastic bag. In it was a boulder about the size of a Fabergé Egg. He also had grass and LSD. We smoked a lot of grass that night and he snorted a lot of coke. Considering the rarefied

company I was in, I temporarily tabled my opinions about cocaine. I saw Elliot as a way into the industry, and so I pretty much followed his lead. He hired me to write the score to *Tiger.* I was to lay down some tracks in L.A.

I left in the morning, completely ripped.

Elliot had provided me with two big joints and a fair-sized rock. I went to the barber shop on Seventh Avenue, next to the Carnegie Delicatessen, to get a shave and a shampoo. When my hair was all wet, I looked in the mirror and said to myself, "My God! I'm losing my hair. I've got to make it right now, before it's too late." (I always figured if I went bald, I'd become a director.) Before I left the shop, I smoked my last Players cigarette and threw the pack in the wastebasket.

I arrived at the theatre and was told my audition was canceled. I'd be called back some other time. I stood there, swimming in cocaine, with my guitar over my shoulder, my heart sinking like a stone. I could see that, on stage, they were auditioning chorus girls. I knew that the scene I was supposed to act out had chorus girls in it. I thought, why don't I just hop up on the stage, and start doing it? What's to lose? I couldn't get up the nerve. I stepped out into the sunlight, totally lost. Well, I had my plane ticket.

I had a number in my pocket for John Hammond, Jr., an archival blues singer and an old friend. I went to a phone booth and called him up. He said to come on over. As I left the booth, I remembered I was out of cigarettes. Then I suddenly realized the coke and the joint had been in that empty Players pack I had thrown away. Just as well.

John and I took mescaline and played music together for a couple of hours, me on piano, John on guitar. Then two people showed up: a tall, slick black man and a blond Amazon. The three of them proceeded to blitz my expanded consciousness in an attempt to convert me to Scientology. They worked on me for about three hours, to no avail. Then John drove me to the airport.

When I got back to L.A., Barbara wasn't around. She had been offered a movie called *Dealing* or *The Berkeley to Boston 40 Brick Lost Bag Blues.* She took it because she was tired of turning pictures down. I spent a day in a recording studio in Hollywood and then flew back to New York with the tapes. I played them for Elliot. He loved them.

He also was dipping deep into the various substances. We took a humongous acid trip.

He told me he had given up on acting and went to a studio boss he knew, telling him he wanted to get into the production side. The magnate said, "Okay, Elliot, but read this script first." It was *Bob and Carol and Ted and Alice*. He took the part and stole the picture. He was on top again immediately.

I became aware of the fact that Elliot was, in fact, a very frightened and humble person, which had never occurred to me because he was so apparently forthright and gregarious, and would just sort of walk right through people and situations. I remember watching the whole panoply of his personality go by: fits of violent temper, monumental insecurity, vast good humor, and everything else—all in the space of a half hour or so.

For this period and the time surrounding it, Elliot and I were, perhaps, best friends, but everyone who knew him thought I was his advisor or something.

At that time, I always had a listed phone. I wanted people to be able to get hold of me if they really needed to. I listed it without an address. Sometimes interesting contacts would result from this. As a result of this openness, I ended up getting into psychic mystic slavery. A man named Kareem from North Africa called me up. He wanted to talk to me about some third-world problem. Kareem was an infiltrator who dedicated himself to recruiting upscale talent for various good works. He showed me mantras and taught me some yoga. He gained control of my dangerously open mind and I slid down the rabbit hole.

Basically, he wanted me to become a traveling medic for leper colonies in North Africa. I turned him down because I had a puppy and I would have to leave my puppy behind and he would grow up without me, and wouldn't have been my dog. I was willing to do it if I could take Buffalo, but that was where they were drawing the line. Kareem thought that was sort of a dilettante idea.

He didn't understand how important a dog was to me, and how important my having one and loving one was important to the rest of the world. Maybe more important than a medic for the lepers. There was nothing dilettante about it. Buffalo was a job begun, and you

don't walk off a picture. Once I stopped his mother from eating him, my destiny was in his hands (paws!).

Kareem talked me into putting him in touch with Elliot. He then invited me to visit Elliot with him. I was under the impression I had been invited only because I was with Kareem. Elliot was under the impression that this person was here only because he was with me. For about two weeks, he drove me, Elliot, and Jenny mad. He offered Elliot a princedom, complete with a palace in Morocco and unlimited funds.

Jenny finally managed to get us away from Kareem to talk to each other. We both discovered that we were under a spell. Elliot took that as his cue and exorcised the man.

He pulled a scrap of carpet out of a pile in the corner of stuff that he had bought at the auction when they tore down The Roxy Theatre. He bellowed, "You see all these designs, these, what? Mantras? Whatever! You know where I got this? From the men's room at The Roxy. I piss on your weird-looking guys with the ooglie booglie eyes. If you ever show up around anybody in show business again, you're dead!"

I doubt that Kareem was ever the same again. He certainly learned that film artists can be tempted, but it's best not to try to put a spell on them.

Buffalo and I stayed with Elliot and Jenny until we had almost worn out our welcome. Then up came an audition for an Off-Broadway musical called *The Ballad of Johnny Pot*, about a guy who goes all over the country planting marijuana. A cross between *Oklahoma* and *On the Road*. I asked Elliot what he thought about it. He told me I shouldn't do a musical unless I wrote it myself. An exhilarating idea, but I did it anyway.

The experience was a holocaust. Joshua Stelling was the director. Another one of the Hollywood ten or twenty. I was starting to wonder why this kept happening to me. Josh was one of the most devious, manipulative directors I have ever worked with. He broke my heart, confused and confounded me.

Betty Buckley was my costar. She had just come out of *1776*. Her voice was clear as a soprano trumpet. She was my first real blonde. During rehearsals, we came back from a long dinner break.

We had gone over to her apartment and taken a half hour or so too long. We came in with our eyes shining. Joshua took me aside and said "You son of a bitch! How could you do this?" I thought he was being excessively prudish. "Don't you see?" he said. "Now you have to keep up the romance at least until opening night or the show will flop!"

The music was stiff. I worked at it, made it my own. The composer hated what I was doing with the phrasing. But I turned the music into something that had life in it.

There was something wrong with the play, something wrong with the direction, and something wrong with some of the performances; not because of the actors, because of the direction. The cast was the best part of the whole thing. Everybody else was farting around, but the actors were working.

As rehearsals progressed, Josh became more frantically agitated and more cruelly dictatorial. It was a pity because there were moments of brilliant insight between the tantrums.

The cast, led by me, almost staged a real honest-to-God mutiny. Peter Jason and Betty Buckley were behind me all the way. After two weeks of previews I was fired for insubordination. The whole cast stood behind me. I said, "Let it go." They cheered because I had escaped. Without me, the show closed in two weeks.

I decided I would never do an Off-Broadway show again. I don't like working with amateurs and they don't like working with me. I don't blame them. As a second-generation professional, I have no patience with incompetence.

I went back to my composing job with Elliot.

Elliot really wanted the picture to be different than it was. I remember he wanted to change the title from *A Glimpse of Tiger* to *The Three-Legged Man*, a title from a circus sideshow poster he had in his house. He said, "The name of the picture is *The Three-Legged Man*. Everybody is calling it *A Glimpse of Tiger*, but it isn't. It's sort of like we were making a picture that everyone was calling *The Burning of Atlantis*, but it's really *Gone With the Wind*."

He dosed both of us with acid and proceeded to shoot down his own movie. The point was that he wanted more control. He was the producer and he wanted to be the director. He hated the little English

guy who had the job, Anthony Harvey, who was responsible for *The Lion in Winter*, among others.

We were sitting in the living room of his Barbra Streisand mansion, out of our minds on his LSD, when he decided to talk to Anthony, of whom he was terrified. When Anthony arrived at the mansion and rang the bell, Elliot said, "David, can you help me at all? Isn't there anything you can say?"

I said, "Do you want me to talk?"

He said, "Yes. Talk. Yes, I want you to talk."

I stared at him through the shimmering bird cage that the acid had surrounded me with, and tried to think. I said to myself, "That can't be it." But nothing else came, so I said, "I'm not afraid?"

Elliot said, "RIGHT!" turned to the stairwell, and yelled, "HEY, TONY!"

From that moment on, we were in the Twilight Zone.

Elliot gave Tony a rip-roaring imitation of an imperatively territorial rhinoceros and sent him away. Then he called up everyone he knew of importance and arranged for a power meeting, right now! A group gathered, me acting as doorman, and Elliot addressed them while perched on a step ladder. At one point, Ray Stark took umbrage and walked out. Meeting adjourned.

⇒ ⇐

ANTHONY HARVEY TOLD Warner's that he was afraid of Elliot. They gave him two bodyguards to calm his fears. Elliot's character in the film was a madman. He didn't see how he could act that out when there were two guys with guns on the set for the express purpose of protecting the director from Elliot, the madman. On the third day he refused to go to work, on the fourth day Warner Bros. pulled the plug on the picture. Elliot pretty much lost his whole career for the moment. He was declared uninsurable. Warner Bros. blamed me for the whole thing, blamed me for leading Elliot astray. At that time, I already had a reputation within the industry. Hell, it was *his* acid. Actually, I was completely overpowered by the force of Elliot's personality and totally nonplussed by the whole experience.

When they canceled the picture, that sort of canceled my whole

relationship with Elliot. It all just collapsed. We've seen each other since and the love is still there, but we treat each other very carefully. It ain't the same. Elliot bought the establishment's version and never forgave me for destroying his career. I never bothered to even think about not forgiving him for destroying mine, such as it wasn't. More important to me was the destroyed friendship. Well, shit happens. Hearts get broken, magnates mangle, soulmates separate. We don't really have any control over that stuff. Shed a tear and go on.

I flew back to California, stopping off in Berkeley to visit Barbara on the set of *Dealing*. I got along famously with the director, Paul Williams. The second male lead was John Lithgow, who I had last seen when he was ten years old. He was an eager, short, sturdy, tow-headed kid with absolute tunnel vision. I thought that kind of concentration might see him through. I couldn't predict that he would also grow another six inches.

SOME BROADWAY PRODUCERS asked me to come and look at a play that was trying out in New Haven. The vehicle starred Geraldine Page. It was in trouble. Miss Page believed that the play would be a success with a real man in the other role: me. I was flattered, but I turned it down. Dumb. I could have had a lot of fun and worked with one of the finest actresses. With my career in the shape it was, how could it hurt me? The play folded in New Haven. I haven't had a crack at Broadway since then.

"Ironsides" kept offering me villains. Saul kept turning them down. Finally, they gave me a sympathetic role. They couldn't stand to just make me a good guy, so they gave me the role of a suspended cop, accused of a crime he didn't commit. About six months later, I landed a movie of the week with Sally Field: *Maybe I'll Come Home in the Spring*. I had hair down to my knees, and I exploited it all. Indian beads, deerskin shirt, flower power demeanor. It was only three days' work but it was pivotal. It was also my first comedy role.

I went to Oxnard by the Sea to visit Dad and Chris. Doris was playing the dominatrix. I got toe to toe with her. She was used to people accepting her proclamations as law. I just told her she was full of shit. She was. Nobody talked back to Doris. Dad crouched in his

easy chair and peered trepidatiously over his crossword at the battle. I went really overboard, leaving them all shaken and shocked.

A month or so later, in a bar called The Lobster Trap, his favorite haunt, I laid into Dad. He was swept over by it all. He became shy, rarer than rare for him, and quiet, even rarer. He was, I guess, hurt. I'd never stood up to him before. It was, I suppose, my time to rebel. Our relationship was never the same after that. He had always introduced me as "My son, John, known in the trade as David." After that evening, he dropped the "John."

Dad went off to do a production of *Tobacco Road*. He took Keith with him to play Dude (my part), and Bobby as Keith's understudy. Keith's hair at this time was about two feet long. He wore a wig to make it shorter for the play.

Toward the end of the run, Keith had to leave: he had a movie in the offing, a small but extremely memorable role in a Robert Altman picture: *McCabe and Mrs. Miller*. Warren Beatty and Julie Christie were the stars. Bobby was given Keith's wig and told to go on. I think that was the first moment Bobby realized he was actually going to have to play the part. He was terrified but he went on. He had to. Dad would have killed him. Bobby told me that one time while he was on stage watching Dad go through a long speech and thinking how great the old man was, Dad stopped talking. Bobby wondered why he had stopped. Dad just glared at him until Bobby suddenly realized he was supposed to say his line. Boleslawski's first acting lesson: concentration.

Robert Altman cut off most of Keith's hair and let him run with the ball. Keith came through. The rest is history.

Dad called me up. Doris had left him. He was broke and couldn't afford to keep Bobby in boarding school and he certainly couldn't take care of him himself. I said, "Give him to me. Let me take care of him." He said absolutely not. I was a bad influence. After a while, he changed his mind. I put Bobby in the shack and sent him to Hollywood High School.

Bobby, Barbara, and I became a close-knit little family. Barbara was a very happy clam at this time. Come to think of it, she always was. She had become an excellent chef and a great surrogate mother. She would sit and contentedly watch us play music and sometimes

sing along. After a while, she bought a flute and taught herself how to play so she could join in. We formed a group and played in little clubs and on television, just the three of us. The name of the group was Water.

I was offered the role of the heavy in a John Wayne epic, *The Cowboys*. I turned it down. Saul said I was crazy. This was a big picture. I said I didn't want to be the guy who killed John Wayne. Bruce Dern took the part. Saul sent Bobby over to Mark Rydell, the director, and Bobby got in as one of the boys. They taught him how to ride and shoot, and the Duke taught him how to act.

As I was driving onto the Warner Bros. lot one day, I saw displayed across the street a humongously beautiful car. I checked it out. It was a Ferrari 250 California: a short wheelbase roadster. I wanted it. It was being sold by John Calley, then the president of Warner's. Warner's held an option on me for three more pictures, so I offered John one of the options for the Ferrari. He said that wouldn't work for his taxes. I borrowed the money from Barbara, which made it her car, I suppose, but she never had the passion for the beast that I had.

Barbara and I took the Ferrari to Santa Fe to visit Bobby on the set. We had a hard time finding the location. After searching the desert for hours, I saw the silhouette of a Chapman crane against the skyline. I turned the Ferrari off the road and came upon a herd of cattle with Bobby riding point. I was proud. I always had the dream of all the brothers making it. A sort of dynastic obsession, derived, at least in part, from Dad's stories about the Barrymores. The Duke never came out of his trailer. I would have liked to have met him.

We spent some time with Bobby and drove on back, stopping here and there for Indian reservations and natural wonders. Bobby came back with his paycheck and said, "I guess I don't have to go to school anymore."

I said, "Wrong. You're going to graduate."

Donna wrote me that Calista's eleventh birthday was imminent, and she wanted a bicycle. I took one up to her in Fremont, where they lived. Calista was incredibly beautiful and ready to love me. Donna was just the same as ever. Neither of us had started to get old yet. She even smelled the same. Tabu, I think it was.

CHAPTER FIFTY-ONE

A VISIT WITH THE GREAT MAN

Because of his special position on the Warner's lot, Saul explained to us that we could have free screenings of movies anytime we wanted. I asked for *The Wizard of Oz*. Saul said it would be a lot easier if it were a Warner's picture. We decided on *One-Eyed Jacks*, the epic western directed by Marlon Brando.

Barbara, Bobby, Tony Zerbe, and I sat all alone in a huge screening room and watched this remarkable piece in Cinemascope and four-track stereo. We were all blown away. We wanted to tell Brando how much we loved it. He was supposed to be on the lot that day. We missed him. Tony knew where he lived, so we decided to drive up there and beard him in his own lair.

We arrived at his palace on top of Mulholland Drive in Tony's Citroen and made our way to what we assumed was the front door. (It was hard to tell.)

A gentleman in a suit opened the door and we explained our mission. The gentleman, an attorney as it turned out, knew Barbara. He asked us to wait for a moment.

I looked across the Japanese water garden and saw the top of the head of the great man seated with his back to us in a wingback chair and the attorney crossing into the shot. There was an incredibly

graceful gesture from Marlon's left hand, and then, miraculously, Marlon stood up and presented himself to us.

He talked to us for about an hour, giving each of us a bit of himself. When he got to me, I was transfixed by his gaze. He seemed to be looking right through me. What he told me was the best and the most complete acting lesson I ever got.

It wasn't couched in those terms, but that's what it was. He stood there, dressed in jeans and a sweatshirt, occasionally making beautifully expressive gestures with his hands. He could have been a dancer, or a professor of philosophy at Heidelberg University. He was looking right through my soul. His face was colored with a golden light. I was transfixed.

Suddenly the golden light faded. Marlon said he had to go back to work. I turned around and realized the sun had just set behind me. He hadn't been looking at my soul, he had been watching the setting sun. Well, it didn't really matter; I got the message. I think Barbara and Bobby got it too. I'm not really sure about Tony.

OPENING ACT

R oger Corman, the legendary king of cult films, offered Barbara a picture. It was a really good script for her, *Boxcar Bertha*. She said she'd do it if I played the male lead. Roger went for it. The director climbed the steps to meet us. He was a little round guy, very nervous. He talked very fast in short, explosive sentences. He told me he would have preferred Bruce Dern. I liked him immediately for his forthrightness. His name was Martin Scorsese. This was his first picture. It was also my first leading role. Not starring, leading. There's a difference. Barbara was the star.

I bought an old Packard straight 8 ('51 Caribbean with the 357 Thunderbolt engine) and we started out to drive to Arkansas where the film was being shot. Might as well have some fun and see the country. The Packard broke down almost immediately. We had it towed to the shop, had a Mustang delivered by Hertz, and loaded the dogs and all our stuff into it. Off we went.

Somewhere in Oklahoma we decided we needed a break and checked into a motel. We took in a movie. A thing called *Billy Jack*. It was amateurish but it hit a chord in me. The maudlin message and the kind of fighting that Billy Jack did fascinated me. I had a feeling there was a future in that kind of movie.

When we arrived in Camden, Arkansas, the first thing we noticed was the smell: like rotten eggs. The production manager told

us that was the paper mill. He said we'd get used to it. I suppose we did. We took all the furniture out of our hotel room and lived on the floor as we were used to doing, with pillows and candles. Our costars were Bernie Casey and Barry Primus. The movie was about union leaders in the thirties who become train robbers. AIP, Sam Arkoff's company, wasn't too sure about the social message aspect. Roger told Scorsese, "Just keep talking about train robbers and guns. Don't say anything to Sam about unions or oppressed minorities."

Martin Scorsese and I became fast friends. At one point he screened for me a student film he had made in 16 mm, which featured his friends from childhood, Harvey Keitel and Robert De Niro among them. It was called *Who's That Knocking at My Door?* We screened it in the local theatre, the only one. We had to sit through the midnight show, *Hot Spurs*, a soft porno western, before we could put up Marty's film. He asked me what I thought of it. I said, "Well, it's great. It's innovative, it's deep, it's funny. It's boring, but it's great. There's no way you could make this movie [*Boxcar Bertha*] boring, so I don't think you've got a problem."

Barry Primus wanted nothing to do with this collaboration jazz. He just wanted to do his job and go home. Bernie Casey was writing a book of poetry (he actually got it published); the stuff was very special. Bernie picked up Barbara's flute in the middle of one of our nightly musicales. He played the thing like a virtuoso from the first moment, at least I thought so. I was dead drunk, so who knows. I had started out with beer and switched to wine. Later, we walked through the dark streets with the focus puller, passing a bottle of Jack Daniel's back and forth.

The next morning I played a scene wherein I was beaten up by prison guards. That was a rough morning. I was sick as a dog.

There were many obstacles. Many. We overcame all of them. At one point, the associate producer pulled a gun on Marty. That cramped his style for a bit, and then Marty solved the whole thing by putting the producer and the .38 in the movie. The guy turned into a pussycat. Everybody's a sucker for their moment in the limelight. It turned out to be a good movie. Barbara and I had two love scenes, and we really got into them. I saved the outtakes. They're still pretty

racy, even by today's standards. Somehow a story got circulated that we conceived our son during the love scenes. A romantic idea, but untrue. We didn't go that far.

We re-enacted the scenes for *Playboy's* photographers and became what must have been one of the very first nude couples ever shown in that magazine. In Boston the movie was banned because of those pictures. The censors hadn't even seen the movie, which was not radical in sexual terms. In the South, it was banned because it shows a black man blowing away a bunch of white guys with a shotgun. Eventually they just cut out that part, leaving Bernie Casey with spatters of blood all over him for no apparent reason. AIP was advertising the picture as a sexploitation film, which didn't help.

I pointed out to Sam Arkoff that the people who came to see what he was advertising would be disappointed, and the people who would want to see the picture as it really was wouldn't come. Sam wouldn't budge. So I turned over his desk into his lap and walked out. Later I mentioned to Saul that maybe that was not a good idea. He said, "Who cares? You're never going to work for them again anyway."

When we were out in the woods in the depths of Arkansas during the filming, some hunter told me what kind of dogs we had. He said, "That there's a Leopard dog." I didn't know what he was talking about but eventually found out.

The dogs took off after a deer. While they were gone, it rained and they couldn't find their way back. They were lost. Barbara said, "I'm not leaving here without my dog." So my mission was clear. It was a weekend. We made the company leave the trailer there in the woods. We had our Mustang. We went all over looking for the dogs. Everyone had seen them, but the dogs just kept circling. It was the first day of deer hunting season. Most of the hunters thought they'd walk up to a pack of hunting dogs and get taken in. They didn't know our dogs. If they saw a pack of dogs, or people, they'd run the other way. I offered a hundred dollar reward for them. I even asked a daddy long legs if he knew where to find them. After two days of searching, we came back to the trailer, and there they were. The orphan boy who watched the sawmill was feeding them. I gave him the hundred dollars.

➴ ⃪

O<small>N THE SET OF</small> *Boxcar,* there were some *LIFE* magazines from 1936 being used as period pieces. One of them contained a photo story of Mata Hari, the famous exotic dancer who was executed as a spy, implying that, perhaps, she wasn't a spy at all.

It was interesting to me that there were newly discovered facts about Mata Hari and there was a series of photographs that went from her childhood to her execution. I just thought, "My God. Right here between these two pages is a whole screenplay, a complete scenario." It fascinated me. The whole life of a woman, the truth of it.

I remembered two pictures by Sergei Eisenstein I had seen in New York: *Ivan, The Terrible,* parts one and two. He shot the two pieces ten years apart and with the same cast. It was fascinating to see the actors age in their roles, beyond anything makeup could do. I talked to Barbara about making a picture and taking a few years to finish it.

Barbara had a certain unwarranted youthfulness. She could be like a teenager even though she was a full-blown woman. It seemed to me that she could play youth at the beginning of the picture and then catch up with herself, play herself as an older woman. Shooting over a five-year schedule, I could present a fifteen-year period without using all those false makeup techniques. I told Martin Scorsese about it and he thought it was a great idea.

In the last part of *Boxcar* I was supposed to be twenty years older, so I thinned my hair with manicure scissors and bleached white streaks into it. I was supposed to have been beaten up a lot in prison, so I shaved little patches and put plastic scar tissue over the spots. With my wire rim glasses I looked like Trotsky. Marty loved it.

At the end of the picture I was crucified with railroad spikes on the back of a boxcar: archetypal Scorsese.

➴ ⃪

S<small>INCE MY HAIR</small> was so screwed up, I decided to shave it and start over. Halfway back to Los Angeles, we almost got arrested. Hertz thought we had stolen the car, it had been gone so long. The cops who stopped us were not too sure about me with my shaved head, but

Barbara charmed them and, after checking with Hertz and our checking account, they decided that we were not Bonnie and Clyde.

I had saved that *LIFE* magazine and brought it back to Los Angeles with me. My friend Billy Record put me together with a crew and some equipment and we started shooting some 16 mm footage: the idea behind it is that a girl is cleaning out her garage and she finds an old copy of *LIFE* magazine. She looks at it, then takes it up to her house, sits in her favorite chair, and imagines herself as Mata Hari.

That's how Mata Hari did it. She imagined. She made it all up.

As she's sitting there dreaming, the camera cuts to her feet and the feet start dancing. Her moccasins become dancing slippers. Then you see her dancing, all dressed up like Mata Hari. We shot this in the house we were living in at the time, and then went over to the back-yard of the Burned Down House.

Down the hill, there was a building that looked sort of like a small, European chateau. I put that in the background and put Barbara in front of it. We didn't have any sound, but I thought if I had a shot of Barbara looking as if she were listening to an offstage speaker, and then had her turn and look off across the hills, we could put dialogue in later as though she was speaking as she was turned away. She could answer questions about her life. It seemed like a good start.

I wasn't really too happy with the footage. I didn't like the way the 16 mm looked; nothing was as grand as I had envisioned it. And then I had more work to do. I became so busy that I put everything else in the back of my mind. When Barbara and I broke up six years later, I just forgot about it.

It wasn't till Calista came down to live with me that I started to think about *Mata Hari* again. I asked her what she wanted to do with herself and she said she wanted to be an actress. I thought, "What can I do to help her in this direction?"

But that wouldn't happen for years.

CHAPTER FIFTY-THREE

GRASSHOPPER

I t was around the time of the *Boxcar* shoot that my ship came in. Saul Krugman called me up and said, "Look, I'm sending you a script for a TV movie. The only thing is, it's got a series tied to it."

I said, "Saul, you know I don't want to do another series."

He said, "Yeah, I know that, but I think you better read this script."

I had only heard the words "kung fu" twice before at that time. The first time was when I was out in the middle of the desert, making *The Violent Ones*, directed by Fernando Lamas. Tommy Sands, who was also in the movie, challenged me to a duel and told me what he was going to use on me was kung fu. I didn't think anything about it. I figured I could take him apart, but what for? Anyway, I liked Tommy. I just walked away. The other time was when I was doing *The Ballad of Johnny Pot*. The choreographer, Jay Norman, gave me a move and I said, "What's that?"

He said, "It's a kung fu preparation."

Greek to me.

I knew nothing about Eastern martial arts except what I'd seen in movies and read about from time to time.

I took the meeting.

I couldn't believe that the network, knowing what they did

about me, would hire me. It was like hiring a monkey wrench to throw himself into their machinery. My own mission on TV would be to teach the audience to turn the damn thing off and get a life. This was also the same studio that had blamed me for the Elliot Gould debacle. I finally figured out that they just didn't care as long as it made money.

There was a series contract attached to the role of Caine. I couldn't play the part without signing up for the whole ball game. Five years they wanted. I definitely did not want to do a series, but I decided not to take that eventuality very seriously. It seemed unlikely to happen, considering the strangeness of the material. The other thing was that I decided I could not, in any conscience, refuse to play this part.

During the shooting, I told director Jerry Thorpe, "What I want is for this film to be so brilliant that it's too good for a TV series."

He said, "Let's do both!"

And I guess that's what we did.

We had no idea at the time that we were starting an explosion. We just knew we had a great script. You have to understand that none of us knew anything about the martial arts. The closest we could come was that we had all seen the Japanese Samurai movies with Toshiro Mifune when they were a popular thing, which had been years before.

I was a little closer to the source, but that's why I was playing the part. I knew exactly where to go in myself to find Caine.

Kung Fu was shot in twenty-eight days in and around Los Angeles during a bitter cold spell in December of 1971. We tried to make it as good as was humanly possible.

The first day, I drove onto the lot in the Packard. The head of transportation pointed and said, "That's your parking space." I pulled in. The sign said Lorne Green. The transport guy told me they'd change the name tomorrow. I walked onto the soundstage. It was the Ponderosa set. "Bonanza" had just been canceled. It was clear to me that I was Warner Bros.' current hope for the future.

Then came Frank Westmore and the bald cap: two hours in a chair. We had decided to keep my Nazi hairdo for the old West sequences. Near the end of the picture, I shaved it for real.

While I was in the chair I met Keye Luke, a grand old man in his late seventies with coal-black hair, a twinkle in his eye, and a great talent. Then came Radames Pera, who was to play the little Grasshopper. With him was his mother, Lisa Pera, the girl who had taken her screen test with Jeff and me eight years earlier.

We started out in a grotto, deep within the castle set from the movie *Camelot*. We had converted the castle into the Shaolin temple. Keye Luke put in his blind eyes, and we went for it. After the first take, it was clear to everyone we had a tiger by the tail.

Brother Keith came in to do Caine as a teenager.

The first kung fu move I did was walking on the rice paper. I didn't have any rehearsal whatsoever. I just made it up.

At one point, after we'd been shooting for a few days, Jerry asked me to come down to see the rushes of yesterday's work. I was not used to this kind of deference, or this kind of openness on the part of directors, so I told him it wasn't necessary and I didn't need to.

He said, "Please! We want you to see what wonderful work we're doing."

So I went. I came in late and the first thing I saw was myself on a huge screen, twenty feet tall, flying across the frame in flowing saffron yellow monk's robes to plunge a spear into the heart of the emperor's nephew. This shot was quickly followed by an eloquent close-up of Keye Luke as the dying blind Master Po. I was stunned. I knew we had a hit. More than that, I knew we were doing something no one had ever done before, something beyond the pale.

For the western town, we moved to Laramie Street on the Warner Bros.' back lot. The first shot was Caine walking out of the desert into town. After that, we did the scene in the saloon where I performed my first fight. The Laramie Street set goes back at least seventy years. I'd worked on it before. So had my dad, many times.

For the country sequences we moved out to Vasquez Rocks, a wind-torn mountaintop with marvelous stone promontories and cliffs. The skies were breathtaking, as was the weather. To acclimate, I bought a little open race car and drove it to and from location every day and night. The only heater was the engine, a Buick 215, tweaked up to about 275 horsepower.

After a day or so, I realized the strange thing about this show:

we were doing two pictures at once, and the only actor who was in both of them was me. Barry Sullivan, Albert Salmi, Wayne Maunder, and Roy Jenson had no knowledge of what we were doing in the temple, just like it said in the script.

We finished up just before Christmas, all of us feeling enormously fulfilled; we knew we had been part of something great.

On New Year's Eve, in our little cottage, Barbara and I conceived our son. We both knew it for sure. We knew it was a boy and we named him Free.

The picture made a big splash when it showed the first time. No one seemed to know what to make of it. Then something happened that gave me my first hint that this thing might have a more far-reaching effect than anyone thought.

It seemed that a lot of people hadn't watched it the first time because they had no idea what it was. As word of mouth spread, everyone wanted to see it. The network scheduled a second showing, and then, just when the whole country was tuned in to see this Chinese western they'd all heard about, it was pre-empted by Richard Nixon shaking hands with Chairman Mao to commemorate the acceptance of Red China into the United Nations. This seemed to me remarkably synchronistic. I wondered if it was remotely possible that, in some small way, our little television movie was having something to do with creating détente with inscrutable China.

The network cautiously ordered up four hour-long segments from us to be shown once a month as a mid-season replacement. My contract didn't allow for that; if they wanted to pick me up, they had to renegotiate with me. At this moment Saul and I were temporarily on the outs with each other, so I didn't have an agent. While I was trying to figure out what to do, I ran into Jeff Cooper's agent. He told me I should charge Warner's for the four shows what they would have had to pay me for the twenty-six replaced shows. But I didn't want to do anything to stand in the way of the project. Suppose they said forget it? I signed up without a squawk. The money had never been the point. Why start now?

To them, it was a chance at a hit television show. To me, it was a mission from God.

CHAPTER FIFTY-FOUR

YOU AND ME

K nowing that I was going to become suddenly very busy for, probably, years, I determined to make a movie of my own while I had the chance. Billy Record put me together with Bob Henderson—a writer with a beautiful script, *You and Me*, about a mean biker and an eight-year-old runaway boy—and Bob Collins, an award-winning cinematographer. Collins brought in an entrepreneur, Skip Sherwood. He showed up in an ice cream suit and a straw hat with a red, white, and blue band. An energetic little redhead with immense enthusiasm, he represented a bunch of ministers in Washington State. Skip told me we could get the financing for the film if Barbara was in it. Barbara was willing. The problem was we had to start filming immediately or Barbara would be too pregnant.

We started looking around for a director. They all wanted to rewrite the script. We were in a hurry.

Skip and I went to Goldwyn Studios to meet Steve Inhat, an actor I knew from "Shane." He'd made an interesting 16 mm picture about himself walking out of a contract at Universal to pursue art. He wanted to do *You and Me*, but he was on his way to the Cannes Film Festival with his own movie.

As we were walking across the parking lot, Skip blurted out, "Why don't I direct the picture?"

I said, "Skip, before I let you do that I'll take the job at Universal."

When we got to the car, I stopped and said, "The hell with it! I'll direct it."

Steve's picture never made it to France. He had a fatal heart attack somewhere over the Atlantic Ocean.

We formed a company and called it The David Carradine Filmworks. We created a lot of these DBAs. They came and went. It was all part of a dream to put together an umbrella under which we could go our own way, exclusive of the big studios. Dreams are not realized by dreaming. It takes work and something like walking on rice paper. The studios wield almost ultimate power and are not crazy about independent competition.

We forged ahead with innocent zeal and rolled with the punches. I went to Jerry Thorpe and borrowed $5,000 from Warner's. Enough to shoot just Barbara's part if we didn't pay anybody. This became an audition piece for the backers. Billy put together a crew. Everybody worked on a contingency basis.

The first night out, Skip Sherwood, the backers' rep, came along. We didn't have an assistant director, so he started helping me out to the point where he was beginning to take over. I pulled him aside and said, "Skip, you're in my space."

He said, "What?"

I said, "You're in my space. It's my space you're standing in and I can't get into it."

He was a little insulted. He was also a little chagrined and sheepish.

We shot the scene and then we went outside to shoot the exteriors. The sound man came up to me and asked me to listen to the soundtrack. What I heard was a voice yelling throughout the takes. We were trying to shoot a truck starting up and driving out. Very simple scene, right? This voice kept yelling: "All right! Get going! Okay! Keep coming! Keep coming!"

I said, "What is that?"

He said, "That's Skip Sherwood and he's ruining my sound."

Not only was he ruining the sound, he was ruining it by telling people to do what they were already doing. So I went over to him.

There was a lot of noise and I had to shout. "You've got to stop yelling during the takes." He kept saying "What?" And I would yell louder. He was insulted, but he couldn't leave because he'd come out in someone else's car. So he sat in the personnel carrier. He couldn't figure how to turn out the interior lights, so he sat there illuminated. You could see him for a half mile. He was fuming with rage. He told Billy Record he didn't want to have anything to do with me ever again.

As far as I knew, that would be the last I would ever see of him, but Billy talked him into looking at the footage. Billy said, "Just look at it on the wall." Skip did that, loved it, and decided to go ahead with us.

⇒ ⇐

MEANWHILE, A DIRECTOR in Holland named Nicolai Van der Hyde had been sending love letters to Barbara, pleading with her to star in his movie. Barbara told him she was pregnant. He wanted her anyway. In the end, she accepted the role. The film was called *Angela*. She had to leave right after the *You and Me* shoot. I left the film with the guys and let them handle the details with the backers, and I went with Barbara to Amsterdam just to make sure these foreigners weren't going to hurt her or the baby. I swaggered around Holland in my cowboy boots and generally gave the impression I'd stomp anyone who touched a hair on Barbara's head. The traditional Dutch good humor softened me up. I decided these guys were okay. I became fascinated with more of the history of Mata Hari, who was a national hero there. I also became fast friends with Nicolai Van der Hyde.

Barbara, Jeff, and I had agreed to do a promo shoot for a proposed film in the south of France, so Barbara and I made it down to the Camargue and met up with Jeff in a little village called Saintes Maries de-la-Mer. There was a gypsy festival going on and we intended to use it for a background. The town was overloaded with ten thousand gypsies from all over Europe, in old motor homes with their chickens and goats. There were another ten thousand tourists dressed up as gypsies.

Barbara shot for three days with us and then went back to

Holland to start her movie. Jeff and I stayed on for a few days to do some footage on our own.

A very hip-looking, long-haired Frenchman in a purple suede suit asked us if we wanted to score some smoke. We foolishly said yes. That night on the beach, as we were shooting a gypsy dance sequence around a bonfire, he showed up. He didn't talk to us, he just stood there. I noticed there were two sour-looking men standing around wearing, believe it or not, trench coats. Jeff and I looked at each other. "Uh-huh." We slipped away into the darkness. As we were making our way back to the street, a personnel carrier went by us with close to a dozen heavily armed police in it. We had barely escaped a major bust.

Jeff and I flew back to Paris. We got in at nightfall. Our plane to California didn't leave until morning, so we decided to spend the night on the town. Neither of us had ever been to Paris, but I felt I knew it intimately from studying the maps in my eleventh grade French class. We went to St-Germaine-des-Prés on the Left Bank and had drinks and espressos at the Deux-Magots, a famous artists' hang-out. We discovered that Jeff could understand French and I could speak it. We had a great time. We were very chic in our De Voss clothes. The girls loved us. So did the boys. I fell momentarily in love at least twice that night (not with the boys).

⇒ ⇐

BACK IN L.A., now with some real money to work with (not much, but enough to pay a cast), I plunged into *You and Me* with vigor.

The casting of the picture was done by pure coincidence. We needed a ten-year-old boy. Billy Record showed me an eight-year-old, a kid named Chipper Chadbourne. I hired him immediately and hired his mother, Mundy, to play his mother. Billy said, "Don't you even want to read him?" I said, "No. What for?"

Every actor was cast that easily. I visited Bob Collins on a set and a beautiful woman with an unusual quality walked by. I said, "Who is that? I want her in the picture." Bobbi Shaw, of *Bikini Beach Ball* fame, came through with a fine performance. So fine that she surprised us all. Also in the cast were Keith, Bobby, and Gary Busey in some of their earliest performances.

We started shooting in L.A. After a few days, it was clear that L.A. wasn't going to work for us. This was a road picture. It should be shot on the road. We shifted gears and stopped shooting for a couple of days to prepare.

At the last minute Rick Van Ness, a childhood friend of Keith's, wanted to join up. I told him I'd give him $50 a week and gas if he brought his truck, a 1951 Chevy panel truck. He proved to be our most valuable player.

We traveled up the coast from L.A. to Canada, twenty-six people all told, driving our own cars and vans and camping out, shooting as we traveled. Whenever we saw a good-looking location or a beautiful sunset, we stopped and shot something. We cooked all our own food, and there was a pound of high-grade marijuana in the budget, which was dispensed out nightly. An advance unit paved our way for us. Our modus operandi was to meet at the Denny's. There was always a Denny's.

There was a lot of LSD consumed on the trip, the main supplier and resident philosopher being Biker Joe, the owner of the Harley. He made for himself the evangelical task of secretly dosing the straighter members of the company, causing some amusing incidents and near-psychotic interludes.

When we got to Oregon, we looked around for the farm that would be home base for most of the picture. We found, entirely accidentally, a pretty little white clapboard farmhouse owned by a Buddhist couple. They had everything we needed: a tractor, a cow, chickens, a couple of dogs. We camped on the south pasture and dug in for the duration. We would shoot all day and party for half the night. The weather was perfect, and the work went as smoothly as I've ever seen a movie go.

We didn't have any idea what the film looked like since we had no facilities to screen it. Someone in L.A. was monitoring the processing and would let us know if something went wrong. Nothing ever did.

Barbara showed up just before the end of the shoot, considerably more pregnant. We finished the movie on July 5th, having worked a couple of parades and a fireworks display into the movie for

free. We had shot for six weeks, and put the movie in the can for just over $60,000.

We headed for home in a caravan, and I went right to work cutting the movie with Phil Caplin, our camera assistant, in an editing room at Warner Bros.

You and Me taught me how to direct, produce, and edit. By getting that close to the production, I was able to see how it really worked. I also wrote my first score for that picture. I applied all this later to *Americana* and, eventually, to *Mata Hari*. I don't know if *Mata Hari* is a better picture. I can't tell you that. It benefits, or at least results from, things I've learned. We shall see.

The reason I was doing *You and Me* in the first place was because I felt that a television series is potentially destructive to a young artist. One of the things that's wrong with it is that you get rich doing it. It's a trap. You set up a source of goodness in your world, and then you have to continue at it to maintain the goodness. The yearning for creativity becomes secondary, and one day you wake up and you have lost the dream.

Left: As Shane, 1966.

Below: With Jeff Cooper.

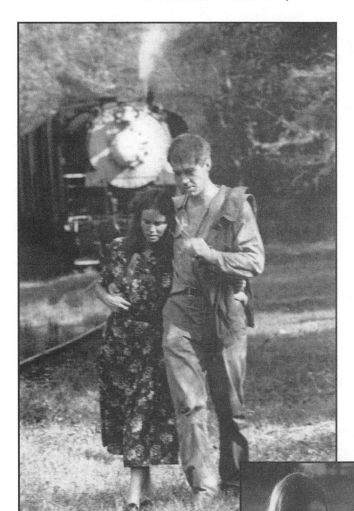

*Above: With Barbara Hershey on
the set of* BOXCAR BERTHA,
1972.

Right: Barbara and our son Free.

Above: Brother Keith Carradine at about eighteen comes out to stay and becomes a member of our little band.

Right: Free at two years old.

Destiny calls: enter the grasshopper, 1972, with Buffalo, the best dog I ever had. Photo by Bruce Carradine.

Left: As Kwai Chang Caine. Photo by Ron Thal courtesy of Warner Bros.

The search takes on a different look, below, in YOU AND ME, my first independent film project, financed with borrowed money, filmed in borrowed time.

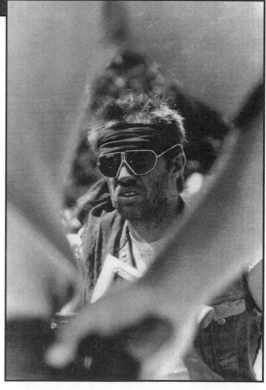

CHAPTER FIFTY-FIVE

LEE WARLANCE

It was time to go back to work on "Kung Fu." Four great scripts had been put together, and work commenced at a luxurious pace of nine shooting days per segment, with Jerry Thorpe directing.

In one of the segments, "Dark Angel," my father created his continuing role as the blind reverend, Serenity Jones. He was eager to play the part. My success was giving him a lot of juice. He was fascinated by the qualities that were particular to me, which he didn't have: my grasp of athletics, my modernity, my musicianship, my flagrant disregard for convention, my mystic bent.

He was also crazy for the role. It was a plum. He had never played a blind man before and was anxious to have a go at that. This segment turned out to be a Carradine festival, boasting performances by my brother Bobby, as Serenity's deaf and dumb assistant, and Keith, as the younger Caine. In this segment, Caine meets his grandfather, played by Dean Jagger, who tells him he has a brother, establishing that quest.

Kam Yuen had been brought in to demonstrate the Praying Mantis form and stayed on to double Keye Luke and teach me to kick. Eventually, he would take over as the kung fu advisor, choreographing the fights. He and I started spending a lot of time together,

and his quiet elegance, his simple, humble style—never forcing, never loud, erect and graceful, and tough as nails and scary as hell—impressed me enough to cause me to change my portrayal of Kwai Chang to be more like him.

During "Blood Brother" they brought in someone to double me demonstrating the White Crane, a difficult style to pull off, unless you happen to be a crane. The guy didn't look so good, so I took a stab. I had it right away. I was a natural, I was told. Well, I knew that.

So I found myself getting caught up in the mystical, political importance of this thing I had become. I think I caused the show to grow in that direction, more than had been intended by the network and the studio. Once it started showing, people all over the country, and eventually all over the world, started picking up on that same idea. People would somehow find their way to this little cabin I had in the woods, right in the middle of Hollywood.

One day I came home from work and Barbara met me at the door. She was really happy; gleeful almost. She introduced me to this extremely beautiful man with long, long straight hair extending halfway down his back. He told me he had to talk to me.

Lee Warlance was a full-blooded Oglala Sioux Indian, and a militant redskin. He felt he had to meet me because everybody had been telling him he looked like me. Of course he didn't, but in a certain way, perhaps he did.

I spent a lot of time with him for several months. I took him to the set, showed him how the movies worked. We discussed Indian problems, mystic disciplines, philosophy, and I don't know what all else with him.

He was a Vietnam veteran and had a bullet lodged in his head. The hospitals had been afraid to remove it. It gave him some trouble from time to time: headaches and, worse, confusion. He'd been in a lot of trouble and he was trying to work that off. At some point during our relationship, he went back to Rosebud Reservation in South Dakota and went through a tribal cure, doing a lot of sweating. He told me that at the end of the experience, which lasted several days, he felt something strange in his mouth and he spit out the shell that had been lodged in his head.

He was involved in the Wounded Knee Massacre. Just before the cordon closed, he took some reporters and some women out over the hills. They were all shot at. His dog was killed. He said his dog actually saved them by turning around and confronting the pursuers. When he tried to go home, he was stopped at the airport. Marlon Brando showed up there to demand safe passage for him and others. Lee found his way back to his little farm on the reservation. His livestock had been slaughtered and the buildings had been torched. He thought the CIA had done it or some federal group, but it could never be proved. That's the way all that stuff is. You have to figure it out for yourself. I was more a listener than an investigator.

I became quite interested in his plight and the plight of other Native Americans. He introduced me to some of his friends, a large group of activists from many different tribes who were living in the countrified part of Los Angeles. They were squatting on a ranch in Simi Valley at the foot of the Santa Susanna Mountains, which had sheltered other similar groups. They were congregating to form an egalitarian community there. The leader, or Grandfather, was an older man named Semu, a reverend in the Native American Church.

These people were considerably wilder than Lee. He was a comparatively sane and stable person. They were not easy to talk to. There were a lot of dark looks from them, and they always wore knives. They were much more militant than he was. Angry.

I think he was not popular with his tribe because he was an inconsistent, emotional person. Also, he did not submit to the authority of his elders, not in the sense that he did anything bad, but in the sense that he ignored what they told him to do. He was a seeker, and he preferred to do his searching out there in the world.

When he went back and took the cure, that changed him somewhat, but he still remained an iconoclast.

I trusted him. I trusted his instincts and his mystic concepts. He was there to teach me, and I listened.

Because of my position with "Kung Fu," I was sort of this dooropener to the Third World. I had an idea I could affect these people's ideas and be a tranquilizing influence. I wanted to get them off what I thought was a negative trip and into a more positive approach.

For several years I called him Lee, and then he told me his name was really Le (Lay). I continued to call him Lee in attempt to downplay his Oglala Sioux conceit. I had great respect for him as a Sioux, but I always discouraged his getting on a high horse about it.

ONWARD AND OUTWARD

There were so many letters coming in that the network changed its plan in midstream and told us to make fifteen more episodes. We shut down to regroup without shooting the fourth segment.

Again, my contract was no good. Negotiations began which never actually ended. The issue wasn't money; they paid me plenty. It was time. They wanted five years. I thought three was as much as I could give. We never could agree. I did the whole series without ever signing another contract.

Tired of talking business and never having cared much for sitting around, I took Barbara, my mother, and brother Bruce to Palenque.

While we were in Mexico City, I bought an inexpensive classical guitar, remembering my promise to Raoul to get Pepe a guitar. Then we started the long trek.

The Palenque Hotel now had more rooms and even a second story. We slept the sleep of pilgrims and went out to the ruins in the morning. Bruce stripped down to his running togs and ran the whole ten miles. I found Raoul in a cabana at the gate. He was now the keeper of the ruins. He told us that the site now boasted three white eagles who flew over it regularly. We talked a bit about the mystic

aspects of the place, and then he said, "I think now we will see the eagles."

We stepped outside and there they were, two of them. I had never before even heard of a white eagle, and now I was looking at two. There seemed to be another something, a sort of pucker in the sky next to them. I squinted, but it was nothing. Barbara touched her belly and said, "Two white eagles, and one unseen."

I asked Raoul where Pepe was. He said Pepe was now the guide at the Pyramid of the Magicians.

We went through the gate and I headed straight to the steps of the pyramid. As I walked up the endless stairs with the guitar held before me and my old Gibson across my back, I had the sudden feeling that what I was doing was making an offering to the Mayan Gods. Pepe was flabbergasted at the gift. We sat on the ledge and played together for a while.

After an exhausting and delightful day among the ruins, we bid good-bye to Raoul and went back to town. We met someone who said he could help us find some magic mushrooms. Next morning, we walked down a narrow dirt road until we came to a cow pasture. Inside were a huge variety of mushrooms: all shapes, sizes, and colors. Our guide told us which ones were good and which to avoid.

We sat in a circle and got very stoned: the guide, my sixty-three-year-old mother, my straight-laced brother, Barbara, with the baby within, and me. It was something like the mad tea party in *Alice in Wonderland*. Bruce took movies of it. I collected a bunch more "shrooms" to take with us and we wandered back (and I mean wandered back) to town.

A couple of years later, I discovered that our guide didn't know a damn thing about poisonous mushrooms. He was just guessing. He could have killed us all.

We drank a few margaritas and Mother and I had a long private time together. I played her a song ("The Lady From Baltimore" by Tim Hardin) and we looked at each other and laughed and cried at the same time. Then we went back to the ruins. We played all afternoon. At one point, sitting at the top of the pyramid, I spread open the newspaper I had put the mushrooms into. An elderly ruin hound behind me gasped. "Do you know what those are?"

I said, "Yeah."

He exclaimed, "I've never seen one before with my own eyes!"

"Would you like some?" I asked.

He replied forcefully, "No, no, no! Amazing! Amazing!"

As the sun went down, Barbara and I watched it from the ledges of the pyramid while I played my guitar. Suddenly I jumped up and flew down the ledges and across the compound. I had to take one more swim in the waterfall before the ruins closed for the night. I dove in with a sense that I was baptizing myself. When I got back to Barbara, she was crying. She had dropped the Gibson and crushed a corner of it pretty badly. I took her in my arms and told her, "It's all right, I can fix it. And anyway, it's just a guitar."

On the way out the gate, Raoul offered to take us to the top of the pyramid at midnight. He said that many strange and wonderful things happened then.

We had some more margaritas. Everyone (except Bruce, the clean machine) was too ripped to feel like eating and, around eleven, we met up with Raoul. He took us in the back way, through the jungle, and we gathered around the orifice that led down to the tomb. We sat there and waited for manifestations. After a while, I got bored and climbed down to the tomb, finding my way by touch. It was pitch black. I could not see anything whatsoever. After I came back up, we did see something unusual. Several orange orbs, about the size of softballs, came flying up out of the hole and buzzed around us. We all saw them.

My mother, who was by now deep into an alcohol-psilocybin-exhaustion dementia, identified me by saying to all of our little world that I was "the King." An odd statement for a devout Christian Scientist. Somewhat embarrassed by this acclamation, I replied, "No, Mother, I'm not the King, but I am an amigo of his." Actually, secretly, I thought she was right. But maybe I was just the priest whose terra-cotta head I had been worshipping.

Back in Mexico City, at the Maria Isabella Hotel, we had another manifestation. Orange balls again. Bruce and his girlfriend were scared out of their wits in their hotel room by them. Barbara and I, in our own room, found them interesting. I don't know what Free thought about them. Mother slept through them.

I couldn't sleep, so I leafed through a *Playboy*. Barbara complained about the light, so I went out into the lobby, taking the Gibson with me. I got tired of the *Playboy* and wrote a song:

I sing a song when there's nothin' else to do
If we're here alone, then I'll sing it for you
I might as well tell you, it's no big thing
Whenever I feel like singin' I sing.

There's no rings on my fingers, no bells on my toes
No scent that lingers, just a feelin' that grows
When I turn on the light, it's because I can't see
And the name of the baby is Free

When I'm feelin' extra good or extra bad I sing a song
If you feel like you want to, you can always sing along.
It's no big thing, so I might as well say it
It's not the song, it's how you play it.

There's no rings on my fingers, no bells on my toes,
No scent that lingers, just a feelin' that grows
Well, I can build you a house, or we can live in a tree
And the name of the child will be Free.
And the name of the baby is Free.

Then I went back to bed.

Throughout her pregnancy, Barbara and I continued to make love regularly. I called it "playing basketball."

On October 9th, 1972, Free was born. Barbara did the deed at home, without any drugs. We had found an old doctor who did home deliveries. He wasn't one of these new holistic crusaders, he had just never gotten around to using hospitals. I wore uncut deerskins tied around my waist and climbed into the rafters and played piano throughout her labor. At the end, I held her hand. When Free was halfway out, he opened his eyes, looked all around, and started making noises. He was totally conscious. He was totally beautiful. He was totally sturdy. He seemed a little pissed off. I thought he probably had

expected to be born into royalty. Well, he was, but in a shack, without any of the usual amenities. I don't blame him for being pissed off. We lavished our love on him, and very quickly he decided he liked the life that was thrown at him.

⇒ ⇐

THERE WAS A DILETTANTE fringe hipster who lived at the end of a cul-de-sac in Laurel Canyon. He operated a sort of salon of interesting people. One night I spent some time there with David Crosby, originally of The Byrds, and now of Crosby, Stills and Nash. We were fascinated enough with each other to spend the whole night talking.

In the morning, it fell upon me to get David home in my Lancia. As we were starting up, Crosby lit a joint. I said, "You can't smoke in this car."

He said, "I never get busted."

I said, "Well, I do. Stash it."

On the way back from this place I always passed a Victorian mansion, which had been partly destroyed in a fire. The place fascinated me. This morning someone was working on it. I stopped the car and told Crosby to wait. He said, "What are you doing?" "Buying a house," I replied. I climbed the rickety stairway and made the deal: $18,000, as is. "As is" included about forty trees on two acres. Rebuilding this place became my new project.

I enlisted Rick Van Ness's help, and we started a long and unique project together. By the time we finished, we had created an eagle's aerie that knew no equal. After tearing the dead wood away and replacing the burnt beams, we turned the little rooms into grand, sweeping vaults, with thirty-foot ceilings, combining rare woods and sculptural elements. The top floor was the teak deck of the USS Los Angeles, along with the kitchen and bathroom fixtures, which we had salvaged, saving it all from the junkyard. The windows, about a hundred of them, the stairways, doors, and just about everything else, we made on the spot in our own wood shop.

Brother Chris contributed a framework of steel girders to support it all. The ceiling was tempered glass, for which we had to go to court and change the L.A. building code. The roof of the bedroom

was a titanium alloy purchased from the aerospace industry. The work took two years and a little over $200,000. When the house was finished, it was an artistic triumph; though, from across the canyon, because of all the glass, it was invisible. The builder told me it was too wild, that a house needed an anchor. I said I preferred a parachute.

I called it the Glass House.

⇒ ⇐

THERE WAS A segment in "Kung Fu" called "The Chain," which needed a very big guy who could play a sort of slow-witted character. Jerry asked Barbara if she knew anybody. She recommended an actor named Michael who had done something like that on "The Monroes." This innocent little gesture would open a Pandora's Box that would cost me and Barbara and Free, and even Calista, our happy family. It would cost me a lot of money and screw up my career.

Michael showed me how to make a bamboo flute and gave me one he had made. Caine began carrying the flute with him somewhere along the way, though no writer or director saw fit to have me play it on the show until well into the next season. Michael became one of my closest friends.

Mike was great in the show he did for us and it looked as though it was going to be a comeback for him. A few weeks later, he called me up and said that John Drew Barrymore wanted to talk to me. I had known about John for years. He was pushing the hippie/beatnik thing long before anybody else had even thought up those terms. He was variously rumored to be a shaman, a sorcerer, bad news, and the inheritor of a noble theatrical heritage.

He occasionally came around to actors who were on their way and dispensed, at some terrible expense, a bit of sage cosmic connection. I believed at the time that if one rejected John, one was out of the game. I knew he was an extremely dangerous man. He could exalt you or arrange your destruction. It was your choice. Sometimes you have to be brave. I accepted the interview.

It turned out that John wanted to borrow $200. I looked around his house, which was a lovely little chalet that had been built by Charlie Chaplin. There was a lot of beautiful stuff in the place; it

looked like an antique shop. I said, "John, I don't want to loan you money, because you'll never pay it back and we won't get to be friends. But I'll give you $200 for that sitar." He went for it.

A month or so later, he stole the sitar back, out of my house. In his way of looking at things, he thought it was still his.

We finished the year at the top of the ratings, with the blessings of the network, and a no-strings deal for twenty-six more next season. "Same day, same time. Don't change anything" was what the network told us.

I took Barbara and Free out to show Dad his grandson. We found him in one of his favorite bars. The only thing he said was "Why is he so fat?" After that, he paid absolutely no attention to Barbara or Free. He just went on as usual, telling his stories while Free crawled around under the piano and Barbara sat primly and was ignored.

➤ ⇐

I HAD BECOME obsessed with the idea of making a movie out of that story Richard Carr had told to Barbara and me in that station wagon in Arizona all those years ago. I went to Dick and told him that, and he said, "Okay, I'll check out the rights for the novel." I said, "Rights? Novel?"

Dick said, "Yeah. What I told you was a bedtime story. The novel is very complex and long, written by Henry Morton Robinson, the guy who wrote *The Cardinal*."

I said, "I don't want to make a long complicated story. I want to make the bedtime story."

He said, "Well, we still need the rights. And anyway, what was it that I told you? I can't remember."

So I told him his story and he started writing.

Around that time we began hearing rumblings in the East about somebody called Bruce Lee. Some of us were worried he would steal our thunder, but I saw something else: balance.

Back at Warner Bros., others heard the rumblings too. Fred Weintraub, perhaps feeling stupid for having passed on *Kung Fu* as a

movie, regained his losses by making a movie called *Enter the Dragon*. To spice things up, a competition-karate champion named Chuck Norris was brought in as Bruce's opponent. So, in essence, one screenplay by a little-known Jewish writer had ended up being responsible for creating the entire international Asian martial arts explosion.

Enter the Dragon was made required viewing for the "Kung Fu" executives and crew. After seeing it, Jerry said we were up against the "James Bond of martial arts." I said it was more like the "James Dean." Anyway, we weren't up against it; we were part of it. Hell, we were the original.

Bruce was the yang, we were the yin. Bruce was fire and machismo, we were peace and humility. Together, we added up to perfect balance, like the Beatles and the Rolling Stones. The movement grew and we mushroomed together.

CHAPTER FIFTY-SEVEN

KANSAS FLYER

Just before the end of "Kung Fu's" first season, I went to a screening of the working version of *You and Me*. Skip Sherwood, my "financier," asked me what we were going to do during the hiatus. I told him, "I don't know what you're going to do, but I'm going to make that movie about the merry-go-round."

I sent Rick Van Ness, who had been with us on *You and Me*, to search for a location. He traveled across the country in his panel truck and found the town we needed in Drury, Kansas: population, 52. We had found an old merry-go-round in a carnival graveyard in Los Angeles, and acquired a bunch of broken horses in Kansas City.

John Drew showed up with his seventeen-year-old son, John Blythe, whom I didn't even know he had. He asked me if I could give the kid a job. I took him on as a surrogate son. John Drew, never being anything but self-serving, added that he wanted a part too. I told him I'd give him one day. Any more, due to big John's reputation, would sink the movie.

I took John Blythe around to a few people. His social graces weren't too graceful. At the house of Theodora Von Runkle, the famous costumer, he had some kind of little fit and dropped his coffee on the rug, Limoges cup and saucer and all. I told him if he did that very often, he would be as much a social pariah as was his father.

Years later, John was at a gathering that included Theodora. John figured after all that time she couldn't possibly remember. When she saw him, she pointed her finger and cried out, "You!"

In my infantile enthusiasm, I decided to do another movie at the same time: a period country musical called *A Country Mile*, with Bobby playing opposite me. I was told that was too ambitious. This only fueled my fire. I did compromise by letting Michael do the directing of the musical. I had what I thought was a good reason— the character was supposed to be drunk all the time. I wasn't sure if I could act drunk and direct myself at the same time.

We put together a company, which we named Kansas Flyer, a metaphor for a check that bounces. Nobody can say I don't have a sense of humor. We had a big get-together at a mansion belonging to one of the partners. In the middle of the meeting I was told we had lost the rights to the novel. They were being sold to someone else. I was pole-axed. I told Skip. He said, "Don't worry, David. It's just another obstacle." Later, he told me he had seen my ashen face and had been determined to say that to me, no matter what I had to tell him. He was actually as thunderstruck as I was.

I called up Marty Scorsese in desperation and asked him what I should do. He told me nobody could stop me unless I distributed it and made money off it, and since all I cared about was taking it to festivals and getting it reviewed, why didn't I just go ahead and make it anyway?

We all went to Kansas and started working. The Carradines and the Barrymores in the Packard, everybody else in their own cars and trucks. On the way, we drove through a tornado. Brother Bruce pulled up beside me and yelled that we were supposed to take refuge in the basement of a certain Baptist church. I told him I'd rather die in my Packard. A few minutes later, the tornado hit us and ripped the convertible top right off the Packard. We kept going. I felt like Dorothy in *The Wizard of Oz*. Well, that's why were in Kansas: to go over the rainbow. A couple of days later, I read in a local newspaper about forty people who had died in the basement of a Baptist church.

We found a big house and put everyone in it. We slept all over. The loving couples got the privacy of closets. We cooked all our own

food. To have some place to hang out, we commandeered a little restaurant where we could all sign tabs.

We started out shooting the musical, with minimal, almost antique equipment. The story centered around brother Bobby and me.

Michael, as the director, did not exactly rise to the occasion. For example, we didn't have a generator for the lights, and he chose a location that had no electricity. One moment I remember in particular: we were doing a dramatic scene while Michael was lying on the grass looking at the sky. Larry Bishoff, the assistant director, leaned over him and said, "Is that a print? Do you want coverage?"

Mike continued to stare at the moving clouds and said, "Beautiful. Just beautiful."

Somehow, we managed to get *A Country Mile* more or less finished, and went on to the big one, the merry-go-round movie. The feeling was totally different. We had state-of-the-art equipment for this one—better than we had at Warner's for "Kung Fu"—and we were not stoned all the time. I ruled the outfit with an evangelical zeal, and the company followed me like disciples. Barbara and I were fasting on wild greens and watermelon. An occasional cherry pie showed up from one of the ladies of Drury. It was the season.

Since the movie centered around the repairing of the merry-go-round, we had to stop every few days to fix it up some more. Everybody pitched in.

Bud, the location manager, started to go after the cracked and ruined paint on the horses with a blow torch. I blew my top. Bud asked Barbara what the big deal was. Barbara told him, "David thinks the horses are alive." True enough. They were.

Just when we were absolutely stuck, Danny Haggerty showed up, with his wolves and his woodworking tools. We rallied behind him. He set up a program to finish the merry-go-round. We created teams. Mike Greene and I established a woodworking shop, rebuilding the broken legs, tails, and heads of the horses. Danny carved the chariots with a crew he had trained. Each of us painted a horse of our own. Barbara's was the best: a flamboyant Appaloosa which looked ready to jump over the rainbow.

Halfway through, I went back to Hollywood to attend the

Emmys. I was up for Best Actor. I didn't win. For some reason they gave the award to the wrong actor. I wanted to run away, but now was not the time, so I stayed and danced all night, smiling all the time.

I went back to Drury ready for bear. I smelled a rat in the financing. I refused to take any more money from the backers. I was right about the rat. They all ended up in jail, but the movie went on. When we ran completely out of money, Skip told me we could still be stopped. We were out of film. We went back to working on the carousel. A theatre owner from Wichita showed up and wanted to invest in us. Skip got the guy into his gold Cadillac, locked the doors, and turned off the air conditioner. He wouldn't let him out until he had written the check. We were back in business again.

Barbara and I got fed up with the "boarding house" and moved, with Free, Buffalo, and Bluebird, into a tent in the alfalfa field behind the merry-go-round. The completion of this movie had become an obsession with all of us, and none of us were completely sane anymore.

Michael and his wife put up a tent in the forest. Drury was a strange corner of the state. Everybody knows Kansas is largely all flat plains of wheat, but Drury had more trees than all the rest of the state put together. One night I was visiting Mike in his country campsite, and he said we should put out the lantern. I said, "Why?"

He said, "Well, we're running out of oil."

I said, "Can't we get some more?"

He said, "No. I mean the planet's running out of it." Mike was definitely ahead of his time. A complete dingbat but a dingbat ahead of his time.

Finally, both movies were finished. We had been on the road for six weeks, shot a total of eleven days on *A Country Mile* and eighteen on the merry-go-round movie, which we were now calling *Around*. We had broken every rule and had barely escaped with the shirts on our backs, but we had two movies in the can. The film was sent safely back to Hollywood to be processed, and we all started the long trek home in a little caravan, with the Packard in the lead.

We stopped off in Santa Fe to visit Paula, Marty, and Warner. They were living in a country house on the banks of the Pecos River. Paula had two children, one by Marty and one by Roger.

I remember once during "Kung Fu" Paula showed up on the set with a baby in her arms. She tried to convince me that I was a legendary hero and had a mission to perform. I was, to her, Robin Hood, some character out of Tolkien, or King Arthur.

I had said to her, "You're taking this stuff too seriously. I'm just an actor. Look around, Paula—this right here is Camelot, and it's all plastic."

Paula had as her lover now a Vietnam vet who called himself "Eagle." He was one. He owned a young Appaloosa filly, which had been found running wild in the Pecos wilderness across the river. Someone had caught her along with a wild mule she had been running with. He had brought them in and offered to sell them both for $250. Eagle put up his severance pay from the army.

With his pockets full of grain, he led her back with his belt around her neck. He didn't have any place to put her, so he just let her go. She ran off straight away. He figured that was it. That night he heard her crashing around the Navajo hogan he was living in. He set out some food and water for her and little by little, after several days, lured her into letting him touch her. He named her "Venture."

I took her for a wild bareback ride and was hooked. Eagle was in some kind of trouble and had to make a run for it. He couldn't take the filly with him. I offered to give him the $250 but told him he could keep the mule. A tame mule is hard enough to get along with, much less a wild one.

We loaded the filly into a pickup truck, surrounding her with bales of hay to keep her from falling out, and she ate her way to California.

⇒ ⇐

BARBARA AND I TOOK a trip to Hawaii with Free. We'd never been there before. We played in the surf and ate magic mushrooms. We rented a helicopter to take us to The Valley of the Lost Tribes. There was no other way to get there except by sea. The chopper dropped us off and came back for us five days later.

One day, while eating mushrooms in a field behind The Sleeping Giant Mountain, we realized with a shock that our romance was ending. As I remember, Barbara asked me abruptly, really out of

nowhere, if I was going to leave her house. I don't know why. The making of the movie that had brought us together had somehow started a process that would bring us to a close. We were still very much in love, but we had this knowledge of the future now that we couldn't shake. We began making plans to somehow go on without each other.

I went back to work with a vengeance. We opened the "Kung Fu" season with a sizzling two-hour special, and just about everybody with a TV set watched us. Every actor in town wanted to be on the show, every writer wanted to write one, and every director wanted to direct one.

To help the process out, I moved myself closer to the action, doing more of the actual stunts than I ever had.

I took a little beach cottage in Malibu. I would stay there when we were working up on the mountain. It saved me a forty-minute drive. My Appaloosa, who had turned into a giant of a horse with the good food and water, was billeted just up the road. I gave her a new name: Indian Woman. Between the two of us, I called her "Squaw."

People were developing some mistrust in Skip Sherwood. Jeff came up with the suspicious information that Skip had been trained in a sales technique by an infamous teacher of con men in Florida who was now serving time. The technique was based on promising the "mark" that he would achieve his secret dreams. It was Jeff's opinion that Skip had been sent to take me for everything they could get. I pointed out that Skip was actually *giving* me my dreams and, as far as cheating was concerned, he hadn't cheated me. I added that Skip was only carrying out my orders. I was the one who should be shouldering the blame. A film director becomes obsessed. He is capable of moral lapses and will do anything to get the job done. I didn't go that far, maybe because I didn't have to with Skip on the job. Skip was my hit man. There were questionable practices, for sure, but I was the guilty one.

Skip and I had become very close. Actually, we were buddies. We spent a lot of time together, discussing movie theory and the meaning of life meanings. I now think he had been sent to con me, but had liked the action so much he had gone over. In any case, I was too happy in the relationship to let go of him.

I started editing the merry-go-round movie and Michael went to work editing the musical. He was dissatisfied with his progress, so he packed it all into a van and took it to Taos, New Mexico, and played with the movie as though it were a kindergarten finger-painting project. When he showed me the finished version, I was ashamed. He had turned *A Country Mile* from a small ruby into a greasy piece of broken glass. I put it on the shelf.

CHAPTER FIFTY-EIGHT

SEASON

The year 1974 had begun with the Crater Festival in Diamond Head, Oahu. Barbara and I, along with our year-old son, Free, and my visiting eleven-year-old daughter, Calista, were there to celebrate the New Year. We climbed the crater on Maui to watch the sun rise, then took a helicopter to Diamond Head. At the end of the day, the David Carradine Space Orchestra played before a crowd of 15,000 as the sun set on the crater behind us.

A tighter, more loving family group than the four Carradines could not be found. We lived in a little house in the Hollywood Hills among the trees, with dogs and cats, subsisting on fruits and vegetables. All of us went everywhere together. We were the model of connubial bliss for all our friends and for millions of people in the world.

I was making my living playing a half-breed Chinese martial arts master on a show in the top ten. Every week, thirty or forty million people tuned in to watch me spout philosophy and kick ass.

Soon the ax blow that would change all this would fall into my life.

At this time, John Drew Barrymore was considered a great actor who was impossible to work with. He had also been known to walk off pictures. A very expensive quirk. The general opinion was that he was insane. Not true. John was not a psychopath, but rather

a sociopath. I managed to get him a guest star role on the show, and helped him to regenerate his career by showing everybody that he could do a professional job. The network did not say no, they just said, "Go ahead. The show will be canceled. The studio will burn down, but go ahead." The director, Richard Lang, a fearless man, took on the job with gusto. After spending half a day with John, he said to me, "Sanest man I've ever met." Between the two of us we kept him in line.

John was on the wagon for this thing. Nobody had seen him like that in years. There were a couple of moments when he started to lose it, but we reeled him in. Richard designed a shot that would prove to the industry that Barrymore could cut it. He put together a shot wherein the dolly moves down the street alongside the two of us while we're talking. At the end of the move, John has to hit his mark, then after a couple of lines, move to the other side of me so that at first you're looking over his shoulder at me, and then over my shoulder at him. There would be no cut. This would prove the man was sober and capable. We made one close-up of the last part, in case we needed variety. It was a difficult shot, for the actors and the crew. He did it perfectly.

When we got the footage back from the lab we found that, just as John walked behind me, the film inexplicably turned bright red. As John passed me to his second position, it turned back to normal. Things like this always happen around John. He is so magical and unpredictable that the world around him becomes unpredictable.

Still, he proved himself. He was magnificent in the role and his conduct was exemplary. He could not be blamed for the paranormal phenomena. It drives him as crazy as it does everyone else. Thank God for that extra close-up. It saved us.

Throughout my work on "Kung Fu," I had been a dedicated householder. Michael was trying to convince me to be more of a revolutionary, to concentrate on liberating myself and society from our puritanical inhibitions. Jeff Cooper too told me that, even with all my wildness, I had sexual hang-ups. So I had, by now, adopted the attitude that my tendency to be faithful was just a tendency to be a stick-in-the-mud. I was resisting my own ideas of what I wanted to do out of reticence rather than out of a sense of values. I was, at this juncture,

trying to alter myself. I wanted to be sexually liberated. So I set about accomplishing this very deliberately.

During this period, I started having little flirtations on the set. I was doing this because I thought I'd always been a little retarded with women. I'd never really dated to speak of. I had had two or three very long relationships with a single woman and that had been my total experience. I thought I should experience something else. Variety, to be specific. I thought there was something manly about not being rooted to a single relationship exclusively, and I thought that doors should be left open. I've never locked my cars or my doors, and I was fond of saying when someone mentioned locking a car, "Well, I haven't locked my car for twenty or thirty years, and I've only had about four cars stolen." That's actually a pretty good average. Think about it.

I was talking to John Barrymore outside the soundstage and a girl came up and said something to me. I started lightly flirting with her and when she left John said, "David, are you playing around with girls?"

I said, "Yeah."

He glared at me as though I had committed a sin, and I said, "You're supposed to, aren't you?" He looked at me in a very strange way.

A couple of weeks later, he called me up. "David, I'm in a little trouble. If you could come down here, it would be really helpful. I'm stuck here without a car, and this woman is giving me a hard time," and so and so and. . . . I said, "All right." And I went down and he wasn't exactly ready to leave, but it was a crazy atmosphere. He did need to get out of there, and while I was trying to get him to leave, James Earl Jones came in with this girl, Season Hubley.

There I was, lying on a couch barefoot, with my guitar in my lap. Season sat down at the other end of the couch. There was something about Season. I don't know what it was. She was talking in a bubbling, happy way. She was wearing an almost transparent silk lace blouse, with a lot of buttons undone. I could see clearly her sweet little breasts. The nipples were standing up.

I sang a song directly to her, one that I had written. This was a dangerous thing to do, for at that time I could turn on my charisma

like a faucet, and if I looked into someone's eyes and sang a song, they would think they were supposed to do whatever the song told them to do. That always seemed to work on a woman through a sort of mild hypnosis; that combined with my soulful eyes, which could melt icebergs.

Let me take you for a ride
Quiet all that pain inside
You know you're looking for a place to hide
Understand, hold out your hand
Let me take you around

No need to tell me your name
Just grab, grab ahold of my mane
Let me unwind you, help you find you
Show you yourself how you look comin' up behind you
Understand, hold out your hand,
Let me take you around

Come along, follow me across this crazy land
I can understand, please hold out your hand
Gimme your hand, I need your hand
Lay on your hand, join the band

Let me take you around

When we looked into each other's eyes something happened. Her eyes were a soft, electric blue with a little bit of cold steel thrown in. She had a face like an impish angel, and a halo of thick honey-blond hair. I reached out with my right foot and slid it into her blouse, brushing her left nipple lightly with my toes. Her eyes widened, but she didn't pull away. James Earl Jones's reaction was stronger. Shock, I would say. He sat up suddenly, looking as if he might be about to jump me. I turned my eyes on him and sang a song, a soulful, racist tune calculated to soothe the savage beast within him, while incidentally removing my toes from Season's blouse.

I used to rob my daddy's pockets
While his pants were hangin' in the closet
I used to rob my daddy's pockets for nickels and dimes

If you ask me where I've been, I'll tell you I've been 'round
The block and back more than a couple of times
There's nothin' that I've got that I'm afraid to lose
I got no right to sing the blues

I used to hang around the drugstore
Readin' comics by the score
I used to hang around the drugstore just like a cowboy
Don't ask me where I'm goin'
I'll have to tell you when I'm gone
I'm free, white and twenty-one
And I've got three pairs of shoes
I got no right to sing the blues

I used to wear my mama's bra and panties
and parade around the room like a queen
What are you laughin' at? You know what I mean
But I put aside most of that stuff by the time I was seventeen
And now I'd rather be on top than any kind of in-between
Well, it seems like I could get to be
Just about anything I choose
I got no right to sing the blues

I had never in my life done anything like that before. I couldn't imagine why I did it now. Perhaps she had her own hypnotic powers. In any case, I was definitely smitten.

The two of them stared at me. Then James began talking very easily. After a while, I thought I had better get out of there. When I got outside, John said, "Isn't that a wonderful girl?"

I said, "She's a fabulous girl."

And he said, "There's an even better one coming later on."

I thought about that on the way home and came to the conclusion that John had set me up.

You get the picture? I had said, "Aren't you supposed to?" and he's saying, "Oh yeah? Let me teach you a lesson." I think, in a sense, he deliberately worked to destroy my relationship with Barbara in order to teach me not to play around. He wanted me to be a better man than that, at whatever cost to myself. That was one of the dan-

gerous things about John. He was the kind of Medicine Man whose cure is liable to plunge you into an abyss of despair.

That was June. In August I walked onto the set and there was Season. She'd gone on a campaign to get on the show. That would not have meant so much on the normal seven-day schedule; however, this was a two-hour show, a very important one. It would premiere the new 1975 season. Patricia Neal, fresh from her debilitating stroke, was stooping to episodic television to prove to the world she was all right and ready to work. The other guest stars were Eddie Albert and Edward Albert (father and son). The schedule was fourteen days—too long to resist the obvious attraction between Season and myself considering our constant proximity for eleven hours every day, five days a week, without falling under her spell. The dangerous moments came on the weekends.

One Friday night we drove away together in Season's Audi Fox. We had a drink at the Raincheck, one of Season's favorite hangouts, and ended up at her little house just off of Valley Heart Drive beside the river. Outside her door, in the dark, our lips were slowly and inexorably drawn together by a force other than ourselves. When we finally kissed we both felt something like falling off a mountain, combined with a definite rush of dizziness.

We parted breathlessly. Season stepped back and dove into her ice-cold swimming pool with all her clothes on. I followed suit. We tore off each other's garments and made love right there with our teeth chattering.

Afterward, we went into the house and Season made tea and put on a record while our clothes dried: Waylon Jennings singing Willie Nelson. I'd never heard Waylon or Willie before. Whenever I hear them now I think of Season.

We drank our tea and then, after another one of those kisses, made love again in her big bed. I stayed the night.

The incident could conceivably have remained just that: an incident, a brief flirtation. But none of us were to be that lucky. Life would never be the same.

It seems to me that the moment I passed the point of no return was when Skip Sherwood, visiting me on the set and seeing Season, got a sort of bird dog look.

I said, "Skip, that one's mine."

He said, "They're all yours, David."

I said, "Yes, but I'm hers."

Skip looked at me as though I were a lost soul, which I guess I was, and said, "I see. That's different."

It certainly was.

The last shot of the two-parter, with me walking away from Season forever, high on a cliff above Malibu, long hair blowing in the wind, became our logo for all the subsequent segments. The picture taken of me on the beach, same long hair blowing and something like smoke in my eyes, became the most circulated still photograph of the series. I was staring past the camera at Season. The shutter clicked, I think, exactly at the moment when I fell for her.

The day the show ended, I caught Season just as she was driving off. I leaned down to her foxy car window and mumbled, "Season, I don't know what to say. I'm not sure. I suppose I shouldn't use the word love, but—"

Season looked me straight in the eye and said, "I love you." And drove away.

A week or two later, those same inexorable outside forces drove me by her house. She wasn't there, so I left a little love note on her door. Maybe that was really when I passed the point of no return. We started talking on the phone, and I spent many nights at her little house.

A little later, things had actually progressed (or deteriorated) to the point where I went to a martial arts competition at the Forum with Season and Barbara as my dates. When I introduced them, Barbara said, "Well, at least they're getting better." Little Johnny Blythe Barrymore came along as a "beard."

We killed a bottle of tequila during the evening and then, after dropping Johnny off, found ourselves together at the Burned Down House. The place was only half reconstructed at the time. The only finished room was the bedroom. I was attempting to make some kind of peace between them.

We stayed together until the dawn was breaking. Barbara and Season actually were getting along. I loved both of these women, they both loved me, and we were managing to be friendly.

I had a date that night with the Native American Church. Some Indians who were friends of Lee Warlance were constructing a sweat-lodge on their self-proclaimed reservation in Simi Valley, and I was invited to attend the first (open air) peyote ceremony to be performed there. It was much too late to go to it but I thought I should go anyway.

I left the two of them alone together.

THE FALL FROM GRACE

I pulled on my best boots, loaded my guitar and my silver flute into my '65 Corvette, and drove off to my rendezvous with the Indians.

When I arrived at the ranch, the Indians had just finished with the peyote ritual and were having a little feast. These Indians were from several tribes and were determined to make a place for themselves here, living in harmony with their families in the old way. Some of them were part of the militant movement who were more or less in favor of the overthrow of the U.S. Government.

They were sorry that I had missed the fun, and disappointed that I had not brought my family with me. I thought of what I had left behind at the Glass House.

However vicious or unstable or explosively violent these people might be, they were very family oriented. They respected their elders and believed in the sanctity of marriage. And I was, well, bringing the devil in with me.

"I am on the edge of becoming a really serious sinner," I said to myself—complacently, I think. I believe this sinful feeling is identical to that of a radical evangelist about to start a movement. Too much love is what it was—for myself! Self-centered son of a bitch that I was, I actually thought I could take my hand to these savages and turn them from violent activism toward quiet acceptance and inner peace,

to solving their problems through passive resistance and prayer. Like a fucking missionary! Who did I think I was—Gandhi?

I was hoping that this experience might cure me of this whole thing that was undermining my own family. Instead, the whole thing exploded. Everything exploded!

After we'd eaten together, it was suggested that we all go back to the circle and do a whole other ceremony. A bunch of us trooped up the hill and flopped down on the grass to wait while the others made the necessary preparations. I got my flute and guitar out of the car and took off my boots. We talked easily, if somewhat strangely, and I played and sang a little.

We all moved into the "lodge," which was simply a round hole in the ground, about three feet deep and eight feet wide or so. We sat around in a circle. In the center, behind a small wood fire, was a display of thirteen fresh peyote buttons, a rare sight. These were not what we would take, except perhaps at the end of the whole thing. What we began with was the tea, made by boiling the dry buttons: an incredibly bitter, but barely palatable elixir. Later, we would graduate to the paste: a mash made by pulverizing the buttons that had formed the tea. Eventually, we would start in on the dry buttons themselves, carving the strychnine blossoms out of the tops and softening them in our mouths until they could be chewed up and swallowed.

Into our little fire we threw flat cedar leaves, the smoke of which would minimize the inevitable nausea. The sun climbed over the Santa Susanna Mountains, and things got weirder and weirder. A full dose of peyote is about seven buttons. Altogether, I estimate I ate about thirty buttons, perhaps more.

As we sat there, the world changed around us. The little dugout became a circle of huge proportions. We looked at each other in awe, or we dared not look at each other. The sun was a radiant purple; the sky was a person; the wind, the dust, the bird songs were magical manifestations.

I sat and watched a small child playing with my flute, getting dirt all inside it, completely wrecking it in fact. His father offered to take it away, but I said no. The child was more important than the flute, or I was afraid to interfere with anything that was happening—I don't know which.

As the sun rose higher, something happened. I'm not really certain what it was, but I could say I started to feel like Custer—surrounded by Indians. Danger, or so it seemed to me. I decided it was time for me to leave. I didn't think it would be prudent for me to advertise my exit, so I left my boots, my guitar, and my flute and walked to my Corvette. Before it became anyone else's business, I had peeled rubber and split.

I drove home with devils jumping out in front of my car and roads that turned into Jell-O. Somehow I made it. There was nobody there. I took off my clothes and dialed a few numbers on the telephone. No one was home. I called the operator and asked for help. She asked me if I needed a doctor.

I really didn't know what to do, so I went down the stairs and walked around the neighborhood naked. That worked for a while. Then things started to get a little strange.

I walked through the neighborhood, stopping at a house occasionally. I would make a point of turning off appliances: stereos, air conditioners, washing machines. As I was strolling through someone's living room, I heard a voice say, "That sweet, gentle man? Let him be. He doesn't mean any harm." I was going to effectively dispel that image before the afternoon was over.

Brother Bobby told me later that he had been driving his Corvette down the road and had seen me walking along naked, but figured I didn't want to be disturbed. Actually, all I was doing was looking for someone I knew. Things would have been different had he stopped.

I went on up the mountain to Michael Greene's house. No one was home there. I let myself in and wandered around a little. It was kind of stuffy in there. I tried to open one of the windows but it was nailed shut. I thought, "This is not right!" So I put my fist through it. There was an unfinished oil painting on an easel. I took up the brush and worked on it for a while.

I cut down through the woods, the shortcut to my house. On the way, I stopped at the little cottage at the edge of the woods. I knocked on the door. The door was locked. I never locked my own doors, and I thought people really shouldn't do that.

Whenever I was left alone and unoccupied, it all became a

nightmare—not with monsters or anything like that, but I had dis-
torted perceptions of what was going on and even of the shapes of
things: what the light looked like, whether trees could walk or not.
None of this was very solid in my mind and I felt as if I had to get
into this house, so I broke the window and let myself in.

I went up a couple of steps and came to a beautiful little child's
bedroom. The windows were closed. I started to open them but the
crank had been removed. There was a little plastic radio on a shelf. I
threw that at the window but it just bounced off. I struck the win-
dow with my fist in the proper manner—stopping the blow at the
surface of the glass so as not to cut myself. Nothing happened. "My
God! This is not right! Triple-pane tempered glass. This place is a
prison!"

I hauled off and threw my best punch, a left, following
through. The glass shattered, incidentally putting a deep gash in my
arm. I looked at the blood gushing out. I thought, "Hmm, that's
strange." I climbed through the window and dropped to the ground.
It disturbed me that I had cut myself so badly, but I didn't know
what to do about it, so I walked back through the front door and
played the piano for a while, bleeding all over it. After a while, I got
restless and I went back to the broken window and jumped to the
ground. Again.

I made it through the woods to my backyard. I found my bar-
bell there, and thought, "Well, I'll do my exercises." Barbara looked
out the window and saw me there, stark naked, blood streaming down
my arm. She came running out. She brought me inside and tried to
quiet me down enough so she could fix me up.

Someone was there waiting for me, a fan who had found the
place by dead reckoning, as many did. He had been a paramedic in
Vietnam, and he wanted to stitch up the wound. I refused. I thought
it should be allowed to heal by itself. He said to Barbara, "Don't
worry. He'll pass out from loss of blood any minute, and we can do
whatever we want." He wasn't counting on the supernatural energy I
was getting from the peyote, particularly since I hadn't thrown any of
it up. I did pass out. I woke up to find him sticking a needle and
thread into my arm. My energy had been renewed. Peyote will do
that, and at that time in my life, I possessed enormous stamina and

power. I pushed him away with the strength of madness and pulled out the needle.

He said, "I've got to have some clay. I can make a compress." I pointed at the Mayan head in the corner. "You can crush that up." He didn't want to destroy it, but I said "Go ahead." I giggled as I watched him smashing up my precious sacred object with a brick. He said, "This isn't going to work." Of course it wasn't. The clay had been fired and could not be returned to its original state. I just thought it was all very funny. In that state, everything is a joke. Jesus on the cross is a joke, a bad joke, but a joke like a gory joke. God sends his son down to lead us all to the most happy state possible, and we torture him to death. Now that's funny. Barbara was wide-eyed with terror.

I decided I'd had enough of this shit. I bolted out the door and leapt, fairly flew, down the seventy-nine steps, where I discovered Barbara's Ferrari. I jumped in and drove to the Burned Down House. That would be a safe haven. I drove pretty quickly because I remembered someone saying to me when I told them I don't really have the nerve to be a race driver, "All you have to do to make a car work like that is put your foot on it and don't take it off." On the way up the hill, some neighbor yelled, "Slow down!" and heaved a big rock at the car. I thought he said, "Don't slow down!" and I floored it, escaping the rock at the same time.

Just at the hairpin turn, the Ferrari stalled. I stepped out, leaving the door open, and started up the hill on foot. There were two girls standing there staring at me. I must have been a sight. One was a lovely thing who was tan all over: tan hair, tan skin, tan eyes, tan suede hip-high skirt, with a flap that split up the front, matching halter, bare feet. She looked like a long-haired version of Veronica Lake as Peter Pan. The other one had dark hair and thick, black eyeliner around wild, dark eyes. She was dressed in a ground-length old-fashioned black velvet dress that was held together at the neck by a safety pin, black, high-button shoes, and a great deal of costume jewelry.

I asked her, "Are you a witch?"

She said, startled, "No."

I said, "Then why do you dress like one?"—reaching out and

touching the neckline where the safety pin was. She pulled back an inch or two and the safety pin tore the fabric slightly. This scared her. The tan Peter Pan took my hand and said, "David." She put her hand around my wrist to staunch the gushing blood. She squeezed so hard it hurt. I tried to pull away. I looked into her eyes and saw an angel. Somewhere around then I passed out.

I came to with little Johnny Barrymore beside me. He said, "I think this time you've really blown it, Dave. You've cut an artery. You're going to bleed to death if you don't get help."

I said, "I want to talk to your father. Bring him. I'll talk to him."

The image I remember most out of all of this was lying in my garden, being gently awakened, looking up and seeing, outlined against the sky, the incredible gaunt and grizzled head of John Barrymore, and feeling "Now everything will be all right." A totally insane concept. He looked down at me from behind his long gray hair and beard, with his soft blue eyes, and said, in his voice that makes Orson Welles sound like a teenage girl, "What do you want me to do, Dave?"

Behind him, I could see at least a half dozen people had gathered—for the funeral, I suppose. I just wanted to be left alone. I said, huskily, "Get rid of those people." John's a very extreme person, but he does come through sometimes, and this time he did. Then he came back and asked, "What do you want me to do now?" His face was so close to me, he was almost out of focus. I whispered, "Go away."

It took a great deal of, I think, love for him to do what I told him to do, which was leave me, maybe to die, just because that was what I wanted. Most people would just sweep your desires out of the way if they seemed too strong. Also, knowing John, I think he knew that this was a cosmic moment, perhaps of utmost importance, and not to be messed with. Anyway, he left.

Mescalito, the peyote God, came to me, as tall as the jolly green giant, with skin like the rough, serrated surface of a peyote button and a head out of some pre-Columbian temple carving. He leaned his ancient face down out of the clouds and said, in a great, booming voice, "Come. Time to go, my son."

I said, "No. I'll stay here awhile."

He said, "You don't have to. You can come with me right now."

I said, "No. I've got things to do. Women to love, songs to write."

He said, "All that has already happened. Time is not a river. It's a circle. It has all happened before. You don't have to go through the toil and pain again."

I said, "But I want to. I want the feelings. I don't mind the pain."

He said something like, "Suit yourself, Dave, but it's a waste of time." And he walked off, stepping over the mountains. (How can it be a waste of time? Time is a circle. How can you waste it?)

There I lay, alone in the cool mint patch, my life's blood draining out of me, staring at the clouds rolling by for a while. It was very quiet. Once in a while, I'd hear the twitter of a bird, the flutter of wings, the cry of a child. "Life goes on," I thought. I got to my feet and weakly made my way upstairs to my unfinished bedroom, knelt down, and finally threw up the peyote.

I lay myself down on the cedar floor and stretched out my arm. I watched the blood and vomit congeal together. The alkali in the peyote would clot the blood. I turned my head upward, closed my eyes, and, finally, breathed easily. I fell asleep and dreamed wondrous dreams.

When I awoke, Barbara was there with Free and little Johnny Barrymore. They had cleaned up the blood and gore and moved me onto the tatami mats. I pulled my arm out from under the Indian blanket and looked at the wound. It looked okay. Keith showed up with a jug of red wine and I drank a lot of that. It's supposed to replenish the blood.

The cops followed me through the woods by the trail of blood, but lost the scent when I took off in the Ferrari. They estimated I had lost three pints up to that point. They figured I'd collapse any moment, but they, like everybody, weren't counting on the effect of the peyote. I lost another pint at the Burned Down House.

The truly amazing thing about the whole adventure was that I was never the least bit frightened and, in later years, was still willing to eat a lot more of the stuff.

Meanwhile, out there in the world, that great ax blow kept falling right into the center of my life.

The next day at the studio, I managed to get through a fight sequence with a lot of help from Greg Walker. The police showed up. Jerry talked them into going away, but I still had to face charges. The media had a party with it all.

I didn't appear at the trials. The lawyers handled it all and so I more or less lost the case. Well, of course. I knew if I showed up there'd be more media coverage while, if I stayed away, it would just happen. And I preferred to take the gaff. Too much publicity could hurt the series, and probably did anyway. The series was canceled prematurely, unilaterally, by the network, the studio, the production company, and myself. We all decided to stop doing it shortly after that.

The incident was really like an ax blow in the center of my life.

The publicity itself, the lawsuit from the woman, the man whose house I had—whatever you call it—vandalized, plus the criminal prosecution for malicious mischief. For a little while, they were vacillating as to whether or not to bring felony charges. All of that had a very real effect on the audience, who up to that time had trusted Caine to be a certain kind of person and perhaps they couldn't relate to him that way anymore.

My family broke up very quickly after that, along with my whole life. I pretty much had to start over.

I had to pay $15,000 in damages. The judge and everybody else probably thought that fifteen grand was nothing to me. Actually, it was a considerable amount of money to me. I know most people thought I was filthy rich, but I was spending a great deal of money on my own filmmaking ventures. I pleaded no contest to the malicious mischief charge and served a two-year probation.

The homeowner on whose piano I had bled only wanted the repairs, which was amazing. When he came home, it must have looked as though Charles Manson had been there. Later, he changed his mind and wanted a whole lot of money, but I think we worked it out.

The poor guy, after a while, moved out of the house. He could not bear to live there any more.

I avoided talking to the press about the incident, but Michael Greene basked in the glory of giving them a garbled version of what he'd heard from me and Johnny Barrymore, who was Barbara's confidant. I just kept on working. Articles appeared in the tabloids expos-

ing a "triangle" between me, Barbara, and Season, gleaned from the same source. The image of the serene, kindly Shaolin monk deteriorated somewhat. Hell, it was totally blown apart. I'm pretty sure grammar school teachers stopped making the show required homework.

A few years later, I had an eyeless seagull tattooed over the V-shaped scar on my arm—actually, a tern. A "blind" tern. Get it?

➤ ⬅

IT HAD NEVER occurred to me that I could lose Barbara. Well, we were soulmates. But about this time, everything just collapsed. All this was not easy. She was nursing Free. She couldn't really work. She had to deal with everything while I was out there, pursuing a variety of things in an obsessive way.

The movies I was producing were rife with difficulties and she had to share all that with me.

Rolling Stone magazine did an article about me. Tom Wolfe wrote a very surrealistic story in which he mentioned that I had a listed phone number. *Rolling Stone* found this extraordinary. I wanted people to be able to get hold of me; I sometimes found new things from new areas of the world. Fresh blood, I called it.

After the *Rolling Stone* article there was a flood of calls from strangers. Fifty to one hundred a day. I didn't want to withdraw from my position and change the listing or put an answering service between me and my "constituents." I figured eventually it would blow over. We had to answer thousands of nuisance calls. Barbara had to. I was at work. She was home. She would talk to them very patiently until she got them off the phone. Then it would ring again, immediately. I knew from the few calls that I took what it was like: "Hi, man. Wow! It is you! Hey! Are you stoned? We're really stoned."

Then there were the little infidelities. These hurt her more than I knew—actually demeaned her. With the arrival of Season, this problem became more serious. Barbara felt she couldn't compete with a real love affair. I think the window-smashing incident was the straw that broke the back of the romance. She needed some moment of something that wasn't so damn much trouble. She needed more chances to breathe easily, deserved them. A woman with a babe in arms needs a safe, soft haven, with caresses and attentiveness. She

needs respect and a little excitement. She was not getting a lot of joy out of life.

I was out of control. All I could do was play out my line to the end and then see where I was.

I started staying every night with Season. We cut a wide swath in town, hanging out with great artists, psychics, astrologers, musicians, and so on, and drinking a lot of tequila. Season was a smoker, which should have been difficult for me, but I discovered I loved the way she tasted.

I had a bunch of clothes at the cleaners. One day I picked them up and, instead of taking them home, took them to Season's place. By the time I took notice that Barbara and I were splitting up, I hadn't really been home in a month or two. Season had become home to me.

Together we were a happy, lovable feast. We were as safe a bet as matches and gasoline. The world predicted disaster for us. We didn't care. Part of it was the sex: incredible, to say the least. There were other factors, though. We were a powerful couple. One thing I liked very much about Season was the fact that she had absolutely no small talk. If she didn't have something she really wanted to say, she didn't say anything. She wouldn't put up with any bullshit, and didn't have any herself. Season had a gold dog tag, which hung around her neck at all times. On it was inscribed: if lost, return to Joyce Selznick. Joyce was a casting director with a lot of clout. She had once said that I would never be any good for anything but "heavies." She managed Season. She didn't like me at all. Actually, the only person who approved of our romance was my brother Bobby. He said we were a fun couple and he liked to be around us because we were always laughing and happy.

My mother told me that what I felt for Season was something she called "animal magnetism"—a phrase from Mary Baker Eddy's Christian Science writings. My sentiments, as I put them together on my fancy made-in-Kansas Mossman guitar, were:

> *Carry me away*
> *Go ahead and lay it on me Baby; I can take it.*
> *Lead me to a better day;*

It'll be worth it if we can make it through.
If we can't, we're not worth keepin'.
Wake me up, I'm tired of sleepin' through it all.
Don't you know I'm startin' to fall in love.
(corny as it may sound)
Keep it a secret.
Carry me away
To a better day.
When you were a little girl
With your curls and your good pink dress
Sittin' on a shelf to have your picture taken
Did you know that it would be like this,
When you would awaken?
Did your mama tell you about me and you?
Did she tell you what to do, when I came along?
Did she tell you how to make it through this day?
Did she tell you I would come and carry you away
To a better day?
I'm in love with you, fallin' in love with you,
Fallin' in love, fallin' in love.
I'm in love with you.

I was deep in, for sure.

There was a group of people around Season who controlled her to a certain extent: her manager, friends, astrologers, faith healers. I was required to meet all these people. One weird one was some guy, a house painter, who fell off a ladder, landed on his head, and woke up in the hospital with psychic powers. He worked occasionally for the police, finding serial killers and the like. He had a trick of bending spoons with his mind. He bent Season's dogtag—not polite, I thought—and predicted some disasters for me. If he was such a great psychic, why couldn't he straighten things?

CHAPTER SIXTY

PARADISE LOST

In an effort to raise money to finish my movies and complete work on the Glass House, I sold my residuals back to Warner Bros. I thought I was getting a good price for them for those times; there were no rumors whatsoever of future syndication and, anyway, I didn't want to be a coupon clipper. A hungry fighter is a good fighter.

In the series I changed the costume to a classic black silk kung fu outfit. We did a lot of great shows that year including a two-parter that took place entirely in a temple in China. I managed to talk the studio into letting me direct that one.

I cast Barbara to play opposite me as a girl kung fu master with whom Caine falls in love. She dies tragically at the end. For two weeks we recaptured, at least on film, the flame of our love. Every night I would go home to Season.

When my directorial turn was over, we had a cast party in the temple. Barbara tried valiantly that night to put us back together, but I was lost. I could see how poor my relations with the crew, the studio, and the network had become. Morale was irreparably low. I had been too hard for too long, screamed in anger at too many people, and stayed too much to myself. They also all loved Barbara and thought I was a cad. I guess I was.

I was approached to do a two-day country music festival in Devonshire Downs. Waylon Jennings was the headliner. I was to

appear just before him for a handsome fee. The place could hold 15,000. About 5,000 showed up. The promoters had blown it and the festival was a bust. Waylon wouldn't go on until he'd been paid for the night. The promoters came up with just enough to cause him to go on, which meant nobody else got paid.

Our act—acoustic guitar, bass, and flute—was not well received. After a few tunes, the audience started chanting for Waylon. The promoter tried to hook me off the stage, but I'm not easy to get rid of. We finished the set. Waylon was a smash hit. After the gig, he, his entourage, his buses, and his equipment broke camp.

What to do for the second night? I was their only hope. We borrowed a drummer from another group and I borrowed an electric guitar and sang louder. The excitement generated by those little changes was all it took to make us a hit. Season and Calista came on stage and danced to the music.

Work went on. Barbara came to the studio one sunny afternoon with Free and we sat on the grass gazing at each other with nothing to say. Free slept through it.

Finally, with my heart in my throat, I said, "Good-bye." It was over. I went back to work. I couldn't stop crying. They had to use a fog filter to hide the tears.

Michael Greene arranged for his old friend Hampton Fancher to have a date with lonely Barbara. Suddenly I became afraid of losing her. The shoe was on the other foot. I considered that Michael had betrayed me, but Jeff said Mike had done the right thing. He'd been faithful to his friend. I didn't see why that had to include matchmaking with his other friend's girl. I thought Mike was a devious man. Later on, it became clear that they reveled in seeing me in trouble. They got a kick out of lording it over me after I'd lorded it over them and everyone else. When an empire falls, the looters move in.

Calista was having a little trouble in school; she was that age: twelve years old. Her mother had just begun to find it impossible to answer all her questions and she really needed a father. That's not what her mother thought, that's what Calista thought. To me, she was a Godsend. I was all alone. We lived together in a tiny one-room house right on the beach in Malibu and subsisted on raw fruit and vegetables. My relationship with Calista was . . . well, a common yearning

was probably the most definitive thing we had; a yearning for each other.

We went up to visit my mother—all of us—Barbara, Free, Season, Calista, and me. There was a big family dinner. Mother sat at the head of the table with me on her right hand and Bruce on her left, Barbara beside me, and way down the table, with the neighbors and kids, they put Season. Sparks flew all over the place. I was torn, to say the least. I put Free in my place and sat next to Season.

My mother archly asked Season how I was in bed. Season replied, "Remarkable."

➤ ◄

SEASON AND I announced plans to marry. We had rings made, simple bands of white gold. Our plans hit the fanzines and tabloids. Columnists vilified us. I received letters saying, "DON'T DO IT!" Not one letter congratulating us. I ignored them, but it hurt. Season wanted to be married under the arch at Washington Square Park in New York.

We went to New Jersey to visit with her family for Christmas. We took Calista with us. We went Christmas shopping in the snow and had a great time. On Christmas Eve, I had an attack of regret. I called Barbara and talked to Free. Meanwhile, Calista had let the canary out of its cage and the cat ate it. Some little boy was devastated. There was a pall over things. I got drunk with Season's aunt on Amaretto, avoiding the mourning going on in the living room.

After Christmas, we stayed for a few days at the Plaza in New York. Season introduced me to all her old friends, including the fellow who had deflowered her. In between we made love to the point of disability.

It's hard to explain, but all this while I was having more and more doubts. I loved Season past caring about myself or anything else. It seemed to me that I could be wrong to feel that way. How do you censor your feelings? I found myself (after an incredible day with Season in New York, and half a night spent in the fine madness of her embrace, with her now blissfully and beautifully sleeping nearby) sitting on the ledge of the window, looking down at the carriages on

Central Park South and seriously considering just sort of falling out the window.

The time came when I had to go back to work. Season was to meet me later in Los Angeles. I met her at the airport with Free on my shoulder. She knew things had changed. We held each other in my little house on the beach. The whole thing was very painful, but I couldn't help my feelings any more than I could when we started up.

I tried to get back together with Barbara, but it was a little too late to do the right thing. I gave her the Glass House, which was more or less finished now and incredibly beautiful. What the hell, I'd built it for her. I committed myself to living in Malibu.

I called my mother. She told me I'd get over it. Because of her Science of Christ, she believed that everything would always turn out all right. She added that she had carried a torch for Dad for twenty-four years but gotten over it. I reeled. Twenty-four years!

I went out to Oxnard by the Sea to visit Dad. He took me sailing. This was supposed to put my head straight, but I just got seasick. There was no way around it. We were out to sea, so there was no escape. I didn't get over it until we were back in port. I vomited over the side until there was nothing left to vomit. Then I started throwing up liver bile. Back in the harbor, I curled up in misery before the mast while Dad went into the bar. After a while, someone came out with a glass of cognac and more or less forced me to drink it. It did the trick. I joined the revelers. Dad had told them that throughout the sail, in spite of being sick as a dog, I had never taken my hand off the tiller. An absolute lie. I spent the night at his place. In the morning I felt perfectly wonderful. I guess I'd barfed up all the poison in me. That was the last time I ever went sailing with Dad.

The series was starting to seem completely fucked up to me. I had a big blowout at work. Trying to keep up, much less improve, the quality was like tilting at windmills. We were recycling old stories. The dialogue got poorer and poorer. One day, Jerry Thorpe came out to the location to thank me for making their stupid writing sound good. He knew it was bad and he couldn't fix it. It frustrated me, and that made me mad. My shattered heart didn't help.

Jerry, Alex, and Herman had a meeting in my trailer and Jerry pointed out what the network was doing with our series, which was

putting it in a different time slot every week to bolster up failing ratings on other shows. "Cannon fodder" was what he called it. I felt if that was all they thought of us, maybe it was time to close up shop. The guys agreed. No one was having much fun anymore and we all needed to get on to other things.

The network said they'd have to think about it. I told them to look at the contract. (Remember, I didn't have one.)

We finished up with a five-hour marathon show in which Kwai Chang finally finds his brother, and little Grasshopper walks off into the sun for the last time. That show was so good we almost reconsidered, but the die was cast. We threw in one more for nostalgia's sake, bringing back my father's Blind Serenity Jones for one last time. Everybody was tearful and loving at the end, and again we wavered, but I had always sworn that the third year would be the last, and at the end of the season, on February 5th, 1975, I walked.

CHAPTER SIXTY-ONE

FRANKENSTEIN UNBOUND

T
wo weeks after I left the series, I went right into *Death Race 2000* for Roger Corman in a deliberate move to kill the image of Caine and launch a movie career. Lee Majors was about to take the part. Saul Krugman convinced Lee's agent that it would not be good for Lee, and Roger gave me the part.

Season was slated to do the movie but she dropped out, reasoning, more or less correctly, that we were staying together only to make the picture. Season would never allow career to interfere with her own sense of personal ethics. Simone Griffeth replaced Season. Simone owned the most perfectly constructed human female body I was ever personally naked with. I was carrying my torch and didn't try to take advantage of the opportunity. She was very kind to me. Simone didn't think she knew how to act. She asked me to help her. She didn't really need it. Her instincts were infallible. Anyway, in the shape I was, how could I help anyone? But I tried to give her a hand anyway. It gave me something to do.

Paul Bartel, the director, was a strange man. Roger was paying him $200 a week to direct the movie, which he had to get from petty cash. It meant he had to document it all as expenses. When you went to lunch with him, he'd collect the receipts from everybody.

Paul and I had a run-in very early. It started out about who

would play my navigator, after Season dropped out. Then there was some big deal about wardrobe. It all escalated to the point where he went to Roger and had me fired. He told me that this was a movie of compromise and I was not a compromiser. Well, he had that dead on, but I still wanted the movie. Right then was not a great time for me to suffer another loss. Jeff Cooper went in and talked to Roger like a Yale lawyer or a Harvard philosopher. Roger, a Stanford engineering graduate, bought Jeff's pitch and rehired me.

Paul and I got along pretty well once we started shooting. He himself, in interviews, referred to the shoot as a "collaboration" between us.

I never figured out Paul's sexual preferences. I'm not sure that he did either. He had a strange sense of humor, which comes out in the movie. He was a fine pianist, his favorites being Mozart and Gershwin. Once, in between shots, he played while I danced in my skin-tight black vinyl, with Simone, her alabaster skin and pale blond tresses writhing on the satin sheets behind us while Tak Fujimoto adjusted the lighting for the next shot.

Sylvester Stallone was Machine Gun Kelly, the comic villain. His stuntman was hurting my stuntman, Greg Walker, in the fight, so I gave it back to Sly when I got the chance. Sly was a good sport about it. He turned and said, "Ya know what this guy's doin? He's pullin' all his punches, but he's pullin' 'em a coupl'a inches inta my stomach." After that, I decided I liked him. I didn't know he was a genius who would shoot straight to the moon.

We shot the picture in three weeks. It rained almost every day. There were some near tragedies. The cars looked great but were a joke as far as the mechanics went. Mine was the fastest at a brisk 54 mph. Stallone's could do 48. Even so, with the chances we took on the wet mountain roads, there were some close calls. Roger Corman showed up on the set just once to make certain there was enough nudity in the steamy scene between Simone and me. When he couldn't see her breasts, his eyes turned black with anger. We fixed it, and his eyes turned blue again. The next time I looked up, he was gone. I had a small salary and 9.3 percent of the producer's world gross. The film became a cult classic and I made close to a half million.

Calista was in junior high school. It was not entirely successful, her coming down to live with me. I was not able to control her or make her better in school or anything else. I wasn't able to keep her in school a lot of the time. Calista is more or less a mystic person. All her life, she's believed in magic. She doesn't take anything literally. Everything has psychic or mystic meaning. She was never able to knuckle down in school for something as prosaic as what they wanted to teach her. She used to run away from home and be gone for a few weeks at a time. When I took her on the road, to London or some exotic place where I had to work, it would all come back together. When it was just the two of us, we were happy and clung to each other, awash with love. We shared each other's pot luck.

Skip Sherwood and I had put together a trial run for *You and Me* in two theatres in North and South Carolina. We did a little tour of the area to drum up publicity. I took Calista with me. I made some speeches, sang some songs, and gave some kung fu demonstrations. To give the tour a little extra juice, we tied up with a motorcycle club: The Tar Heel Stompers. I rode with them between appearances. They all carried .45 automatics. The night before the first screening, we had a party at the Holiday Inn. The boys had to check their weapons. At one point, I left the dance floor and went to the suite for something. There was a pile of .45s on Calista's bed.

When the party wore down, "Clean," the vice president, invited us to their clubhouse. "It's way out in the sticks, away from everybody. We can do anything we want. Bring your daughter." I passed. I didn't think that would be a good idea.

The weekend that *You and Me* opened was the same weekend as the football playoffs between North and South Carolina; a big error in scheduling. No one in either state went to the movies that weekend.

This kind of thing has been happening to me over and over again. *Bound for Glory* would open simultaneously with *Rocky*. UA owned both pictures and they would throw the money toward *Rocky*. *Safari 3000* would open opposite *Rocky II*. *Americana* would open opposite *Rocky IV*. There seems to be something about me and Sly Stallone. Maybe I should have been a little easier on him in *Death Race*.

⇒ ⇐

I WENT TO London to do an album of my music. Somehow I talked Barbara into meeting me there and playing her flute. We had a brief rebirth of romance. We romped around London with Free and Calista. Barbara was much changed. It seemed she'd abandoned all the values we had shared together and picked up new replacement values which were alien to me. I had no power over her anymore. All I could do was bend to her will—which I was happy to do—grovel if necessary. She decided we should live together again. I didn't understand her anymore at all but, of course, I went for it.

She and Free went back to California to wait for me. Calista and I stayed to finish the album. Barbara was to pick me up at the airport on May 20, 1975, the anniversary of our first date.

While I was in London, I sold the European rights to *You and Me*. When I screened it for the buyers, I discovered that Skip had recut the film without my knowledge. This was our first breach. I took it in stride.

A few days later, I called Barbara. I could tell there was something wrong. I asked her and she said it was all over. She said I could have the Glass House back. She didn't want to live in it anymore; it reminded her too much of me. She sold the Ferrari to the mechanics for peanuts. Same reason.

Hampton Fancher made a long speech to me about the shortcomings of the Ferrari: something about the rear suspension and the fidgety handling. I wondered to myself if he said that same kind of thing about Barbara when he was talking about *her* in conversation. I cried for a couple of days, and then continued the overdubs on the album.

The record company had put together some of the best musicians in London to play with me. Hugh MacDowell, who played electric cello with the Electric Light Orchestra, accomplished wonders with my music and we became friends. On Calista's birthday, the three of us took a lunch boat through the canals. When we came abreast of Heathrow, Hugh's home turf, we jumped off the boat onto the shore and prowled around bars, listening to new, young rock and roll, and meeting some of Hugh's friends.

When we got back to the hotel, I got a call from Keith. He told me there was a guy in Connecticut who wanted me to appear in a play called *Black Elk Speaks*. I had read the book; we all had, back in the teepee days. I called up the guy. Chris Sergel was his name. It turned out he had written the play for me, having seen me in *The Royal Hunt of the Sun*. He was a dreamer, and his enthusiasm was irresistible. I found my spirits rising. The future was beckoning. I agreed to do the play. How could I refuse?

Calista and I went to Holland to visit with Nicolai Van der Hyde, the director of Barbara's Dutch movie; actually, to cry on his shoulder. Barbara had already been there, and his love for her took precedent. He told me that she was a new woman. He said that Barbara had been my slave of love and now she was her own woman. Calista was a big hit with him. She got bitten by the Mata Hari bug.

We went on to the Cannes Film Festival. I had the finished version of *You and Me* under my arm. The authorities would not allow me to bring the print into the country. I didn't know the rules, so they took care of me. Somehow I got it through. Apparently, they were used to brainless underground filmmakers.

I went to the Grand Palais, print in hand, and told them I wanted to show the picture. After a certain amount of elegant Gallic confusion, they agreed to screen it in the Jean-Paul Sartre Theatre, a little place where they showed movies that had nothing going for them.

Calista and I wandered around the festival. I had two remarkable meetings. One with Alejandro Jodorowski, who had made a film called *El Topo*, one of my favorites. We began making a deal to do a movie together. It never happened, but almost nothing that you start at Cannes ever does happen.

I met a statuesque, flamboyant lady from L.A. She had had some plastic surgery that made her look almost exactly like Sophia Loren. Carlo Ponti enjoyed walking around Cannes with her. She was writing a script for an action movie that was going to be shot in Colombia.

She and I spent some hours on the beach one night, busting the cherry of my broken heart. Then I shouldered my guitar and walked through the sand to my meeting with Alejandro.

He received me in bed. He had two movies in his craw. One, *Le*

Roi du Monde (*King of the World*), ended with the destruction of life on Earth and became a prequel to his next project, *Dune*. I was definitely signed on that night. A year or so later, as a result of Alejandro's eccentricity, the studio, Gaumont of France, sold the package to Dino De Laurentiis. I was out again.

THERE IS HOPE

Jorge Rado, an old buddy of Jeff Cooper's, sent me to a salon in Malibu full of artists and writers. The lady in whose house it took place was guaranteed to be a cure for sexual atrophy. I took Calista with me. I drank strong coffee and played a few songs on my guitar between the poetry readings. We spent the night.

The lady of the salon reawakened my sense of myself. I stood on the tidal flat at dawn and realized what the real problem was. I had a whole lot of love to express and I had no one to express it to. I was looking for an object for my love. I know that's something women don't like these days—being love objects—but that was what I was looking for. I looked at the sky and thought, There's got to be more. More than this. I have to find love again. The lady came out and asked if she had not pleased me. I said, no, it wasn't that. I just had to go. Calista stood in the doorway, watching it all.

I asked Neal Ames what I should do about my broken heart. He told me to put my attention to something else and suggested either to start dating or meditating. I said dating was absolutely beyond me. So, meditation. He told me there was a Buddhist temple in northern California. Or, he knew of a guy who taught a sort of street meditation. I picked the latter. I fell into a benign cult of what they called Actionism. This turned out to be an ancient Hindu discipline known as Agni Yoga. Calista joined me in the sessions. The results were fairly

amazing. Everything started to get better. People have said it was merely self-hypnosis. I think there was something quite a bit more. Anyway, who cares? Things were working and I was actually starting to feel sort of happy.

I landed a movie of the week at Universal. The vehicle, *The Family Hovac*, starred Glenn Ford and Julie Harris. My part was a good warmup for Woody Guthrie, if it ever came through. One day I was walking between the soundstages at Universal feeling pretty good. I said, "If there were only a woman, I would definitely be okay." I walked around the corner and there before me was a beautiful woman. I spent the afternoon with her, totally in love. I found out her name was Kathleen Quinlan, an actress in the first glow of success. The whole thing was perfect. There was no follow-up to this. I called her a few times. When I finally got her, she told me there was someone else.

There was going to be a big party at Michael's house. Barbara was expected to be there with Hampton Fancher. I didn't want to go to the party feeling like a slighted lover or like whatever it was I was feeling. I decided I needed to show up with a girl—two girls—just so as not to look forlorn. So I took the receptionist from the meditation center as well as my lawyer's secretary.

We all listened to the album I'd just cut in London. Everybody said they loved it. I couldn't tell. I felt so small and powerless in that company. I seemed to have lost my confidence in a big way. It had been some time since I'd been in a situation I couldn't control. Barbara was self-assured and at ease. She asked me if I was up for *Bound for Glory*. The movie was finally going to be made, with Hal Ashby directing.

She told me to call Saul. I said, okay, I would. She said, "Call him now."

I did. I said, "Why aren't I up for *Bound for Glory*?"

He said, "I don't know."

I said, "Saul, I *am* Woody Guthrie."

He said, "Okay, I'll call Hal in the morning."

There was a shy but delightful minute between Free and me. There was one transcendental moment when Free fell and cried, and we both rushed to his side. For that instant, we were together again.

Barbara and I embraced. I looked for the electric spark. It was still there, but very faint, pitifully so. The embrace became just a hug. It was demeaning, a sin, for something so bright to have shriveled into this dim ember.

Michael Stringer, who had been my cameraman on *Americana* and *A Country Mile*, had his own kids at the party. He was monitoring the games. He took Free away to play some more, leaving Barbara and me alone together. Our child didn't need us, so we just let him go. We stood there looking at each other. She embraced me again. Something in me denied the embrace. I realized then that it was all over.

When I left the party with the girls, in my new 1975 Chevrolet Caprice Classic convertible, I looked back and Barbara was standing there, looking after me with Hampton beside her. She was looking at me very intently. I had given them my blessing but I had a hard time keeping my thoughts straight. I had to convince myself that she wasn't looking after me hungrily.

I thought for a second there must still be a chance. Then I realized that when someone dear walks out of your life, you need to see all there is to see before you turn away. Her resolve hadn't changed. The situation was the same. She was just living it out to the last moment. I have no doubt, when I was out of sight, she turned confidently back to her new life, and smiled.

⇒ ⇐

MY MEETING WITH Hal Ashby lasted an entire afternoon. I still didn't have the part, but I thought he might sort of like me. I asked Saul how he got me the interview. He said, "Hal thought the idea of 'Kung Fu' as Woody Guthrie was ridiculous, so I said, 'David is Woody Guthrie'!"

After the Barbara thing died, I started seeing Season again. I crawled back to her on my belly. She didn't want any of me at first, but she came around. The relationship now had a certain desperate quality, but it was still love. We clung to each other for a few months, and then she finally left me.

So there I was, living in my little house in Malibu, a strict vegan

vegetarian (no animal products whatsoever). I consumed no drugs of any kind, kept my house clean, and went to bed early. I did a lot of reading. My only associations were with my twelve-year-old daughter and my dog, Buffalo. Life was very beautiful and very sad.

Now that I was getting my confidence back, I settled down to a regimen of running on the beach. I worked my way up to seven miles a day. I think running past Hal Ashby's house every day had a little to do with my finally getting the part of Woody.

Barbara came out to the beach one afternoon. She wanted to see how I was living. The place was a shrine, mostly to her. It was as though she were visiting Grandma's house. I was so deep into this heartbreak syndrome that my movements were slow. I ate very little, and the days were soft and muted. I sort of felt like a grandmother.

Whenever Barbara and I touched, there had always been an electric shock between us. It was there now in full force. Jeff Cooper once told me that whenever that happens to a man, it's happening to the woman as well. It's an expression of Chi: the life force, a manifestation of the electrical network that runs through the body. It takes two to make that spark happen. If a woman denies it, she denies it with knowledge of the fact that she does feel it.

I tried a kiss.

She said, "No way."

I gushed about my love for her.

She told me I just wanted anything I couldn't have.

I asked her, "What about the dream?"

She said, "Forget the dream, Dave."

Hard words.

We walked down the beach. I was aching for her. We sat on a little dune and watched the ocean for a while. She asked me if this was where I ran to. I told her it was about three miles farther down. I don't think she believed me. She left just before sundown.

On a stormy night, in a fit of depression, with huge waves and wind and rain, I threw myself into the Pacific and asked it to take me. I was tossed mightily by the waves and went under a few times. I refused to help myself in any way; I just let my body go limp. The ocean threw me ignominiously back on the shore.

I picked myself up, exhausted and shivering. I was a half mile

down current from my house. I trudged back through the slapping waves, my white East Indian pants soaked and baggy, my waistline bulging slightly over them: sad sack posture. I thought I must look like Walter Matthau. I felt like Walter Matthau. I was so out of it, I passed my house and found myself at Point Nowhere (that really is the name of it). When I finally made it back home, my friend Peter, who had helped me build The Burned Down House, was waiting with a roaring fire built with olive wood. He said, "Yeah, but what a great place to live!"

➔ ◂

Well, the Phoenix is a bird that lives for several hundred years,
Then lights a fire and burns away his laughter and his tears.
She dies an agonizing death so she can be reborn;
He rises out of his own ashes early in the morn.
I lost all my feathers in the fire of '68.
My true love was buried with my jealousy and hate.
Too late for the man I used to be.
I tried to help myself, but I guess it was my fate.
I learned my lesson finally, but I guess I was too late.
Too late for the man I used to be.
I'm gonna rise up like a Phoenix from my ashes and take wing.
I'm gonna put myself together once again and learn to sing
A new song like I never sang before, just wait and see.
I'm gonna rise up like a Phoenix from my ashes, and be free.
I lost all my blood in the battle of '74.
I lay there on my back and watched it run out on the floor
Good-bye to the man I used to be; I had to say good-bye
To the man I used to be.
You've gotta die a little, if you really wanta grow.
You've gotta forget, if you really wanna know.

➔ ◂

CHRIS SERGEL INVITED me to join him at the Pine Ridge Reservation for a picnic with Black Elk's family. I took three-year-old Free with me. When we got off the plane, it was raining, out of season. Chris said it was a good omen. At the picnic, Wounded Knee

Creek had risen ten feet. It was a bright, sunny day. I stripped down and dove in. The current was so swift it took me a quarter of a mile to get out. Then I had to creep back through the trees naked to get my clothes. The Indians were very impressed. I felt ridiculous.

Included in the feast was a bear that had been cooked underground for a couple of days. I told them I did not eat meat. They were a little taken aback. Now I wish I had eaten that bear. What is vegetarianism next to eating a bear with the descendants of a great Sioux medicine man on the banks of Wounded Knee Creek?

Free fell in love with a cute little girl named Honey Bee. We were given a lot of homemade bead work. I did the pipe ceremony with Black Elk's granddaughter, Lucy Looks Twice, and took a walk across the road to see Ben Black Elk, Black Elk's brother, who wasn't allowed at the party because he was drunk.

Chris then took us away to climb Harney Peak in the Black Hills, which Black Elk had said was the center of the universe. He had added that the real center of the universe was wherever you happened to be standing.

It was really a hike, not a climb. Free wanted me to carry him. I made him walk. He wanted some ice cream. I told him there was not any on the mountain. At the end of the climb, there was a breathtaking view of the surrounding wilderness. On the way back down, I carried Free. He fell asleep with his head on my shoulder.

CHAPTER SIXTY-THREE

BACHELOR MADNESS

I then spent a number of months acting like a crazed kid in a candy story. I saw the Sophia Loren look-alike a couple of times. She lived in The Sunset Towers, right next to Stacy Keach's townhouse. She was fun but she had a parrot who ran loose. The parrot had a habit of pecking at my balls as I was mounting her. I decided to pass on any more of that action. After all, who knew where that beak had been?

As it turned out, my meditation practice led to dating, and the dating led to meditation. It started when Jill, the receptionist at the Actionism Center, took Calista home to meet her daughter. Her daughter was about Calista's age. They got along famously. One thing led to another. Well, Neal had said it would work—he just hadn't said how. Jill was a beautiful blonde, sort of mysterious. She was kept in a lovely apartment by a man who didn't ask much of her. She had a diamond in her nose. I took her out to my beach house. To ease the moment I picked up a half bottle of wine. It turned out Jill didn't drink. No sweat. We didn't need the wine.

I had definitely not made a mistake with this girl. Jill had a remarkable body, lean, muscular, and tan, with a Wasp waist and huge breasts that hung down almost to her navel. She was very tender, undemanding, and giving. She was a perfect place for me to park my libido for the moment. The moment lasted for a while. As we got to

know each other better, she stopped wearing the nose diamond. Jeff expressed his opinion that a girl with three nostrils was worth more than one with a diamond in her nose.

I went to a strip joint one day for a business lunch and a crazy girl named Lyla came over and more or less sat in my lap. She was quite picturesque, and very well equipped. I noticed that the other girls were putting her down. Well, she was drunk, and probably stoned. The manager or somebody told me he'd get rid of her. I said, "No. She's all right." At one point, I licked her cleavage. It seemed to be the thing to do. Her skin was very salty. I got her phone number.

About a week later I called her up. We made a date. I stood her up. I decided to go back to the place where she worked. I showed up just as she was announced. I took my Coke and sat at ringside. She strutted around while taking all her clothes off and flirting with the other guys at ringside. She completely ignored me. I figured she was mad at me for standing her up. After the dance, I figured she'd come over, but she was busy making money table-dancing. I left.

I called her up later in the week and we met at a little motel of her choice. The honeymoon suite. We took a Jacuzzi to break the ice. We were very shy with each other, but we got over that. About a week later, I left a message for her to meet me at a sweet little inn I knew about. I took my guitar with me but never took it out of the case.

In the morning she was shy about walking through the lobby since she was dressed as she had been coming directly from work—not dressed for any breakfast date I had ever heard about. We slipped out the back. As I was driving her home, the car threw its fan belt. This was a big problem since it was a rare Italian sports car, a 1956 Lancia Aurelia Spyder. I needed to tow it somewhere; this raised another problem. It was the morning of the Fourth of July. Nobody wanted to work.

We were near her house so I nursed the car along to get her home. I'd drive it until it started to overheat, and then we'd park for a while until it cooled down. We stopped for breakfast and then hit her neighborhood bar. Now that we were on her turf, I got to know a new side of her. She took charge and had everybody hopping for her. She was actually magnificent. She found a tow truck company

that had a flatbed, which was absolutely required for towing the Lancia. In no time I was on my way.

She had a daughter, about ten years old, who was a darling. I spent some serious time with this woman. She and her daughter were very fond of Calista and Free. I gave Lyla a credit card and sent her out to do some shopping. She came back with some great clothes and presents for me and the kids. I got her jewelry out of hock for her and fronted her some money to move to a better place. She had been there for me in my hour of need. The least I could do was help her out a little.

My heart went out to her. She had had a terrible childhood and never got much of a break. Her body and her pheromones were her greatest assets. Her work meant freedom for her. At thirty-five, she didn't have long to go as a naked dancer and there wasn't much else she could look forward to. Calista thought she was setting a trap for me but I don't think there was much truth in that. She knew who she was. She and I kept seeing each other for a little while.

What can I say? One interesting thing about this bachelor madness was that I met women from very different walks of life than I had ever known before.

BOUND FOR GLORY

I had another meeting with Hal Ashby. He told me that if I were six years younger and six inches shorter, he would hire me right on the spot. I told him I'd do the part with my knees bent.

Hal talked to Dustin Hoffman, who told him he didn't play guitar well enough for the part. He sent the script to Bob Dylan, who wanted to direct it. Finally, he made an offer to Richard Dreyfuss. When Richard asked for more money and a shorter schedule, Hal said, "The hell with it!" and told me I had the part. United Artists was a different matter. They took a lot of convincing. Hal brought in Haskell Wexler, the cinematographer, and made a screen test in his office. He kept showing it to UA and pitching me. In the end, they agreed.

Right about then, Chris Sergel called me with an offer for *Black Elk Speaks*. It was a big one: a class A national tour with the Nederlanders, the biggest road show producers in the country. It broke both our hearts, but I had to turn it down. I said, "Chris, I have to play this part. I just have to." He, honorable man that he was, agreed. He told me it was not entirely a surprise. There were too many elements that had to miraculously come together, and he had never been able to juggle more than five apples at once. Rather than doing it without me, he canceled the tour.

I was invited to sing at a Guthrie celebration at Will Geer's Theatricum Botanicum in Topanga Canyon. Will Geer had been a close friend of Woody's. There I met a sweet, crazy, beautiful girl with thick red hair down to her ass. Holly was her name. I took up with her to kill the pain.

The first time I took Holly home, she didn't exactly kill the pain. She inflicted it. She was fascinated with the idea of making it with "Kung Fu." She came at me like a tiger. I pretended not to notice the attack and she finally settled down.

At the beginning of the shooting of *Bound for Glory*, I was virtually suicidal. I thought I should finish this great film before I did anything about it, and then see. It would either be a time to end it all or time for a fresh start. *Bound for Glory* became an opportunity to escape from my old life. It made everything look bright, though I was still broken-hearted and in a terrible state. I told Hal that I hoped he had at least one wonderful woman in the movie as I was just ripe to fall in love with a beautiful actress.

Bound for Glory lived up to its name. I was starring for the first time in a major studio movie. I was giving the performance of my life. My days were filled with fulfilling labor, drama, comedy, music, fights, jumping on and off trains—all presided over by the best director I had ever worked with. Hal sent me to Oklahoma to soak up the lingo and study the fiddle. I visited Woody's home town and went to a party in a house full of fiddlers. I went from room to room, standing in with different bunches of them. There was one very tall fiddler who told me there was only one way for me to learn to play. I said, "What's that?

He said, "You have to play your fiddle in a graveyard at midnight."

I said, "And that will teach me how to play the fiddle?"

He said, "Yep. Because the devil will pop up and offer to buy your soul, and that's the only way you're ever going to learn how to play the fiddle."

We started out the shoot in Stockton, California. Since we weren't really in Oklahoma, it was up to the actors to make the audience believe we were. The era was created perfectly. Everywhere one looked it was the thirties with a vengeance. We built an expansive

migrant workers' camp, which filled up very quickly with pilgrims from all over the country. We created a dust storm that was so real it gave Hal dust bowl fever.

Melinda Dillon and I had a scene in bed. We were playing a married couple and we had all our clothes off. It took in a big way. We stayed under the covers, mooning with each other, while the crew quietly took the equipment away. We considered a long-term relationship, but we couldn't quite get up to that. Melinda had been in the Broadway production of *Who's Afraid of Virginia Woolf?* The show had driven her over the edge. This was her first movie. She was still somewhat lost. Saul told me to grab that girl. I told him I already had and it didn't work. He said, "Try again!" At one point Melinda proposed we stay together forever. I said, "Forever is a long time." She said, "It's only now." I told her she wasn't in love with me, she was in love with Woody. And being Woody's girl was a bum trip. I still dream about her.

An extraordinary thing happened to me one night. I was sick in bed with the flu, running a high fever, when I got a phone call. A female voice told me she had some pictures she wanted to show me. I told her I was too sick. She said she'd come a long way. I wavered. She asked if there was anything she could bring me. I said some aspirin would help.

I left the door open and a lovely, slightly plump young girl came softly into my room. She got me a glass of water, sat on the edge of the bed, and gave me the aspirin. I asked her about the pictures. She brought out a little booklet full of beautiful drawings, done in a Chinese style, that told a story.

A perfect likeness of Kwai Chang Caine sits in a meditation posture in the middle of a road. A beautiful Chinese girl who looks just like the artist walks toward him. She stops before Caine and begins to take off her clothes. The two make love in a very graphic series of images. Caine walks on down the road, leaving the girl naked and spent, an angelic smile on her face.

I said, "These are beautiful!"

She asked me what I thought she should do with the drawings. I said she should publish them. She put them aside and opened her blouse, revealing full breasts just like the ones in the drawings. She

leaned close to me holding the left one in her hand and said, "If you try hard, you'll get milk." I did, and I did. It wasn't that hard. We made love. I fell asleep and when I awoke, she was gone. My fever had broken.

I got tired of rooming in the motel in Stockton, so I found an uninhabited island to live on. I rented a tiny sailboat to get back and forth, or I swam. I spent my nights sleeping under the stars. I imported Holly and Calista, and the three of us had an idyllic existence.

I needed to find someone to continue my meditation studies. One of the Agni Yoga founders was living in San Francisco, just out side of Stockton. It was Ralph Metzner, one of the three professors who had been kicked out of Harvard in the 1960s for experimenting with LSD. Leary had become an evangelist. Professor Alpert had gone native and changed his name to Baba Ram Dass. Metzner had retreated to a quiet life. I drove the Chevy out there every weekend or so for another lesson. He was sort of sad. He struck me as someone who had burned out on drugs—a reasonable assumption.

One wild night on the island under the stars, Holly and I conceived. As usual, I knew it right then. Holly confirmed it a few weeks later. I took her with me to my mother's house. Mother had abandoned her libido and had given up liquor and tobacco as well. She went to church every Sunday. She now was as sharp as a tack. She didn't go for Holly at all, thought she was a gold digger and was sure the pregnancy was a trap the little tart had set for me. She didn't know Holly and didn't know me. In spite of her reservations about Holly, she treated her kindly. As we settled ourselves into the spare bedroom, Holly said, "Oh, I get it. This is Grandma's house."

After a while, when the company moved from Stockton to Bakersfield, Holly went back to live in my little house in Malibu. I took Highway 99, in the Chevy. The distance on the map was 99 miles. I thought it would be cool to drive down old 99 for 99 miles at 99 mph. I lit up a joint and proceeded to do that.

Driving very fast does something to me. It releases a certain part of my brain. It leaves me without the higher judgment necessary for the task of avoiding sudden death. Even though I'm performing a very concentrated task, the very concentration of it causes my

thoughts to free themselves. In the space of that 99-minute drive, this answer came to me:

I determined that all my present troubles dated from my losing my own direction, starting with the John Barrymore crowd. This was even before my getting involved with Season. Michael Greene was the best friend of Hampton Fancher. Hampton was known in gentle circles to be a dark force. Michael introduced Hampton to Barbara for romantic purposes. I thought it over and thought it was a faithless act toward me on Michael's part.

I wouldn't say that Michael is himself a faithless person or that he's not trustworthy. He's just not my friend. He had introduced me to Barrymore, and Barrymore had set me up with Season. Almost all the digressions from my path had been brought about by this bunch.

I made a decision to get out of it all. Getting out was not the soft and tender way with which I normally dealt with people. I thought I'd remain blameless if I exiled not only those who had given me trouble, but those who had been good to me as well. I wanted to exile myself.

I systematically cut off virtually every friendship I had in the world. My friendship with Barbara and Free had been my whole world and I'd lost that, so what was the point of keeping all the rest of it?

I started out with my old and best friend, Jeff Cooper. He had said he wanted to be my manager. This had frightened me. You know, your best friend is the person you can talk to. If you're on a mountain top, your best friend is not really standing there beside you. He's on his own mountain top. You need him to be there, not hovering around you. And there he was, attempting to step into my shadow. I thought it would be awful for both of us: bad for my career and bad for his life.

When I got to Bakersfield, I phoned him. I was absolutely vitriolic on the subject and just went on and on. Then I paused.

He said, "I can see you don't think it's a good idea."

I plunged in, with my heart beating fast. "Not only that, I see no future in our relationship."

That gave him some pause. We were very close. Very, very close. Then he said, "Well, Davey, this comes as a big blow. I cherish our

times together, but I've never heard your mind sound so clear. I'll miss you, but you have to go with this. Do your thing, man."

➔ ⬳

HOLLY LOST THE baby. Maybe she got rid of it, I don't know. She was doing a lot of, I guess, cocaine and we could no longer get along. I asked her to leave.

I continued with the reaping of my acquaintances, starting with John Barrymore. John was living in my old house at that time. I went up there and he was lying on his pallet in the dining room next to the house's only heater. He was sick with the flu. The place was filthy. Surrounding the pallet were a dozen or so withered grapefruit skins. I woke him up and told him to get out. The bond between John and me had also been very strong. John was not about to leave.

I knew I couldn't get rid of him unless I convinced him, in no uncertain terms, that I wasn't kidding. I threw a roundhouse punch at him. If I had connected, it would have hurt him a lot. He dodged the punch and said, "I'm not ready for you, Dave."

I said, "Damn right you're not!"

He said he was going to stay.

I said, "No. You're not!"

I told him I didn't want him living in my house and that I would make his life hell if he tried to stay. He finally asked me when I wanted him out.

I said, "Well, next Monday's my birthday and it would be great if you were gone by then."

I hired a big, strong guy to carry his stuff down the stairs that weekend. There wasn't anything John could do about it. And so I systematically broke off with everyone, none as brutally as that. With most of them, I just said good-bye.

➔ ⬳

CALISTA AND I gave up on the meditation. The people were just too weird. It was back to the dynamic trio: Buffalo, Calista, and me. What with the crashing surf and this great movie I was making, I should

have been happy—or at least cheerful—but I wasn't. My mother told me that, after all was said and done, all that sucking and fucking did not amount to a hill of beans. Try and convince a Carradine of that. I was on the prowl.

LINDA

I was looking for a woman all the time, one that would last for a while. I took to prowling the bars, coffee houses, and various meeting places every night with my next door neighbor, Tim Crane, a horny young stone mason with a pick-up truck. He frequented places I'd never been; a whole new breed of people for me. I was able to be more or less anonymous. We talked to girls and drank coffee. He used coffee as his party drug. He was good for me; he was always trying to get me out of my doldrums. At that point in time I could hardly relate socially; my interior monologue was keeping me in a waking dream state. He got me talking. I began to bounce back.

I was also on the prowl for a car; in fact, I was itching to get into a performance car. The Chevy was okay, but I was ready for some flash. This idea became paramount when Hal showed me the Mercedes 450 SL he had just bought. He let me drive it. It was a fine car, but boring. I talked to Bobby about it. He asked me what I wanted to buy.

I said, "Well, what I really want is a Ferrari roadster."

Bobby said, "Well, Dave, you should get what you really want."

So he found me one. We went up to Monterey to check it out. It was a yellow roadster. The salesman took me for a spin and opened it up: I bought it on the spot.

We drove it back that night, both of us in heaven with the sound of the engine and the rush of speed. Halfway home, the engine started making a terrible noise. I pulled over to a truck stop. Bobby said, "We've got to get those guys to give us our money back." I said, "Bobby, this is my car now." I was hooked. I called a tow truck with a flatbed, and we sat in the cab while he drove us and the beast to L.A. We took it to Bruno's. We broke the lock, set the Ferrari inside, and closed it with another lock, leaving a note.

I called Bruno the next morning and he said, "Come anda picka upa da car atta lunch." He'd put in a new cam. The car ran like a top. As I buzzed down Old Malibu Road, people along the way came out of their houses to watch. The V12 engine has a great sound. It draws enthusiasts and other dreamers like moths to a flame. And a flaming creature it was. Tim said they all wanted to see who was the free spirit on the block.

⇒ ⇐

ONE SUNDAY AFTERNOON (December 17, 1975), I went to a benefit for the migrant workers union thinking I might find a beautiful, intelligent, socially active young woman who was looking for a good me. Jane Fonda was there running the auction. There was a definite spark between us and I had visions of combining the two dynasties, but she was a married woman as well as way out of my class. I donated my Woody Guthrie work shoes to the auction and went on cruising. I hooked up with Tim. We prowled the spots, but pickings were slim.

At the end of the evening, as a last stab, we stopped at The Crazy Horse Saloon in Malibu. It had dancing. I was dancing with strangers and not having any fun. It was looking like one more lonely night. I was on my way to the men's room when I saw an extraordinarily striking woman with long dark hair and flashing green eyes. (Nicola Simbari, the great Italian painter, would later remark to me that she and Barbara were the same Madonna by different painters.) On the way back, I stood on my toes and peered over the little curtained railing at her. She caught me at it.

Embarrassed, I walked back to our table. I said to Tim, "That's

the kind of girl I'm looking for." Just then I saw her peeking at me around the corner.

Tim said, "You've got to go talk to her."

I said, "What do I say?"

He said, "Say, 'I'm sorry for staring at you. I didn't mean anything by it. It's just that you're so beautiful.'"

I walked over to her. I said, "Hello."

She said, almost whispering like Norma Jean, "Hi."

Then I repeated Tim's words exactly. Right then the lights went on, signifying closing time. After an awkward moment, she asked me if I wanted to drive her home. I looked at her male companion. She said, "He has his own car," and added that he was her bodyguard.

I said I'd have to get my guitar.

She laughed like the dawn breaking and said, "We have plenty of guitars."

I said, "Well, I can't leave it. It's in my friend's truck."

I drove her big Mercedes up the canyon. She said, in a surprised voice, "You can drive!"

"Yeah."

"I mean you can really drive. I wouldn't have thought you could drive."

I laughed. "Well, Caine can't but I can." And I put my foot on it, slipping around the tight curves and through the electric gates.

The "bodyguard" was already there. We entered the house through the kitchen and went straight into an opulent bedroom with a big brass bed, and she sort of paraded around, tossing her huge mass of dark hair, showing off her ample breasts, her slim waist, and her well-turned legs. She asked me if I thought she was too extravagant. I didn't think so.

Her name was Linda. She lounged back on the pillows and smiled. She seemed pretty drunk. I talked to her about all kinds of things until she sobered up. She explained that she was the estranged wife of Roger McGuinn, the leader of The Byrds (which meant next to nothing to me), and was in the middle of a separation. It seemed my way was clear. I put my hand on her perfect little foot and drew it up her leg. There was a large green parrot tattooed on her ankle.

We made love most of the night and it was quite remarkable.

She was bright and witty and very sexy. At one point I asked her if she was crazy. She said, "I don't think so. Why?"

I said, "Because if you're not, you're perfect."

She said, "Perfect for what. What do you want?"

I said, "I'm looking for a good woman."

She said, "What for?"

I said, "To stay with me and bear my children."

Then we made love again.

Wandering around her house in the early hours, I found a lot of empty guitar cases and a liquor cabinet full of empty bottles. I also found bullet holes in the door and the ceiling of the bedroom.

In the morning I realized that I had to be at work and my driver didn't know where I was. Linda said, no sweat; she'd call a limo. When it arrived, I asked Linda if she'd like to go to the set with me. She sat in the corner of the limousine and said, "Are you sure I won't be in the way?"

I looked at her, incredibly beautiful with her lavish head of uncombed dark hair and her wide emerald eyes and no makeup. She looked beautiful in the sunlight. I said, "As far as I'm concerned, I'd like you never to leave my side as long as I live."

She said something like, "Well, I don't think I can do that."

She hung with me at the studio for an hour or so, wearing dark glasses, then told me she had to leave. "There are too many folkies around here," she said. "Someone will recognize me."

After that, she wouldn't have anything to do with me. When I got back to my little beach house, in a state of high euphoria, I called her. I got her answering service. I tried again and again. She wouldn't take my calls or return them. After a week, I got some reaction from her. I sent my driver up to her mansion with a Christmas present very carefully chosen. She took my next call. I talked her into visiting me at my little beach house.

She showed up late in the afternoon looking beautiful and trembling like a frightened bird. I had hoped for some more of that great sex but that was obviously out of the question. We walked on the beach and, sweetly and virginally, fell asleep against a sand dune. I don't think we were even touching. We watched the sun set, and she slipped away.

I felt young and in love, but it was complicated because she wasn't as oriented to getting a divorce as she had said. She felt funny about it. I finally realized that was why she hadn't returned my calls.

I wanted to take the pressure off her. I called her and told her I thought we shouldn't go on with it, that I would just like to be her friend. She heaved a relieved sigh and told me that was what she really wanted and it had been driving her crazy, too. She said she was having a party that night and asked me to come. I asked her if I could bring my daughter and she said, "Of course."

Calista and I roared up to Linda's house in the Ferrari. The party was already going strong. I stood in the doorway, getting the lay of the land. Then I found Linda and walked over toward her. Someone offered me a drink. A plump older woman with red hair approached me. She said, "I'm Louise."

I said, "How do you do."

She said, "Linda's mother."

I said, "You have a beautiful daughter."

She said, "I know."

Linda walked up to us. Louise said, "Don't marry him."

Linda said, "What?"

Louise said, "He's the one. I know you're going to live with him. I know you're going to marry him. He's the one. But don't do it. He'll cause you grief." Then she turned, glared at me, and walked on past. I looked at Linda and shrugged.

I was passing a bottle of Jose Cuervo back and forth with Bob Dylan when I noticed a drunken Indian who was staggering around with a little Martin guitar, almost dropping it. This was Gene Clark, one of the Byrds. I caught him just before he and the Martin hit the floor and took the guitar away from him. I went back to talk to Bob.

Gene (known more or less affectionately to the Byrds as "Uncle Cherokee") followed me. He started talking to Dylan in a loud voice, saying Bob was a no-talent wimp, and he'd be nobody if the Byrds hadn't recorded his song, "Mr. Tambourine Man." (I think Gene had it backwards; it was the other way around.) Bob was trying to shrink into the wall. Gene cornered him there and went on insulting him.

Suddenly, with a sort of it's-a-good-day-to-die, blood-curdling cry, he came at Dylan, brandishing a pool cue. Dylan jumped, almost

dropping the Jose Cuervo. I leaned in between them. Gene stopped and stared at me. He put his mouth close to my ear and said, "You like Linda." He got even closer. "Everybody wants to fuck her." Then he walked away. I turned back to Bob, but he had split.

I solaced myself with an occasional glimpse of Linda. In the center of the room was a full-sized pool table where a constant round of eight ball was going on. I was relaxing in a big easy chair, the left arm of which had been removed to accommodate a guitar player, when I saw Gene pushing Calista around. I thought, "Oh shit. I'm going to have to get into a fight with a drunken Cherokee."

I stood up and resolutely stepped toward the fray. Linda interposed herself, and said, "Gene was not invited and he is ruining my party but please, David, don't get into a fight with him."

My way was clear. I put my arm around Gene as though we were old friends. It looked that way to everyone else, but I had him in a vise grip. I smiled and said, "Come on, man. Let's get out of this crummy scene." I asked Linda to "take care of my treasure"—Calista, of course—and propelled Gene out the door and drove him home in the Ferrari. Well, it wasn't home. He was living in someone's back bedroom. I put him to bed and talked with the family a little. There was a scream. We went running to the back. Gene was in the daughter's bedroom. She had been awakened by the fact that Gene was pissing on her. I got him out and calmed the parents. Finally, Gene passed out.

➤ ⬅

I DROVE BACK to the party. It was all over. Calista and Linda were sitting on the bed in the famous bedroom becoming best friends. We talked for a while, until they both fell asleep. I covered them up and went to sleep on the couch. That was all she wrote. I spent the following night with Linda—not on the couch. We played with each other in the big bed.

In the morning, I stepped out through the shot-up bedroom door to take a piss in the garden. Linda's 140-pound Newfoundland, the Mighty Quinn (when Quinn the Eskimo gets you, everybody's gonna jump for joy), walked up and took my cock in his teeth; gen-

tly. He just wanted to show me who was boss. I roundhouse punched him in the side of his head and it became clear who was boss. Dogs are suckers for a roundhouse.

CHAPTER SIXTY-SIX

PARADISE REGAINED

O ne Saturday morning in 1976, while relaxing on the beach, I spontaneously fell into a state of meditation. When I came to, I jumped up, vaulted into my yellow Ferrari, drove as fast as was possible to Torrance, a distance of about forty miles, and walked into Kam Yuen's 11:00 o'clock class. Kam was very surprised. He hadn't expected ever to see me again.

I continued working out with Kam daily at home in my back yard, which was Malibu Beach, learning new forms and techniques. I started into Tai Chi Chuan, and began working the Ling Po form. I got into the nine-sectional staff, also known as the whip chain. Kam gave me a very special nine-sectional staff as well as a three-sectional, both made in the People's Republic. I still have them.

I decided I should have a piano of my own. I started looking for one. I went all over L.A. playing pianos in stores. I finally settled on a nine-foot concert grand made in Germany. I bought it new for more than I could afford and moved it into the Glass House.

I went off to do another movie with Paul Bartel. *Cannonball* it was called. Hal Ashby didn't want me to do it. He thought it would only reinforce my reputation for "exploitation films." I didn't know I had such a reputation. I told him it was my next picture and I couldn't turn it down. I was broke. I pointed out that Paul was pay-

ing me almost three times more than my last film, for four weeks work. *Bound for Glory* had taken nineteen weeks out of my life.

The picture's about an automobile race from L.A. to New York. We never left L.A.; highways all look alike. Bob Collins, from *You and Me*, shot the second unit. I choreographed one of my favorite fights. Brother Bobby was in it as the kid who wins the race. There was a cameo by Martin Scorsese. I got to do some of my own stunt driving, which was a gas. Roger Corman released the picture. It did all right but it did not become a cult classic.

I had hoped for more, but the real point was to make some money.

Universal gave me the role of the rescuer in a Charlton Heston disaster movie called *Grey Lady Down*. Also in the cast were Stacy Keach, Christopher Reeves, and Ned Beatty. Since I am killed rescuing Charlton, we never met on the picture, though we were acquainted. We used to run into each other at the hardware store. The director was the same drunken Englishman who had confounded the crew of "Shane."

We started shooting in San Diego to get the Navy ships. I called up Linda and asked her to come down. One morning, I walked around the corner and saw a beautiful girl, dressed in torn jeans and a sweatshirt and sneakers. She was trying to get through to my room on the phone. "Wow! I can't believe it. That's my girl," I said to myself. I grabbed her up and spun her around in the air. We moved into the El Coronado Hotel, a very special place on an island. I bought her a live rabbit, which we sneaked into the room. She named him "Bugs."

After that came a movie for 20th Century Fox: *Thunder and Lighting*, an adventure comedy to be shot in the Florida Everglades. Roger Corman was producing it; Alan Ladd, Jr. was overseeing it for the studio. The director was Corey Allen, who had become a hero of mine years before because he was the actor who did the chicky run with James Dean in *Rebel Without A Cause*. While I was down there I found a great place to live: The Rod and Gun Club, in the depths of the Everglades. There were no dogs allowed but the proprietor said, "No. This is different. Buffalo is a gentleman."

The picture was largely fast cars and fights. I learned to drive an

airboat. I was doing my own stunts and I cracked one up, almost wiping out the director and the camera crew. I sank their airboat with all the equipment on it. For a minute there was nothing on the surface of the water but hats.

I called Linda and asked her to join me. During that phone call, she confessed all her sins to me. I didn't understand a word she said. For that matter, I didn't care.

I said, "Just come."

I drove to Miami, about ninety miles, to pick her up at the airport. She wasn't there. I called her friends in L.A. They were pretty sure she'd caught the plane. It was a mystery. I drove back in a funk. When I stepped into the front room of my little refuge I saw, in the middle of the floor, a pair of tiny sneakers. Further on were the socks. Following the garment trail I found Linda, asleep in my bed, Buffalo at her feet. From that moment on we were together.

When I got back to Malibu, I discovered the landlord had thrown all my stuff into the street—we had been having a little rent war. I had lent the Glass House to brother Christopher, who was having trouble with his marriage and needed a place to regroup, so I was homeless. Kam gave me a key to the school and for a while I lived in a little room at the back. I spent my days sweeping the gym and working out, eating health food from the company store, and talking with fellow martial artists.

I was living the pure, holy existence of a Shaolin monk. Then one night while I was out on a date with Linda, I lost the key in the bushes somewhere on Mulholland Drive. Kam never gave me another. Calista and I moved in with Linda, and that was the end of my life at the school.

There was an inevitable confrontation with Roger McGuinn. He had been calling Linda and making threats. I told him it was none of his business anymore and to stay away, or else. It was my understanding that he used to beat her, and the bullet holes in the bedroom were not reassuring.

Calista, in one of her efforts to change the face of the future, said to me, "Don't you think you should marry this girl?"

If you're not going to listen to your firstborn, who are you going to listen to? Not long afterward, during a glorious dinner of

roast lamb with Linda and my father, I raised my glass and announced my intention to marry the chef. Dad was not in the least surprised.

➤ ⬅

IN FEBRUARY OF that year, Bobby and I went to Florida to watch the Daytona 24-hour endurance race. We were both infected with the idea of running our own car in this race. Bruno, our mechanic, went with us to Connecticut to buy a very special Daytona Ferrari with an illustrious history from Luigi Chinetti, the American distributor for Ferrari. Bruno made me get under the car and engrave my name on the block with a pocket knife so they wouldn't switch engines on me.

My impossible dream was to win the Daytona in a Daytona, with Bobby driving. The first thing I did when the car arrived in California was have Von Dutch paint our names on it. The car was terribly beautiful. It was painted red, of course, but with a blue and red racing stripe to commemorate its career with the North American Racing Team.

Bobby loved Linda because she was happy to hang around when we were doing all this car stuff. He invited me down to a gathering of Ferrari owners where we could get the chance to test the car. Clint Eastwood was there with his Daytona, destined for the same future task as ours. I don't know if Clint knew it, but our car had in it the only competition engine ever installed in a Daytona, with larger valves and a wilder cam. Clint's car, #65, would be no threat to the Corrodini Brothers' car, #64. Bobby took me for a lap. There was no passenger seat. I sat on the floor and held onto the roll cage for dear life. The experience of hurtling straight at a wall at 110 mph and, at the last possible moment, making a 90-degree turn at the same speed is burned into my memory forever.

Bobby said, "Are you ready to take your lap?"

I said, breathlessly, "No. This car is to race."

A few minutes later, the owner of a Boxer Berlinetta slammed his car against that same wall. The car was never the same. Clint stayed out of his car, too.

CHAPTER SIXTY-SEVEN

FOREIGN WARS

 got a call from Paul Kohner, one of the legendary Hollywood agents. He told me he was prepared to offer me a picture in Germany with "the world's greatest director." He added that he could not tell me the name unless I said yes first. I thought that was sort of backwards. I told him I was not available. I had agreed to do a picture with Roger Corman. He asked me if it was not possible that Corman would release me.

I said, "Yeah, I suppose it's possible."

He said, "All right. Then I can tell you. It's Ingmar Bergman."

Unimpressed, I said, "Who's the costar?"

"Liv Ullmann."

I said, "Hold on a minute." I got Roger on the other line. He said of course he would not stand in my way. I said to Paul, "When do I leave?"

He said, "In four days."

I packed up Linda and a mountain of luggage, mostly consisting of musical instruments, and we went off to Munich. I was picked up at the airport by a '54 Rolls Royce, which became my regular transportation. Ingmar welcomed me with open arms. He had originally cast Dustin Hoffman in the part, but Dustin backed out. His replacement, Richard Harris, had taken ill at the last minute.

Ingmar had seen me in the German version of *Death Race 2000* and was pretty sure he wanted me. He said, however, that he had to see me in English before he made his commitment. Hal arranged to have a couple of reels of *Bound for Glory* sent to him.

Ingmar told me I was a gift from God. He told the press I was a gift from heaven. I think he didn't want to advertise to the world that he believed in a supreme being.

After quite a bit of wardrobe testing and such, we started shooting. Ingmar had a unique way of working. Sven Nykvist would set up a shot while the actors were in make-up. At precisely 9:00 A.M., the door to the set would be unlocked and we would begin shooting immediately. The door to the sound stage was always locked. You could get out, but you couldn't get in. This was a closed set. The producer was not, by contract, allowed on the set before 3:00 P.M. Dino De Laurentiis, who could be called the "owner," was not allowed in Munich. Within fifteen minutes, we would have our first shot in the can.

At noon we went to lunch. Ingmar did not want me to talk to people during lunch, so a woman would bring my food to my dressing room. There was a tree outside my window. That tree became my only friend. I would point my camera out the window and take pictures of my tree, covered with snow. I must have taken a hundred pictures of that tree.

At 1:00, we would resume. At 3:00, we would take a coffee break while Ingmar held a staff meeting. After the break, he would often call it a day. If he did continue, it would never go past 5:00. Ingmar believed that an actor could not function at full bore for more than five or six hours. True enough, but Hollywood could care less about that. They work us till we drop.

Ingmar wanted me to smoke in the movie. I told him, "I don't smoke."

He said, "Of course, I cannot force you to, but if you don't smoke it won't look like the twenties."

He had an image of a snap brim hat, a loosened tie, a drink in one hand, and a cigarette dangling from my mouth, viewed through a window with rain trickling down the glass. I couldn't very well refuse him the butt. He was right; it completed the picture. So I smoked. I have never managed to kick the habit since.

Between scenes Ingmar would psychoanalyze me, asking me about my childhood and my mother. He did not want me to go out at night; he preferred that I have no input outside of his influence. If he could have gotten away with it, he would have locked me up at night. Linda and I cut a wide swath around Munich anyway.

Kam Yuen and his assistant, Janet, came and lived with us. In between shots, when Ingmar was not probing my psyche, we worked out.

I began violating my vegetarianism by consuming a steak tartare on a weekly basis. Ingmar was very happy about this. He thought vegetarians were some kind of perverts. Ingmar himself was allergic to almost everything. He subsisted on hard boiled eggs and yogurt. He told me he was afraid of everything except his wife.

The workouts were numerous, and intense. I was in superb physical condition. My reflexes were lightning fast; my speed, balance, and power were at their peak. Linda and I were dining one night with Kam and Janet in our favorite late night eatery, The Cave—me on steak tartare, Linda on a huge mound of haricot verts—when she started tickling me. I pushed her away. She flew backward and bounced her head off of the frame of a painting on the wall. Linda was not disturbed. She knew I didn't mean it. No one is responsible for what happens during a tickle attack. What got her was that she didn't even feel the blow. It was so light; just a flick of the fingers, a touch. I resolved to pay more attention.

Kam said, "You have to be careful, David. You have the chi in your hand."

As Christmas approached, we imported Calista and Free. We all moved into a rural rooming house that had been converted from a manor; very beautiful, right beside a little river with ducks in it. The room we had was the former dining room, the best room in the house, with a fireplace. Santa Claus made an extravagant visit.

Linda has her problems but she loves kids and she does the right thing instinctively by them and for them. She actually overkills, giving them more attention than they need or deserve. There's certainly nothing wrong with that.

Free never got over his jet lag. He would wake up at six o'clock in the evening. He wondered why Germany was always so dark. We

would all go sledding in the park at 2:00 in the morning, under the artificial lights. We'd crowd onto the sleigh and go down the hill. The sled would roll over and we'd all bounce around in the snow, laughing and screaming under the stars. It was weird, but a lot of fun.

I bought a Zundap motorcycle for fun on the days off. We went to museums and art galleries at a constant risk to our lives, but when we fell, it was always in deep snow. We laughed a lot. Linda made sure that Free was always on top of her when we hit the tundra.

Ingmar would have preferred that my family not be with me, but as long as it was static it was okay. Linda wanted to take Calista to Italy to show her the Sistine Chapel. Ingmar was afraid if she left, it would upset the mixture. He didn't want me to leave Munich at any time, but I did. I went to Paris for a day. He was outraged because I hadn't told him about it. I didn't tell anyone. It was a secret. I was there to pick up a surprise for our wedding-to-be. Ingmar was virtually apoplectic. He told me he would not have permitted me to go. I didn't get into that with him, as I don't respond well to people telling me I'm not permitted to do things.

Working with Liv Ullmann was not what I had expected. She was very straightforward, doing her work matter of factly, getting almost every scene in one take. No temperamental outbursts, completely lacking in the expected star-style pretensions. Once I asked her how her beauty had served her in her native Norway. She told me that, in Norway, women were prized principally for the strength of their arms and the broadness of their backs.

It's hard to describe what it was like to work for Ingmar. He is a very strange man, both lovable and hateable. The closest I can come is to say that working for him was exactly like being a character in an Ingmar Bergman movie.

He had built a saloon set for a brief, one-shot scene. It was a long narrow room, almost a tunnel, dressed in red velvet with mirrored ceilings. Being inside it was like being inside a blood vessel— one looked fearfully around for the anti-bodies poised to attack. The real purpose of this set was for Ingmar's little "heart to hearts" with me. We would stroll through the blood vessel, discussing the inanities of American movies (he hated them) and my mother. He built another one-shot set, very complicated, that had to do with a recurrent

nightmare he had been having for years. He had the idea that if he put it in a movie, he might stop dreaming it.

With the holidays over, we had to say good-bye to Calista and Free. Linda and I became very busy with the legalities of trying to arrange a marriage in Germany—no easy feat. There are a bunch of rules left over from Germany's efforts to block precipitous unions between American soldiers and the eligible maidens they had left after World War II.

Ingmar had talked Dino De Laurentiis into building Berlin of the 1920s on the back lot of the Munich studios. He intended to use it again to film *The Student Prince*, and after that, *The Three Penny Opera*, with me as Mack the Knife. We also planned to do *Peer Gynt* on Broadway, with Ingmar directing me in the role. One night, all of these plans became history.

I walked out to the Berlin street set, frozen and freezing. I was confronted with a dead horse. The idea was that a cart horse had fallen in its tracks, and the starving Berliners run out of the buildings and cut the carcass up for food. Ingmar had hired some butchers to play the parts. They told him they had to first let the blood out by cutting the carcass's throat or it would spurt when they cut in. He said, no, he wanted the blood to spurt. I found out later that he really wanted to see the horse die on camera, but the German government wouldn't let him do that. This wasn't Mexico.

This scene was not in the script I had read. It was Ingmar's little surprise. I was supposed to walk from the end of the Berlin street through the snow, out of the darkness, through pools of light from the street lamps, and discover this carnage when I was close to the camera.

I was stunned into speechlessness. I couldn't believe that these people—the extras, the crew—could, apparently as a matter of course, involve themselves in what seemed to me a satanic rite of some kind. I couldn't look them in the eye.

I walked out to my mark. I was so angry I was shaking. To cool myself off, I went through some explosive kung fu forms. As I was executing a spinning reverse crescent kick, I came around to see Ingmar standing about eight feet away, gazing at me with a kindly expression, his hands in his coat pockets, steam coming out of his nose, like a thin, gray-haired dragon. His eyes were strange, mysteri-

ous, and the light hitting his face from the side illuminated him in an arcane way.

I lunged forward and grabbed him by his sheepskin lapels, about to do I-don't-know-what. He . . . embraced me. I don't know if he embraced me to block my aggression or because he didn't understand me and thought that was what I was doing. In any case, I melted. He said, "What's the matter, little brother?" I felt so lost. I had thought I was so close to this great director and yet I was compelled by my own sense of morality to dislike him. It was a tragic moment for me.

We walked back toward the set and I had a long philosophical discussion with the monster maestro on the subject, in lieu of simply wringing his neck. He said the horse was purchased from a slaughter house and this was a much more pleasant way for the beast to die, outside, in the gentle snowy night, without the terrible smells and the fear. I told him that was not philosophy; it was rationale.

I told him, "Killing animals and photographing the act for profit is extremely perverted. This makes your movie a 'snuff film.'"

He said he didn't hurt actors.

I said, "What's the difference?"

He said, "Actors are people."

I said, "So are horses."

He said, "That's ridiculous. That's just not true." Then he said, "I'm doing this for Art. This is a reasonable thing to do because it's for Art."

I said, "Ingmar, there's nothing more artistic than a live horse."

He said, "That's not true. I'm showing people this horror so they can be shocked into seeing something. They are used to going to movies. I'm showing them something to shock them out of their complacency."

At this point, we had stopped. I grabbed him and said, "What about your soul?"

For a moment, he didn't know what to do. I guess in his world, at that time, he didn't expect anyone to come up and ask him about his soul. Then he recovered himself. He looked at me as though I were a stupid child. That's probably what he thought I was.

He said, "Little brother, I'm an old whore. I have shot two other horses, burned one, and strangled a dog."

I just stared at him. What could I say?

I walked back to the set. As I came back into the scene, I suddenly saw these people, not as accomplices in a dark, godless ritual, but as innocents, caught up in the web of Ingmar Bergman, the power and the influence. They undoubtedly did not understand what my problem was. They were grateful for the opportunity to work with such a great director. These were Germans. They follow orders.

I had been standing apart from them, refusing to touch them, shunning them, treating them as pariahs, giving them a sense of guilt and unhappiness. I went by and touched everyone and smiled at them. Then I finally had the nerve to touch the horse and tried to make my peace with it all.

When I was confronted with that dead horse on the set in Mexico, Bernie Kowalski was slated to direct *Americana*. I stepped away from him because I didn't want *Americana* to be directed by a man who condones killing horses just so a more exciting movie can be made. Also, the whole point of movies, the magic of them, is in pretending. I don't see why we should abandon that sense of pretense.

There's really no reason to do things for real. I don't think it helps the energy in any way. The audience doesn't feel the difference. I don't think they even really care how an effect is achieved. They respond to the image. The excellence of a filmmaker is measured in the ability to make something out of nothing.

I've often wondered if every bit of Ingmar's production was not calculated, including the delay in getting official authorization for my marriage, which, in a miraculous coincidence, resolved itself on the day following the end of the shoot. Like magic, the way suddenly cleared. Ingmar had great influence, and he had said he would prefer that I not change the mix by taking my vows in the middle of the picture.

Two days later, on February 1, 1977, we wrapped the picture. The next afternoon, in a little chapel high up on a snow-covered mountain, I married Linda.

The night before the wedding, Linda made a clean breast of her

shortcomings; she wanted me to know that she had problems in her life that she was trying to work through. I was a little deep in. Too late to back out with any panache. Anyway, I loved her. I told her we'd fix any problem together.

Linda was absolutely ravishing in her wedding gown. The service was totally lovely, even though we didn't understand a word of the German. Ingmar did not come to the wedding. He had pickups to do, unimportant little shots, but he had to do them and he respectfully could not be there. After the ceremonies, we flew to Paris in the producer's Learjet for a short honeymoon. We sat on the floor of our suite at the George V, in front of the four-poster bed, she in her white lace wedding gown buttoned to the throat, me in my kung fu silks, and toasted with Château Haut-Brion '61. We were very happy.

From Paris, we flew on the Concorde to Daytona Beach, Florida, for the maiden flight of the Ferrari. When we arrived, the race was in progress. I stood in the infield and tried without luck to pick out our car. Bruno walked up to me and said, "I suppose you want to know what has happened to your car." My heart jumped. "Bobby!" I thought. He explained that Bobby had crashed it in practice. Now my heart really leapt. No, Bobby was not hurt. And the Daytona was not wrecked, it simply was not safe to drive at 180 mph. It would live to race another day.

Linda and I rented a car and drove to Disney World. We stayed for a week. It was absolutely wonderful to be drenched in warm, icky, plastic Americana after four months of Bavaria in the winter.

⇒ ⇐

OUR MARRIAGE BEGAN with gusto. I was the lord of the universe and Linda was my field of play. She was a bright and cheery companion. She had a great sense of humor. None of my jokes got past her, no matter how erudite or obscure; and she threw in a lot of her own gags. I remember our good times together as being full of giggles.

She had an absolute genius for sex. We did everything that two people could do, pushing the envelope without fear. We played chess and drank tea and we talked philosophy. I wrote songs to her. She

cooked for me and cared for me. Every now and then her own prob-
lems would surface, but we were always working on that.

The first time I ever yelled at her, I came charging through the
house and slammed the front door so hard, the whole house literally
shook. She jumped up and said, "What's wrong?"

I said, "Free's Tom!"

She said, "What?"

I said, climbing into the Trans Am, "Free. He changed his name
to Tom." And I burned rubber. The tires spun, spewing dirt all around,
and I shot backwards up the driveway and out. I ended up at some bar.

MATA HARI

Calista and I were standing in the sand on a beautiful day in Malibu when I asked her what she wanted to do with her life. She was 14 years old. She said her dream was to just walk down the beach, never turning back. To walk all around the world. She thought people would take care of her wherever she went, and her entire life would be an adventure.

I said that, well, she could actually still do that if she really wanted to. She said no. Now she'd rather be an actress. I thought to myself, what could I do to help that? *Mata Hari* came to mind. I got in touch with a writer I knew and asked her if she could knock out a few pages. She said, yes, if she could do it with her lover, a French journalist named Michel Mangois. I thought that, since it was a woman's story, it would be great to have a woman write it, but a Frenchman isn't a bad idea either. They produced a short, sweet beginning, which we called *The Scarlet Truth*. Our prose was very purple in those days.

I re-envisioned *Mata Hari* then as a way to help Calista and me be together. It was a way to teach her. Creating a rational situation between us was the thing that was uppermost in my mind. It also seemed as if it were in an emergency. Something had to be done.

When I moved in with Linda, Calista had started disappearing again. She and Linda didn't get along very well when I wasn't around. She'd be living at home and then she'd just vanish. By the time she was fifteen, she and I had started to get a handle on a friendship

between us—a real friendship. We started being more honest with each other and I stopped trying to make her do things. It was just too late in her life for me to come along as an authority figure, I guess.

There were a lot of amazing things about Calista, not the least of which was that she has never seemed to lack for the necessities of life. Those were not a problem for her. Now that she has her children, things are a little more difficult for her. There's more concern on her part. Not because it's any harder to do—I think she could get by just as easily—but because she has a responsibility to the children and she can't treat them the way she would treat herself.

It was virtually impossible to keep her out of trouble. It's remarkable that she turned out to be as literate as she is. She sure didn't learn it in school. She wasn't home that much. She was living with young men, or she would move into a neighborhood with friends of hers who had run away, or with people slightly older than herself who were living on their own. Short of locking her in a tower, there was really no solution to it. She simply did not want to share my kind of existence. It bored her and it also didn't have enough of the family aspect to suit her. My home life was as bare and desperate as hers on the street.

I had put her in a private boarding school, which was, in a sense, a paradise. It turned out to be not at all useful for straightening out the "wrong" ideas she had. The boarding school was full of other kids who had the same rebellions. In the framework of what was supposed to be a safe place, the kids were really leading as morally dangerous a life as they were before, just as if they were out on the street someplace. Then, when it got too constrictive for Calista, she'd just run away and hang out with some musicians or something.

Mata Hari is a project we began together in 1977, and still goes onto this day. The thing about *Mata Hari* is that it produces a situation wherein, while she's working on the picture, Calista adopts a professional attitude. As a result, more than at any other time, it's easy to communicate ideas to her. I used it as a key to open a door. The making of the movie is really not as important as the activity between us.

To a certain extent it's working and to a certain extent it isn't. It does make it possible for us to have a rational dialogue, but it also opens up other parts of Calista that are difficult to control. The movie

has a lot of sexuality in it. This comes to her very naturally. I have to discourage that. I know that's a large part of what I look for in a woman, and it seems very hypocritical of me to discourage it in Calista just because I'm her father.

If fathers could really train their daughters the way they say they want to, they would all grow up to be ice-cold prudes who could ride horses and use the correct fork and do arithmetic. I don't think that's what we really want.

What I've done with Calista, for better or for worse, is to let her find her own way. She has made her own mistakes and discovered her own solutions. Eventually she came back to me, and even now she is showing me the way.

Carl Jung said, "If you can see the path before you, you are following someone." I can think of no better way to finally get it right than to be led out of the morass I have made of myself by the fruit of my own loins—my daughter—who has discovered, through her own painful experience, a better road than I could have shown her.

But back to 1977: Now that I had a few pages of a script, I needed to put them on film. I had to go to the Cannes festival for *Bound for Glory*, so I arranged to do a little shoot for *Mata Hari* in India afterward. Our producer was Ismail Merchant. We told him what we needed and he jumped into the fray and made it all happen for us.

I left California, having arranged to meet Calista and the others later in India.

After I had made all the appearances, the press conferences, and insulted all the Gauls I could, and while I was waiting for the jury to decide whether or not I was the best actor of the year, I boarded a flight for India, leaving Linda behind to smooth things over.

When I came into Bombay, the authorities were insisting I had to have a health certificate. I told them my daughter was in India with a strange man (more or less true) and I had to rescue her. Then they offered to give me a battery of shots. I said no thanks. When I asked them if they really thought I was going to bring a disease into India, they realized the ridiculousness of their stance and let me through the gate.

Bombay smelled like a barnyard. The extremes of richness and

poverty were shocking. One, of course, couldn't drink the water. When people spoke to me at close range their breath smelled like flowers because of all the spices. I checked into the best hotel in town, the Taj Mahal.

In the morning, just after dawn, I walked to the beach. On the way, I passed colorful tribes living in shantytowns and hundreds of people just living on the street, right next to high-rent apartment houses and banks.

The beach was a light brown. Here and there, I saw people meditating. I watched one of them gather up his robes and step away. As he walked off I saw, where he had been sitting in "meditation," a small pile of do-do. He had not been meditating, he had been taking a crap.

I couldn't find Calista, Michel, or Paul Hunt, the cameraman (he used to work for Orson Welles, which was good enough for me). I tried to get a call out to L.A. to find out where everybody was staying. Impossible. I flew back to Cannes to make the call from there.

I made my calls and flew back to Bombay, where I found all my people at the President Hotel, not as fancy—by a long shot—as it sounds.

Ismail had everything together. He provided us with a couple of great Indian actors, a choreographer, costumes, a half-grown tiger, extras, a couple of temples for sets, and all expenses paid while we were shooting.

We shot in India for four days, all we needed, and all we had a script for. We came very close to getting arrested a couple of times. We had no permits (it takes two years to process one and they always say no in the end) and we had smuggled in the film. That was easy. The tough part was smuggling it out again.

The system broke down the first day, when the Brahmin refused to let us into his temple: the Temple of the Goats, in Nasik. He locked the gate and went for a bath in the river Godavari. I joined him. We stood up to our necks in the filthy stream and stared at each other. He brushed his teeth with his finger. I emulated him and sipped some of the water for good measure. He climbed out and opened the gate. Maybe he thought I was holy. More likely he thought I'd be dead in a couple of days and wanted to grant my dying wish.

The third day, in the holy city of Tambakshaywa, I collapsed

with dysentery. Calista took over directing herself. She inserted nudity into every shot. I missed it all. I was in the hotel, flat on my back. The doctors told me I'd die by morning but they gave me the shots anyway. Obviously, I rallied.

On the last day, we shot at the harbor. The police came and asked for our permit. Ismail put us all in a cab with the film and told us he'd handle it. He told the cops he was shooting a commercial. They asked who the "Europeans" were that had left in the cab. He said we were some hippies he had hired as extras. The cop told him he wasn't allowed to shoot there.

The truth was, the Russian fleet was parked out there in the Indian Ocean, a violation of India's neutrality. They didn't want any pictures of it. We had actually been going to a lot of trouble to avoid seeing the ships on film. Battleships don't belong in a movie set in 1890. The cop said he had to confiscate the film. Ismail gave him a can of film he always kept on hand for just such purposes.

On the way back, in the Frankfurt airport, the authorities again tried to confiscate the film. They thought we were smuggling drugs in the film cans. They x-rayed them all. We didn't know until we had it processed at MGM if the film was ruined or not. We waited with crossed fingers and our hearts in our mouths. If anything, it might have improved it. The footage was dazzling, Calista was spectacular. As we say in show business, "The camera loves her."

India had taken its toll. Paul Hunt developed malaria. He left his window open on a hot night and was bitten by a dozen or so mosquitoes. The disease hung onto him for years. Calista was so in love with the blatant truthfulness of the place that she didn't ever want to leave. She contracted a mild skin fungus that wandered all over her body. It's still with her. It's actually almost charming. She has the markings of a faded leopard. Something had happened to her spirit too. She had become Mata Hari.

THREE TRIALS

I had become obsessed with a fantasy kung fu script called *The Silent Flute*; a project dreamed up by Bruce Lee that had foundered since his death. Stirling Silliphant's agent informed me that they were in the process of making a deal with Sandy Howard to make the film, and asked me (actually demanded of me) not to interfere. I didn't see a conflict. I called Sandy. He said he was already considering me for the film. I said stop considering—I'm in.

Sandy was hot to have me play the role of the Seeker. I said, "Look. I've already played that part. I've been doing it for five years. It's time for me to play the teacher; and anyway, who can we find to play Bruce Lee's parts?"

He said, "We'll get a bunch of guys: Alec Guinness for Ah Sahm, Oliver Reed or Omar Sharif for Changsha, and then we'll just double them in the fights using great martial artists."

I said, "It won't work. You can't do that anymore. The people won't accept it. In a martial arts film today, the fans demand that the actors really do it themselves."

He said, "It's too much for you; you won't be able to pull it off." Fighting words. So I gave him a little bit of each character, jumping around the room, talking in different voices, kicking at chairs and walls.

I showed him what Jeff Cooper calls my "Blowfish routine." I can scrunch my spine down so that I look short and squat, with a roll of fat around my middle, then stand up tall and grow muscles like a Greek statue, or make it all disappear so that there's nothing there, just skin and bones. Sandy caved in.

Instead of Alec, Omar, and Oliver, we had Roddy McDowall, Christopher Lee, and Eli Wallach in the other roles.

Kam Yuen was signed up to do the fight choreography and we started auditioning fighters. I stepped up my workouts even more. We were on our way.

I harvested several bamboo saplings from the forest I'd cultivated on the back lot of Burbank Studios, and seasoned them by tying them in a bundle and leaving them, weighted with a stone, in Malibu Creek for a few months. This was in preparation for transforming them into the "silent flutes."

Despite my "we're no longer friends" phone call to Jeff Cooper, I knew he was the right choice to play Cord. I was having a hard time selling him to Sandy. Jeff and I had alternated the roles of teacher and seeker in real life for years, so it seemed natural to continue doing it on film, but Sandy wasn't buying it.

One day we all got together at Kam's school for a power meeting to see if it would gel. There were a lot of fighters around, showing their stuff. Jeff and I got into it. We started out sparring easily, with me trying out bits and pieces of the Monkey King style on him. Suddenly, things got serious, and when we stepped away, I had drawn blood. Sandy was convinced. Hell, he was zapped. It was agreed. Jeff Cooper was Cord. I was everybody else.

Sandy Howard thought it necessary to do a rewrite on the script, for reasons I could never divine. It seemed perfect to me as it was. Stanley Mann, a screenwriter with formidable credits, was brought in. The only thing I can say about his efforts to improve *The Silent Flute* is that he probably didn't hurt it much.

Stanley's main contributions were an argument between the boatman and his wife (in the old legends, the boatman is the Buddha and not likely to have a nagging wife, but it takes all kinds), and the Man in Oil, played by Eli Wallach. The Man in Oil is standing in a huge pot of oil, trying to dissolve his genitals to get rid of Desire.

Since this scene was totally a creation of Stanley's, one wonders a little about his inner psyche, but it was a blast to have Eli around for one day. He's definitely a giant in his own right.

Always the Lone Wolf, Jeff decided to look elsewhere for his final martial arts training, determined to develop his own very different style. Cord is supposed to be a mean, rough, renegade of a fighter, so Jeff worked out in a sort of kung fu-outlaw-biker place for a while, doing heavy bag work and a lot of full contact. Then he discovered Mike Vendrell.

Mike is a very tough guy. He had spent some time as a professional street fighter and cage fighter. He's supposed to never have lost one of these fights. I certainly wouldn't want to get into a cage with him. I've never met anyone else who would.

According to Mike, he had a Master that only he could see, who first appeared to him when he was about ten years old. This Being was apparently a spirit, or an astral projection of some kind, who lived a life of his own in some distant land or time. His name was Leong.

Mike's mom and dad would look out in the backyard and see him playing with a stick, hour after hour, and talking with an invisible playmate. To them it was childish fantasy, but to Mike it was serious training with a real Shaolin Monk.

I'm not saying anything about the truth or fantasy aspects of this story; it's what he told me and Jeff. I've seen what Mike can do and I prefer to reserve my judgment. My feeling is, true or not doesn't really matter, considering Mike's prowess. As proof of his strange abilities, I was around when he teleported himself to retrieve a forgotten passport and appeared again, passport in hand. You don't have to believe that. Actually, I don't expect you to, but it's true. Mike told me there was a place between that was very dangerous. I asked him please not to show me how to do that trick, even if, later, I begged him to. He never did, but I never begged him either.

Trial One

MIKE VENDRELL TOLD me that he had an ambition to be a stunt man. I thought that was a lowly goal for someone who could travel through hyperspace. While waiting around for *The Silent Flute*, I was to begin a motorcycle film shooting in Oklahoma called *Fast Charlie,*

The Moonbeam Rider. Mike was a member of the Teamsters, so on this movie I brought him along as my driver.

I told him I would introduce him to the stuntmen, most of whom I knew pretty well from other films, and the rest would be up to him.

We all were sleeping in separate little bungalows. Most of the stuntmen lived together in one of them. I told Mike, "Okay, this is the night, but I've got to warn you, they're going to offer you pot. If you turn it down, with your haircut, they'll figure you're a cop. You won't get in."

Mike gulped and said, "I'll do it."

We walked across the field together. It happened just like I said it would. Mike smoked their weed and totally zoned out on the walls, the doors, the windows, his own hands and feet. He was very funny. The stunt guys loved him. He was in.

Mike's first stunt was crashing a motorcycle into a bale of hay and taking out a table of food. Having never been on a bike before in his life, the crashing part would be easy for him. Coming out of it in one piece was the hard part. When the moment came, one of the other bikers had the feeling Mike wasn't going to go for it, so he put his foot against Mike's front fork and shoved. Mike took out half the table, which was enough. He then proved himself useful in other ways. One of the stuntmen had a mishap during a stunt. The assistant director called for the ambulance. The guy said, "What for? I'm fine. Let's do it again." He was standing sort of funny, with his right shoulder up around his ear. Mike said, "What's wrong with your shoulder?"

"Nothing!"

Mike said, "Let me see it." He popped the dislocated shoulder back in. Mike is a doctor of sorts; I have seen him more than once make an injury disappear on the spot. There were a lot of calls for that kind of thing on *Moonbeam Rider.*

Steve Carver, the director, turned out to be a really funny guy. Right off, he took me aside and said, "David, the crew always works better if they think the director and the star like each other, so do me a favor. Pretend you like me." I did that, and pretty soon I discovered I really did like him.

There are some hairy stories to be told about *Moonbeam Rider.*

I had a few close encounters on that antique motorcycle, most notable being the "David as a ball of fire" incident and the time I got run over by an airplane. The plane was supposed to come close, but there were tire tracks on my helmet. I have witnesses.

There was one time when I missed a turn on a gravel road and disappeared into the wilderness on the bike, totally out of control, bouncing over rocks the size of coffee tables. No one expected me to walk out of that one. When I did, Jesse Vint told me that what he had been doing while I was missing was thinking about what he was going to say to the press as the last person to see David Carradine alive.

⇒ ⇐

IN THE MOTEL in Oklahoma, during a remarkable erotic night, Linda and I conceived. Linda was very easy to predict. Her menstrual cycle was always right in sync with the phases of the moon. All you had to do to know the right moment was look at the night sky. If it was full, so was she. We knew it would be a girl. We named her Kansas.

Trial Two

After *Moonbeam Rider* I had one more duty to perform: I had a contractual obligation with Roger Corman to do a sort of sequel (one thousand years later) to *Death Race 2000*. It was a futuristic-sword-fighting-motorcycle picture. This was the obligation he had released me from to do the Ingmar Bergman picture. Roger Corman himself urged me not to do it. He thought it would be bad for me now. I said, "No. I want to do it." Roger was right. The picture turned out to be pretty much of a fiasco.

Nick Nicifor was the director-writer. Even though his script was at times brilliant, his direction seemed to me to consist mainly of hysteria and episodic tantrums.

At one point, he physically attacked my costar, Claudia Jennings. We all loved Claudia; she was a great lady. I stepped in to teach Nick a lesson and I'm afraid I got a little carried away. I threw him down and pulled off my belt. I guess I was going to beat him with it. I don't know with which end. You'd have to know Claudia to understand

how I could get that far out about someone hurting her. She was really special.

Gene Heartline, the stunt coordinator, had to pull me off Nick. He said, "Don't do anything you'll regret, David."

I said, "I WON'T!" and shook him off. He grabbed me again. He was a very strong man. He said, "David, we all feel the same way you do."

I said, "Oh" and stopped struggling. Knowing one is not alone changes everything.

Nick jumped up and ran for his car. I ran after him. He locked his door. I went around to the driver's side, and climbed in behind the driver. I gave Nick a pep talk. I told him this was his movie, the script was brilliant, no one could direct it but him. He couldn't run away. I said, "Nick, you're tougher than any of us." And, for emphasis, struck my gloved fist against the windshield. It shattered. Nick said, "I'll do it." And jumped out of the car. He did the one shot and then slipped back in and was driven away in the windshieldless BMW.

Relations were extra-strained after that. He came back with two body guards and a gun in his pocket. Someone convinced him to give the gun to one of the bodyguards.

When it was time to shoot the sex scene (in a Roger Corman picture, there's always a sex scene), Nick pulled me aside. He told me he hadn't had a woman in six months and he couldn't be in the room when Claudia undressed. He asked me to direct the scene. "Just go in and give it to her," he said.

I was damned if I was going to take advantage of Claudia to please Nick. I stripped down to my black panties and touched her naked body. I ran my hand down her torso and kissed her. Then I kissed her neck and her shoulder. I moved down and lightly kissed her left nipple. Then I backed softly out of the shot, and left the room. It was very natural and tender.

When I got outside, Nick accused me of wanting to direct the picture. Odd, since that was what he had just asked me to do. I said, I didn't want to direct the picture. I wanted to produce it. Since that wasn't enough sex for Roger, he inserted a sequence wherein Claudia, naked, was tortured by the emperor.

Nick quit the picture in the middle, leaving Roger's young and

inexperienced apprentices to finish it. *Deathsport* was Claudia's last movie.

One definitely okay aspect of *Deathsport* was the sword fighting. The swords, supposedly diamond, but actually Plexiglas, were so delicate they would break at the slightest clank. The fight coordinator, Jonathan Yarborough, and I invented a style of sword play wherein the swords never touched.

Shooting in rolling hills, we were fighting the sunset. We would get a shot and then jump in a jeep and run to higher ground, chasing the sun. Altogether, we shot five sunsets that day.

Jonathan Yarborough later changed his name to Pendragon, and became one of the most famous magicians ever.

The heavy was played by Richard Lynch, who had distinguished himself years earlier by seating himself on the steps of the Capitol, head shaved and dressed in Buddhist robes, and pouring gasoline over himself and setting himself on fire to protest the Vietnam War. He survived, like the war, with a lot of scar tissue.

A big damper was thrown on things during this picture when I took a bad spill off a motorcycle and pulled a ligament in my right knee. The orthopedic surgeon told me it was a permanent injury. He also said I had to give it complete rest. I pointed out that I was in the middle of an action movie and had to be back on the bike that afternoon. He shot me up with cortisone and painkillers, gave me a brace, and I went back to work. But how was I going to be able to do *The Silent Flute*?

Trial Three

I WENT TO my Chinese guys. Leo Wang examined my knee and said, "Oh. Ligament. Very hard to heal. Sometimes never the same." That sounded a lot better than "permanent injury." He treated me with herbs and massage, and the knee started to get better right away. It eventually did heal completely, but it took over a year. I ended up doing *The Silent Flute* with the brace in place.

Sandy Howard was a tough master on *The Silent Flute*. He demanded a minimum of one hundred and ten percent from everyone. My nose was broken twice, and Jeff's face is scarred for life. Due to the weakness of my ligament, I broke the meniscus, but I can't

blame that on Sandy. Anyway, you don't ordinarily really need the meniscus; you can do just fine without it, as long as you have the ligament.

We started filming in Israel late in 1977. We showed up in Tel Aviv in force. Kam had assembled a dozen or so martial artists. The crew was Israeli and British. The producer and director, American. We shot in locations with important historical and religious significance. I have always felt that this significance somehow managed to become part of the picture.

For example, there is a fortress that guards the pass between Tel Aviv and Jerusalem that dates back thousands of years. The pass was at one time or another controlled by many different factions of the various Holy Wars—sometimes for hundreds of years, sometimes for a day. This could be seen by the different architectural styles in which it was built, strengthened, repaired and expanded: Phoenician, Sephardic, Persian, Turkish, Crusader, Egyptian, English.

We performed a fight to the death one night in the courtyard of the castle, lit by bonfire, between the blind Master, armed with the silent flute, and eight rogues. Standing on the walls around us, Israeli soldiers appeared and disappeared quietly, armed and in uniform, watching for awhile, and then going on back to their own Holy War. In the dust beneath us was the blood of three or four thousand years of defenders and aggressors.

The silent flute, the best one of them, shattered during that fight.

During the shoot, I swam in the Jordan river. I caught a fish in the Sea of Galilee. They cooked it up for me; it was awful. I visited Bethlehem and was mobbed by three thousand Arabs. I walked the route that Christ walked as he carried the cross. I played the silent flute at all of these sites.

One of the most interesting aspects of the picture was getting to know Christopher Lee. He professed to know how to do anything. I thought he was completely full of it. Later, I discovered everything he had boasted to me about was absolutely true. Four languages (five, if you include Elvish), knife-throwing, anything-throwing, actually. I saw him throw a ten penny nail into the bull's eye of a dart board. Fencing—he's an absolute master. He made eight movies with Errol

Flynn and, when he was quite elderly, had eleven duels in *The Three Musketeers*. He had served in the Rhodesian Air Force and was a member of the S.A.S, one of the REAL James Bonds. His knowledge of history and literature, and everything else for that matter, was beyond belief.

He introduced me to an old man who used to play in a quartet in Vienna with Albert Einstein. The old guy said Einstein was a terrible violinist. He also said that Al was an example of a completely wasted life. He maintained that Einstein formulated his theories before he was twenty-seven years old and never did anything else. He walked on the beach, played bad violin, regularly forgot his umbrella, and never learned how to comb his hair or drive a car. He was also a practical joker. There was some suspicion in Christopher Lee's mind that the theory of relativity was one of Al's practical jokes.

Linda stayed with me during the filming in Israel and took over the job of installing and removing the contact lenses I had to use for the blind Master. In the middle of the sandy desert, this was a tricky business.

When the shoot ended, we took a holiday in Greece. We prowled the Acropolis and I left an offering for Theseus, my personal favorite. We motored down to The Temple of Poseidon, which is on a promontory at the intersection of the Aegean and Adriatic Seas. There, I saw the most blatant piece of graffiti in the Western World. Lord Byron had carved his name on a fallen pillar in letters six inches high. The only monumental vandalism that beats that is Napoleon ordering his troops to shoot off the nose of the Sphinx for target practice.

With *The Silent Flute* in the can, I went on with my life as a movie actor, studying martial arts less and less and, though I always kept up my friendship with Sifu Kam Yuen, gradually drifting away from the martial arts community. Still, I couldn't really escape the art completely. I still danced in my backyard from time to time.

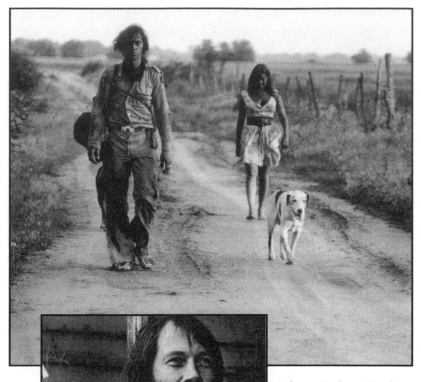

Above: Barbara Hershey, me, and Buffalo in AMERICANA.

Left: A COUNTRY MILE.

Right: with Hal Ashby on top of a freight train in BOUND FOR GLORY. *Photo reprinted courtesy of United Artists.*

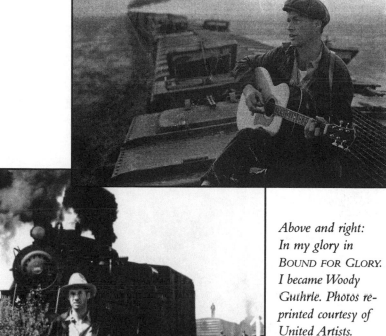

*Above and right:
In my glory in
BOUND FOR GLORY.
I became Woody
Guthrie. Photos re-
printed courtesy of
United Artists.*

*Right: Woody Guthrie, and
me as Woody.*

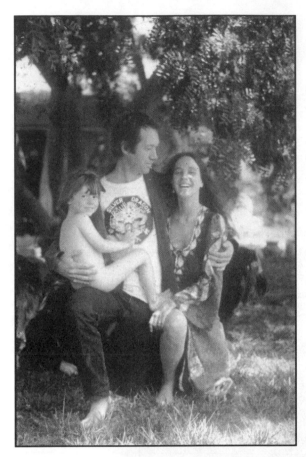

Linda, me, and Free, in 1977.

Linda.

Top: Calista as Mata Hari.

Center: Calista, Linda, Kansas, and me on location in Holland in 1979 for shoot of MATA HARI.

Below:Directing MATA HARI *in India.*

CHAPTER SEVENTY

YOU'VE GOT TO PICK UP EVERY STITCH

While we had been in Israel, an Arabian stallion had jumped the fence and impregnated Squaw. She dropped the foal on Linda's birthday. What came out was an Appaloosa with a perfect blanket, the spitting image of Squaw. We named her Indian Girl.

Something appeared on the horizon: a miniseries on the subject of Tom Horn, the legendary cowboy, Indian fighter, and gunman. I read the script and said, "Why the hell didn't they offer me this ten years ago when I needed it?" I took it anyway.

Robert Redford had developed this project, written by William Goldman, who had penned *Butch Cassidy and the Sundance Kid*. He called it *Mr. Horn*.

Mr. Horn was shot principally in the high desert of Mexico, near Tecate. The temperature in August was a consistent 130 degrees. People were falling like flies. Two horses collapsed. I just sat on Zebar, drinking mescal, soaking up the sun, and happy as a lark. I've never minded the heat much, having lived through winter in Vermont as a boy. I always thought if I'd been told hell was a cold place, I would have been a much better behaved boy.

Richard Widmark developed sunstroke and couldn't remember who he was, not to mention his lines. He kept saying, "There's some-

462

thing wrong here! You don't understand. There's something wrong here!" They sent him home to recuperate. He came back two weeks later and proceeded to steal the show from me.

Linda was extremely pregnant now and absolutely charming in that state. Now that we were married, it seemed a good idea to get out of Roger McGuinn's house. I reasoned that there was no reason to live in Malibu if you were not on the ocean front. We looked all over and found a beautiful house on a cliff overlooking the sea that had been built by a writer of psychic books. It had some strange and wonderful vibes. This was in 1978.

I discussed with William Blatty, the author of *The Exorcist,* making an intense, perhaps even deep movie in Czechoslovakia, but he wanted to shoot it in April, exactly when Linda was due.

I said, "Change the date and I'll do it."

He said, "I can't. That's the only time the castle we need for the set is available. Bring her. Vienna is only an hour away by plane. They have wonderful hospitals and doctors."

I said, "I don't think so." I turned him down. What the hell! If his location was more important than I was, I shouldn't be there. On the way home my Trans Am dropped its engine all over Pacific Coast Highway. I think Bill Blatty hexed me. If so, I'm grateful he stopped with the car. Stacy Keach ended up playing the part.

My next epic turned out to be *Cloud Dancer,* a movie about aerobatic flying, essentially gymnastics in an airplane. The writer/director, Barry Brown, wanted me very badly. He told me I wouldn't have to fly the plane. I told him that sounded boring and I wasn't interested.

He said, incredulously, "You mean you want to do your own flying?"

I said, "Yeah, that would make it more interesting."

Barry had originally placed the movie with Warner Bros., but they wouldn't believe he could shoot the aerial footage for real. They wanted to fake it all on a sound stage. Barry wanted to show the effects of the gravity on my face, which is considerable. Without the effects, it just wouldn't be realistic. He put me together with some of the best aerobatic pilots on the planet, notably Art Scholl, the absolute master of them all, and then Tom Poperesney, a member of the Red

Devils, the greatest of the prop plane synchronized teams. I also got to go up with The Blue Angels, the Navy jet team.

Almost all of these guys have since died in their planes, an occupational hazard. During the difficult maneuvers you black out. Usually you come to in a few seconds, but it only takes one time that you don't and you're history. I went through the course very quickly. It got easier once I stopped throwing up.

➣ ⇐

SINCE I WAS fighting a deadline for the Cannes Festival, I transported a portable editing room to the location in Phoenix, Arizona, along with Paul Hunt, who was now my editor. He worked on *You and Me* all day long and I joined him in the evening.

Part of my deal on *Cloud Dancer* was that when Linda's labor began I would fly back to L.A. from Arizona. When the time came, Barry tried to talk me out of going. It turned out I really needed to be there. Linda required a cesarean, blowing our idea of the peaceful, drugless Le Boyer-style birth with dim lights and warm water. Kansas came out like Julius Caesar, with no knowledge of the birth canal, no trauma, no squeezed head. I watched the doctor stitch Linda up. It scared the hell out of me. I thought she'd never walk straight again. It was only a few days before she was on her feet and, after a few months, the scar would all but vanish. Linda went through it all like a trouper. I stayed with them for a few days and went back to finish the movie.

I received an offer to do a movie called *Wise Blood*, directed by John Huston. Like a fool, I turned it down. I shouldn't be forced to judge scripts while I'm on a movie. I always say no. I don't like to turn my concentration away from what I'm doing right now.

While we were in Arizona, *Deathsport* opened there. I sneaked into the theatre to check it out. The house was packed with kids. When I made my entrance, they all whispered, "There he is!" I felt a thrill go through me and everybody else. Within a minute, the thrill was gone. I could feel the bubble burst. It really was a terrible movie.

Roger was right. I shouldn't have done the picture. The review in *The Hollywood Reporter* read, "Don't let the fact that David

Carradine is terrific in this film talk you into going to see it, because it's one of the worst movies ever made. You really can't make a silk purse out of a sow's ear." My career never really fully recovered from that blunder.

⇒ ⇐

BOBBY GOT A CALL from Mike Bowen. Little Mike (you remember Sonia's little baby boy back in Berkeley) was now pretty much grown up and was in nothing but trouble in San Francisco. Bobby and I said, "Send him down. We'll whip him into shape." We moved him into the burned down house, which Mike rechristened "The Glass House." That place could cure anyone. Over the years that I owned it, the house sheltered and healed me, Barbara, Chris, Bobby, Calista, Robby Ramirez (the future father of Calista's child, Mariah) and others. Mike started to straighten out immediately and became a cherished member of the brotherhood, with full honors.

Linda and I moved out of the psychic's cliff house to a wonderful place right on the beach, arguably the best house in Malibu. Kansas lived in our bedroom in a wicker crib right under a window facing the sea. Linda continued her moratorium on drugs while she was nursing.

We took Kansas to the Cannes Festival, where I presented the completed (for the moment) *You and Me*. The economy was collapsing at the time and the movie business was drying up. It was theoretically a time to pull in my wings, but I figured that whatever I gave up I would lose and whatever I didn't give up I would keep, so I snuck in eight days of *Mata Hari* in Holland using my American Express card and bouncing checks.

We put together a sizable chunk of the story, using the actual locations in Leeuwarden, Friesland, where the events had happened, most of which were preserved as museums. Costumes were going to be an expensive item, but we found a way. Hert, the designer, bought fifteen kilos of old clothes for about $45, and we adapted them into perfectly acceptable period costumes.

Calista was taking the role very personally, too personally. It occurred to me that it might be bad for her to look forward for a

decade or so to her tragic death, so I decided to get that out of the way by shooting it out of sequence. I told Calista that because she had done poorly in school this year I was going to execute her. The press showed up from all over the continent to cover the execution. Headline:

THE SHOT THAT WON'T BE HEARD FOR 15 YEARS

We were short of extras, so we pressed the reporters into service as the firing squad. Calista, in her first movie, was executed by the foreign press.

If you got a secret, now's the time to tell.
If you got a penny, better drop it in the well.
'Cause there's not much time to go.
Gypsy woman told me so.
It's all over. Don't you know?
Better get in your licks.
Hurry up and have your kicks.
Unlock your locks.
Last chance to get off your rocks.

They're gonna give the order,
tomorrow morning just at dawn.
And by breakfast time, Daddy's little girl
Will be long gone
So, if you got a secret, now's the time to tell.
If you got a message, now's the time to ring the bell.
'Cause there's not much time to go.
Gypsy woman told me so.
It's all over. Don't you know?
Better get in your licks.

Then Linda and I went to Hawaii and had a bang up time. A porpoise or a dolphin (I can never tell the difference) gave Linda the gift of an old wet washrag. We kept it.

We had been spending an inordinate amount of money. When we got back to Malibu, we were broke but unbowed.

After that, I lost contact with Calista for quite a while. She had a burst of liberation bordering on juvenile delinquency. Just about the time I got her bolted down, she disappeared again.

At this point, as though I needed more money hassles, the IRS audited me and disallowed the deductions for losses related to *You and Me*; a lot of money. Their position was that making movies was for me a hobby, not a business venture. Christ! It's what I do for a living. Am I to believe that if I'd shown a profit, they wouldn't have hit me for the taxes on that?

I had always been straight with the IRS. I consistently hired the most conservative accountants I could find. I figured the American Revolution needed my money. I don't like some of the things they spend it on but, hell, I'm a patriot. You can't really very well fight the IRS. You have to pay them first, with all the interest and penalties. So far, for me, an impossibility. I've never been free of them since then.

⇒ ⇐

I GOT AN OFFER to be a member of the jury for a fantasy film festival. Roger Corman was the president of the jury. I met Yanou Collart, the publicist, at the airport in Paris. I was a little miffed as they had sent me tourist class. I asked her, since she had issued me a second class ticket, was this going to be a second-class festival? She reassured me by taking me to dinner at a superb restaurant and putting me up at the Hotel George V. We took a private train to the Alps. The trip was one long party, with music, jugglers, and clowns.

When we got off the train, we were herded onto a cable car, which was the only access to D'Avoriaz, a ski resort. The idea was, you went up to the top, spent the night in the little village, and then in the morning skied to the bottom, which would take all day. Then you hopped the cable car back up and partied. The first morning, I saw an extraordinarily beautiful girl with short blonde hair about to go down the slope. It turned out she spoke English. She was a famous chanteuse. Her name was Joelle. She was involved in the festival. Later on I met her at one of the functions and we got along very well. I walked her home that night and, in front of her hotel, we kissed. The electric charge was definitely in evidence—in force, actually.

We parted breathlessly and she said, "What do we do now?" With all the will power I could muster, I said, "We say, 'Au revoir.'" I left her there and plunged through the snow to my own hotel.

I had not realized that what being on the jury of a fantasy film festival would mean would be watching four horror movies a day. Everyone else was out in the snow, playing, while we were in a dark room underground looking at monster babies and dismembered body parts.

Back in Paris, I met with Joelle at my hotel. She brought a girl-friend with her and we drank champagne. I decided to miss my plane and go to her place. She left to drop off her friend and come back. I sat there, bathed in forbidden desire. The limo showed up to take me to the airport. Suddenly I woke up to reality. "I can't do this!"

I left a note for Joelle. When I gave it to the concierge, his eyes widened. He said, incredulously, "You know Joelle?"

I ran. The note said, "Je regrette."

CHAPTER SEVENTY-ONE

THE BROTHERS TAKE THEIR SHOW ON THE ROAD

Brother Bobby and Jim Keach came to me with an idea for a movie about the Jesse James Gang, which would star the Keaches, the Quaids, and the Carradines. I thought it was a pipe dream. They told me that Stacy had said yes, so I signed on. I later on found out they had played the same game with Stacy. Enterprising young lads.

We contacted Walter Hill as director and Tim Zinneman as producer. They went to United Artists. UA thought it was a good idea, but doubted they could get us all together. Jim said, "When? Name the time for a demonstration."

We all came together at Stacy's house in Malibu: UA, Walter, Tim, Randy, Dennis, Keith, Bobby and I, and Jeff and Beau Bridges. We partied and played music and pretty much got the thing going that night. It was still a pipe dream, but the team for *The Long Riders* was assembled.

I needed a new editor to help me finish up *Americana*, the movie about the merry-go-round. I called up a film school and put an ad on their bulletin board, something like: WANTED. FILM EDITOR FOR LONG TERM EMPLOYMENT AT LOW PAY ON ART MOVIES. CONTACT DAVID CARRADINE. The guy who took

469

the ad over the phone said he thought he knew exactly the right guy for the job: Dave Kern. It turned out he was Dave himself.

Dave came to the house and I interviewed him. He had been an art teacher in Iowa when he realized that movies were the art of this century. He moved to Hollywood and started studying. He had made two student movies. Perfect.

I showed him the editing room and turned him loose on the film. For a month he looked at all the footage and I left him alone. He was crazy about the movie. Kansas looked just like Iowa to him. I'd show up every day and answer whatever questions he had. Finally I said, go ahead and start cutting.

The idea was to take about twenty minutes out of the film. I thought I couldn't do it; I loved it all too much. He turned out to love it all more than I did. He actually added twenty minutes, so I took over the ruthless chopping-out of great stuff, and he took the job of saying, "No. No!" The system worked beautifully.

I had moved the negative out of the secret vault to the MGM lab. Skip had tried to pull another fast one. He went to MGM to grab the negative. I had anticipated that possibility. Roger Meyer, who ran the studio, refused him.

Skip said, "I have an irrevocable letter of access."

Roger said, "We're revoking it."

Skip said, "I'll sue you."

Roger said, "Second door on the left."

In a strange moment of serendipity, Bobby and I were offered Jesse and Frank James in a Menahem Golan movie. The script was much more ordinary and the movie would surely shoot down the other one, but I had to see what Bobby wanted to do. He was ready for it, his reasoning being that he would like playing Jesse James a hell of a lot more than Bob Younger. We almost committed to it. After all, it was a firm offer, not a pipe dream.

While we were thinking about it, Jim Keach had a near death experience. He was scuba diving and lost it. As he was drowning, all he could think of was, "How could the Carradines do this to me?" Bobby and I decided to skip the cheap Menahem version, and Jim was saved from a watery grave. I got back to more serious stuff when CBS offered me a miniseries based on the life of Paul Gauguin:

Gauguin, the Savage. It had been offered to Anthony Hopkins, who said he didn't want to play a drunk. Apparently, he'd rather play serial killers. The role was a definite plum. The schedule was two weeks in London, one week in the south of France, six weeks in Paris, two weeks at Warner Bros., and six weeks in Tahiti. The director was Fielder Cook. He was a wonderful old fellow who gave me my head. I played Gauguin to the hilt.

While we were in London, I met with Walter Hill at the American Bar in the Savoy Hotel. He wanted to know if I really wanted to do the brothers western, which was now called *The Long Riders*. I wanted to know if he really wanted to. Both of us were depending on the other's answer to go on with the idea. I was the keystone actor, being the most financeable of the brothers. We shook hands and it was no longer a pipe dream. The deal was on.

My marriage to Linda was falling apart. As much as I had tried to help her through her personal problems, they had begun bogging down our marriage. I was considering divorce. In London, Fielder Cook showed us a film he had made about divorce. I cried through the end of it and had to bolt out the side door when the lights went up. I walked around London, unable to stop crying. I stopped in a record store and, through the tears, bought a Bob Dylan tape. Over the loud speaker they were playing the Eagles' "Take it to the Limit," and I knew what I had to do "one more time."

When we got to Paris, I looked up Joelle. We had an outing with her father. He was attached to UNESCO and spoke five languages. A very interesting man. The three of us sat at sidewalk restaurants and I took them to the Musée Rodin. The old man and I talked philosophy all the way.

I had developed a passion for tattoos. I started out with one by Cliff Raven on the Sunset Strip. While I was in Paris, I thought I should do some more. People always asked, "Where did you get that tattoo?" I thought it would be cool to say "Paris." I went to Bruno in the Place Pigalle, the only tattoo artist in Paris. He didn't do a great job. I had scar tissue almost a quarter of an inch deep. Over the years I've submitted to the needles many more times, but never again in Paris.

I sent for Linda and Kansas. I threw in Calista for good measure.

We had some wonderful times there and spent a lot of money drinking fine wine, eating fine food, and going places. Joelle visited the set and she, Linda, and I went out afterward. Linda and Joelle got along famously.

One of the most memorable junkets of the shoot happened by accident. At the Hotel George V, if you want to have a babysitter, you have to arrange it days in advance. We set one up for Saturday night and then promptly forgot about it. Saturday, the babysitter showed up. We quickly improvised and asked her if she knew of a good restaurant. It turned out she had a degree in restaurant management. She noted that we were drinking a bottle of Château Mouton-Rothschild and sent us to a three star restaurant that was famous for its wine list.

Calista had developed a penchant for getting drunk and taking her clothes off. She would be listening to Mozart and would start dancing. She'd kick her shoes off and shed her jacket. Before she knew it, she would have most of her clothes off. I never witnessed any of these exhibitions, just heard about them. I didn't judge her for it. I actually admired (grudgingly) her daring. I'm an exhibitionist myself, though I prefer to get paid for it. My objection was to how crudely I imagined her audience judged her, and what they were thinking while they watched this free-spirited, unashamed nymph. The Mata Hari parallels are endless. Casting her pearls before swine. I called the concierge and asked him to get us tickets for The Crazy Horse.

In the restaurant, we were seated at what was actually a table for two—very intimate. I ordered a 1961 Lynch-Bage for starters, a rack of lamb with a 1929 Château Haut-Brion, and a split of Barsac for dessert. The '29 was so high-priced, Linda had to go back to the hotel and get a wad of money out of the vault.

A note here about the drinking of fine wines: the price of the stuff is not the point. The value is in the taste experience. The little drops of fermented grape juice contain the essence of the place and the time and the care that went into its preparation and preservation. I once drank a '43 Lynch-Bage in Brussels. I could taste the summer of '43, the Germans marching overhead as the wine lay where it had been hidden from them. The sacrifices of the French Resistance were there in the finish. The tannin was so thick, one could only drink a little more than half the bottle. The '29 was the last crop before the

stock market crash. In it were the dreams and excesses of the twenties, distilled by the years into a fine elixir with a cutting edge that was so finished, it wasn't really wine anymore. Take it or leave it. If you can afford it, you drink it. Slowly.

After dinner, we rushed off to The Crazy Horse and I ordered a bottle of Dom Perignon. Then we sat and watched the classiest, most artistic, entertaining, tastefully erotic girlie show in the Western World. The Crazy Horse is an institution in Paris. The choreography, the girls, the costumes, the music, the themes are all a cut above any other such effort on the planet that I know about.

I looked at Calista and said, "If you want to get drunk and take your clothes off, this is how it's done."

Before we left Paris, I took Linda to one of my favorite places, Le Musée Rodin. We stood beside the "Burghers of Calais," a group of six men in chains about nine feet tall, and Linda put her hand in one of theirs, like a little girl with her father. I told her all the stories I knew about the sculptures and the sculptor. At one point, a man said to Linda, "You're the best piece of art in this place." I totally agreed. The difference between stone and flesh.

During the five-day break after Paris, before we would start up in L.A., we went to Holland and shot some Mata Hari. Hugh MacDowell showed up to play his cello for us. Nicolai Van der Hyde played a part, too. Bruce screwed us up a little by leaving early to catch a plane, but we got some really good stuff in the can. I put Linda in front of the camera. She was great. I also put in big brother Bruce and Calista's mother in the show. I thought having Donna there would help Calista's rational side come together, and it did for the moment. But as soon as the shoot was over, Calista had her fling again. I had more problems extricating her this time.

In L.A., I impersonated Gauguin again. We shot the inside of crazy Van Gogh's little house and re-did a scene from the Paris shoot which hadn't worked because I'd been drunk. This time, it went off without a hitch and we were on to Tahiti. We left Kansas with a governess. We were going to take Calista with us, but she had disappeared. We left instructions with the governess to send her along when she showed up.

Tahiti was paradise, just like it's supposed to be. After a few days

in the hotel I decided to go native, so I moved into an elegant traditional Tahitian abode, with no walls on the ocean side and outdoor facilities. It was owned by an heiress who had spent all her money trying to stop the French from conducting nuclear tests in the area. Linda and I were ecstatically happy. We didn't even mind the bugs, some of which were four inches long, seven if you counted the antennae. The Tahitians called them "beasties." They were everywhere. Every night or so, there was a big one that would buzz down to the bed in the dark and land on my face. Linda dubbed it "The Fan."

Many of the women in Tahiti are six feet tall and wear nothing but a towel, which they don't even tie with a knot. They just tuck it in. I plucked one loose and it fell, revealing all her exotic beauty. She just giggled and put it back on. The men are huge, strong and athletic, but not the least bit jealous. Even the roosters get along with each other. Free love abounds. I took no advantage of this fact, though I could have had any girl I wanted, since I was playing Tahiti's national hero. I was immune. I couldn't see past my gloriously wonderful Linda.

When we got back to L.A., I looked at our beautiful house with all the flowers and the crashing surf. It looked drab next to Tahiti, but there was Kansas, and there were still the horses and the dogs. And there was the editing room.

I went to a vintners and bought a bottle of every 1976 bordeaux that I could find. Dave and I would edit all day and, at around 5 o'clock, we'd open a bottle, decant it, read the wine book, look at the map of the region, and taste the vintage. We had a good time and learned a lot about wine.

When I was stuck, I'd step out to the porch and watch children playing on the beach, beautiful women, surf crashing. Then I'd go back into my dark street of dreams and get lost in Drury, Kansas.

It turned out Calista had taken up with a scrofulous little unreconstituted hippie who had learned Charles Manson's techniques of brainwashing. I couldn't shake her loose. I told her he was a Mansonite. She thought I was talking about some rock and roll group. My lawyers told me that prosecuting him for statutory rape just wouldn't work. I decided to wait for the time to be right and then beat the crap out of him, or kill him.

Meanwhile, I had lost Calista.

Just about that time, Warren Beatty asked me to play Eugene O'Neill in his picture *Reds*. I had to turn it down as it conflicted with *The Long Riders*. He gave the part to Jack Nicholson. That's one of the things that's very frustrating about being an actor. You're continually being offered two great parts at the same time. You have to make a choice.

Calista's evil boyfriend tried to sue me for a half million dollars. I just ignored him. Then he tried to sell his story to *The National Enquirer*. They called me up to check it out. I told them there was no truth to it whatsoever. I wasn't covering myself, I was protecting Calista. They didn't print it.

We managed to make it to the Cannes festival again for *Cloud Dancer*. We had a great time. I saw Liv Ullmann, and met Tennessee Williams and Cary Grant. They were all on the jury. There was no *Mata Hari* that time because there was no Calista.

We had lost the Bridges brothers from *The Long Riders*. Jeff didn't want to be the guy who shot Jesse James. We went with Christopher and Nicholas Guest.

To tune up the brothers we were all assembled at a ranch run by the man who was going to wrangle the horses. They put each of us on a horse and we rode around a corral. It was really boring. I didn't understand the point since I had three horses of my own. I was used to cross-country bareback (I didn't even *own* a saddle), helter skelter over mountains and ravines, on the beach, etc. Squaw had become so strong that the only way to give her a real workout was to gallop her through the deep sand or straight up the mountain.

I used to take her into the ocean and surf with her. We'd swim out and I'd slip off and take a wave with her. She'd land on her feet every time. These horses they put us on were just weak tea. It was also an hour's drive to the place, which really cut into my day.

I informed the guys I would just as soon stay home and ride my own three babies. Keith said, "But Dave, we don't want to look bad in the picture."

I looked at him and said, "I don't think I'm going to look bad, Keith."

When it came down to the final negotiations, they were trying

to hold me up for money. I finally caved in, but I said I wanted to ride my own horse, Zebar. The negotiator asked me what kind of horse it was. What did he know, for Christ's sake? I said, "What do you care? It's a brown horse."

He said, "Okay."

I said, "You've got to pay him."

He said, worried, "How much?

"Hundred dollars a day. That's what he gets."

Zebar turned out to be the best horse in the movie. As a result of his talent, I became the only actor who got to make his own transfer from a horse to a train. The other horses were good, but Zebar was virtually flawless in his performance.

I went to the airport to begin my journey and met someone who was very close to the sexiest female I have ever personally encountered. Savanna Smith was dressed in hot pants, cowboy boots, and knee-length socks (a shirt, of course). She smiled and laughed and exuded pheromones all over the place. I would have jumped her right there in the airport if I had been brave or depraved enough to violate my vows. Ah, well.

Our first location was Clayton County, Georgia, the same place *Deliverance* had been made. Since my part was really rather small as written (I had to share the picture with all the brothers), I wondered what I was supposed to do with my time. Keith was a sad sack right then, having just broken up with Christina Rains after nine years. I decided my job was to make Keith laugh. That's what I did. On the side, I made everybody else laugh, and my part got better.

That picture was more fun than I can even describe. All we did was ride horses, shoot off guns, hang out with the brothers, and drink moonshine. In between, we made a great movie and had a lot of laughs.

The head wrangler was a tall, blond, absolute gentleman, name of Jim Maderas. He saved my life once. Well, maybe he did. Bobby didn't believe Zebar would have dragged me but, anyway, Jim was there and we'll never know. He also saved a horse. The critter was drowning in a wild river. When he came up for the third time, Jim lassoed him from about thirty feet and pulled him out. I'd put my life in Jim's hands any day.

One time, we were riding at full gallop down a stone road when my cinch strap broke. I went off, with the saddle still between my legs and, knowing the whole gang was galloping behind me, rolled off the road. Bobby was right behind me. He brought his horse up, turning him sideways, effectively blocking the rest of the cavalcade. He looked down at me and said, "Did you really think I'd let them run over you, Dave?"

After a few weeks, Linda came to join me with Kansas. I sent one of the transportation guys to pick them up. While I was waiting eagerly for their arrival, I was informed that the driver had not been able to find her in the airport and had returned without her. I was hopping mad. How could he miss a beautiful woman with a mass of dark hair carrying a baby? I called L.A. and, yes, she had caught the plane. I was absolutely beside myself. The airport was three hours away and this was the deep South. Then she showed up on her own. She had walked down the row of taxis until she found a woman cabby.

The reunion was pretty great. I decided not to fire the driver. I mean, what the hell, so he was stupid. Even dummies need their jobs.

After Georgia, we went to Texas and then to the Warner Bros.' lot. Something happened there that would change my life forever, though I wouldn't know that for a year or so.

Keith worked opposite a girl who was a natural platinum blonde. He noticed that Buffalo liked her, to the extent that he would follow her around all day. When she went to the ladies' room, he would wait for her. When she would go to her dressing room trailer, he would sit outside her door.

Keith said, "What is it with you and that dog?"

She said, "Animals like me."

Keith said, "Not that dog; he doesn't like anybody."

The story I got later was that this girl had lived, for about nine years, with David Somerville, the lead singer of The Diamonds. When she got this part, he asked her which of the Carradines she was going to take up with.

She said, "What?"

He said, "Well, they are the princes of Hollywood."

Keith took her around and introduced her to everyone he

477

knew. Keith is a very social being; he knows everybody, and everybody likes him.

Keith came to me (I was busy having a knife fight with James Remar in the Texas saloon set). He told me I should meet this girl. After all, Buffalo didn't even like me that much. He was his own man. He didn't love me; he was merely bonded to me. If you tried to pet him, he would bend out of the way like a cat. He figured you were some kind of pervert. He wouldn't take food from a stranger, no matter how hungry he was.

I met the girl and offered to smoke a joint with her. I added that it was red-haired sensemilla that had been provided by my wife, just so she wouldn't get the wrong idea. She said she didn't do pot but she would keep me company while I smoked it. We went behind the trailer and I toked away. I have no memory of our conversation.

Ever, Bobby's five-year-old daughter, was equally impressed by Buffalo's fascination with this girl. Ever asked her if she wanted to see the paint shop, and they bonded. Buffalo stuck with them. Gail—that was her name—became romantically involved with Bobby. Keith was a little stiff for her, but he didn't have a daughter she had bonded with. I didn't actually know anything about all this until much later.

We finished the shoot in the hills outside of Stockton, California, for the train robbery. It was the same train we had used in *Bound for Glory*.

All the time we were making *The Long Riders*, UA was dumping an unprecedented amount of filthy lucre into *Heaven's Gate*, which was about to become the greatest fiasco and money loser in the history of movies. We needed their train. Michael Cimino, the director of the debacle, did not want his train to appear on another picture, so he spent about a hundred thousand dollars painting the train red. Tim Zinneman and Walter Hill obtained photographs and repainted the train exactly as it had appeared on *Heaven's Gate*, just for spite. Hollywood is a weird place.

Walter Hill wanted to shoot a special credit sequence that would cost $50,000. UA refused. Walter said something like, "Give me the money or I'm off the picture." They were spending millions of irresponsible dollars on Michael Cimino's excesses. UA acquiesced. We went back to the Stockton hills for two days. It was two months after

we'd wrapped up principal photography. The gang and the horses were way out of shape. We did one take where we all rode by the camera. The field was deep in mud. The horses couldn't handle the turf, and we couldn't handle the horses. We were slopping around, losing a foot or two out of the stirrups and looking like greenhorns from New York. Jim lost his pistol, a rare model. We searched the hill for an hour. It's probably still there, waiting for a future archeologist to ponder over it.

Walter took his cigar out of his mouth and said, "Very impressive, men." In shame and disgust, I turned Zebar out to the field and put him through a few figure eights. He got himself together and so did I. We did better.

Stacy was one of the designated "Executive Producers." Stacy came up to me with some typed pages. I began reading them. It started out pretty well: a new dialogue scene wherein the James and the Youngers first form the gang while hiding in a cave from the feds. After a couple of pages, it started to sort of fall apart. Obviously, he'd spent the whole night coked out and writing. I always thought Stacy didn't need that stuff, not that anyone does, but it was so unlike him. He had such a legitimate talent: Shakespeare and all that.

I flipped to the back and looked at the page number. It said "10." We had never shot more than three pages in one day on this picture. I said, "Stacy, what do you want to do with this?"

He said, "Shoot it."

I said, "Today?"

He said, "Yeah."

I said, "Stacy, we don't have any sound up here."

He stared at me, and mumbled, "Oh . . . , yeah. Right," and wandered away, shaking his head.

We rode like hell that day. The footage as it appears in the picture is memorable, to say the least.

I was called down to Glenn Glenn Sound, maybe the best post-production sound facility in Hollywood, to do the looping: replacing the dialogue that was unusable, usually because of background noise or glitches in the equipment. Walter was there. We took a break and stood in the open doorway, taking in the southern California sun. Walter never looked at you when he talked. He'd puff on his cigar and

then take it out of his mouth and talk to it. Then he'd look at you for the answer.

He said, "I'd sure like to work with you again."

I said, "Walter, I can't tell you how strongly I feel about that."

He looked at his cigar and said, "Well, it's bound to happen sometime."

Within a few days, Walter started talking to me about a movie he'd been writing and developing for a couple of years or so. He had a deal for it at UA. It was called *The Last Good Kiss*. The part was mine. Everybody in Hollywood knew it. My costar was John Huston. The guys at UA turned Walter down. They said he had to get someone else. I wasn't a big enough name to carry the picture. Walter's agent replied, "If you want to be in the Walter Hill business, don't tell him who he can hire." Sounds like bravado, but Walter just canceled the picture. He'd been developing it for years, but he was an honorable man. That's all there was to it.

Linda got an invitation from some rock and roll friends to be their guests at the Telluride Film Festival. These people were obscenely rich. We were flown up in a privately owned 707. The affair was tacky, but fun for a day or so. Then the drugs started. I did a lot of reading. At one point I went up the mountain to score some peyote, which was more my speed. The contacts were a bunch of hermits, who all looked like grizzly bears, living in a cabin on top of the mountain at the edge of the sky. They were a dangerous bunch, all armed, but we got along.

On the way back home the plane stopped in Las Vegas, ostensibly for fuel. We didn't de-plane. We sat out on the tarmac. While we were there, I watched a couple of briefcases containing backgammon boards exchanged with other identical briefcases brought in by the refueling crew. You didn't have to be James Bond to figure out what was going on.

Later on, one of the richest of the gang was murdered. The FBI came to the house to ask me what I knew. I told them I didn't know much more than I had guessed, and had told my wife if she continued seeing those people I would throw her out—which was more or less accurate.

Cocaine was a large part of the life in Malibu. One evening at a party in my house, I noticed that I was all alone in the living room. I went to the bathroom. From behind the door, giggles abounded. That was where the party was. After the bathroom emptied out, I went in, spread some baby powder on the counter, and separated it into several large, neat lines. Later on, there were a lot of sneezes.

The society I was living amidst in Malibu, and the people I was rubbing elbows with, were an interesting bunch. Stacy Keach lived up the beach on a hill. His brother Jim was further up and way back in a low canyon on a huge cattle ranch. Gary Busey had a place out in Trancas. We used to jam once in a while. Jan Michael Vincent drove a high-rise black pickup truck and dressed like a cowboy.

Then there was Malibu Colony, a rich ghetto that had a guarded gate. Once you got in, if you turned up the beach, it was all movie people: actors, retired stars, directors. The smell of burning pot was almost overwhelming from the middle of the street. If you turned down the beach, it was all rock and roll. The air was thick with cocaine.

There were the icons of rock and roll, most of whom Linda knew from her Byrds days. I hung out with some of the Beach Boys, and with Robby Robertson and Rick Danko of the Band; I went over to Rick's basement music room to hang out once. There was a big stain in the concrete floor. I asked him what it was. He said, "Oh, somebody committed suicide there a couple of days ago." Okay. I didn't press for further details.

I hung out with Mick Jagger a little. Mostly we watched horror movies on TV, starring Vincent Price, Peter Lorre, and maybe my father. Mick seemed sort of afraid of me. He didn't talk much. I think he made a pass at Linda once. No big thing. Mick is Mick. When I got bored with my silent TV partner, I went and jammed with Ron Wood. I played my acoustic and sang and he plugged in and played quiet, sensitive leads. He's a much finer musician than the public has ever seen.

I spent some time with Bob Dylan, a hero to me. He had built a big mansion on Point Dume that looked like a copper onion. I got him and his kids to study kung fu with me. Bob was a natural. We

would talk while he noodled on his guitar; he played great too. Then he'd suddenly get up and go to his old upright and start writing a song.

His wife, Sarah, would hold court in her bedroom suite. She became Kansas' Godmother. Bob usually slept downstairs on the couch, curled up in a fetal position with a jug of red wine on the floor beside him.

Then there were the Eagles. We called them "the Beagles" because we thought of them as the American Beatles. The complex chord structures and lyrics, the perfect close harmony, the American country feel. Glen Frey told me he had written the song, "Desperado" about me. I replied that he probably told that to every movie star he met. Years later, the Eagles' manager, without prompting, told me the same thing, so maybe it's true.

There were some regular people too; even some who didn't have a lot of money. The strange thing about Malibu was that everybody looked so healthy and wholesome. The truth was that the per capita consumption of drugs and other single person crimes and sex was higher than the ghettos in the inner city. Just classier. Myself included, though I was very particular.

I was faithful to Linda and was so busy that I didn't really have space to play with drugs much. Alcohol, yes. I loved my tequila and my fine wines.

My business managers told me I had to stop spending all this money on rent—$50,000 a year. That's how high I was rolling. They convinced me I had to buy a house. I didn't think this was a really good idea. I'd just finished reading a prophetic book about the coming great real estate crash of 1978, but I went for it. I took their advice. After all, what the hell did I know?

I said, "Okay, I'll buy this house that I'm living in." I checked into it. The price was $2.8 million. I wasn't that much of a high roller. I bought a house on two acres just down the road from Stacy Keach. I dreamed about having my horses with me there. That never happened.

A little later, just before Thanksgiving, Calista showed up at the new house. She had left the "monster," finally having figured out his depravity, and she was pregnant, though not by him. I welcomed her

with open arms. There were a lot of hugs and tears. I put her in the back bedroom.

The next morning, the "monster" showed up bearing gifts. I greeted him in the driveway, and beat him up with a claw hammer. I was very careful not to really hurt him, which I would not have been if I had used my bare hands. He left in a hurry. He tried to make a complaint to the Malibu Police, but he couldn't prove any damage. There were no cuts or bruises, though I'm sure his knees and elbows bothered him for months, perhaps years. Calista was mine again.

Calista decided to get out of town to escape the little creep's influence. She spent her gestation in upstate New York, where she had lived as a child. An abortion was never considered.

ONE MORE GOOD KISS

I got a phone call from an executive at United Artists. She told me that my performance in *The Long Riders* had fascinated her. She wanted to get to know me. She asked me what I did with my time.

I stood there in my little editing room and stared out at the Pacific Ocean. "Well, actually I spend my time making movies of my own."

She asked if she could see one of them.

I said, "Sure." I showed her *Around,* the merry-go-round picture, which was almost finished by then. She became my greatest supporter. When *The Last Good Kiss* fell apart, knowing I was seriously short of money (I always was), she put me in another UA movie, shooting in Africa. South Africa, actually, the Union of. I had very definite attitudes about their apartheid program and had always turned down offers to go there. I decided it was time I checked the place out personally, so I accepted the role.

She and I became the best of friends. We hung around together a lot. She had a real interest in my work. We had some similar pages in our books. Her beginnings could not have been more different from mine. She had been an actual debutante. At her coming out party, a hundred cases of Château Haut Brion '61 were consumed, a hefty percentage of the world's supply.

I needed money to shoot some more *Mata Hari*. She gave me $5,000.

One day she asked me if it would ruin our friendship if we made love. I told her I didn't know. She said she didn't want to if that would happen. Eventually, we did try it. It was not successful. Calista told me it didn't count as adultery. She said if neither of us got off, it never happened. Our friendship did fade, though. I still think of her and miss her good vibes. I'm sure she feels the same.

I took Dave Kern and Johnny Barrymore up to Rochester, near where Calista was hiding, and shot a very pregnant Mata Hari for two days with a Panavision camera and a stereo Nagra. We got everything else free by giving a job to a student at the Eastman Film School and using his student i.d. to borrow everything we needed.

There was a character in Mata Hari's life: a childhood sweetheart. Who better to play that role but little Johnny Barrymore, Calista's childhood sweetheart and, incidentally, later on, the possible father of Calista's second child, Sienna. This is not known for sure either way, but Sienna is a dead ringer for Johnny's little sister, Drew. There's a night Calista doesn't remember and Johnny was so stoned during those years that he probably had no clear recollection of anything.

Johnny needed to be changed into a shirt befitting the period (1900). He wanted to do so privately. I said, "Johnny, are you kidding? I've known you for seven years. You don't have to be shy with me."

I took his shirt off. There they were. Tracks on his arms. He was ashamed, mortified. I asked him, "How long have you been doing this?" He almost cried. So did I.

We went on. Johnny worked like a trooper. Halfway through the shoot, the camera went on the blink. It took good pictures, but they were out of sync with the sound. This turned out to be a stroke of good fortune. Panavision agreed to give us a new camera for a day or so for free.

I needed to shoot the last pickup shots of *Around,* so we ran right back to L.A. and shot with our new camera. My executive friend from United Artists commandeered the fire station on the Fox lot for a set. We did this with no permission from anyone. It was a total underground operation. We did the shoot on Memorial Day. We borrowed our lights from the "Love Boat" set.

Fran Ryan from *The Long Riders* came in for a cameo as a battle ax army colonel with a heart of gold. My UA executive friend played a lieutenant.

Then we did a day on the backlot of MGM; again we had no permission. We kept the camera in Dave Kern's VW van, pointing it out the door. We got caught anyway. We were in the middle of a shot when we saw two studio cops walking toward us. I whispered to Dave, "Keep rolling."

The head cop, who was about the size of a Kodiak bear, said to me, "Hello, Dave. You really should have asked someone before you did this. Did you get your shot?"

I said, "Well, yeah, you're in it."

"No, no," he said. "We don't want that. Go ahead and finish up, but you really should have asked someone." And off he went.

Just before I was to leave for Africa, *Playboy* sent someone out to interview me. I figured I'd give him the whole shot. I put him in the Ferrari and zoomed him out to Malibu, scaring the hell out of him. I kept him with me for two weeks. I offered him some wine. He said he didn't drink. I offered him some grass, but he turned that down too. Then he proceeded to drink up all my wine, smoke all my pot, and bum all my cigarettes. So one Sunday morning I went down the block to Paradise Cove to get a pack and, while I was waiting for the traffic to clear, got rammed in the side of the Ferrari's door by a woman in a Hillman Minx. The door buckled in and separated my ribs for me.

I remember looking left just after the impact and thinking that the window had been up. Then I realized there was no window. I tried to park the car out of the way, and then reasoned foolishly that I was only a block from home and the car ran. The woman in the Minx seemed all right. I turned the car into the tunnel. Someone yelled, "Do you need a witness? I saw it all."

I waved at him and kept driving.

I limped out of my ruined 330GTS and made it into the house and collapsed on the couch. Linda jumped in the Mercedes and drove down to the scene to represent me. Michel Mangois stood at the door, staring in amazement at the wreckage. He asked me if I needed a doctor.

The cops showed up. I didn't want to deal with them, so I slipped out the back, Jack, and climbed up the hill to my neighbor's back yard. He greeted me with a 12 gauge shotgun. After I told him my problem, he dressed me in a blanket and a straw hat. I looked like an old Indian. He put me in his pickup truck and we drove right straight through the cop cars at the accident site.

He took me up to Keith's house and I hid out there, healing up, until the heat was off. I felt like Jesse James.

When things quieted down, I went to the Hollywood Hills for one last visit with the interviewer. He was hanging out at a home-away-from-home Playboy house. They were all doing a lot of coke. I had wondered what the interviewer had been doing when he regularly left the house. Now I knew.

The article, when it came out, was a complete black-wash of me. Most of it was untrue. All of it was distorted. As an example, he wrote that I was always barefoot. I was never barefoot. At that period, I wore Gucci loafers with no socks. I think that's more interesting, but he had to write what he was expecting. The car wreck gave him a lot of extra ammunition. Well, that's the way it goes sometimes.

⇒ ⇐

I WAS WORKING frantically to finish *Around*. I took up residence at MGM and followed Bill McCaughy to Ryder Sound for the mix. Dave cut the negative himself. No one else could have done it.

The optical house that was doing the credits, Howard Anderson, sent me a little book of type styles. I settled on one that was called "Americana." I was trying to figure out what it would look like if it said "Around." Suddenly, I said to myself, "Why am I doing this, anyway? It's right here in front of me."

I called up the title designer and told him I was changing the title to *Americana*. I heard voices in the background, yelling, "Yeah!"

It was clear I was on to something.

As Gauguin in GAUGUIN, THE SAVAGE. Photo by Ron Thal.

In THE SILENT FLUTE. Photo by Stan Unger.

CIRCLE OF IRON, THE SILENT FLUTE.

Above: Left to right: Robert, David, and Keith Carradine are the gunfighting Younger brothers, Bob, Cole, and Jim in THE LONG RIDERS. *Photo by Ron Thal reprinted courtesy of United Artists.*

Right: Israel in the Rain. With Stockard Channing in SAFARI 3000. *Photo reprinted courtesy of United Artists.*

CHAPTER SEVENTY-THREE

DARKEST AFRICA

S omebody who saw the wrecked Ferrari at the body shop offered a lot of money for the car, as is. Twice what I paid for it. I went for it. What the hell! He wanted it. He could go through the agony of restoration. I was on my way to Africa anyway.

I left for South Africa alone; Linda and Kansas were to show up later. I swung by Rochester, New York, and made it up to Geneseo to see Calista and the baby. We sat in the yard of the Kelly family—childhood friends of Calista—who were now watching over her. The house was unbelievably messy but the people were nice. I watched her nurse Mariah. It all seemed so pitiful; my little daughter a teenage mother. I steeled myself, kissed them good-bye, and went on with my journey.

In New York I hooked up with Christopher Lee, who was doing the film with me, and we flew on together over darkest Africa. I couldn't help but notice his leather blazer. I asked him what kind of skin it was. He said, "Elephant."

I asked him how old it was. (The jacket, not the elephant.)

He said, "Thirty years." I suppose that was all right back then.

As we were gaining altitude after a stop in Nairobi, Christopher had me look out the window. He said, "You can't see very well through the clouds, but right—THERE—was where I shot my first elephant!"

490

Johannesburg was pretty much what I had expected: prejudice, huge disparity between the rich whites and the poor blacks, nuclear reactors here and there, hypocritical Calvinist bible thumpers, clean streets, dirty ghettos. But some of it was quite beautiful.

We started working on the movie, *Safari 3000*. The director, Harry Hurwitz, had done a picture called *The Projectionist*, a take off, or homage to, the Buster Keaton movie. He was okay, though he was over his head trying to make a four million dollar movie. He did the best he could.

The first scene was at a race track. I was doing 360s in a Peugot with Stockard Channing in the passenger seat. She was absolutely terrified. The scene is hilarious in the film. I continued to scare her with my driving all the way through the picture.

Very shortly after we started shooting, the Screen Actors' Guild staged a strike in Hollywood. Halfway around the world, I wasn't allowed to work. The producer wanted to shut down the picture and send us home. I said I'd stick it out. Life was boring: living in a hotel and having nothing to do. I was bound to get in trouble. All my overseas calls were being monitored, and my room was being searched periodically. I read *The Lord of the Rings* again, and three of the *Dune* books. I saw *Star Wars* eight times.

During this period, I had the dream date of the century. Tina Turner was playing in town; there were no seats, but I got in and watched the show standing in the back, behind the sound mixer. We got friendly and he asked me if I'd like to meet Tina. I said, "Sure!" Tina was very cordial and I asked her if she'd like to go out for a drink somewhere. We went over to a place I knew near the hotel and they put us at a table in the back and just ignored us. We were chatting away happily, though thirstily, when it occurred to me they were not going to serve us.

We went to a couple of other places and were refused. We were a mixed couple, a no no. I thought it was strange. I'd just watched 10,000 people stand on their feet, screaming and cheering for Tina Turner, and now she couldn't even get a drink. At one point, I got fed up and bounced a security guard off a wall. I found out later he was an off-duty cop. A doorman handed me a piece of paper and said, "Go there." We did.

The door opened to the nicest place we'd been that night. We were ushered in past well-dressed, genteel people. The kitchen was re-opened for us. A piano tinkled in the background. Tina became so comfortable, she sang for us. I took her to her hotel and chastely bid her goodnight. I walked away with my head spinning. I had definitely been in the presence of royalty.

Two days later, I was arrested for "Bestiality."

I said, "What's that?"

"Hugging a black woman." I hadn't even gotten a kiss.

I was getting a first hand look at the madness of apartheid.

There was more to come. I went to a barbecue party with the film crew. It was held in the inner courtyard of an apartment complex where most of the crew lived. We were all languishing around the bonfire when the guy next to me, who looked exactly like James Dean, lit up an enormous joint. He offered it to me. Something didn't seem right. I demurred. He passed it the other way. Suddenly, from over the wall and out of the bushes, came, at a dead run, six cops and a large Alsatian dog. They held us at bay while they searched us all and everybody's apartment. All together, according to the report, they came up with 104 grams of marijuana, some of it mine.

We were all taken down—twelve of us. The thirteenth had escaped. One thing you don't want to do is spend three days in a South African jail. There were virtually no facilities, very little food, and no protection from the elements. The girls were incarcerated in another part of the facility with the hookers. Their accommodations were no better, and they were scared as hell.

The police chief came into the compound dressed, believe it or not, in jodhpurs and riding boots, and tried to scare us while slapping a riding quirt against his leg, talking in an Afrikaans accent that sounded for all the world like movie Nazi. He told me that if I thought I vas famous now, I vould be much more famous after dis. I refrained from responding that this was nothing new to me. We were being held more or less incommunicado, but our thirteenth man, the escapee, got the word through. The producers arranged for the attorney general to get us released, which pissed off the chief no end.

But now we had to stand trial.

They staged a hearing. We all stood in a line in front of a mag-

istrate. He declared ten of us innocent. The guy with the joint who looked like James Dean was given a five-year moratorium before sentencing. He was obviously under their thumbs. According to South African law, that left me in possession of all the grass. The movie company made an arrangement with the attorney general that the trial would be delayed until after the movie was finished, in case I were deported or something.

United Artists made a deal with some English lawyers to put the movie under the banner of a British company. That ended the strike for us. I was allowed to go back to work; I plunged in with a fervor and continued with my apartheid baiting. The producer's wife made some disparaging remarks about the mental inadequacies of the black drivers, one of whom was a crown prince in Zimbabwe and spoke six languages. I told her to shut her mouth but she wouldn't, so I gave her a shove. She landed on her butt, her dignity anything but intact.

My stunt double, Christian Alan Oberholzer, and I cornered the police fink that looked like James Dean and roughed him up. It must have been strange for him to be chased across an airport by two guys dressed in identical cowboy hats, leather jackets, Levi's, and boots; like a weird guerrilla army of twins. He disappeared from the unit. Dumb idea, I suppose. There would be another one and now we wouldn't know who he was. However, there were no further incidents and it made us feel great. We flew to Rhodesia to shoot some wilderness footage. Just before we took off, we were told that if we left the "Rhodesia" signs on our equipment, it would probably be thrown out the window. It was Zimbabwe now. The country was a wonderful place, like Tahiti without the ocean. Everywhere were happy faces in fatigues carrying automatic weapons. Happy. Well, they had won the fight. This was before the various factions were to begin to slaughter each other.

We were trucked, bussed, and chauffeured into the jungle, carefully avoiding the land mines, and hosteled in a hotel-sized hunting and animal watching lodge. The area was bursting with animal life since, for the duration of the revolution, the poachers had stayed away.

We sat on the porch at dusk and watched them at the watering hole, which was separated from us by a dry moat lest the pachyderms decide to take an elephant walk through the lodge. First, the antelopes

and other herbivores timidly came out of the woods, carefully look-
ing around for lions and such. Then, some of them raised their heads
alertly, and a few scampered away. We looked at the woods and saw
nothing. Then, out of the gloom appeared the elephants. The rest of
the creatures now vacated the pond. The elephants frolicked, washed,
and drank under the watchful eyes of the gray guard. At a signal from
the lead bull, they faded into the woods again. We were told to make
sure our windows were locked. All night long we heard crashings and
bangings, animal screams, and roars.

All the time we were there I taunted the producer's wife with
pleas to kiss and make up. I began sincerely, but after a couple of rejec-
tions, it became a sport; her reaction was so predictable.

We devoted our days to recklessly driving the Peugot through
the jungle more or less on, but often as not off, the unmaintained dirt
roads with a couple of Panavision cameras strapped to it, while two
Land Rovers herded rhinoceri and giraffes toward the car. There was
one memorable race with a very tall and large giraffe at about forty
miles per; about the limit for the Peugot in this terrain, but not for
the giraffe. He was just cruising.

One day, at twilight, we came across the elephant herd—about
two hundred of them. We placed the car in front of them and I backed
up to get a shot from the hood-mounted camera that would look as
though I had driven through the herd. The bull who was guarding the
road extended his ears and trumpeted, a bad sign. I got out of there
fast. As a parting gesture, he ripped off the spoiler with his tusks. It
looked wonderful on film.

We went to a huge compound that was there for less hardy
tourists. There we did a scene about a flat tire. While I'm changing the
tire, Stockard Channing trots behind the rocks to take a tinkle. She
returns at a dead run pursued by a herd of five elephants, that were
marginally domesticated. I thought to myself that it might be easy to
get elephants to chase a comedienne, but how do you stop them?

She comes up to me and is aghast to see that there are eleven
lions behind me which I'm supposed not to notice. There was actu-
ally no way I could not have known. They were making a lot of noise.
The way they obtained these "actors" was by throwing a side of zebra
onto a flat bed truck and driving it slowly through the compound.

When it came back, there were eleven lions ambling along after it. They kept them interested throughout the scene by occasionally throwing baseball-sized pieces of zebra to them, which they would fight over.

Then I discovered they had done a really dumb thing. To try to get a lioness into the car to add to the excitement, they had caught a cub and put it in a cage in the backseat. We stood there scared while the lioness circled the car. I couldn't help but notice that the wives of the owners of the place were on the other side of the fence, while we—Stockard, the crew, and the director's wife and children—were on this side. The only protection we had were big pieces of corrugated tin that the "trainers" beat with sticks while they yelled at the beasts. They didn't want to shoot their lions. They were the bread and butter. All I had was a tire iron.

The hardest part of the scene for me was acting scared. I was actually just mad as hell. I kept saying to myself, "If I get out of this alive, I'm going to strangle this director." When it was over, I yelled at him, "Do you realize the chance you just took?"

He hugged me, grinning from ear to ear, and said, "Yes, and David, we'll never have to do it again. We've done it." Later, I found out that, on their last picture, those particular lions had mauled the camera operator and killed the boom man.

Back in Johannesburg, we plunged into the last half of the picture. The press asked Stockard if she wasn't scared working with the wild animals. She replied, "Not as much as I am of David's driving!"

Finally, Linda and Kansas arrived. I found a hotel with four-poster beds and we attempted an idyllic reunion. The three of us had a good time. Linda learned about my feud with the producer's wife and joined in the fun, playing cat and mouse with her.

When the picture was over, everybody went home. I thought of sending Linda and Kansas along and facing the music alone, but Linda wouldn't hear of it. I had made arrangements to fly to Botswana with a revolutionary in a small plane. There all I would have to do is tell the embassy I was a fugitive from South Africa and they would welcome me with open arms, issue a new passport and ticket, and I'd be on my way home. Brother Bobby was arranging the same plans from the other end.

With Linda beside me I was determined to go through the trial. It was pretty much a travesty of justice. The judge and the prosecutor spoke only Afrikaans. I had to have two lawyers and an interpreter. The trial went on for days. It wasn't going too well. There were contradictions in the cops' stories. Much of the testimony of my witnesses was thrown out the window. The court accepted what would, in an American court, be inadmissible evidence. When I saw the arresting officer lean over behind the bench from the side and whisper into the judge's ear, I knew that we were definitely not in Kansas.

The day the inevitable guilty verdict came down, I held a press conference on the way to the airport. I told the reporters what I thought of South Africa and apartheid and jumped on the plane quickly, before they had a chance to change their minds about letting me go.

SOME ENDINGS AND SOME NEW BEGINNINGS

Calista had made it back to L.A. with her baby and was living in the Glass House again. I went over to see her and, low and behold, she was living with Gene Clarke, the songwriting, drunken Cherokee who had tried to beat her up over a pool game at Linda's party so long ago. He was very kind and loving to her now, and didn't seem to be drinking much anymore. The songs he was writing were just beautiful; some of the best rock and roll around. He was a strikingly handsome man. Who could blame her?

The "monster" showed up again. He fired a .45 round into one of the windows of the Glass House. Calista and Gene caught him in his lair and made him lie on the floor with a .22 rifle pressed to the small of his brain, while they threatened to remove him from the planet if he ever bothered them again. I replaced the window with stained glass. Calista tells me the gun wasn't loaded.

I hired a sort of anti-publicist, Elliot Mintz, who was John Lennon's best friend, according to John. He stayed in touch with the creep on the phone and regularly defused him until someone finally put him in jail.

Marianne Ruuth, then the President of the Hollywood Foreign Press, had taken a liking to me. She invited me to a private birthday party at Ma Maison, one of L.A.'s most exclusive French restaurants.

She said she had a surprise for me. We picked our way between the Jaguars and Astons parked out front and were led to a table for two in the patio. I began to wonder what was going on.

Then, just after our drinks had arrived, John Cassavetes walked in. He kissed Marianne's hand and pulled up a chair. He was my surprise—the acknowledged mentor to the likes of Marty Scorsese. I had been a fan of his for years and Marianne was introducing me as a fellow director. We talked happily about movies and art, having a great time until the waiter leaned over to me and said, "I thought you would want to know that John Lennon has just been shot!"

That sort of put a pall on things for a while. If he died, which seemed likely, it would be the end of an era. His music and his ideas, however bizarre, had touched everyone and I loved the guy. I think he was really trying to reach critical mass. To be summarily cut down by an assassin who had no reason except that he loved him—and on my birthday. What an affront, what a senseless stroke of garbage insanity. We were all going to miss the old walrus.

After some time and a few tears, we got the party going again.

The subject drifted to guerrilla movie-making, something John Cassavetes and I had done a lot of. John said that the first thing you had to do was get free food and everything else would follow. Marianne started up about *Mata Hari*, explaining it was a long-term project with my daughter, shooting a few days every year. John was fascinated. He asked me how much more I had to do. I told him I was one scene away from finishing the first of the trilogy: a birthday party—very simple.

He said, "What's stopping you?"

I said, "I'm broke. I can get almost everything for nothing, but I have to buy a roll of film."

He said, "How much is a roll of film?" (You'd think he'd know.) I said, "About $400."

Without a word, he reached into his pocket and pulled out a large wad of hundred dollar bills. He peeled off five of them and placed them on the table. Almost brought a tear to my eye. I pushed them over to Marianne. "Let her hold the stakes." Saved by John Cassavetes. *Mata Hari*, like Blanche DuBois, has always depended upon the kindness of strangers.

In the series "Kung Fu," Caine walked away at the end of every story and never looked back. I was beginning to glance over my shoulder at the glorious past. I was catching a faint, blinking light at the edge of my vision.

"Kung Fu" had gone into world-wide syndication and was now more popular than ever. People everywhere wanted to talk to me and asked me the same old question: Do you really know karate? And a new one: Are you ever going to make any more of them? I started thinking about it. Not a bad idea. The only hitch was, I wasn't at all sure I still remembered how to do the character. Nevertheless, without really trying to, I started to get an idea for a story— something sort of like "Son of Kung Fu."

⇒ ⇐

WHILE I WAS thinking about it, I went to New York to host "Saturday Night Live." On the plane I found myself sitting next to my old Army buddy, Larry Cohen. He handed me a script and told me I could play the lead. It was called *I, The Jury*.

I said, "I'll do it."

He said, "You haven't even read it."

Hell, I read the book when I was fourteen, which is a perfect time to read it.

We exchanged numbers and I went off to Rockefeller Center to start trying to be funny. The way SNL works is: the host arrives Tuesday morning, and meets the gang. There is no script; none whatsoever. We stay up all day and all night, sleeping on couches and eating sandwiches until Saturday night when we go on across the country LIVE, doing what we made up.

We did one skit where Caine is walking through Harlem and goes into a haberdashery looking for a drink of water. Eddie Murphy tries to sell him some cool clothes, and Master Po talks to him through the mirror. Then he kicks the store to pieces, in slow motion, dismembering a store window dummy at the end. Playing it for laughs, I felt absolutely free to try anything. I discovered the character of Caine came back to me as though we'd never been apart.

SNL was about to be canceled. I got the reputation for having

saved it. If they had canceled it, my reputation would be as the host who killed it.

Radames Pera, who had played little Grasshopper, was grown up now and living in New York. We went out to dinner together one night. There were helium-filled balloons dangling in the restaurant. We inhaled the helium and said lines from "Kung Fu" in chipmunk voices. We settled down and talked about my story idea while Linda snoozed. Radames had one of his own very much like mine. We both thought the movie should be set in China. I thought it would be great if we could actually shoot it there; I remembered Jim Weatherill saying how he longed to see a shot of Kwai Chang Caine playing his flute beside the Great Wall.

The next morning in the NBC cafeteria, with a helium hangover, I wrote it all down on a napkin.

Americana was finally ready, so we took it to Robert Redford's USA Film Festival in Utah. *Americana* swept the festival and I came very close to making a distribution deal with Warner Bros. While I was at the Utah screening, back home in Malibu, Buffalo died. Killed by the neighborhood poisoner. He had been in operation for years. No one had been able to catch him. Some cranky old man, I suppose.

I buried Buffalo at the foot of a little hill, overlooking the sea. It took me most of a day. I cried a lot. He'd been my best buddy for eleven years.

I talked to the head of Warner's feature production. He said I should do a *Dirty Harry*. I told him about *I, The Jury*. He said it would never happen. Nobody would work with Larry Cohen. Larry had a worse rep than I did. It did happen, but not with me. The studio involved said I talked too slow. Larry said, "He'll talk faster!" No go. They hired Armand Assante. Larry was fired off the picture early in the shoot. I guess the guy at Warner's was right about him.

I plunged into spending John Cassavetes' $500 on *Mata Hari*. We got Gary Graver to do the camera work: a perfect choice. He had worked hand in hand with Paul Hunt on the Orson Welles' projects. We shot the birthday party scene in Dan and Gertie Culliton's house, a half-block off of Sunset Boulevard. Mike Bowen stopped traffic at the corner to keep the noise down until someone pointed a gun at

him. Mike's role in this shoot was more or less his debut, though he had been eaten by a mutant in a Corman film previously.

We then moved up the mountain to the house of Culliton's son, Patrick, and kept on shooting. Marianne continued the financing. Patrick was, at that time, engaged to Calista. Patrick was a shell-shocked Vietnam vet, and half-crazed a lot of the time, but he had a sweet nature and was very intellectual and a hard worker. I approved the match.

Behind his house was a stone structure that looked for all the world like a corner in a Hindu temple. We shot a lot more than one reel of film, and we spent a lot of Marianne's money. She was happy—loved it, in fact. The thing was, we had expanded the movie and now we had to shoot even more.

One time, Patrick and Calista were walking down the street with old John Drew when John picked some mushrooms and started eating them with gusto. He offered some to Calista and Patrick. Patrick asked, "How do you know they're not poisonous."

John said, "Because they taste so great."

They then each took a nibble. A couple of hours later they were doubled up with pain. They got to a hospital as quickly as possible. They survived. Miraculously, so did John, who had eaten ten times as many as they had. It would take a thermonuclear device to wipe out that son of a bitch. Meanwhile, for old time's sake, he was poisoning my daughter.

As a result of this and other incidents, I exiled him. I told him if he ever showed up in my life again, I would throw him off the mountain. He never did.

Menahem Golan, the Israeli film mogul, announced plans to make his own *Mata Hari*. When asked "What about Carradine?" he said, "So what? His won't be finished for years." I devised a way to throw him off the scent. I fashioned a 14-minute product reel out of what we'd done and took it to Cannes along with *Americana,* which had been accepted at the Directors' Fortnight, a competition for new directors.

We arrived in force: me, Calista, Dave Kern, Skip Sherwood, his new wife Sumiko, her two sons, Alison, our publicist, and Linda. We rented a cheesy little villa and slept all over it: on the floor, every-

where. We took a booth at The Carlton Hotel where we advertised all four pictures: *Americana, You and Me, A Country Mile,* and *Mata Hari.* We flooded the town with flyers. The festival had to outfit a theatre for us as our format was too technologically advanced for their facilities. We were a sellout. There was a riot on the street because people couldn't get in. They had to schedule an extra screening. We even outclassed the big studio pictures in the main competition. United Artists bought the picture.

Linda and I had a fight. I told the boys to put her on a plane and get her out of here before she endangered the whole project. Linda was mad as hell. She said she felt like she was being sent home. I said, "You are. Go home to your baby. You're no good to us here."

I received a telegram from Larry Cohen. It said, simply, "Come to the Mayflower Hotel in New York on June 7, with clothes befitting a police detective. 2 weeks. $30,000."

I collected my honors *(Montenegro* won the critics' prize, but *Americana* won the people's prize), stayed for the party, and flew home to Linda. She met me at the plane. She was still mad and was very unfriendly all the way to the car, but we completely made up in a very physical way before we even left the airport (difficult to do in a Ferrari, even a 2+2.)

I slept a night at the house, hugged Kansas, petted Patrick, the tricolor Collie, packed my bags, and set out for the good old Great White City of Hope once again.

I arrived at the Mayflower that night. I found the script in my mail slot with a message that I would not be needed in the morning. I had a few drinks at the bar where I found out that the cast of *I, The Jury* was in the hotel. Larry, with his impeccable ability to rebound and his bottomless sense of humor, had taken the money they paid him to get rid of him and financed his own little movie, which he had written in a week, to be shot simultaneously, more or less around the corner. Also in residence were Robert De Niro and Marty Scorsese, who were making *King of Comedy.* Brad Davis, of *Midnight Express* fame was a permanent resident. I went up to bed, my head swimming. I was too tired to read the script.

Next morning at breakfast, I read the script. To my horror, it was a monster movie. Q, it was called. The story revolved around a pre-

historic flying dinosaur who lived in the top of the Chrysler building and flew around eating people. I was supposed to play the city detective who was investigating these bizarre killings and disappearances. There was more to it, but that was enough.

I said to myself, "I can't do this. It will destroy my career. But I have to. I said I would—I need the money, my house is in foreclosure, Linda will lose her Ferrari. We've got to keep one Ferrari in the family. At least, I'm not playing the monster."

Right then, one of Larry's minions showed up to tell me that Larry had written me into the scene and they needed me, more or less right now. I hopped in the cab with him, the sacred script—that mean little scrap of foolscap—clutched in my trembling, sweaty hand, and we went to the set: a bar downtown.

Before I went inside I stepped behind the grip truck and threw up my breakfast. Then I walked in and went to work—always the trouper. Dad would be proud. Hell, he would have taken the job in a second, with no qualms whatsoever.

Inside, Michael Moriarty was playing jazz piano, supposedly auditioning for a job in the bar. He was playing the junky, petty criminal who accidentally discovers the dinosaur's nest and tries to ransom NYC for a million dollars and amnesty for all his crimes. Michael was wonderful. A great guy and an excellent actor. Candy Clark played his long-suffering girlfriend. Richard Roundtree was in it too, but he got pretty much written out because he was afraid of heights.

There was a retired detective as a technical advisor with whom I hung out, picking his brains. I was approaching the role seriously, though I did take to retitling the movie "The Chicken That Ate New York." Larry was wonderful to work with. Nothing daunted him; he could improvise at the drop of a hat. In between shots he would pace back and forth doing comedy routines and impressions. He could imitate anybody.

Amy Irving was staying at the hotel, about to take over from Jane Seymour in *Amadeus*. I had always had a crush on her. I caught her in the dining room and tried to get to know her. I told her, "You know, I studied with your father at San Francisco State."

She brightened up and looked at me more closely.

Way to go, Dave, I said to myself.

"Yeah. As a matter of fact, it was because of him that I dropped out of college"—warming up.

She said, "I'm not gonna listen to nothin' bad about my daddy!" and turned away. Way to go, Dave.

Brad Davis dragged me to a clip joint. If you bought a girl a drink, she would sit with you. It was always champagne. Cheap champagne, at $40 a split. Brad bummed the money from me. Idiotic. There was no way he'd get anything out of it. I got him back to his room and he passed out. Dammit! The horny little fart had just spent my per diem.

Linda showed up with Patrick the Collie. I met her at the airport and gave her head in the limousine on the way back. I was feeling great. I showed her my New York and she was quite wonderful. She could be quite a lady when she was in her right mind.

The most memorable moment for me in the film was hanging out of the open spire on top of the Chrysler building, secured by a harness, rigged by the guy who had rigged the fellow who scaled the World Trade Center, firing a Smith and Wesson machine gun at the monster. The wind was blowing and I could feel the building sway. It was like being on a sailboat.

On the floors below, in outrigger baskets suspended on cables, were a dozen of my cops doing the same thing. The target was a helicopter which had the camera in it. The people on Lexington Avenue, 70 stories below, looked up and thought they were seeing a terrorist attack. The police commissioner rescinded our permit and kicked us out. Larry was prepared for that. He had gotten his shots. He moved to a place he had set up in Little Italy for the interiors.

Later on, on talk shows, people would ask me why I had made this movie. I told them Larry was an old Army buddy and had saved my life once. That made Larry madder than *The Chicken That Ate New York*. Funny thing is, Q became a cult classic and made all of us a good chunk of change, while *I, The Jury* sank like a stone.

⇒ ⇐

WHEN I GOT back to California, I talked to Warner Bros. about my idea for a kung fu movie, and after dragging their feet for a while, they

decided to put together a script using the helium story Radames and I had thought up.

All of a sudden I was back in the game. I started working out seriously again, and spent many hours, days and weeks sitting with the writer, lending him books, telling him stories, explaining the mysteries of *Kung Fu, the Movie,* as we were calling it.

Around this time, Patrick the Collie started to bond with the kid next door who had lost his dog. He hardly came home. Linda got me an Irish Wolfhound puppy. I had always dreamed of having one. I named him Joe.

A very dry period came my way. The house was in and out of foreclosure altogether four times. I wanted to sell it but there was no market. Linda's Ferrari had to go to pay for Kansas' future schooling. Linda still had her father's Mercedes.

Linda's problems continued. Once, I drove her to a private hospital in Westwood where they took care of celebrities very discreetly. After a couple of days, I drove down to see her. I parked the Pontiac at the corner drugstore and called up the hospital to get the lay of the land. I asked to speak to her. They told me it wasn't allowed. I said I was her husband. Still no. I said, "I demand to speak to my wife." No. No.

I strode down the block and burst through the double doors of the ambulance entrance. I said, "Where is my wife?"

Someone said, "You can't come in here."

I said, "I'll leave after I see my wife. I know my rights."

The orderlies were moving in on me. "If you don't leave, we will be forced to subdue you."

I said, "It'll take a five point suspension and someone's going to get hurt. Then I'll pull her out of here so fast you won't believe it, and I'll take all of you and the hospital to court. My lawyer is on his way." (A bluff.)

Then Linda came out in a hospital gown. I walked her to the door, propped it open, and stepped outside. We stood there in full sight and talked for a while. She was in great spirits. I walked her back in and kissed her good-bye. A uniformed female took her away. From then on, they didn't give me any trouble. They started letting me take

her out once in a while for an hour. We'd go to the Holiday Inn and spend the hour in bed. Finally, she came home.

Things ran along pretty idyllically for a while. There was a little job here and there, and Linda, Kansas, and I were pretty happy. We went to see Abel Gance's *Napoleon*; seven hours of it, with a dinner break. I was struck by its similarity to *Mata Hari*.

Linda's problems continued. She took up making stained glass for something to do. There were lapses. I was afraid she was going to stumble and cut herself to death. She crashed a couple of cars. Sometimes she was wonderfully lucid and sometimes she just wasn't there. It was breaking my heart. I was being carried down into an almost suicidal despair. I realized with great regret that I had to get out.

I had closed up my editing room in Malibu a few months before and put all the stuff into a garage. Then I transferred it all into the spare bedroom at the Glass House. I had always called that bedroom the "editing room" because I had thought I would edit *Americana* there. Now I was moving *Mata Hari* there.

I was spending more and more time there, curling up on the couch in the editing room. Gradually, I started moving books, clothes, and little things into town.

I was unbelievably broke. I had no money. It was difficult getting enough gas to get back and forth from Malibu to Hollywood. I started collecting unemployment insurance. I hadn't done that for years, but I had to do it now. It was the only cash I was seeing. I funneled some of it to Linda. She was just as broke as I was.

Sometimes Linda would come by and I would entertain her, but there was a definite thing happening. I was gradually moving out. Whenever I went back to Malibu, I would pick up little items and take them to the burned down house. At one point Linda said to me, "Are you moving out?" I denied it, but that was the first moment that it was brought up to me and questioned. Very shortly after that I really did move out in the sense that I stopped going home entirely.

Linda was really trying hard. She started to protest, the way that lovers do, when they say, "I'll change. I promise I'll be different. Things'll be better." I discovered I really didn't care if she cured her-

self. I had lost too much affection for her during this whole process—or my fascination for her just faded.

The thing that was holding me at this point was Kansas. I knew that if I left Linda I would be losing, to a great extent, Kansas. I used to stay late at the house on Winding Way just so I could spend the time with her. I didn't do much—I'd just sit around—but at least I was there. She'd come up and talk to me, then she'd go away, then she'd come back. It was delicious.

She started going to school part-time when she was three-and-a-half. She was too smart to be hanging around the house. When school started, it released me from the responsibility of trying to stay with her since I wasn't with her anyway. I'd drop her off at school and then figure that I might as well go since Kansas wasn't home.

I finally realized totally clearly to myself (I hadn't made it clear to Linda, but it was clear to me) that I was really in residence at the Glass House. The only thing that was holding me now was the growing embryo inside Linda. I had already, with great anguish, faced up to losing Kansas.

My mother sent Bruce down to gather up all the Will Foster paintings. I was furious, but she was right. Things started disappearing from the house. First the wine collection went. All of it. One day it was there, and the next it was gone. I still had a case of Bordeaux and two cases of Burgundy that I had stored with the vintner.

One week seven guitars went out the door, among them the *Bound for Glory* Gibson and the very special twelve-string that Stu Mossman had made for me. Damn! I still miss that ax. There was only one like it and I had designed it. No other twelve-string could ever replace it for me. I have a good one now: a Lauden, made in Ireland to my specifications, but the Kansas wheatstraw Mossman holds part of my heart and my soul, and it's out there somewhere in someone else's hands. I hope they treat it gently.

Since my career was in the shithouse for the moment, I decided I had to break it off with Saul Krugman. Before I could talk to him about it, Linda spilled the beans. He got really mad about it.

He said, "Were you afraid to tell me? You were just going to leave me in the dark? That's a shitty thing to do."

I said, "It's just not working."

He said, "No! It's not working! You're in the toilet. Nobody wants you!"

I hadn't really made up my mind but now I did. Both our hearts were broken, but I had to go on.

Two weeks later, he died. He'd had by then a triple bypass, pig valves, and a pacemaker. He went into the hospital for a checkup. He was sitting in bed hooked up to all the machines watching a football game. He had laid a large bet when he suddenly went flat line. Either his team scored or the other one did, and his heart stopped. No one knows which. We'd been together for seventeen years, and I'd deserted him at the two yard line.

Mike said to someone that I was looking for a new agent. Somebody, whoever it was said, "What happened to Saul?"

Mike said, "Dead."

"What of?"

"David firing him." And laughed.

The Clan does not lack for gallows humor. Well, shit! I didn't know where to turn. Saul had done everything for me. I got in touch with my attorney, whom I hardly knew, and he found me an agent— a well-known agency run by a father and two sons. That didn't work out too well. No jobs were forthcoming. I showed them the *Mata Hari* promo reel. The guy said, "I didn't know Mata Hari was Dutch."

"Oh, yeah."

"Silvia Crystal is Dutch." This I knew.

He said "We can get you a two-million-dollar deal if you'll start over with Silvia Crystal."

I've always gotten along with Silvia, but I said, "Are you kidding? I'm supposed to abandon my daughter?" Walking out on Kansas was bad enough.

They went out and sold the idea to Menahem Golan. I talked to Silvia about directing her. How many *Mata Haris* could I direct? After some soul searching, I passed.

The next evening, just as I was closing down my editing room (I didn't like to work after dark; it got too dismal), I got a call from Bobby. "How'd you like to go have a drink, Dave?"

An odd invitation from Bobby. He hardly drinks, to this day.

I said, "Sure."

He said, "Okay. Go to 7101 Woodrow Wilson Drive."

And I thought, "What the hell is that? It can't be a bar." But, I hopped in the Trans Am and went.

I was lonely.

NOW AND FOREVER

1981-1995

CHAPTER SEVENTY-FIVE

GAIL

I pulled up to the house on Woodrow Wilson Drive. Bobby was out front. He pointed and said, "Right. Park there. That's a really good parking place." I always listen to Bobby about anything to do with cars. We walked down and across a foot bridge past a stand of tall bamboo to a little wooden house.

Inside, the party was alive. The girl's family had come down from the farm and they decided to have a Margarita party to keep the grandmas warm. The place was full of farmers, musicians, entrepreneurs, and a couple of Carradine brothers. I felt a little shy, so I sat down at the piano to get the lay of the land. This girl carrying a tray of Margaritas sat down beside me and started playing lead with her left hand.

I looked at that little, tough farmer hand and up the arm to her face, and there was the girl Buffalo had taken a shine to on *The Long Riders'* set. We locked eyes. Blue, hers were. Lidded like an Indian's; hair like flax, skin golden. She parted her lips. Little white teeth. I said, "I love you."

I danced with her sister and her mother. Her mother had had an accident and couldn't walk quite straight, but she sure could dance. I told her as I twirled her that her daughters took the cake. She told me if I did them wrong, she'd have me killed.

A few of the boys harmonized on some old good time rock and roll numbers, most of which they had done the hit records of. We had David Sommerville of The Diamonds and The Four Preps, Keith Barbour and Michael McGinnis of The Christy Minstrels, Val Garay of The Beau Brummels, and Kevin (Rocky) Mitchel of The Mellow Kings. Also on hand were Michel Rubini and Carl Frieberg, world-class composers and pianists. Jeff Cooper would have given vital body parts to hear that concert.

I played Rocky's conga and blew all the musician's minds. I heard whispers. "My God, who's that?" "David Carradine." "Naw!" I'm pretty good; my beatnik training. I left the party early. At the door, I took my new love's hands in mine, kissed them both, and said, "Good night, Princess." I walked past the bamboo in a definite state of euphoria. That night, I slept deeply and dreamed powerful dreams.

I guess that party was when the die was cast. Bobby had been having an affair with Gail that had started with *The Long Riders*. That didn't matter to me because I didn't know about it. I didn't even know there was going to be a liaison between us. I still hadn't given up being faithful to Linda. I was quite content being celibate.

When Mike would bring girls over to the house, which was often, I'd say hello and go on working at the moviola. I was this weird old guy in the back who never came out. That party was my first attempt at getting out, except for one place out on the strip: a classy old time Hollywood establishment that catered to the underworld, big Italians in suits who drank scotch and ran call girls, among other things. I used to nurse a beer at the bar and talk to the whores. They were interesting women. They usually came in twos; a nice one and a mean one.

Two days after the party, I was drifting off in the big bed when I was awakened by what I can only describe as an obscene phone call.

In the morning, I went downstairs. Shelly was making breakfast with, as usual, no shirt on. I said to Mike, "You know, I got an obscene phone call last night."

He said, without looking up from his work, "Oh, that was Gail Jensen."

"Who's that?"

"You know, the girl who gave that party the other night."

A little rush went through me. "That Gail? Do you know her phone number?"

Still not looking up, "Ask Bobby."

I called Bobby. He said, "Are you sure you want to do this?"

"What? Yeah, I'm sure."

I invited her to a screening I was having. She couldn't make it. She invited me to something she was doing. I couldn't make it. Finally, she said, "Why don't you just come over to my place. I'll cook you dinner."

I showed up with an inordinately good bottle of Burgundy, the last of my collection. She was in the kitchen, cooking up a storm. We talked a little. She said, "Why don't you open up the wine?"

I did so and poured two glasses. We toasted. She, going back to her cooking, said, taking another sip. "This is pretty good wine."

I said, "I don't fuck around."

She looked up. "You don't?"

"Nope."

We sat down at her beautiful dining room table, me at the head, she at my right hand. One candle. The dinner was pan-fried sea scallops, Brussels sprouts, and salad. Wrong wine but what the hell. I thought it took courage to serve Brussels sprouts on a first date. A lot of people throw up when they try to eat them.

Afterward, we lay in front of the fireplace. We talked. We kissed a little. It was very nice. She unbuttoned my shirt somewhat and said, "Oh, you have a tattoo!" I laughed. She tried for my belt buckle. I stopped her. We kissed and talked. We got along really well. I said good night and went home.

It was my turn to buy her dinner, so I took her to Chez Denis. I knew they'd treat us special there. They gave us the best table, which was inside a little gazebo; very private, very romantic. When we got the check, it was over my head. I had to borrow the money from Gail.

On Valentine's Day, I received a delivery from her. A little basket containing a jade elephant, a jumping frog operated by a squeeze bulb, a bag of flower petals, and a poem on a little card with dancing mice on the front:

I've known you for a thousand years, do you recall?
We fought the war, and we danced at the victory ball.

And so, my Prince, I offer you my aid and friendship,
As I did a thousand years ago.

Needless to say, if I hadn't been hooked already, I was now. I called her and she asked me to meet her at a recording studio. I walked into the control booth and there she was, waving her arms, dancing and blowing kisses through the glass at the beautiful seventeen-year-old boy, who was wailing away on a French racing blue Custom Stratocaster. The music reached a big climax. "Shot Full O' Your Love" was the name of the song.

Gail pushed the talk button, said, "That's the one, Mitch. Come on in and listen." Then she turned to me and gave a short kiss, just a peck, before she went back to work: producing the session for a song that she wrote and sang lead and backup on. While she arranged with the engineer to get some cassette copies right off the board, I went back and talked to Mitch for awhile about guitars and cars.

When she was finished, we went out for a drink and ended up at her place. We listened to the tapes, drank coffee and wine, snuggled a little on the Princess Ann couch.

I called her up again during the day and she said, "Come on over. I'm just finishing up my work." When I showed up, she was in the kitchen (her office) answering phones and issuing orders to her assistant, Joyce. I was amazed at her sense of business. She was a whirlwind. I took to showing up every other day or so. It gave me somewhere to go when the light started to fail.

One day she gave me a long diatribe on my career. She said I was a great talent but I'd never had a chance at the right material to show it off. She thought I should write my own movie, making up whatever I wanted most to see myself do. We started doing that together the next day. I would talk into a tape recorder and Joyce would type it up and bring it back and we would edit it, and so on. We started a schedule of doing this every day from three o'clock to five. One day, at five, she brought out two little tiny thimble-like glasses and filled them with Jack Daniels; so now we were drinking buddies.

I asked her if she would manage me; something I'd been thinking about for a while.

She said, "I don't do that."

I said, "Well, you're already doing it. I'm just offering to pay you for it."

She said, "I'll find you a new agent and we'll see what happens."

She took me up to the ridge where she kept her horses. There were two: an Arabian stallion, Majetek—whose sire was Druzba, the number-one rated Polish-Arabian in North America—and a Palomino Quarterhorse gelding, Captain—the last get of Three Bars, the most famous racing Quarterhorse ever. These were seriously expensive horses. She put me on the gelding and she rode the stud; both of us bareback. Part way up the road, Captain was acting lame. Gail said I was too much weight for him, so we switched horses. The last thing I wanted to do was ride a strange stallion bareback but I swung up on him. The moment I put my legs around him, I felt the power in him. This was the real thing. He thought the same of me. We've been buddies ever since.

Whenever we greet each other, I whinny and snort to him. He always answers. Then he rubs his nose against my side and nibbles my ear, while I scratch his chest and ruffle his forelock. When I let him go, he jumps off and kicks his heels up.

Gail has a long-time friend, Earl Miller, who photographs naked women for *Penthouse* magazine. She had appeared in his features a few times. From time to time, *Penthouse* would publish a feature with one or two beautiful girls, draped over a couple of horses, a sorrel and a Palomino. The horses were always Majetek and Captain. Those horses developed very special personalities as a result of these jobs. They really loved women.

Captain, who looks exactly like Roy Rogers' Trigger, the Wonder Horse, eats hamburgers and bananas. (He peels them.) He loves beer and Coke. He has a habit which is disconcerting to the uninitiated. If a door is open, he walks into the house. He looks around for something to eat and then maybe watches television for a while. He loves to listen to Gail play the piano, cocking his head over like Edison's dog, Victor.

He can count, will smile and laugh like Mr. Ed, and will pick up

a rake and pretend to rake the corral. I've never actually seen him dial a telephone with a pencil in his teeth but I wouldn't be at all surprised. What I have seen him do is walk up the hill, sit like a dog, and slide down the hill on his butt, just for fun.

Captain is very opinionated. He loves women and children, but he doesn't like drunks on his back. He'll buck them off. He's not crazy about men, either. Danny Haggerty tried one afternoon to master him. He bucked Danny off nine times. Then gave him a good ride through the hills, down Runyon Canyon, past Errol Flynn's "Millionaires' Club." Danny was pretty sore the next day

Captain took an instant dislike to me; Gail says he's jealous because he can smell her on me and me on her.

He became my fast friend, though, when I saved his buddy, Majetek's life; or so he thought.

Gail and Patrick went for a ride. (Patrick is one of the few men Captain will tolerate.) Patrick came storming up to the front door hell-bent for leather, pulled up and boomed out in his musical comedy baritone, "David, we've got a serious horse problem here!" I rushed out and said. "What's the story?" He said, "Majetek's down and Gail's pinned under him." That does qualify as "serious."

I said, "Get off that horse!" I swung up, turned Captain around and galloped to the rescue, with Patrick running infantry behind us. I had visions of a horse with a broken leg, or a crushed Gail, or both. I found Majetek, without saddle or bridle, in the street, directing traffic. I rode up beside him and reached for his halter. I almost caught it, but he shied and trotted down the street, slaloming around the startled motorists.

Captain and I followed. Majetek stopped to climb a fence that had a mare behind it with a come-hither look. I dismounted and, after a couple of tries, got hold of him. I slapped him to get his attention and got him off the fence. He danced around a little, snorting wildly, and started to rear up, but I gave his halter a jerk and he quieted.

Just then, Roland, our resident Turkish Cowboy came driving up. I handed Majetek to him. He knew how to handle him for sure. I passed Captain to Patrick, jumped into Roland's Jag, and barreled up the horse trail, now limiting my morbid fantasy to merely a crushed Gail.

A third of a mile up the trail, I came to Doc Bob Bradley's Vet truck, parked in the middle of the roadway. On top of it was Majetek's saddle. Inside was Gail, happy as a lark, sharing a bottle of Jack Daniels with the good doctor. I joined them. From that moment on, I was Captain's hero.

⇒ ⇐

ONE DAY WHEN I came to work, she invited me to go to an important party with her.

She went down to the bedroom to dress. We were talking through the stairwell. She said, "Why don't you come down?" I said, "No, I don't think so." I made it through that night, but eventually the wall crumbled. I took her to bed.

After we'd made love, she stood up and twirled around, showing her body to me. She said, "Well, it's good for making babies." I agreed. Then she said, "What would you say to 35 years?" I said it sounded all right to me.

She told me about a balloon trip she was taking on Thursday with her cousin and asked me if I wanted to come. I told her I had to work. I went home. She couldn't understand why. Neither could I. I just had to sleep in my own bed.

⇒ ⇐

MARIANNE RUUTH AND I had put together another *Mata Hari* shoot to finish up the new story lines we had added. We had discovered a Dutch theme park that was half constructed, south of L.A., about two hours' drive. It had a windmill, canals, a couple of bridges and a gazebo band stand. All we needed.

I had some trouble with Johnny Barrymore. He refused to work. I had to have him. I bounced him off a wall and he changed his mind. I told him I would finish off his character, so he'd never have to be troubled again. I lined up a photo-double, just in case, but Johnny came through, sort of. He showed up with his hair cut short. It wouldn't match. So I put in a scene where Johnny gets his hair cut by Shelly.

The night before we left, I went home to Linda and Kansas. I had to finish up the preparations for the shoot, so it was very late. Linda was unwakeable. The bedroom smelled of the miscarriage. I stayed the rest of the night beside her and left at 5 A.M. She never knew I was there.

I took Joe with me. He was about six months old now. We all met at a parking lot on Sunset Boulevard and set out in a loose caravan. I parked the Trans Am and Joe and I went with Marianne.

On the way we saw, in a pasture beside the road, a balloon that was down. About four people were trying to fluff it up, with the flame on high. I said, "Marianne, please. Stop the car." Yes, sure enough, that blonde girl working the folds of the balloon was Gail. I wanted to hop the fence and give a hand, but Marianne said we were already late, and I reluctantly moved on.

When we got to the location, we were not late at all. People and equipment were still trickling in; however, we had a problem to solve: the girl who was supposed to play Muck's sweetheart in the movie had canceled. I paced along the hillside and there was Shelly lounging in the grass.

I said, "Shelly, how would you like to be in the movie?"

She said, "What would I have to do?"

"Take off your clothes and neck with Michael."

Her face went through a couple of changes. "Well, all right."

My description of her role was not strictly true; she ended up dancing, doing dialogue scenes, and attempting suicide by jumping off the windmill.

That night it rained. It pretty much rained all the next day. Everybody stayed hunkered in their cars and trucks, except me. I had to stay out there and set an example for the others so we could get a shot when, every once in a while, the rain stopped. I was in costume, a black velvet suit and a top hat. I spent the day soaked to the skin. The velvet suit was never the same.

That night and the next, my band was booked into a club. By the time we got back, I was sick as a dog. Marianne took me to a doctor. He told me I had tonsillitis, bronchitis, and pneumonia. I got him to give my throat a cortisone shot so I could get through the gig.

It was a full house, packed actually. Gail was in the audience. The

band was hot. We gave a great show. The next day, Friday, we shot all day at Dan Culliton's house. When I arrived at the club, I was hoarse as a frog. It was another packed house. I forced the notes out through the pain. It made all the songs sound mean, but it worked. For the last couple of numbers, I brought Calista up to do the vocals. I simply had nothing left.

I lay down on the desk in the office (there wasn't any dressing room), my body exhausted and flooded with sickness. I called Bobby over and asked him to bring Gail here. He said, "What for?" I said, "Just bring her." When she showed up, I said, "I need some tender, loving care. Can I come home with you tonight?"

Gail put me to bed and plied me with mustard plasters and Vick's Vaporub. She made me a drink of tea, lemon, honey and Jack Daniels taken with two aspirins, to make me sweat. I stayed all night with her for the first time. I never went home again.

The next weekend, I hired some piano movers and went out to pick up my concert grand. Gail and I drove out to show them the way. I sent them in, then dropped Gail off at the corner coffee shop. It didn't seem like a good idea to walk in with her. When I got back to the house, the guys were just standing around. I asked them what the problem was. They told me Linda wouldn't let them take the piano.

I went inside. She was pretty mad, but I calmed her down. The guys came in and started working. I sat with Linda and we talked about the impending divorce. I convinced her that I would take care of her, that I didn't wish her any harm. I told her I was not going to try to take Kansas away from her. A child should be with its mother. With all her lapses, Linda had always seen to Kansas' welfare. I also thought that having Kansas to take care of might straighten her out. I did tell her, though, that if she screwed up with Kansas I would have to take her. My heart was in my mouth, but I muscled it through.

When the piano was in the truck, I got up to leave. Linda said, "Where are you taking it, to a recording studio?"

"No, to Hollywood."

"The Burned Down House?"

I said, "No. To Gail's place."

"Oh," She said. "Happily married again, huh?"

When the piano was set up in Gail's living room, I sat down and played it. I was definitely home.

To drum up some notice, Gail put her credit card on the line and borrowed money from her sister, so we could go to the 1992 Cannes Film Festival—it was to be the last time there for many years. We hobnobbed with the moguls and magnates, danced at the discos, and saw a couple of movies at the Grand Palais. We rented a VW Rabbit and visited the Camargue to the south and Italy to the north. We caught the Monaco Grand Prix. At an exclusive luncheon up in the hills (SuperCannes, it's called), Yanou Collart informed me that Joelle had died of an overdose. I was thoroughly bummed out. When we got back to the hotel, Gail took a bath. From the tub, she hummed a haunting phrase. She trilled it at me on the balcony and asked me to play it on my flute. I said, "I don't do that. I can't play a tune on the flute. I just improvise harmonies." She yelled, "Try." I did. She started to sing, "I love, you, Joelle." Before the afternoon was over we had fashioned a song at the piano in the bar.

I Love You, Joelle. All the songs you sing,
Sweeter than the spring that brought you to me.
Joelle. Tres jolie Joelle.

Still your song lives on. It lingers in my ears,
Unfaded by the years.
Joelle, tres jolie Joelle.
Tres tres jolie Joelle.

We fleshed it out and finished it up and sold it to a French record company. We never followed it through, something about bad taste; not the song, the record company; pure sleaze. They only cared about making a profit on it. No need. The song had done its work. My heart was beating normally again. The songstress was laid to rest.

While we were having lunch at the beach pavilion of The Carlton Hotel, Menahem Golan, from the next table, handed me a menu. He said just sign and we'll fill in the details later. We declined.

Gail put me together with Freddie Fields. He invited us to a

Hollywood power party in a mansion in the hills. I started to get close to an important director, one whose work I love. Tony Bennett arrived at the party. I took time to introduce myself and give him his due as the royalty he is. The director was insulted at my lack of attention to him and the deal was off. Oh, well.

We received a couple of offers which, predictably, never came through, but people knew I was back.

While going down the stairs at The Carlton Hotel, I got down on one knee and asked for Gail's hand. She said if I did the same thing tomorrow at the same place and the same time, she'd consider it. I did all that and she provisionally accepted.

When we got home, we went straight to Fresno County to meet the folks. On the airplane, I wrote a song about the party at which we met. I wrote it on two barf bags. It had some good lines in it. I never got around to setting music to it and eventually I lost track of the barf bags.

> On a cold Thursday in January when I'd finished up my day
> I called my brother Bobby, who's my best friend by the way
> How'd you like to drink some booze and listen to some jive
> Go to 7101 Woodrow Wilson Drive.
> Now I've lived in this here town as long's I've been alive
> But I never heard of any bar on Woodrow Wilson Drive.
>
> Her folks from up in Fresno had come down from the farm
> And they were havin' a Margarita party to keep the grandmas warm.
> A girl was in the kitchen, making Margaritas in a blender
> A teenage boy was working out on a Stratocaster Fender
> I sat down at the Hambro to get the lay of the land
> The girl sat down beside me and played lead with her left hand.
> I looked into her angel eyes, my heart was in my throat.
> I said, "I love you," and that was all she wrote.
> This party was alive!
> 7101 Woodrow Wilson Drive.
>
> Michael McGinnis was playin' so good, I gave him my cowboy hat.
> I danced with the girl's mother tryin' not to step on the cat.

Her mother'd had an accident and couldn't walk quite straight
But she could dance as good as any mother in the state.
I told her as I twirled her that her daughters took the cake.
She told me if I did them wrong, she'd throw me in the lake.
I kissed the girl's little hand and went away alone,
But I knew that someday I would make that little house my own.
7101 Woodrow Wilson Drive
That party was alive!

Gail's father's family was Swedish and Danish. They had come around the Horn on an immigrant boat in 1905 and arrived in San Francisco just in time to put their backs to straightening up after the Quake. The Johnseys, her mother's family, hailed from Arkansas. They were Irish, English, Scots, I think, and Blackfoot Indian. The late Vernal Jensen and Pat Johnsey ran a farm with 80,000 fruit trees. I had to be accepted by every member of the Johnsey clan. There was Uncle Bruce, contractor; Uncle C.C, insurance; Auntie Glad, post-mistress up at the Edison dam, who fell in love with Uncle Eddie who worked with Edison himself, and played soprano and C melody sax with Benny Goodman's band. He gave me his C melody. Glad was easy. I just drank a bottle of gin with her at the kitchen table. Auntie Val, Percy McCahill—Gail's old riding master. I made it through. Her mother was the tough case, but I got through to her too.

We went up to the lake with Gail's brother, Scott, and his fiancée, Patty, to see Uncle Bruce. He was sort of a family outcast, as a result of his having divorced his reportedly awful wife of 36 years, a definite no-no in the Jensen and Johnsey families, and married a somewhat younger girl named Alice, who was a lot of fun. They had transformed the cabin into a shameless love-nest.

Brucey broke out a bottle of pretty good California champagne and we all lounged around on the deck and got giggly. When everything was going pretty good, Gail blurted out, "Doesn't David remind you of Vernal?" Bruce drew himself up, trembling with rage and Parkinson's and replied with down-home outrage, "This here kid reminds me about as much of Vernal Jensen as I remind myself of that blue Ford pickup across the street." Then, warming to his sub-

ject: "Vernal Jensen was the most generous man I ever knew. He had a heart as big as the whole outdoors; he was the hardest worker I've ever seen; and, God! Could he drink!"

Then he shakily poured himself another glass of bubbly, spilling about a third of it on the table. Sounded a lot like me to me.

We proceeded to illustrate the last Vernal Jensen commandment until the night was half over, when Bruce and Alice retired to reconsumate their marriage some more.

I heard some great stories from Gail on that trip. The Johnseys came to California with the dust-bowl migration, from Arkansas. The Jensens came around the Horn from Sweden and Denmark. They were not permitted to dock in San Francisco. The windy city didn't want a shipload of immigrant "Square Heads" cluttering up the streets.

While the ship was sitting offshore, the great earthquake of 1906 shook Frisco down. In the chaos that followed, city officials rowed out and asked the Swedes if they'd come ashore and help out. The Jensens and the Lundgrens and the rest of them cleaned up the town and then went looking for good bottomland.

Vernal and his bride-to-be, Pat Johnsey, were on their way to Lake Tahoe to get married, when Pat expressed cold feet. Vernal stopped the car in the middle of the Sanger River bridge and went around and opened her door for her. She thought, "Oh, how sweet. He's going to romance me on the bridge." Vernal picked up Pat in his strong, farmer's arms and held her over the railing, above the rushing river. "Make up your mind right now, Pat. Are you going to marry me or not?"

Gail's grandmother used to hold Gail and rock her and say, "You poor little ugly thing. You've got no coloring at all. You'd better study hard and make something of yourself, 'cause no man's ever going to want you." An interesting way to make sure the kid didn't turn out a stuck-up princess type.

When Gail was about six, she and her big sister, Tamila, noticed that the other kids in town went to Sunday school to learn about God. They asked their father if they could do that. He said, "Sure, if you want to." They trotted off to a Baptist prayer meeting in their best dresses. Gail came home crying. Vernal wanted to know what was

525

wrong. A few of the boys had teased her after bible class and dragged her into the bushes, pulling her dress up and her panties down. Her dress was torn and her legs were scratched from the bushes. She said, "Do I have to go back there?"

Vernal took her by the hand and led her out to the peach orchard. It was spring. The trees had been pruned. Where the trimmings had hit the ground, they were performing the small miracle of taking root and blooming. He reached down and picked up a blossoming twig. "This is God," he said. He pointed at the trees, heavy with the blooms, the sky, a mourning dove on wing. "This is God. That's God. That's God. That's God."

He scooped up a handful of soil and let it trickle through his fingers. "This is God. You don't have to go to a Baptist church to talk to God, girl."

Tami was an "A" student. Gail was always on a horse. When it came time for college, Tami got the breaks. They sent her to Davis, then to Berkeley. She graduated summa cum laude and became a lawyer; field: real estate and land use; she was also editor of the *National Law Review* and champion of the little people.

Gail, they figured, was tough enough to make it on her own. She applied for a scholarship in music and was turned down. She won one for drama and enrolled at The Pasadena Playhouse, where she was taught by the likes of Hume Cronyn and Jessica Tandy and got all the good parts.

She joined Henry Mancini's band as a backup singer and toured. In Las Vegas, she got a part in a musical. While she was there, she entered the Miss Las Vegas contest. Her father was proud of her, but he told her she couldn't win. (You have to have big tits.)

She went to New York to audition for *Hair.* She got the role and went looking for an apartment. She found a nice one, at a good price. The superintendent, who had shown it to her, got off of the elevator on the fifth floor. On the third, three very large black men got on. One of them said, "Hey, a flashlight!" (Platinum blondes carry their own key-lights.) "Where you goin, honey?"

Gail, innocently, "I'm going to the lobby."

Laughter. "No, you ain't. You're goin' to the basement."

Without skipping a beat, Gail, with her best good neighbor

smile, stuck out her hand and said, "Hi! I'm Gail Jensen from Fresno" (punching the first floor button behind her back). "I just love New York! My! You're all so tall! I love tall men! What's your name?"

They stood there, frozen with awe at this stupid white chick. The door opened and she ran. She went straight back to the theatre and said, "Thanks, but no thanks! I'm going back to California where I belong." She caught the first plane.

> ←

WE SWUNG BY the Jensen farm on the way back from the lake. Thirty-thousand peach, plum, and nectarine trees; grapevines and then the annuals: tomatoes, Bermuda onions, and melons, all at the foot of the Sierra Nevada range; a thriving "fruit stand" on the corner called The Purple Plum, famous all over the area for its beer and sandwiches. Her mother was named Farmer of the Year two years running. Ma Jensen took me outside. She looked at me straight and said, "You know, we Jensens don't get divorced."

I said, "Yes. I know that."

She squinted at me through her glasses. "You be good to her."

"Yes, Ma'am." I said. "I will."

When we got home, we discovered that Johnny Barrymore had stolen some checks in our absence and written $250 worth to a drug dealer, forging *my* signature. I was furious. Johnny showed up at the house. I thought he had taken some checks while we were away. I was on the phone with my agent. Johnny silently mouthed, "I've got to talk to you."

I silently mouthed, "You. Out!"

He didn't move. Just stood there, like a despairing supplicant. I said into the phone, "Call you back," and jumped at him. He saw it coming and ran. I chased him, grabbing up my three-sectional staff from beside the door on the fly. He's fast. I'll say that for him. He had to pause to open his car door and that's where I caught him. I raised the three sectional, held together like a club. He blocked high and I smacked him in the ribs.

He said, "That was unnecessary."

I said, "I don't want there to be any misunderstanding. Don't ever come back."

I figured that was it for me and the Barrymores. Not so. I got to know and love Johnny's little sister, Drew; and, much, much later, I broke bread with Johnny again. He had married, had a beautiful child, and got himself clean to the extent that he was leading AA meetings.

He became a computer whiz and, when my Mac crashed, got it going again and saved this book from computer limbo. That right there was enough to earn him his pardon.

Back then, though, he was nothing but trouble.

➤ ⬅

DAD WAS DOING a play in San Diego, playing Scrooge in a musical called *Bah, Humbug.* I took Gail to the show. It seemed an ideal way to introduce her to him. We sat through the show without alerting Dad. Though he was almost crippled with arthritis, he was wonderful. Afterward, we went backstage. When he saw me, he broke into a big grin. I said, "Dad, I'd like to introduce you to Gail Jensen." He started to try to get up, when Gail ran across the room and knelt beside his chair. He looked at her with a definite twinkle in his eye, stroked her hair, and said, "Finally!"

A period followed when Dad would stay at Gail's house for a few days at a time. The brothers would show up and we'd make an all-nighter of it. These were great times.

His arthritis was always kicking up. On one occasion he was very quiet. Unusual for him; he was always talking.

Bobby asked him, "Dad, are you in pain?"

Dad said, "It's merely mechanical, son. Merely mechanical."

BACK IN THE SADDLE AGAIN

G ail went to work finding an agent for me. First, she went out and bought me some clothes: silk shirts, clean jeans, a jacket; ties, even. I was really ragged. The bags in my jeans had bags. She tried to get me to shave, but I hung on to the beard for a while. Then she called up Freddie Fields, president of United Artists and an old beau of hers, asking him who would be a good agent for me.

Freddie told her the best agent in town was Peter Rawley at ICM. ICM was the result of mergers between Ashley–Steiner, Famous Artists, The Marvin Josephson Agency in England, General Artists Corporation, and Creative Management Associates. ICM stands for International Creative Management. I had been with all of them off and on throughout my career, so when I walked in, I was greeted by lots of people I knew.

Peter hooked me in by saying that what he'd like to see for me was five more *Bound for Glory*s. But of course. I signed.

Gail started looking for a part for me. Her idea was to put me to work immediately. An old friend of hers was directing a movie with Chuck Norris. I asked her what the director's name was. She said, "Steve Carver." I thought back to *Moonbeam Rider* and said, "Perfect!"

We went over to Orion Pictures, ostensibly on a social visit with Steve. A glint appeared in his eye and he took us into Mike Medavoy, whom I knew from *Bound for Glory.*

Mike said, "What do you think about doing a picture with Chuck Norris?"

I said, "Well, I don't know, it hadn't occurred to me. What's the part like?"

He said, "Would you play the heavy?"

"Maybe."

"I'll give you a script."

I called him back and said, "You know, Mike, there's really nothing here for me." (You understand, I needed the job, desperately.)

He said, "What? What's the problem? We'll change it."

I said, "Well, I really don't like the idea of killing a woman in cold blood. And I don't like the idea of dying on camera." (John Wayne said, "Never die in a movie unless it's your own picture.") "And I don't relish being defeated in hand-to-hand combat with Chuck Norris."

Mike said, "We'll fix it. We'll fix it. We'll fix it."

Gail negotiated the contract over the phone with me coaching her in the background using all the expertise I had picked up from seventeen years with Saul. We knocked the price up to a very respectable figure. Finally, I said, "When? Let's do it." A movie with Chuck sounded like a sure way to find out if I still had the touch for Kwai Chang Caine.

I started working out every morning with one of Kam's former instructors, Rob Moses, easily the most flexible martial artist I had ever seen and well up on all the same familiar styles that had by now become my old friends.

I worked out with Rob in the mornings and in the afternoons I studied Competition Karate techniques with P.J. Lee. He was the head bouncer at a really rough nightclub in Hollywood. My brother Mike was a bouncer at the same club and P.J.'s student.

I thought it would help me when I came up against Chuck to know something about Competition Karate. It turned out not to be additive at all, but simply, limited. Rigorous, though, I'll say that for it. Hard and fast. The bouncers' techniques were actually more interest-

ing; spontaneous, sudden, ingenious, and obviously necessary for survival. Real.

Much later I found out that Chuck was doing the same thing: working out with Kam Yuen.

I showed up in El Paso in great shape and plunged into the work. Chuck carries several fighters with him and I worked out with them every day for three weeks, choreographing the fights. The guys wanted me to go through a class with them every day before we started working on the fight. This bored me. I didn't need training. I just needed to go to work.

The second day, I walked them over to the bar to buy them a beer. They were reluctant—Chuck didn't like them to drink—but they went. I let them order their beers and when they were set up, I said, "151 rum for everyone." I toasted the show and we downed the shots. After two of those and the beer chasers, they were pretty out of it the next day. I was fresh as a daisy. I said, "Okay, let's do the class." They struggled through. At the end, they were all sort of gray. I said, "Let's not go through this bullshit anymore, guys. We don't need it." They agreed. That was the end of that.

Steve Carver ran into me one afternoon and told me he'd heard I was doing some great stuff. He seemed surprised. I said, "Well, Steve, I didn't come to you totally unprepared."

People don't realize that, what with the years of a weekly TV martial arts show, the only long running martial arts series there ever was, I've done more of these fights than just about anyone on Earth. However, I could understand Steve's surprise. This was a comeback.

Chuck never came to the sessions. The first time I ever worked out with him was the day we started shooting the fight. He turned out to be very easy to work with. Smooth and totally professional. Well, it was to be expected. After all, he was four times World Champion.

His brother, Aaron, was the stunt co-ordinator, though he had nothing to do with the fight choreography. They couldn't be any more different from each other: Aaron was big, hard drinking, a practical joker, and loved the ladies. He's a talented martial artist, though not as good as Chuck (who is?), mainly because he doesn't take it very seriously.

Orion and some others had the idea that Chuck couldn't act. He'd been taking acting lessons. In my opinion, mid-career is a little late to learn how to do it. Steve was devoted to the task of making Chuck look good. He directed him the way you do a little kid: talking him through the scenes, making him say every line ten times in his close-ups. It was also thought that working with me would bring him up. The system worked. Chuck's performance in *Lone Wolf* is the most complete portrayal I've ever seen him give.

Barbara Carrera is a whole other thing. What you see is what you get. Turn the camera on and stand back.

When it came around to the big fight scene, it became clear that Steve Carver had no intention of abiding by the specifics of my contract. He said, "I'm not shooting a contract. I'm shooting a movie. A certain kind of movie. The villain must go down." Agents, attorneys, production heads all began throwing wadded-up paper balls across the conference table at each other.

Orion had never delivered a contract, obviously anticipating this eventuality. However, we had a raft of deal memos and recorded phone conversations to back us up. I wasn't really that concerned; unhappy, but not concerned. What I cared about was the principle of the thing: they made a deal. Either they came through or they were liars. I don't like to be lied to. I also don't like to complain. In the arena in Texas, while the infighting went on in the board rooms in Beverly Hills, I went ahead and performed.

It took us four days to shoot it and by the end we were so sore, we were hobbling around like little old men. My old ruined ligament was acting up, making my signature flying double front kick a risky undertaking, and Chuck had pulled a muscle in his groin, making his famous flying reverse spinning heel kick very painful to him. It was hard, dirty work. We both loved every minute of it.

⇒ ⇐

AFTER THE FILM was in the can, the issue became how it would or would not be cut into the picture. One of Orion's lawyers said to me. "Well, why did you go ahead and do it? Did they put a gun to your head?" An unoriginal, uninformed remark. A movie set, with its sense of desperate expediency, an eighty-man crew, millions of dollars

worth of equipment, a powerful peer group looking down their noses, a manipulative and hard-nosed director, the looming specter of a future lack of employment, or even blacklist. . . yes, I would say that's like having a gun to your head.

I said to the mouthpiece, "You're a perspicacious fellow, but I could put you in front of a movie camera and turn you into a piece of jelly."

Actually, as it turned out, I did kill Barbara Carrera, but not in cold blood; she jumps in between and takes the bullet meant for Chuck. A better piece of drama, since we are both in love with her. I don't die on camera. I kept pumping the idea of a sequel to put them on the path of keeping my demise undocumented. The hand to hand fight is never actually concluded. We switch to guns at a certain point and then Chuck throws a hand-grenade, which may or may not have blown me up.

Chuck's character actually took most of the punishment, as is his style in his pictures. He's always getting the hell beat out of him and then coming back strong. The lawyers went to a screening of the rough cut with stopwatches. The longest I was down for was four seconds, while Chuck was down for seven seconds, so it's pretty much a matter of interpretation who won the fight.

The point was, as far as I was concerned the fight looked great, and some of my best acting was when I was getting hit. My face going out of shape as it snapped around, the spray of sweat; it was hard even for me to believe Chuck wasn't really connecting. It looked like a real prize fight. I've never seen anything like it in a movie before. I wouldn't have cut that footage out for the world.

The legal hassle became a publicity stunt to sell tickets. It worked pretty well. *Lone Wolf* was, by a huge margin, the most successful Chuck Norris picture to date. And while the lawyers and publicists were fighting it out, me and Chuck were laying back, having a beer together. He liked Pearl; I preferred Lone Star.

There was a story that Chuck broke my nose and another story that I broke his. The truth was, with our reputations to precede us, neither of us wanted to get too close. We faked it all.

After it was all over, Mike Medavoy did talk to me about a sequel. My position was that I could get into fighting back to back

with Chuck; he and I against the world. Being Orion's resident Darth Vader didn't appeal to me. I suggested the character be hopelessly disfigured by the blast and wear a mask. They could bring someone else in to play the part.

They never paid me my deferment.

CHAPTER SEVENTY-SEVEN

THE LONG ROAD
BACK

O
ne day I got a call from Kam Yuen. He gave me a task: to write a book about kung fu philosophy. He said it was needed to dispel the many misconceptions caused by the superficial way the subject was being treated in films. I had to agree with that. I started off, making notes and doing research. It turned out to be a much bigger project than I had imagined. *Spirit of Shaolin*, published in 1991, took me years to complete. I learned a lot about the subject in the process—became an authority, actually.

⇒ ⇐

JOSÉ LUIS BORAU, a Spanish director, wanted me to participate in a movie; his first in English. He chose as his subject the border between Mexico and the U.S. *On the Line,* it was called. The full financing never really came together, so he decided to resort to guerrilla filmmaking, which I, of all people, could certainly get behind. I was paid $25,000, with a very large deferment. We shot in Nogales, right on the border and across the Rio Grande in Nuevo Nogales.

José was always getting in his own way. He fell far behind. He didn't just leave some scenes out, he left them unfinished. More of a problem, since to complete these sequences he had to be able to match what he had already. His English was not so good and neither

535⇐

was his Mexican Spanish. He made an enormous mistake in casting, hiring a boy for the juvenile lead who was not an actor. He was a waiter whom José had met at a restaurant. José liked his energy. Not only couldn't the kid act, but he decided he was a "star," making it impossible to deal with him. We ended up having to cut to shots of boots, hands, anything to stay off his doltish face. We broke up camp with the movie unfinished.

I arranged a screening with Nene Montez for some backers to finance completion of the film with money from Nene's Third World Foundation, which, miraculously, still existed. The project was ideal for them, but they couldn't get past the waiter.

About a year later, Angie Dickinson asked for me to play opposite her in a TV movie. At the same time, José came up with money from Spain to finish *On the Line*. I did both pictures at once, one in the daytime and one at night. Predictably, whole sequences of *On the Line* had to be reshot. The light was different. The cameraman was new, some of the minor performers were unavailable. *On the Line* won prizes at European film festivals. It was never released in the U.S. I never saw the deferment.

Working with Angie was a dream. She was a rough, tough, sexy woman who every once in a while became a sweet grandmother. She was a real trouper. We were working nights at Indian Dunes, out in the cold and windy desert. She spent the whole night right out there with the boys, wearing a white nightgown and barefoot. It was her show and she wasn't about to let any of it go on without her.

The name of the show was "Jealousy." I played a broken-hearted ex-lover who just happens to own a gun shop.

⇒ ⇐

GAIL HAD A COTERIE of old cronies with whom she would constantly party. I couldn't figure out how she did it. Night after night until dawn. She'd sleep it off, then wake up fresh as a daisy and work all day.

One morning Gail came to bed just as I was waking up. She passed out the moment she became horizontal. I was angry that she'd been up all night and I had had to sleep alone. I went upstairs to the

kitchen to make coffee. On the table was a letter from her. A love letter. As I was reading it, I suddenly realized it wasn't a letter at all, it was a song. I took it to the piano and started working up music for it. After a couple of hours, Gail came up and said, "You've got it almost right." Suddenly we were a song writing team.

There are no mistakes, only new beginnings.
The past was as good as we could make it.
There are no failures, only other hills to climb,
And there's a star, just for you. Reach out and take it.

Sometimes it takes a while, so hold on to the dreams that you
Always had in mind.
And then somewhere you'll find, it's right there at your door.
There's so much more, just waitin' for you,
just waitin' for you.

There are no mistakes, only new beginnings,
And there's a star, just for you. Reach out and take it.
Reach out and take it.
Reach out and take it.
It's yours.

Dad, like the rest of us, fell in love with Gail and, seeing how well she was doing by me, asked her to take him on as a client. She started getting him work right away. His first job was a commercial for *Encyclopaedia Brittanica*. He rode down from Montecito on the Amtrak and she had him picked up by a limo, outfitted with Players cigarettes and La Iña sherry. He remarked that it was the first time in his career that he had been treated like a star.

The shoot went late and we had a dinner party to go to with John Claude Fredreich, an old friend from Europe whom I rarely got a chance to see. So, we took Dad along.

Dad had set fire to his closet the year before and had only a Harris tweed suit with a tweed hat to match. He looked like Sherlock Holmes. The party was at Morton's, an exclusive and very loud restaurant. There was a beautiful young German girl there. She looked like

Marilyn Monroe at her best. She was wearing a black lace gown, drinking black coffee, and would speak only in German. She seemed unhappy.

Dad started reciting to her in German, which I didn't even know he could do. She perked up. Then he sang to her in German. She melted. At one point she turned and said to no one in particular, "I don't know vhat is happening. Dis has never happened to me before. I love dis man." Dad leaned across her to me and said, "Son. You're only young once!" By the end of the evening they were necking in the back of Jean Claude's Rolls Royce. Dad was 76. The girl was 22.

He went to an interview one day and got lost. He sat down on a bench to catch his breath—actually, he was having a mini-heart attack. A little blonde girl stepped up to him and asked, "Aren't you my grandfather?" He must have thought he was seeing an angel. It was Martha Plimpton, Keith's firstborn. Perhaps she was, for that moment, an angel. She took his hand and led him to his interview. He got the job. I think that may be the only time they ever met.

Gail represented him for two years, during which time he made more money than he had ever, in his whole career, made in any four years. Then he fired her. His reason was that it was too much for him; he did not want to die on a soundstage.

After that, we rarely saw the old man. He drifted away from us into a new life with new people.

➤ ⬅

WARNER BROS. WAS bogging down on *Kung Fu: the Movie*, so I looked around for some other way to make use of my renewed interest in martial arts.

My old friend Roger Corman came up with it. He sent me a script entitled *Caine of Dark Planet*, which was a sword-fighting picture that takes place on another planet, to be shot in Argentina. It was essentially a remake of *Yojimbo*, the Samurai movie by the great Japanese director, Akira Kurosawa. I liked the idea, but was uncertain about the legal aspects.

I called up Roger and told him I loved the script, but what about the *Yojimbo* factor.

Roger said, "Yes, it is rather like *Yojimbo*."

I said, "It's not like *Yojimbo*. It IS *Yojimbo*."

Roger said, "Let me tell you a story. When *Fist Full of Dollars* opened in Tokyo, Kurosawa's friends called him up and said, 'You must see this picture.' Kurosawa replied, 'Yes, I understand it's rather like *Yojimbo*.' His friends corrected him, 'No, it's not like *Yojimbo*, it IS *Yojimbo*. You have to sue these people.' 'I can't sue them,' he responded. 'Why not?' 'Because,' Kurosawa confessed, '*Yojimbo* IS Dashiell Hammett's *Red Harvest*.'"

I went for it.

The title was eventually changed to *The Warrior and the Sorceress*, which was odd, since there was no sorceress in it, only a priestess. Roger said market research had told him the new title would sell more tickets.

When I arrived in Argentina, I was informed that one Anthony de Longis was to play the Bad Guy and choreograph the sword play. I had a grudge with Tony that dated back to *The Silent Flute*. I thought I would have to fight him. I asked, "If I kill someone over a blood feud in Argentina, what will happen to me?" I was told, "In Argentina, no problem."

As it turned out, Tony and I became friends and I had to abandon my grudge.

Three days into the shoot, I broke my right hand in five places, so the picture had, for me, the added advantage of teaching me how to use a sword with my left hand.

I went to the emergency clinic. The doctor x-rayed it. He looked at the x-ray and said, "I can't set this hand." I looked at the picture. It was terrifying. The two center bones weren't even there. Just disconnected bits and pieces. The one for the little finger was a clean break, the wrist was broken and dislocated. I thought to myself, "Oh God and I'm in Argentina. I'll end up with a hand like a claw."

As it turned out, a doctor who had been named in the U.S. as the best hand surgeon in the world was an Argentine. He was at that time on vacation in Tierra del Fuego. He came out of semi-retirement to fix my hand. I only saw him once, when, in the middle of the operation, I started to come out of the anesthetic. I could see this very old face looking down at my hand. He didn't wear a mask. This was

Argentina. Then I went out again. I woke up in the hall again and in the room. I was deliriously trying to smash the irritatingly painful cast against the stainless steel bedstead. They were going to strap me down. Gail said, "NO! You'll make him crazy. He'll tear the whole place apart. Just give him another shot."

I was back on the job in three days. The cast, which left my fingers and thumb free (important so that they could be exercised) I encased in black leather with metal studs over the knuckles, making it a warrior's glove.

They had sent me home with a jug full of Demerol and a bunch of needles. Gail, with her equine smarts, shot me up until one time when she popped me three times without getting it in.

Gail had to go back to California to do some business. While she was gone, I looked for an engagement ring. Gail likes emeralds. I checked out every emerald in Buenos Aires. When I found the best one, it was in a setting that surrounded it with twenty-five diamonds. I said, "I'll take it if you get rid of the diamonds." They were shocked. They said such an important stone needed to be displayed properly. I offered my opinion that the stone would look a lot more important without being smothered in all those little diamonds. Four would be enough. An engagement ring is supposed to be a solitaire. They didn't like it but they complied.

When Gail came back, I took her to the zoo, where she fed a giraffe and was almost eaten by a polar bear, then for a hansom cab ride. On the ride, I gave her the ring. It promptly fell off, bouncing off the carriage floor into the park. I got on my knees and combed the grass until I found it. She put it on another finger for the moment.

We had an engagement party at the British Consulate. This was happening in 1983 during the first anniversary of the Falklands War. The British had all prudently exiled themselves. The country was a shambles. The English had been the administrators of all the industry. Now there was nobody there who knew how to read the labels on the boxes. The Consulate was under constant surveillance. Because of partying with the ambassador, so were we.

Luke Askew and I crawled the city, looking for Irish whiskey. We actually drank up the whole city's supply, pub by pub. Everywhere we went we were followed by, get this, men in trench coats with the col-

lars turned up, who pretended to be window shoppers whenever we looked their way.

There were soldiers with machine guns on the street corners and in front of the hotels. This was a military dictatorship—a desperate one. The democratic coup that was to come was already visible on the horizon.

Inflation was rampant. The standard bill to carry was a million peso note, which, when we arrived, was worth $20. When we left three months later, it was worth $10.

Buenos Aires is the most misnamed city (Good Air). There are no smog devices. Trucks and buses leave a black smoke trail sufficient for combat camouflage.

The beef is good, though they don't know how to cook it, and there are some good wines.

For some reason, in Argentina everybody seemed to want to fight me. I was forced to answer a number of challenges. They were all punks, so the situations were never exactly life-threatening, even with a broken hand. It never took more than a couple of moves or so to dispose of the threats. I didn't hurt these pilgrims, just neutralized them; maybe humbled them a little.

A memorable one was a day when we had an army of swordsmen, actually two armies, all of them fencers or martial artists. One of them challenged me. I said, "Don't be ridiculous. You don't want to fight me. Nobody wants to fight me." He threw a punch, which I slipped. He threw another one, which I blocked. Then he threw another one. This was too much. I caught his wrist, spun him around in a 180, took his feet out from under him so that he was forced to sit down hard, and then kissed him all over his head and shoulders.

He jumped up and complained, "You tore my tee shirt."

I said, "You started it. You're lucky I didn't tear your head off and, anyway, the tee shirt is probably worth a hundred dollars now."

He later asked me to autograph it. I thought of telling him what he could do with his tee shirt, but I figured what the hell and went ahead and signed it.

The cast kept self-destructing. Once it melted from being painted black, once dissolved in a hot bath, once it just came apart from banging it around. This was a very physical picture. In the eight weeks

I had eight casts. I got tired of going to the doctor to replace the cast, so I went to the special effects shop and made my own out of super heavy, essentially unbreakable materials.

I threw a right roundhouse at one challenger, the only punch I had to throw in any of these confrontations. (He was a very large specimen). The industrial-strength cast barely touched his chin, but it knocked him cold.

One of the convenient things about martial arts mastery is that really dangerous fighters rarely feel they have to prove it to you. The martial arts are a spiritual discipline at their apex. When one is experiencing the cosmos opening like a flower, picking fights with strangers hardly seems worthwhile. In any case, these incidents definitely strengthened my image in Argentina.

Meanwhile, in between challenges, we made this great left-handed sword-fighting picture. Since it's supposed to happen on another planet, we thought the sword play should look like nothing anyone had ever seen before; so Tony and I got together and worked out a very special style between us. A combination of classical French fencing, tai kwondo, kung fu, Philippine stick fighting, and some stuff we made up ourselves.

The movie went well, though it never played much in theatres because of an odd decision on the part of the director. He was obsessed by the body of the actress who played the priestess, so he costumed her in a topless outfit. Everywhere you looked there was this bare-breasted woman. Since the picture appealed primarily to kids, censorship dictated that it would never really reach its audience. It has, however, become a perennial hit on cassette.

If you get a chance, by all means take a look at it, if not for the exotic bare-breasted priestess, for the exotic left-handed sword play. I kill fifty-two people in it; each with a slightly different esoteric blade technique. Don't expect a great movie. John Broderick, the director, quit during the editing because of a money problem with Roger. John had gone almost two weeks over schedule, a huge fiasco for Roger. The editing was finished by two teams in two countries. It's all a little uneven.

After all the madness of Argentina, we decided to decompress in Rio on the way back. We got off the plane there and were going

through customs, when we discovered that we couldn't get into Brazil without a visa. The travel agent in Argentina had neglected to tell us this. As we discovered this glitch, our luggage was on the belt, going across the line. Gail jumped on and illegally entered the country to retrieve the stuff. There was a mountain of it. We had picked up a couple of cubic yards of souvenirs. Then followed a heated discussion in pidgin English with the officials. Suddenly we were deserted as they all converged on a newly discovered dope smuggler. We hauled our suitcases and boxes back across the line and caught a plane to Miami. I was by now eager to hear some English spoken.

We stayed two days in Miami Beach and then drove a rented Mustang convertible down to the Keys. We intended to spend one night—we ended up staying for two weeks. The place was one big party.

Somehow, we made contact with my old friend, Nene Montez, now living in Miami with all the other Cuban refugees. He was trying to get a huge consortium together, with vast funds, to assemble works of art in support of "The Third World." (I never did understand this "third world" crap. There's only one world and we all have to live in it.) He wanted me to head up the motion picture arm of the project. Okay.

Nene was on his way to an important meeting with a banker who was supposed to have spent some time in a Havana prison as a political prisoner of Castro. Nene said that there was a secret code word that would prove whether or not the dude had really been there. Everybody who had knew it. Before we went to the meeting, which was dinner at the banker's house, Nene's lawyer told him, "Listen, Nene, one thing. While you are in this man's house, you must not say, 'Motherfucker.' This man is very straight. If you blow this meeting, you don't just blow it with him, you blow it with the whole banking community."

Nene promised to be good. We went to the banker's house. Nene spent the first part of the evening telling the hired help that, after the revolution, they wouldn't have to do this work. Then he tried his secret code word on the banker. The dude failed the test. So when we moved into the drawing room for brandy and cigars, he said he had something to say.

"My friend, this attorney, who has introduced me to you and who is a very wonderful man, has told me that, whatever I do, while I am in this house, I must not say, 'Motherfucker.' So what I want you to know is that, no matter what, I will not say, 'Motherfucker.' Because he told me not to say 'Motherfucker,' so I will not say 'Motherfucker,' even once."

Of course, that was the end of Nene's consortium, but it was almost worth it.

Later, the attorney raved at me that Nene was on coke. I said, "Man, I was with him every minute. He wasn't on anything. That's Nene."

AMERICANA

C hris Sergel came up with a venue for *Black Elk Speaks*: six performances in a twenty-eight hundred-seat state of the art house in Tulsa, Oklahoma, with plans to take it on the road: Window Rock, Arizona, The Tyrone Guthrie Theatre in Minnesota, Denver, Colorado, the Ahmanson in L.A., and then New York.

We made another pilgrimage to Harney Peak. Gail went along on this trip. This time we went up the mountain on horses. J.R., the Iroquois producer, consecrated a peace pipe for me. I was given the name, Sees Buffalo.

We attended a Pow Wow, where Gail struck up a conversation with a handsome, beautifully muscled red man in full ceremonial dancing garb, eagle feathers down to his ankles. After a few minutes, he said, "Now I must dance," and hop-shuffled off.

Gail said, "That's the softest, sweetest man I've ever met."

I laughed, "Gail, that's Russell Meanes, the most dangerous militant redskin in the country."

She wouldn't believe me. Chris corroborated me. Later, we were made fun of over the P.A. by the chief and then honored with tribal memberships.

Back in California, my divorce finally came through. Linda and I parted as friends. After the courtroom appearance and the crash of

the gavel, I watched Linda trotting, almost skipping, out the glass doors to the street, her wild hair blowing, her lovely print dress whirling about her legs. I'll never forget that moment. It was the real good-bye.

It was time to go to Tulsa to do *Black Elk Speaks*. I cut back on the booze and plunged into rehearsals with a vengeance. Rehearsals were me, a sprinkling of white men, and twenty-four red Indians. We spent a few hours in a sweat lodge out in the country. I had two experiences. I can only call them: visions.

One was of a red eagle with a white head, in the center of a huge round stage, trying to reach the world beyond with an important message. This was my great fear; that, not having worked on stage for years and having more words to speak than Hamlet, my voice wouldn't hold up. The other vision was more in the nature of a manifestation: a bear, in the sweat lodge with us. I blinked my eyes and he was still there. He was real enough to blot out the glowing red-hot rocks in the center of the lodge. He turned his eyes on me and seemed to be silently trying to communicate something to me. Then I felt an energy flow into me, so powerful it was almost too much for me. The bear is a symbol of strength. The seeker next to me, at that moment fell over and writhed around in the dirt. Someone moved to help him outside, but the leader said, "Let him be, he'll pull it together." After a minute, he did. He sat up and finished the sweat. I described the eagle vision. The leader told me my voice would not fail me. For some reason I kept the bear to myself.

The leader that night was a young man named Hector. He was wise beyond his age and sure with himself and the others. I said to him, "You are going to make a great old man."

He said, "I doubt if I'll live that long."

Militancy has its drawbacks. "A pity." I said. "We need old men like you."

He later became president of the Sioux Nation.

When we came out of the sweat, a young brave asked me, "Was it hot enough for you?"

I replied, "It's not supposed to be an ordeal, it's supposed to be a gift."

Three of us lounged in a hot tub while the others ate. Hector said, "It would be perfect if there were eagles."

I looked up. "There they are." There were three golden eagles circling directly above us.

The show was a big hit. My voice did not fail me. We played to standing room only. It was the first time the theatre had ever had a full house. My dad, Free, Bobby, Ever, and Gail came to see the show. Dad was impressed. He told me we should take it to Broadway. My sentiments, exactly. More than that, I expected to be playing Black Elk from time to time from then on, like Yul Brynner and *The King and I*. A good dream; alas, not to be forthcoming.

⇒ ⇐

BECAUSE OF THE *Heaven's Gate* debacle, United Artists changed hands. The story I heard is that Kirk Kerkorian, who owned MGM, called Transamerica, the parent company of UA, and said, "I know you're in trouble, so I want to buy UA."

Transamerica said they weren't in that much trouble and they didn't want to sell.

Kirk said, "Let me put it this way: if you don't sell me UA, I'm going to buy Transamerica."

They said they'd get back to him. Later, they called and said, 85 million."

Kirk said, "Done."

Suddenly, there was no one left anymore at UA who had even seen *Americana*. The interest seemed to have vanished.

One morning Gail said to me, "Why are you depressed?"

I said, "My movie is going to open in one theatre with no publicity. I spent twelve years on it and it's all going to just go down the drain."

She went right to work.

I reluctantly bought the picture back from UA. We went all over looking for a distributor. At one point, we thought we had a hot one. A company run by Mormons in Utah had big plans for us. The president of the company turned out to be a closet profligate: after-hours

liquor buys, suites full of hired girls, bags of cocaine stuffed into the cushions of the couch. We passed on them.

Roger Meyer at MGM found us a release. There was no front money and there were no guarantees. It wasn't an ideal situation, but at least it was a situation.

The MPAA sent two ladies to establish the rating. I was trying for a PG. Their objection was that the killing of the wolf was too graphic. I was amazed. I said, "It happens off camera."

The lady said, "It does?"

Her companion said, "I noticed that."

The first lady said, "It's the crack of his spine. It's too shocking. Can you make it softer?"

I said, "That requires a remix. I can't afford it. How about if I shorten it?"

They said, "Okay "

After a week, I showed it to them again. They said, "That's much better." I got the PG. I hadn't changed anything.

A woman from the American Film Institute looked at *Americana* for possible inclusion. They passed. She said, "I don't know. It's a very disturbing film." After sheltering the likes of *Freaks, Paths of Glory,* and *The Little Dictator,* they found my little morality play too disturbing. How about *The Oxbow Incident,* or *The Execution of Private Slovik*? How about *Of Mice and Men,* or *The Killing Fields*? What about *Citizen Kane* for disturbing?

Well, if they can't take a joke, fuck 'em.

Americana opened in New York in two theatres. I went there to promote it. I went on TV shows. I gave interviews and had my picture taken. My poster and ad had been replaced by inferior ones, but they were there.

The day of the opening, I started the push again with the morning talk shows. As I got into the limo, the New York publicity aide handed me some reviews. I said, jokingly, "Are any of them any good?" She said, "Not really." I felt a chill. I read them: five of the worst film reviews I had ever seen. They not only hated the picture, they hated me for making it. I stumbled ashamedly through the talk shows and then went to the first performances at both theatres. There was an audience of fifty at the first one and seventy-five at

the other. Both audiences gave the picture a standing ovation, but we were a flop.

We smiled and waved and ran. Back in our suite at The St. Moritz, I stood in the wind on the balcony and stared at Central Park. Michel Rubini, on hand to act as musical director for a gig Gail and I had set up for ourselves at The Lone Star Cafe, said to me, "Well, David, you're telling people some things they'd rather not hear." I went to the bathroom. I sat on the edge of the tub and cried; one good shuddering sob. Then I threw up, brushed my teeth, splashed water on myself, put on a clean shirt, and went on with my life.

First up was an interview with Fred Yager, a journalist who had attached himself to the adventure. Fred said, "David, don't you know how the critics watch a movie when they're by themselves? They talk and joke and throw spitballs at each other, drink wine or whiskey, and decide among themselves what they're going to say." I resolved never again to let the critics, or anyone else, see the picture without an audience.

Gail and I did a photo shoot for *The National Enquirer* and we let it all out with the band at The Lone Star Cafe. We filled the place to the brim and got them all shouting and dancing. Sometimes the magic works.

Back in L.A., I started my own campaign to get *Americana* in front of America. First, I arranged a glittery screening at The Cary Grant Theatre at MGM. Gail put together a tiny task force of three beautiful ladies, and together we generated enough interest to fill the house. I had the small satisfaction of watching the fire marshal turn away a few immensely powerful moguls who had come late. I sat on the carpet halfway up the aisle and lost myself in Drury, Kansas. It all worked. The enlightened crowd of successful, jaded movie people laughed and cried at my simple story and went away with their heads spinning. Walter Hill said, "It's not a movie, it's a poem, and there is no greater compliment than that."

I took it over to the Laemmle family, old Hollywood pioneers who at one time owned a big chunk of Universal. They owned a the-atre chain in L.A. They liked it enough to book it. They used my ad campaign and threw it out there. This time, the movie received the five best reviews I've ever read for any movie. The first week, the picture

broke the house record. It played for seven weeks. Nothing much ever happened to it after that. That was its only moment of glory. It was on cassette for a while. Even today, though, a decade later, people from all walks of life stop me on the street and speak of it with wonder.

➤ ⟸

ABOUT THIS TIME, Kam Yuen came up with another task for me. He wanted to make two video cassettes instructing people in the art of kung fu and tai chi. He wanted me to be the instructor. He introduced me to his partners and they proved to know a lot about martial arts and absolutely nothing about making movies. They had done one thing, however, that gave me faith in them—they had hired Kent Wakeford to photograph it. Kent had done the same honors for Martin Scorcese on the movie, *Mean Streets* and is one of the best, in my book.

Kam and I worked out together for a week or so to tune me up and we proceeded. The production was extremely fancy, with special costumes and a spacey indoor set, complete with a "class" of photogenic female and male athletes. I thought it would have been more in keeping to shoot it outside on a beach or in a forest. And the costumes smacked of "Star Trek," but the message was there. There was a preamble on a set more in keeping: the walled meditation garden of The Yamashiro Skyroom.

Kung Fu: the Movie finally came around as a movie for TV. I thought this was a marketing error myself; there's a lot more money to be made in a blockbuster movie. A TV show, however, would reach more people and TV was where Kwai Chang Caine's fans were, so I said yes.

The change to TV lost us China and required an extensive rewrite and a delay. We also lost Radames Pera. The studio, in its infinite wisdom, had selected Brandon Lee, Bruce's son, to play Caine's son. Radames and I didn't get credit for our original story and they wouldn't let me have Jim Weatherill or Herman Miller. Jerry Thorpe, Alex Beaton, Chuck Arnold, and Richard Rawling were unavailable. You can't always get what you want.

While I was waiting for the rewrite, I prevailed upon Warner Bros. to pay me a holding fee. They said they had spent all they were

allowed to. I said, "Well, then, throw me a bone. Give me a job in something else." They came up with the role of the weird gardener in a TV remake of *The Bad Seed*.

At that time, I had a spiral fracture of my left shoulder. The way that happened, I'd had a hemorrhoid operation. While I was recuperating, Gail threw a birthday party for someone. I took my pain pills and a Halcyon sleeping pill, lay down in the spare bedroom like a good boy, and went to sleep.

While I was in the Land of Nod, the Wolf Man rose up and went to the party. I got wild and woolly and then talked about suicide. I was sitting at the top of the stairs, being calmed down by an attractive female psychologist, her arm around my shoulder, when she asked if I'd like some orange juice. I said yes and she took her arm away and left. I promptly rolled down the stairs and bounced off the newel post, landing in a perfect yoga "plow" position. Right away, I knew something was very wrong.

The only thing that was holding the shoulder together was the sheath, or ligament, that surrounds the bone, which was especially rugged due to my kung fu training.

I played the useless arm as part of the character and threw in a dragging leg and a lopsided face for good measure. I affected an idiot smile to top it off. I had an immense amount of fun. ABC saw the footage and put me in the miniseries "North and South," playing the meanest man in the South. I worked on that picture for six months: in Charleston, South Carolina, someplace in Louisiana, Natchez, Mississippi, and in the hills of greater Los Angeles. I did awful things. I whupped slaves, cheated at duels, fed opium to Lesley-Anne Down and kept her locked in the bedroom, all the while acting the perfect gentleman. The character was a cross between Rhett Butler and Count Dracula.

The reviewers raved about my performance, calling it the role of a lifetime. I sure hoped not. When I pour my heart into something, it usually goes right over the critics' heads. When I smoke cigars, talk mean and kick people, they call it great acting.

⇒ ⇐

WHILE I WAS IN Charleston, the inevitable finally happened. The board

of health took Kansas away from Linda, who they charged with neglect. I pleaded with Chuck McClain, the executive producer, and he let me fly back to L.A. for the hearing. I won Kansas. Her grandmother turned her over to me with the clothes on her back and an Easter basket, nothing else. I took her to South Carolina. She was seven years old, scared, and wanted to go home. Gail came and took over. She took her shopping and moved us to a better hotel. We had the Elizabeth Taylor Suite, with a room for Kansas. We hired a tutor so she could get her homework done. We became a happy little family.

In Louisiana, I discovered a litter of "Leopard dogs"—official name of breed: Catahoula Cur. A dozen little Buffaloes. I realized, "Of course! This is where they come from." The Catahoula is the oldest American breed. It's a cross between a Spanish War Dog (the Matin de Napoli) and the Louisiana Red Wolf. Its forebears are rare to the point of extinction. Catahoulas aren't much better off. They hunt, catch, herd, track, fetch, fight, and guard. They come in five colors, sometimes all together. They have brown, blue, or green eyes, usually unmatched. Their mucus membranes are pink and their paws are webbed. I picked up four puppies from various breeders, to take home with me.

Back home, we shopped for beds, clothes, toys, and a swing set. We enrolled Kansas in the local school. It turned out Linda had been neglecting to take her to the school in Malibu. She hadn't been there in months.

Meanwhile, Calista and Patrick Culliton had a fight. That was the end of the engagement. Calista had found another man.

CHAPTER SEVENTY-NINE

BEHIND ENEMY LINES

I continued with the finishing touches for the Instructional Video. It seemed to need more footage, so I volunteered to pay for some extra shooting. The editing was not going well and the music was inferior, so I brought in David Kern, the editor of my personal films. The music was solved by giving it to Gail to coordinate; she had the smarts for the job, as a singer, songwriter, and record producer of great ability and some note.

One morning I came upstairs to discover a Xerox machine sitting next to my piano. I said, "Okay. That's it. You either get yourself another office or another house." Gail started working on that.

With the video resolved and in the works, Menahem Golan finally came through. I went off to film *Behind Enemy Lines* for him, later changed to *P.O.W. : The Escape*, shooting in the Philippines. I had to do the final pre-production on *Kung Fu: the Movie* by remote control from Manila. However, I felt secure about it, having ensconced Richard Lang as director, the person I would most trust with the material, Jerry Thorpe, being unavailable.

The Philippines was a fairly bizarre experience. There was a lot of guerrilla activity. Every day we took a different route to avoid being taken hostage. We changed cars every two days. When we were working in the jungle, we were guarded by Marcos' army. Out in the

553

trees, surrounding them, were the communist guerrillas. They had great interest in watching us fight the Vietnam War.

There were two kinds of guerrillas: Communist and Muslim. There were also the pirates who ruled the outer islands and went anywhere and did anything they wanted.

A Japanese tour bus was stopped on the highway by some of these patriots. The children of the rising sun were relieved of their money, their luggage, their watches, cameras, calculators, sunglasses, clothes, Nikes, and the bus. The perpetrators left them standing beside the road in their underwear, 60 miles from Manila, with no money and unable to speak the language. From a distance it's funny. The Japanese tourists probably didn't think so.

The director, Gideon Amir, was some kind of genius. During one scene I overheard the cameraman, a veteran of six Middle Eastern conflicts, say, while looking sideways at me, something that sounded like, "Musha shu b'ma bot."

I said to Giddy, "What does that mean?"

He said, "It means, 'Something about your look.' You're watching a jeep full of soldiers get blown up. You just talked to them less than a minute ago. These troops you think of as your children. There's something unnatural about your children dying before you do."

I stared at him and said, "Giddy, you're a goddamn philosopher."

He said as he walked away, "You gotta do something."

I became fast friends with him and with a fellow actor: Charles Grant. Charles and I hung out together all the time. Charles discovered a Philippine moonshine made out of coconuts: Lumbanog. We consumed a whole lot of it.

Greg Walker, who was there to stunt for me, came down with an almost fatal case of dysentery as a result of sampling food from street vendors. They sent him home. He vowed he would never leave North America again. The Pacific Rim is no place for a cowboy.

I got a message from Christian Alan Oberholzer, my buddy from South Africa. He was being sought by the thought police for militant anti-apartheid activism. Translation: he had written a protest song and played it on street corners. His assets had been frozen and his arrest was imminent. I escaped him from South Africa by remote control, and Gail arranged for his acceptance into the Philippines by

showing her legs to the immigration official. Alan became my stunt double.

We weathered a monsoon—shot right through it. Very danger-ous, but it looked great on film. Everything was dangerous. I got blown up once. I discovered that a flak jacket really works. There were leaches and, needless to say, a lot of poisonous water. The Manila Hotel was twenty acres of heaven in the middle of all this. We rented the honeymoon suite. On a Saturday night we rented the penthouse, which had its own swimming pool, for a cast and crew party. We tore up the place and at the end everyone went in the pool with all their clothes on. In the pre-dawn darkness, we looked down and saw tanks being deployed in the streets.

Gail took me into the village to see a sick child. An angelically beautiful young mother was holding the child. I put my hand on his forehead. It was burning. Gail said, "They can't afford the doctor. You could get our company doctor to treat him by snapping your fingers."

I snapped my fingers. The doctor cursorily examined the kid and said, "He has meningitis."

I said, "No, he doesn't. Don't say that! Just give him the shot."

The next day, the baby's fever was down. I became a hero in the village. The boy's father was the chief. A few days later, Charles and I were strolling along and saw through a window the mother nursing the child. The sight was so beautiful we had to catch our breaths. She smiled at us shyly and we discreetly moved on. That was our reward, that smile from an angel.

An interesting sidelight: in the rumors that circulated and became history, it was Keith who saved the baby. I guess people don't expect that kind of stuff from me.

Charles and I were the only cast members who did not get sick at all. Charles followed my lead in every way. I had many tricks and Charles adopted them all, no matter how silly they seemed on the surface. The other actors and those of the crew who were new enough not to have acclimatized all came down with something. No one gave up. Phil Brock worked right through hepatitis. He was bright yellow, but he kept on fighting. We were a tough bunch.

The Manila Hotel was a safe haven amid the filth, disease, and impending revolution and we clung to it like a life preserver. By the

end of the shoot, I was totally used up. I received an invitation to visit a Shaolin temple in China, a once-in-a-lifetime opportunity. I was so beat that I turned it down. I flew to Hawaii, where I met up with Gail. We stayed about five days while I regenerated myself.

When we got back to California, I walked into a new house. A huge place with four fireplaces, an almost Olympic-sized pool, a basketball court, and hundreds of trees. The house had once belonged to Marlon Brando and was full of quirks, including a secret room behind a bookcase. We settled in very comfortably, though we had to buy a lot of furniture to fill up the empty spaces. The house on Woodrow Wilson became the office. Gail moved her brother Scott into it.

There was some good kung fu fighting in *P.O.W.*, so I arrived at Warner Bros. in a high state of training. Three days into the shoot, I broke my hand again. I expected Richard Lang to be devastated by that news, but he merely looked at the cast and said, "That should make it more interesting." Richard loves a challenge.

I arranged a work visa for Alan and he stunted for me. I did all the fighting, but he jumped off buildings and stuff like that.

It was just like old times. Lots of the old boys were on hand: Keye Luke, of course, Benson Fong, Roy Jenson, Kam Yuen, Mako, Mike Vendrell, Alan Fama, Jim Spahn. Unavoidably missing were Philip Ahn, Richard Loo, Victor-Sen Yung, and Frank Westmore— God rest their souls. There were some great new people: Kerry Keane, Luke Askew, Bill Lucking, Martin Landau. For extra spice, Calista had a part. We knocked out an excellent show and, as Richard Lang proudly announced at the end of the last day, we did it without a single camera trick.

After the show was aired, there was talk of doing a new series— a modernized version, with Brandon and me playing Caine's grandson and great grandson, to be produced by the team that had been responsible for "The Dukes of Hazzard." I had visions of kung fu car crashes, midget mayors, and underdressed, over mammalian girls and decided to pass.

Calista married her new guy. Right away, she was pregnant again. The husband had no job and two other children he didn't support, so this didn't look good. They lived on welfare. The husband,

Adam, had a hard-on about me. I was not allowed to see Calista or the granddaughters. We met secretly on street corners.

With Calista gone, Patrick started drinking a lot. We mourned our loss together. One night he got completely out of hand and physically attacked me. He came at me with a maniacal, crazed Vietnam vet grin. He was so drunk he could hardly stand up, but that didn't make him any less dangerous. I side-stepped his lunge and he went right into the balcony rail. He almost took it out and had a flying lesson. I caught him before he plunged to his death. He left in a huff. I don't know how he made it home. He didn't remember anything about it in the morning.

> <

MY NEXT PROJECT was *Six Against the Rock*, a prison-break movie for TV. We shot most of it on Alcatraz. That was an eerie experience. Even with its teeth pulled, the island weighed on your head and shoulders like an iron blanket.

The show was excellent, though sad and very bloody.

Menahem Golan offered me a five-picture deal. I was riding on a cloud until his company went belly up.

I went back to Mississippi to do more "North and South," the sequel: another twelve hours. During the interim, everybody had been divorced, or married, or both. Some were with child. I went to Lesley-Anne's wedding. There were a couple of new babies among the guests. I got an okay review from *The Hollywood Reporter*. It said, "David Carradine's early demise is a loss from which the movie never fully recovers." It's nice to be appreciated.

> <

I LEAPT INTO being a hands-on Daddy with gusto. I woke Kansas every morning, or she woke me. One of us would make breakfast. I would make her lunch or give her lunch money, whichever she wanted. Then I would drive her to school. I'd stop at L'Express for an espresso and a Pernod. Sometimes I went up to the ridge and visited Captain and Majetek, or over to the Equestrian Center where I was boarding Indian Woman and Z-Bar. When I got back to the house,

I'd usually go to the editing room. At 4 P.M., I'd pick Kansas up. She'd play around the place and do her homework. (Kansas loves school.) We'd have dinner and I'd tuck her in and read her a story.

Because the courts were involved with Kansas' welfare, we had social workers all over us. Kansas had too many friends. (?) There were too many musical instruments. (?) Too many horses. (?) The swimming pool was too luxurious. I had too many weapons (true enough: swords, knives, guns, kung fu stuff—my business, as long as Kansas didn't get at them.) Every day was a violation of our privacy. They went around opening cupboards, looking for liquor or sex toys. They demanded that I be randomly blood tested. I didn't see why. I was not the offending parent, but I said, "Sure."

They also wanted my fiancée tested. The judge said, "Fiancée today, girlfriend tomorrow, stranger next week. I don't think that's necessary." It was clear to Gail and me that he'd be more on our side if we got married. We had tried more than once. We'd send out the cards and then have to cancel because of a job somewhere. We had the trousseau, the rings, the church, everything.

I converted the garage to an editing room. My editing rooms had always been picturesque. This one was English Tudor. I installed a large window, so that I could lean on the sill and watch the kids playing in the pool. I was working feverishly on *Mata Hari* and *You and Me* in its new version. I added a re-edit of *A Country Mile* to the mix. I was doing it all completely alone now. It seemed to work better.

We met a big Swede named Roger Mende. He took to coming over to the house with a jeroboam of Mumm's Champagne. We would talk about making movies. I told him everything I knew. Sometimes he'd sleep over. He always refused a bed. He conceived two of his children on the rug in my office. One of them he named after me. After about two years, he disappeared for a while. The next time I saw him, he had made two movies of his own, using my guerrilla methods.

Fred Olen Ray, who had made a picture or two with my father, offered me a pretty good script. Theoretically, the size of the project was supposed to be beneath me, but I needed money, as usual. Lee Van Cleef was my costar, playing my father. Lee was a certain amount of fun and his performance was excellent.

The first day of the show was at a bar in Hollywood. The A.D. told us that only one of the trailers had arrived, so we could take turns changing into costume. Lee said, "No. We'll just wait till the other one arrives." The A.D., somewhat taken aback, said, "Uh, fine. Would you like some coffee?" Lee said, "No. Bring me a beer." The A.D. laughed. Lee said, "I'm serious. That's what I have for breakfast."

The picture came out somewhat lame—the studio had gotten its hands into it. One of the executives, an extremely beautiful woman with a bite like a rattlesnake, pretty much took over. Fred didn't have much to say about it, but at least it got a theatrical release and it paid the rent.

I ran into Red Hershon, who I knew all the way back from *Heaven with a Gun*. He was putting together a picture to be shot in Colombia. I was to play an Hispanic capo in an organized family which is smuggling cocaine into the U.S. My co-star was a painfully young newcomer named Madeleine Stowe. There we were, making a movie about dope, in a country that was fighting tooth and nail over the subject.

It was fairly dangerous. I had a couple of close calls. We were fairly well separated from the madness. The money for this movie was squeaky clean. It came from milk; thousands and thousands of cows.

The story was sort of like *Romeo and Juliet*. I was the serpent in the garden. While we were there, the Pope made a visit. I saw him from a second story window going right by in his bullet-proof glass Pope-mobile, his hand in constant motion, blessing everyone.

⇒ ⇐

A MOVIE CAME up in Yugoslavia. I was to play a Nazi colonel. It sounded interesting. We took Free (now Tom) along with us. Oliver Reed was in the movie. He played the general. After the movie was finished, we vacationed for a week in Dubrovnik. We were lucky enough to have lunch with the man who had been responsible for the restoration of the city. It had just been completed. He took us on a tour of the place. I was stunned by its beauty. Today the place is in much worse shape than it was before the restoration. What the Turks, Napoleon, and Hitler had been unable to destroy, the warring factions of the former Yugoslavia had turned into rubble.

We went from there to Milan, where we discovered our luggage was lost. It had been sent to Trieste. We had it shipped to us in Colfosco, in the Italian Alps. We drove to Munich and caught a plane to Paris, where I was to promote the opening of *P.O.W.* Paris was as usual, which is to say, just great.

I did a broadcast for Radio Free Europe. They asked me, "Why are you here? Are you not afraid of the terrorists?" I said, "Fuck 'em." On the way out of the building, Free said, "Dad, would it be okay if I went home on a different plane than you?" Pretty good for a thirteen-year-old. We went home together.

� ⇒

AFTER FIVE YEARS of captivity, Calista finally left her husband. I thought I had her back, but she ran away. She had decided she didn't want the hassle of being a Carradine anymore. She wanted to do it on her own. The family wouldn't give her the time of day anyway. I wasn't supposed to know where she was, but I traced her to a little town outside Seattle where she had taken up exotic dancing to support the kids. She had tried waitressing in a health food store and other wholesome jobs, but they just didn't pay enough.

With the money she was making, she established a homestead: five acres in the middle of the woods, with a river on one of its borders. There was no water or electricity. She cleared the trees away and put up a trailer. She hauled the water up from the river. The package included two horses and a few sheep and rabbits. She had trouble with men who took advantage of her, but that's Calista.

The dancing came as a shock to me but I had to admire her grit. I could only wait to hold out my hand to her when she was ready for it. That took quite a while.

Red Hershon arranged a meeting with Terence Young at the Polo Lounge. Tarence was about to catch a plane to Rome. He was trying to cast the lead in his next film. When I left the Polo Lounge, I had the part.

When Terence got to Rome, he received a call from Peter Rawley at ICM. Peter wanted to know when he was going to get the counteroffer on Kris Kristofferson. Terence said, "I'm not using Kristofferson; I'm using Carradine."

Peter said, "Oh. Well, he was our second choice."

Thanks a lot, guys.

The movie was about a marathon runner. I started running in the hills next to the house and hired Monique St. Pierre's husband as a trainer to build me up and strip off the excess. He put me through a sort of daily dozen at the local Nautilus club. I told Vince about it. He said, "That's AIDS city, isn't it? Just don't use the locker room." We didn't. We'd come dressed to work out, do our stuff, and leave.

Gail and I went off to Rome, leaving Kansas with the people at home. Rome is a great city, one of enormous beauty and fun. We lived in L'Hotel de la Ville, right at the top of The Spanish Steps, where all the remaining hippies and folkies hang out. Many guitars. At the bottom is home plate for the horse-drawn carriages.

My co-stars were Lauren Hutton and George Segal. George was easygoing and sweet. He played pretty good banjo. Lauren I never really figured out. I'm not sure that she has.

Right away, I was assigned an Amazonian trainer to get me in shape to act out the marathon that was the centerpiece of the picture. I avoided the sessions as much as I could, but some of it sunk in.

Terence was a blast to work for, a fresh breeze from the old school. He had myriad stories, having worked with many of the greats. He was also an excellent tactician, having done all the battle scenes in Olivier's *Henry V* and having directed the first three Bond pictures.

He was a tank commander during World War II. There had been a tank battle that would be pivotal to the outcome of the war. It was going to happen in Brussels. Terence parked his tanks outside the city and sent a motorcycle messenger around to the other side to invite the German tank commander to lunch at a fine, sidewalk restaurant in Brussels. At the luncheon, Terence expressed what a pity it would be to destroy this beautiful city and couldn't they have their battle somewhere else? The German agreed. They picked a spot twenty kilometers south and chose a date and time. "All right. Tuesday it is. Tally ho, old boy." Terence won the battle, the tide of the war was turned, and they saved Brussels.

Brother Bruce showed up on his way to South Africa. For some reason, he liked the place. He was scandalized by the amount of money we were spending.

⇒ ⇐

GAIL AND I CAME up with an answer to the problem of always being on location when we wanted to get married: get married on location. I asked Bruce to be my best man. In Rome, the only legal marriage is a Catholic mass or civil ceremony. We said our vows in the ballroom of the Hassler Hotel, the service performed by a lay minister who was part of the production. Bruce had left town just before the wedding, so John Phillip Law, an old friend, stood up for me. Terence gave the bride away.

There was no honeymoon. I had to be at work at six A.M.

Three days later, we were married in the Campodoglio, known as the "wedding cake." It's an immense building, over a thousand years old. Caesars had walked the broad steps. In the wedding room, the walls were red brocade, the imposing chairs were covered in gold leaf. The Mayor of Rome performed the duties. Our friends from California, Beth and Roland, were witnesses.

That afternoon, Gail and Greg and I frolicked about Rome, seeing the sights and acting like kids.

In the chill winds of Rome, I caught a cold, which became pneumonia. At one point I was doing a scene with Lauren, chasing her around with a hunting knife. My whole body was awash with sickness. Lauren said, "I won't work with him anymore. He has some kind of horrible disease and I don't want to catch it."

After the doctor examined me, he said to Terence, "I don't really care about the stuck-up actors I examine, but this boy [boy!] will run that marathon if it kills him and it might. At best, his heart will be damaged."

Bad news, but it came at an opportune time: Terence was out of money for the moment. He shut down production, just before Christmas, owing everybody a week's pay. Gail lined up all the unpaid members of the crew and gave each of them a hundred dollars, so they wouldn't be broke for Christmas. We were to finish the picture after the first of the year.

We fled for home, leaving most of our baggage and our liras in the vault. We had an enormous amount of stuff. When we got to the airport, there was a two-hour delay because of a terrorist threat. We

would miss the plane. We took all the bags to the nearest hotel, rented their best suite, and honeymooned for three days. We ate pasta at the formal dining table, which seated fourteen. Mostly we frolicked in bed while *The Bridge on the River Kwai* played over and over on the hotel's closed circuit television.

We got home Christmas Eve morning. The electricity was off in half the house and sparks were issuing from the rain-drenched power box. We called an electrician to come save us. We sat in the bedroom, drinking vodka as we watched him work. We had just flown a quarter of the way around the globe. Time meant nothing to us. Gail asked him if he'd like a beer. He said he didn't drink. Gail said, "Not even in the morning?"

It was February by the time Terence got things back together. We took Kansas with us this time, with the blessing of the school. We had lost George Segal to another job, so we had to rewrite the ending. The shoot went very smoothly and we were out of there.

We stopped over in Amsterdam to visit with my old Dutch friends. Gail and Kansas both fell in love with Holland—easy to do. Just when we were having the most fun, I came down with a terrible infection of some kind, the final gasp of the pneumonia. In my delirium, I told Gail to go to the oldest spice shop in Europe and bring me a bunch of stuff and that would cure me. She found the place. Just to make sure, she asked the owner if there was a trapdoor in the floor. The owner looked around and lowered his voice. "Uh, yes. Why do you ask?"

"May I see it?"

Again, the nervous look around. "Why?"

Gail said, "Well, does it have seven steps going down and a little dock with a boat? And are there barrels on each side of the stairs?"

The owner's mouth dropped. "How do you know that?"

Gail: "I want some of what's in each of those barrels."

She came into the hotel room with a big bag, stuck it under my nose, and said, "Breathe." I did and felt instantly better. Then she made teas. I was quickly cured. At customs in Los Angeles, there was quite a stir over the strange smells issuing from our bags.

Roger Mende was about to make a movie in Mexico called *Open Fire.* He wanted Kansas to play a part and me to do a cameo. It

was three weeks for Kansas and three days for me. The only problem was, he couldn't afford me. I said, "Just give me the rights to France."

Two days into the shoot, Roger got fed up with the Vietnamese martial artist who was supposed to do all the heroics, so over lunch in the cafeteria he wrote him out. I took over. The three days became two weeks.

Roger was a remarkable and hilarious director. He did everything himself, even to setting his own explosives. He was always doing something no one had ever done before. The Mexican crew thought he was completely insane. I'm not sure they were entirely wrong. Nothing daunted him and he was very funny. He never got mad. If someone did something wrong, he'd sort of growl to himself and just do it himself. It never occurred to anyone to get in his way.

Roger blew up, burned, or ran over half of Churubusco Studio. By the end, they were saying, "Please, senor. This studio is our living. Save something for us."

A little black dog came into my trailer while I was sleeping and curled up beside me. This sort of thing happens to me all the time. Gail gave the dog a bath and she came out gray. After four washings there was a snow white little ball of fluff of some expensive breed. Some starlet had lost her and left without her. She had been sleeping under cars and eating garbage ever since. She became attached to us in a big way. Well, this was Mexico. She was lucky someone hadn't eaten her. We adopted her and took her home to L.A. We named her Churubusco.

At one point, I just had to leave. I had to catch a plane to do a movie-of-the-week in Hollywood with brother Bobby. Roger Mende worked me up to the last second. My parting shot was carrying Kansas out of a burning building, preceded by a very large explosion. Kansas was really scared. I sheltered her well, but I singed off all of my eyebrows and the front of my hair. Just as I was getting into the limo, I said to Roger, "You don't have enough footage. Why don't I come back after the CBS shoot and give you another week?" He was flabbergasted.

I got the CBS thing out of the way (it was a snap for me; Bobby carried the show). Then I flew back to Mexico to finish up *Open Fire*.

Hugo Stiglitz, my old friend from *Macho Callahan*, was playing

a part and I ran into Jose Armendariz in the cafeteria. I had a wonderful time. The only bummer was that I never did get my French francs, but that's not why I was doing it.

About this time, my upper teeth sort of exploded and they all had to be pulled out. I had to wear choppers, which I hated. I didn't wear them at all, except when I was on film or in some other kind of public appearance. I kept them in my pocket, killing forever the notion that all actors are vain.

Right away I went to Toronto to do a segment of "Night Heat." I had many loud, long speeches. It was quite a trick keeping the choppers from shooting out.

I had been offered a movie and had turned it down a couple of times. Because I was continuing to have problems with the IRS, I called my agent and told him to close the deal. We went on to finish the tour: London, Rome, Washington D.C., New York (to visit Keith, who was doing a Broadway play), and a swing up to Connecticut to visit with Chris Sergel and discuss *Black Elk Speaks*. Keith was invited up. I called him and said, "Incidentally, I left a briefcase under your couch. Could you bring it with you?"

He said, "Sure." Then prudently asked, "What's in it?" I said, "Fifteen thousand dollars in cash." He showed up in Connecticut with an Army .45 in a shoulder holster.

Then, with great trepidation, I flew to New Mexico to do a movie called *Sonny Boy*.

Sonny Boy was a crude, ugly, bloody, violent and perverse, funny, sweet, and sensitive film. The story was essentially *Bonnie and Clyde*, with me as Bonnie. Paul Smith, a four-hundred-pound actor, was Clyde. Add to that *Bringing Up Baby* and *The Rocky Horror Picture Show*. I wore a dress throughout the movie, not like a drag queen but more like a midwestern housewife—dressed in a slip and a polka-dot housecoat with sensible shoes. The story spans twenty years. In the sixties, I wear a Joan Crawford wig; in the seventies, a Jane Wyman flip; and in the eighties, a Mammy Yokum gray bun at the back. I took my teeth out for the old lady. I made the ugliest woman imaginable, except for the old broad, to whom I lent a certain venerable, statuesque beauty. She reminded me of Granny Peck. My name in the show was "Pearl."

I spent my off-hours at the motel bar, hanging out with truck drivers, cowboys, and federal agents. (The Mexican border was twenty miles away.) Sometimes I'd forget to take off my nail polish. The good ol' boys had to get used to that. While I was there, I joined The American Legion and did a poor kids' shoe drive for The Fraternal Order of Police, mostly in various stages of drag.

CHAPTER EIGHTY

THE WORKING FOOL

A t this point, in a futile attempt to get the IRS off my back, I started to accept any offer as long as there was money in it. A deluge of work came my way; almost more than I could handle. In two years, I made twenty-five films: big ones, little ones, good ones, bad ones, indifferent ones.

It started out with *Animal Protectors* in Sweden in January: two weeks in the snow. The sun, of course, never rose above the horizon. There was also a blizzard, which was synchronous with a drive across Sweden to Stockholm at night. We weren't absolutely certain we were going to make it.

Then *Crime Zone* for Corman, in Peru: a cross between *1984* and *Bonnie and Clyde*. I arranged to be paid in Peru in American dollars. I sent a bank draft for $40,000 to my Italian accountant. Then I met with him in Cairo, where he was trying to set up a movie with Arab money.

I got pneumonia and had to stay in Rome for two weeks to get over it. There's something about Rome and my lungs. The accountant's wife nursed me like her own child. By the end of the visit I had figured out that he was a junior member of an organized Sicilian family but, more important, a fake: no accountant's degree, no IRS computer, no federal prosecution for tax evasion (I was in trouble with

them, but not that much trouble) and he had my money. He knew he'd got all he could get, so he played one last joke.

He gave me a three-carat zircon as we parted, representing it as a canary diamond that had been in the family for years. He knew I'd have it appraised. Actually, I didn't have to. Gail knew the moment she saw it. I had it appraised anyway. Sure enough! Altogether, he had taken me for $110,000. I would have done better by giving it to the IRS. Now I owed them even more.

He wasn't a bad guy; he had good taste in movies and wonderful ideas and he was a real friend. It was nothing personal—strictly business. Shortly after that he was extradited to Los Angeles County Jail. He got a note to me asking me to come down and bring him a pair of size fourteen Nikes. (He was a big guy.) I didn't think I should see him, but I had somebody send him the Nikes. Then he was extradited back to Italy. I'm pretty sure he went to prison.

Back in L.A., I did *Crime of Crimes*. I don't even remember what it was about. The point was, I could make $50,000 in two days on these pictures.

Roger Corman had come up with a zany idea that was making money. He welded together the action sequences from a few of his sword and sorcery epics, wove a new plot from them that used the stars of these movies, shot a little more action, and called it a new movie. *Wizards of the Lost Kingdom II* worked just that way. I played the dark warrior from *The Warrior and the Sorceress*. I would play a scene, brandish my sword, and say something like, "I'll take care of them." Then I'd walk out a door and they'd cut to footage of me killing twenty-four lizard people from *The Warrior and the Sorceress*. It was shot in ten days at Roger's studio in Santa Monica.

Nowhere to Run was a Julie Corman project. It was essentially a picture about high school kids in their graduate year and what happens to them and the town they live in. My character was pivotal to the plot and the only action. It was a rough and tumble anti-hero role and I bit down on it good.

We were shooting in Cagle Canyon. Horse country. Gail and I had been thinking about a ranch for some time, so we could have our horses with us. Boarding mine was expensive and we missed them. The Brando house was a lot of rent and the area was getting too built-

up for our taste. We started looking around there in the canyons. One day around sunset we were looking for a place we'd heard about, when I saw a metal sign that read, For Sale 34 Acres and a telephone number, fastened to a chain link fence. The gate was open.

I said, "Gail, drive up there."

She said, "We can't."

"Yes, we can. Tell them we're lost. We are."

We drove up a 400-foot driveway, under big, spreading trees, to a shingle-sided farmhouse. Behind the house was a narrow valley, feeding into the hills. We were greeted by an unreconstituted hippie who identified himself as the caretaker. He took us inside. The place was an incredible mess, but we could see past that. He offered us some LSD. We passed. Then he ran outside and came back with a freshly picked pomegranate. I looked at Gail. "This is it!"

We started after it. The phone number was extinct, so Gail had to do some detective work. The land was owned by a consortium. A group of Japanese developers were after it. Michael Parks, of all people, was renting it and had been for fifteen years. We made a bid and struck half a deal. Then I took Gail to the American Legion. We had two drinks and bought a round while we told them we were thinking of moving into the area. The developers were denied the permits and we had the ranch.

To cut down expenses and to be nearby for the renovation, we rented a horse property a few doors away from the ranch. Gail sold her house on Woodrow Wilson Drive to make the down payment.

Sundown, The Vampire in Retreat was a comedy vampire movie to be shot in Moab, Utah, where a lot of the John Ford westerns were made. In the meantime, David Winters, an action filmmaker, virtually a mogul in his own kingdom, got in touch with us. He liked me a lot because when we were introduced in Cannes, I identified him as one of the dancers in the original *West Side Story* and he later became Broadway's hottest choreographer. No one in the trade was even aware of this. His associates in Hollywood were, by and large, not fans of choreographers.

He wanted me to do a picture about a futuristic bounty hunter, *Future Force*. The only problem was he wanted to do it right in the middle of *Sundown*.

We did them both, synchronously. The vampire picture, of course, shot mostly at night. *Future Force* was a daytime picture. I would work all night in Utah as Count Dracula and at dawn I would take a private plane to Burbank, where I would be picked up and taken to the set. I would be the bounty hunter cop all day, then fly back to Utah and repeat the cycle. Pretty much the only sleep I got was in the plane.

There was one close call. I was sleeping in the co-pilot's chair. When I woke up, I looked at the gauges—an automatic reflex if you're a flyer. The fuel gauge said empty. I thought, "It's just one of the tanks." I looked at the other. Empty. Below us were the Utah badlands, with absolutely nowhere to land as far as you could see. I said, "What's going on?"

The pilot said, "I'm lost."

I said, "And we're out of gas."

"I'm homing in on that right now."

We landed at a tiny airstrip, running on fumes. When we took off, we had two problems. We were still lost and night was falling. Gail, from the back seat, said, "See that pass just off to your left? Go through there and turn left until you come to the river. That's the Colorado. Turn right and follow it north until you come to Moab."

By the time we reached the river, it was night. Fortunately, it glows in the dark—whether from the starlight or from its high uranium content I don't know. When we saw the lights of Moab and the airstrip we all breathed again.

A note of trivia: I believe *Sundown* is the only film ever made in which Dracula is a sympathetic hero.

Back at the ranch, we moved Scott into the house in exchange for his working on the place. The first order of business was to take all the junk out of it. I stood there and looked at a pile of mattresses, broken furniture, hundreds of newspapers and magazines, you name it. The pile was almost as big as the house. I noticed a loose shingle next to the chimney. I pulled it off and saw white clapboards underneath. We ripped off all the shingles and there was a beautiful white farmhouse. The shingles had been added years before for a movie. The ranch had been used for a lot of movies, including *Satan's Wives* with my father. We also found an enormous number of Black Widow spi-

ders. We began the slow process of putting the place together. It took us two years.

Scott was hot to get into movies, so we sent him to the USC film school. He graduated at the top of his class. His final exam was a movie. He wanted to make a western.

I said, "Use me."

He said, "That would be cheating."

I said, "No way. When you're making a movie, you take every advantage. Look at that kid with all the family money who can afford professional equipment. He's got dollars; you've got a betacam and me."

The rich boy came in second. We got Scott a job on one of Fred's pictures and he was on his way.

In *The Cover Girl and the Cop*, I played a renegade CIA man, who was the executioner of Jimmy Hoffa.

About this time, Bob Christianson, a producer at Warner's, started trying to put together another MOW about kung fu. We spent months working on the script, which took place in San Francisco during the 1906 earthquake. After a couple of false starts, we came up with a great script: *The Rage of Cain*. The problem was, we couldn't sell it to anybody. Bob kept pitching it at the staff meetings, but without an interested network, the project couldn't go anywhere.

PASSING OF THE PATRIARCH

Gail and I decided to get married again, to use the rings and the trousseau and to let the families be involved. Gail was a little embarrassed to get married for the third time as a big deal in front of everybody, so we called it a reaffirmation of our vows.

We set it up to happen at St. Thomas Episcopal, the church my father founded and where I was baptized. We tried to find my father. We discovered he was in a hospital in Milan, dying.

We canceled the wedding. Keith and I hopped a plane to Milan and found Dad in a clinic, virtually in his death throes. We never would have got to him if it hadn't been for Keith's fluent Italian. He went up with the doctor while I waited in the hall. After what seemed forever, he came back for me.

He looked at me very levelly and said, "Brace yourself." I went in. Keith was right. I just stared. Keith said, "He can't answer, but if you talk to him, he might be able to hear you."

Byron, the little twisted man who had kept him away from us the last year, was there at the foot of the bed.

I bent over and kissed Dad on the cheek. "Hi, Dad."

Keith leaned down and said, "I have to leave now, Dad. I'm starting a movie. I know you know how that is, but David will stay here with you. He'll take care of you."

I sat beside the bed and did the death watch. I read to him and recited Shakespeare. He died within a few hours. I was told his last words were, "Milano. What a beautiful place to die," but he never spoke to me or opened his eyes. When he died, I was holding him in my arms. I knew it was over when I heard the death rattle. I reached out and closed his eyes. It's not as easy as it is in the movies. The eyes don't want to close.

What killed him, according to the doctor, was the fact that Byron didn't bring him in until it was too late. I followed the gurney down into the catacombs of the hospital with Byron lurching along in front of me, like Igor. The whole thing felt like a scene in one of Dad's horror movies.

When we got outside, I turned to Byron. I said, "Look, you're not too popular with the family but, for today, I bear you no ill will."

He said, "Would you like to have dinner with me?"

"No, thank you. Could you loan us some money? We're stranded here."

"No. Good-bye."

I escaped around the corner.

About a half-block later, I lost it. A wave of grief sprang up in me and I stumbled against the wall of a building. I crouched there and the tears came. Hopeless tears of someone lost. I overcame them, more or less, and turned so my back was against the wall. I took a deep, shuddering breath and looked at the sky. There was a light rain.

I walked back to the hotel with tears streaming down. In the morning, Bobby showed up to help me through the complicated process of getting the body shipped to the States.

We brought him home to Los Angeles and the family gave him a grand funeral and a real old-fashioned Irish wake. It was not exactly a sad occasion. He had had a long and eventful life and was tired.

Since his birth in 1906, he had grown up with the movies. He'd lived through two world wars, had survived the depression and the McCarthy era, watched man walk on the moon.

Dad once said to me, "Son, I've done everything I ever wanted to do. I have a few regrets, but I've had every woman I ever wanted. I've played Hamlet. I skippered my own seventy-foot schooner and

I've raised a bunch of fine boys." (There are eight of us.) "Like every dog, I've had my day. I'm ready to go."

The memorial was at the church in Hollywood he had founded and where I was baptized. A few years before, Dad had told me that he had completely lost faith in religion. He said he just liked the spectacle, the pageantry of it. We didn't let him down. My brother, Chris, arranged for a full requiem mass with Holy Communion and the whole shebang. If anything could have gotten him back into a state of Grace, I figure that did. Each of the brothers gave an eulogy and I read a passage from Shakespeare's *The Tempest* and ended with "Good Night Sweet Prince" and "Flights of Angels sing thee to thy Rest." Tears were streaming down my face, but I got through it.

All his old friends who were still walking around were there, as were two of his wives. Jane Fonda showed up to pay respects in her father, Henry's, name. It was a packed house; standing room only. Dad would have been proud and touched.

Afterward we carted the coffin over to our house and opened it up. I looked down at him and the undertakers had put a demonic, artificial grin on his face—like nothing I had ever seen him do in real life, except in a horror film. I reached out and, using the sculptural skills I had learned from him, I remodeled his face to be more naturally him. Then I poured a half a bottle of J&B Scotch (his favorite) down his throat and we had the wake.

The day after, a Sunday afternoon, Gail and I renewed our marriage vows. Most of the same people were there. The bride wore white, Keith was best man, and we exchanged rings.

Scott gave Gail away. He had grown a beard to look more adult. Gail, in her gown, was startlingly beautiful. Her arms were like willows. Her hair flowed like soft gold. Her face was shining. As she was coming down the aisle, she leaned toward Scott and whispered something. They both smiled broadly. Later, I asked Scott what she had said. He said it was, "Slow down, Scott. I don't think we get to do this again."

We rode down Hollywood Boulevard in a horse-drawn carriage with an escort of eight Harley Davidsons (courtesy of biker brother Mike) to a reception in the Academy Room at the Hollywood Roosevelt Hotel. We all had a fine time. It felt like a fresh start for everyone.

We weren't sure what to do with Dad's body. Dad had asked to be cremated and his ashes cast over the sea, but seeing him there in his chestnut coffin, looking exactly as he had in life, with a faint smile on his face, I just couldn't bear to burn him up. I always was a rebellious boy.

I talked it over with the brothers. We favored a burial at sea. Uncle Leonard took onto himself the task of making that happen. Meanwhile, we put the old man on ice in a mausoleum, next to some of his old friends.

⇒ ⇐

EUROPE BECKONED WITH a movie in the south of France, which was one good reason to take it. Two other good reasons: a lot of money and a very interesting role. I played an international art thief. I wore disguises, so that I was essentially playing five different parts. The name of the picture was *Le Grand Faux* (The Big Fake) but was changed to *Try This One for Size.*

Guy Hamilton, the director, had handled the second unit on Terence Young's three James Bond films and took over as director when Terence left. He was not a totally pleasant experience; however he was a fine director.

We took an apartment right on the promenade in Nice. We rented a white parlor grand piano. We were very happy, in spite of Guy's spitefulness.

The time came for Dad's burial. I was determined to go. I had to actually walk off the picture to do it. Guy, of course, was furious. He had said I could go, but then he kept holding on to me. By the time I broke loose, I had missed the plane. It cost me $7,000 to take a private jet to London, where I caught the Concorde. I left Gail in Nice as a hostage. She should have been part of it, but they were afraid I wouldn't come back

The burial at sea was thrilling, with full military honors, including a twenty-one gun salute. He was entitled to this because of his participation in the 1941 coastal defense system.

There was a huge collection of Carradines on board. Seven of the brothers managed to be there, along with their wives and chil-

dren. Also present was Uncle Leonard Peck, Dad's half-brother, who I hadn't seen in forty years. My mother couldn't be present as she herself was failing. Still, it was the largest gathering of the Carradine clan that I remember.

It was an incredibly clean and hopeful emotion we all felt as we watched his coffin slide out from under the American flag into his beloved ocean. A sailor piped him over the side. The seamen fired off their M-16's. The flag was folded while a bugler played taps. The commander presented the flag to me as the eldest son. I still have it; I'm looking at it right now.

I've unfurled it twice since then, once for the Flower Festival in Nice, France, and once for the Fourth of July parade in my new home town, Sun Valley, California, where I was grand marshal of the parade.

Every time I look at that flag I think of Dad down there at the bottom of Catalina Channel in Davy Jones' Locker with all the other sailors and marines. I hope I did the right thing.

I stayed the night with Keith and flew back to France at dawn.

We had a beautiful Christmas in our apartment in Nice. Guy Hamilton was absolutely pleasant! He helped out with the fixings and didn't make one snide remark. Next day, he was back to his regular form.

The show was a crazy caper picture in which I wore a lot of disguises. I cracked all the jokes and kept my tears back and got through it somehow, as we all have to do.

Just before New Year's, Bruce called me on the phone and let me talk briefly with my mother, who was dying. Bruce had been renovating the house. Mother was almost blind and was unsteady on her feet. She had tripped over a four-by-four and fallen hard. Her ribs were broken and one of them had punctured her lung. She lay there for fourteen hours before anyone found her. When I talked to her, she only had about an hour left. She sounded so pitiful. I wanted to say good-bye, but I was afraid it might push her over the edge if we acknowledged that it was the end.

Two hours later Bruce called again to tell me it was over. I went into the cold, back bedroom and curled up in a fetal ball in the dark. I kept thinking of her limericks. She had had a wonderful collection

which she would tell in her sweet little old lady voice—especially after a couple of Mai Tais.

Gail called up Guy and told him. He said, "Do you realize what time it is?" Then he said, "Is this going to interfere with my movie?"

Gail said no, she just wanted him to know so he wouldn't be hard on me tomorrow. He said, "We shall see." A very nice man.

Finally, I fell asleep. Gail came home and couldn't find me. She went down and searched the bars. Finally she discovered me. She walked in and put a puppy beside me. I said, "I hope she's a girl. I really need a girl right now." Gail closed the door and left the two of us together. The puppy snuggled against my neck and stayed there for about two hours.

We finished off that picture and went to Spain to do a small independent film. *Labyrinth* it was called and it was. I stayed drunk the whole time. It sort of worked anyway, since I was playing a heroin addict.

One day I woke up and remembered my last words to Dad. Just seconds before he gave it all up, I had said, "I promise to do better, Dad."

I pulled myself together and went back to work.

ONLY THE STRONG SURVIVE

We flew into San Francisco just too late for Mother's funeral. We went with Bruce to her house on Spring Street to bury her ashes. He wanted to plant them under an azalea bush in the back yard. He asked me if that was a good idea. I said it was if he wasn't going to sell the house. I threw some of them into the wind. That was it. As we were driving away I realized it was probably the last time we'd be there.

Bruce gambled all his inheritance on the stock market and lost everything except that house. Calista was sort of pissed off at him. Any one of the three houses would have dramatically improved her life. I was sort of pissed off too, for the same reason, but not surprised; and, hell, it wasn't his daughter.

We were home for just a moment. Then we went off to do two pictures simultaneously in Sweden. We shot in an old castle that was now a hotel. One picture was shot in one room and the other was shot in the adjoining room. We had two cameramen and one director. We also only had one gun, so we passed it back and forth. To change my look for the two characters, I changed jackets, put on glasses, and messed up my hair.

In Stockholm, we took a few days R & R. We had the best hotel suite in the city. I had a big argument with Gail and tore the room apart. The next day, I went to a hardware store for supplies and

repaired the damage. You couldn't tell it had ever happened. One thing about being in the habit of breaking furniture: you learn to become a good repairman.

The time came to go back to my dentist and drill holes in my skull and screw in little titanium implants. I still had to wear the choppers, but I was one increment closer to eating apples again.

Norbert Meisel, who was married to Nancy Kwan, offered me a cameo in *Night Children*. I liked the script. I said, "Why don't I play the lead?" He said, "I can't afford you." I said, "Try me." He didn't have a leading lady. I said, "What about Nancy?" She wasn't too sure, but we convinced her. The story was about a cop who keeps locking up juvenile offenders who's in love with the social worker who keeps letting them out. Charles Grant played my partner. It was great working with Nancy again. I kept my teeth in my mouth instead of my pocket, out of deference to her.

We got back just before Easter and spent the night cooking a turkey and coloring eggs. When the hunt was on, Kansas wasn't finding eggs. She asked Gail to help her. During the process, the kids talked Gail into showing them some stuff on the trampoline.

Kansas came into the kitchen in a state of panic and said that Gail had fallen on the trampoline and couldn't move. I rushed out to her and found her completely paralyzed. I called 911 and some big firemen showed up with a little ambulance. Somebody brought down the ironing board so we could use it as a hard surface to slide her onto without bending anything. It still wouldn't work because their weight was making a big dip in the middle of the trampoline.

I got underneath and held the tramp, Gail, the ironing board, and the two big fireman up straight with my back. I don't know how I did that; it was theoretically physically impossible. I went to the hospital with her. The surgeons wanted to operate. I wouldn't let that happen. Gail didn't want to use any painkillers. She wanted to know if she was tweaking anything. I stayed with her the whole time she was in the hospital, for moral support and so they would keep their hands and knives off of her.

After about five days, she was getting restless. I went down to the gift shop and bought a baby blue dress, a pair of sensible shoes, and a purse. I told the nurse I was taking her for a walk, by which she

assumed I meant down the hall. We stepped into the elevator, pulled off her hospital gown, pulled the street clothes out of the purse, and put them on her; then stuffed the gown into the purse. We stepped out of the elevator and walked down the block to Ma Maison, where we had lunch with Michael Caine and Roger Moore. When Gail began to tire, we bid our adieus and reversed the process. I got her back to her room without anyone being the wiser.

The doctors were amazed at her recovery rate. They expected her to be on her back for six months. They kept testing her: x-rays, of course, CAT scans. I held her hand through all of this. When they got to the MRI, they discovered three broken vertebrae. One was thirty years old, one was twenty, and one might be new or it might be ten years old and rebroken recently. Now they were interested in her as a phenomenon. They wanted to study her. And they still wanted to operate. I told them they had no idea of the strength of the organism they were dealing with and took her home. I bought her a chinchilla neck brace and we went on with our lives. She recovered completely without the help of the neurosurgeon, though for about a year she kept dropping things.

I knew she was recovered when, one day, she mounted Strawberry, the little Appaloosa filly we'd acquired through Bill Shatner. The filly had never been ridden. Gail showed up outside the kitchen window, bareback, with a rope hackamore. I said, "That's wonderful, Gail. Now get off." As an answer, she slipped the bridle over Strawberry's neck and rode away on her completely naked, wild pony.

⇒ ⇐

WORK WENT ON. I was offered a road tour of *The King and I.* Twenty weeks in the U.S. and then maybe Japan and some other places. The money was pretty good and I would have a piece of the gross. I turned it down to play a heavy in *Bird on a Wire* with Mel Gibson and Goldie Hawn. It paid about the same as the tour and it had been a long time since I'd appeared in a major studio movie. The job turned out to be thankless and boring.

In the middle of the three-and-a-half month shoot, I had a three-week hiatus. I booked myself into *Future Zone,* the sequel to

Future Force. The film was made in Mobile, Alabama. They shot around me and got me out of there in two weeks. I was playing scenes with people who weren't there and watching explosions and car wrecks that weren't going to be shot until weeks later. Gail played my wife in the movie and Patrick Culliton played the heavy. Ron Taft played a bounty hunter.

In Mobile, we had our share of alligator scares and a hurricane; and I shot myself in the groin with a blank. The fire department came and wanted to take me to the hospital. I refused.

The paramedic said, "Wiggle your toes."

I said, "Wiggle my toes? How about if I just kick you in the head?"

He quickly folded his clipboard and left. A heart surgeon cleaned up the wound. He remarked that he hoped his colleagues didn't find out about it, since he was a long way from his specialty. I told him he was real close to my heart.

The incident made the wire services. If it hadn't been for that, *Bird on a Wire* wouldn't even have known I was gone.

Think Big was a comedy with the Barbarian Brothers. I played a shifty and somewhat insane repo man who is after their truck. It's one of my zaniest performances to date.

Project Eliminator was shot in New Mexico. The director, Kaye Dyal, was one of the writers on "Lone Wolf McQuade." Calista had a part in it, as did Kam Yuen. Kam played an assassin. He killed his victims by giving them chiropractic adjustments. I had adopted a practice of drinking only at night. I told Patrick about this. He said, "So you're not drinking while you're working!" I said, "Well, we're shooting nights." With more money and a better title, this picture would have really gone somewhere. As it was, it was definitely okay.

Fatal Secret is another movie I don't even remember.

⇒ ⇐

I EMBARKED ON the project of recording the score for *Mata Hari.* Gail found me studio time and the best musicians around and I walked them through the fifty-four pages of manuscript one at a time. I had to do this between jobs, whenever I had the chance. The whole

process would take three years. This was some of my best work and I relished every moment of it.

One night Gail and I were driving home from a dinner party in my Corvette, a powerful and distinctive custom rocket ship, painted black, with the Harley Davidson wings on its leading edge as its only insignia. We were sedately motoring along Mulholland Drive, discussing Calista's future, when we were stopped by two motorcycle cops. I stepped out of the car and the first officer said to me, in the dark and from a distance of about ten feet, "Mr. Carradine, may I see your operator's permit?"

I knew right then that I had been singled out. If he wasn't a big fan, I was in trouble.

I was made to perform the tests—walking the line, reciting the alphabet, touching my nose and so on—until the second officer said, "All right, he passed. Let him go."

The first officer said, "Whose side are you on?"

Now I knew I was definitely in trouble. I was handcuffed and put into the backseat of a squad car. By this time, there were six officers at the scene.

The arresting officer, who by tradition has absolute authority, refused to give my car keys to Gail and left her alone, in a party dress, on a deserted road at midnight, which was tantamount to leaving her for dead. She survived by taking off her high heels and running a half mile to her lawyer's house. She couldn't go home; the cops had those keys too.

As we motored to the North Hollywood police station, the cops asked me questions about the Corvette. The car fascinated them. Well, it was one of a kind. No one would ever hit it from the rear.

At the station, I was breathalyzed three times. I passed. I thought then that the ordeal was over, but no. The arresting cop wanted my urine. I was so worried about Gail by that point that I would have done anything to get out. Right then, lawyer friend David Sommerville showed up to take me home and confirmed that Gail was fine.

We went home and had a fine late-night get-together, with music and an omelet by Gail.

Later, I was told that my urine contained cocaine—an absolute

impossibility! My attorney, Mr. Gallagher, told me how that was done. The cop walks up to the holding pen and says to a known user, "Piss in the bottle and we'll let you out." They also regularly add drops of alcohol to blood samples. Mr. Gallagher also told me that I had to cop a plea. Judges become very judgmental when they hear the word "cocaine."

I had to go to AA meetings as part of my punishment for the fake drunk driving charge these cops stuck me with. I also had to do community service and two days in jail. I decided to really go for it and sober up. I used the two days in jail to get me started and then checked into Studio 12, a facility operated by The Screen Actors' Guild. I stayed there for twelve days and came out clean. I stayed that way for 126 days before I fell off over a big emotional blowout.

For the community service, I joined the "Graffiti Busters." Armed with paint and a sand blaster, I removed spray can artwork from the walls and sidewalks of Sun Valley. I also operated a bulldozer for the Parks Department.

While I was still in the program, I went to the Philippines again for *Battle Gear*, where I played a fighting general. It was supposed to be five days, but I did everything in one take and got it done in three and a half days. The director, Cirio Santiago, was impressed.

Martial Law was a martial arts picture about a karate cop who goes undercover. I was the martial arts master/villain. The picture was okay, but the martial arts were very muddy. The cop was played by Chad McQueen. He was arrogant and he had a lot to learn, but he made a likable hero.

Right away, I went back to the Philippines to do *Dune Warriors,* in which I recaptured the teacher from *Circle of Iron* and the dark warrior from *The Warrior and the Sorceress* and *Wizards of the Lost Kingdom II.* The teacher treaded softly and helped people. Then, when things got too rough, he changed to *The Dark Warrior* and slashed up the bad guys with his big sword.

I saw, in my agent's office, a promo reel for an actor named Craig Wasson. He was great. My agent, who handled him as well, told me he'd written a screenplay which was going to be made, with him in a secondary role. I told him I wanted in. The agent said they didn't have enough money. I said, "I don't care."

I ended up playing the lead: a genius homicide detective who was always drunk. This while I was cold sober. The location was northern Idaho. Incredibly beautiful. The original title was *Moonlight Sonata,* so called because a mysterious character was always playing that piece on the piano in the dark. The title was changed to *Midnight Terror.* Craig and I were the only seasoned actors. The rest were all kids. The movie was definitely a "film noir." It all happens in the dark and everybody's dead by the end of it.

Right about then, I fell off the wagon. The pressure was getting heavy at the ranch. Gail was drinking a lot and the same thought was crossing my mind too often. I went to a meeting at Studio 12, my home base. I was thinking of checking myself in, but everybody was on a big bummer because SAG had sold the place and it now had to be a profit-making business. No more haven for the needy. I didn't want to sleep in that vibe. Instead I went home with Billy Record.

I got a phone call there. Gail was in the emergency room at the hospital. I jumped into the Cadillac and barreled out there, running red lights. She was sitting on a bench, covered with blood. She had been clipping the inside of the Springer Spaniel's ears, when the mastiff crowded in and knocked her over. She stuck the manicure scissors through the bridge of her nose. She needed a plastic surgeon to stitch it up.

We woke Doctor Birnbaum and he met us at his operating room and performed the operation at two in the morning. I was the nurse. When I got her home and into bed, the bathroom and the kitchen were covered with blood. The place looked as though a serial killer had been there. I downed a shot of Jack Daniels and that was it: the end of the abstinence era.

Fred Olen Ray gave me two days on *Evil Toons,* a horror movie wherein the monster is a cartoon, a la *Roger Rabbit.* I played the keeper of the book, who is a ghost.

Roadside Warriors was one day. I was a guitar-playing mad hatter at a mad tea party. I shared the picture with several other celebrity cameos.

Larry Cohen from my Army days wrote a screenplay for me about a small-time actor who always played heavies. The character is accused of a set of serial killings in a small town because, though no

one recognizes him, everyone thinks they've seen him before. He has to escape a lynch mob and then catch the murderer in order to clear himself.

We shot two days in Las Vegas and New Mexico and then Larry shut the picture down, ostensibly because of personality differences between him and me. He used me as the scapegoat, throwing in my alleged drunkenness for good measure.

I went straight into a movie-of-the-week for Universal, which was also a pilot: *The Brotherhood of the Gun*. My various producers gave me a clean bill of health and nobody pays attention to Larry, anyway. The only thing I regretted about the whole affair was the loss of an old friend.

We shot the movie-of-the-week in Santa Fe. It was a western soap opera. I played the big rancher with an illegitimate ne'er-do-well son and a nymphomaniac daughter. I had a hook on my left hand. When the head wrangler heard I was playing the part, he gave me a big stallion to ride. He was sometimes a little hard to handle with only one good hand, but I managed. I took hold of the show and tried to lead it to victory, unsuccessfully—the series didn't happen—but I came out smelling like a rose.

I played Kwai Chang Caine in *Gambler IV* with Kenny Rogers and Reba McIntyre. The picture was loaded with cameos from former western series' stars.

Back to the Philippines for *Kill Zone*, essentially a prequel to *Apocalypse Now*. I played the crazy colonel.

I was gone nine days. While I was gone, Gail got a crew together and painted the ranch house inside and out, laid in new carpets, and moved all our stuff in. I walked in the front door and said, "I've never been in this house before." The house was humble, soft and pretty, very comfortable, with a deliciously good feeling about it all. The horses were on the property and all was well. It wasn't paradise; it was merely heaven.

⇒ ⇐

MARCELLA CARDINALE helped put me in a play: George Bernard Shaw's *Don Juan in Hell*, with Ricardo Montalban, Lynn Redgrave,

and Stewart Granger. Four weeks at the Henry Fonda Theatre in Hollywood. The show was a lot of fun, but it was a flop. Simultaneously I was doing book signings for *Spirit of Shaolin*, a guest star on an ill-fated Warner Bros.' pilot, "Human Target," and the promo parties for *Gambler IV.*

Tony Hickox, the director of *Sundown*, asked me to do one day as a favor on *Waxwork II*. I was a wizard. I wore the blind Master's white robes from *Circle of Iron* to tie it together with the others. I've always thought of that and *The Dark Warrior* as continuing characters. Someday people will look at a shelf of videos and see a whole cycle like *Tarzan* or *John Carter of Mars*, or both.

The Bitter End was an art movie about the sad life and death of a prostitute who doesn't do the deed. I was her torturer.

Night Rhythms, I don't know. I think it was a soft-core porno.

Southern Frontier was written, produced, and directed by my old friend, Hugo Stiglitz. He also played the lead. Another favor. It was shot in Chiapas, right on the border of Guatemala. You could hear gunfire occasionally from across the border. I developed a case of cholera. Hugo was on a tight schedule, so I just had to keep working. Throwing up in between shots.

Crazy Joe was a one day favor for Steve Carver. I did it because it made him look good that he could get me to do it.

Distant Justice was a Japanese-American story shot in Boston. The director did not speak one word of English. The star was a famous Japanese actor. I was the crooked mayor.

After all this, I still had not made much of a dent in my IRS debt and I was now forced to file for bankruptcy. It all looked pretty bleak. Then something we'd all been working toward for quite a while finally came through and saved the day.

Left: Gail and me with the Arabian Stallion, Majetek, sired by Druzba, the number one rated Polish-Arabian in North America.

Below: Riding the Appaloosa Indian Woman. I found her in the Pecos Wilderness in New Mexico.

Playing a wide range: Left: LONE WOLF MCQUADE, *1982. Photo courtesy of Orion Pictures.*

Right: POW: THE ESCAPE, *1985. Photo by Gail Jensen.*

Below: SONNY BOY, *1990. Photo by Rory Flynn.*

"Kung Fu: The Legend Continues":

Top: Kwai Chang Caine and the young Peter, played by Nathaniel Moreau.

Right: Caine.

Below: The Ancient (Kim Chan), Caine, and Peter (Chris Potter).

Kansas at her work.

December 4, 1988.

Cannes Film Festival, 1981. David and Calista outside the Grand Palais after a screening of HEAVEN'S GATE.

⇒590

Top: The Carradine Clan:
Chris (in hat), Keith, Bruce
Carradine, Big Mike
Grimshaw (stepbrother),
Robert, David, Dad on chair.

Above: "The Fall Guy" hal-
loween show. From left: Keith,
Dad, David, and Robert

Right: Dad at 74.

THE WORM TURNS

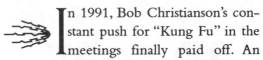In 1991, Bob Christianson's constant push for "Kung Fu" in the meetings finally paid off. An executive at Warner Bros., Greg Maday, had barnstormed around the country and formed an "ad hoc" network to take the series: "Kung Fu, The Legend Continues." A further permutation of "Kung Fu car crashes" again, but without "The Dukes of Hazzard." The deal was made. Ed Waters took a stab at the pilot script, but nobody liked it.

Michael Sloan, who had been responsible for the new "Alfred Hitchcock" and "The Equalizers," among other jewels, came aboard. He wrote up something that was just right. We were off and running. Bob, however, was told his services would not be needed. Later, Norman Stevens, who had given Bob his papers, suffered the same fate. That's showbiz.

I got Mike Vendrell in as fight coordinator and Rob Moses as my trainer. I was figuring that everybody I knew would work. Then they threw a curve at us. The show had to be shot in Toronto. The entire crew, the directors, and most of the cast had to be Canadian. Worse yet, I had to relocate. I had gone to all this work to secure a ranch ten minutes from Warner Bros. Now I was going to work 3,200 miles away.

We had to find someone to play my son, Peter and he had to be Canadian. The guys in the office came up with a kid for me to read

with: Chris Potter. He did his bit and then went out to wait. The executives started to pick his audition apart.

I said, "Hey, guys, what are our options?"

Michael Sloan said, "He's the best we've found."

I said, "So? Tell him he's got the part."

Michael said, "Okay. We'll call up his agent."

I said, "What are you talking about? He's sitting right outside."

"We can't do that," he said.

"Well, I can."

I went out front and said to the kid, "Come on. Let's go have a beer." I took him around the corner to a Mexican restaurant. Over shots of Tequila, I told him he had the part. He flipped.

Then I said, "Have you got a car?"

He did.

I said, "Follow me."

I took him to the ranch. Right away, Gail put him on Captain, bareback. He rode gingerly to the other end of the ranch. Then Captain just stopped dead and wouldn't move. Gail whistled and he came running. He stopped right in front of her. Chris was glad to get off, but he had passed the test. Before he left that day, we were friends.

Chris is a great person. I'd be tickled pink to have him for a son. He's a regular guy without the advantages of a family acting tradition. He's a great physical specimen, from his hippocampus to his toenails. He was an oil rigger and a hockey player. He learns quickly and he rarely blows his top.

It took a while for anyone to realize how lucky we were to have him. No one knew he was an athlete. He was hired strictly for his acting ability. He took to the action and to kung fu as though he had been born to it.

The part of Peter had been written as a sort of punk. If we'd hired a real punk, the show could not have been as good and we would have to deal with that punk for five years or so. Instead, we hired a gentleman who can act like a punk. It's a happy set.

We have to make, actually, two movies here: the main one for the fans. After all, the only reason this series is being done at all is because a lot of people want to watch it. We're just lucky: the series contains philosophical aspects and the father and son tear-jerker story

going on in between the fight sequences. What we're doing, without really meaning to, is what Michael Landon was doing when he was still alive. We're the only people around now who are making anything like that. The wisdom of the ages, the inner view of third world culture making its way in the USA, the almost Shakespearean quality of it all combine to make the show a hit, but sweetness and light is what sustains it.

Aside from all that, we have to get to the people who program it. That's the other movie: for the executives at television stations and movie studios who have to make most of their decisions on the basis of what their kids tell them, they're so far out of it.

The final decisions, though, come from the audience. We are allowed to plumb the depths of our deepest dreams and put them on film because that's what the folks want from us.

When we arrived in Canada, Gail and I looked all over Toronto for horse property. Nothing worked. We finally settled on a house in the suburbs that backed up on a designated conservation area: Piney Woods. Plenty of room for a couple of dogs and very near the studio.

On the weekends, during that first season, I played at kung fu on the grass with Rob Moses. During the week, I worked, which sometimes was play too.

Rob has an interesting way of working out. He invites a bunch of guys over to his place and they go up to the roof and try to beat him up. He laughs all the way through it.

I managed to get some of my friends working: Mike Bowen, Patrick Culliton. Calista campaigned for the role of Chris's songstress girlfriend but she lost out to a "legit" singer from New York. After a couple of segments, the bosses decided they didn't like the girl's work. I didn't tell anyone "I told you so."

There was some great casting that helped a lot to pull the show together. One bonanza was Kim Chan, who was hired to play the old master. He turned out to be the real thing at eighty-two years old. He was constantly showing up with a girl on each arm. He had a pitch. He'd say, "You need an old man like me. I have learned so much. I know every part of a woman's body. I know how to make you feel happy." He was always laughing. He was a little guy, skinny to the point of apparent starvation, but he ate like a horse. He was, all over

his body, as hard as a piece of oak. I could not beat him at Indian wrestling. I never saw anyone else beat him, either. Once, at the hotel, a big drunk wouldn't stop bugging us, so he threw him out of the place.

Several weeks in, a sassy, sexy actress with a wild blonde mop of hair named Belinda Metz, showed up as Chris's partner. Then in the second act they killed her off. I stormed into Maurice Hurley's office. "What the hell are you doing? We finally get a good female for Chris and then you kill her off." They rehired her as her twin sister.

Caine started having a romance with the other cop, a flashy, classy brunette named Victoria. Between those two, we had the field covered.

The first year, we were working six days a week. For me, most of the time it was seven days. The schedule was very rough, but "what does not destroy me makes me strong." We worked through rain and snow for long hours, averaging about fourteen per day. By the end of the season, we were all exhausted and pasty faced, but we'd made it through; and the proof of the exercise was the enormous audience response. We finished off with a two-parter that gave Calista a juicy part. Caine shouldered his backpack and wandered off again at the end.

During the four-month hiatus, I just relaxed at the ranch and worked on the book. There was no way I had the energy to do anything else.

I had a meeting with the brass and we straightened out some stuff. One thing I got through was to stop killing so many people. Our audience doesn't like that.

The second season started off with a pretty good bang and just got better. We were on a five-day-a-week schedule now, so things were a little easier. We began with "Where's Caine?" For the first fifteen minutes or so of the show, Caine was missing. Everybody wondered where he was. Then, just when he was most needed, he showed up to save the day.

The characters evolved; we started throwing some comedy in and dipped more deeply into the mystical aspects. I brought in a new martial artist to take up some slack: Mike Dawson. He was one of Kam Yuen's instructors.

Gail and I made some good friends in Toronto and settled into a real life there. We never got a chance to get out much, but our home was a haven for us and all the good people. The dogs loved it there. The dog catchers got so used to finding them roaming around that they would just bring them home.

The company released me to do a commercial for Lipton iced tea. This would be my first commercial ever. The script was so funny I couldn't resist. We shot for three days right back in southern California. It was a real relief to spend four days in the desert (104 degrees) after the cold misery of Ontario.

⇒ ⇐

ROBERT LANSING BECAME so ill with problems he'd been battling for years that he was about to become unable to do the show. The writers were going to kill the character off but I talked them out of that. Robert felt he would rally and come back. I didn't want us to throw a wet blanket on that hope.

We gave him a big send off. One of the best roles he'd ever had. It all took place in the freezing snow and was pretty physical. Robert came through like a trooper.

I'd never really gotten to know him. During his show, we got to work together at length. I decided I really liked him.

A few months later, I went to New York to visit him at the hospice. I took Patrick Culliton along for moral support. There's no way I could have brought it off alone. After a Mack Sennett comedy, *Lost in the Bronx*, we walked into Robert's room. There in the bed was what looked like a corpse, his eyes rolled up in his head, his skin the translucent alabaster of an angel. I kissed him on the forehead and he opened his eyes. Quickly, the corpse look was put aside and there was Robert Lansing. We talked for about an hour. At one point, Patrick had to leave the room to hide his tears.

He gave us an acting lesson, taught us a magic trick, and dispensed some philosophy.

He said, "You know, I don't mind dying. The thing that pisses me off is that I won't get to be an old man. I was looking forward to that. I wanted to be that cranky old guy that stands on his porch and

yells at the neighborhood kids, 'Get the hell away from my apples!' And now, I won't get to do that."

Finally, he said, "Boys, I think I have to rest now." Outside in the hall, I had my cry. Patrick and I went to an Irish bar and tossed a few for the man. He was dead a week or so later.

➔ ⬅

FOR CHRISTMAS, Gail and I went to Key West, Florida. We had a great time in the sun. We just ignored the big family Christmas mess and lay around on the sand.

Alcohol was beginning to catch up with me. My curse was that I could drink a quart of vodka a day and still function—think straight, remember my words, and not bump into the furniture. I'd have been a lot better off if I got drunk and fell down. Then I would have had to do something about it.

They say you drink to forget, but I never forgot anything. I just really enjoyed drinking. I'm a really thirsty person.

It got to the point where, if I was awake, I'd be drinking. I tried to control it. I stopped having a couple before I went to work and I stopped carrying a hideaway with me, but I eventually found a way around that.

Right toward the end of the second season, I more or less collapsed. The good Dr. Babb took blood and poked around and told me my liver was enlarged. The way he actually put it was, "David, I have to talk to you about death!"

And then he told me I was going to die. I told him he was full of it and I'd see him when I got back from Spain. He asked me when that was going to be.

I said, "Three months."

He said, "You won't make it."

I walked out in a huff. Still, he had scared the hell out of me.

CHAPTER EIGHTY-FOUR

LAZARUS LAUGHS

Gail and I spent some time at the ranch and then went off to Europe. The project was a French production to be shot in Spain: *The Eagle and the Horse*. The story revolves around a cantankerous old rancher, a young Indian boy, and a racehorse.

The movie had to be shot in French and English. Two complete negatives, one in each language, so in effect we had to shoot two movies in the time allotted for one. To complicate things further, the director didn't speak one word of English. The crew was French, Spanish, Basque, and Portuguese. A veritable tower of babble. Somehow we got it finished.

It's probably a pretty good movie. For sure it's one of my best performances, if not the best, though I don't think the director understood it at all. I'll be interested to see what it looks like if it ever makes it to North America. Some of these foreign independent pictures never do.

When we got back to California, we took a few weeks off to go to Shaver Lake in the high Sierras. We swam and boated and taught Kansas to water ski. I wrote a song about the place; I called it "God's Country." Wrote it on a barf bag in the airplane. I played it for the country folk on my twelve string and everybody joined in on the choruses.

I spent a few more days at the ranch and then I was on my way back to Canada. The season started out better yet. Lots of new ideas, and the whole company was now operating like a well-oiled machine. We had become a family. Loyalty and morale were fiercely high. So were the ratings.

Gail stayed behind for a few weeks and worked on the ranch. We had a colt on the ground and one in the oven. We needed facilities. Gail got a gang together and built a large corral for the colt and its mama. White, three-rail fences. She put in a small barn, installed a watering system, planted a couple of dozen trees and thirty-five bougainvilleas around the perimeter. She also put in outdoor lights and a hot walker. There's lots more to come, but that's a healthy start.

We flew to Vienna to make another commercial; this time for Eurocard. On the way, we stopped over to see Nicolai Van der Hyde in Amsterdam and started planning for a 1995 *Mata Hari* shoot. Since the bankruptcy, I don't even own the picture anymore, but I'm not going to let that stop me. I'll get it out somehow.

Back in Toronto, we worked like demons and knocked out twenty-two more episodes. For Thanksgiving, Bobby, who happened to be in Montreal, picked up a spot on the show. Kansas came up and we gave her a scene. Ever came up and Calista came with daughters Mariah and Sienna.

I took all the kids to a Rolling Stones concert at the Sky Dome. Gail advised me not to go. She called it a prescription for disaster. I had VIP backstage passes and a limo, so I figured it would be okay. We got mobbed. Some tough guy offered to knock the hat off my head. I started to respond and Calista said, "Just keep walking, Dad." Someone made a lewd suggestion to one of the girls. Well, I should have known 70,000 Rolling Stones fans wouldn't be the most polite bunch.

I shattered a glass door getting the children out of harm's way. It was an accident, but I was arrested. I didn't think much of it but the Canadian authorities feel differently. I retained Chris Osborne to litigate for me. It cost me two dollars. I'm sure it's going to all come out in the wash, but meanwhile, the thing is a stone drag.

Calista had two or three good parts and stayed up here for about eight weeks. She did a couple of great fights. Her martial arts skills are

sky-rocketing. She's awesome: fast, precise, powerful, and graceful. Whatever they hand her, she just goes for it.

The jealousy between the two ladies in my life was fierce, but we managed to have a good time anyway. I made good progress in my mission, which was to get Calista out of her life in Seattle and back into the fold, to try to realize her destiny.

Right after Christmas Day (I stuck around for the family festivities) I slipped away with Calista to the Millcroft Inn, a fancy country resort and I stopped drinking, cold turkey. I could not have done it without her. Right now, I'm very clear headed and full of energy. Without the liquor clouding things up, it's hard to get me down.

And I'm bound to live longer.

CHAPTER EIGHTY-FIVE

RAMBLIN' ON

I've come to realize that these are some of my best years, my glory years, you might say. It's not the way I had imagined it, but this strange, out-of-left-field television series is my contribution, my, I suppose, destiny. I'll stay with it until it dissolves, or I do. It could be a long time. The rest of the stuff is pretty sweet, too. I want to stick around for it.

I guess my work is the most important thing in my life. I'd like to say it was love, or family, or maybe charity, but that's just not the way it is. I'm a driven man. I can't help it; my life is my art. Everything else gets leftovers.

Women have always obsessed me. Some men are caught in webs by women who wish them harm; some pick perfect postcard wives who will look good on the mantelpiece and give them serviceable babies. Me, I just fall in love. It doesn't always work. I persevere until it fails. No matter how badly it all has ended, I have never lost my love for those ladies. I think, by and large, they feel the same way. I still have long phone conversations with my first wife, Donna. The relationship is not much different from what it was when we were sixteen.

True love doesn't always work out. Calista told me, in the infinite wisdom of Woman, that loving a creative person is potentially

counter-productive, even destructive. "If you are with him," she said, "then he's not creating. He's being attentive to you. So your job is to leave him alone."

Suddenly, Calista and I have become very close. After years of arguments, tears, and absenteeism, all the walls between us just fell away. We now have no problems at all. We're the pals we were when she was thirteen, only now she comes with a dividend of munchkins: Mariah and Sienna.

Calista says her priorities are: health, peace, and happiness. I told her I wish peace and happiness to everyone else, but don't expect it for myself; as a matter of fact I relish the chaos. My priorities are health, of course—that's the bottom line; work, by which I mean acting, directing, editing, sculpting, music, writing, building things, helping people—and, if you please, a little lovin.'

Calista said, "But work and love add up to happiness for you."

So what the whole thing is really about must be Love. It's true that without the hugs and kisses nothing seems to taste too sweet, but the really lasting loves of my life have been my family. You can't really divorce them.

Linda remains a great tragedy. I miss her to this day. She did me wrong and I suppose she's not to be trusted; I'm to stay away from her, but I love her still. Kansas has trouble dealing with this. Mommy is fun and Daddy is the boss, but Mommy's a bad girl, so what does that make Kansas? She has to be perfect, which she does a pretty good job at; and she has to love her mother. We're always working on getting the whole thing straight between us; the older she gets, the more she understands it.

When Barbara left me (I know everyone would say, "Barbara left you?" but that's the way I see it: she turned her back, I carried the torch) when I lost her, I lost Free. We saw each other, first on a regular basis, then from time to time. Once, when I missed a pickup, I called him to apologize. I said, "I love you." He said, "Yeah, yeah, yeah," like a Beatle. We kept our closeness by remembering what's inside us. When he dropped out of college, he showed up at the ranch. "Tom" showed up. Little by little, Free came out again. We still don't talk much, but we can sit together and watch bad horror movies all

night long. When we do talk, it's about the Cosmos. The stars and quantum physics.

Looking back, I guess I'd have to say I never did anything really right. I faked most of it and when I couldn't cut it, I jumped clear. My women have had all of me, yet I always let them down at the end. Gail manages to weather the storms. She, I'm fairly certain, will be with me to the end. She is, definitely, my last wife. If this doesn't work out, I wouldn't expect to try again.

In a way, its like two men living together, up to a point. "The Odd Couple." One of us is getting old and subject to aching joints and depreciating organs. The other is going through menopause.

Gail has an unerring ability to grasp the temporal and material aspects of life and pretty much shake 'em. She can tell a diamond from a zircon from thirty feet, the value of a fur, the breeding, age, and condition of a horse. And land. The music, the constant help with everything, staying away when she doesn't belong. The cute mystic tricks, startling flashes of philosophy and humor.

Yes, she does the business. It takes all day, every day, but somehow, she gets all the rest in as well. Even when she's drunk, she gets it all done. We hold hands a lot.

I'm sort of a recluse. I like to be by myself. My main interest is art and you have to do that alone. I know dogs, guns, cars, and horses, though nobody knows horses the way Gail does.

I put up with a lot of shit, but I have a temper. I've smashed a lot of chairs and broken my hands against walls and windows. Gail is tough but fragile, and she won't ever give up, so it's risky to get in a fight with her.

Gail's mother, Pat, said once that Gail and I love each other whether we're good for each other or not, and that's the definition of true love. My theory, taken from experience, is that all marriages are rough. The way you keep one together is just keep it together; again, no matter what. That's what you say in the ceremony.

Gail's an excellent athlete and fears nothing, except heights. She can't even watch a high fall on television. The movie, *Vertigo,* makes her ill.

Between the two of us, we're everything there is.

We're a better romantic couple when we're on the road. We take over a hotel, or maybe a whole country, and cut a wide swath. Everything from riding in the parade to candlelit suppers. We're always welcome back.

At home, we're swarmed by people: friends, family, workers, well-wishers, people with their hands out. For long periods, Gail and I never spend a night alone together. When we do, it's heaven—when it isn't hell.

It's a stormy marriage, with moments of great joy and beauty and moments of anger and sadness, like the tides coming in and out. Watch out for that eighty-first wave. It's a killer.

⋙⋘

MY STORY ISN'T a personal saga. It's a chronicle of a time, a period in history when everything came up for grabs. We all had to make choices. I made mine sometimes. Sometimes shit just happened.

Dad gave up sculpting and went out there with a great but narrow talent as a performer. He couldn't dance or play the piano. He couldn't fight. He wasn't too good with guns. On a horse, he wasn't much. He could act.

He took this little thing that he could do and went as far as he could go. Somehow, without paying much attention, he passed on to the rest of us something bigger than he. His dream was the strongest part of him.

It lives on in the brothers, who are making their marks as the darlings of so many different folks with so many different strokes and I've got two kids who are going down the same road. Keith's got one of his own who's making it pretty big.. The grandchildren are on their way too. The rest of my nieces and nephews have yet to show their stuff, but count on them. Free hasn't shown his hand yet, but it's all in there. He's got the acting, but not the bug. He's got the music, the art, the mind of a scientist, the thing with words. Have to wait and see.

If I had to say one thing this family has that makes it work, it's this family. Love, strength, endurance. We never give up. I love this family.

I love this world. It's fucked up. It stinks. It's delicious. It has heart.

And now I have to step away from this book—this catharsis—and get on with things. Eight years is entirely long enough to have spent on it.

My life has been filled with action, adventure, glory, and disgrace, romance, farce and pathos, damnation and salvation—illustrating the best and the worst of life on Earth. I've led a life full of extremes. I've gone as far as I can go in many respects—sometimes right over the fucking edge.

With all the things that have happened to me and all the attention I've been paid, I'm still pretty confused by the whole process of human existence.

After all the triumphs and failures, the lovers, the detractors, I still am not finished, not hardly started really. There's a whole slew of things still undone, dreams not yet realized. I'd better get on with it; get back out there on that endless highway and give them some more hell.

I don't have forever, as far as I know.

A JOURNAL FOR THE JOURNEY

JANUARY 1, 1995

I'M SITTING IN a lovely room in a Country Inn way out in the sticks of Ontario. The inn was carved out of an old mill. Calista is nearby embroidering a pillow case for Mariah. We're here to dry me out, cold turkey, after a decade of alcohol abuse. For those who say this method is not effective, you'd have to know Calista, my guardian angel. It seems to be working. This is our seventh day. Last night we had dinner with the folks and danced a little to a live jazz band. When the rest of the patrons started to get drunk, we left and walked through the snow slush to our little room. We went to sleep early: Calista gave me the big bed and slept on a pallet on the floor.

During the night it snowed. The place became a wonderland. This morning Calista started her day by going through her kung fu forms. Then we went for a long walk in the snow. We left the beaten paths and took the cross country ski trails, occasionally getting off those and trekking through the piney woods, talking all the while. We have so much to catch up on. This is the first time we've been alone together in twenty years. Then we sat and had high tea for a couple of hours (we drink a lot of tea), still talking—about the past, the present, the future, and our love for each other.

I couldn't have done this without her. We're both taking handfuls of vitamins and herbs everyday and drinking fruit juices. I've had virtually no unpleasant side effects from the cure, largely because of Calista's joy at being with me and taking care of me. She laughs and smiles all the time. I have never seen her so happy. The feeling is mutual.

We had a light dinner; the food here is okay and the staff and other guests are friendly as all get out. In a few minutes, we're going past the waterfall and across the bridge to take the hot pool. It should be something else with the snow coming down all around and the thunder of the waterfall.

In a couple of days I'll have to go back to work, but the memory of this sojourn with my firstborn child in this snow-covered fairyland will stay with us forever. We will return to the hustle and bustle in a state of grace.

JANUARY 2

The hot pool was great, just hot enough to make it interesting, but not so hot you want to get out. Calista was fascinated by the Swedish idea of hot-cold-hot-cold. She climbed out of the tub and lay down in the snow several times. Then she stood on her head in it, reasoning that she could last longer if her whole body wasn't in the snow. Then she climbed into a tree, covered with snow, and sat there for a while.

Later, she called Mike, her boyfriend, and told him about it.

He said, "You what?"

Calista said, "Well, it's Canada."

Mike said, "Let me get this straight. It's all right to lie in the snow in your bathing suit because it's Canada?"

She said, "No. If it wasn't Canada I'd take the bathing suit off."

After the hot tub, we went into the sauna. It wasn't hot, but it was a nice warm room. We lay there and talked and laughed for an hour or so.

We had midnight tea at the Millhouse and went to our rooms. I stayed up most of the night, writing. I slept until two. Calista and I read some Marvel comic books and I went back to sleep, watching Calista do her forms. My dreams were full of flying, spinning, reverse, outside, double-crescent kicks. When I woke up, it was dark. We had dinner and went for another hot tub. This time, the tub was cooler and the sauna was hotter. Calista didn't do her polar bear imitation.

We leave tomorrow morning at 6:30. Before we go, I'm going to get a picture of her sitting in that tree in the daylight.

JANUARY 6

Yesterday was the first day on the main unit, which is to say, on the new segment. We went to a huge castle and I was thrown into a cauldron of molten metal in the bell tower, wearing white robes. I have no idea why. I haven't read the script. Then I was surrounded by about fifteen bad guys, some in black robes and some dressed like 1940s gangsters, and taken away to a dungeon. Calista and the kids went to work

with me and stayed all day. Her boyfriend is my stuntman and she spent a lot of time with him, incidentally learning a lot of kung fu.

I had not spent a night at home since I came back. I went home for lunch and the chaos of the place felt too strong and tense for my delicate, new resolve; so, that night, I stayed at the hotel.

Today I fought another twenty bad guys—Hell's Angels, pirates, various rough riffraff, and spent half the day in the dungeon. I was running back and forth between the first and second units, so I didn't have any time off at all. I enjoyed it immensely.

The first two days, on second unit, I put on the bald cap and saffron robes and played rock and roll electric guitar in the temple for an episode called "Kung Fu Blues." When I had a break, I visited the house again. Everything was very calm and Gail was an angel, so that night I went home. She cooked me up some lamb chops and we had a beautiful evening. The next morning, it started all over again. By the time Johnny picked me up, she was more than a little argumentative. She tried to convince me, unsuccessfully, not to do the *Mata Hari* shoot. Too much money. But I have to do it; pretty much no matter what.

JANUARY 7

This is a Saturday. I stayed overnight with Calista again. The home front is just too hot to handle. We stayed up most of the night and slept until about 2 P.M. When we got around to going down for brunch, the restaurant was closed. We had high tea in the lounge. After that, I found a piano and improvised for about an hour while Calista danced in her special way, which she calls pau kua ballet (pau kua being a soft kung fu style). The kids danced around too. Then we went to the health club and frolicked in the pool.

Mike Dawson, my stunt double and Calista's new flame, joined us. Calista consistently falls for anyone who wears my wig. There must be some Electra ramification there.

When we got back to the room, Calista bolted the kids down to their homework, while I bolted myself down to my computer. Calista handled her task like a drill sergeant from hell. She made the girls cry, but they did their math and Mariah and Sienna tearfully fin-

ished their piano practice; then Sienna attacked her violin. The results were cacophonous, but progressive.

I'll be spending the weekend here, unless home gets more friendly.

JANUARY 10

Work has settled down into a groove—good stuff: talking and fighting. The guest star villain is an outrageous guy and completely off the wall. His performance is so good, it's scary.

For the last two nights I've gone home. Things are very smooth. I haven't had a drop to drink and I'm not tempted. I've seen Calista and the kids for several hours every day. It is for this moment the best of all possible worlds.

I'm working on the book every chance I get and getting a lot done. It's an interesting experience remembering my whole life and writing it down. I have to live every moment all over again. Ones of great sorrow and pain and also the glorious ones, the funny ones.

Today we're shooting on a sound stage two hours away. It has its own Shaolin temple. Very different from ours. I just finished a fight scene. We'll be here until the end of the week and working long hours, so I'll be staying in a hotel nearby. I'd certainly rather be home, but I'm looking forward to a long, peaceful weekend with Gail, the dogs, the kitten, and the mice. Lot's of mice. Not the house variety— field mice, their burrows unearthed by all the construction going on around us. That's why the cat. He's already caught three of them.

JANUARY 18

We finished the season last Wednesday, though we're still screwing around, picking up things we missed with the second unit. Calista and the kids are leaving tomorrow. They all had the time of their lives and I think Calista has, with my help, come very close to beginning to realize some of her dreams. I will miss her a great deal but she'll be coming back. I talked to her on the telephone. She told me I'm her only true friend. Maybe so.

Tonight there's going to be a cast party. It will be disco music,

very loud and impossible to talk over, but it will do the job. Gail and I will stay about twenty minutes. Just long enough to say hello and good-bye.

I've seen a lot of shows end, with mixed feelings, but I have no doubt this one's not over yet. Actually, I feel like we're just getting warmed up.

JANUARY 28

I started work today on putting together what I'm going to do during the hiatus. Big Howard (four hundred pounds) has come up with a bizarre way of financing Fred Yager's script, *Close to the Source*, using foundation funds and hooking the movie up with various charities. We wouldn't make any money, but that's scarcely the point; and we'd have a lot of fun and get the movie out. Plus benefiting the poor and homeless and some of the charitable institutions.

There are some other options: a project Mike Dawson is trying to put together with Bobby, Calista, and me. It would take very little of my time and generate some real money, ensuring financing for *Mata Hari*. There's a Russian movie, to be shot in the Ukraine on the Black Sea with a Kafkaesque script and some of the best Russian talent available. That part of the world is a danger zone, but I've been in revolutions before. Then there's a Hollywood picture with the Carradine brothers: David, Keith, and Robert. All still in the dream stage. We'll see.

FEBRUARY 1

Today I had my first editorial conference with Peter Ackroyd, publisher, and Kathryn Sky-Peck, editor. I spent a week putting together photographs from my archives, going back to the nineteenth century. Everybody loves the book, which is a good start. There's some talk of shortening it up, but it became quickly clear that that process will meet with some strong resistance from me. In the end, though, what's good for the book will win out.

Tomorrow, I have to go to court again for what we are calling "the dome kick." People on the street are now calling me

"Glasshopper." The Canadians are really jerking me around. The "Crown" is sticking its nose in. They are a very stuffy bunch. Parliamentary governments are not democracies. Everybody is tripping over their own wing tip shoes, trying not to be caught giving me special treatment, the result being I'm getting especially harsh treatment.

FEBRUARY 2

The court appearance was nothing. I have to appear again on the 10th, but Chris Osborne, my attorney, will make the appearance for me. This thing is going to be stretched out for as long as the British Crown can make it last. Maybe they're going to try to make an example of me. Just so long as the Queen doesn't say, "Off with his head!" I can handle it. I am yet to have a day in court to tell my story. I may never have it.

FEBRUARY 7

Johnny drove me down to Hamilton, Jeff Cooper's turf. I didn't see Jeff, but we spent a delicious couple of hours talking to George at The Guitar Clinic. I brought in my Gibson double-neck for long-needed repairs, picked up my Contreras, and checked out the progress of the custom double-neck George is making for Bobby. It's going to be orgasmic.

Calista sent me dubs of the tunes she's working on in Seattle. The songs are good enough, the guitar player is excellent, Calista's vocals are great, but she's buried in the mix. These guys can't mix their record. They don't know how to do it.

FEBRUARY 10

More meaningless courtroom ritual. There is now a date for March 26th. Perhaps the thing will just go on for the rest of my useful life, like Kafka's *The Trial,* or until I flee across the border. I prefer going to the dentist than this kind of thing. At least the dentist delivers relief and positive results along with the torture.

FEBRUARY 14

After a week's delay because of a blizzard, Gail and I have flown down to New York, as a Valentine's Day outing, to visit Mary and do some business. Gail and Mary together are fairly irresistible. We're working on merchandising, interactive CD-ROM games, and new ideas for movies. No time for vacationing.

I'm having a great time with the women. I have two Valentines. I picked up some trifles for them and Gail gave me an electric razor. I have five now. More in keeping with the spirit of the day, I got myself something from Tiffany. These are the times when a little extra money is fun.

Bobby tracked me down at the Plaza to tell me how much he liked the Carradine brothers picture and give me some input. I think this one is going to happen.

Mary took us to the 21 Club for lunch. They were friendly in a great old-fashioned New York way. There's no place like 21. I used to go there with my dad.

A lot of these places are dying out, mostly because of high-rise development. Chasen's, a restaurant institution in Beverly Hills, went a few months ago. After George Burns had invited everybody there for his 100th birthday party. Well, theatres are supermarkets and bowling alleys. But there's a bright side. Supermarkets are huge country and western bars, with live music and dancing.

There are no horses on Rodeo Drive anymore, but there are a few Bentleys, Ferraris, and an Aston Martin or two. In the country you get big, shiny pickup trucks with great sound systems. I like to drive my cars and keep my horses, too.

After lunching in the dark wood/white table cloth dining room of 21 with these two beautiful ladies and being made to feel like a cherished spirit, I took them to Cartier, for a little more money fun, and to the health food store. You can't enjoy all the good stuff if you don't stay healthy.

We finished off at Mary's house, playing with the cat and watching *Aladdin* on TV. The girls went off to some meetings and I came back to The Plaza. This should be our last night in town. The red rose on the desk is wilting.

FEBRUARY 21

Well, we didn't leave as scheduled. We had some serious talks with Michael Stern and some others about merchandising; the focal point being interactive CD-ROM educational games based on the teachings of kung fu. This means I have to crouch over this computer again, for God knows how long, knocking out story lines.

Gail left on an earlier plane. She's worried about the dogs. I'll get home at about 11:00 A.M. At 2:00 P.M., I'm due at a looping session. This will probably be my last work in Toronto until we start up again in July. We're all very hungry for the hills of home, though I won't get much time there. No rest for the likes of me.

I'm juggling more oranges and bananas than I thought possible: four potential movies, plus *Mata Hari*. The interactive thing, Calista's comeback, Kansas's first testing of the waters, my "non-charitable" foundation to benefit the homeless, the house in Toronto, the ranch in California, the growing menagerie, the new house/cum office, the resurrection of *You and Me*, *A Country Mile,* and *Americana*. Then there's the medical and dental issues, which simply have to get done right now. The beat goes on.

Maybe I'll get a week or two on the lake before the summer's over.

Kansas has a new horse trick. She jumps her steed through a flaming hoop at a full gallop. She's very excited about it. I can't wait to see it.

FEBRUARY 24

Everything in my life is coming together. I just now pulled myself out of the funk the end of the season had delivered me into. It's as though I suddenly woke up, realigned myself, and became a human again after seven months of being a workhorse. I hadn't any idea how exhausted I was. Gail and I are getting along better than ever right now. The stuff we started up in New York is looking good. We've decided we're going to take a few days in the Caribbean before we go home. Everybody else is doing that. Johnny went to the Bahamas; Chris just left for there. Tony and Lynne Stolts spent two weeks in Hawaii. Tom

Treloggen is driving to New Orleans. I have one more day's work coming up and then I'm free. We decided on Bermuda. The history of the place has always fascinated me.

MARCH 1

We stopped in New York to do a talk show: "Jon Stewart" (a hot young firebrand comedian), and to follow up on the interactive CD-ROM project and to visit Mary. A friend of hers was dying of AIDS and she needed someone to hold her hand. New York was cold; the talk show was hot! For the high spot, I did a tap dance. I wasn't ready for it, but I figured if I didn't do it now, I might not ever get it going again. They offered to provide me with tap shoes. If you don't have your own, you probably aren't the real thing. When I pulled them on (brown and white saddle shoes, made in 1922) it all came back.

MARCH 3

Bermuda is very quiet and chilly. Well, it's right out in the middle of the Atlantic Ocean. People are friendly and the place is very beautiful, but we itch for the fast lane.

MARCH 10

We have acclimated. We now love these Islands, to the extent that we have extended our stay. We've moved into the main town, Hamilton, for the last days. It's much more lively here. We will definitely be coming back here again.

The native Bermuthians identify their island as "40,000 alcoholics clinging to a rock." Of course, I'm not involved in that activity and I'm having as much fun as anybody—maybe more. The non-drinking thing is working really well. Seventy-eight days and going strong. I'm alert and industrious and I'm in a good mood almost all the time. I don't yell so much. I'm smoking too damn many cigarettes, but I'll get around to that. Hell! Give me a break! It's the only vice I have left.

All the juice that was missing is back. A floodgate of positivity is drenching us. Gail and I are both working hard and getting things done. We wake up and go to bed happy. What more can you ask?

MARCH 17

This morning we went to the American embassy to sign some papers; pretty much our last official act in Canada for the duration. Within a couple of days, we'll be back home on the ranch. Gail is leaving first to put things in order and I'll follow later, with the dogs, after shipping all our necessary paraphernalia. I don't know how I feel about going home. Toronto is more like home all the time. I have some trepidations.

MARCH 18

Gail called. The ranch looks great but the house is a mess. "Woof" has trashed the place and it stinks. Woof ate a big hole in the carpet. She seems in good spirits about it, though. She's ready to pitch right in. I'm going to delay departure 'til she gets it a little more together. Cleaning house is not my métier. I'm spending a lot of time with Tony Stoltz. I'm also having a blast with the Maserati. Bobby's guitar is not quite finished, which is just as well. I'm going to need the money. The various projects on the books are not coming through as expected.

MARCH 20

I got out of the limousine to open the gate and was greeted by Woof loping down the long driveway (road, really) to greet me. She bears no vestige of her near fatal accident, except for a deep scar on her right haunch. I walked along with her, drinking in the ranch in the late twilight.

The ranch is so green and beautiful that it takes your breath away. The horses are fat and happy, the colt is almost a horse and frisky as, well, as a young colt. Yellow mustard flowers are everywhere. The new fruit trees are all bearing and the grass is as high as your thigh.

The house is squeaky clean. Gail put a throw rug over the hole in the carpet. We were really happy to see each other.

The house that Gail bought next to the ranch to use as an office is in very rough shape, but, knowing Gail, it won't be that way for long.

It's good to be back.

APRIL 17

Calista had made plans to visit L.A. right after Easter to check out moving down here. About two hours outside of town, her car broke permanently down, rather spectacularly, I'm told. I told her if she could get down here, I'd take care of her. I called Stan and asked him if he could come up with a car. Calista arrived with the two kids and a bunch of stuff in a hatchback driven by her ex-husband's ex-wife. We put all the stuff in the tack room. Gail cooked up a pork roast so good that even the vegetarians couldn't resist eating a little bit of it. Calista settled for the veggies au jus.

Stan showed up with a pretty little Chrysler convertible as a loaner. He said he needed time to prepare the car he had in mind. We discussed prices and methods of payment. The kids went off to stay the night in Redondo Beach with Mike Dawson.

APRIL 19

Marcella has taken Calista and the kids in for the duration. Calista danced for a couple of nights at a place in Hollywood and made some money, but her heart isn't really in it anymore. I told her that I had started drinking again. Now that we've become so close, I don't want to start lying to her. Telling her freed me to start telling everybody else.

APRIL 20

Two of Calista's dancer friends from Seattle flew down to check out the dancing scene in L.A. Marcella put them up in the unfinished apartment she's fixing up to rent. Calista said one of them wants me

to father a child for her by artificial insemination. Her special and only condition is that the child be educated in private schools. She's studying to be a surgeon by day and dancing nude at night. A bizarre and titillating suggestion—I'll have to think about that one. I've always wanted to father another child. I wonder if I'd get to name the baby.

I took a meeting with Roger and Julie Corman and pitched a movie to them. I also pitched Calista. Something could happen there.

Gail's new "office" is really shaping up. She had the wood beam ceilings sandblasted. The place is going to look great.

Stan came up with a car strong enough to make it back to Seattle and get her around up there. He let me defer the payment until May 1, when we're supposed to get the official notification of the fourth season of "Kung Fu TLC," at which a sizable chunk of money will be due.

He also wants to outfit the car with everything she might need, in case something should go wrong: flares, gas can, extra fan belts, transmission fluid, all the niceties and his AAA card. A friend is a masterpiece of nature.

APRIL 23

I talked to Linda today. Have not done so in quite some time. The occasion was caused by an exciting moment coming up in Kansas's life. She is about to open in a local (San Mateo) production of *The Will Rogers Follies;* the show that Keith was so great in on Broadway a year or so back, and for which he was nominated for a Tony award. She's going to do her rope tricks and play a scene with the guy who plays Will. Kansas is really anxious to have Mommy and Daddy see it together, so it seems to me that we, for the moment, should put aside our differences and remember that we made this beautiful little creature together, with a little help from the cosmos. Linda sounded the same as ever; and, with a rush of fond memories and sad regrets, I realized that, for better or worse, I'll always love her; just as I'll always love Donna and Barbara.

APRIL 24

I saw Linda today. We met at a place in Brentwood where we used to go, which is not too far from Rudy's dentist chairs, where I seem to be spending a lot of time these days. I had a couple of rums and she drank tea, and we more or less talked philosophy. She didn't look too great. She was suffering from the aftermath of an attack of chicken pox, not a cool thing to get as an adult, but she was bright, sober, and quite charming, though a little, I guess, frightened. I could dig it. She seemed lonely. She hasn't been able to see much of Kansas.

She told me a story which, if true, is quite amazing. She and her mother, Louise, never got along. I was always trying to patch that up. In a fit of rage, Louise threw a pan of hot lamb chops at her, grease and all. She aimed for Linda's face (*Phantom of the Opera*) but Linda threw up her arms. She showed me the scars: deep, third-degree burns and some muscle damage from her wrists to her elbows. Shocking! Horrible, actually. I can't describe it. Appalling. I asked her if it could be fixed. She said, "Yes." But she needed my help. I thought, oh, hell. Money. But, no. Advice, direction. Okay.

Anyway, at the end, Linda took care of Louise, using her horribly disfigured arms to feed her, wash her, give her her medicine, clean up her shit, for seven months. One day Louise looked up at her and said, "Why are you doing this? Why?"

Linda said, simply, "David taught me love is unconditional."

Well, I did tell her that. A day or two later, Louise gave up the ghost.

I let all that wash through me and said, "Well, Linda, you always were able to put yourself in a state of grace when you had to."

She laughed and said, "David, you sonofabitch, you taught me."

I said, "I was supposed to."

She said, "Yeah. My biggest problem is I understand you! Everything you say seems perfectly reasonable to me. You taught me all this weird shit and I believed it and now everybody thinks I'm just nuts."

I had to laugh. Hell, everybody thinks I'm nuts too.

It is dangerous to pick up on my teachings. It's even more dangerous to copy me. What gets copied is the surface stuff, the glitz and

glitter. The real character that sustains me is underneath, hidden away. If you concentrate on the shiny stuff, you go to jail.

APRIL 26

I walked into the "office"—new house, studio, whatever you call it, candy store. Jaimy and his men were putting a textured plaster surface on one of the walls in the living room. Gail was unhappy with the way they were doing it. She asked me to show them how. I grudgingly started in. At first, it wasn't really any better than what they were doing, just different. Then I started waxing, or plastering, creative. I turned the wall into a low bas relief. I started out with a female figure with hair flowing in the wind, blowing a kiss at a tree, with ripe quinces hanging on the branches. A flower growing at her feet. A little house on a hill, with smoke coming out of the chimney. A bird on a branch extending over the doorway. The sun in the sky. I stood back and realized I'd done an underpainting with a pallet knife. It took me about forty-five minutes to do it. All it needed was color. If I'd used colors, it wouldn't have taken me any longer. And it had real style. Suddenly I was on fire to start painting again.

APRIL 28

Had a long meeting with Roger Mende about doing the *Mata Hari* shoot in Holland, which won't happen at all unless a big chunk of money comes in. Everyone is alerted. All the passports are in order. I printed out a complete list of everything I need and a shot list. They are in Roger's hands and in Nicolai's and Herman's, in Amsterdam, via fax.

I went to the dentist. Rudy told some jokes and gave me a gloomy but positive prognosis as he drilled away. He applauded me for succeeding in my sobriety and gave me a little book of inspirational paragraphs on the subject. I didn't tell him I had fallen off the wagon.

APRIL 30

Calista, Maria, Sienna, and I caught a plane to San Francisco yesterday and took a cab to San Mateo, where Chris, Keith, and Bobby spent their early childhoods, to see Kansas do the roping act, which begins the second act of *The Will Rogers Follies*, and she was a slightly better act than the guy who had the spot on Broadway and received thunderous applause, at least partly fomented by the Carradine block in row K, including Linda, who came up from L.A. on a different plane and met us during intermission, because of which I had to hold her hand during Kansas's turn, which was a little strange but okay and the two of us being there together made Kansas happy, though I couldn't take it for too long as Linda had a certain air of hurt and desperation which was hard to take, to the extent that if I had not had the brood with me I would have already jumped and run, walking to the airport, if necessary, but Kansas and I managed, due to a diversion created by my firstborn, Calista (God, did it feel good to be there in the most familiar of all places to a Carradine dynasty, feeling the rush of joy and wonder emanating from my youngest daughter as she took her first firm and resolute steps into the ring that is the life's blood of our family), to get alone together, sitting on a riser backstage, like the couple of troupers we are, and she told me she'd like to end her tenure at the Riata Ranch and go to the High School of Performing Arts there in San Mateo, with which I heartily agree, as the show was as professional as you could ask for and a few of the performances were just as good as the Tony Award–winning ones in New York, and the people are friendly, honest, and squeaky clean, plus many of these kids are plucked out of this theatre and taken to professional venues, though Kansas is determined to go to college, where she will major in performing arts and minor in political science, as she is intent on a theatrical career, leading to a diplomatic career, or possibly, by that time, the presidency, of which she is perfectly capable, and which has its precedents in Shirley Temple Black and Ronnie Reagan; we were all going to have dinner together, but Kansas preferred to stay and strike the set as this was the last time she would see any of these people for a while, and Linda had grabbed a cab and split,

so our personal foursome (D, C, M, and S) checked into a hotel and C went straight to bed to nurse the migraine she had developed as a result of having to deal with the constant changes of plans: will we or won't we, when, how, not to mention the dogged idiocy of the lady behind the ticket counter at Burbank Airport, who did not seem to understand any known language and was totally unaware of the concepts of logic, reason, and/or of the fact that one sentence generally is meant to relate in some way to the preceding and/or following sentences and/or responses, not to mention the Herculean effort required to prevent Linda from inadvertently bestowing the same migraneous mal de tête on myself and Kansas, while Mariah, Sienna, and I had something to eat (in the bar, because I could smoke there) and the three of us got into a real heart to heart, such as we'd never experienced together before, and Mariah is a really smart cookie and one of the most sincerely affectionate humans on this planet, while Sienna is merely a child prodigy who is pushing Coltrane on her ax, and we all went to bed happy and caught an early plane back to Burbank with a huge happy sense of family and if this isn't the longest essentially grammatically correct run-on sentence in recorded English literature, I don't know what is, though I could be wrong, because there's always Jack Kerouac, though I may be actually outrunning even that old beatnik and anyway, he was anything but essentially grammatically correct, but, then, he didn't have a Shakespearean actor for a father.

MAY 1

No word about "Kung Fu."

MAY 5
(CINCO DE MAYO)

Gail and I got tuxedoed up and went to the premiere of a new film: *Mi Familia*. Marcella took Calista and turned her loose to work the room. Lots of press. Gail and I ducked out and hit a bar. Calista said it was a great film.

She leaves tomorrow. Still no word about "Kung Fu."

MAY 7

I was poring over the map yesterday to show Calista the best route to Seattle, when suddenly it was decided that she should stay. Marcella will rent her apartment to her. The kids are now in school and taking music lessons and I've got Calista studying music theory. I've set up an appointment for her to see my agent. We've decided to go off to the Miramar Hotel in Montecito on May 10th and dry me out to the sound of the crashing surf and the night trains going by.

Still no word. The silence is becoming ominous.

MAY 9

J. C. Phillips took me to a studio and listened to Calista's tapes. He and John, the engineer, think she's a "Monster." I asked if that was good or bad. They said good, very good. J.C.'s going to take her on. Record her. Her wildest dreams. My job is almost done. I copped to J. C. my falling off the wagon and my plans to start again. We agreed to get together when I get back.

Calista's meeting with The Agency went very well. They think they might have a job for her. I sent her off to Roger and Julie Corman armed with pictures, a video of her work, and three scripts to peak their interest. They loved her.

We've made a date to cut Medicine Man's nuts off. It's time. He's started humping everything. He has little value as breeding stock and he will be a handful and a half if we don't do the deed. If we do it now, he'll grow taller than he would have if we hadn't.

I've stopped asking about the pickup for the new season. I figure, "If it be now, 'tis not to come; if it be not to come, it will be now; if it be not now, yet it will come. The readiness is all." If the waiting is good enough for Prince Hamlet, it's good enough for me.

MAY 11

Long day yesterday. I made a point of really pushing my capacity for booze to the limit—last chance. Bruce drove down with a truck full

of goodies of mother's, paramount of which being the desk at which I studied in high school and college: a beautiful piece made by taking apart a sixteenth-century organ. We talked for quite a while as the desk reposed under the big saloon-style nude of Mother by Will and I consumed every drop of liquor in both houses.

Calista took the kids back to Marcella's, preparatory to whisking me away to herb tea land.

Shortly before last call, Gail stole me away for a drink at our local pub. I abandoned my pose of sipping Fernet Branca and downed four shots of rum. By the time Calista showed up at the ranch, we were both pretty lit. Gail really didn't want me to go with her. She and Calista almost squared off in the driveway.

Gail went over to the other house for something and, to avoid further confrontation, I said, "Let's go. Right now!" I grabbed my computer and a guitar and we jumped into Calista's car and zoomed away. No extra clothes, no vitamins, nothing. We had to run!

We arrived at the Miramar about 5:30 A.M. We crashed immediately and slept half the day away. When I opened my eyes, the beach looked like a Simbari painting. An old lady with a red hat sat under an umbrella on the boardwalk playing with a laptop computer. Calista put on her bathing suit and practiced the first combination exercise on the beach. We went to lunch at a Mexican restaurant and shopped for a couple of things and went to the bank. I outfitted myself in a Save the Earth beach shirt and boxer shorts. By evening, I was nervous as a cat—scared, actually. Shaky. I discovered I had a toothache (I had skipped an appointment with Rudy and now I was paying for it).

MAY 13

Today we drove in to Beverly Hills to see Rudy. While we were at it, I got them to x-ray Calista. One way to drag her to the dentist is to have her drag me. He prefitted the bridge he had made for me, then put the temporary back on. Then he stuck a needle in the other side of my jaw and, while I was numbing up, examined Calista's x-rays. We conferred together about what needed to be done. Having spent thousands of hours in the chair myself, I'm an educated observer. A lot needs to be done. Her teeth have been sorely neglected. When I

was numb enough to work on, he ripped off the bridge on the other side to take a look at what could be done. Next week, we both get to have root canals. To wait out the traffic, we sat at a bar on Rodeo Drive. I had a bunch of espressos and she drank herb tea; me in my shorts and tropical shirt and she looking like Julia Roberts in *Pretty Woman*. Calista thought it would be fun when people asked how I had managed to stop drinking, if we would say, "Oh, we just hung around bars."

We swung by Marcella's to pick up my power cord for the laptop and a couple of shirts. And cigarettes. Very important. The kids were happy to see us and showered Calista with Mother's Day gifts. Mariah has a new girlfriend.

Sienna showed me her "Book of Nothing" in which she has already filled several pages with drawings and writings. Sienna's not very social. She prefers to spend her time playing with paper. Mariah, on the other hand, is almost too social. She hugs everybody all the time. I'm going to have to keep a shotgun handy.

We drove back to our haven and had dinner in the hotel. I figured something soft. Poached salmon. Calista gets a lot of salmon in Washington, so she went for swordfish. Then we sat in the piano bar and drank tea while a very talented and funny black pianist played old standards with great gusto.

Calista thought it was outrageous that, on the second day of my cold turkey cure, I would amuse myself by being driven for two hours to have my bridges ripped off with a diamond drill at 300,000 RPM.

MAY 14

Last night, we watched a video of *Daddy Longlegs* with Fred Astaire and Leslie Caron. Calista loved it. I always have. We talked for a while and then she fell asleep.

I worked on the computer for hours and, when I shut it down, walked out to the machines and bought a Coke and some corn chips. She woke up and we talked some more while I consumed the junk food. Finally, I fell asleep. I slept fitfully until I don't know when. I would wake up and see her writing in the corner or just staring at me. Finally, she decided to leave so I could sleep peacefully.

I woke up at 3 o'clock. I drank a little of the left over Coke and picked up the room. I assembled the dental care apparatus. Then I took the camera and went outside. I found Calista asleep at the pool. I took a picture of her and then got myself a Coke and some Wheat Thins and sat beside her. She woke up (it takes very little to wake her) and shared my bounty a little. She had a sip of Coke and one Wheat Thin. She's always watching her diet. I took the afternoon sun for an hour or so until it got chilly. I took a couple of more pictures.

We got dressed and drove to the Biltmore where we had tea and a late lunch, while a girl played, with a very manly style, the overture from *West Side Story*. I smoked a lot of cigarettes.

We drove through town and back to the hotel, getting lost as usual. I fell immediately asleep. I woke up at 10:00 A.M. and she showed me what she had been writing: the circle of sharps, from memory. I checked it out and it was correct, as far as I could tell. We discussed music theory for a while and I picked up Boleslawski and read some of the 6th lesson, while Calista talked to her mother on the phone, laughing a lot. Her mother wanted to know why I was reading a book I had read in college. I said, "Uh . . . because." More laughter. Why was I? There might have been something I missed. I wish I could talk to my mother on Mother's Day.

We finished off the night watching Warren Beatty's *Dick Tracy*. We laughed and cried at it.

MAY 15

Marathon movie watch. *Funny Face* with Fred and Audrey Hepburn; Sergio Leone's epic *Once Upon a Time in the West* with Charles Bronson, Claudia Cardinale, Henry Fonda, and Jason Robards—the uncut version: twice; a Gene Autry picture, colorized. Sushi dinner. Three of the new "Kung Fu TLCs" that I brought with me, all with Calista in them. In one of which she kicks ass royally: she, Kim Chan, and me fighting side by side.

Still no word on the fourth season. Warner's and the PTEN have got to be really butting heads over time slots and money. Who cares? I've got you, Babe.

MAY 16

Great day. We went shopping for health food. Lunched on the rustic porch of a little place in Montecito. Just after the last bite of my omelet, the temporary cement let go of the bridge. We started to get into the car to look for emergency dentistry when Calista pointed across the street. Bingo! Dental center. Slipped us right in. Fixed it up. The good doctor marveled at the implants. Told me Rudy does good work. As if I didn't know. Some scintillating dental conversation. Prescribed an antibiotic. Told me it would be helpful for the impending root canals. Wouldn't charge me. Cost me an autograph. Went to a pharmacy to pick up the prescription. A lady had me autograph a *Black Belt* magazine. I didn't know I was in it. The pictures were terrible. Fat and old. Probably drunk. Her son is studying karate. Has a belt of some kind. Calista bought some Nivea wrinkle cream.

Took a long walk on the beach at sunset. Ate our health food, took vitamins, swilled ginseng ginger ale and watched *Camille Claudel*. Then I hit the computer while she slept.

MAY 17

4:45 A.M. Night of the 6th day, morning of the seventh day. Take your pick. Feel great! Yesterday I woke up early. I have so much energy, I don't know what to do with it. I did this and that quietly and, when Calista woke up, I hit the computer again, while she went out by the pool and did kung fu. After about an hour, I took a break and stood in the doorway watching her until she caught me at it. She gave me a radiant smile and went on working. I should have taken a picture. I went back to the Powerbook. We had a fish lunch in the hotel and moved to the bar for coffee and tea (You can't smoke in the restaurant). After some animated conversation, I was itching to get back to the book. We went back to the room and I juiced up the famous window-breaking story. In the old version, I just reported it. The whole truth and nothing but the truth can't be skimmed over. I had to get into the mind of a peyote madman. People want to know.

Gail called. We'd taken the block off the phone. Figuring I'm

strong enough now. Strong? I'm the Laughing Lion Buddha! I'm ready to give Atlas a beer break from holding up the world! She was very sweet. Rattled off a bunch of news. It was good to hear her voice. At the end, it went a little sour over her vendetta with Calista. Give it time. No one can hold out forever. It will be so great when this Berlin Wall crumbles and we can all be together and laugh and sing.

Calista talked to Mike (Dawson, her lover) for awhile and then worked on her music theory with her Seagull 12-string guitar. Playing scales. Then she said, "Okay. Moroccan, Thai, French, Middle Eastern, Country, Japanese, Chinese, Italian, Mexican, or Natural."

I said, "Uh, French or Natural."

She said, "Natural has a health-food store connected with it."

I said, "We're loaded with health food. We even have health junk food."

She said, "Well, what do you want?"

I said, "Fine French cooking is close to the best food there is."

She said, "It's been a long time since I've had fine French cooking."

I said, "Right. You definitely don't get enough fine in your life."

We found the place after getting lost a couple of times: Le Poupon. A tiny little provincial-style thing with the kitchen in the dining room and Edith Piaf over the sound system. They said they were closed. I said, "Ah! Quel dommage!" Calista put on her best smile and said, "No, you're not. You're open for another twenty minutes." We had escargot, bisque d'homard, Truite Meunière et Soufflé au Grand Marnier.

Incidentally, Calista can bone a trout as well as I can, which is saying a lot. I can beat out most head waiters. Actually, she did a neater job than I did, though she asked them to leave the head in the kitchen.

I sang along with Piaf on "La Vie en Rose." I was told I could sing here any time. I said, in my best Inspector Clouseau accent, "You cannot afford me. Very expensive." We laughed and laughed.

Back at the hotel, we paid the bill and had a drink at the bar: Coke for me and a (if you will excuse the expression) virgin piña

colada for Calista. We joked with a lovely couple who were writing a romantic novel with social overtones.

We went to the room and played guitars together for a while, then watched *Karate Kid IV*, the one with the girl. We loved it. We talked and she said, "Look, Dad, I've got to go to sleep or I'll fall asleep driving tomorrow." (Tomorrow is the implants: two for me, two for her.)

That's right up to the minute. We're going back to face the music. I'm ready as I'll ever be.

This liquor thing is a bitch, but I've figured out what went wrong last time. Sure, I quit drinking but I didn't start working on getting my chi back. I didn't do much about getting back in shape. Calista said, "When you quit something, you have to replace it with two other things." Hell, I've got a whole bag of tricks at my disposal. Start painting again. Direct a movie. Meditate. Get back on the horse. Climb the mountain. I've promised to teach Calista how to tap dance. I can't do that while I'm sitting down, bending my elbow.

Maybe I'll be wrestling with this demon for the rest of my life. Okay, then I'll wrestle. If I fail, I'll start again. But screw my courage to the sticking point and I'll not fail.

MAY 18

We made it back to L.A. in an hour and fifteen minutes, through traffic. Calista can drive. We did our root canals in tandem. Two for me, three for her. It was a piece of cake. Larry Brockman is a master endodontist. I asked him how many he'd done. He said about thirty thousand. We walked down the street and had some Japanese food, reasoning it would be better to do that before the procaine wore off. Even though we would dribble a little, at least it wouldn't hurt.

On the way, I taught her the song "We Belong to a Mutual Admiration Society." Seemed appropriate. We got together on a soft shoe step to go with it. Rootless and in love. A father and daughter act. It could sell.

I talked to J. C., who was happy as hell to hear the cure was successful. We made an appointment to get the three of us together

tomorrow to talk record deal. His view is we're going to take an hour out to plan our lives. He said something else very interesting. I mentioned that Country was the biggest thing happening now and he said that it's moving over to folk country rock as we speak, which is right up our alleys. He was ecstatic at the perfect, he called it, timing.

We spent the evening doing a marathon "Kung Fu" watch. Two segments I have on cassette and one on the regular tube. I read a bunch of my book to Marcella. She wanted to go to bed, but she was too fascinated. A good sign. She said she wants to put me on tape reading it. Well, I'm an actor. I'm very expressive.

May 19

Got up, made coffee. Calista was doing her kung fu with weights on her wrists and ankles. She does it to loud rock and roll, so I put on my tap shoes and worked out for an hour or so in my swimming trunks. She came in and I taught her the shuffle off to Buffalo, the step you use to leave the stage, waving your straw hat. Next gig: Buffalo. She made me go outside so she could take a picture. She told me the shot was on a roll with a bunch of naked dancers. We took baths and J.C. showed up. We had our power meeting. He was even more enthusiastic today—if we go about this in an orderly fashion. First, we decide on the vision. Then the artist (Calista) fits it to her. It has to be her vision. Then we put the material together that fits this vision. Then, we assemble the band. Then the band and the artist rehearse. When everybody's got it all down, we take the complete package into the studio and lay it down, and lay it down right. He left saying Monday he'd come in with a rough vision. Calista said, "The rougher, the better."

Calista told us her vision of the album cover. A white horse, with wings (Pegasus) with Calista astride it, dressed in Heavy Metal Valkyrie garb, thigh-high gold boots, metal halter, hair flying, sword in hand, sailing over Mount Rainier, with the full moon between the wings. J.C. said, "Great! We can sell a lot of posters."

I think we should call the album *Fortune's Toy*. That's how Calista describes herself.

In fifteen minutes, we're all going to meet at an AA meeting, which will be full of sober rock and rollers, the best kind. Gotta go.

MAY 20

Okay. May 20, the day Barbara and I fell in love way out in that desert in Arizona.

Last night was quite wonderful. The AA meeting was inspirational to say the least. The bond between the dynamic trio of Calista, J.C., and me grew stronger. Calista really got a kick out of it. She grew within. It did her good to see how happy and together these people are. She's been living all her life, as have most of us, in an environment full of drinkers and druggies. Suddenly, she is not alone; she realizes that she's not the only one on the planet who is having more fun and being more effective on the natch than all the supposedly enlightened users. I took a chip, as did she.

After the meeting, we stood around being convivial for a while. Calista opened up and told a few people her story, or part of it. It was entertaining and, perhaps, the most inspirational part of the whole evening, though later on things got even better.

She dropped me off at the ranch. Woof met me at the gate, jumping up and dancing around me. We walked back to the house together, the other dogs barking like crazy. When they realized it was me, they jumped around and wiggled their rumps. Ruffles and Champ howled with delight. I howled with them and whinnied at the horses.

Gail was graining Medicine Man and Captain. I came up behind her and hugged her; took the bucket away from her and grained the colt myself, petting him and talking to him. We went inside and, after a little conversation, I took her to bed. She protested that she was dirty, which she certainly was, but she looked and smelled adorable in her dirty jeans with her rodeo buckle (a silver heart with a big "G" in gold in the center) and her dirty denim shirt and dirty hands and face that smelled like a young horse.

I lay her on the bed and took off her shirt and camisole, pulled off her boots and Levi's and we made delightful, fun love for a while.

Before consummation, I made her dress and we walked out to the horses; good thing, they had broken into the hay barn. We laughed a lot as we got them back out and secured the gate. Then we walked on over to the new house and I checked out the progress. The place looks great.

Gail lit a fire that she had already built and we sat in front of it and listened to FM while she told me all the news of the last week. Then we walked back to the house. We wandered around the rooms while Gail talked happily and animatedly. Eventually, we went back to bed. We slept for a while and then I woke her up and we made riotous, long love. This time, we finished the job. I went to the piano and played "Easy to Be Hard," "Desperado," and "Lay, Lady, Lay."

After a couple of hours, Earl Miller showed up with a camera crew and a female gladiator named Natalie for his *Penthouse* shoot. The house was full of makeup, hair, and wardrobe, and some of the most prodigious female architecture around. Earl kept saying, "And it's all real!" No silicone. The horses loved her too. Dino was wrangling them, which kept him close to the action.

I slept most of the day. I could have gone out into the woods and watched the action, but all three of the girls were snarling at each other. When I woke up, they were having their lunch break. I love watching beautiful women eat.

Earl showed me the pictures of his baby boy. I considered the humor of this old reprobate (twenty-two years shooting *Penthouse* photo features) showing me baby pictures. I talked to him about his contacts with the headliner stripper agents. He told me they walk away with five figures in cash for a weekend's work. That sort of thing could really take up the slack until Calista's ship come in. She might as well make some real money at her current specialty before she walks away from it.

After Earl had shot the sunset and they all had left, we reminisced and laughed about it. Roger Mende came over and Gail fed him the chicken breasts with mushroom gravy she'd been working on. Roger says that he knows there's no justice on this Earth, because the two best chefs he knows are married to each other.

I mentioned the fact that Natalie's mammaries were real and he said, "Ahh, I picked up one of them and saw a definite scar."

I said, "Dino, how did you happen to get yourself in a position to do that?"

He said, "I'm glad you asked that." It seems that he was crouching down wrangling Indian Woman to get her head in a shot while Natalie was perched on a tree branch, with her legs spread, having removed her barbarian fur scant costume, when Earl asked her to arch her back.

She tried, then said, "I'll fall off. Dino, could you support my back with your hand without it being on camera?"

So Dino is curled up below, holding up a naked barbarian goddess with one hand, while holding the horse's leadline with the other, when Earl says, "Now turn, so I can see those back muscles." She twists around and Dino shifts his grip to her front and, in doing so, pushes up on her left breast and Bingo! Telltale hairline scar.

After some more frivolity and some espresso, Roger drove me to Marcella's and we conferred with Calista about the Holland shoot. Calista pulled out her 12-string and sang a song she'd written using Shakespeare's 29th sonnet as the lyrics. It was dynamite. Roger was knocked flat. He'd never heard her sing. I told him he'd be hearing a lot of that before long. Calista brought out my Mossman and we sang a few songs for Roger and Marcella. Music is really fun when you've got someone doing it with you. Solitaire is okay, but I'd rather play Hearts, anytime. I made it home around dawn. Gail and I fed the horses and watched cartoons on TV.

MAY 23: MORNING.

Left the ranch yesterday, at 1:30 P.M. to go to the dentist. Never made it. Stan showed up, essentially to applaud my sobriety. I gave him some of the money I owe him. He told some great stories about the early days.

Example: Stan came to see me in *The Deputy*. He came backstage and said, "I don't get it. You've got your name in lights and they're paying you more money than you've ever seen, for doing what they used to arrest you for in San Francisco." Calista laughed, a beautiful, raucous, tinkling thing. "And that's not the worst of it," he said. "Outside, they're asking for his autograph. I told them, 'Six weeks ago

that signature would have meant you were burned for whatever number was written on the check.' "

Calista told him a story about our relationship. She said, "I've got this Genie, who knows all the answers to the Universe, but sometimes my Genie is drunk and he might tell me something that isn't quite right. The problem is, you never know whether you're talking to the Genie or the drunk. He could steer you wrong and get you in a lot of trouble. And sometimes [with vehemence!] he won't even come out of the bottle!"

Had another meeting with J.C. He brought a bunch of CDs for Calista to listen to to get a feel for what she wants to sing. Stuff that she loves. He has interested a prominent production group in taking on the project and a keyboard player, whom J.C described as "The first call you make," and played with Jimmy Page and is now doing an act with Robert Plant which has been described as Led Zeppelin with a Middle Eastern flavor, to set her lyrics to music.

Calista told him about my method for dealing with guys who hit on her. I look at them with a cold lizard stare and say, "Don't even think about it." Then I take a sip of my drink. "You couldn't handle her." A drag on my cigarette (she demonstrates all this). "No one can. I can't even handle her. She'll chew you up and spit you out and leave you broken and bleeding; and when that happens, you'll come crying to me and I'll give you sympathy and pat you on the shoulder, once. Then I'll tell you to get out of my life."

Calista says, "Dad. Cut it out. Chase away the creeps. Don't scare off the good ones."

"The good ones don't scare."

I handed her my Mossman and she wailed out Shakespeare's twenty-ninth sonnet. J.C was blown away and made a note of it. She handed him two of her lyrics and I gave him one I wrote for her. They both flipped for the album title, *Fortune's Toy*. I found out she got it from one of my songs, based on an *I Ching* hexagram:

> *I am the wanderer, my home is the road*
> *Fire on the mountain, I've got no fixed abode*
> *Watch out you don't get burned, I'm too wild for you*
> *Don't let me get you down, I'm only passing through*
> *My home is the road.*

I left it all behind me, a million years ago
And now they'll never find me and now they'll never know
Which way I've gone
I'm movin' on
My home is the road.

Feel the wind in my hair
nothin' to hold me anywhere
No place to rest my head
I won't stop until I'm dead.
My home is the road.

There was a woman once somewhere, so many years ago
She left me or I left her; I can't remember anymo'
There was a garden and an apple tree; and a little boy
Old rockin' chair almost got me; but now I'm fortune's toy
My home is the road.

J.C. and I went to a men's stag AA meeting. Very sober people. Funny. Deep. Reaching out to each other, helplessly and shamelessly. No chicks around to take their minds off the business at hand. No coffee break. An hour and a half of pure therapy and Herculean resolve. J.C. is the secretary of the group.

I worked on the book all night. The kids passed by me one by one on their ways to school and gave me a hug. At 8:00 A.M. Marcella came out of the bedroom and made coffee. I flopped down on her bed for an hour and a half. Calista put on a Bonnie Raitt CD and I went back to sleep to that. Woke up at 10:30 A.M.

Went back to the book. Calista tells me I worked on it for altogether twenty-one hours, nonstop, except for the two naps.

In the evening, Gail called about an intruder. She told me she had locked the gate. She didn't want me to think she had locked me out, which I would have.

Calista invited Mike Dawson over and prepared a delicious candle-lit dinner for all of us. She chose the piano score of *Mata Hari* as

background music. The whole evening was charming. I'm glad I could be there.

MAY 24

Worked all day on the book at the ranch. I found a cache of old notes with some good, juicy stuff in them. Spent the day working them into the manuscript.

In the evening, I went up to the ridge with Calista and Marcella and had some food with Roland and Charles. Calista didn't want to go, but we dragged her along.

Many dogs, three of Roland's and Charles': Lola, Buffalo, son of Lola, and Sam, and two neighbor dogs. They fed us butterfly shrimp the way they cook them on the Mediterranean.

Calista was transported by Charles' room, outfitted for a shaman. Full of Native American artifacts, medicine bags, ritual objects, a buffalo robe. Right up her alley. Then Roland offered her shelter for her horses. "Bring them here," he said. "I will ride them, feed them; I will take care of everything." At no charge! Calista was blown away.

When I got back to the ranch, all the doors were locked. I couldn't raise Gail. A gun shot wouldn't have wakened her. I came in through the bedroom window. Woof jumped through with me. She thought it was great fun.

Worked on the book until all hours.

MAY 25

Woke up in the early afternoon. Consumed a piece of cheese, yogurt with apple sauce, raspberry jam, sweet gherkins, and a Coke. Worked on the manuscript all day. For lunch there was a chili relleno on the stove from Los Hermanos.

Had Gail's split pea and hamhock soup for dinner at the office. Saw the new door: very beautiful, light hardwood with leaded glass, perfectly hung. Had a cigarette and a Coke with Gail, while the sun set. The exterior of the house is now burnt sienna.

Came back to the farmhouse, made some espresso, and went

back to work. Talked to Linda about Kansas and recemented some old bonds. Gail came in with Bradley and Morgan, all of them smiling happily.

After a little visit here, we all went over to the office. After they left, I catalogued some things in my studio. It is now dawn.

Tomorrow (today) I'm doing two interviews at Marcella's: E! Entertainment with Calista, Mariah, and Sienna on film, and a photo shoot for Spain.

MAY 29

The ranch has been delightful for the last few days. Gail has been a gem. She went shopping and picked up two giant stuffed puppies for Mariah and Sienna. Those two have been settling in beautifully. The office is looking better every day. Gail has furnished the place with stuff from the warehouse. I found lots of missing and forgotten treasures in the piles of boxes: books, tapes, photographs, paper work mainly. The greatest find was the *Mata Hari* code book, an object of great value. And paintings. Lots and lots of Will Fosters, some of them great, some in need of restoration. I hung some of the good ones here and there. They look great with Gail's grandmother's furniture.

I took the study of Bernie Griggs, the circus clown, to the framer to restretch it and frame it up. I think I'm going to give it to Sienna. I also framed the two cells of the blonde warrior maiden from the animated feature, *Heavy Metal*, for Gail. The character looks just like her. When I picked it up, Calista talked me into picking up some art supplies for the kids. I got some for myself: acrylic colors, brushes, pallet knives. I found some empty canvases in the garage. I hooked one to the brick back of the fireplace and knocked out a sketch right there.

Today being Memorial Day, Gail went off to Beth's for a barbecue and a swim. I'm watching *Fantasia* with the dogs sleeping around me. I have the choice of following her, or going up to Patrick's house, or staying here and continuing to write. I'm not sure what I'll do. I don't need any food. I've been eating peaches, plums,

and apricots from the Jensen ranch, along with almost a whole pan of Gail's corn bread, washed down with black cherry juice and thick coffee. The swim sounds tempting.

Fantasia ended. They only showed the creation segment. Pity. I was really ready for the whole thing. Now it's "Fraggle Rock." Maybe I will go.

JUNE 2

J.C. is now ready to go. I fronted him some money, so he could activate the production staff and the musicians he had put together. I asked him what it would take and he said, "Shoo! David, they pay me a lot of money; but for you," I said, "What would it take to get it started?" He gave me a figure. More than I have until "Kung Fu" drops the other shoe. We cut it in half and he went out to start cooking. Calista is, of course, ecstatic.

She's a little surprised. She didn't realize I would be putting up the money. She thought a record company would foot the bill. I explained that that would require weeks, perhaps months of negotiations, for which we would, in any case, need to have something to show them. Then they would own it. They would dictate to us those things we want to decide for ourselves. This way, we do as we desire, then lease it to them, control the release and promotion, and we still own it.

We'll have to get something on paper but that will happen down the line. We'll all see some good money out of this, but not until after we've done the work.

Our main joy and reward will be seeing Calista grab her dreams from the sky. Making her a star in the firmament. It won't be an easy ride; we've got a tiger by the tail, but it's a friendly tiger.

JUNE 5

Chicago. Yesterday I did the booksellers' convention. A day of hob-nobbing, glad-handing, and looking interesting for the prospective buyers. I had a great time with Peter Ackroyd—who is definitely a real person—and editor Kathryn—young, slim, with an Audrey Hepburn—

style pixie cut. She was very hyper, constantly looking around as though there was something else she had to do. Finally, I said, "Look, go and do what you're supposed to do. Obviously, hanging out with me is driving you crazy." She said, "David. I'm just like this!"

There was a cocktail party at the hotel for the authors and sales reps. Me, an author! I had a nagging feeling that I must be faking it. A room full of visionaries. Dreamers. Highly educated proselytizers and idiot savants. All with a story to tell.

JUNE 7

It took me two nights and a day to recharge after Chicago. I worked on the book, but mostly I slept. Gail and I watched a marathon video cassette show. *Legends of the Fall,* an absolutely great movie with a particularly exciting performance: Aidan Quinn, a name to watch for; and *8 Seconds,* which was cute, right up to the end and then stopped being cute very abruptly.

As soon as I recovered, I started work on the last stage of the terra cotta head of Gail: the hair, the shoulders and back, the breasts. The "head" is now destined to be a "bust-and-a-half." I've been waiting to finish the work until I'm ready to fire it. Otherwise I have to keep it covered with wet towels, which becomes a pain very quickly. I also started a painting in acrylics. I don't like it, but I'm going to finish it anyway.

Gail struck a deal with Menahem Golan to do eight days on a movie in Minsk, Russia, with Barbara Carrera and Oliver Reed as a favor to celebrate Menachem's return to directing, but the timing went wrong, so it would mean a pitched battle with Warner Bros. The part isn't good enough to fight for. Oliver is wonderful to be around and it would have been fun to make screen love to Barbara and two other spectacularly beautiful women, but let's get serious. We wished him luck.

JUNE 8

Went to the art supply store yesterday afternoon to pick up another

fifty pounds of clay. Stopped by Marcella's. Spent some time with Mariah.

This morning, to the accompaniment of Jim Wilson tuning the upright, I started working on the piece. Nothing went right. After about three hours of screwing around, I was, if anything, worse off than when I started. I covered it up. Tomorrow I'll try again.

I just got the official confirmation for the fourth season of "Kung Fu."

I suppose I should celebrate.

JUNE 10

I've been talking to everybody concerned, putting the Dutch shoot together. All I need is for the money to roll in. It will do so, imminently.

I casually told Gail that I would like to buy the next house. I want to be property poor too. She came up with an extraordinary answer. She said I should buy one for Calista. Then she went out looking for one. Figure that.

Tomorrow is Mariah's birthday. For her present, I'm going to send her to the drama study summer camp in Idlewild. Sienna gets the dance course. They'll love it and Calista will get a sorely needed break from motherhood.

JULY 1

I'm sitting in Peter Jason's little guest house, where I'm going to be staying for a few days to get hold of the booze thing again; also, I need rest. I want to go back to Canada in the best possible shape. If I show up tired and stretched out for the beginning of what will be a grueling nine months of fourteen-hour days, I'll be worn to a frazzle by the time I'm halfway through it.

Peter and I get along really well together and he's an extremely sober person. I didn't want to take Calista away from her process. She's so close now. The record deal is almost ready for the studio. She's studying with Seth Riggs, who is about the best if you can't get Judy

Davis. I went to one of the sessions. The transformation is amazing. As she gets more of a grip on her techniques, her whole attitude changes. Her face glows. She is now hitting notes she could never hit before. Her top note is a minor third above Streisand's C; and the quality and power, even up there, are excellent.

Stacy Keach dropped over and sat for a while. He just came from a session with the same coach. He's on his way to Washington, D.C. to sing "Seventy Six Trombones" for a Fourth of July telecast.

Peter and I talk for hours about everything you can think of. He's working all the time, building things out of wood, tile, and glass; gardening, doing business, but we still have plenty of time for conversation.

I took the bust of Gail to the foundry a few days ago. Roger Mende helped me get it there. It weighs almost two hundred pounds. They'll pull the first cast on the 6th. I'll be there for the unveiling. Then I'll have some touching up to do. I plan to take Sienna with me, if she's back from camp. The foundry will blow her mind. They'll fire it while I'm in Canada. I won't have the finished object in my hands for quite a while.

We had to put down Z-Bar. One of his buddies kicked him. His leg was broken in three places, but he was still standing. There was no hope for him and he was in a lot of pain. Gail sang him to sleep. I went over to the back fence and leaned over it for awhile. I took some pictures and we saved his mane and tail. With its sun bleached auburn, almost flaxen color, I'll make a beautiful set of horsehair reins. I think there will be enough, if I keep them delicate and slim. I may have to weave in a piece of leather or two.

He'd had a good life, appearing in five movies and carrying a lot of kids and beautiful women around; and he was very old. We shall miss him, that's the truth. He was the best horse actor I ever knew, with a heart that wouldn't quit. Squaw blamed me for it, but I explained to her that I was as sad as she was. I wondered what she was going to do for a buddy, but she took up with the colt.

Gail took off for Fresno to see the folks. Most of the stuff went up to Toronto a couple of days ago. The rest will follow Monday.

I'm really ready to go. Eager to get back in the saddle.

JULY 3

Calista came over in the evening and she, Peter, and I laughed for a couple of hours. She fell asleep and stayed all night, while I prowled around. Hallmark showed up this morning to take me on some errands. Dan, the wardrobe man from *The Long Riders,* dropped by and we swapped stories for awhile.

Calista has decided that the Carradines are like Gizmo in *Gremlins.* Don't feed us after eleven and don't get water on us. Anything could happen.

"Oh, no! Someone watered the Carradines! The destruction of the galaxy is imminent! Whoops! There goes Neptune, whisked off to another dimension, probably in pieces! It will take us millennia to put this back together! I hate it when that happens!"

Tomorrow will be the first Independence Day in decades that has not included the "watering" to excess of this particular Carradine. Ergo, it should be a safe and sane Fourth.

JULY 4

Actually 5th. It's five in the morning. I've been up all night. Last night, the same. I went to sleep at dawn. About noon, I woke up and the first thing I saw was Calista, sitting across the room on the couch that Peter made with a machete—smiling at me. She was dressed in a shammy sunsuit and six-inch spike heels. She said she was dressed as an American. The real thing. We were almost exactly the same height. She told me this was her third visit, the first at 7 A.M., right after I went to sleep. Peter came over and then Hallmark. Then Peter went off to a party. We hung out together happily—and then FREE showed up! We had a truly wonderful time. It was starting out to be a great day of independence.

We talked about Jefferson and Adams. Somebody told me I should do a movie about Benjamin Franklin. I've pretty much got the hair and with those funny glasses and some padding, I could do it. It would make a good story: statesman, inventor, publisher, womanizer, humorist, mystic. I'm too old for Jefferson.

After a while, I put on my tap shoes and we all went over to Marcella's.

Apparently, not watering the Carradines works. The streets were safe and sane. Not even any illegal firecrackers, which in L.A. are usually liberally augmented by gunfire.

Stan was there at Marcella's. Billy showed up and went off to watch fireworks. Calista cooked up a mountain of super-healthy festive food. Tom and Calista did a couple of hours of getting to know each other again and then Free split. He had an early call to make a monster for some movie. I told him I'd made a couple of monsters myself and that I was looking at one of them right now. He keeps getting taller. I hope no one's watering him.

Then Roger Mende came rolling in with three sleepy kids. Billy came back, glowing.

This was the twenty-third anniversary of the last (sort of) day of the *You and Me* shoot. We shot the fireworks in a field somewhere in Washington and recorded a bunch of drunks singing "The Star-Spangled Banner."

We joked, played pool, listened to music, and drank coffee and tea. One by one, the numbers fell, like the ten little Indians. Stan was the first to go, he had a long drive; then Billy. Calista fell asleep in the chair. I woke her up and sent her to bed. Then I took off for my monk's cell. We'd had an absolute ball, hilarious, loving, and deep and not one of us had touched a drop.

I remembered another of Calista's metaphors about my drinking. Daddy is like God to her. And in he comes, roaring drunk. "Will you get that asshole out of here?" She yells. "I don't care if he is God! I don't care if he can make the grass grow and the birds sing! He's obnoxious! Eighty-six him! The other image she has is of her Magic Carpet unraveling in flight.

We gods, the Indians and the Eskimos; you can't let us drink. As an Irishman, this means giving up my birthright.

But anything for the preservation of the cosmos.

⇒ ⇐

It's all over but the livin'
We the sorry unforgiven.
Fought the war and now it's done.
Silly us, we thought we'd won.
All the pretty flowers are gone.
The magic that we used to have is lost.
Yes! We made it through the storm.
Now it's time to count the cost.

All our tears and all our fears throughout the years,
We just had to set aside.
All the dreams and all the schemes, my dear,
That took us on this roller coaster ride
We muscled up and hung right in.
We thought we had it all worked out.
We kept the faith through thick and thin.
But, finally, Honey, what's it all about?

Yes! we made it to the top.
Grabbed up all that we could find.
We didn't know just when to stop.
We left ourselves somewhere behind.
If after all the toil and pain,
There's a spark that still remains,
The blood may wash out in the rain,
And maybe we can start again.

I hope that that's the way it works.
I hope to hell it is because,
I miss you darlin', I miss me.
Yes, I surely miss the way it was.
Empty saddles in the old corral,
Never been my cup of tea.
So why not ride those happy trails again,
Like the way we used to be.

And maybe find that you're still you, my love,
And maybe, baby, I'm still me.

Let's remember how to fly,
And give old cupid one more try.
Let's give old cupid one more try.
Let's remember how to fly.
Let's remember how to fly.
It's all over but the livin.'